Introduction by Juan Carlos Mondragón

Design by Benoît Nacci

Captions by Virginie de Borchgrave d'Altena

LATIN AMERICA

Olivier Föllmi

Translated from the French by Molly Stevens

Abrams,
New York

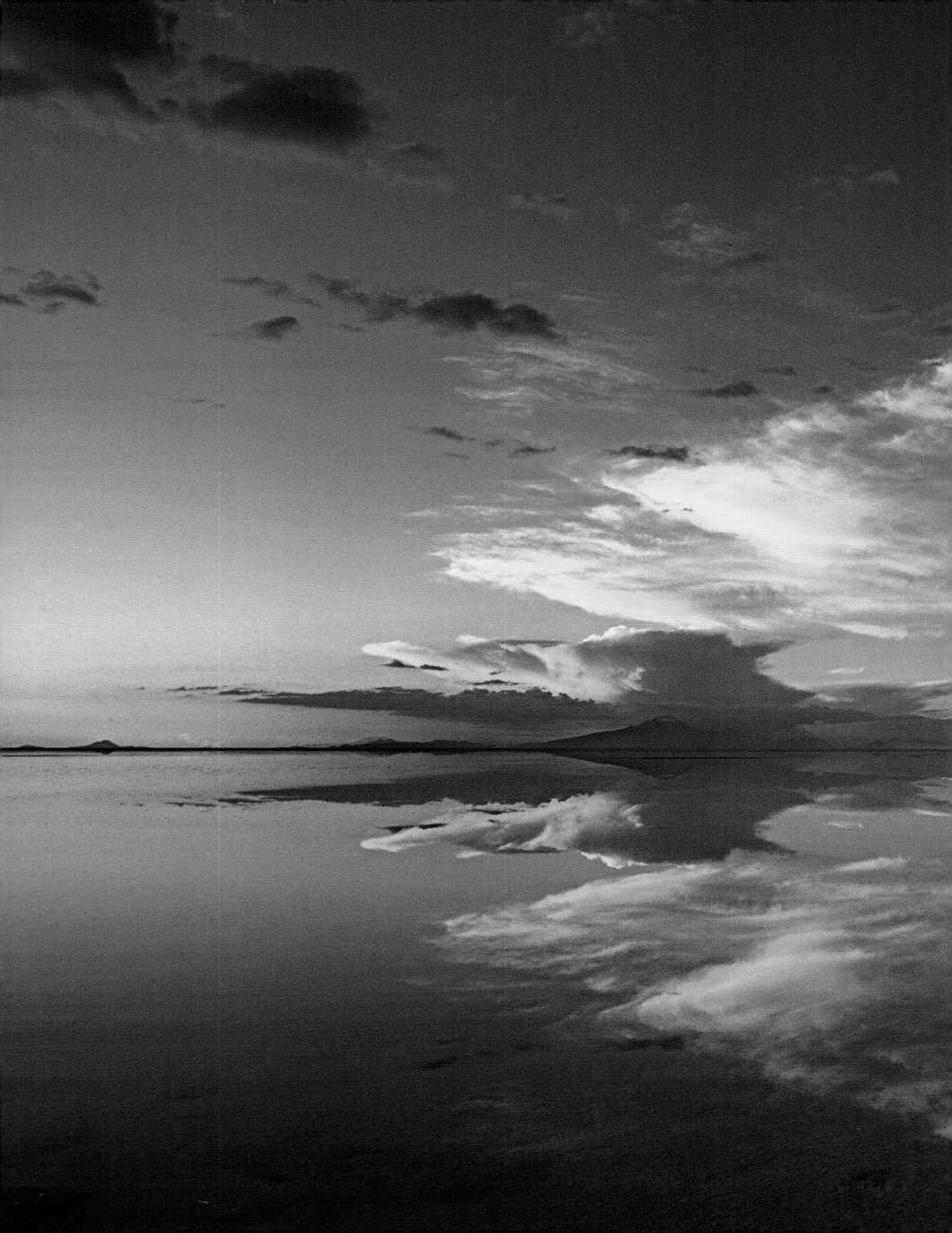

Desarrollos Radiantes y Dulzura
(Radiant Grown and Sweetness)

There are expressions and looks that do not belong to only one
country—they belong to an entire continent, to humanity.
They embody both timelessness and the consequences of history.

In the beginning there was the journey, a journey marked by migrations, coincidences, inner quests, and an imperial undertaking. This prophesied land was but a secondary outcome of the compulsion to embark on the voyage. Part chimera, part conundrum, she has had several names in different languages, multiple lords with feathers and crowns, and her frontiers have been redrawn throughout history. Her true name is a secret one, but there has been a recent consensus to call her "Latin America," which, in a way, evokes her double nature. This region of the world is one where myth, history, and poetry meet. In order to understand it, one must recognize the relationship among the three points of origin, which we can do by examining certain defining historical moments.

The first of these was recounted by the moons that lit the way for the people arriving from Aztlan, the legendary ancestral home of the Aztecs. Guided by their god Huitzilopochtli to the place where the eagle perched on the cactus and devoured a serpent, these early Aztecs would remain in the Valley of Mexico to fulfill the destiny of Aztec splendor and apocalyptic submission. The second date belongs to the historical time that governs our world: October 12, 1492 brought together imagination and adventure, meeting and separation, modernity and the Colonial era. Even closer to our time, on the fifth of February 1949, the Chilean poet Pablo Neruda finished his *Canto General,* the most ambitious and most emotional attempt to examine the simultaneous nature of Latin America, something that only gods and visionaries can achieve.

Then at last appears a fluctuating moment in time, which all Americans respect in their own way, depending on the history of their native land. Revolutions and poetry, names close to their heart or names despised, and the story of their families and the place of their birth converge to form our own nationality and personal history. Into this intimate expression rushes the plurality of the continent, the alternation of the common and the foreign, depending on whether one lives in Managua or Guayaquil, whether one loves in Cartagena or Bahía.

Latin America is nature in all its splendor, a magnificence associated with extreme, archaic landscapes in which different varieties of human culture were brought together and fused. We assume that the first groups of people came from the north, crossing the Bering Strait, joined perhaps by others, drifting along the Pacific coast. Following this first stage of the true discoverers came the slow task of inventing ancient cultures, which reached different degrees of complexity, from the gatherers of fruit to the cultivators of corn on mountain slopes. It includes the enigmatic culture of the Maya; the urban splendor of the Aztec capital of Tenochtitlan;

and the amazing organization of Tahuantinsuyo, the Inca empire, where all the roads led to the capital city of Cuzco and the sacred stones of Machu Picchu.

A knowledge of Latin America, taking into account truth, wisdom, and influence, depends on this consciousness. The Andes are not a mountain chain with silver-filled bowels but rather the site of a brilliant culture; poverty is not the work of angry gods but rather that of men influencing history.

The past is part of the present. Society itself gives proof of this, with no need of encyclopedias or statistics to make its case. Evidence of the gravity of what has occurred persists in the faces of the descendants of the peoples who witnessed these events. The expressions of the old people put to shame the so-called laws of history, which arise from an attempt to predetermine chaos. In the high cheekbones of the women of the highlands as they walk to market with their children can be seen a serenity that has something of the magical about it, simply because it has survived. They are asking if another beginning is possible.

On October 12, 1492, what already existed was discovered and its mystery was forgotten. The Americas became a part of Western history, the result of the most unequal clash of people known to humankind, and the design of the world as it is now began to take shape. After the encounter of these two groups, the indigenous and the conquering, the first unification began. The magnetic compass closed up our spherical world: Geography was no longer full of fantasy. The ocean lost its mystery and monsters and became instead a commercial highway for ingots and slaves.

For the Spaniards, powerful reasons for this enterprise resided in the flagship of its fleet. Spain's dominance in maritime commerce would prove profitable to this empire where the sun never set and allow it to refashion international politics for several centuries. The cultures that began to spread around the world were Spanish and also Portuguese, since the venture affected the entire Iberian Peninsula. The line established by the Treaty of Tordesillas set the boundaries of Brazil and divided the future between Portugal and Spain. After the journey of the famous caravels, the nature of the European West and the history of thought shifted away from a medieval steadiness to a nascent capitalism. There were changes in technology as applied to war and navigation as well as in the concepts of power and society. In this new world, as with all the explorations and conquests of the Renaissance, there was a distrust of the culture of the other, a theological conviction, and a pragmatic goal of acquiring wealth.

This was a time that overflowed with significant events for Spain. In the year 1492 alone, the Jews were expelled from the Spanish territory; Granada was reconquered, putting an end to seven centuries of Muslim presence in the South; the first grammar of Castilian was published; and the islands of the Caribbean were sighted, proclaiming the existence of the continental landmass. Columbus thought he had arrived in the East, but through an error in his calculations, he was actually treading on American soil. The opening of a maritime route presented Spain with wealth that became part of the nation's patrimony and had a civilizing influence on it, but it was exploited without being understood.

The euphoria of the conquerors irrevocably changed the present of millions of human beings. The Spanish legitimized their conquests with dazzling discourse, with canonic arguments based on the natural order of things. Chronicles and testimonies, laws and ordinances have been preserved that relate two versions of the events, depending upon how one deciphers the ambiguous figures found in indigenous codices that were saved

from destruction and in European engravings that depict a magnificence both stirring and barbarous. A not entirely uncommon event was the slaughter of innocents, such as that which took place on May 22, 1520, when Pedro de Alvarado massacred the elite of the Aztec nobility in the Templo Mayor, the main temple in the Aztec capital, an act at once premeditated and revealing.

Territorial expansion was inevitable and resulted in acts of plundering that were denounced early on. The ruins remaining are not only of stepped temples and the social structures of traditional populations, but also of memories, of cosmographies and generations, of beliefs and ancestors, and of gods and marvels that have been almost completely obliterated. This shocking elusiveness can be noticed in the case of Diego de Landa, a meticulous chronicler who recorded contemporary sixteenth-century events in his *Relacion de las cosas de Yucatán* (*Account of Things of Yucatán*) yet condemned indigenous documents to be burned during autos-da-fé. His way of conceiving memory and writing about it is just one example of the penchant of contrast, past and present, between events and what remained of them in papers, between violence and syncretism. The new world proved to be as tangible as the bodies of the native women, the vertigo brought by the sight of the Pacific Ocean, and the mortal embrace of the Amazonian jungle. The governors of frontier provinces accepted what had been denied for centuries in Church councils, as they discovered the other, so different from themselves, along with unexplored intimate areas, and revealed them both in the Jesuit confessional box. Alongside the landscapes, a new way of being human was being formed.

Movement became the model. Historians acknowledged the sequence of discovery, conquest, and colonization; wonder, violence, and the establishment of a system, an equation of power that languished until 1898, when Spain abandoned the island of Cuba, the last of her American colonies.

All of this, and poetry as well, were made possible through the Castilian language. Castilian is, for many, the most precious treasure of those turbulent centuries, a vehicle of knowledge, power, and catechism; and a melting pot of the common things at stake in the new venture. There is certainly some truth in this: The fusion of two histories was forged within the language along with the unity that makes a more effective dialogue possible.

By 1552, the military portion of the conquest was considered to be complete, and colonization was begun. Soon thereafter, two events occurred that were crucial for the development of the Castilian language. First, the *Brevísima relación de la destrucción de las Indias* (*A Brief Account of the Destruction of the Indies*), by Bartolomé de las Casas, one of the most violent manifestos ever written against the atrocities committed by the Spanish colonists, was published in Seville, and in 1554 the anonymous *La vida de Lazarillo de Tormes* (*The Life of Lazarillo de Tormes*), a realistic picaresque tale, precursor of the novels of Cervantes, was published. According to the distinguished humanist Antonio de Nebrija, the Castilian language, destined to be the companion of the empire, found a new double mission for itself: It would serve as both critic of and witness to the American reality and would translate the words of those who had lost the power to speak for themselves. Language would become the province of poetic imagination and creative fiction on both sides of the Atlantic: two worlds and two missions for a language with its origins on the frontier.

There is more that can be said about a fearless, never-ending indigenous resistance movement about which not enough is known. It would have been the proper time to propose an item to be included in the Valladolid

controversy (over whether the Indians had souls). During this dispute, which took place between 1550 and 1551 and pitted the views of Sepúlveda against those of Las Casas (known as the "defender of the Indians"), the agenda should have included a discussion on whether men like Alvarado, the governor of Guatemala noted for his cruelty, had souls.

The colonial system made precise the distinction between here and there. The initial plan, based on charitable "universalism," turned into the search for profit, and scientific advances were matched by obscurantism, as were the aspirations of the social contract to submission, the art of the court to the family loom, and the heyday of letters to the darkness of illiteracy. Latin America is also a part of the conceptual abyss of *Las Meninas*; inexorably the two histories fuse like the planes of Velázquez's painting, and in the mirror a dazzling colonial architecture appeared in the Indies, one that can still be seen in some American cities that seem to exist outside of time.

Communal life proves that religious preaching does not teach love of one's neighbor in a way that was beyond reproach. If there is wisdom to be found in the Americas, it is found in the indigenous sensibility: The god of the Pizarros preferred the merciful ones of Santiago de Compostela. On the other hand, if we limit ourselves to examining the enrichment of the investors and omit the suffering of those who were exploited, colonization as an expansionist enterprise was a triumph.

The strategy of the colonial system was conceived on infamy and fruitful chaos: Slavery brought to the continent millions of beings, who themselves brought their African cultures. Violence and miscegenation followed. It would be among the slave population of Haiti at the beginning of the nineteenth century that the first acts of disrespect toward the authorities would break out, in an attempt to destabilize the system. They would be the precursors of the chain of independence movements.

Ideas and bloodlines mixed together and shaped the colonial inheritance of testimony wrenched from the populace by force of arms, the checkerboard-shaped city, the apogee of the Iberian languages, and the readjustment of the nature of the sacred. The system also began to create a specific cultural fabric using powerful and original expressive forms, the result of the confrontation. Without doubt, the sorrowful identity of the region, different from both the original matrix and the imposed model, was being formed: a new history for the new world.

The colonial centuries established order at that time, but behind the appearance of stability grew the roots of decline. While the Iberian vanguard strove to extract not only gold but also labor and religious conversion from the inhabitants, European intellectuals uttered complaints against the god of the Counter-Reformation. That's where ideas, reason, and methodical doubt would come from—in other words, the Enlightenment that would become the arms of the American independence movement and the worry of the criollos, American-born descendants of the Spanish colonizers. The native people adjusted to an irreversible situation, and some Spaniards began to feel like Americans. The viceroyalties of the Indies began to lay claim to certain characteristics that would later help to create nations.

In the same way that the early years of the conquest saw the passage from a jaguar-shaped Cuzco to the founding of Lima, the nineteenth century saw the passage from the colonial period to independence. Nevertheless, there were powers for whom the centuries of marginalization were not enough, and they continued to dispossess the powerless of their fertile land and to commandeer their labor. This was the result of some-

thing lacking in the criollos that was not resolved at the time of independence, many of whose ideals degenerated into dictatorial regimes. Latin America is called Pacha Mama (from the Quechua, literally "Mother Earth"), and there are groups for whom the land continues to be a symbolic attribute, economic salvation, and their only resource for survival. A solution to the agrarian problem is still awaited.

The word *discovery* retains an unused potentiality. With regard to Latin America, the experience of independence is a definitive chapter full of contrasts: The criollos broke with the metropolis, the natives did not participate in the symbolic strategy, and the various regional histories drew the present-day map of the region. Latin America has become both one and many; it runs on a calendar made from stone and battles that denote different historical times. Along with language, perhaps the greatest legacy is that sense of responsibility stemming from conscience, which can manifest itself in a hundred ways. Memory is a part of this even if those laying claim to it are descendants not of the Incas, but of the boats from the end of the nineteenth century.

Independence assumed the intersection of the religious Baroque and the articles of Diderot, the Count of Olivares and Simón Bolívar. With it began another era and the complexity of the paths that each people would take. The Western Indies began to call themselves Mexico and Zapata, Argentina and Sarmiento, Cuba and Martí, Nicaragua and Sandino. Each country is inhabited by its own creative reality, a dance, a flag, and the conviction that its people are paradigms of the whole.

Latin America is also an infinite narration, a story associated with the wonder of the journey. The first notices of the continent are in a diary written onboard a ship. The chroniclers followed, then the travelers, and later the one hundred years of solitude in Gabriel García Márquez's town of Macondo. The continent proved to be a call to adventure and observation. The conquerors, succumbing to the charms of what they would later reject, stayed there to live.

A perfect example of this is the conversion of Hernán Cortés after his meeting with the emperor Moctezuma. Dazzled as he was by the capital of the Aztec Empire, he determined to conquer it to its very foundations. The conquest was an adventure of travelers who had exhausted a cycle. They were quick to break with the world around them, one which they had made a hell of, created in the image of Dante's Florence. The wars lasted one hundred years, and so they thought about the eventuality of encountering a terrestrial paradise, a hidden harmony that they hadn't found in Flanders.

Once the colonial machinery was set into motion, Europeans became dependent on those territories in a calculated and irrational way because of the spices and the tobacco and the wealth and the power given them over inferior exotic beings. This attic of utopias existed amid the strongest split to have ever occurred in Western culture. Sugar and emeralds, the Amazon and El Dorado were powerful motivating myths, for missionaries and men of fortune, for scientists and fugitives, and for writers and mercenaries.

Travelers project themselves onto the world in the attempt to understand who they are within the experience of their journey, which is also an internal voyage. The continent was a stimulating inventory of specimens for science. Men such as Darwin and Humboldt went there to observe the fauna and vegetation in order to understand the secrets of creation. At times, they lingered among the ghosts of those who had been the lords of the places they visited, but it wasn't easy to associate modernity with those beings who seemed to be part of the landscape.

The chronicle of journeys became a literary genre, and each region of the continent has its writers and collections of works. Some travelers set sail to confirm their faith and take the certainty of their conversion along with them in their missals, while others let themselves be ensnared by wonder and the rum of the ports. The traveler on the edge is one who finds it impossible to return, and the experience changes his life: the delirium of the conquistador Lope de Aguirre entrusting himself to the monkeys in the Amazon; the frontier of the writer Ambrose Bierce, who, in 1913, disappeared in the midst of the shooting of the Mexican Revolution; the enthusiasm of the young Ernesto Guevara, when, with his friend Alberto, he left on a Norton motorcycle to travel through the America that was waiting for him.

The modern traveler's itinerary varies according to weather and whim and must be ready to capture in spontaneous observations what will never be seen again. We can imagine a present-day voyager who, like the buccaneers and pirates of old, left the ports of Jamaica, for example, and trekked around America for seven months. Since there are so many ways to go, the route taken by this person depends on both choices and the fruits of chance. All travelers have their own vision of the changing landscape and the different peoples that they meet on the way, of the stages of the journey, as measured by its hardships and the days it takes to complete.

The result of this possible journey can be seen as if it were the result of Magic Realism—it is what is intangible in America, where what is shared by all of humanity rushes in, and it cannot be found in any other part of the world. It is what is irreversible in this intersection of a moment in the community or the landscape and an observation that decides that this is the moment to tell the others about.

Let us think about a photographer. We can imagine one who shares with us the experience of searching; the scene chooses him, a face peers at him through the viewfinder. The totality of written history and the sensuality of the present are in each image. What is sought and what is found are fused along with a third recourse that is part of the passage of time.

In this way, the continent is both continuing a persistent iconographic tradition and becoming familiar with its most recent reincarnation. This tradition comprises codices and engravings, muralists and artisans who work with *amate,* the same fig-bark paper used for the ancient codices, and pioneering watercolorists and photographers who, motivated by a need to tell tales and color memory, travel the region, adding to the visual chronicle of a history in images.

Each new journey is an experience of initiation, the cosmos re-creating itself from its origins. As in other parts of the world, there is something strange and uneasy in the proximity of modernity, with its assurances, and being a witness to scenes of anthropological depth; there is a truth that modern man has lost, a forgotten knowledge of beings and things. To have access to the wisdom of America, it is necessary to enter into this consciousness of history as something also existing in the present; however, the insatiable forces opposing this are very active. For a few moments, reason is suspended, and there is a yearning for the cyclical nature of time to be real, for the splendor of the Incas to return, or for something to happen. Although there is a need for real justice, only the exiled gods would be capable of imparting it impartially.

Our traveler seeks and accedes to what he sees and suddenly has an epiphany that precedes recognition. It remains fixed in the traveler's mind for a few fractions of a second. A landscape, a face—they seem to simulta-

neously justify and be the result of the instant, of the months of pilgrimage, of all of life, and perhaps of previous existences, as some Andean shamans believe. Each traveler discovers his own America, and the personal experience becomes here something that is shared, a vision of life and the search for meaning. Violence is not apparent because violence can be found without the need to look for it. The forces of the earth make possible another harmony, one between existence and the cosmos. The journey is an invitation to see what we do not see because this is something we're not used to doing and because the uniformity of urban life has turned the world into a movie or television screen.

At times the distance that needs to be covered to arrive there seems insurmountable. What is disturbing and also marvelous is that we are contemporaries of what is shown to us, which allows us to measure the mistakes we make when we try to define the world with some competence. To witness is also to protest; all contemplation carries along with it a desire to accede to the invisible; the wisdom of the other is the measure of our own ignorance.

Each proposal to do something different is an invitation to experience the unexplored potential of our senses. Latin America is the revolution of our sensations, the pledge of the body within an erotic, sacred relationship with the world; it carries us to a second state of odors and colors, sounds and materials, contemplation and movement. The story of a journey is told to indicate a path for others to experience, to say: "It's over there," without being entirely convinced oneself. It is impossible for human beings, in all their finiteness, to embrace the region; if knowledge is what remains after what has been learned is forgotten, wisdom is what is remembered after the journey is over.

And what is happening today? This very week in this never-ending laboratory of the present to come, you can choose from the salsa of the Puerto Rican dance halls to the drug traffickers transporting their wares in light aircraft; from the hard liberalism of the periphery to the grievances like those of the old times; from the defenders of the lands of the Mapuche people in southern Chile to the paramilitaries fighting their own version of the ancient Aztec *guerra florida*; from preachers who during the Inquisition would have been sent to die at the stake to *Santerías* who pray to both Saint George and to Olorun, "the owner of heaven"; from the taste of the strong grape liquor *pisco* to the sight of *mulata* women waiting for the dancing to begin. Latin America is this whirlwind of the future, a simultaneous past and present that is difficult to grasp.

It is time to get on to more important things, to leave you and return to the *Canto General,* which was a poetic journey around South America. After everything he had seen and lived, when he was arriving at the end of this project, during a moment of hesitation, Neruda wrote a poem to himself that is a declaration of love and a plan for living out our lives, while thinking about the day after tomorrow.

JUAN CARLOS MONDRAGÓN

Translated from Spanish by Marsha Ostroff

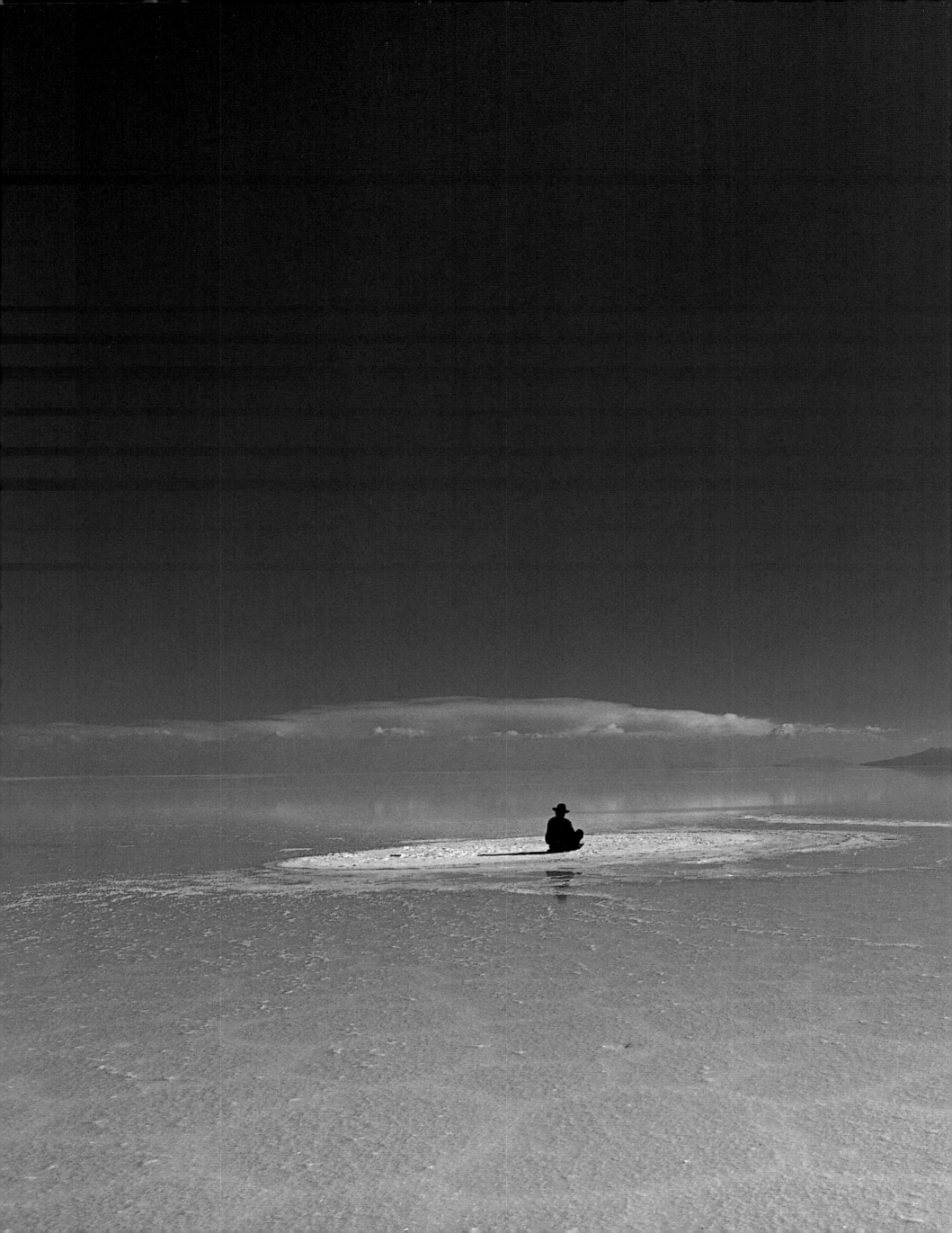

LIFE

Let others worry about ossuaries . . .
 The world
is colored like a naked apple; the rivers
dredge a torrent of wild medals
and sweet Rosalía and her mate Juan
live everywhere . . .
 The castle is made
of rough stones, and my house was made
of clay smoother than grapes and straw.

Wide lands, love, slow bells,
combats reserved for the dawn,
tresses of love that awaited me,
dormant deposits of turquoise:
homes, roads, waves that build
a dream-swept statue,
bakeries at daybreak,
clocks trained in sand,
poppies of the circulating wheat,
and these dark hands that kneaded
the matter of my own life:
for life the oranges are aflame
over the multitude of destinies!

Let the gravediggers pry into ominous
matter: let them raise
the lightless fragments of ash,
and let them speak the maggot's language.
I'm facing nothing by seeds,
radiant grown and sweetness.

 —Pablo Neruda

LA VIDA

Que otro se preocupe de los osarios . . .
 El mundo
tiene un color desnudo de manzana: los ríos
arrastran un caudal de medallas silvestres
y en todas partes vive Rosalía la dulce
y Juan el compañero . . .
 Ásperas piedras hacen
el castillo, y el barco más suave que las uvas
con los restos del trigo hizo mi casa.

Anchas tierras, amor, campanas lentas,
combates reservados a la aurora,
cabelleras de amor que me esperaron,
depósitos dormidos de turquesa:
casa, caminos, olas que construyen
una estatua barrida por los sueños,
panaderías en la madrugada,
relojes educados en la arena
amapolas del trigo circulante,
y estas manos oscuras que amasaron
los materiales de mi propia vida:
hacia vivir se encienden las naranjas
sobre la multitud de los destinos!

Que los sepultureros escarben las materias
aciagas: que levanten
los fragmentos sin luz de la ceniza
y hablar en el idioma del gusano.
Yo tengo frente a mí sólo semilla,
desarrollos radiantes y dulzura.

 — Pablo Neruda

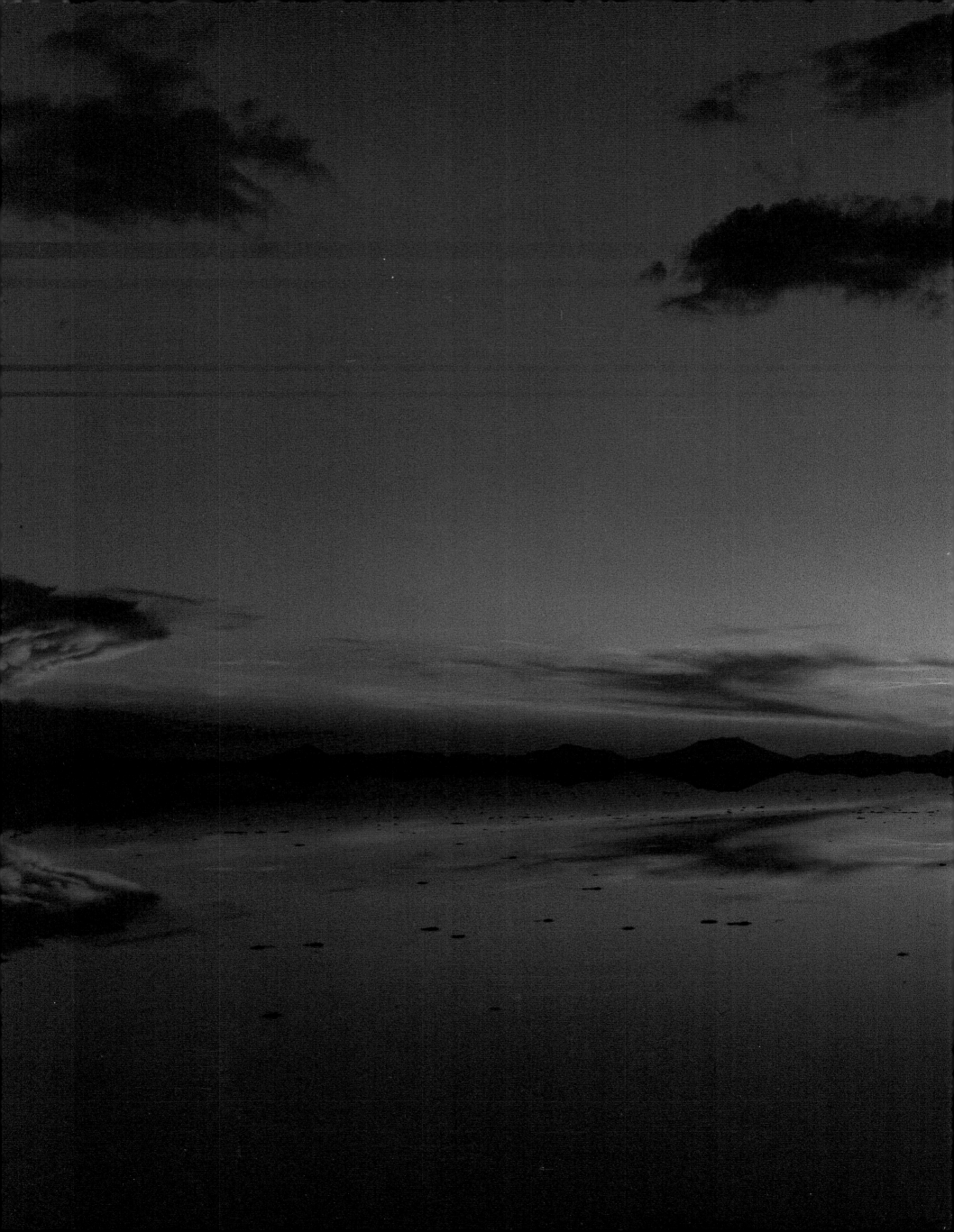

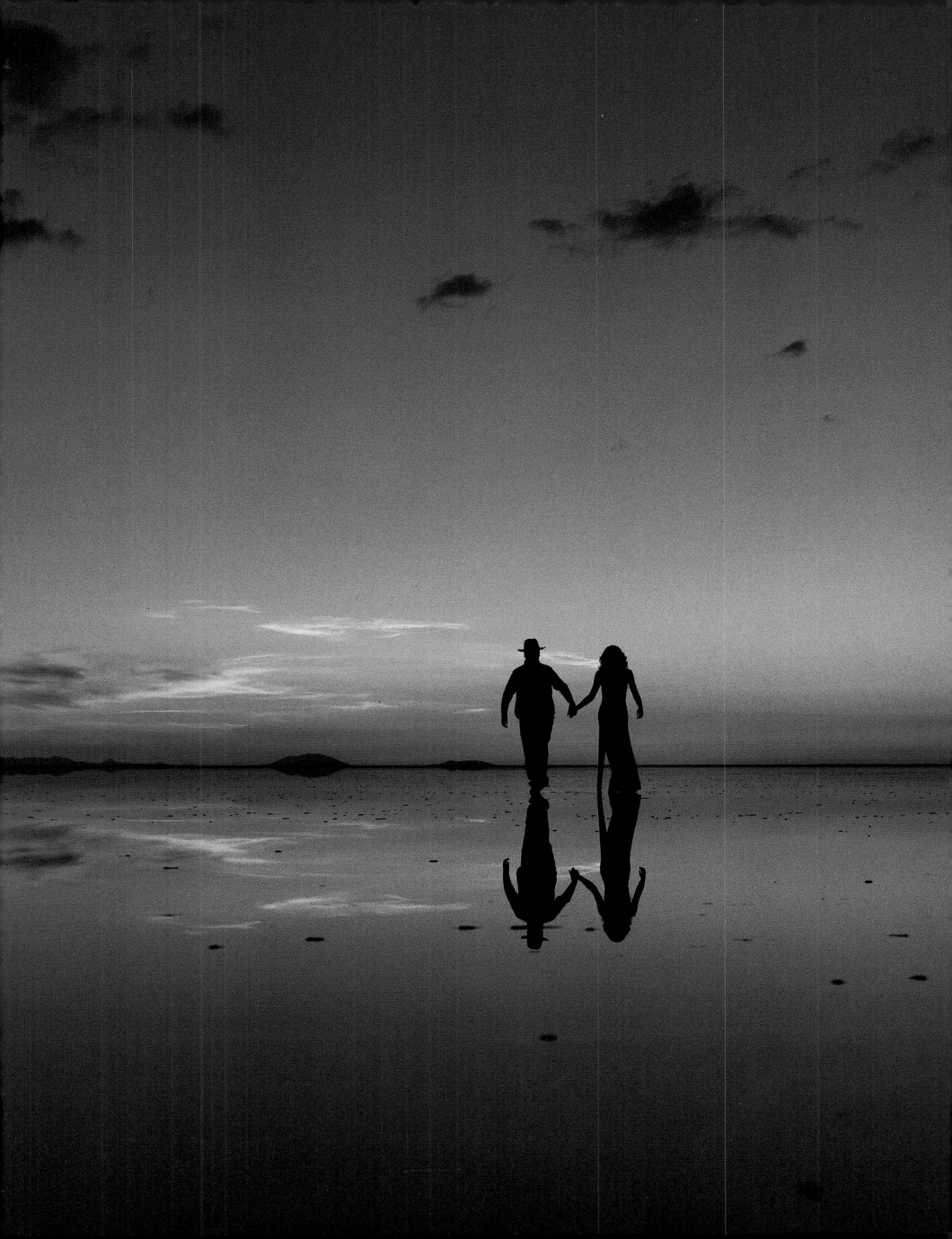

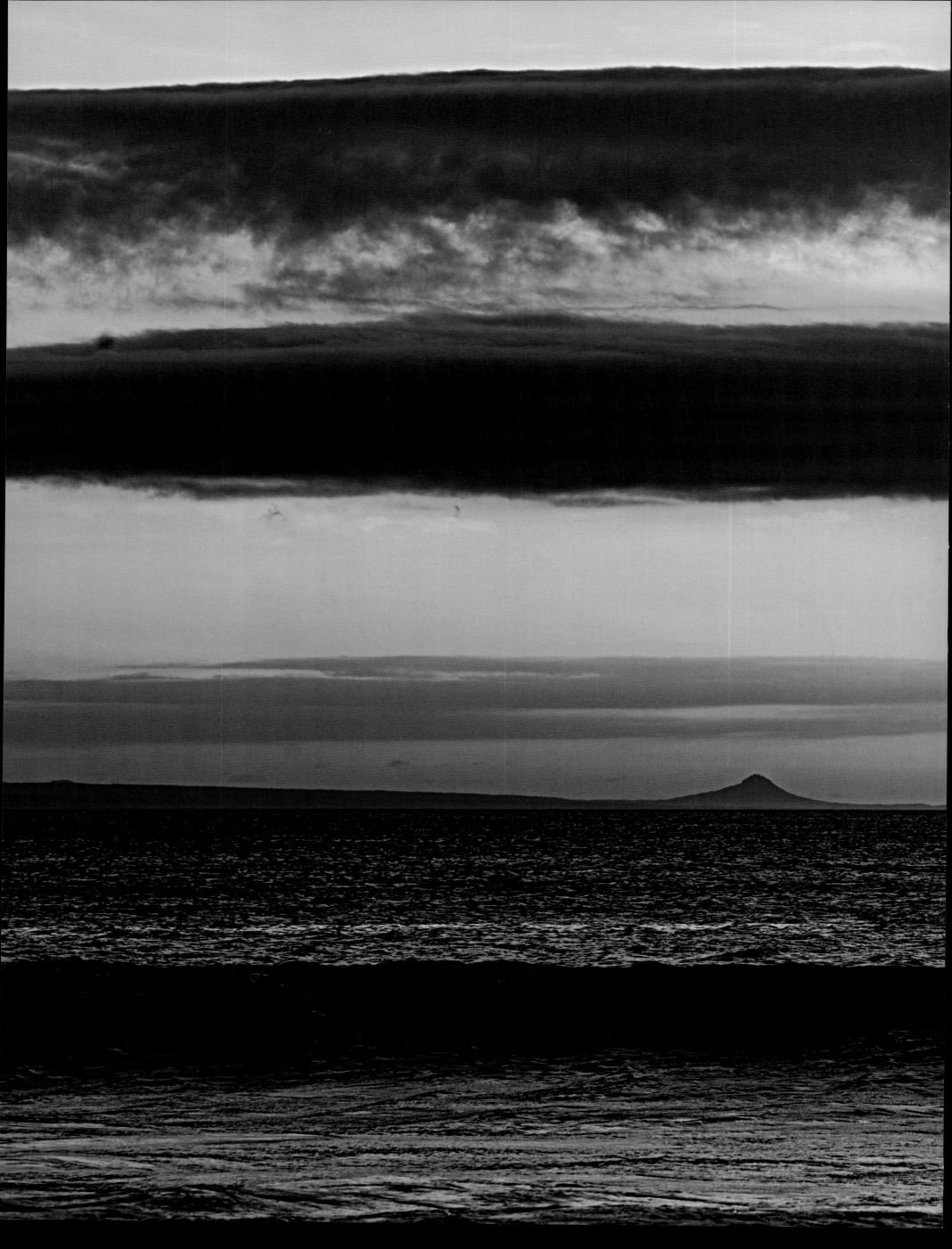

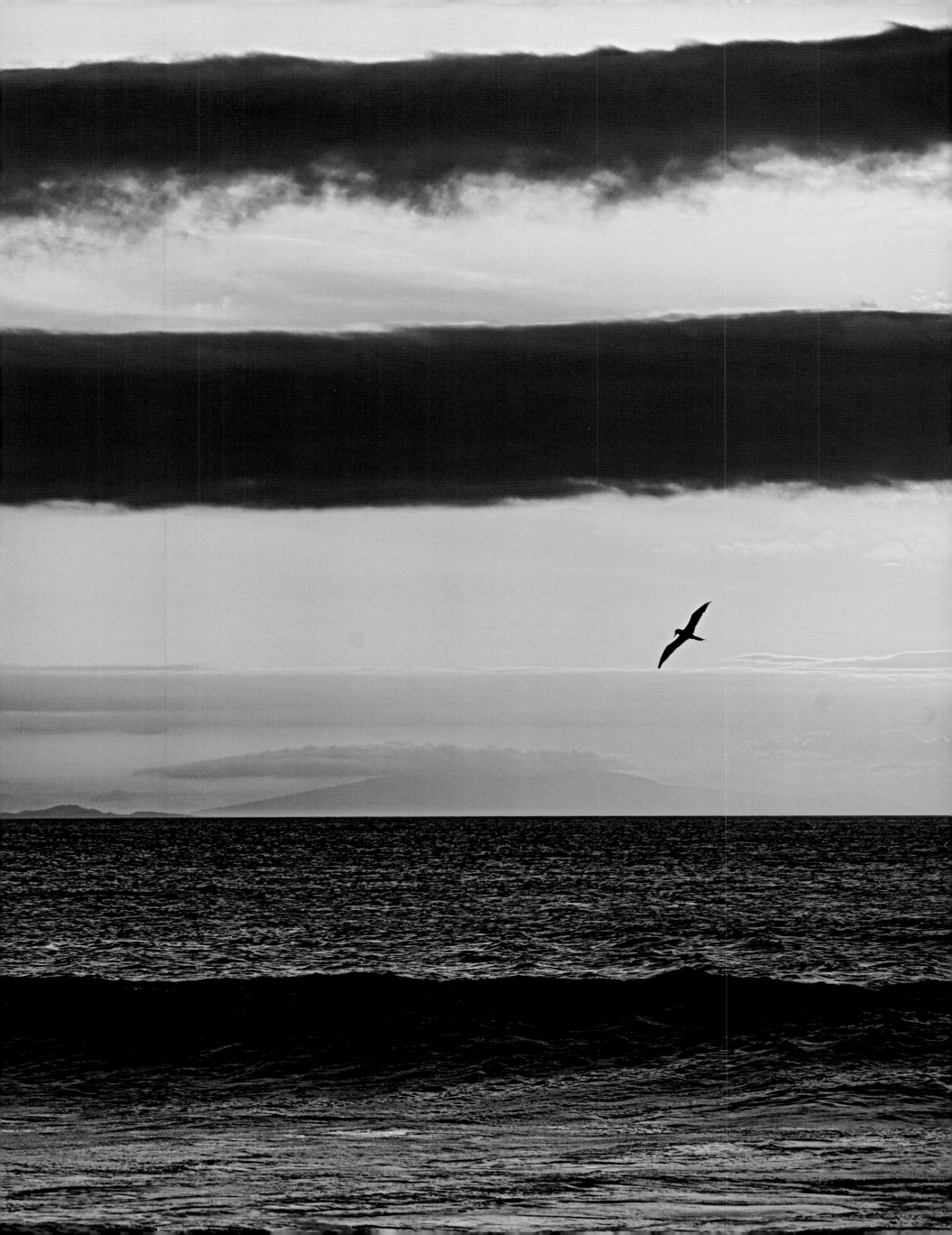

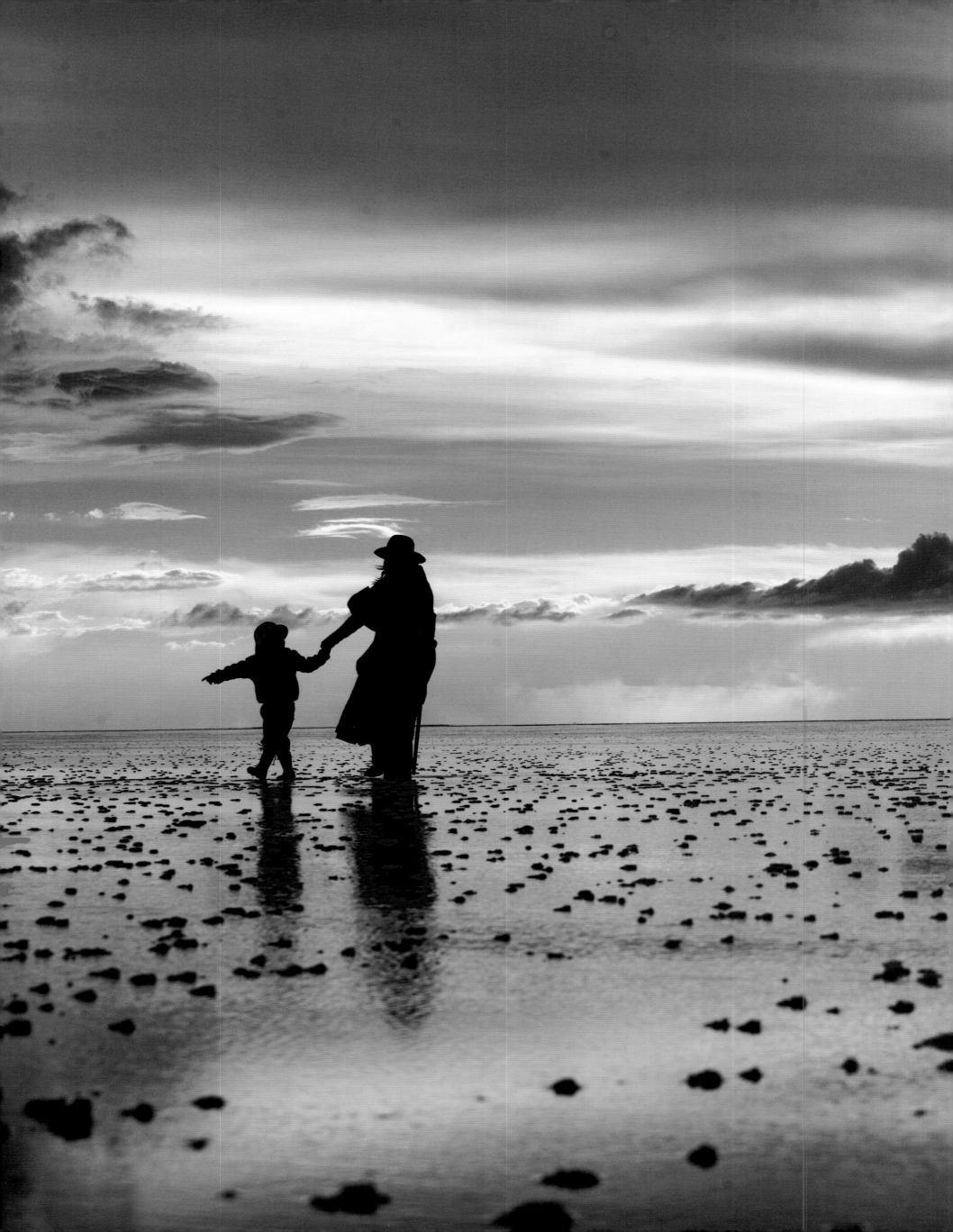

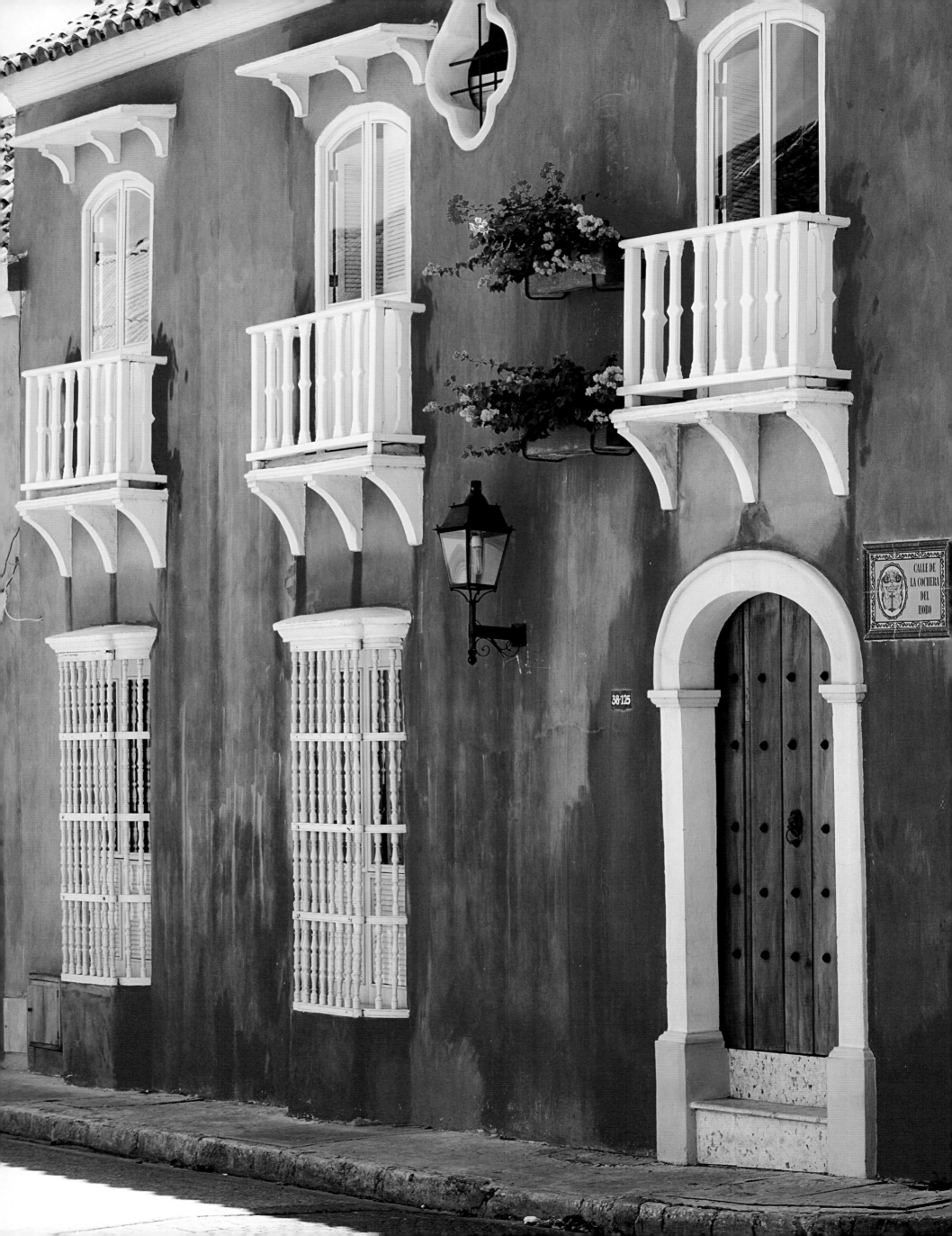

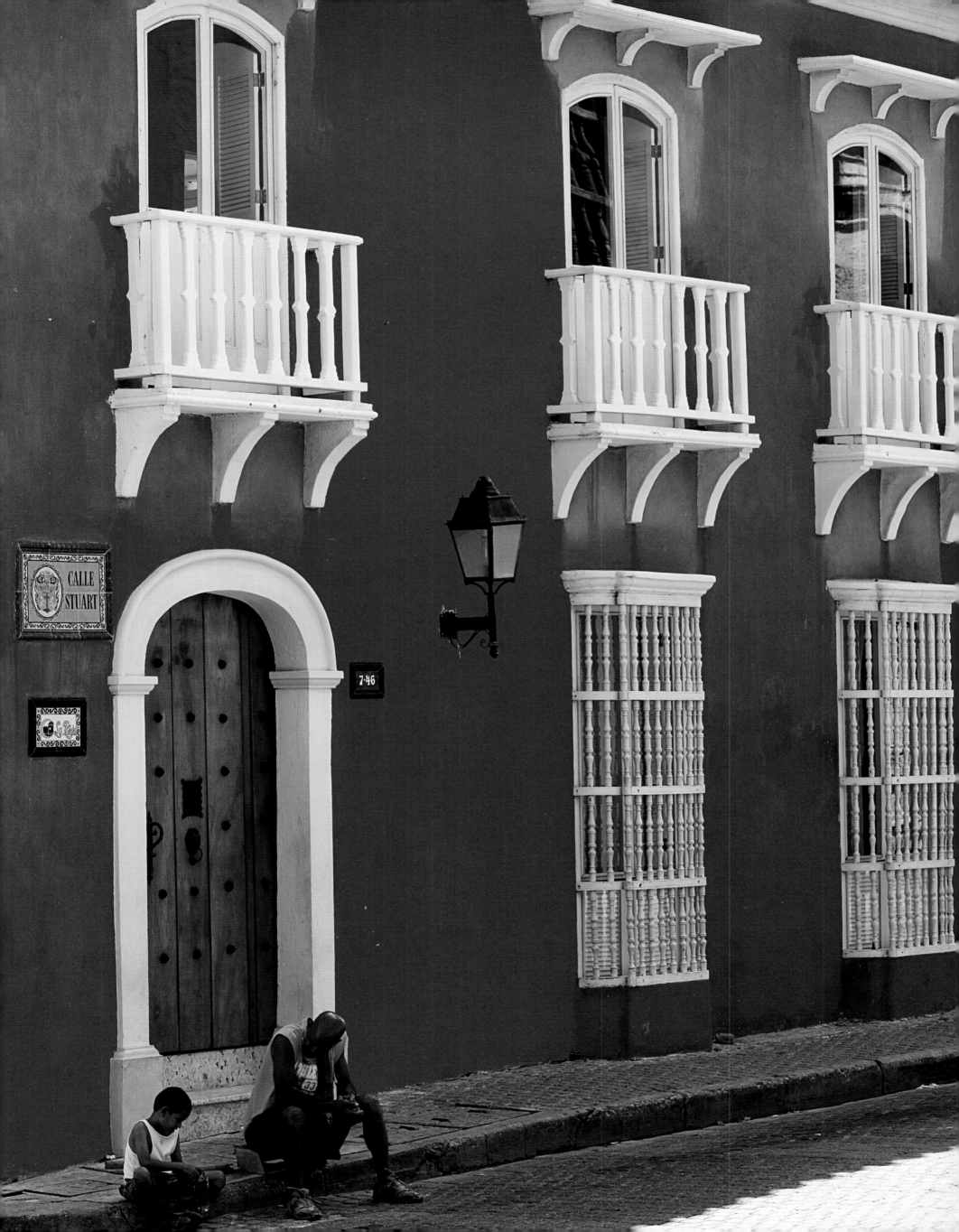

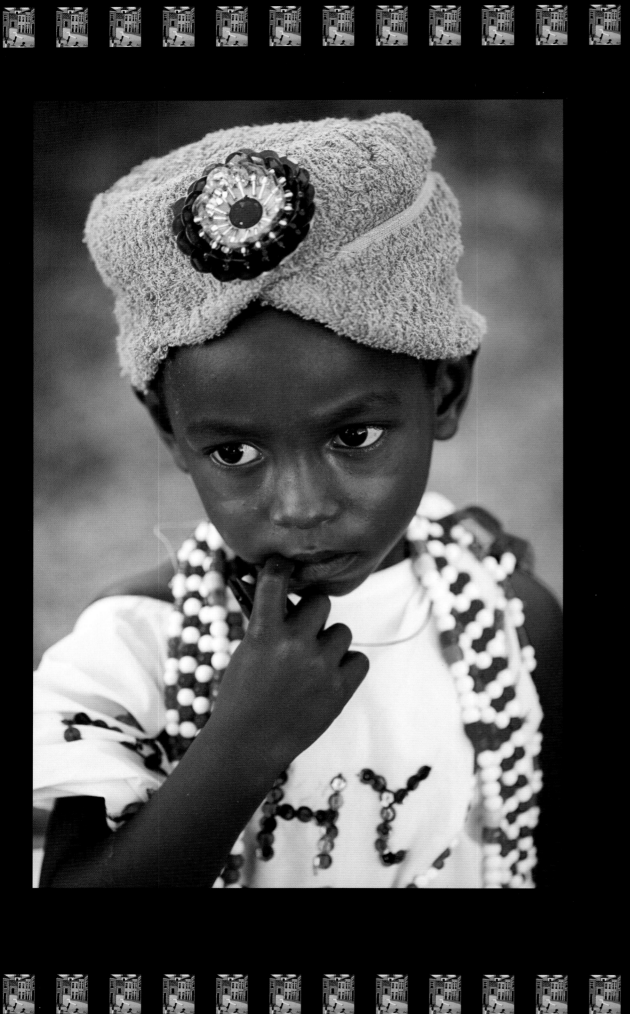

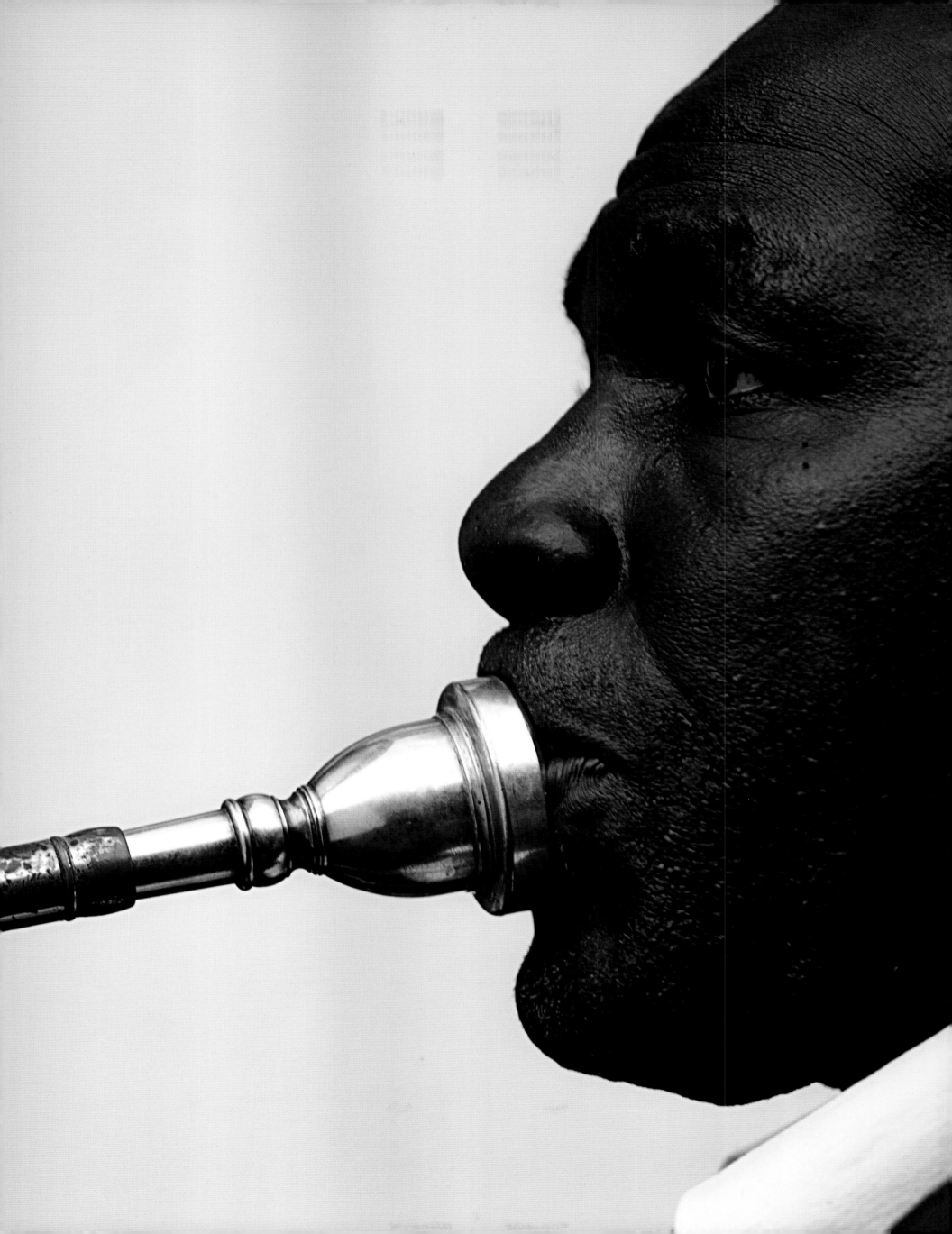

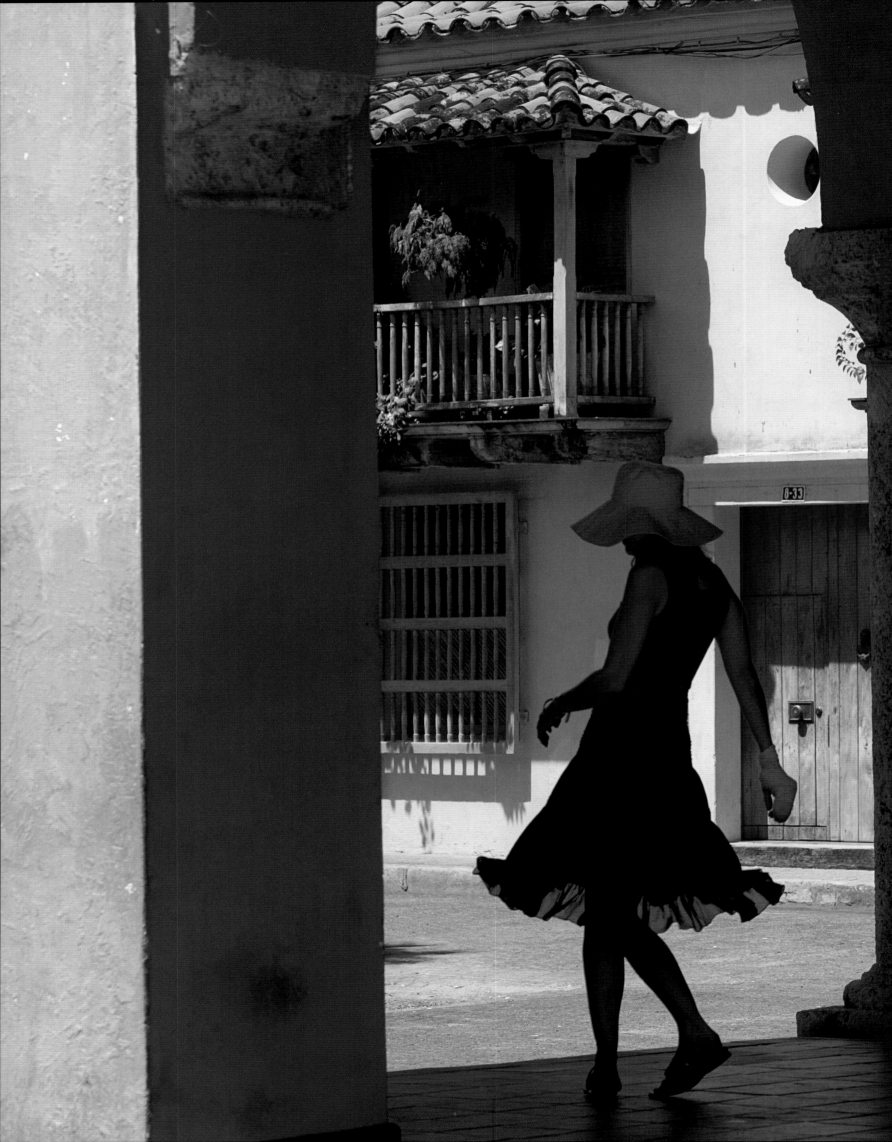

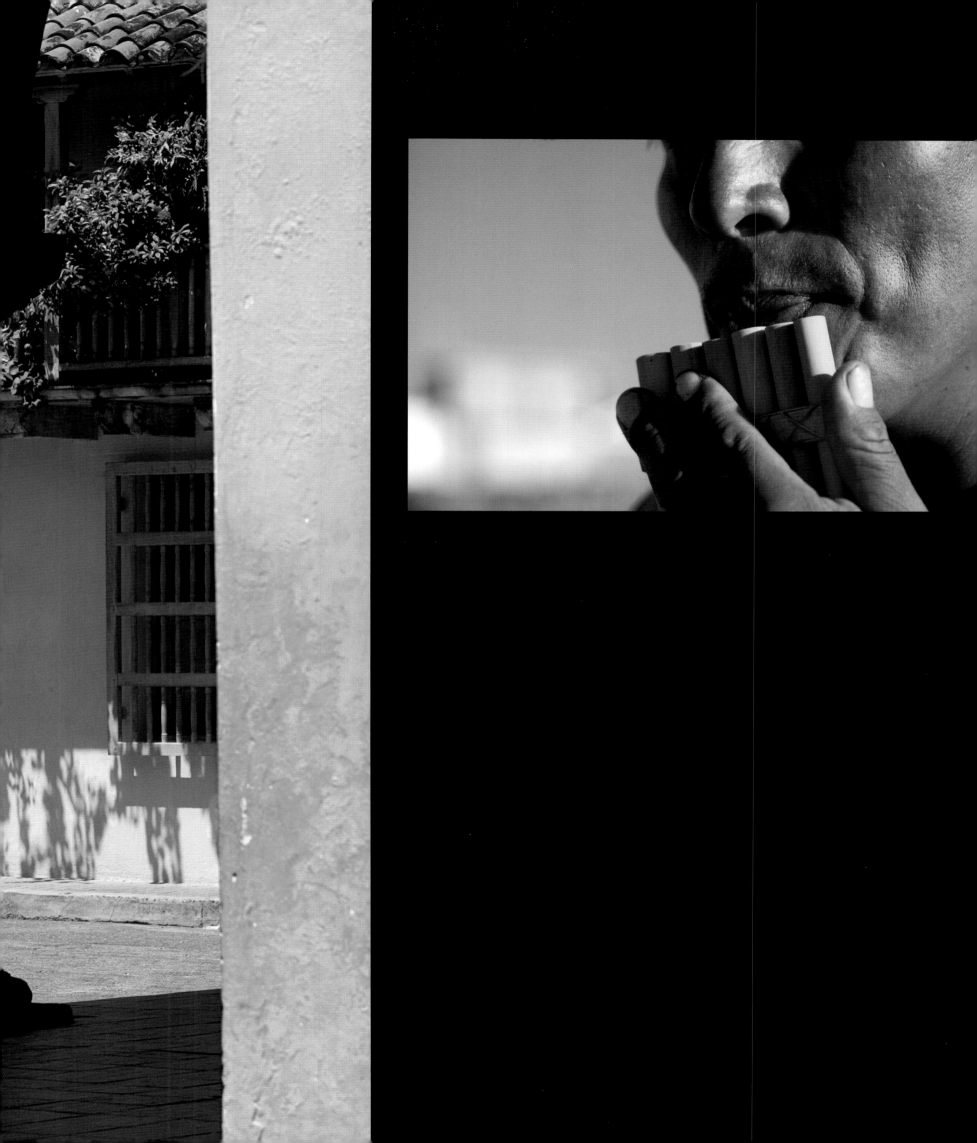

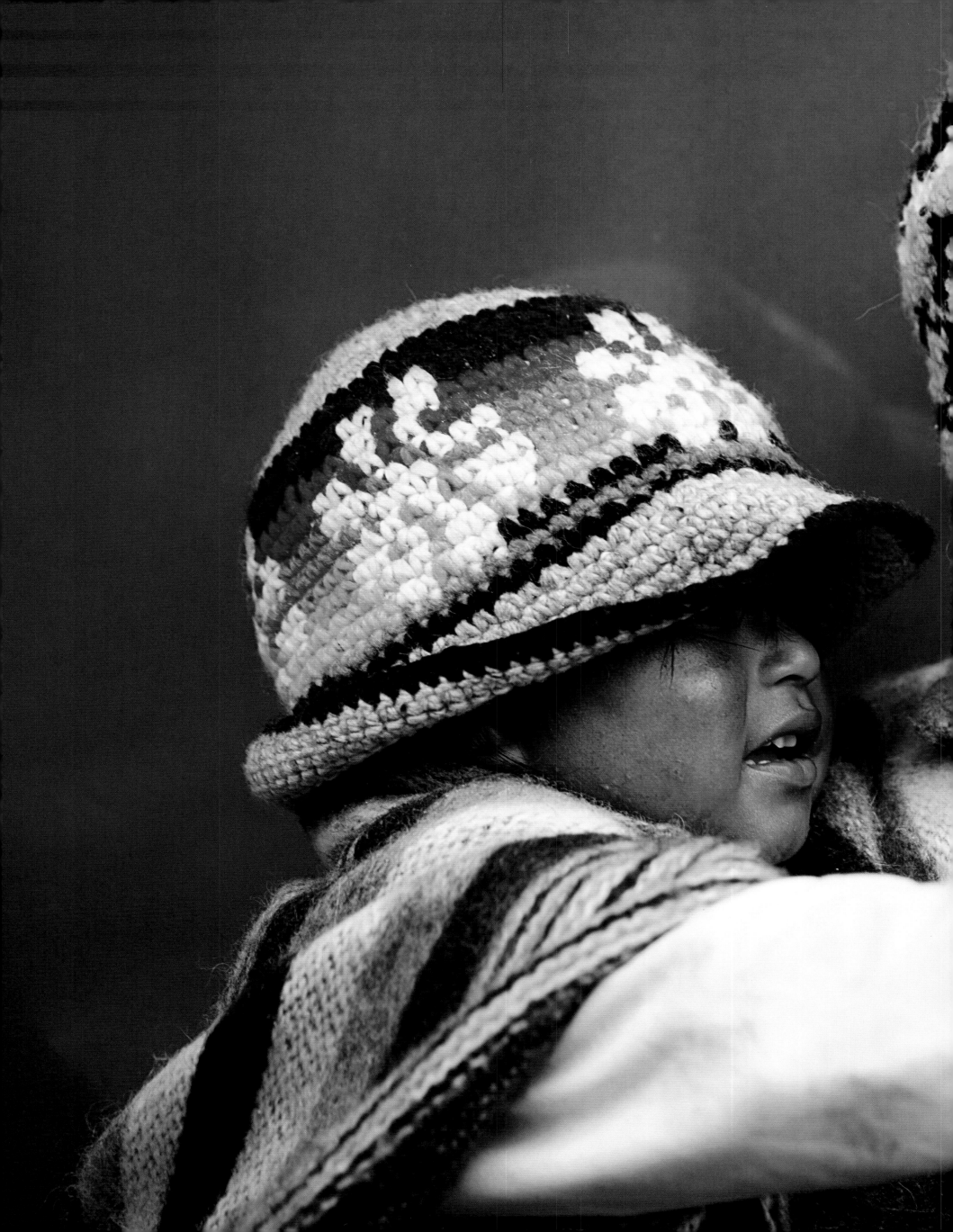

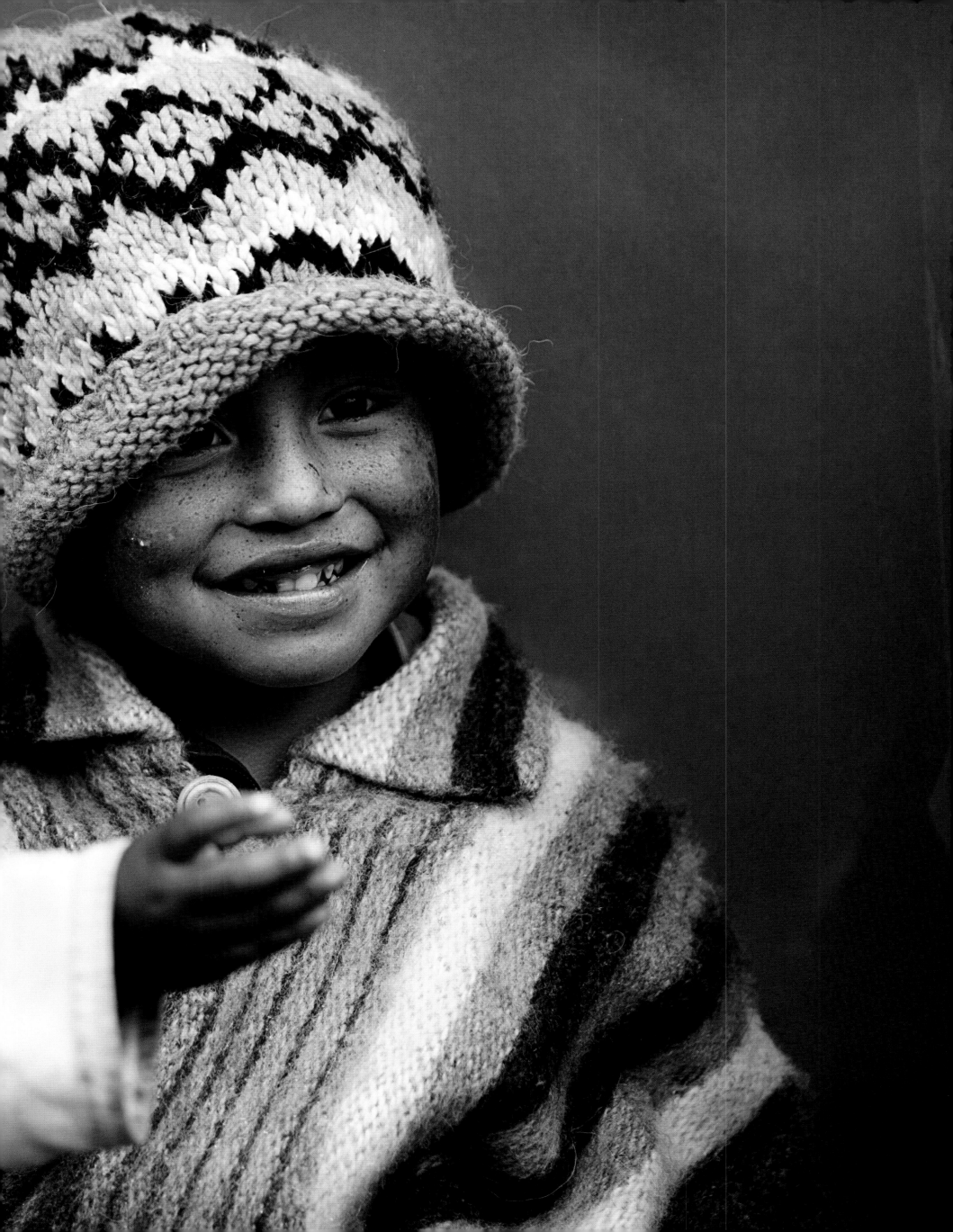

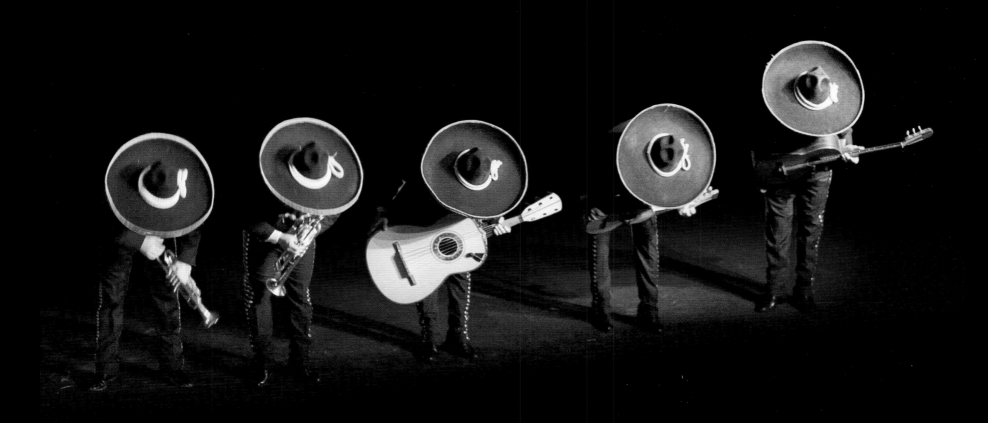

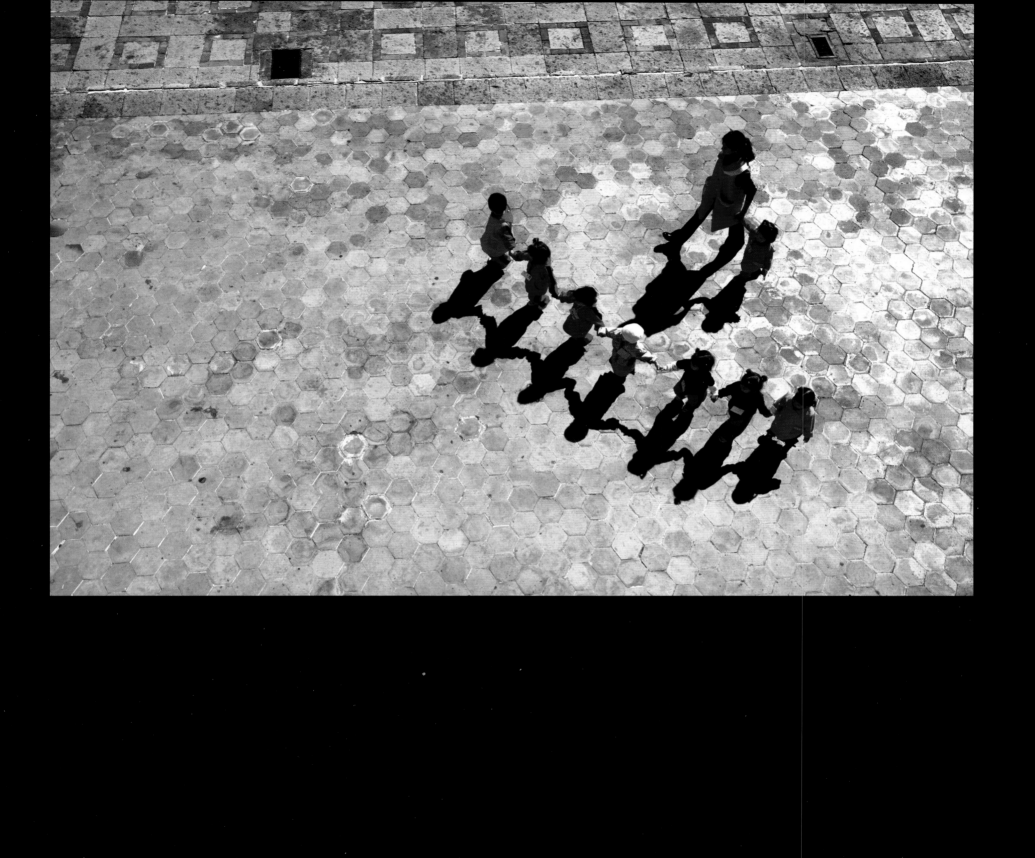

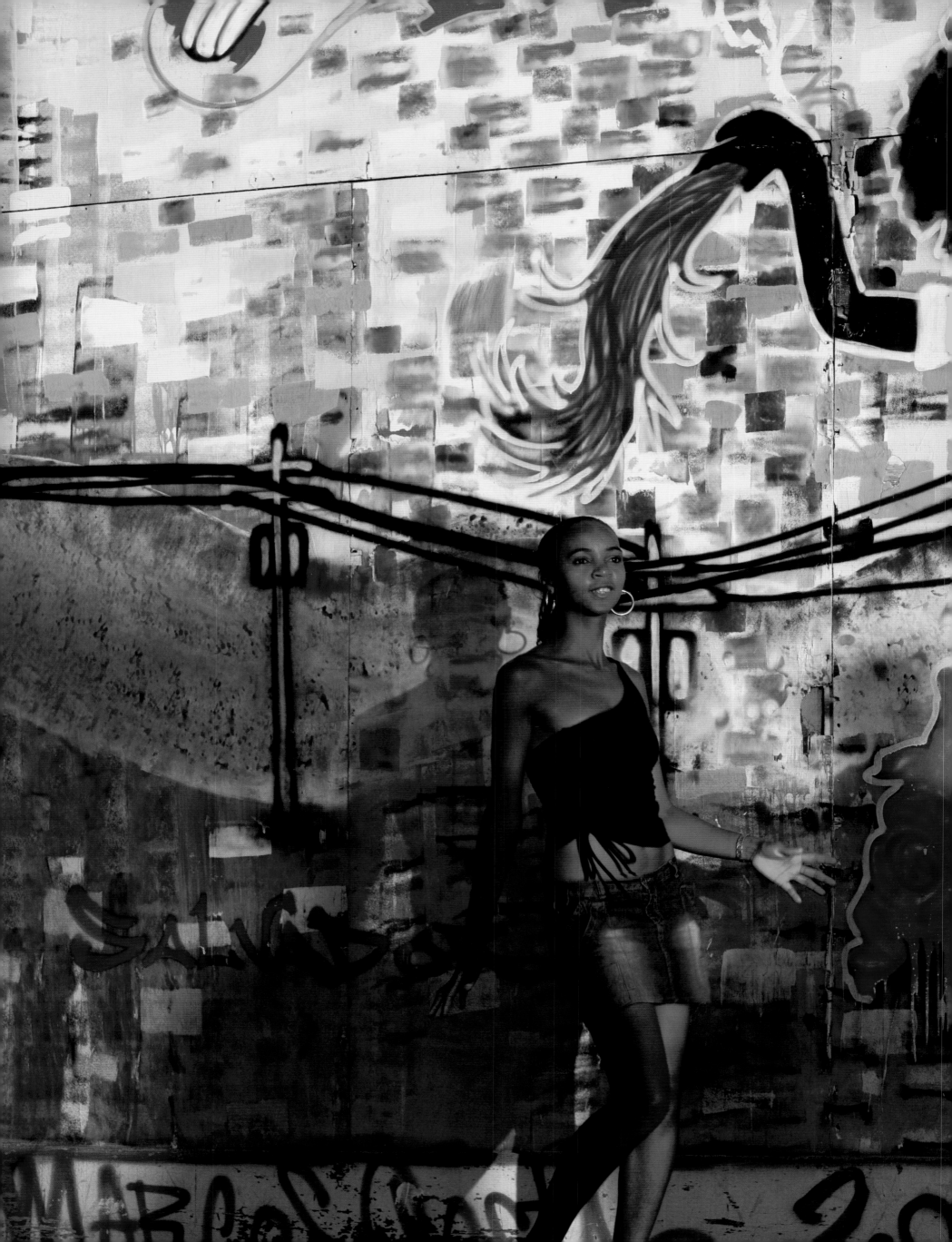

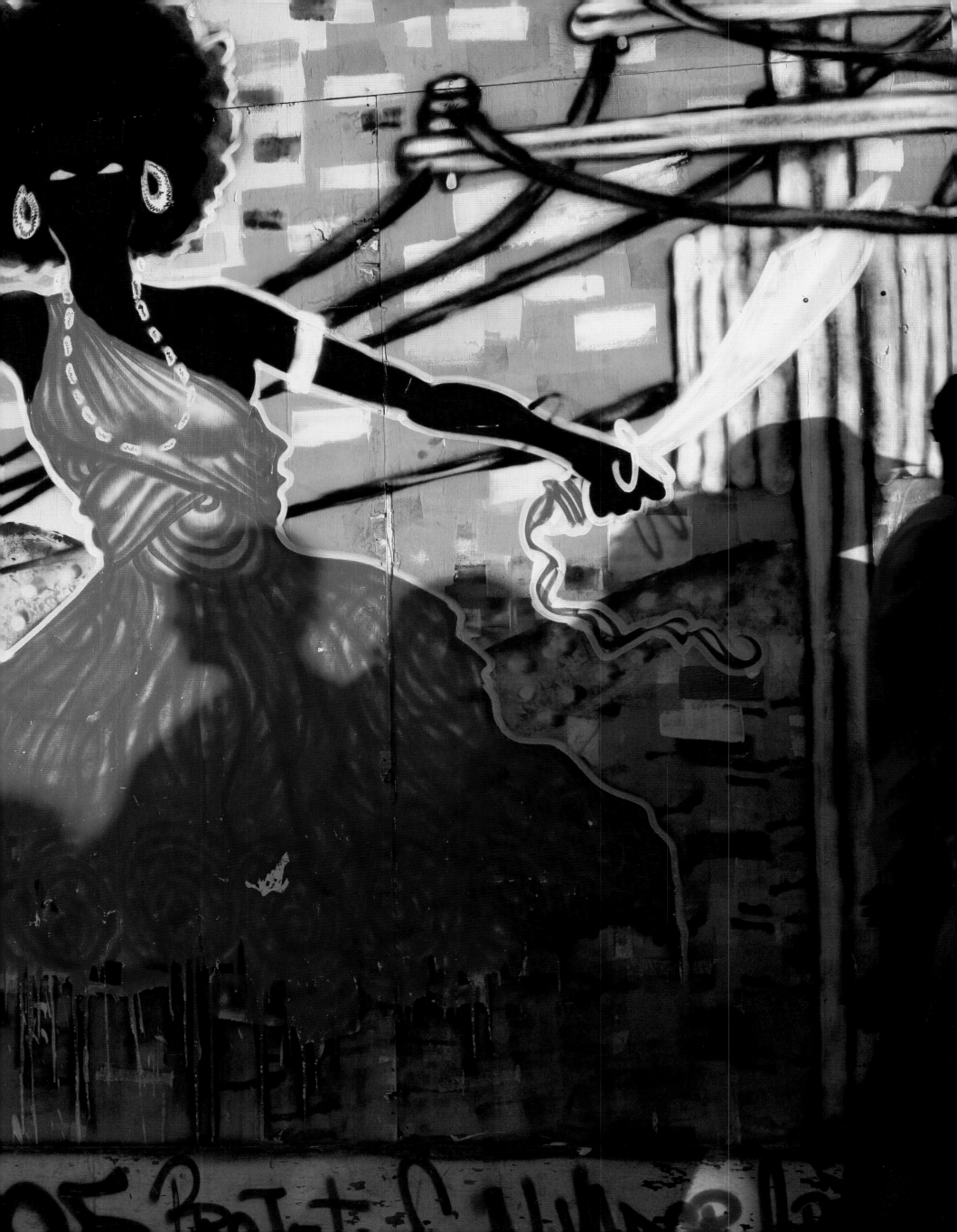

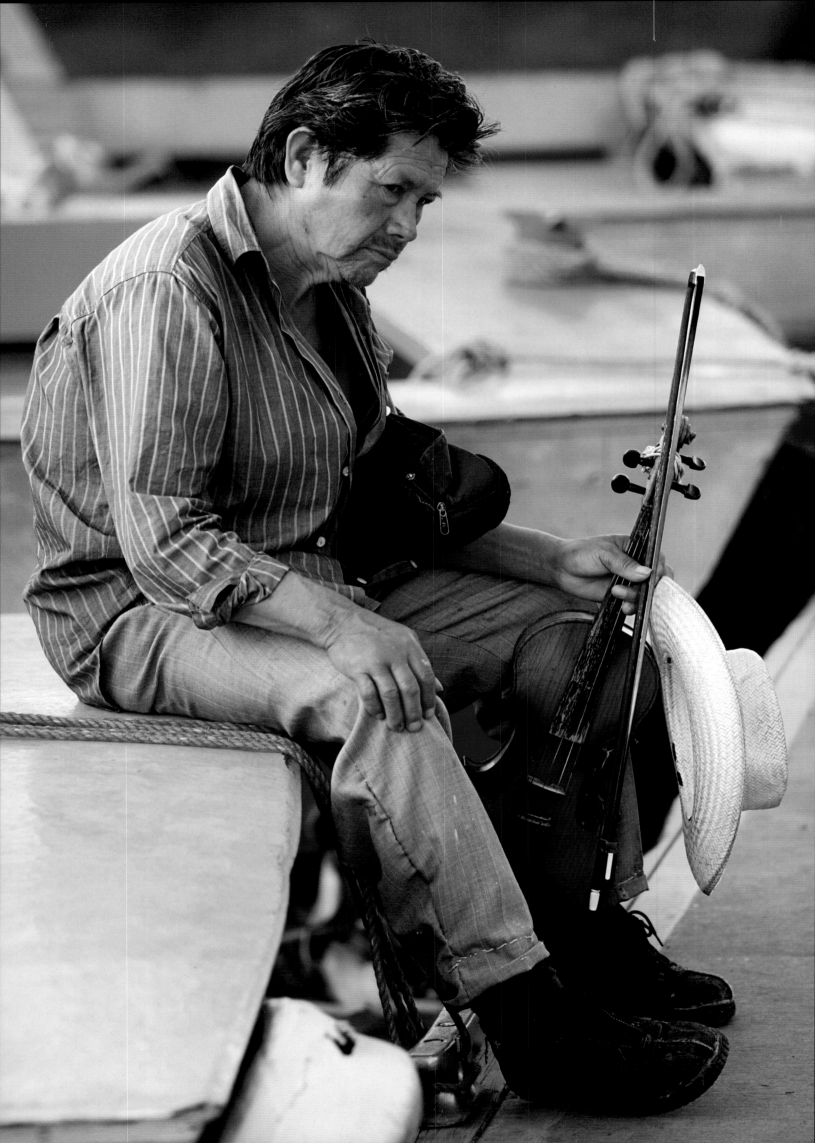

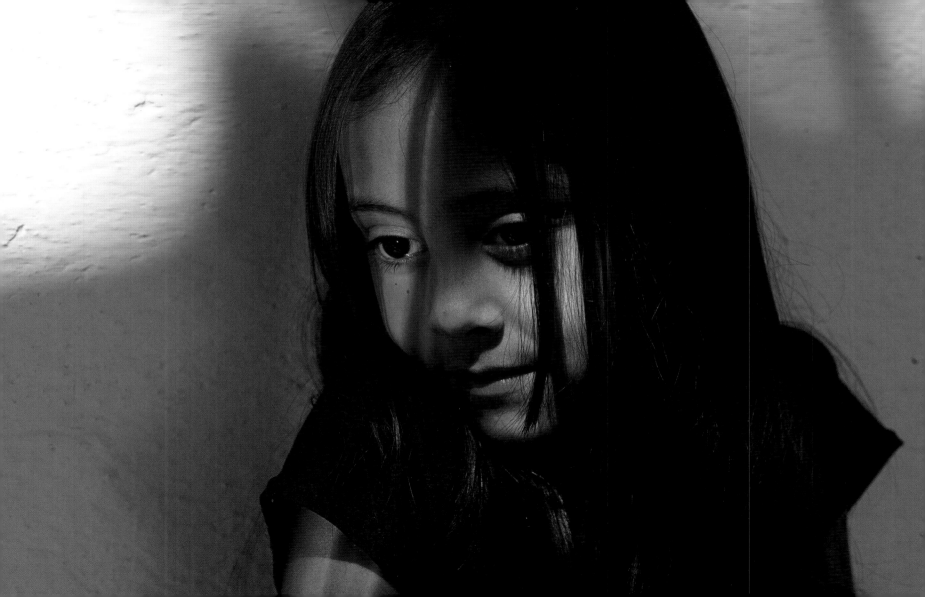

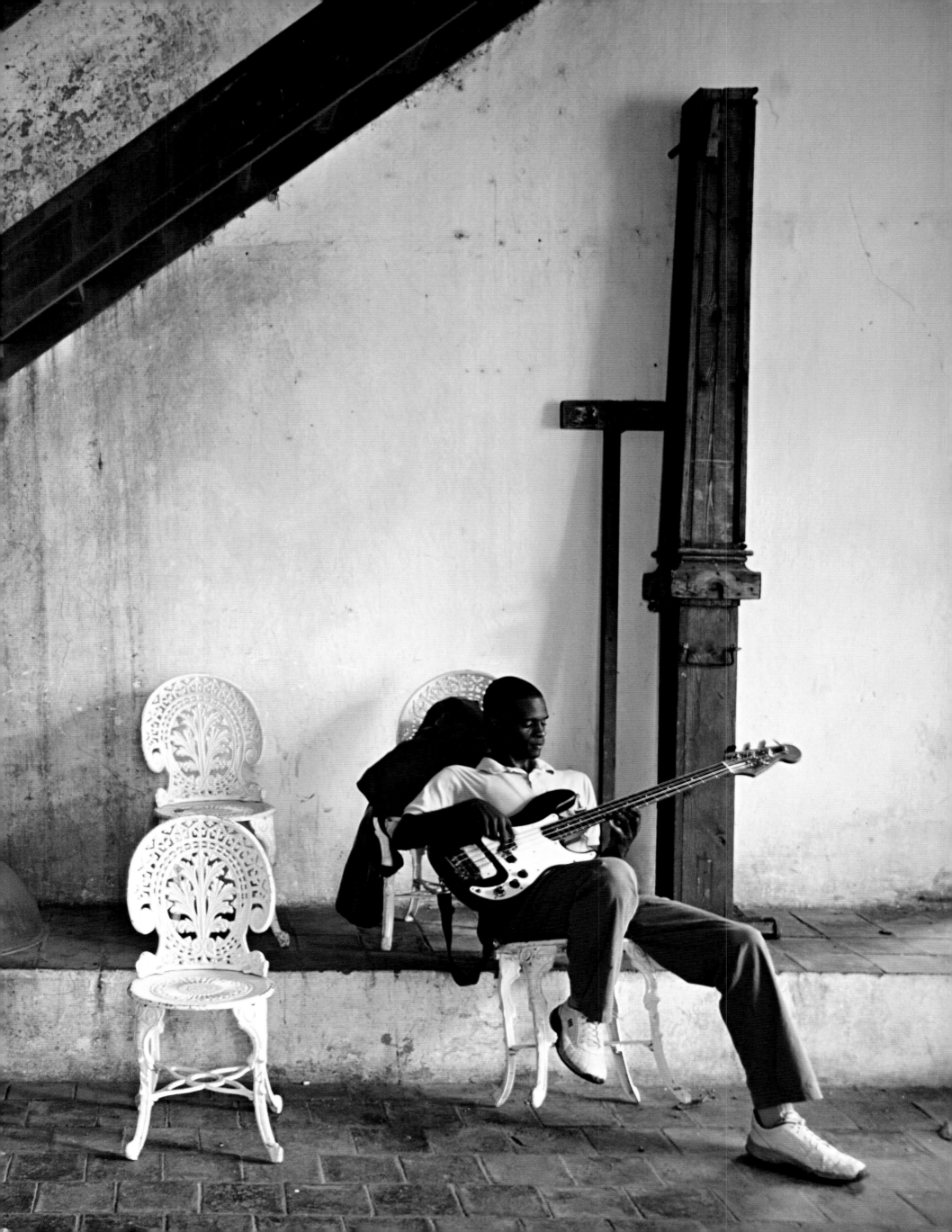

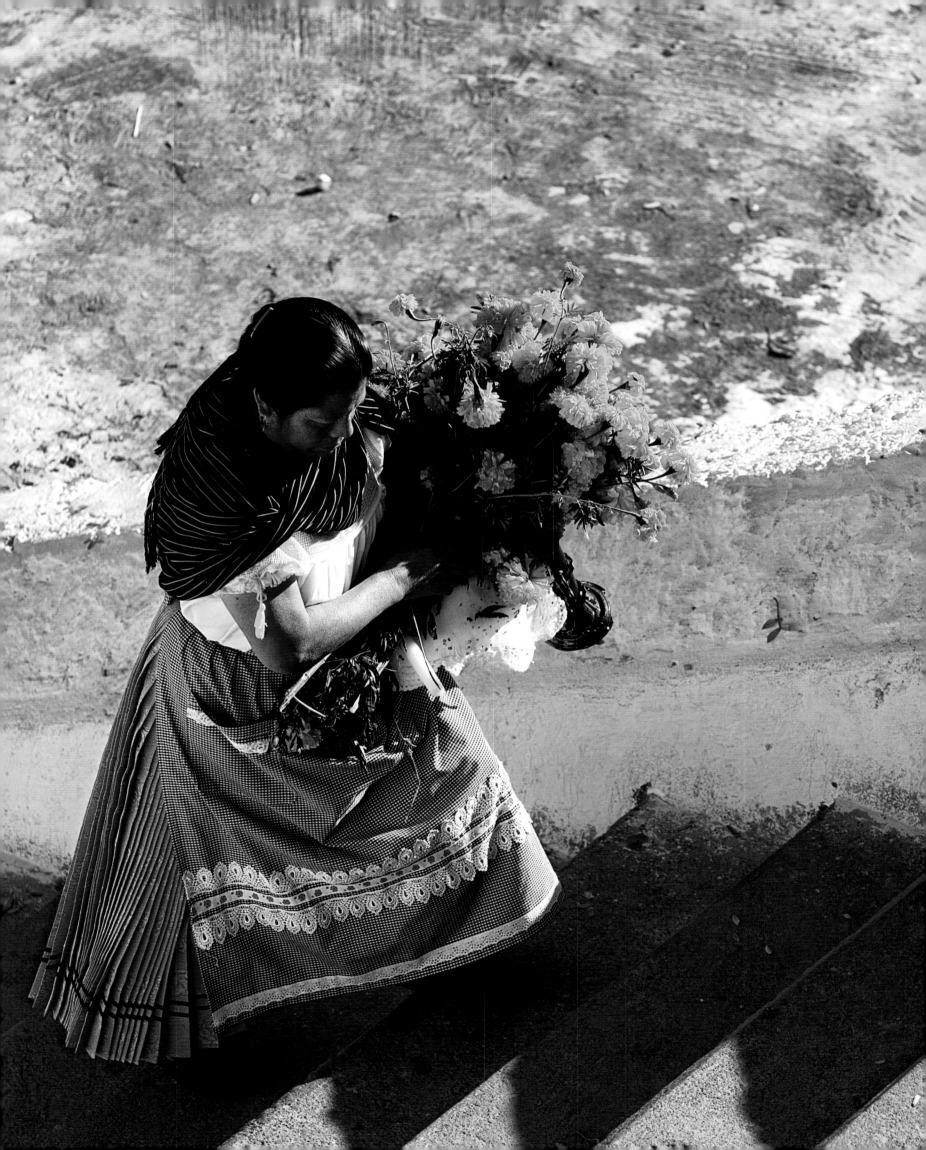

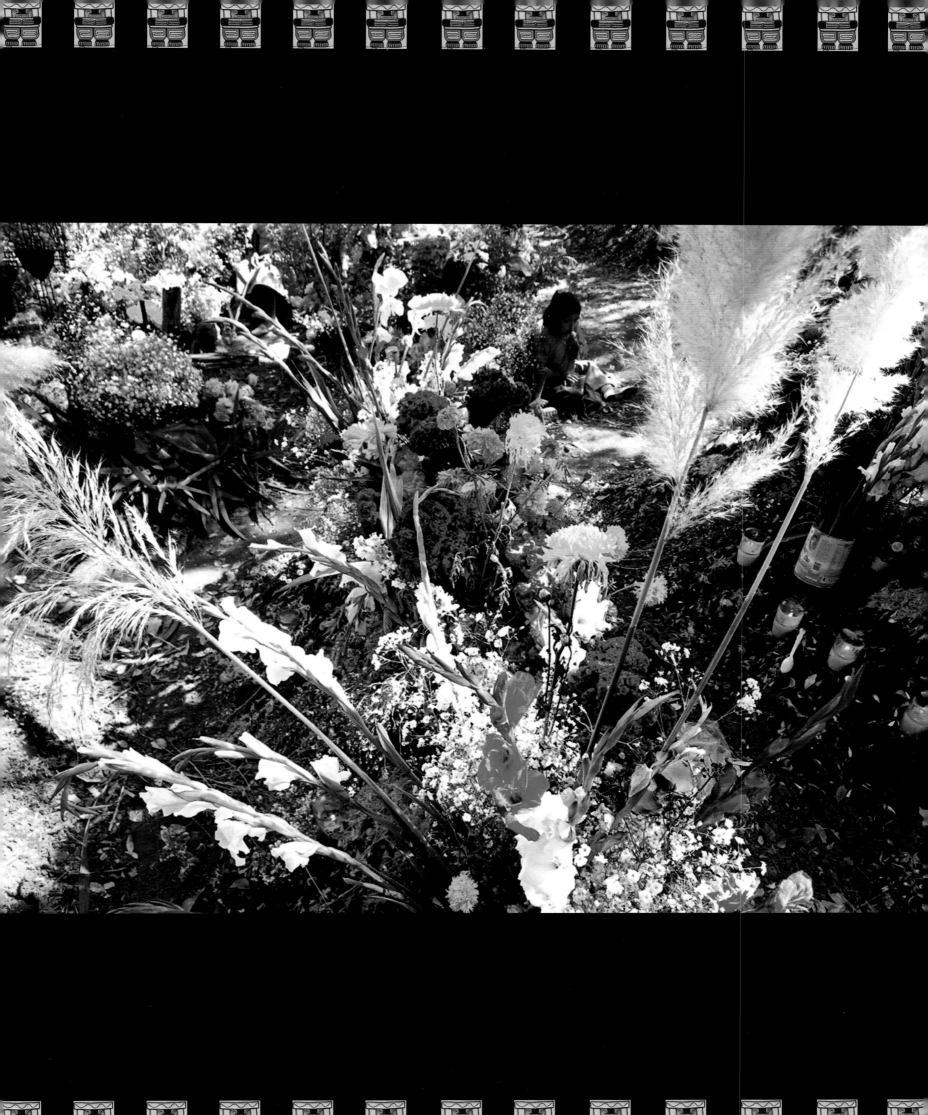

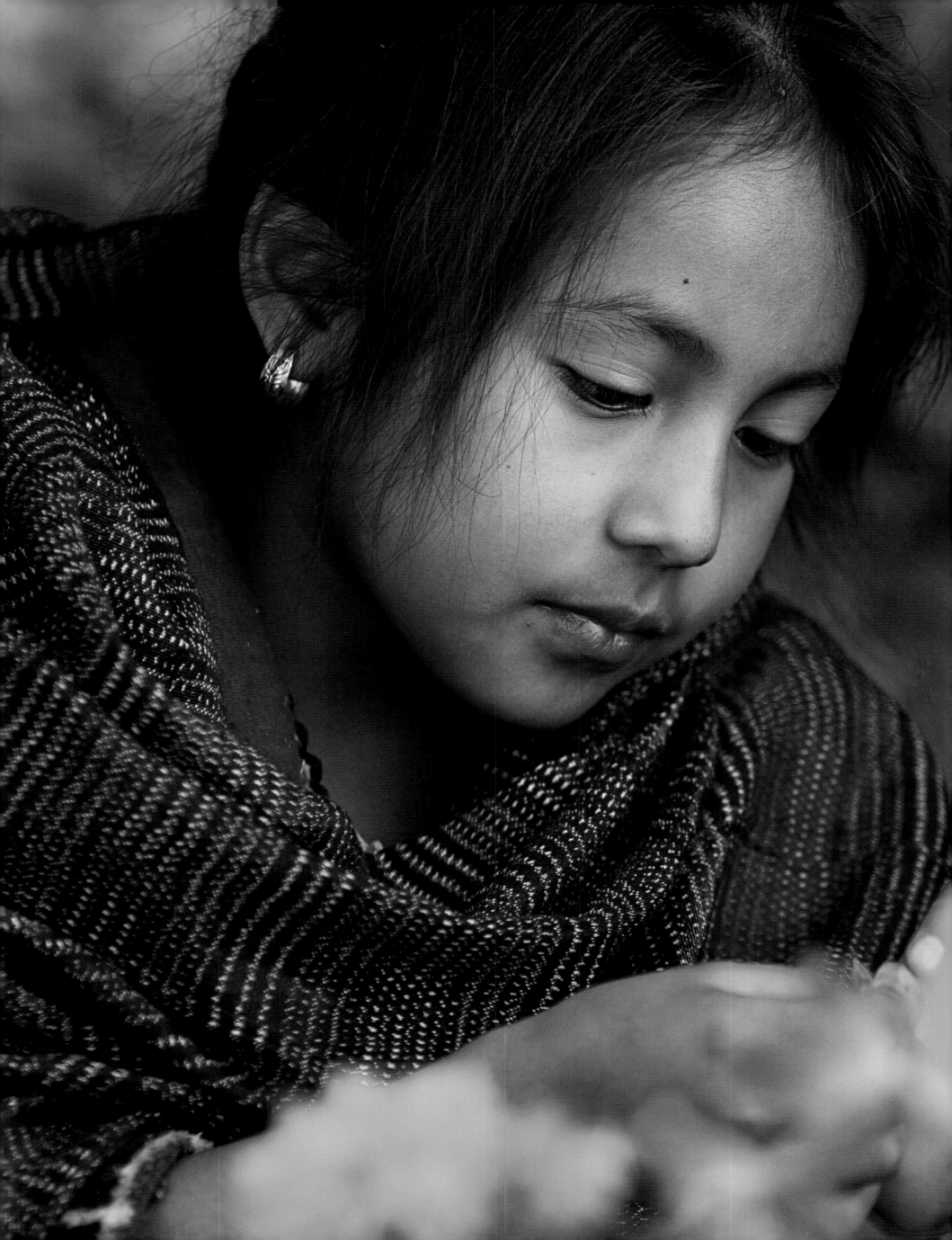

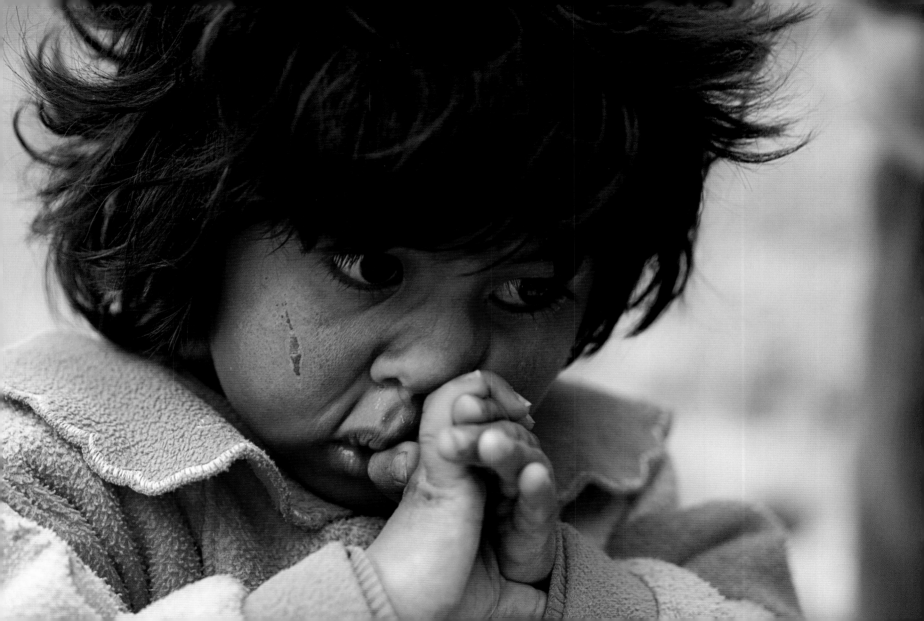

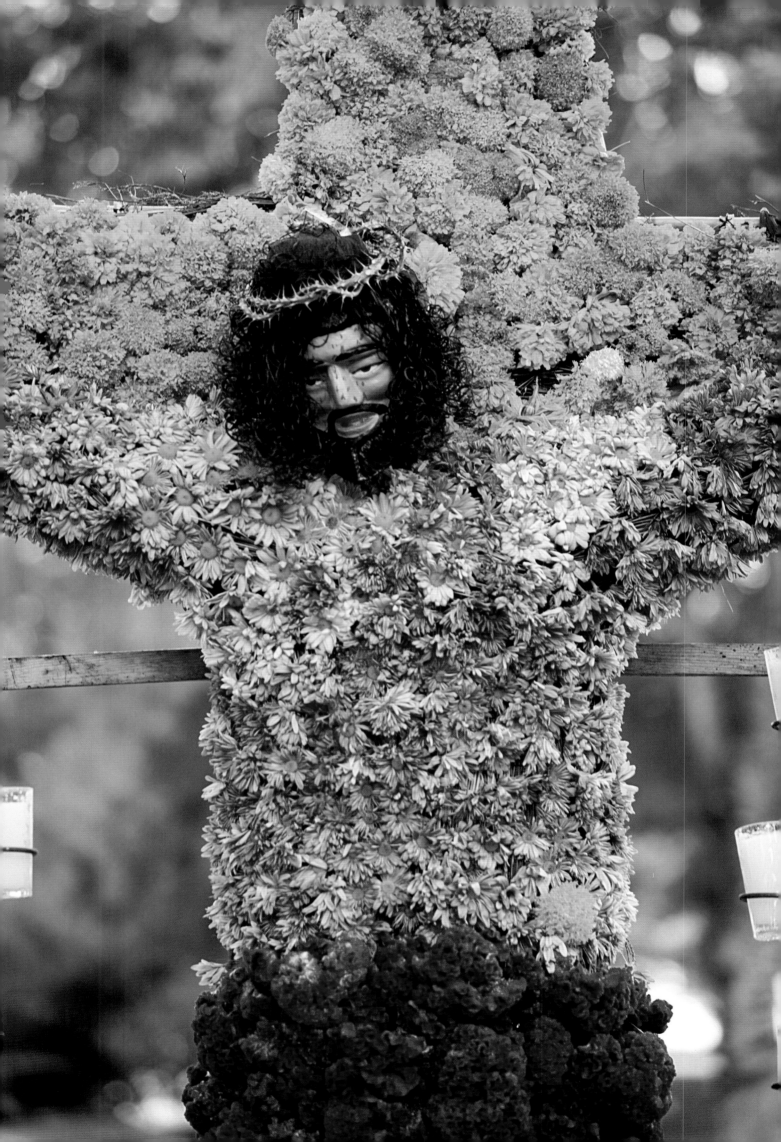

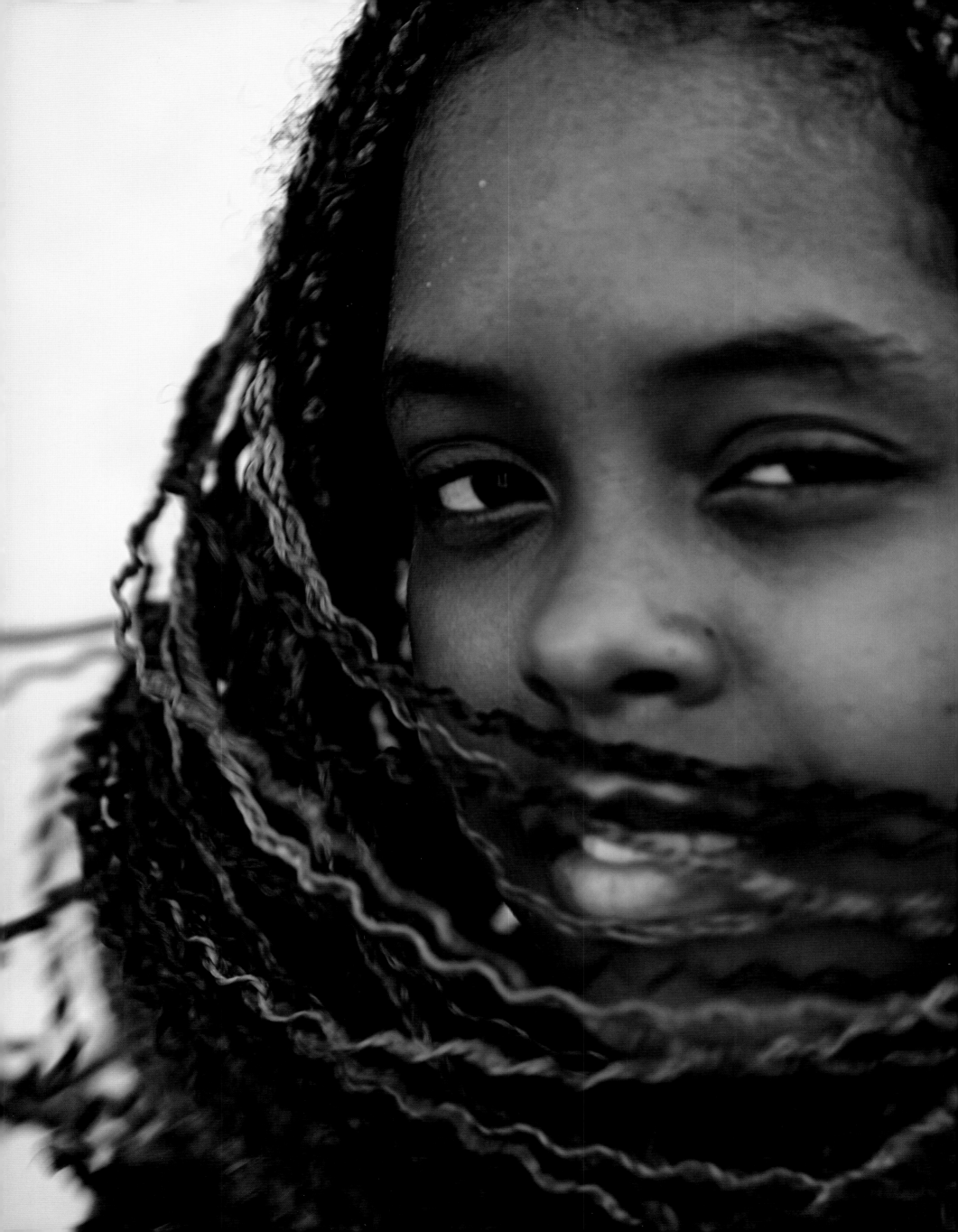

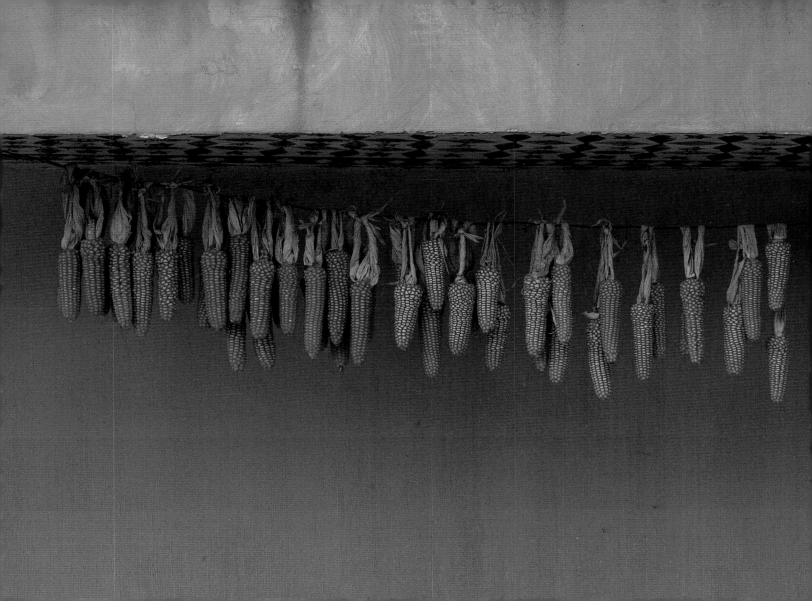

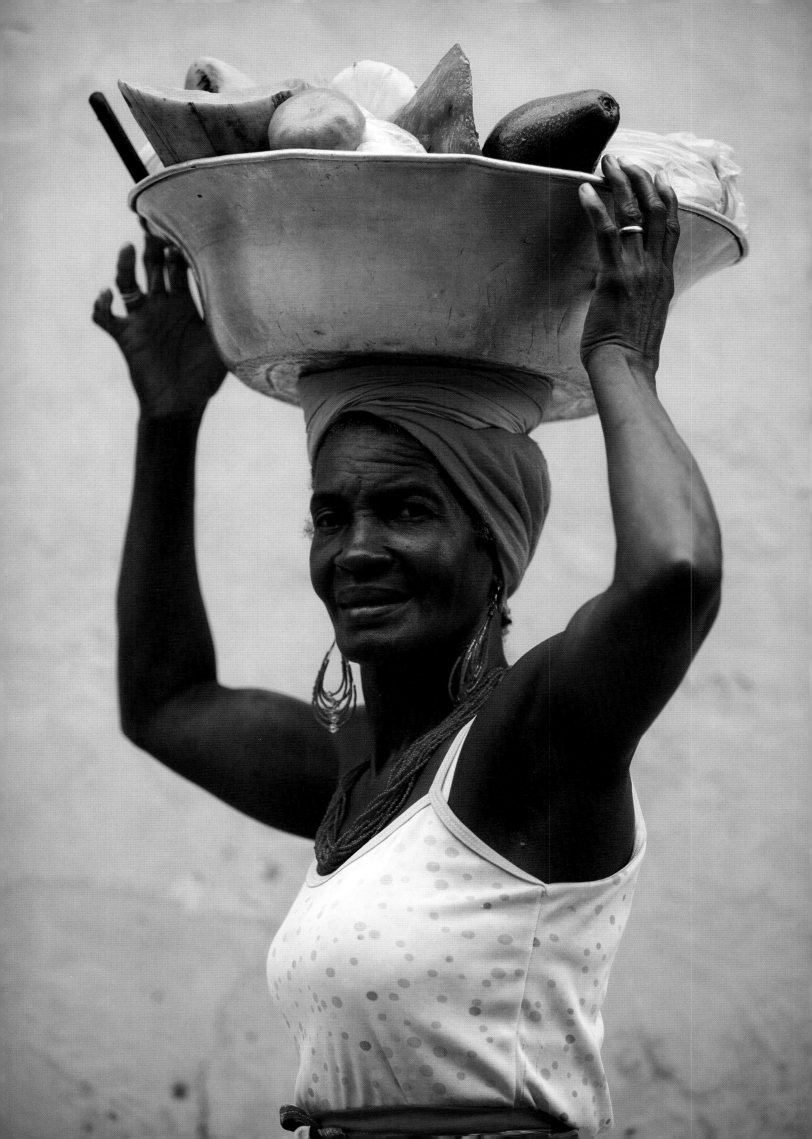

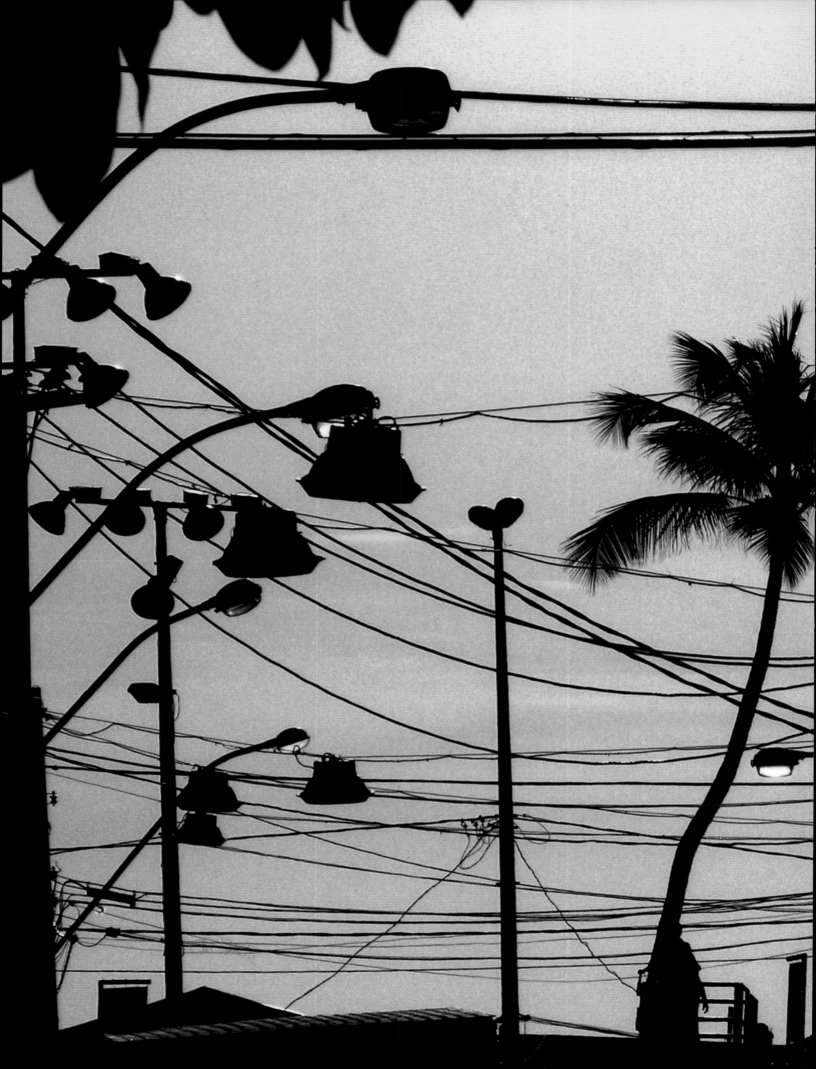

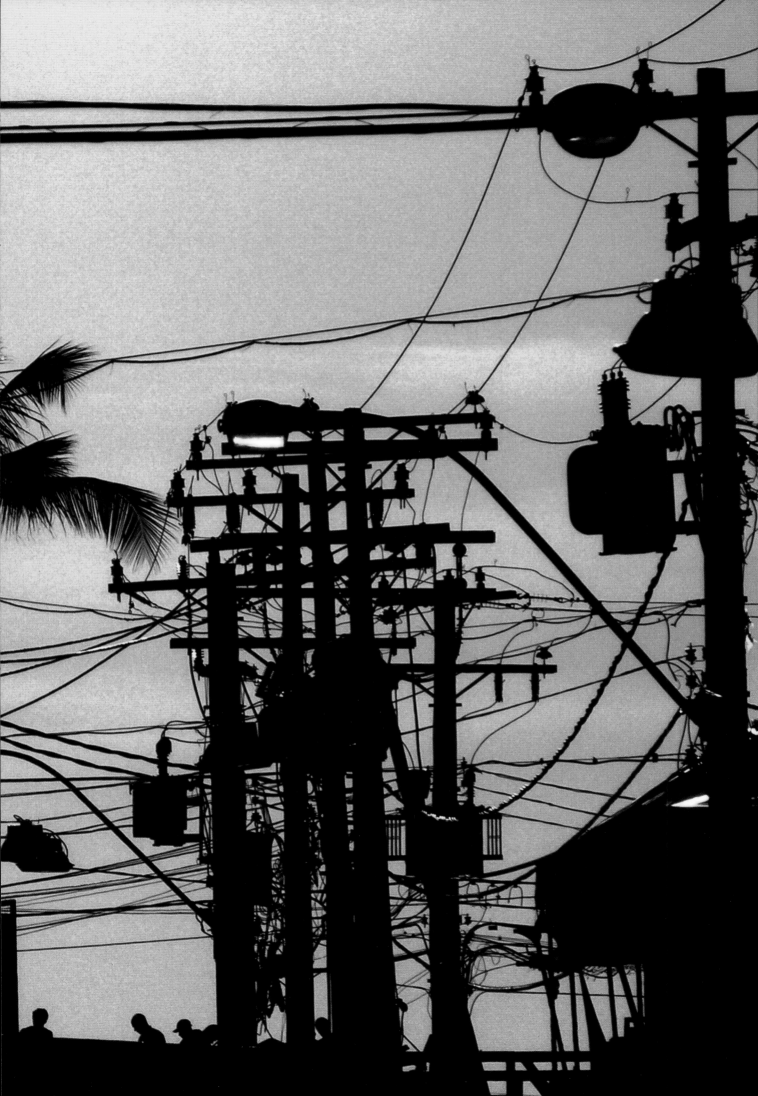

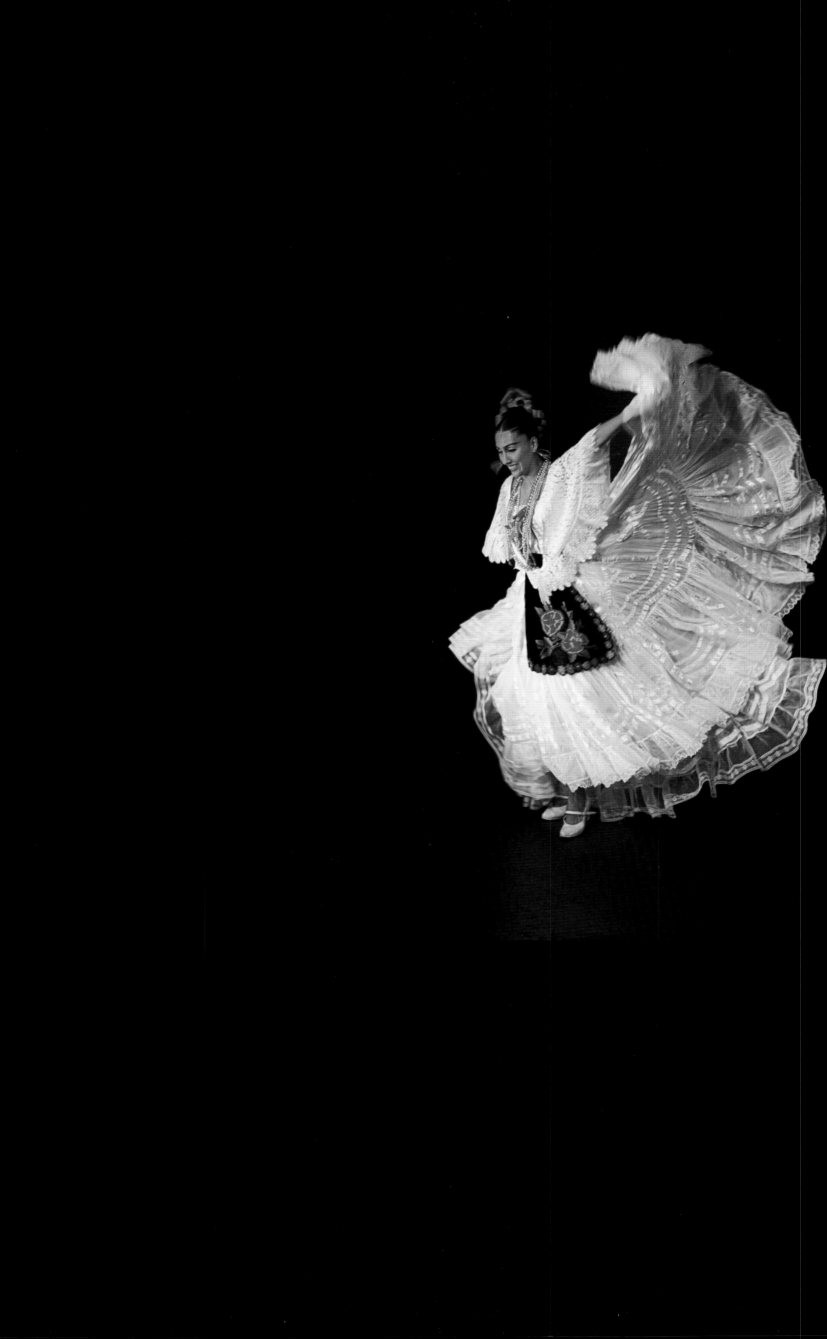

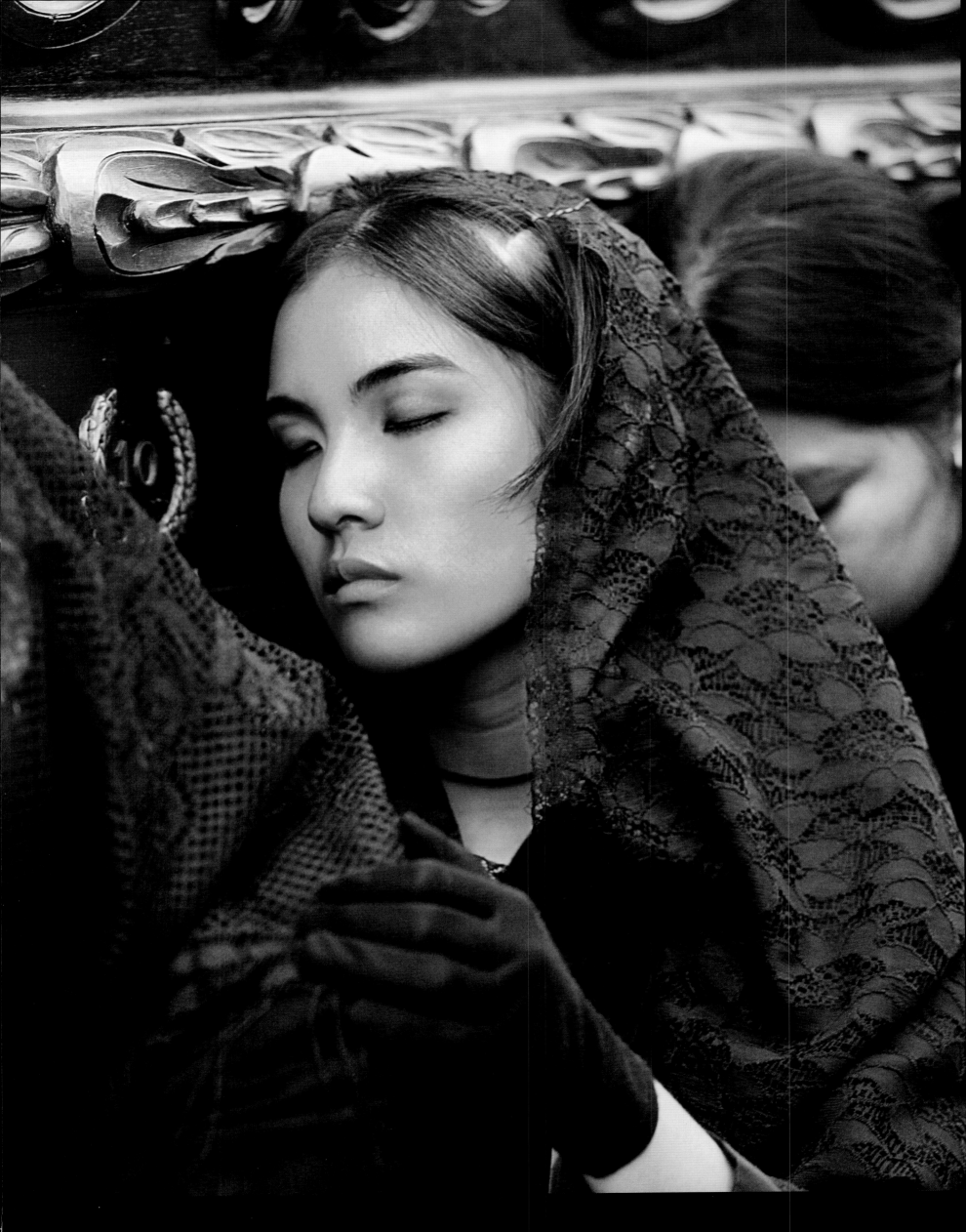

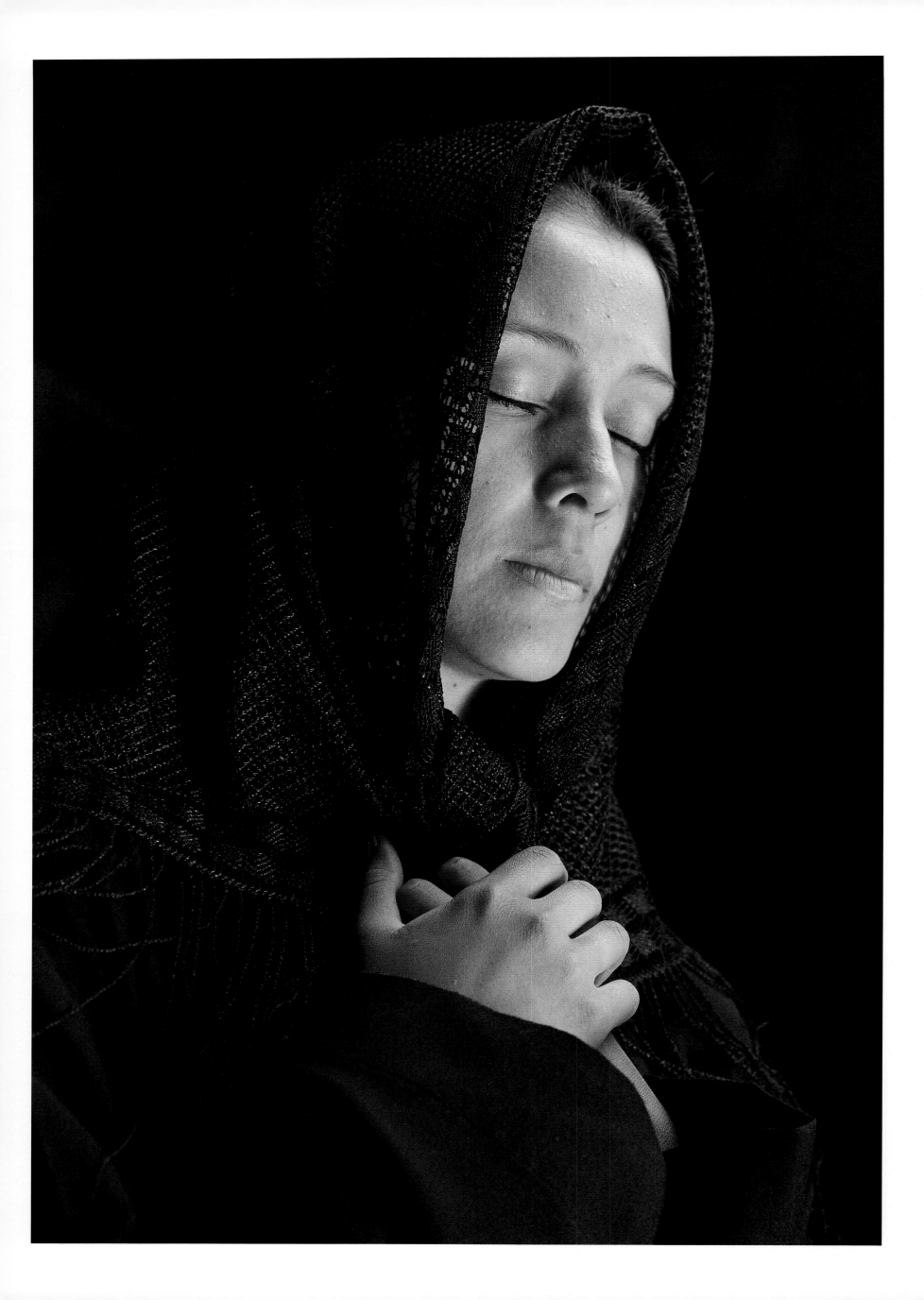

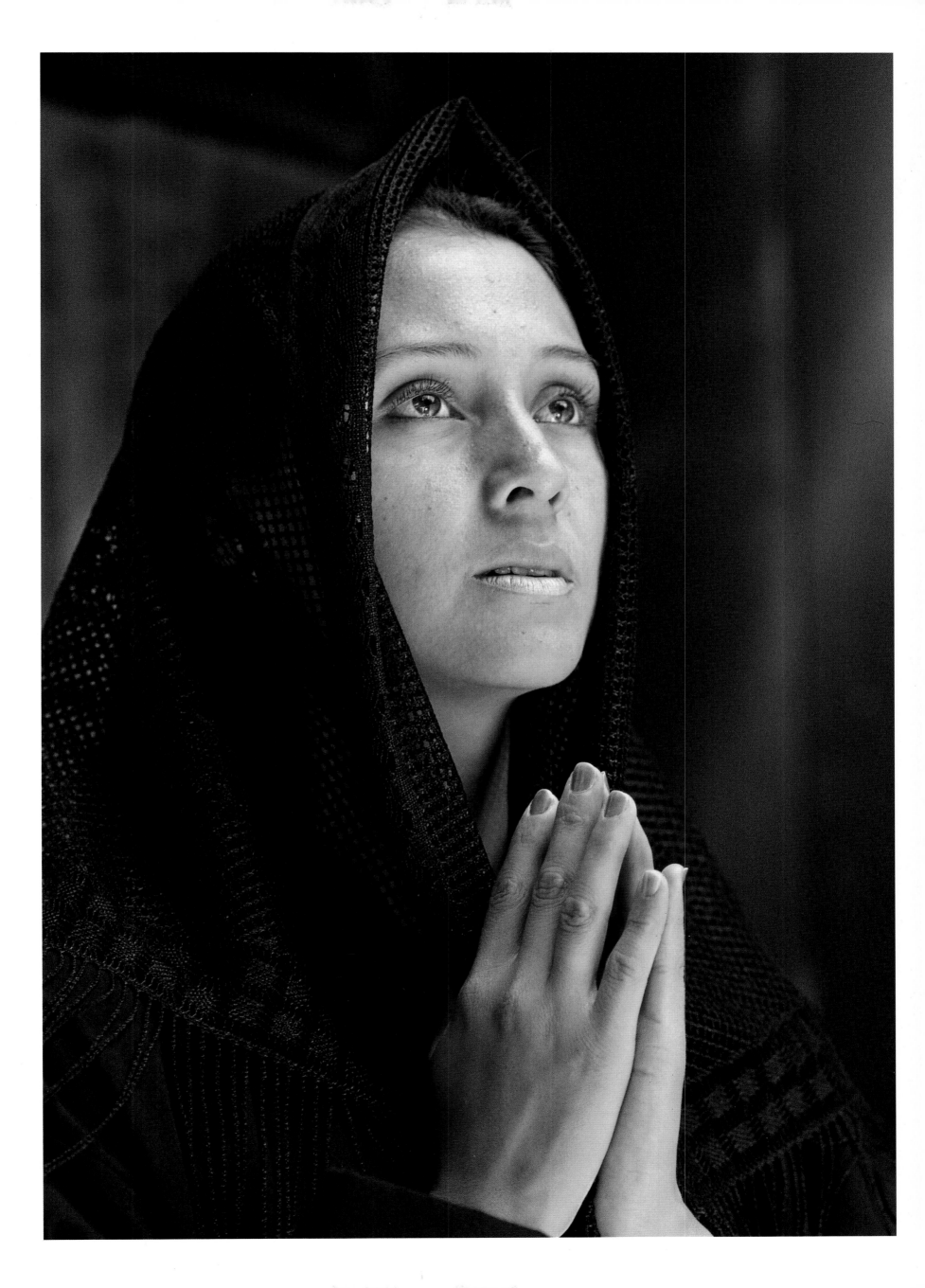

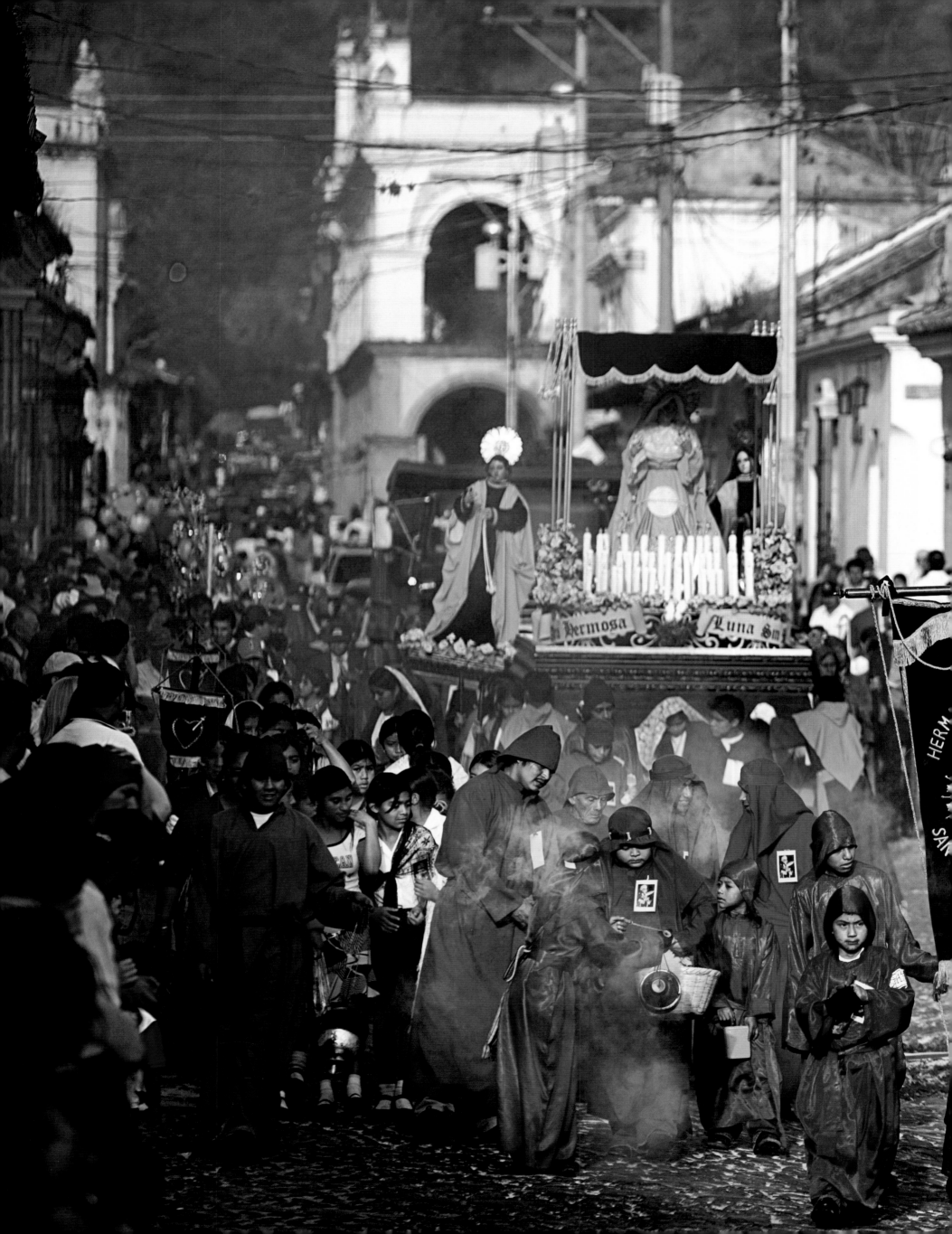

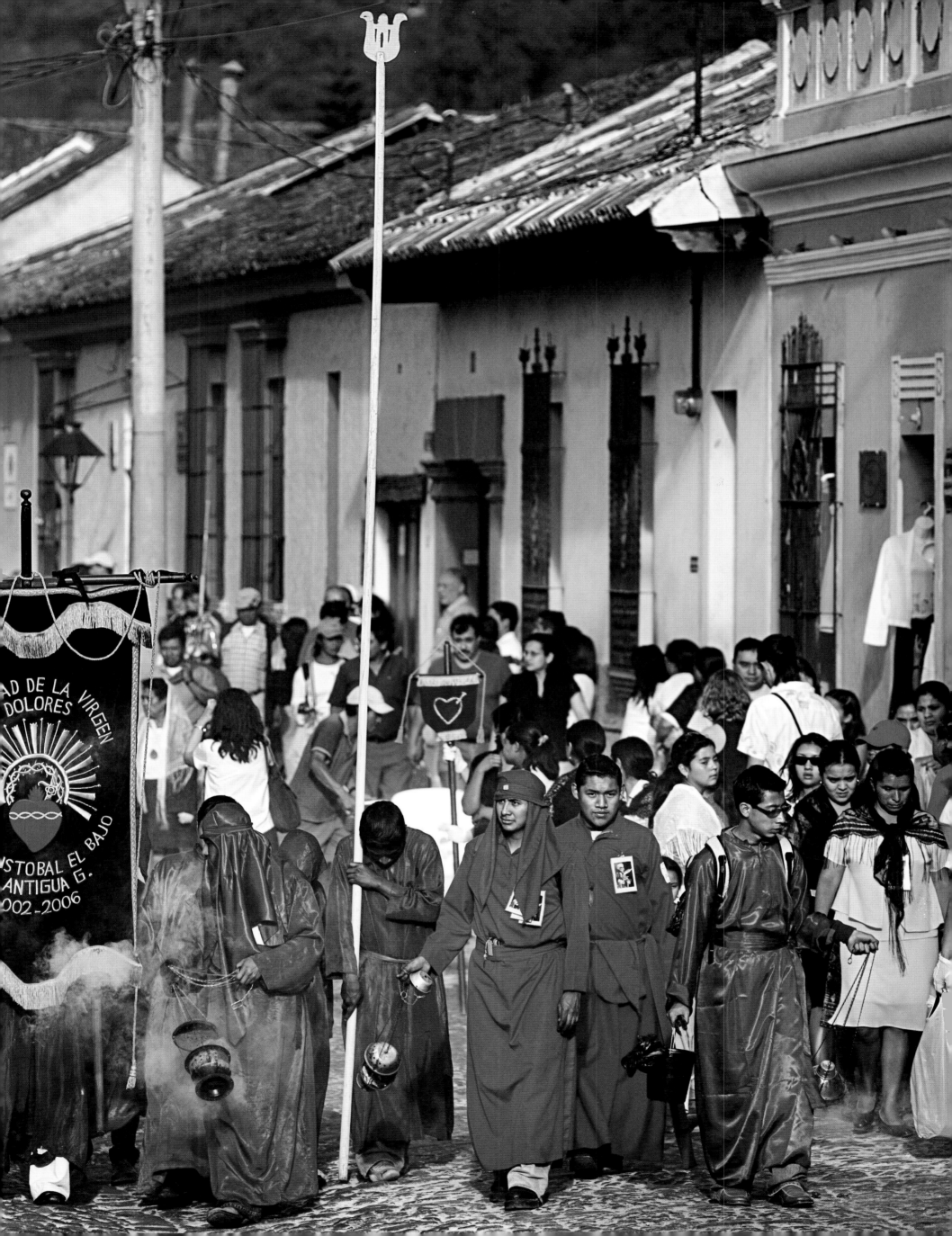

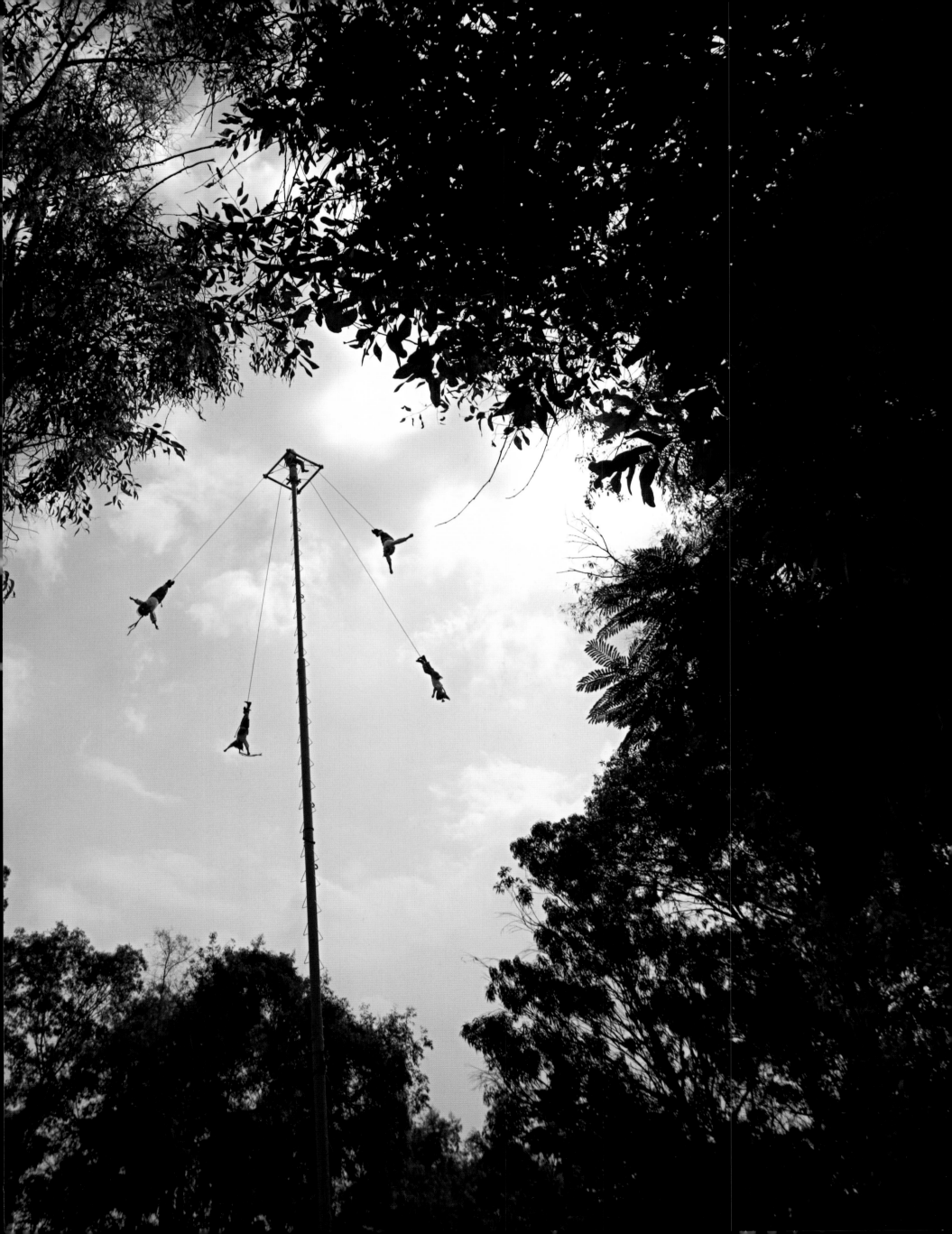

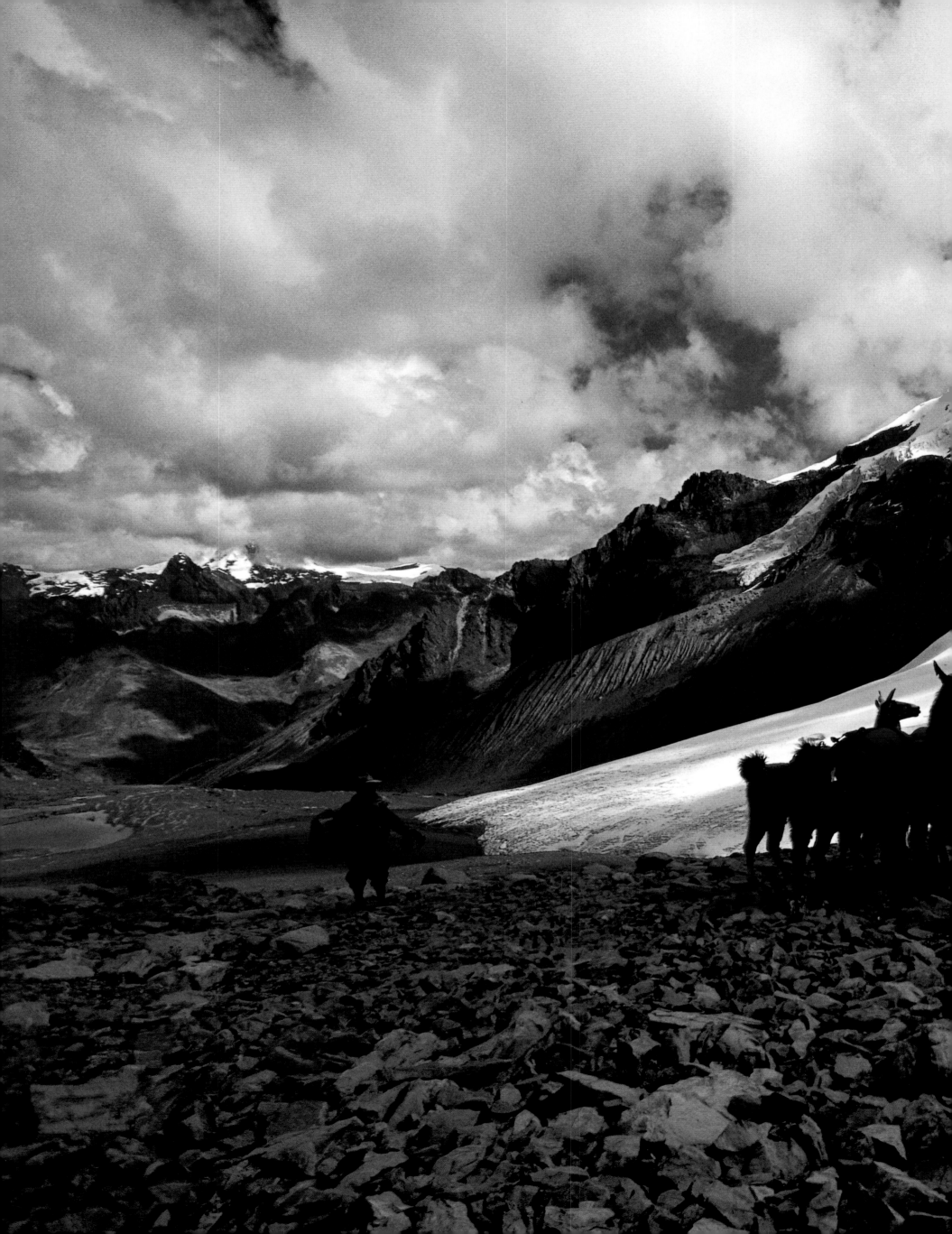

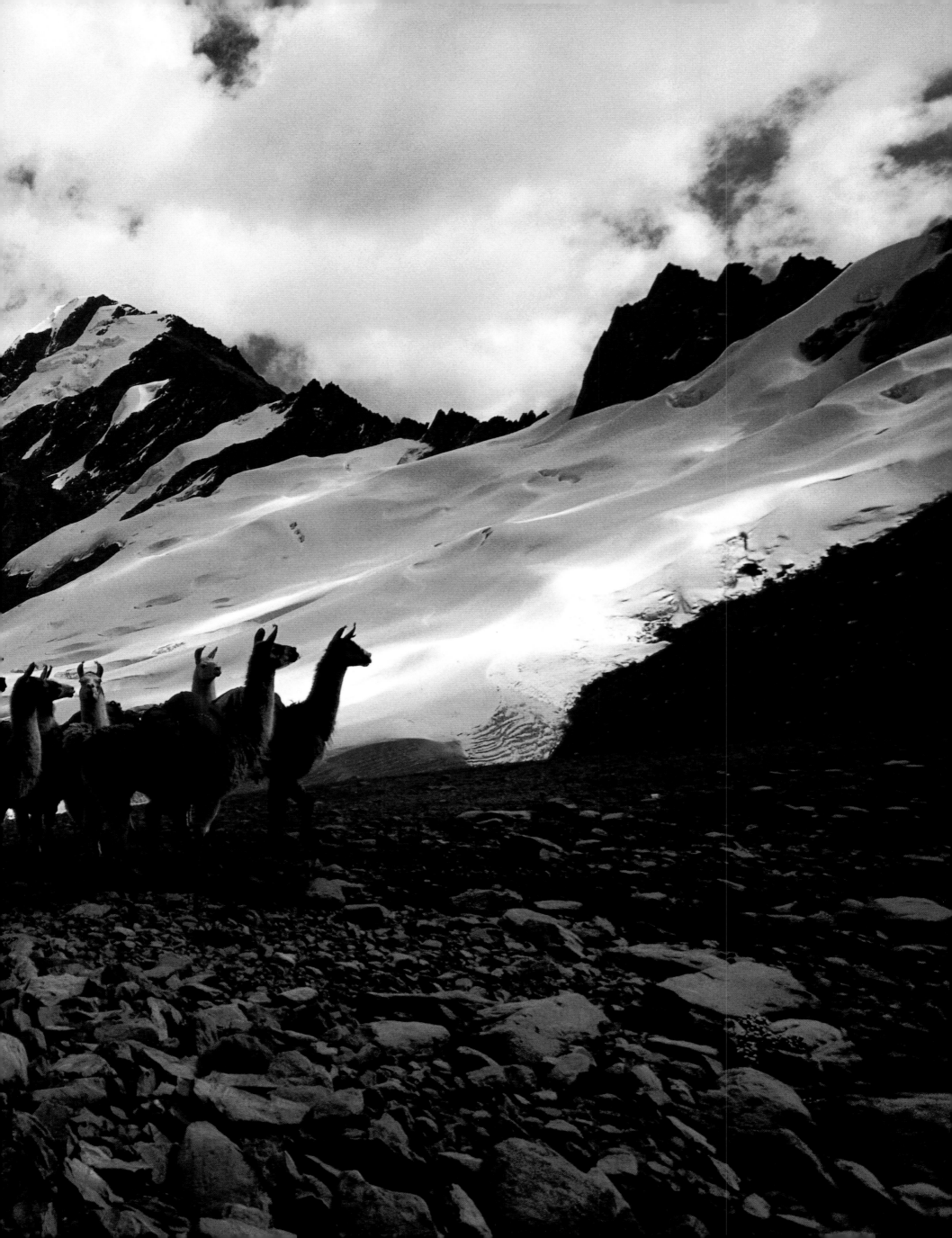

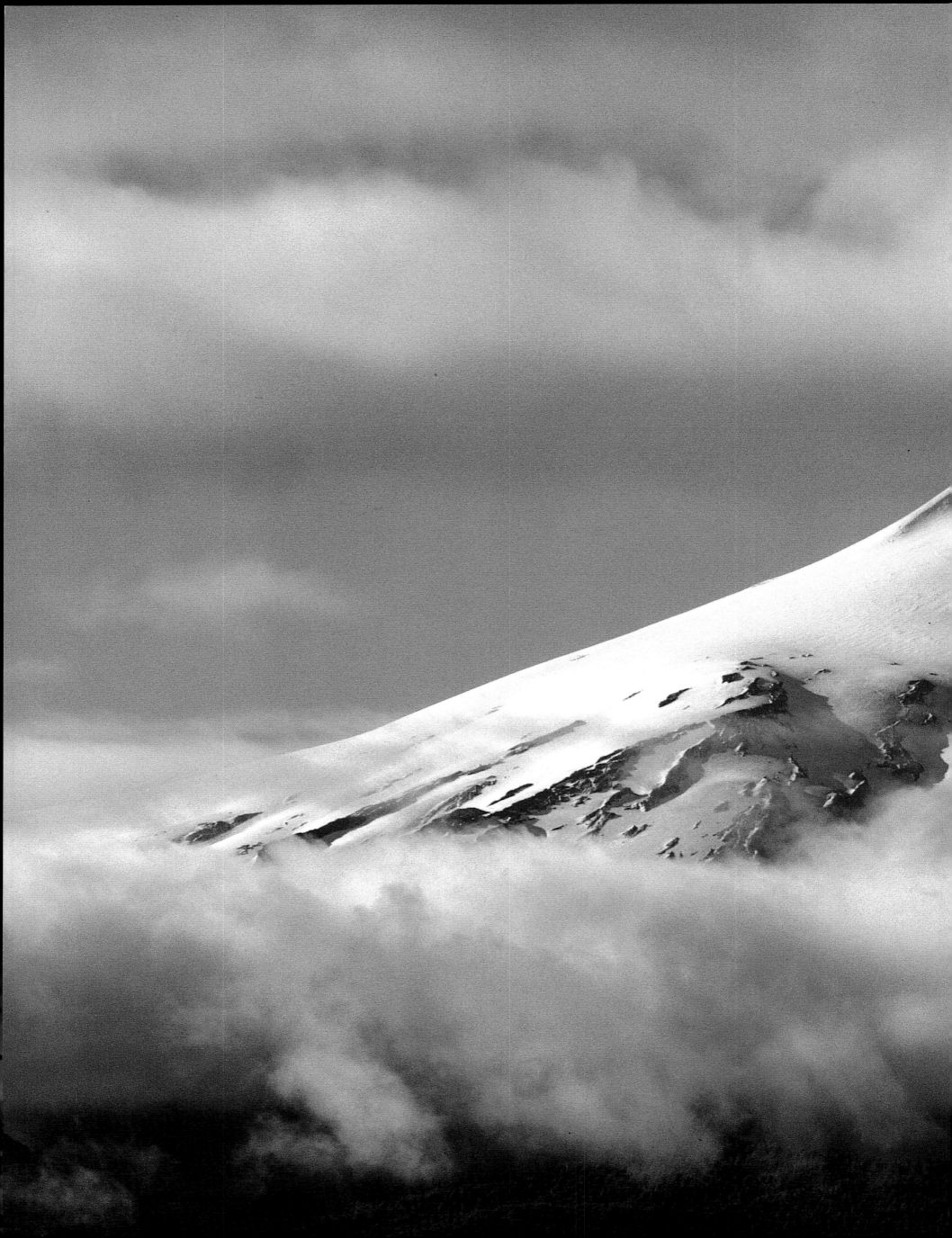

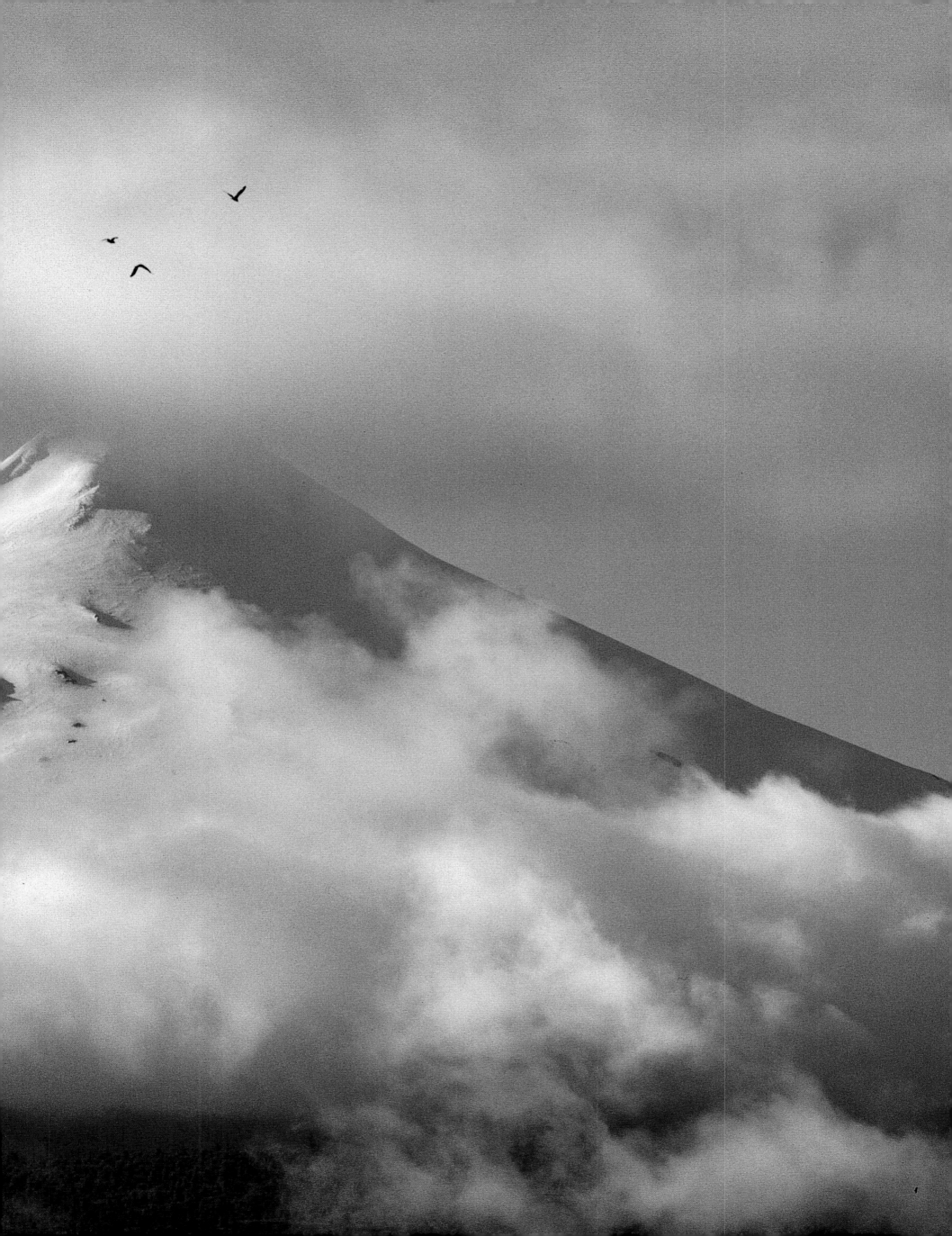

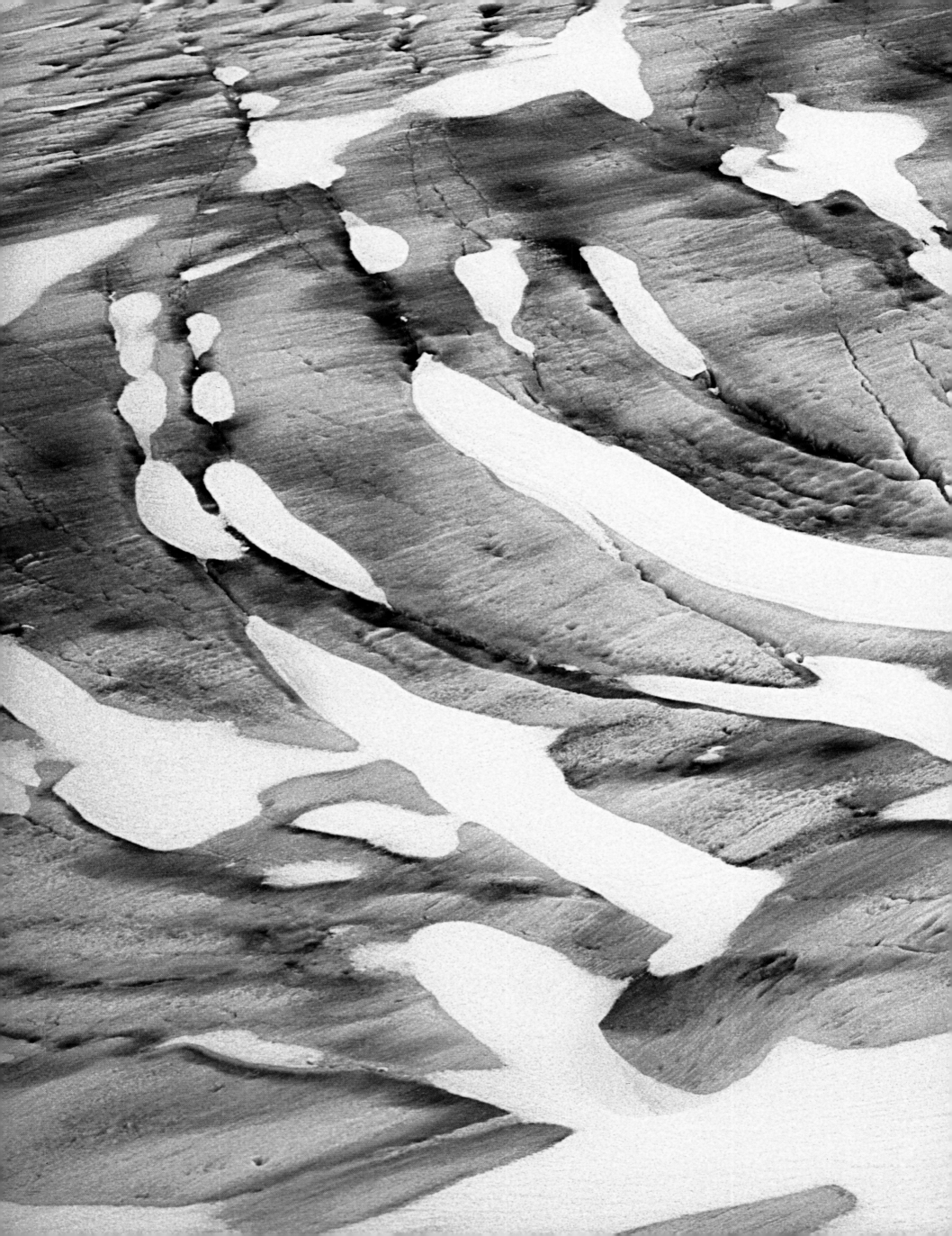

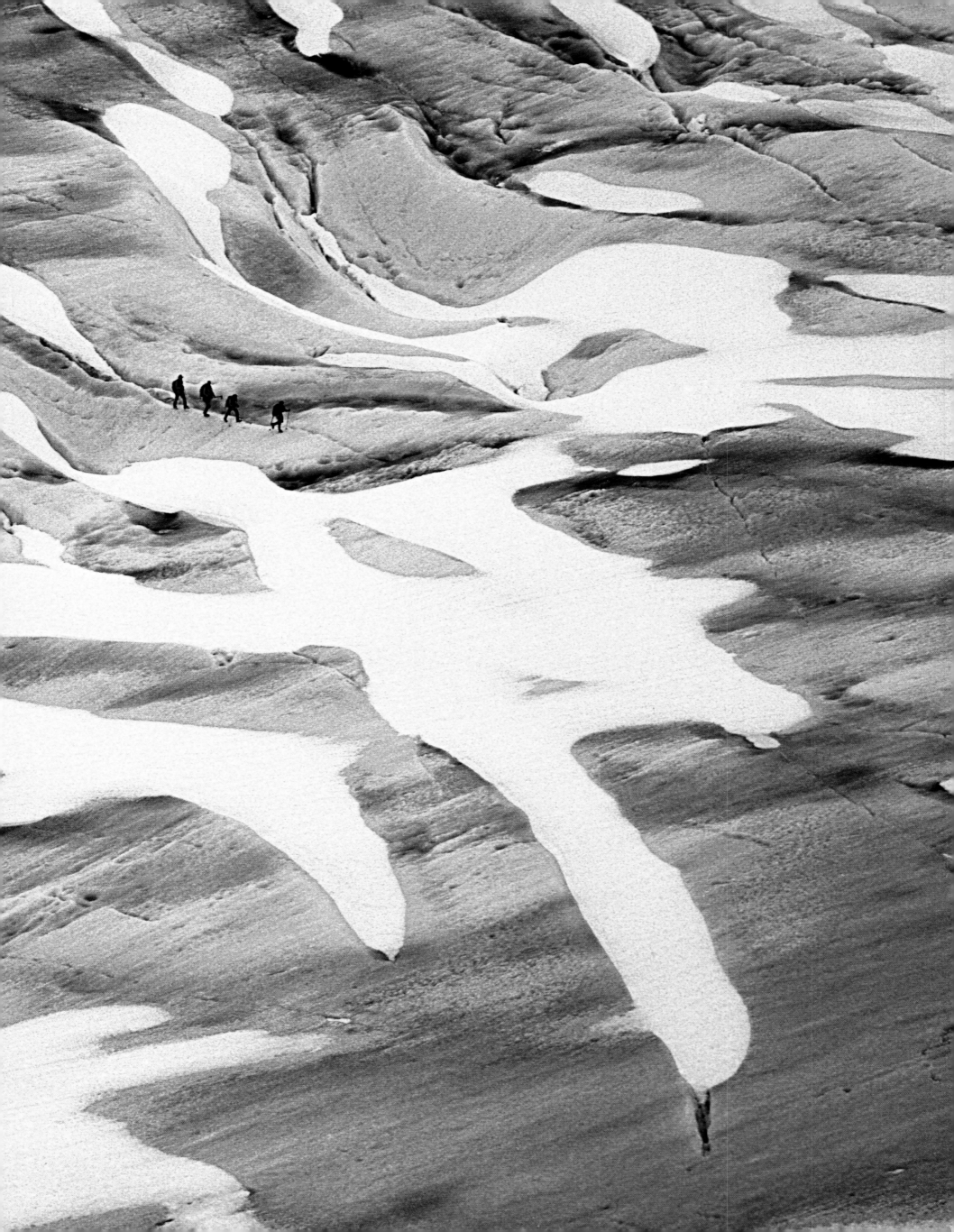

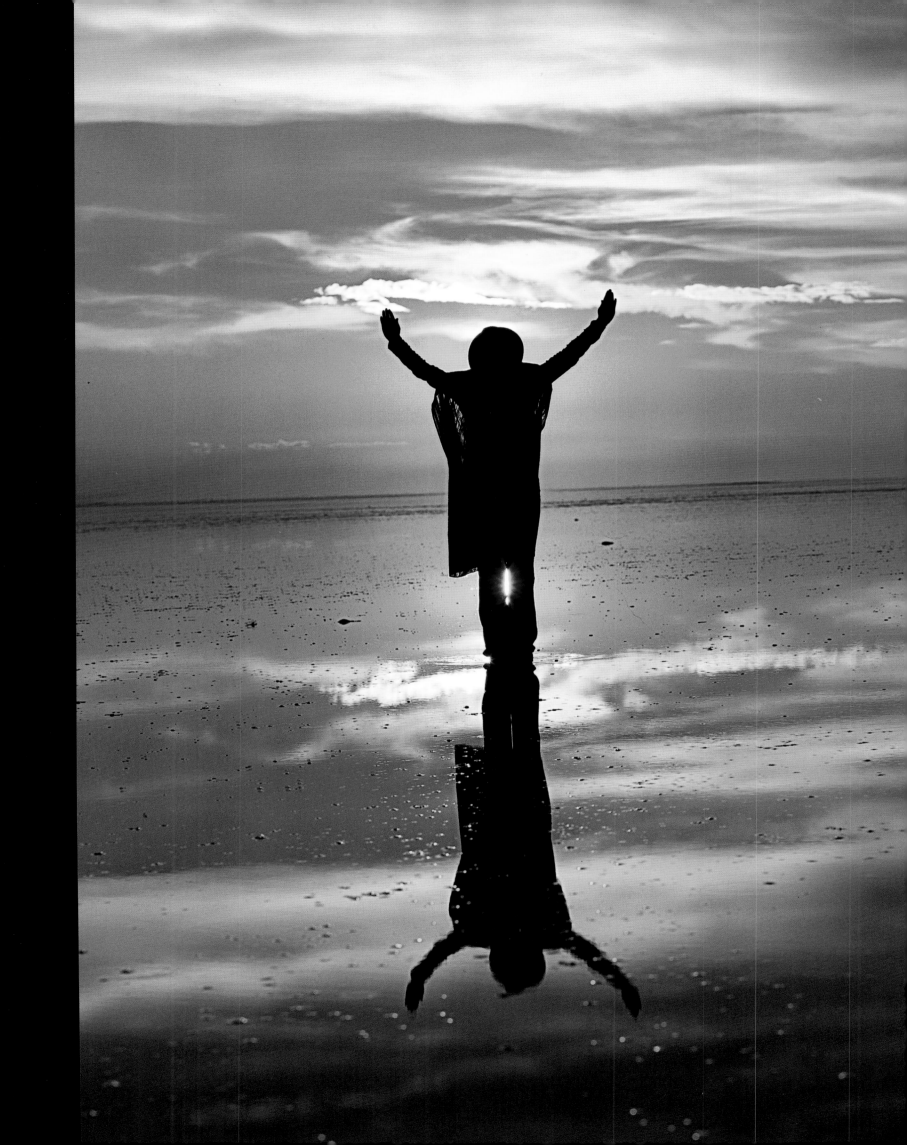

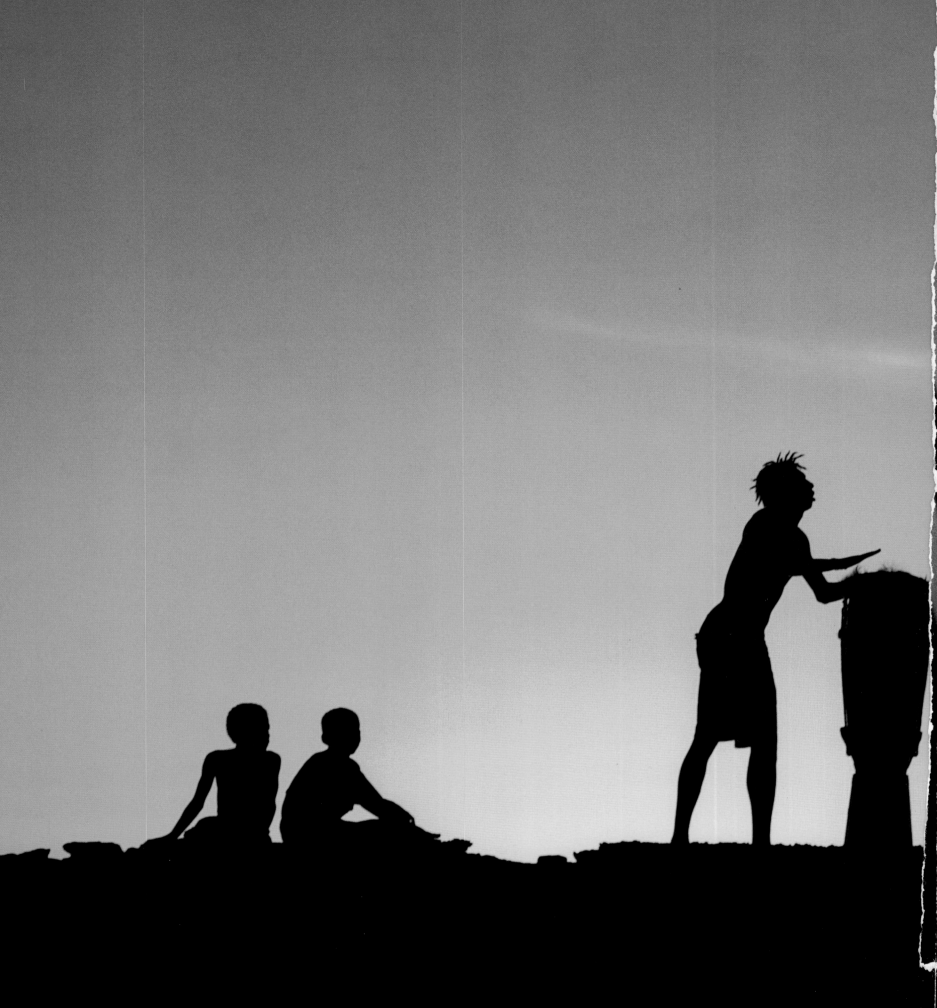

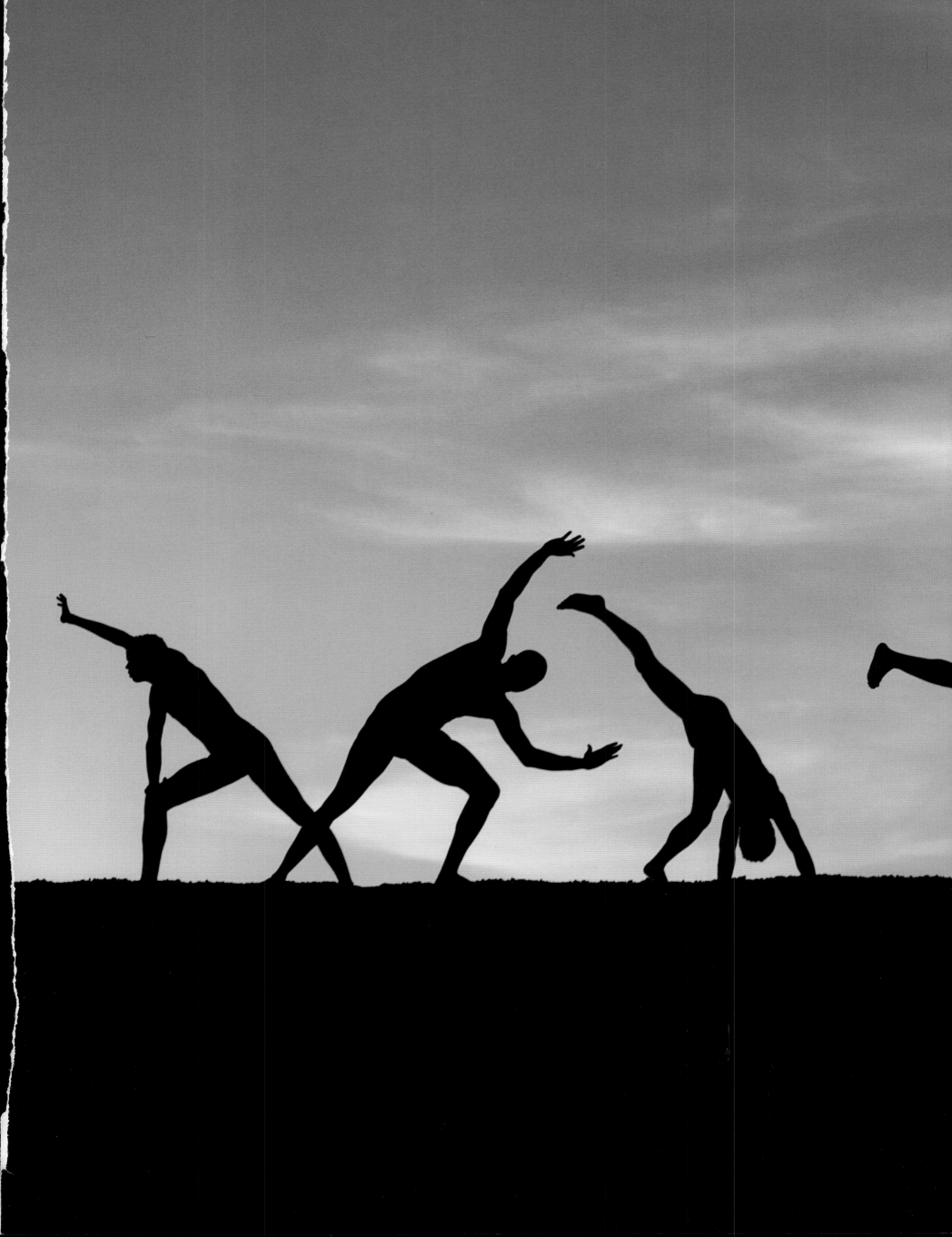

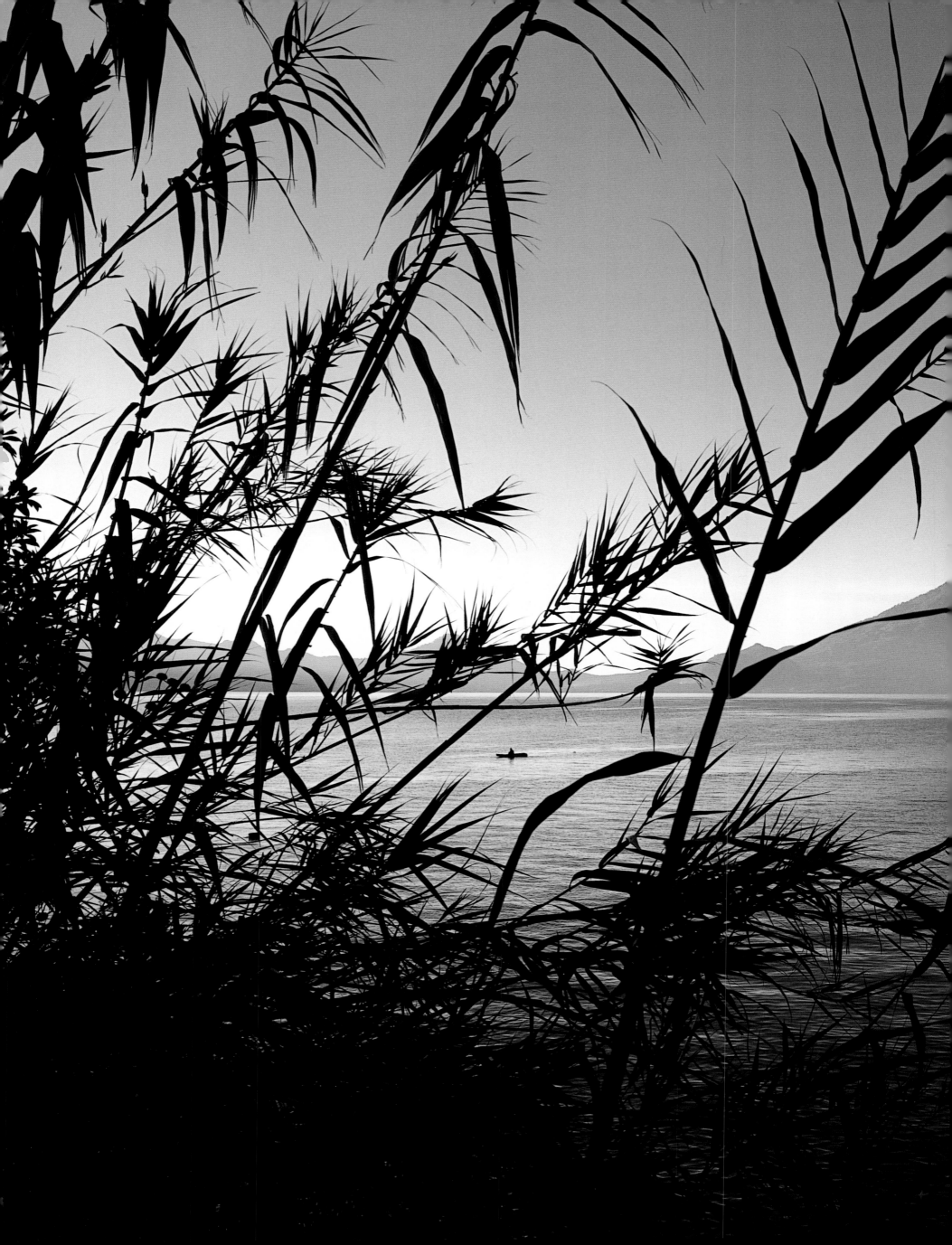

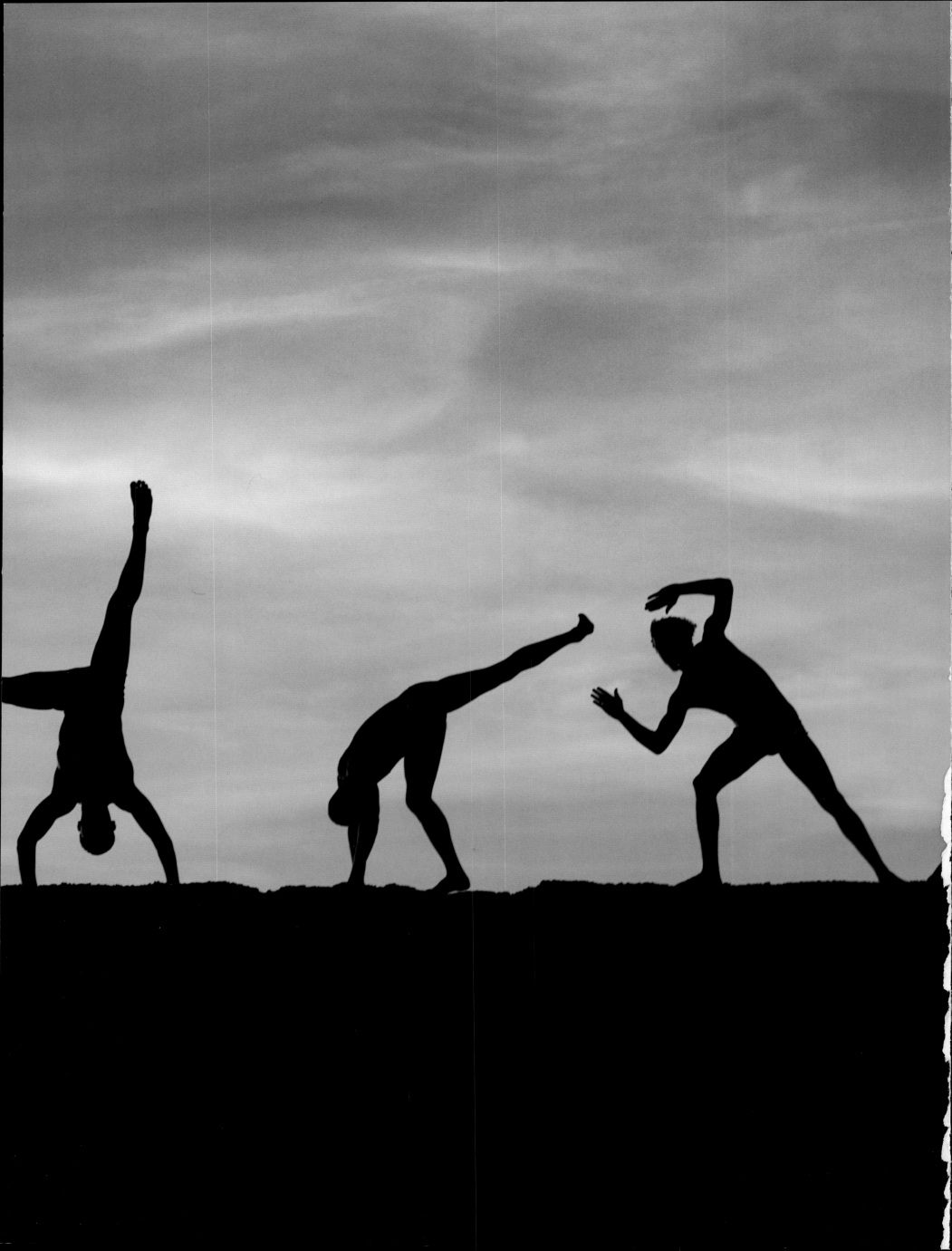

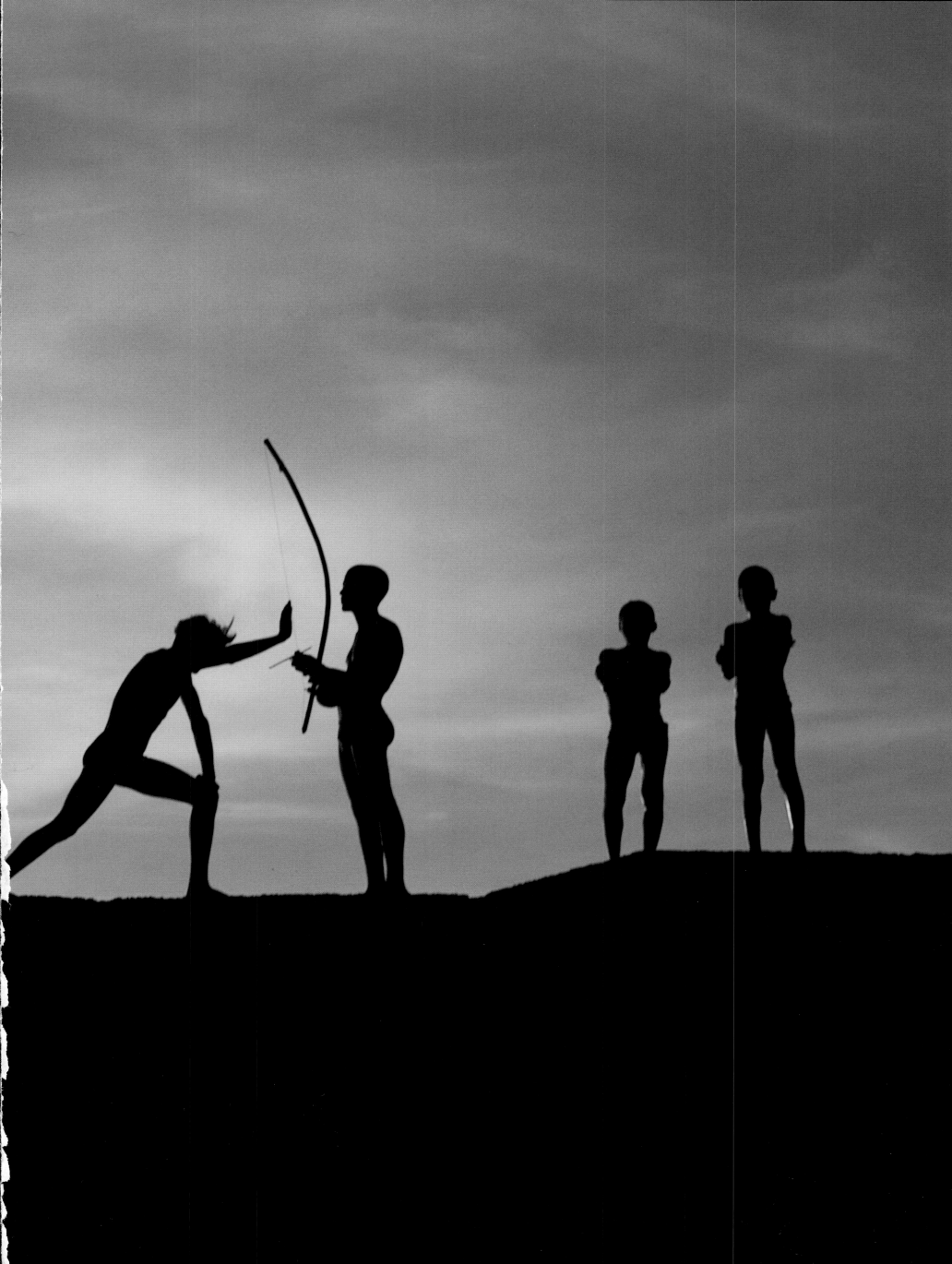

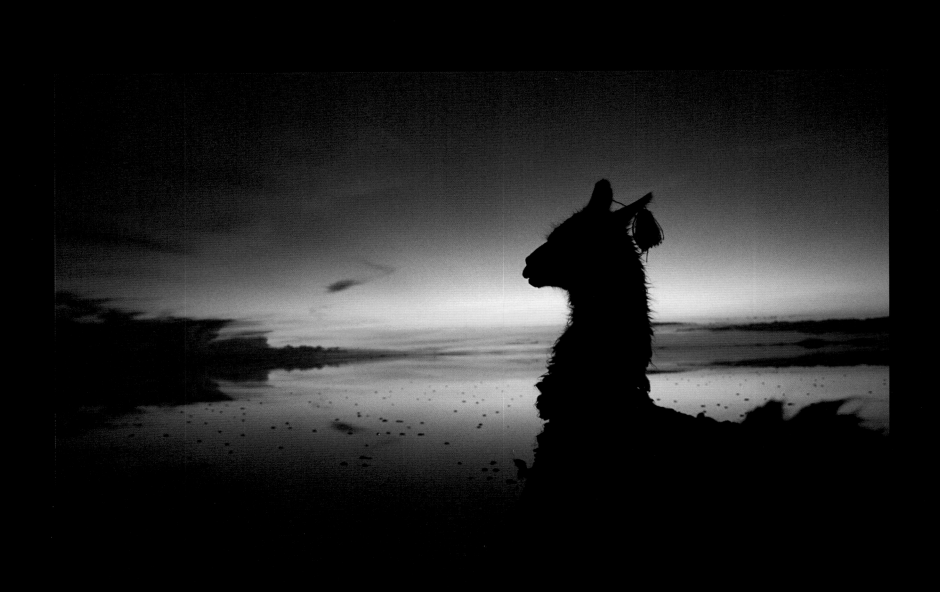

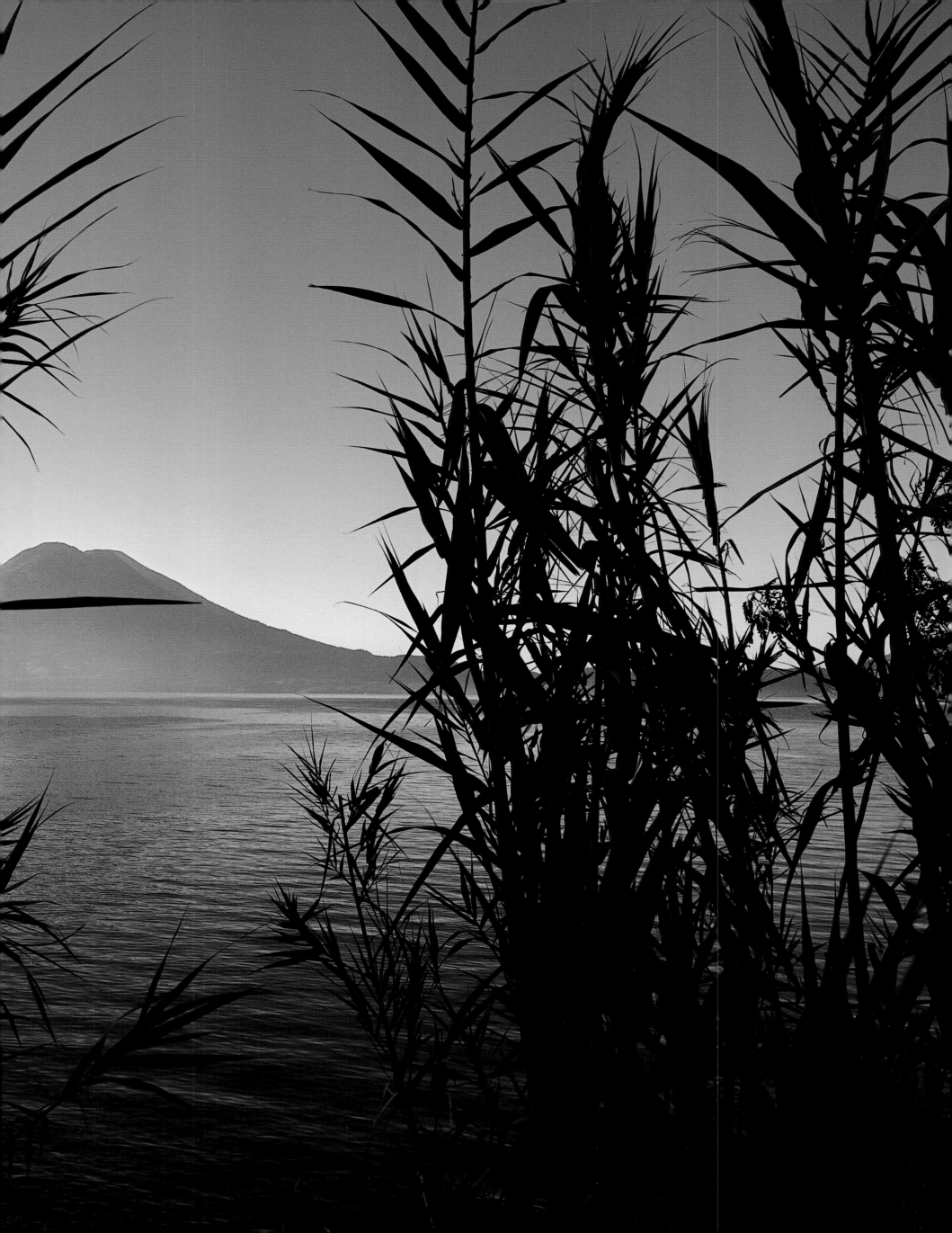

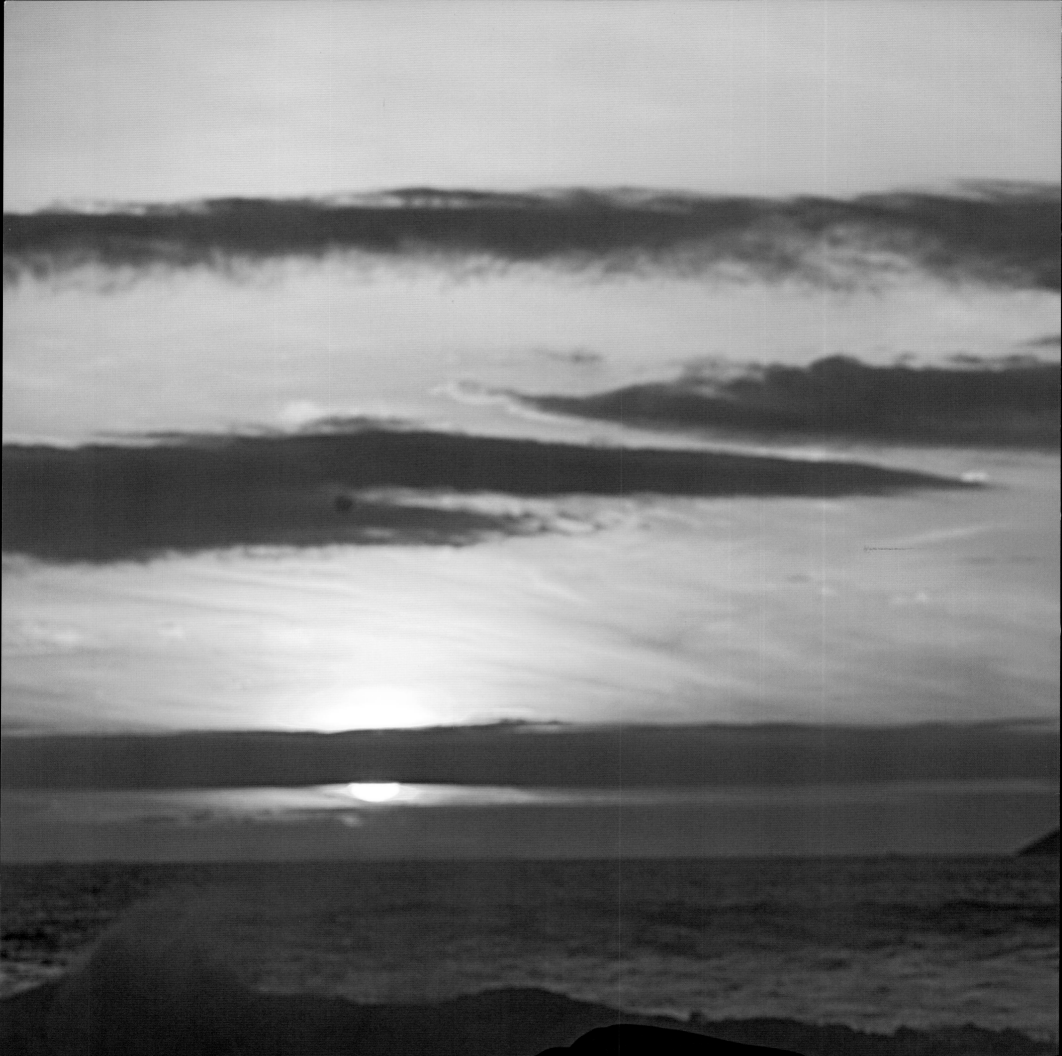

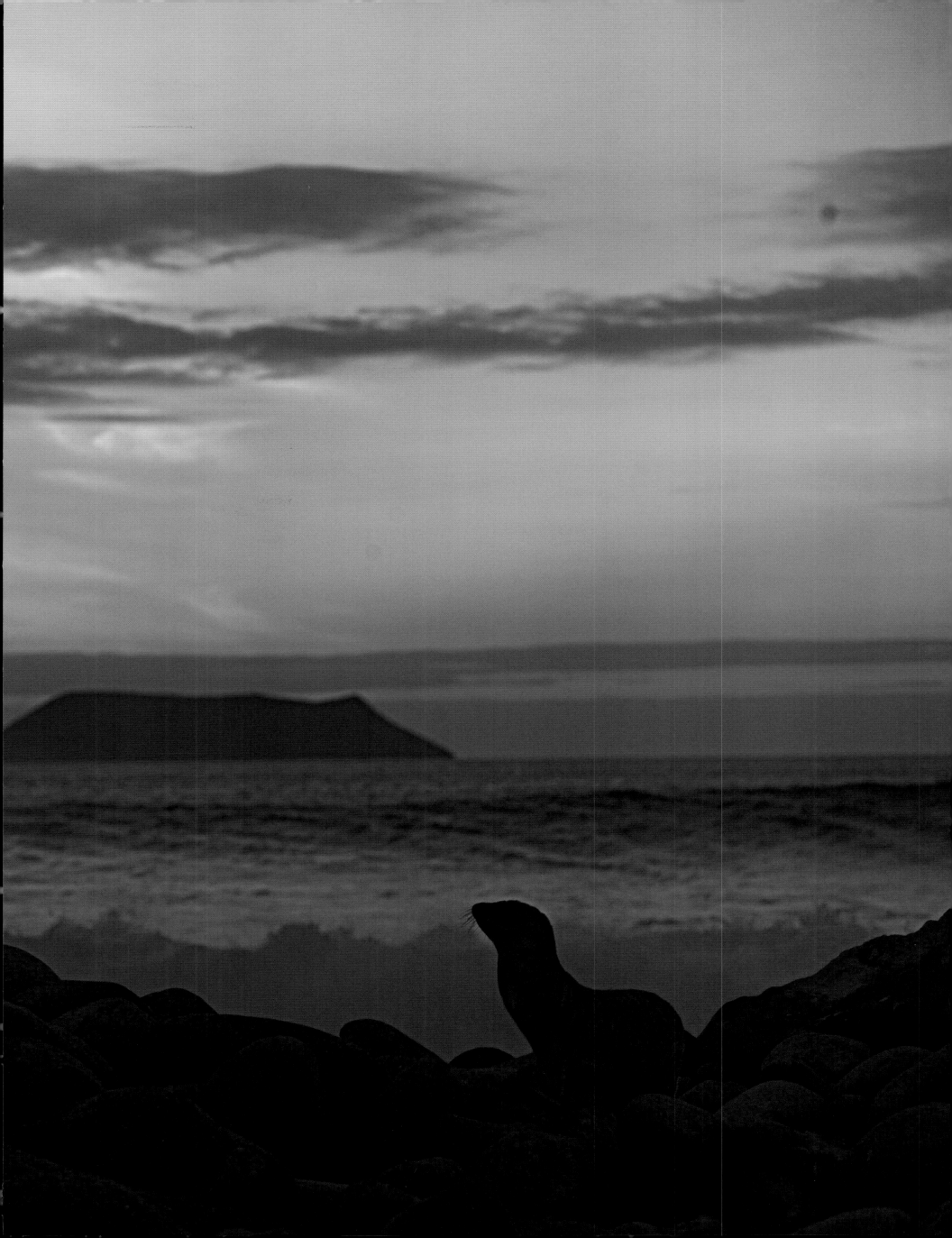

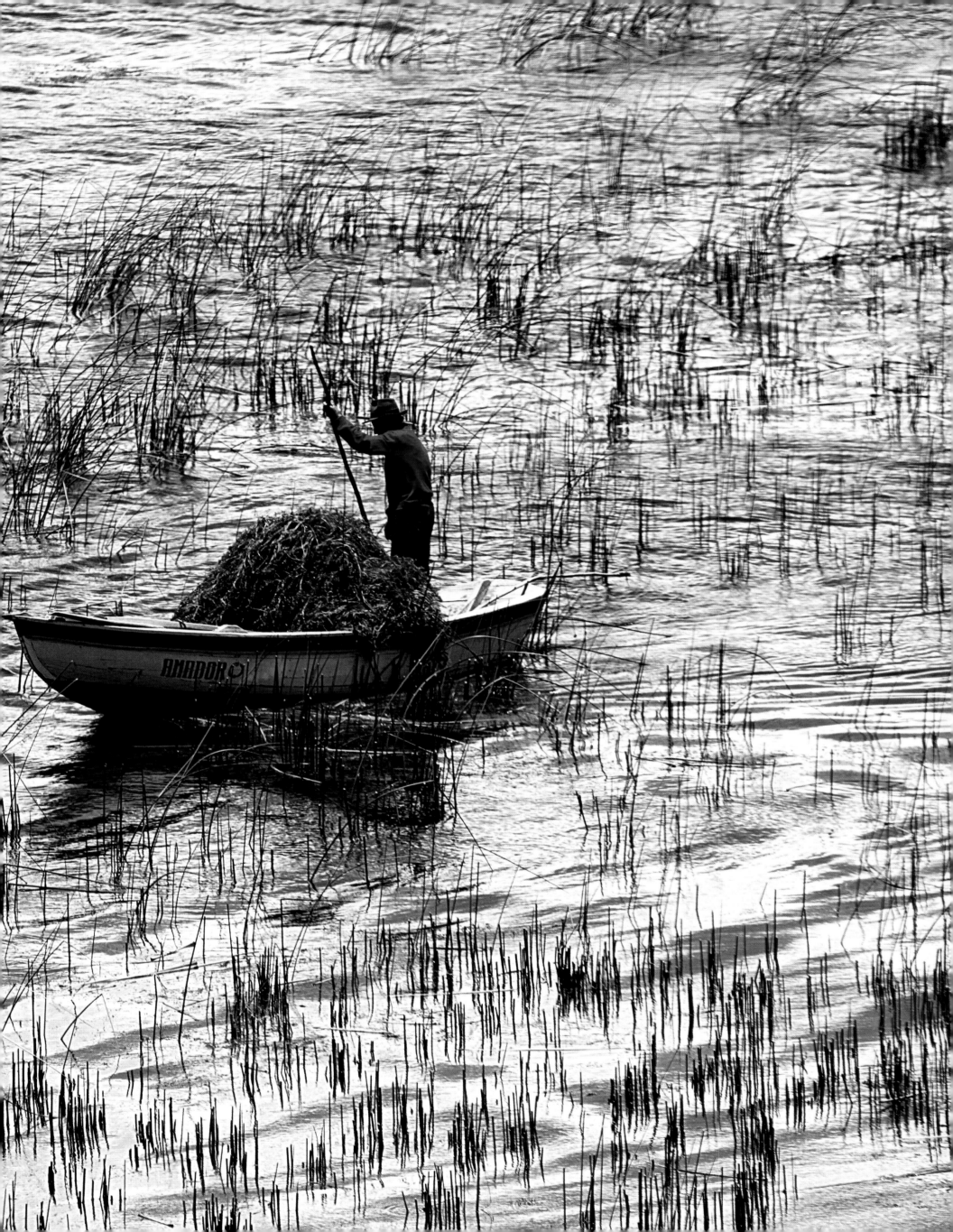

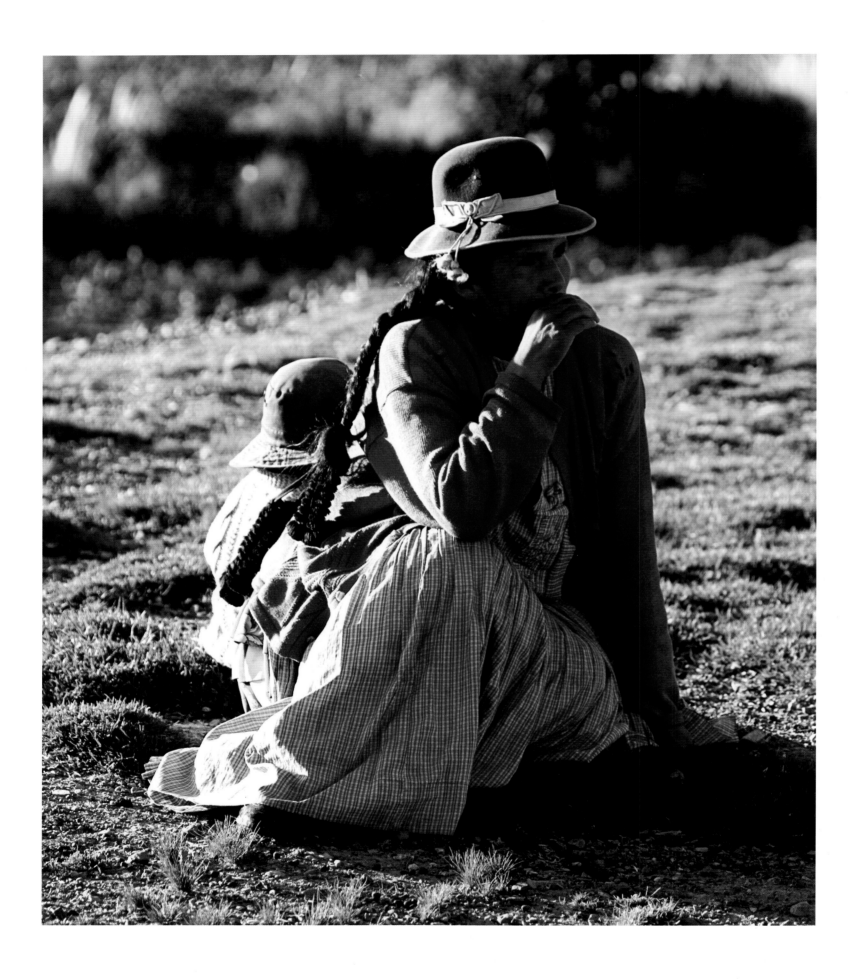

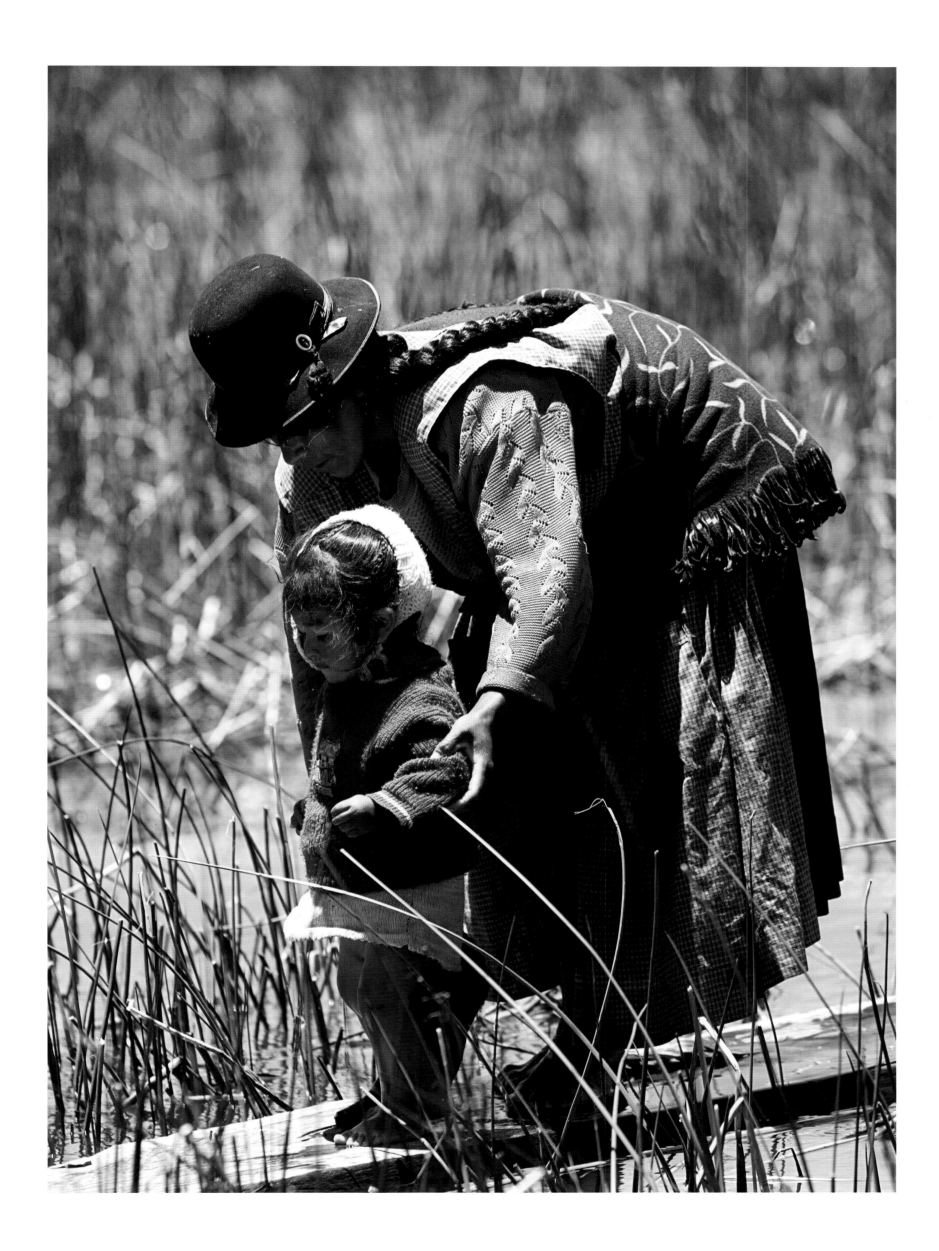

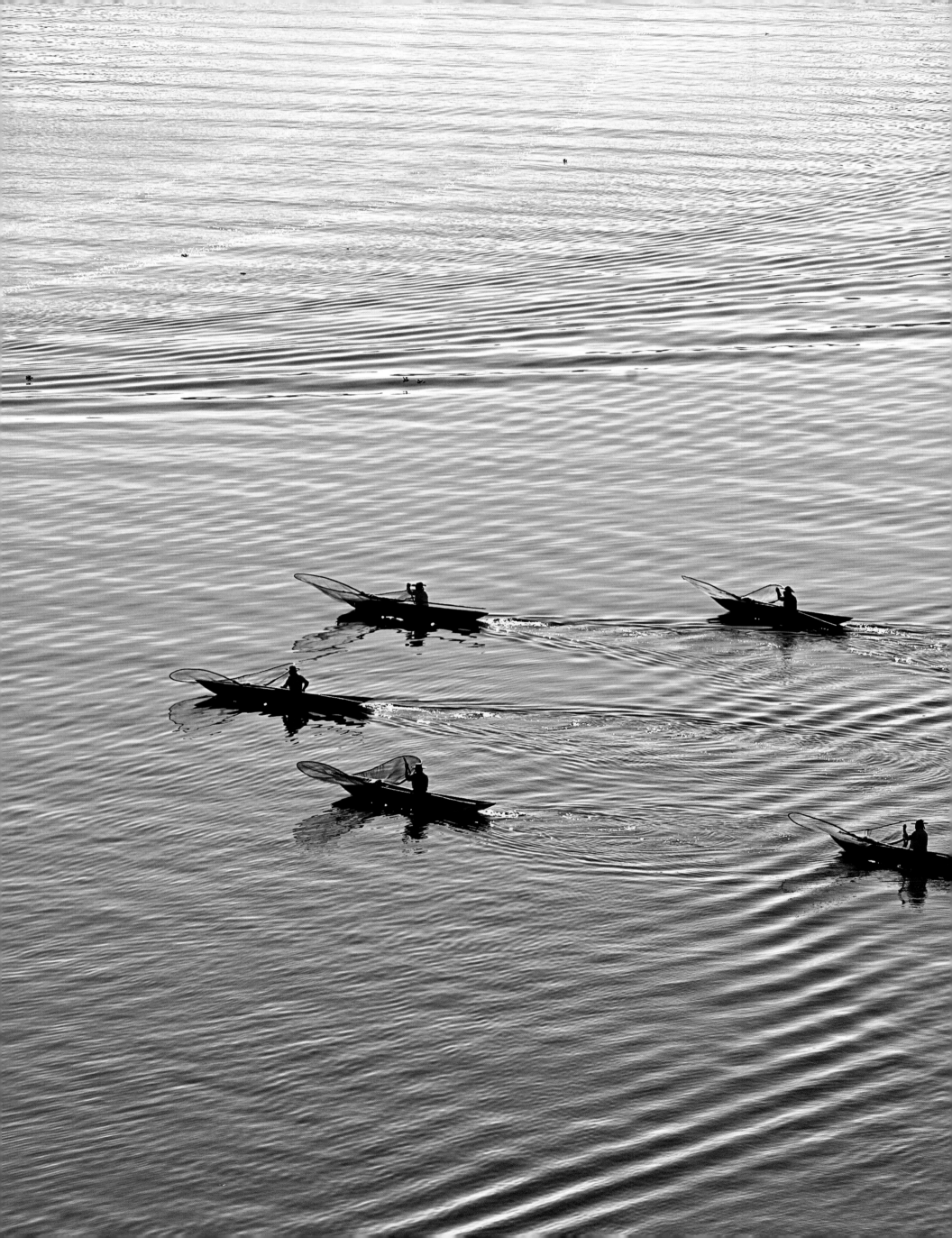

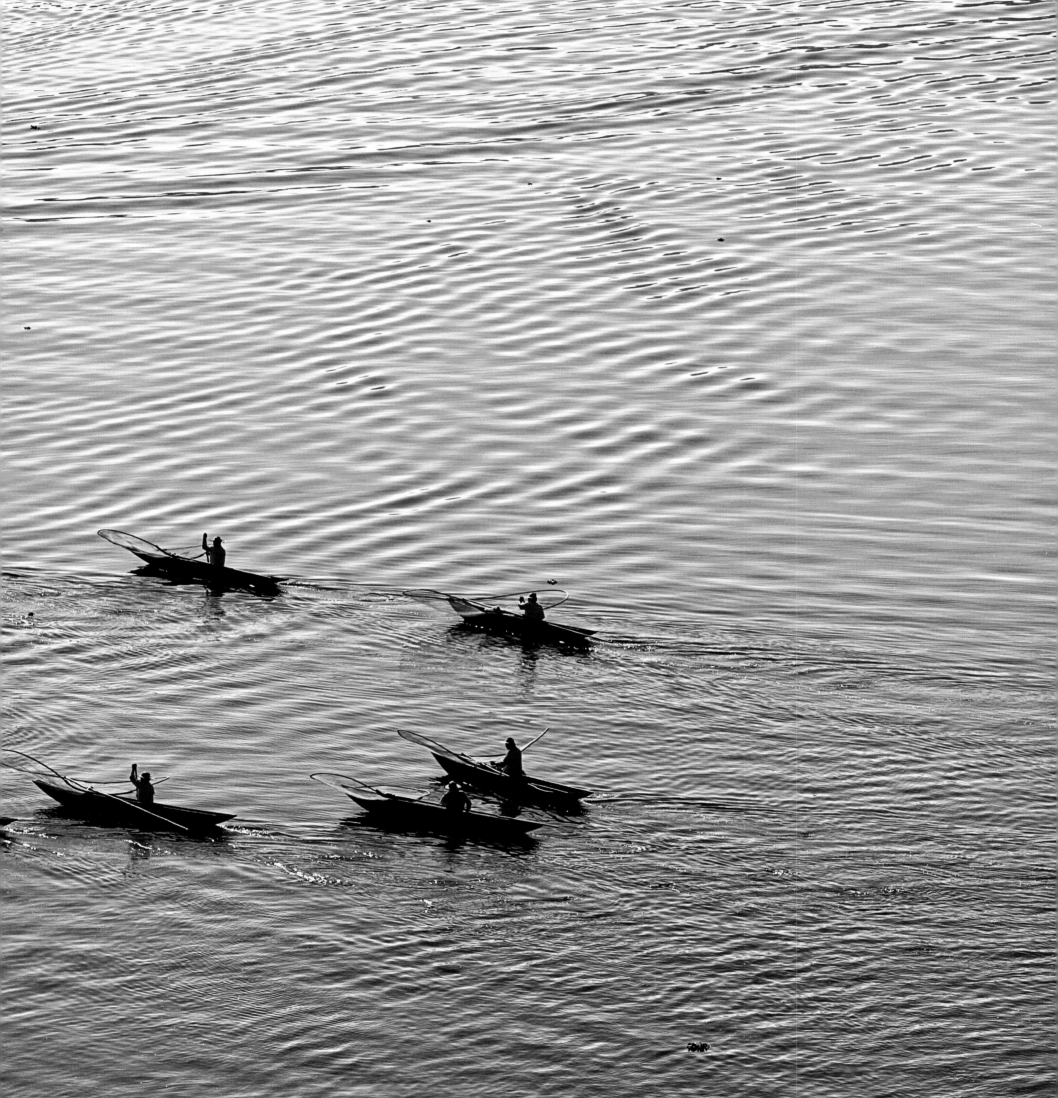

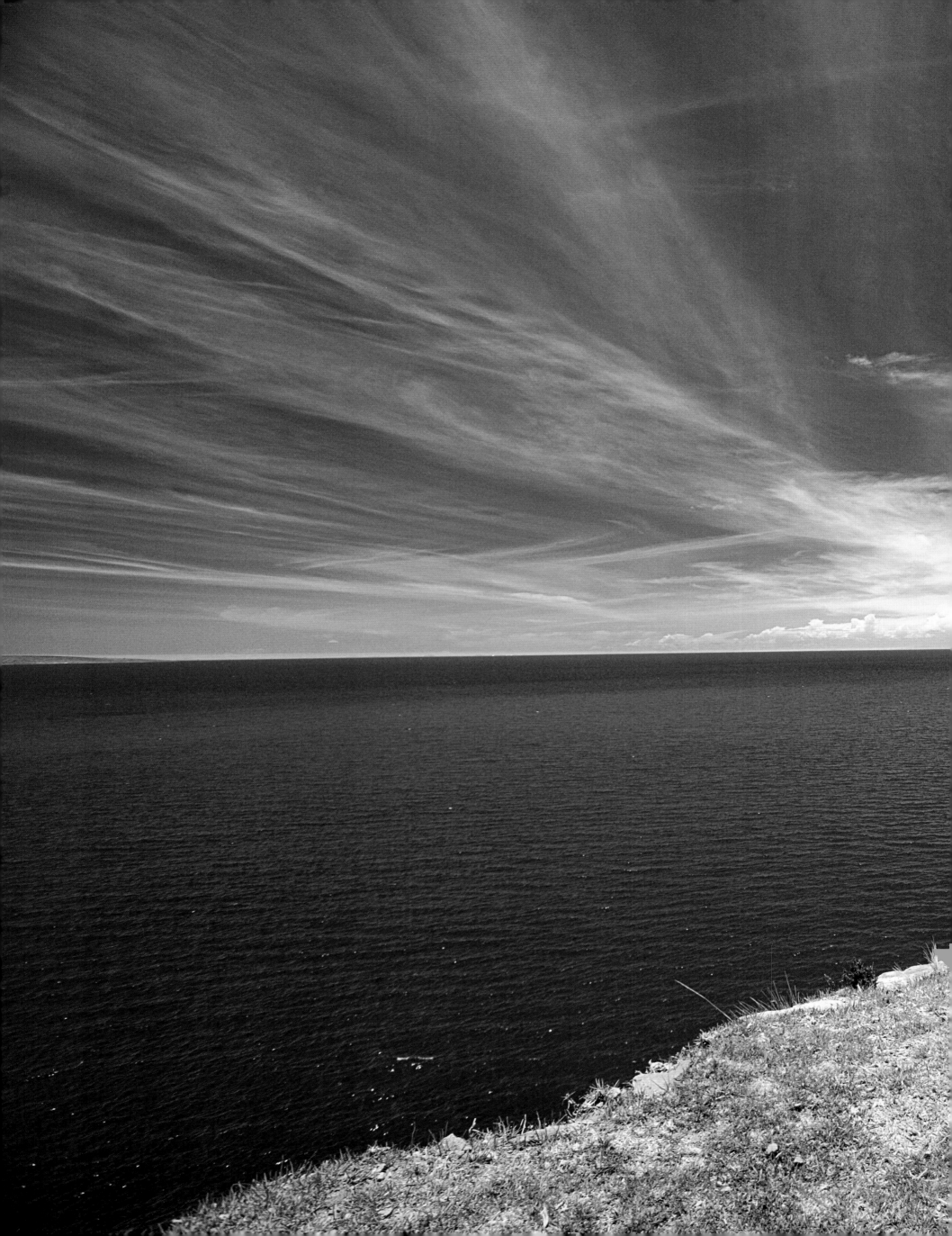

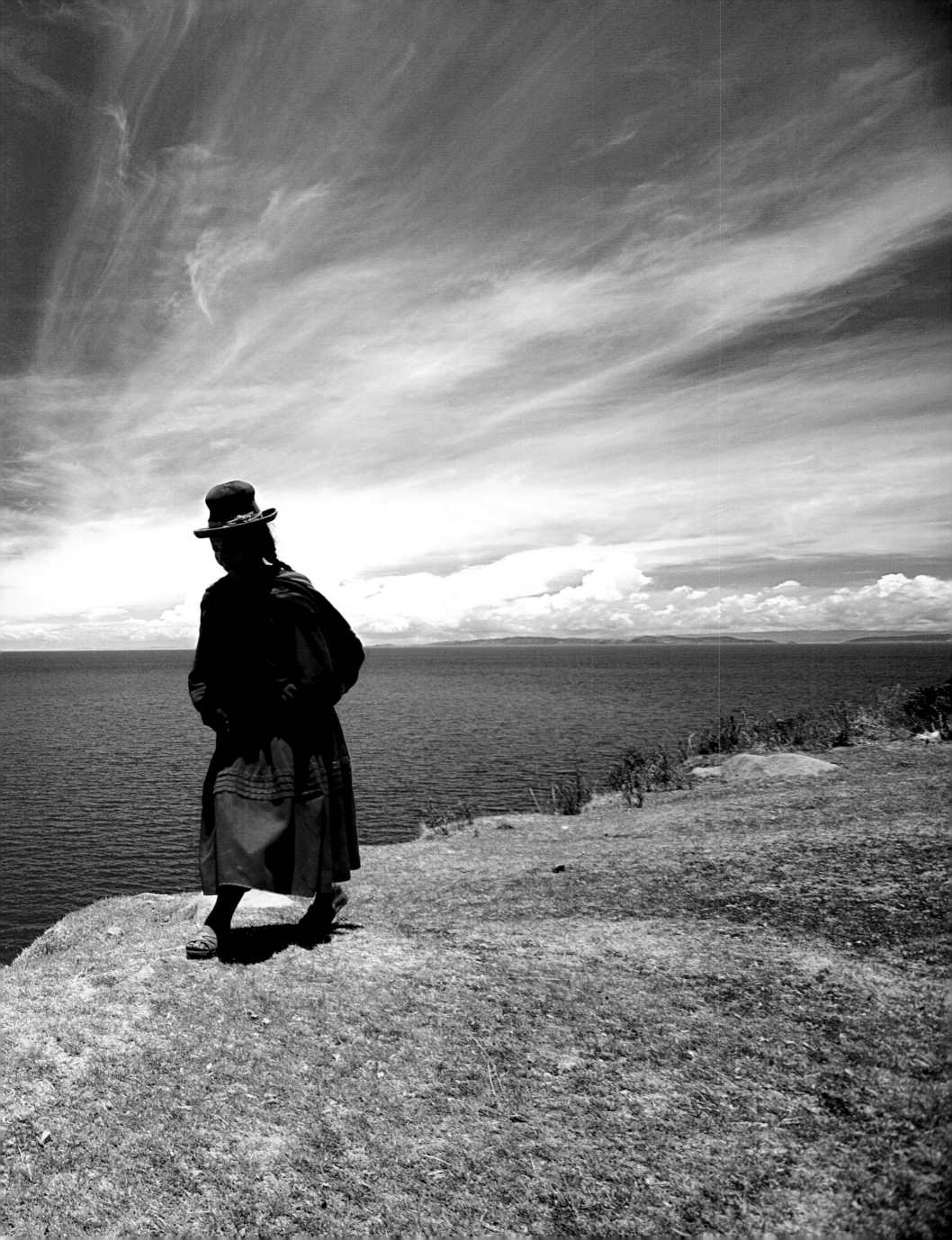

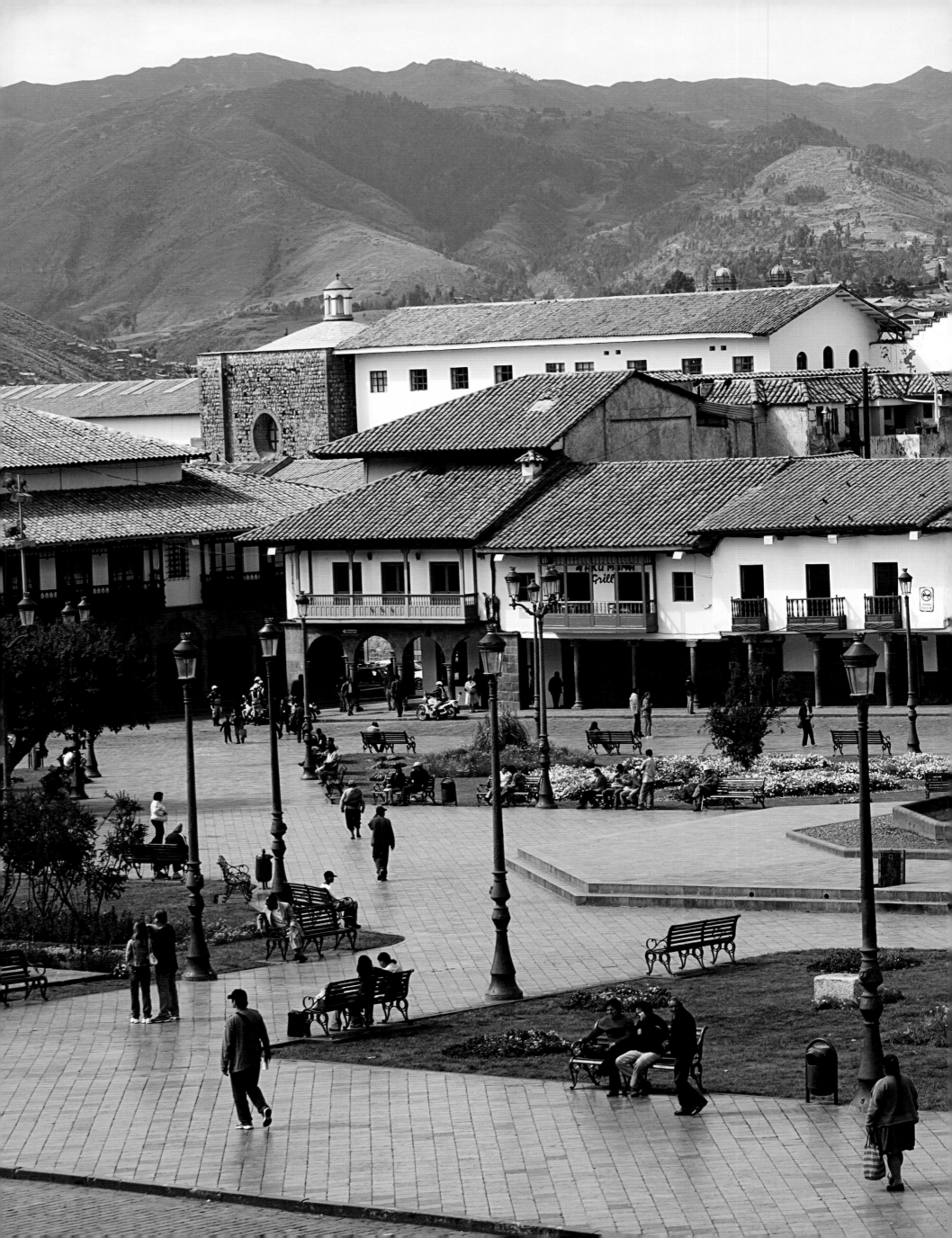

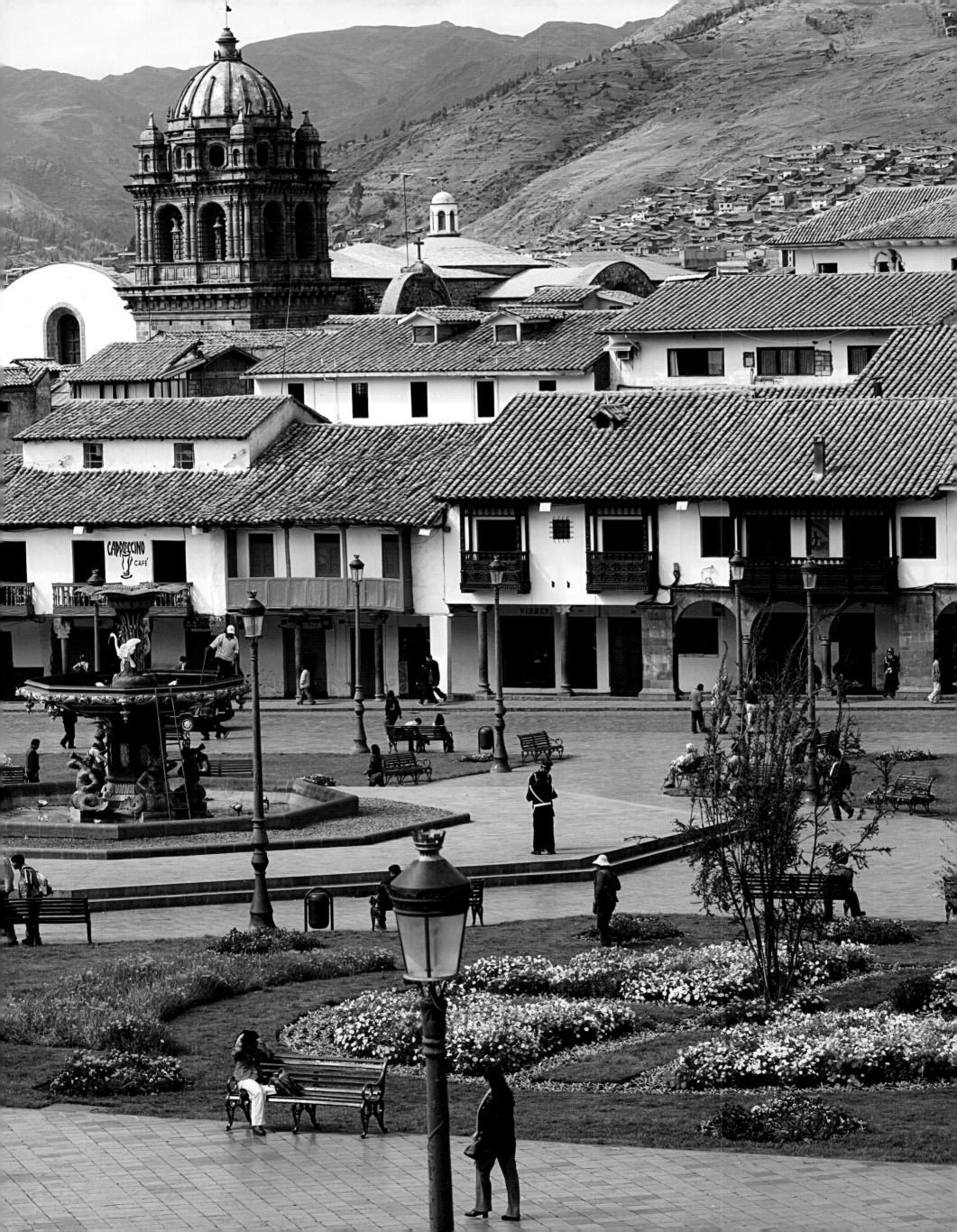

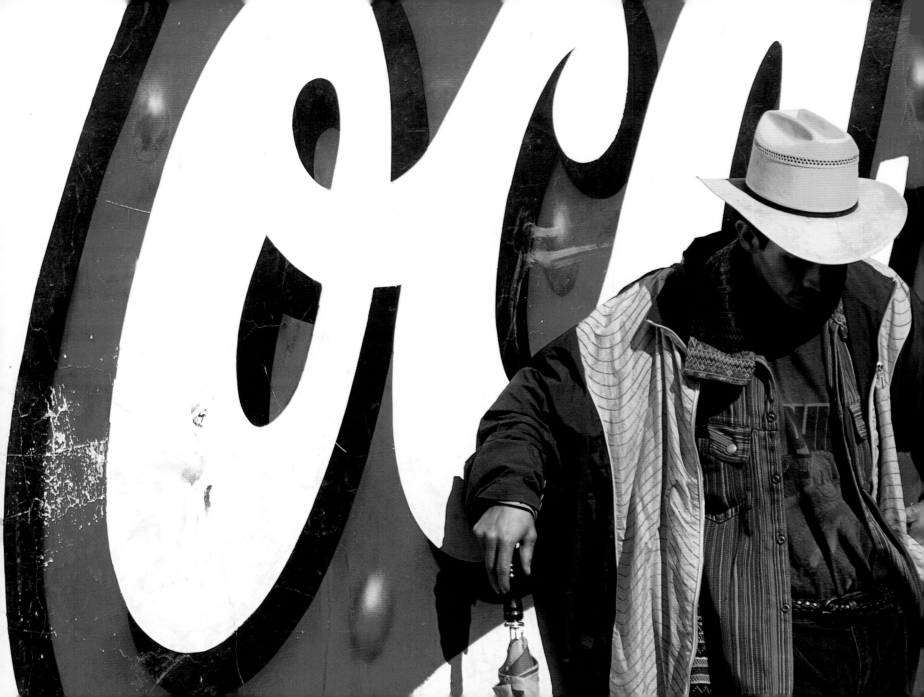

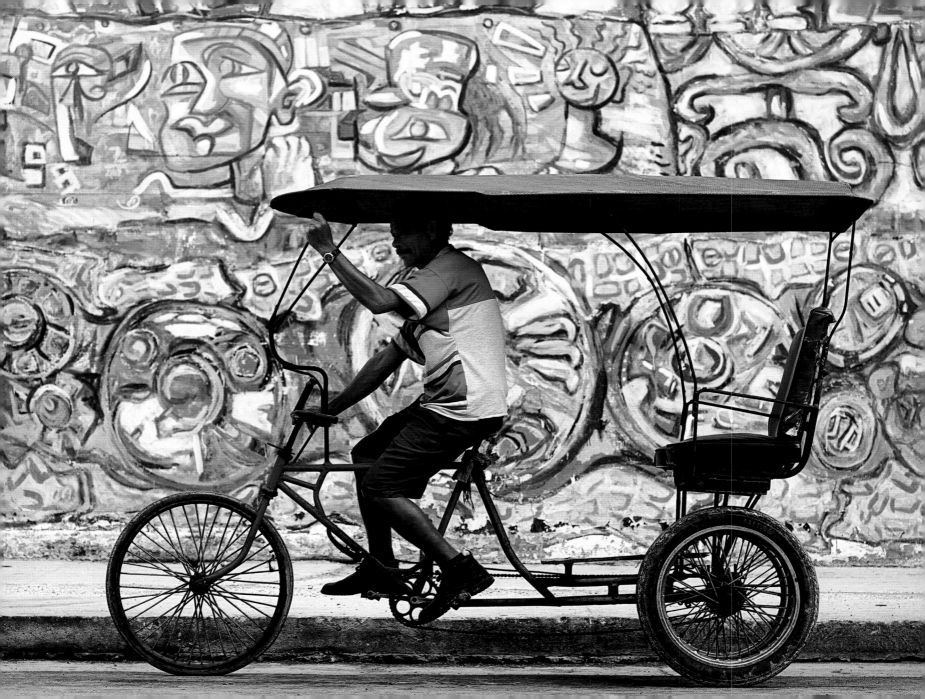

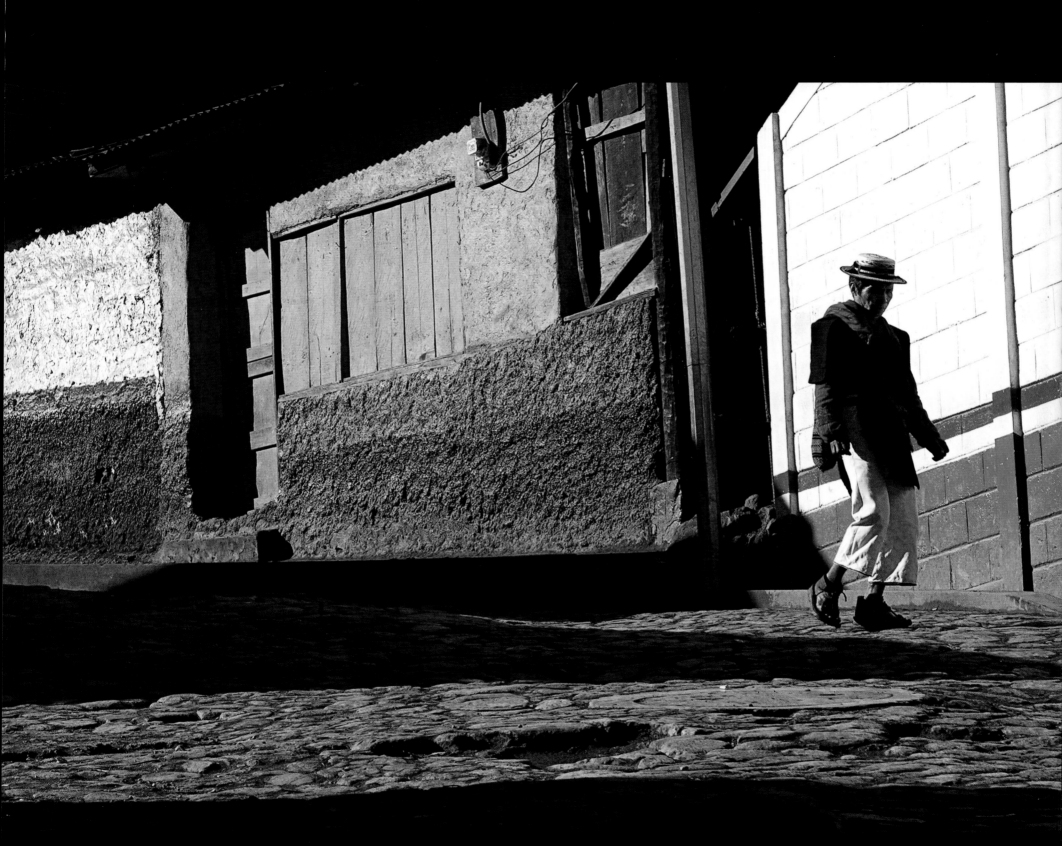

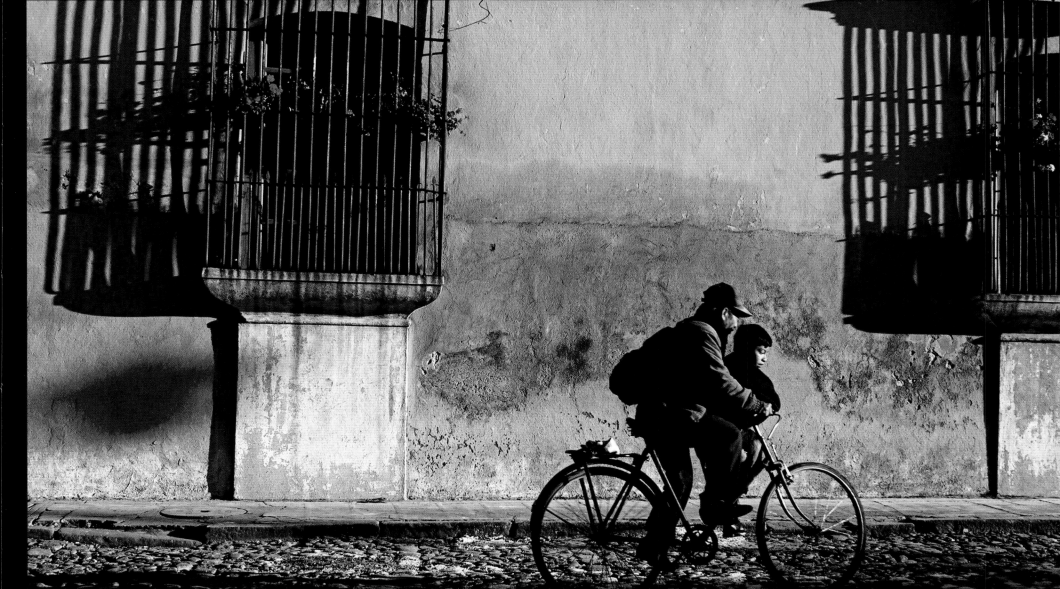

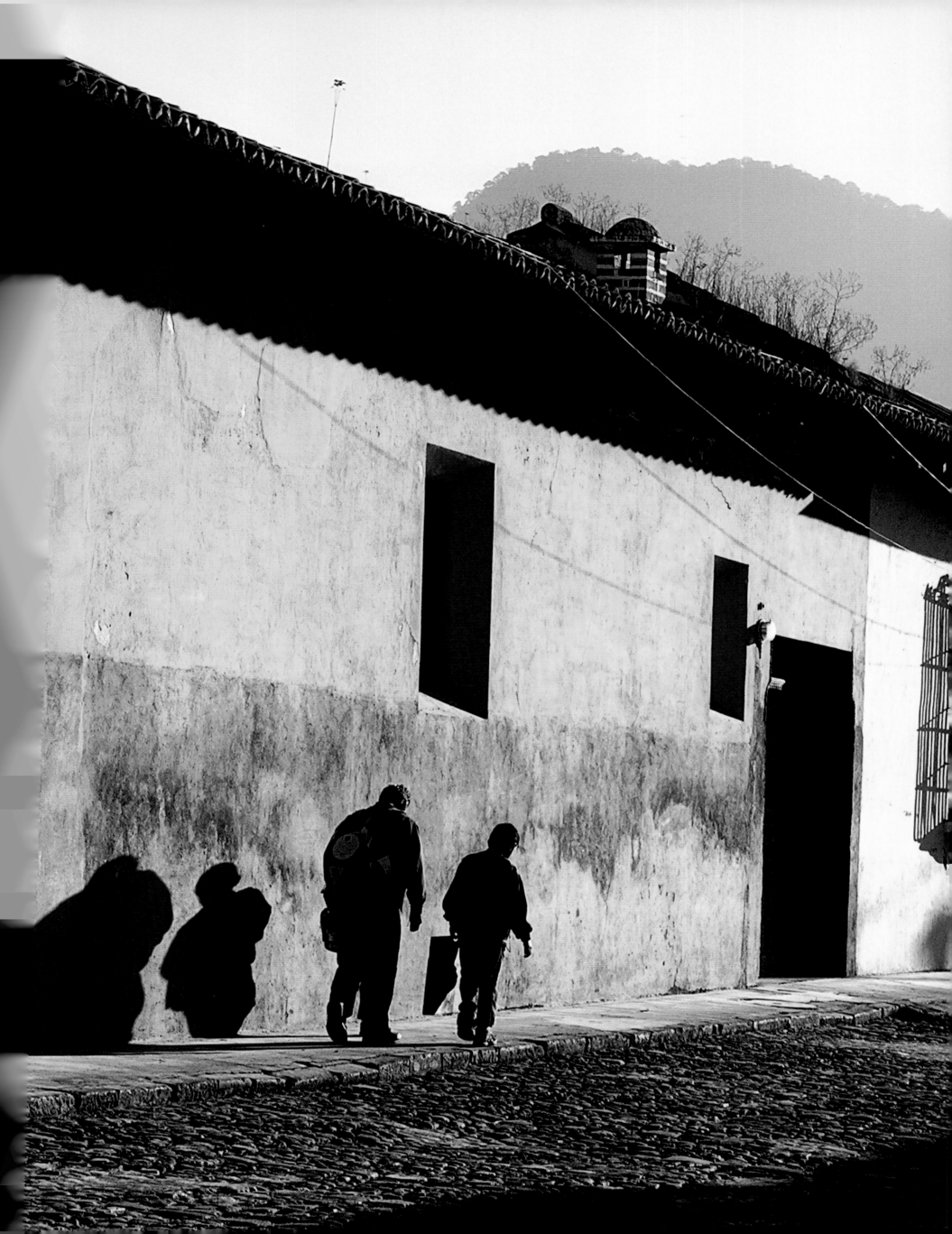

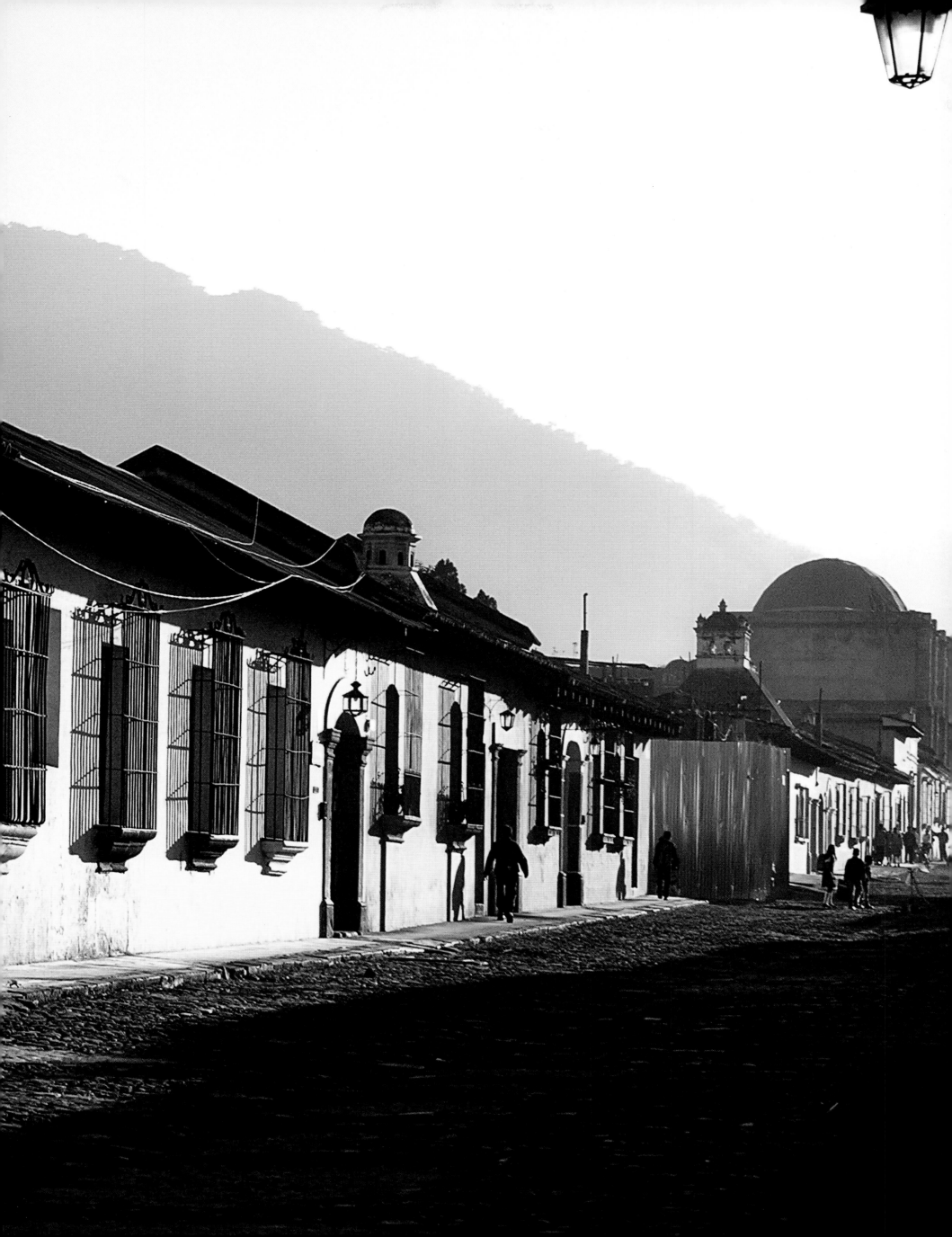

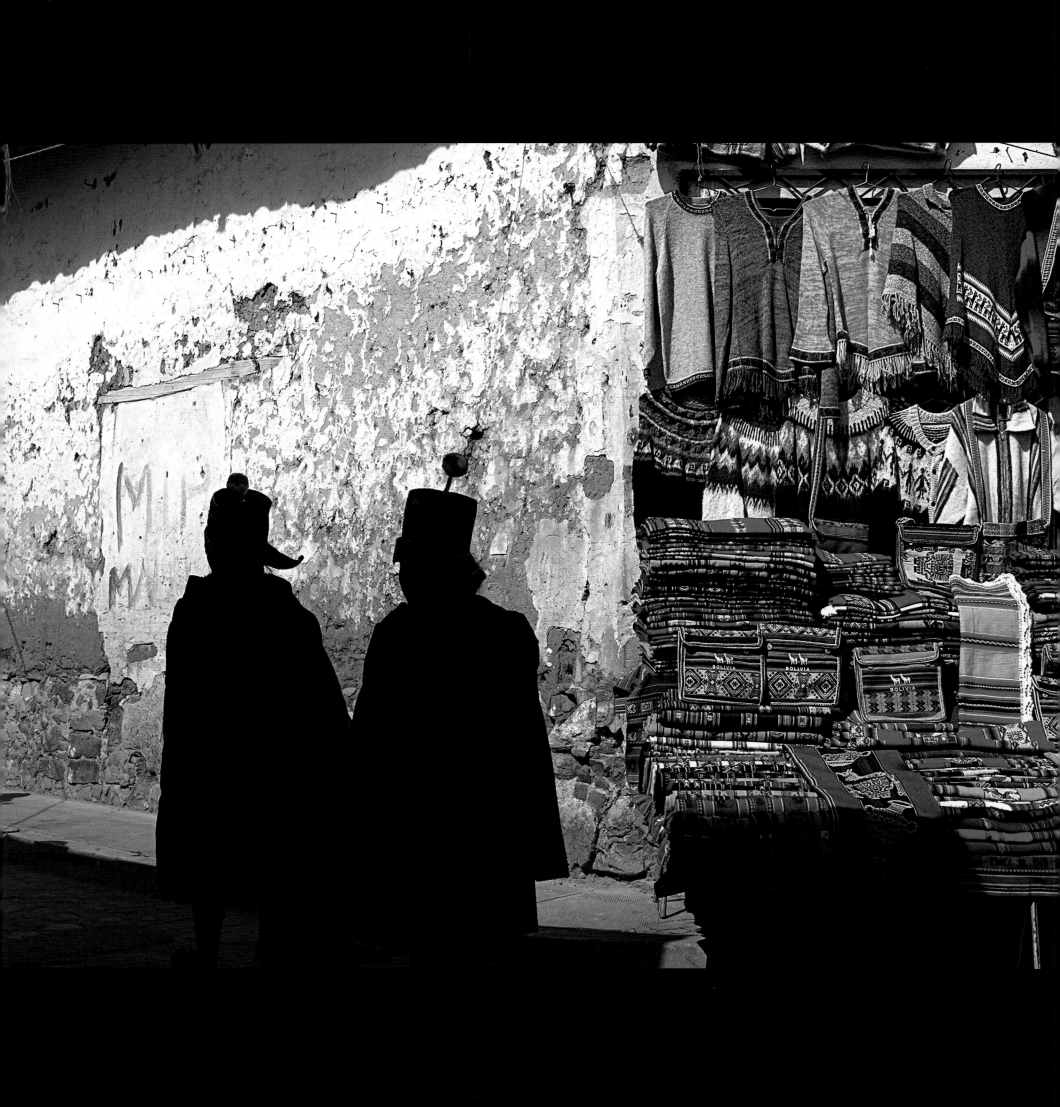

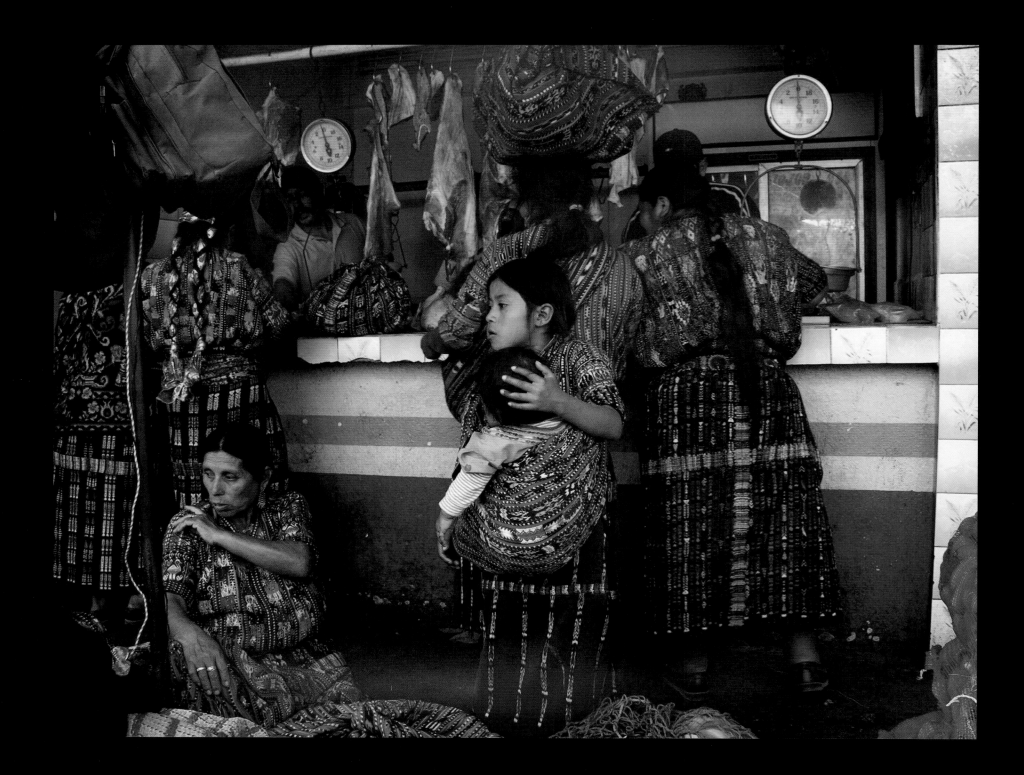

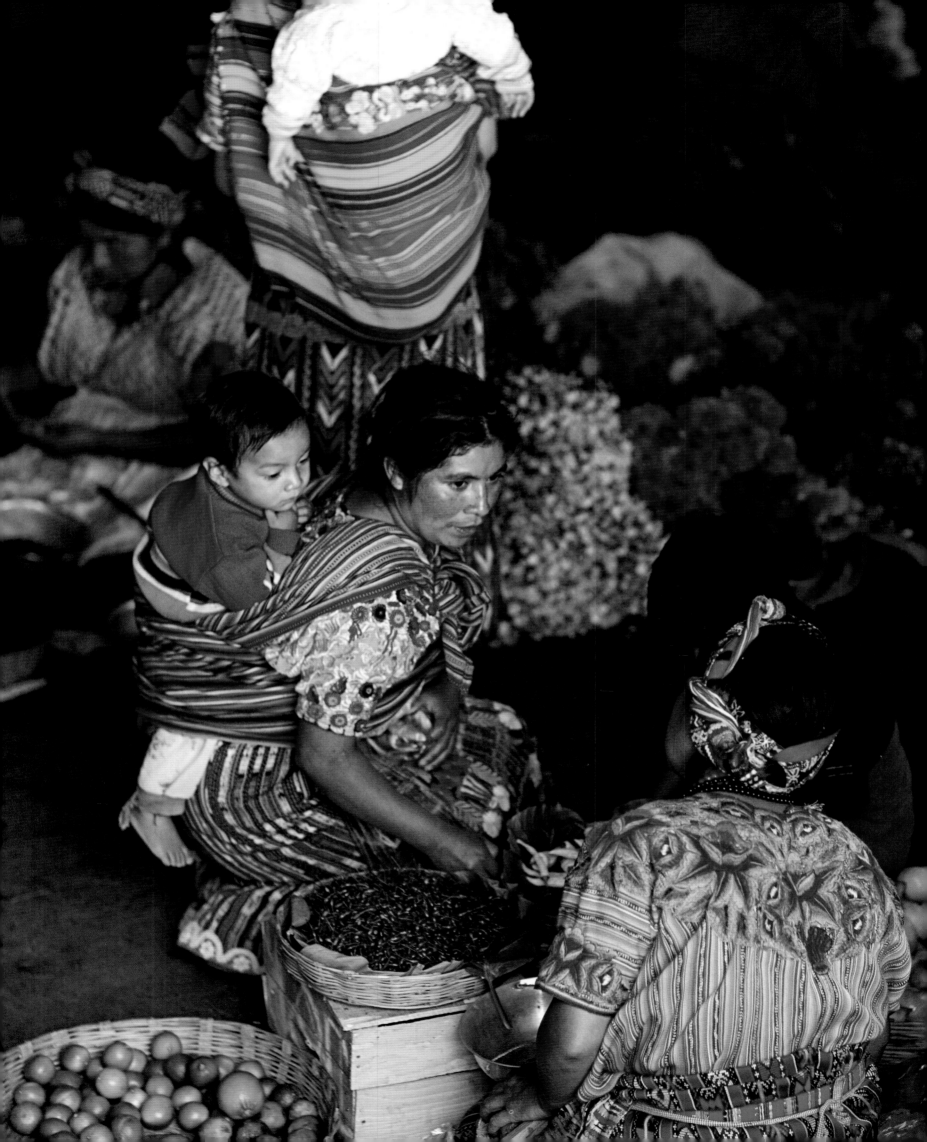

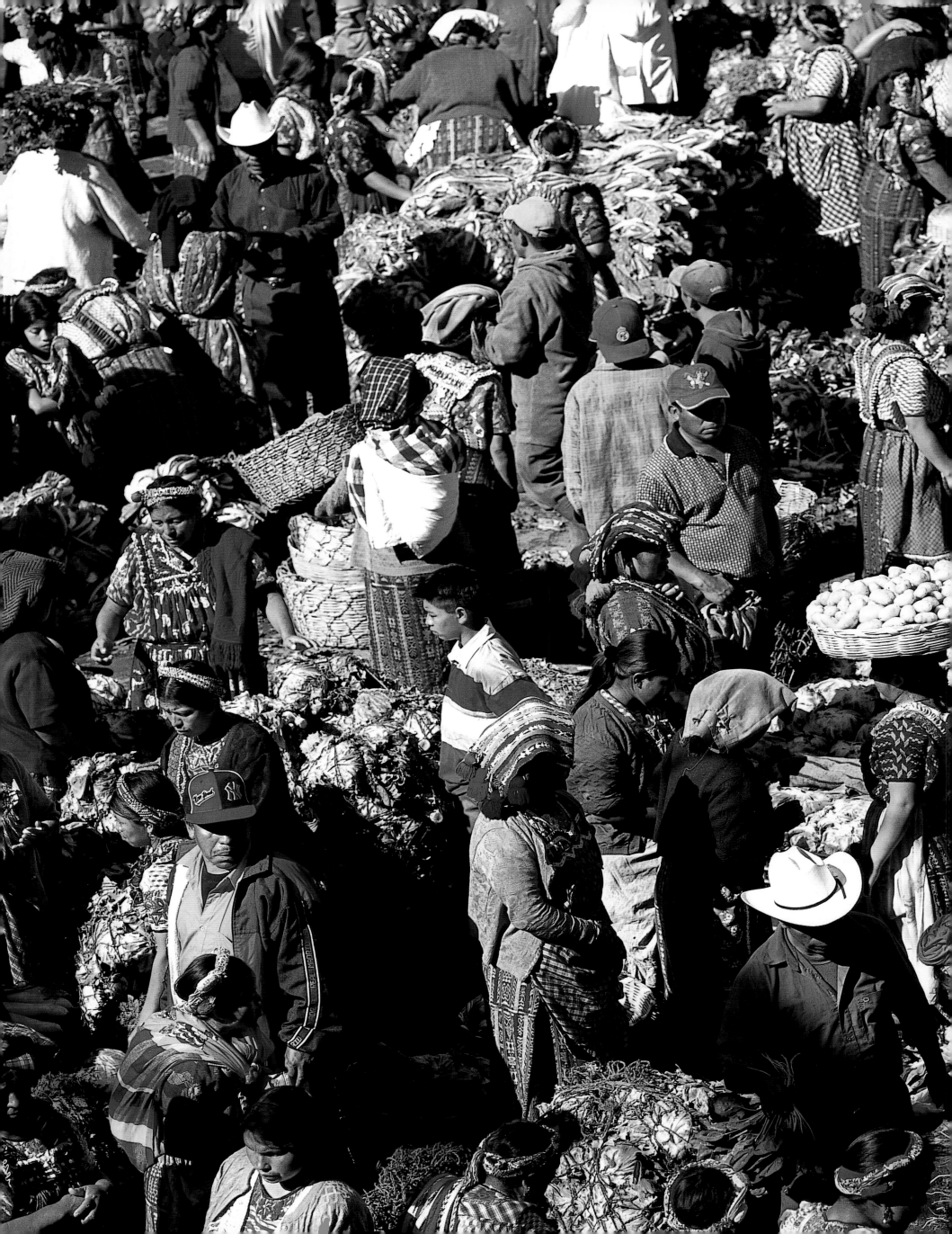

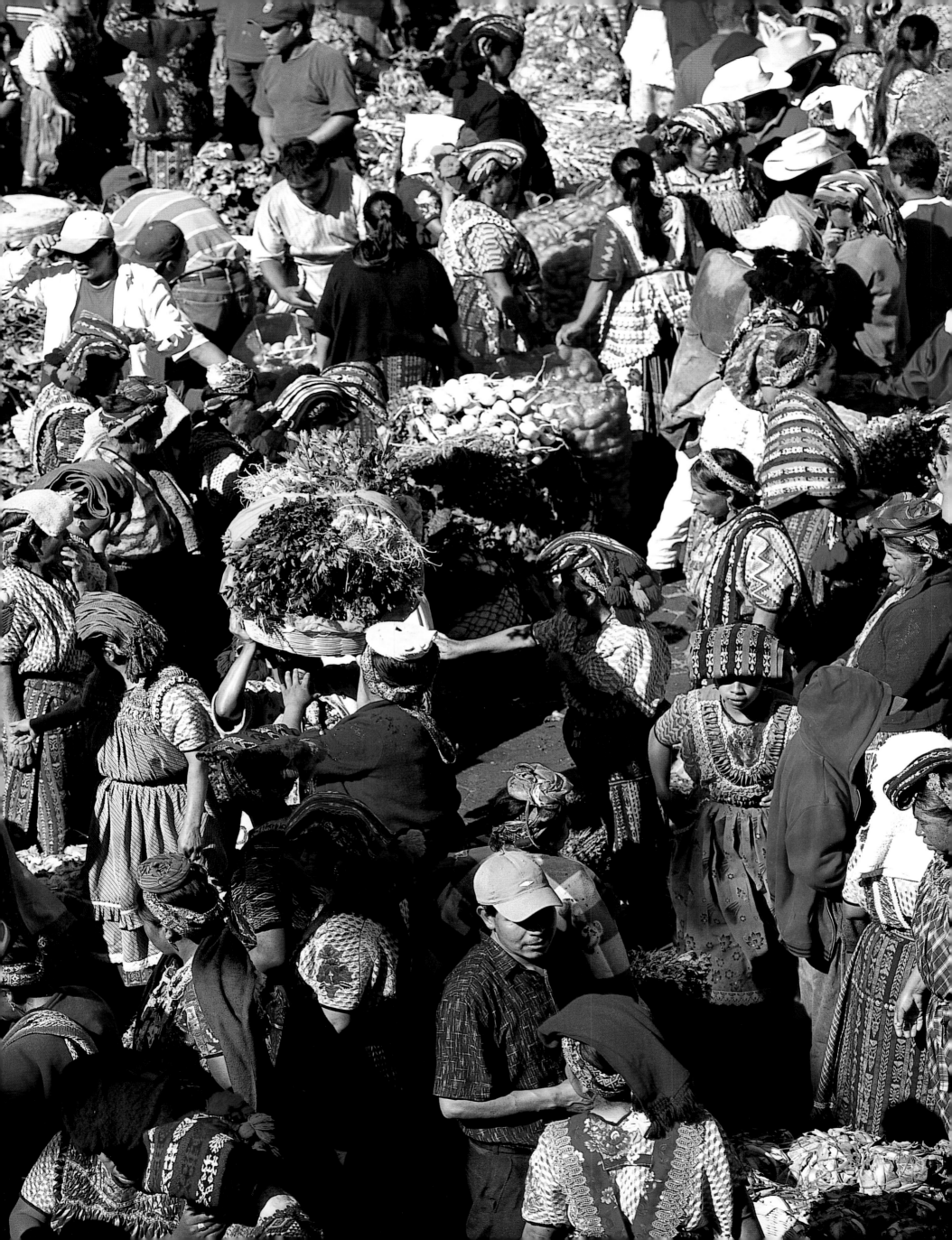

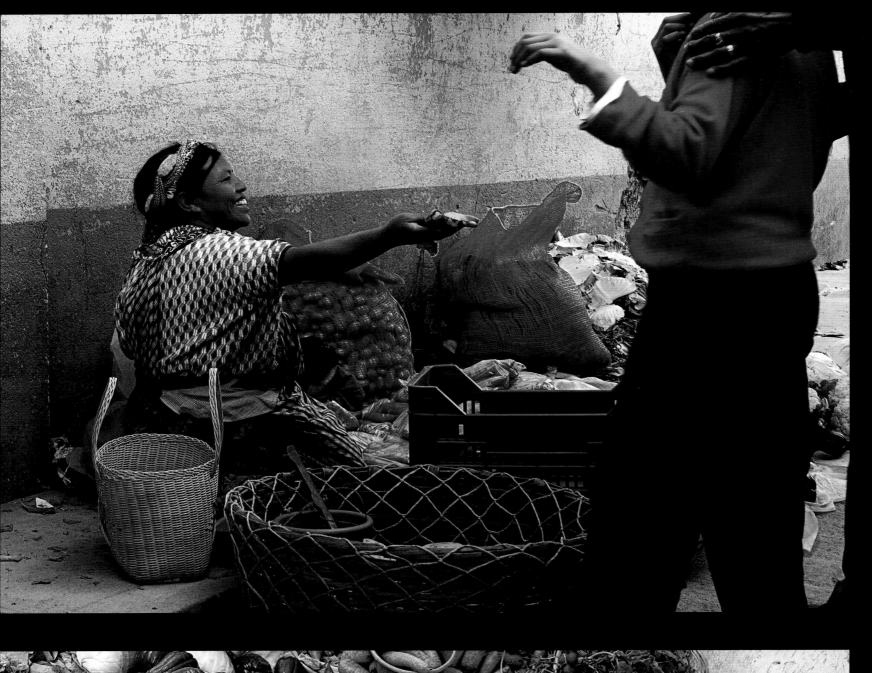
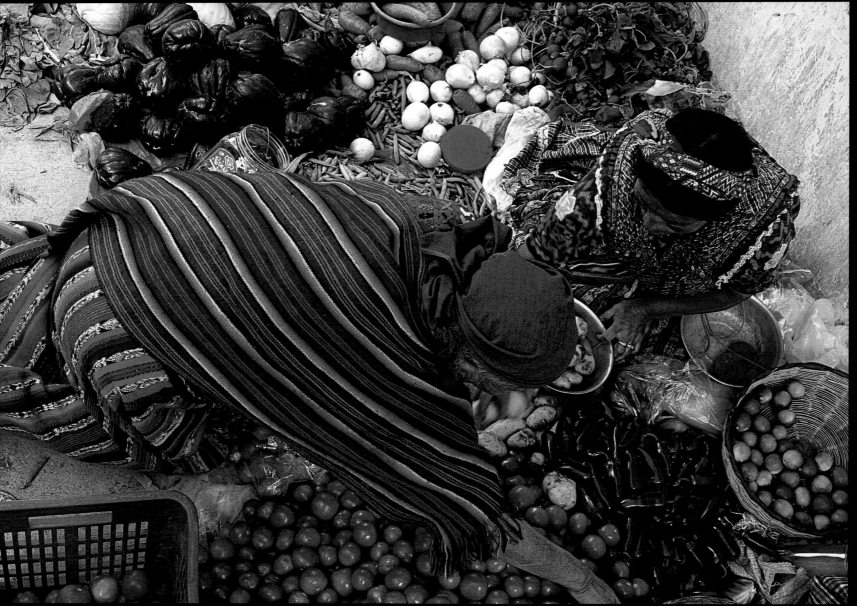

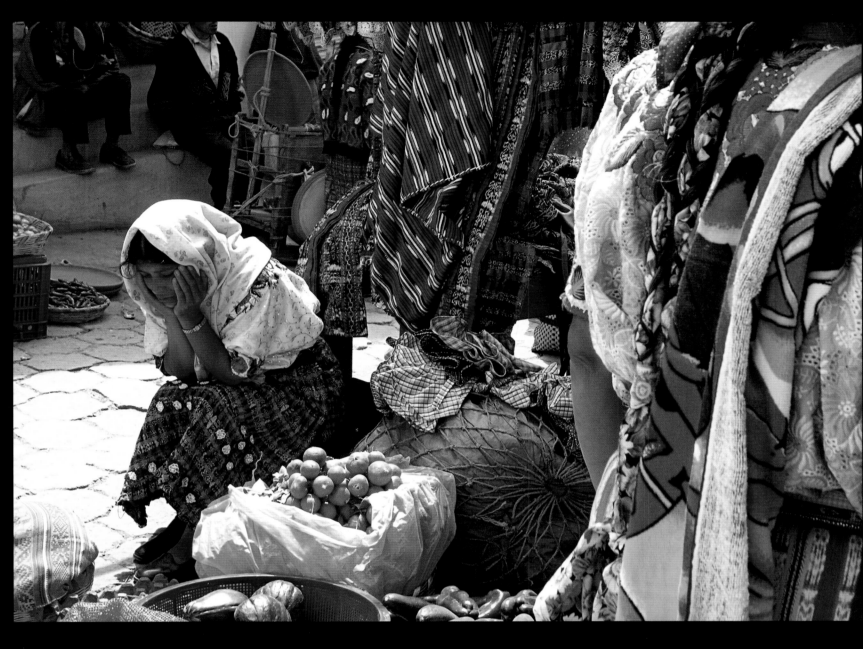

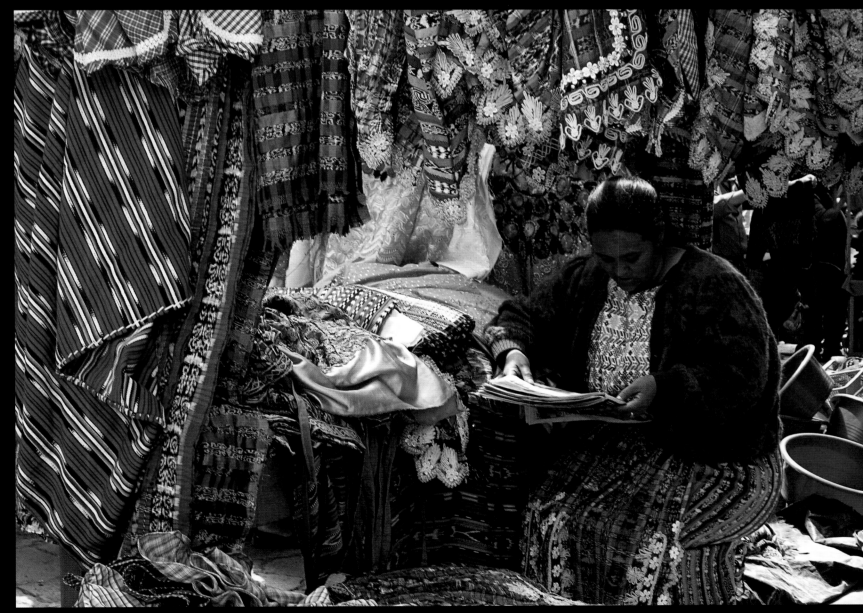

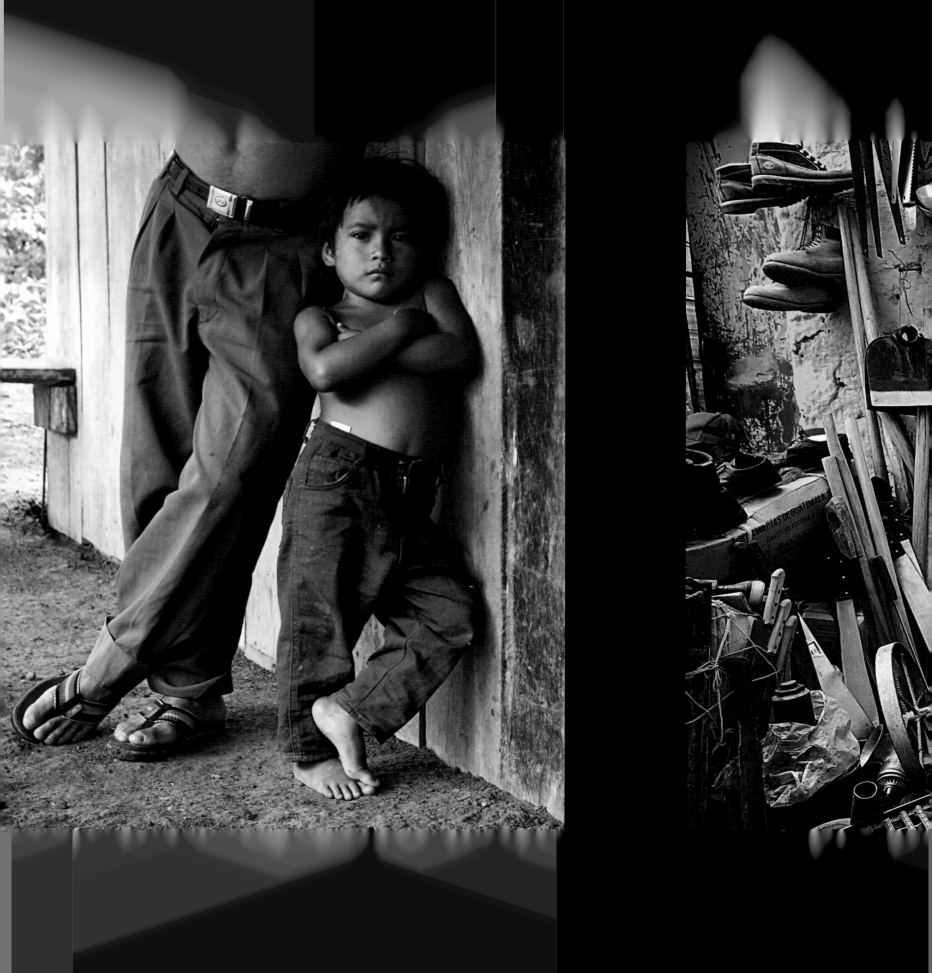

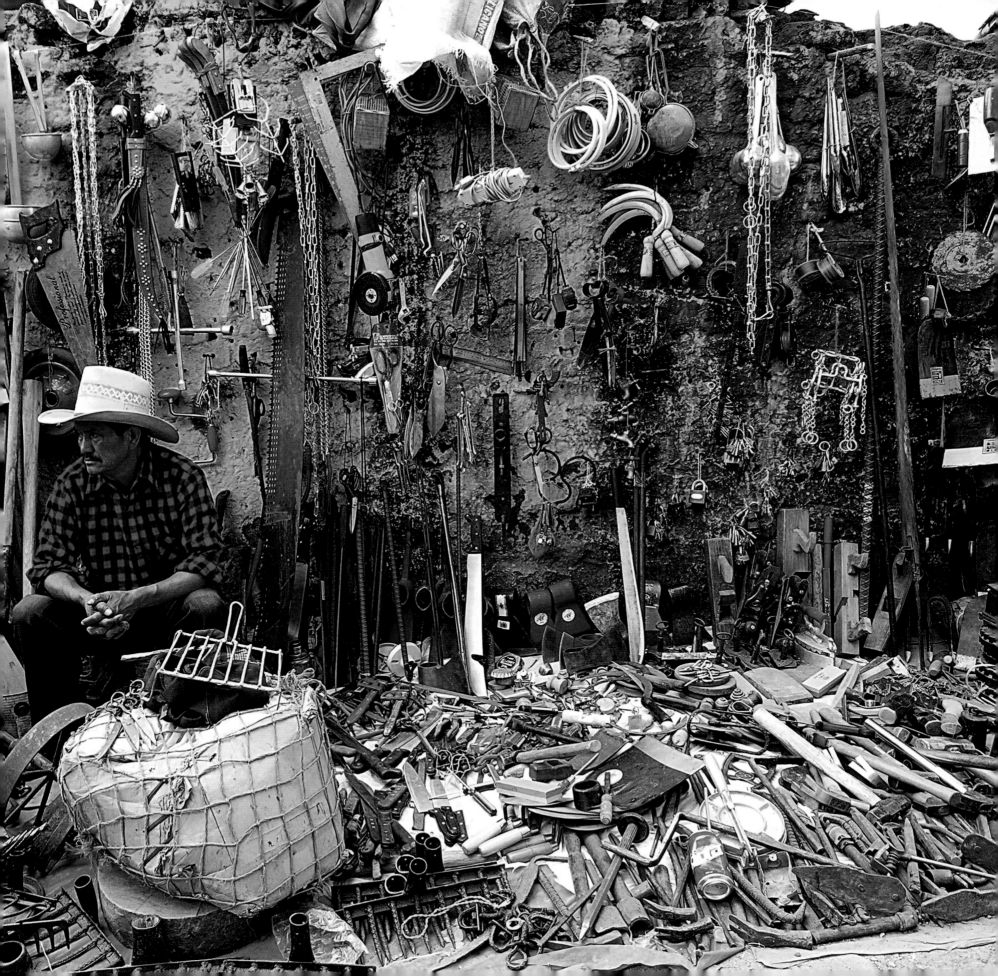

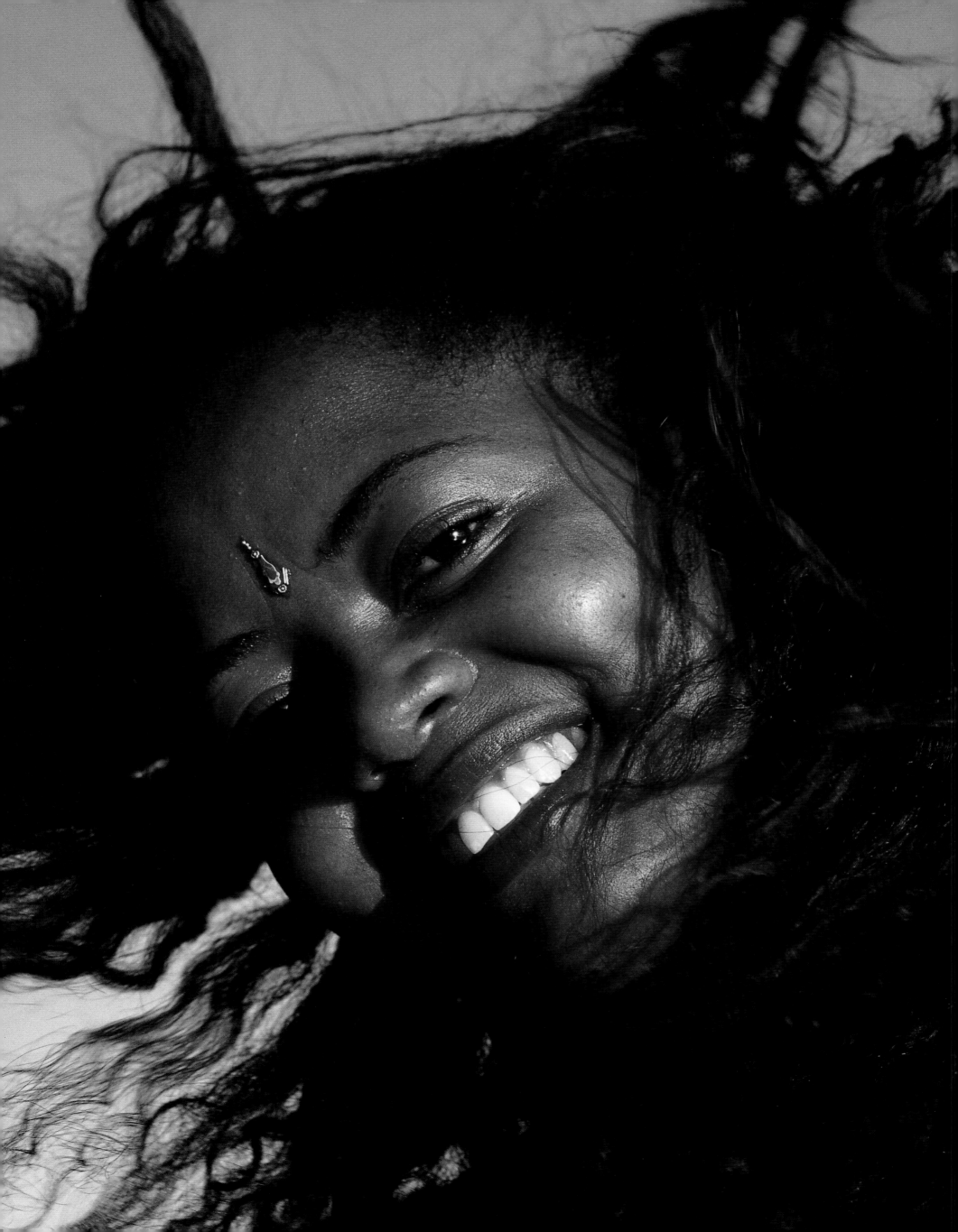

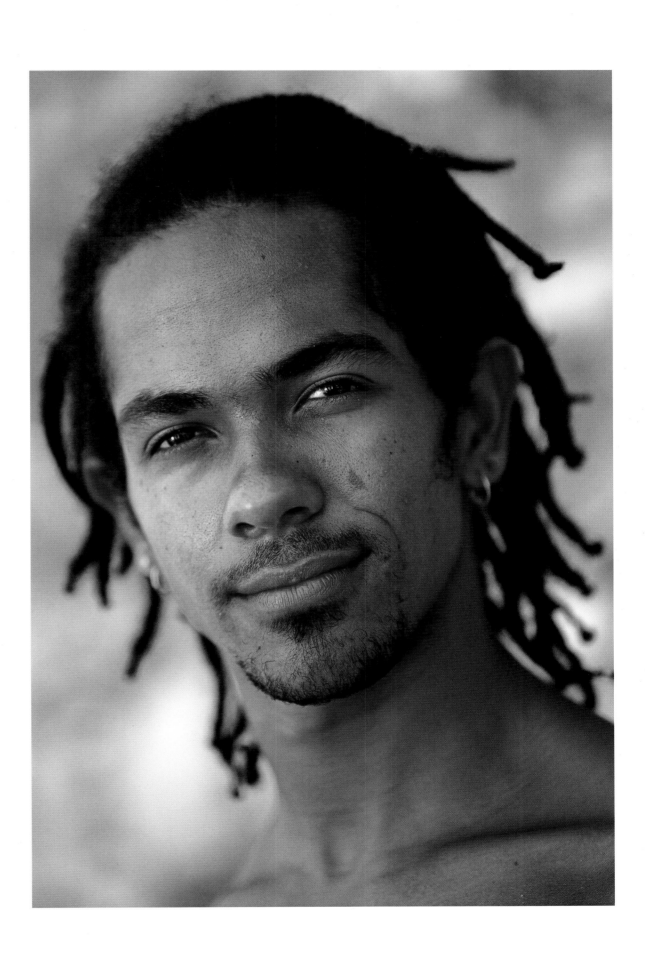

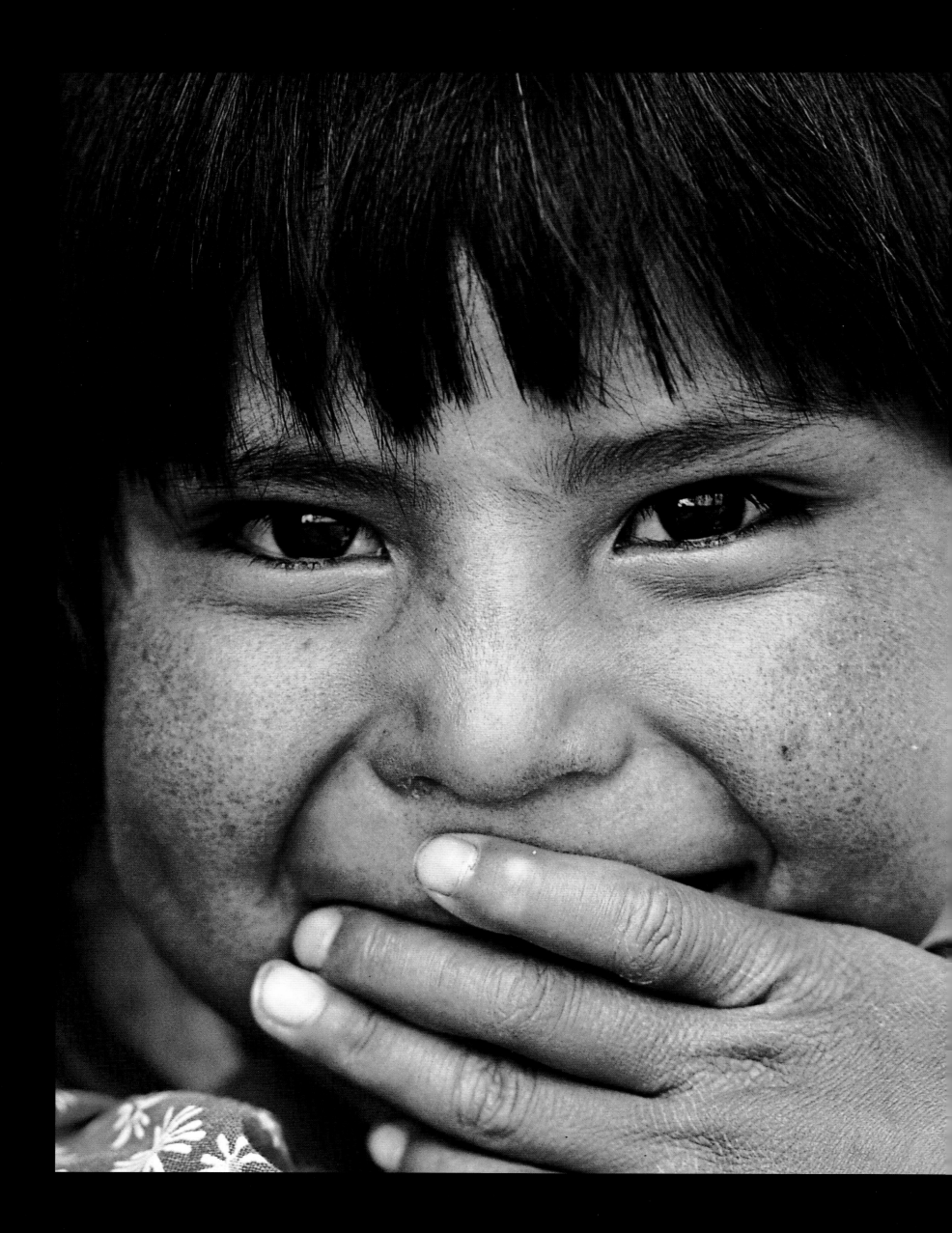

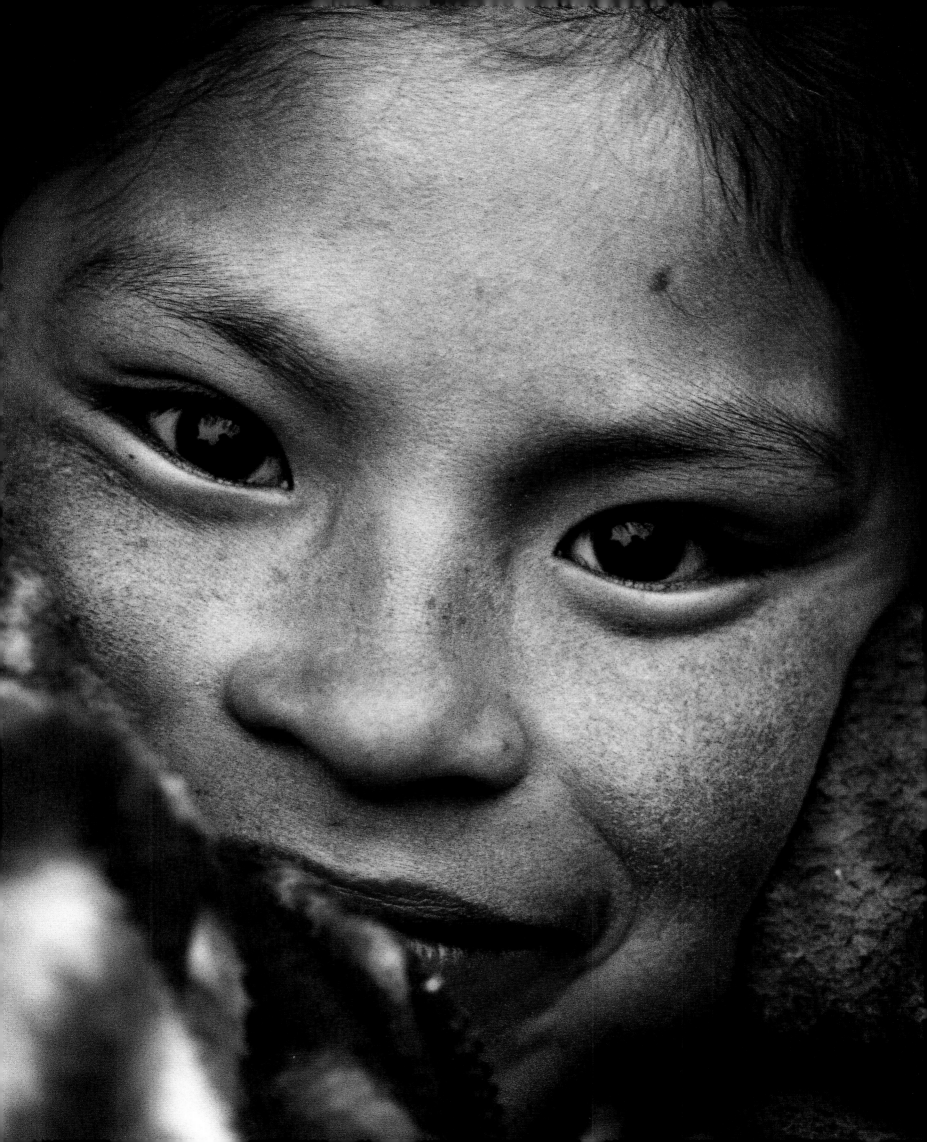

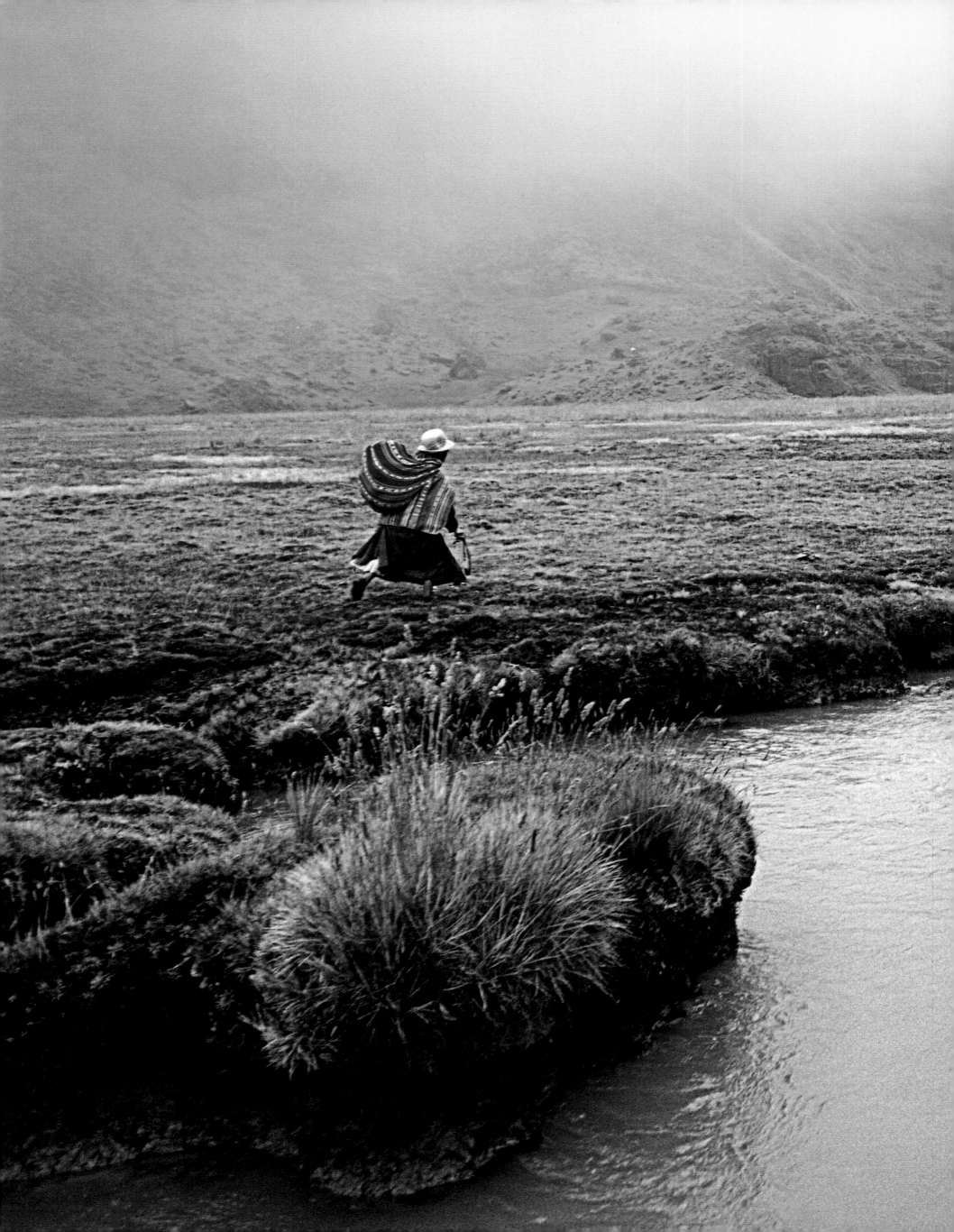

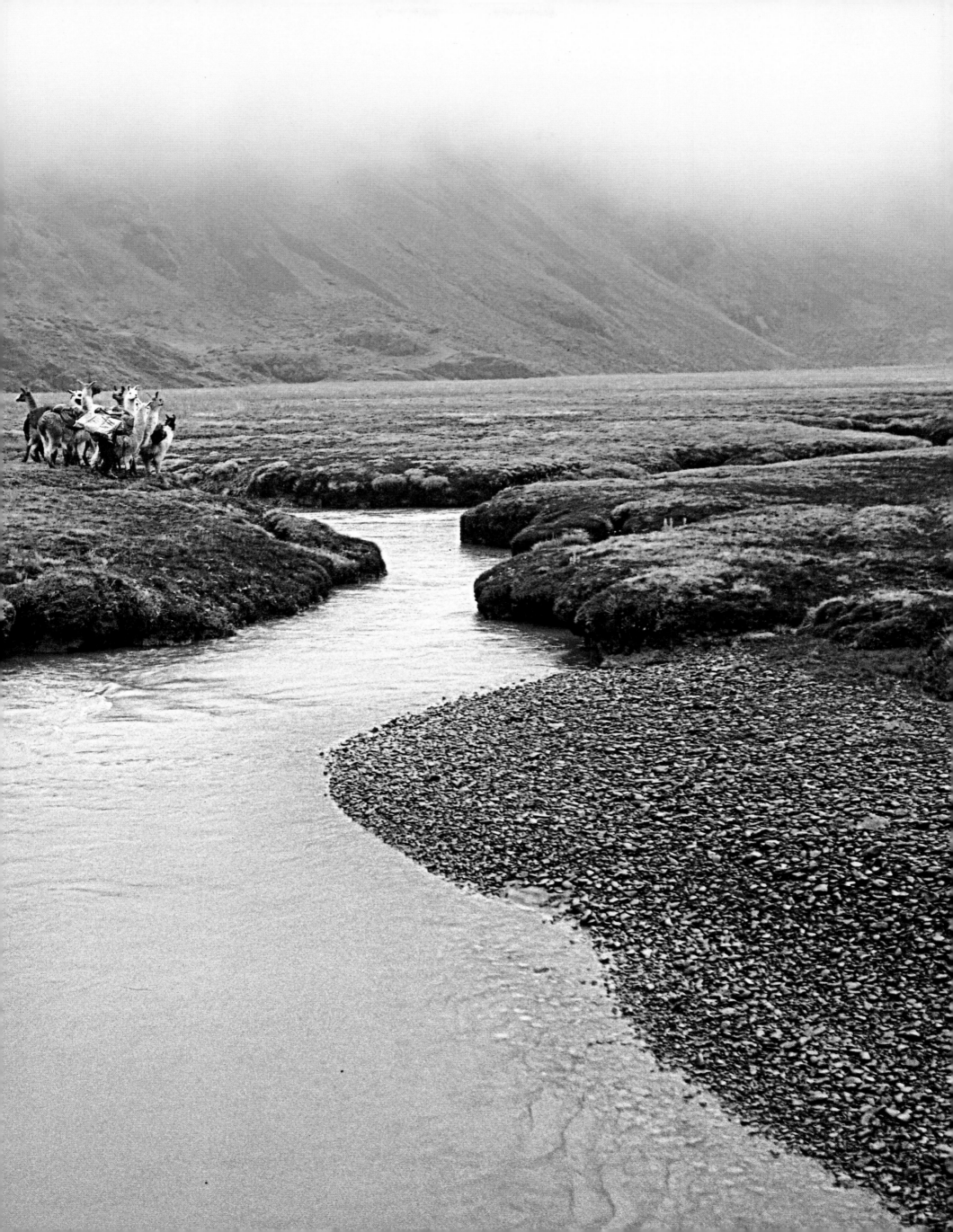

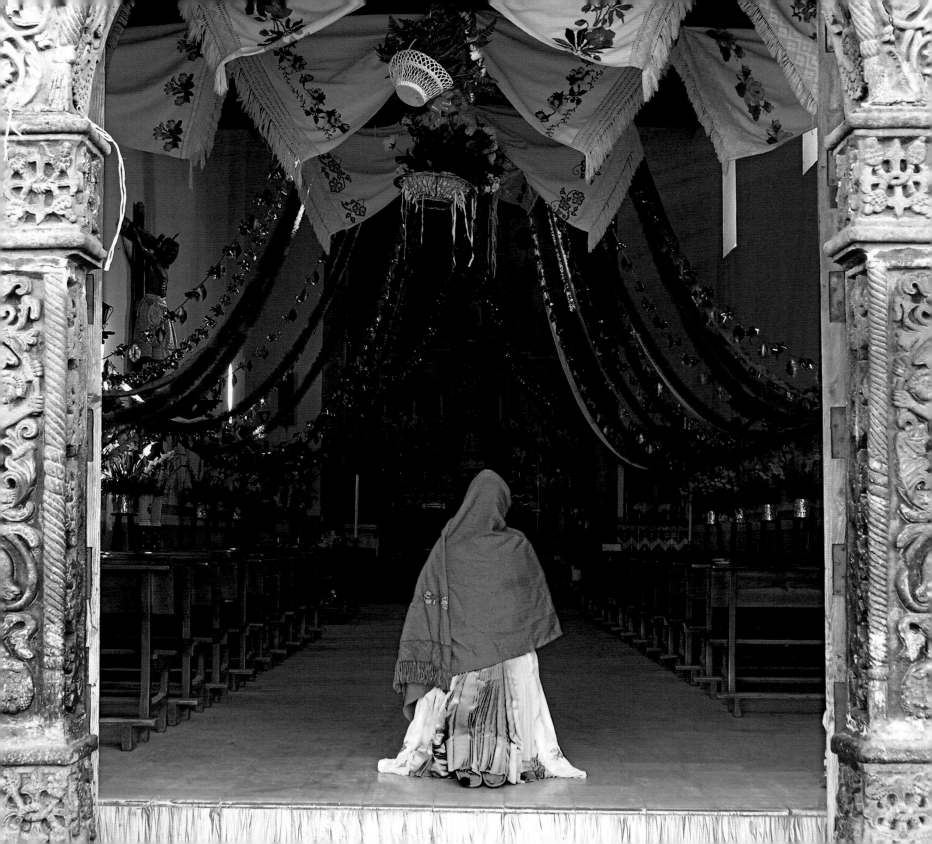

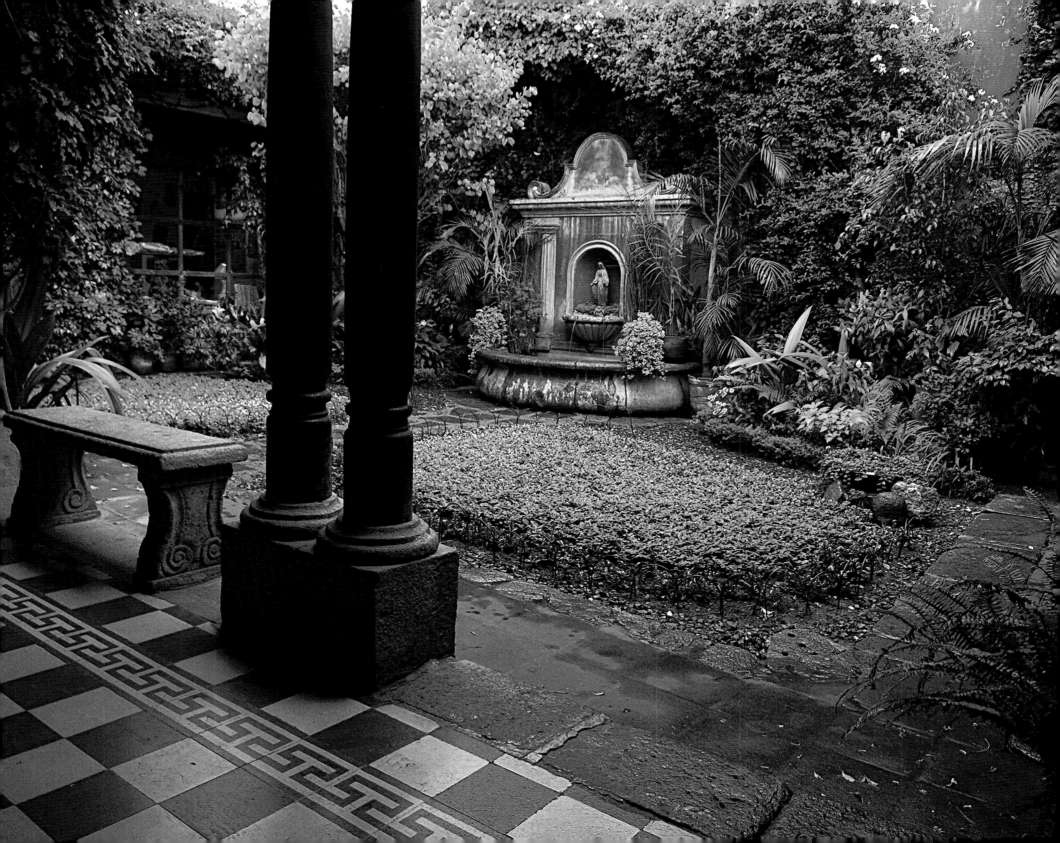

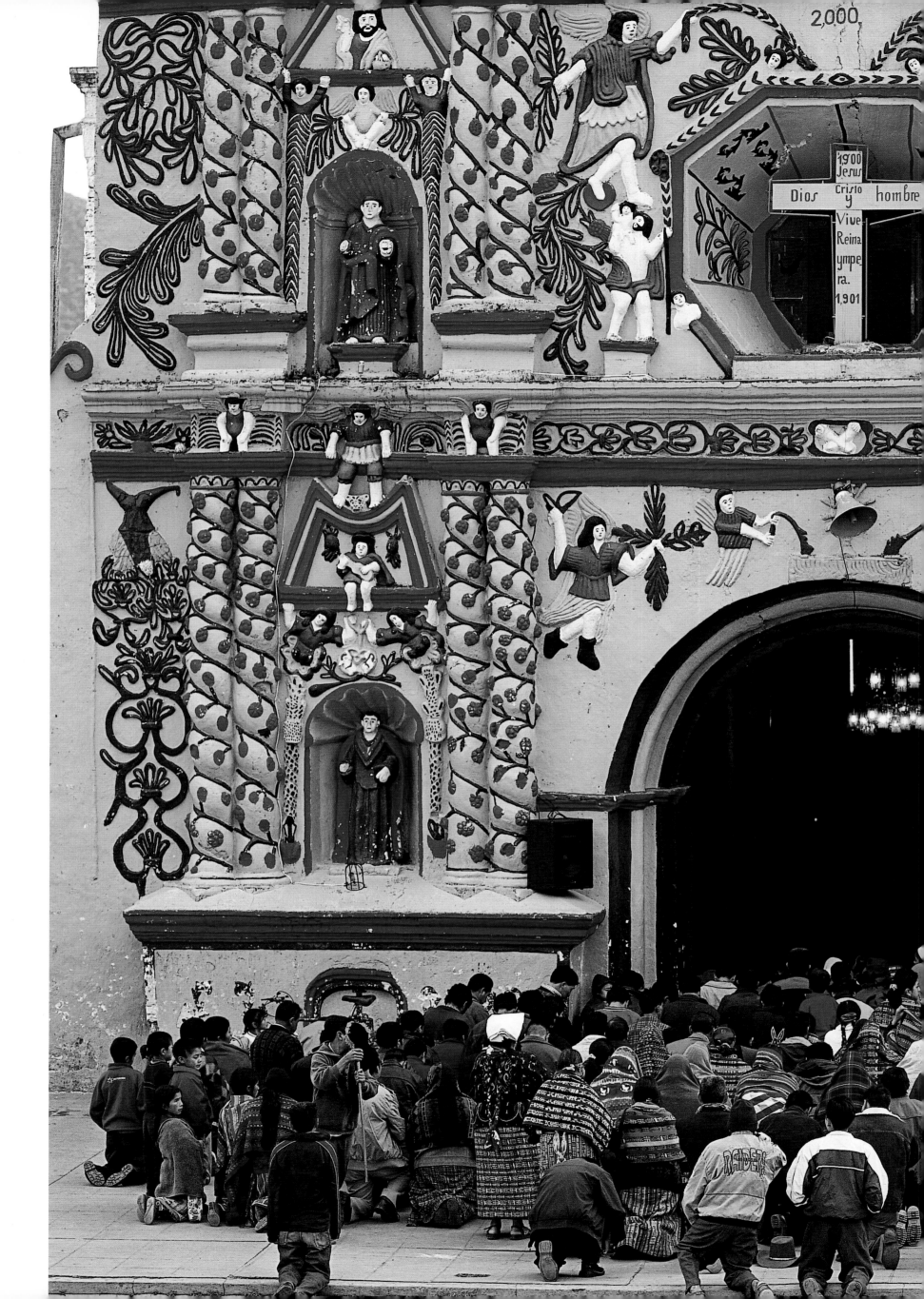

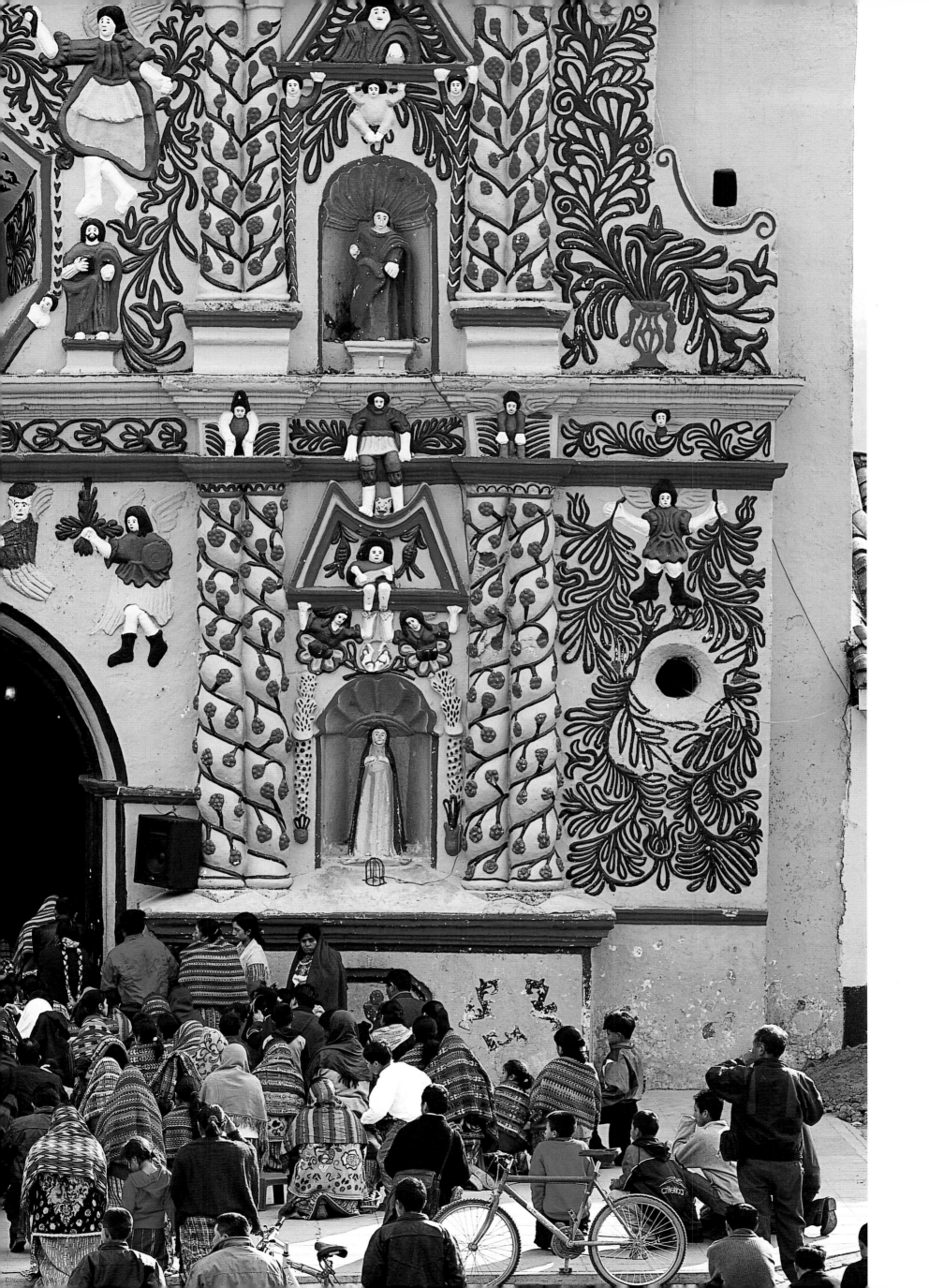

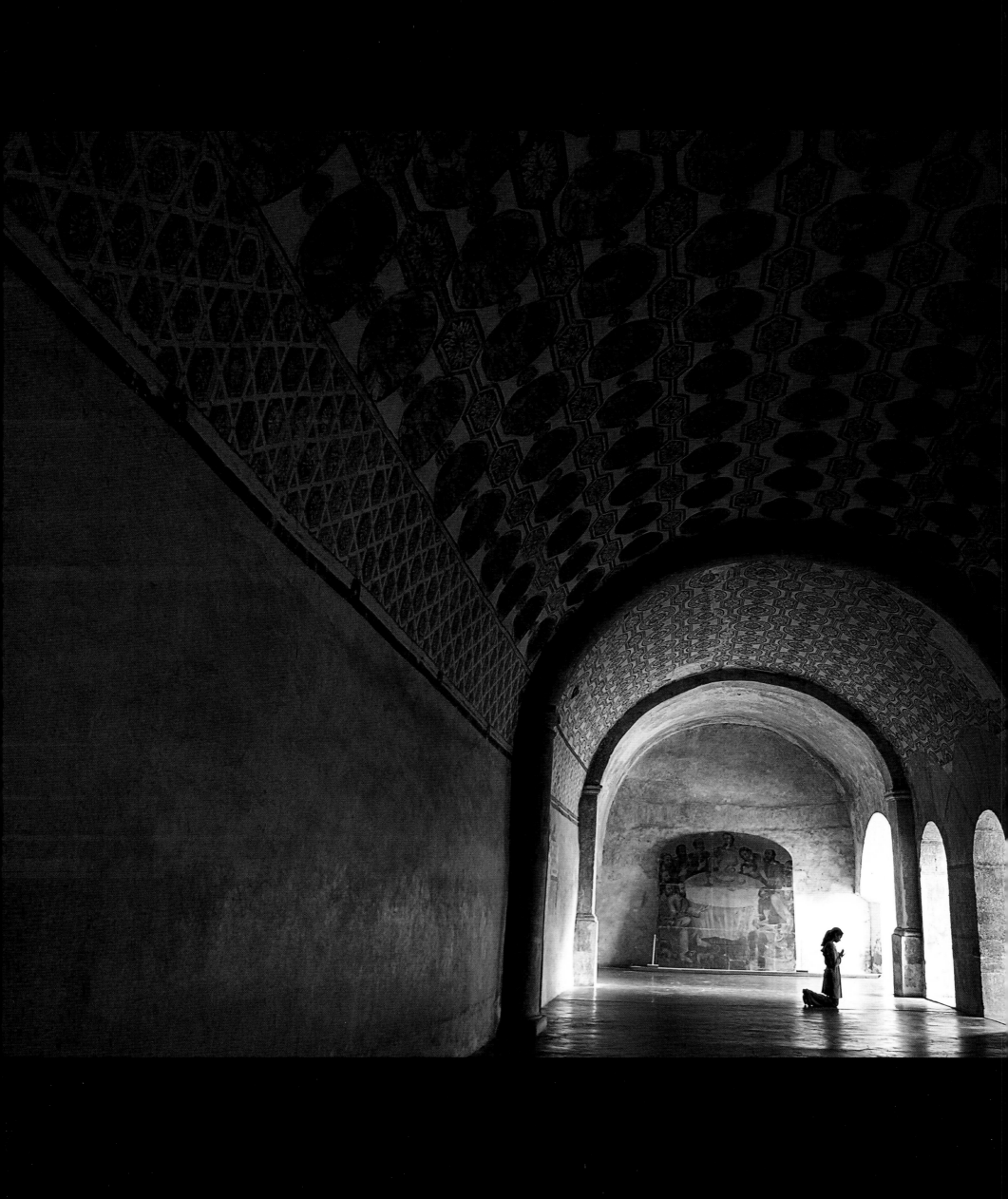

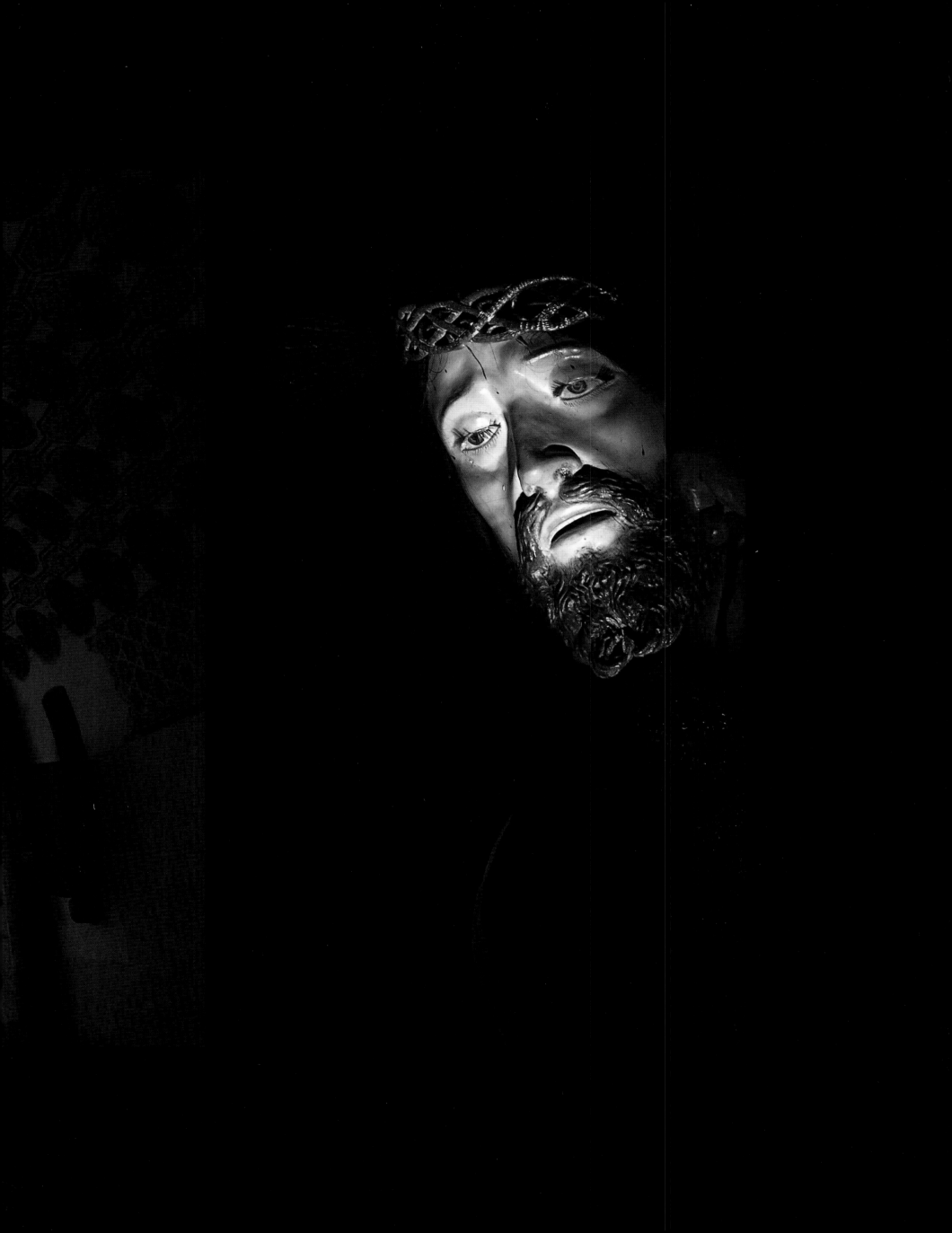

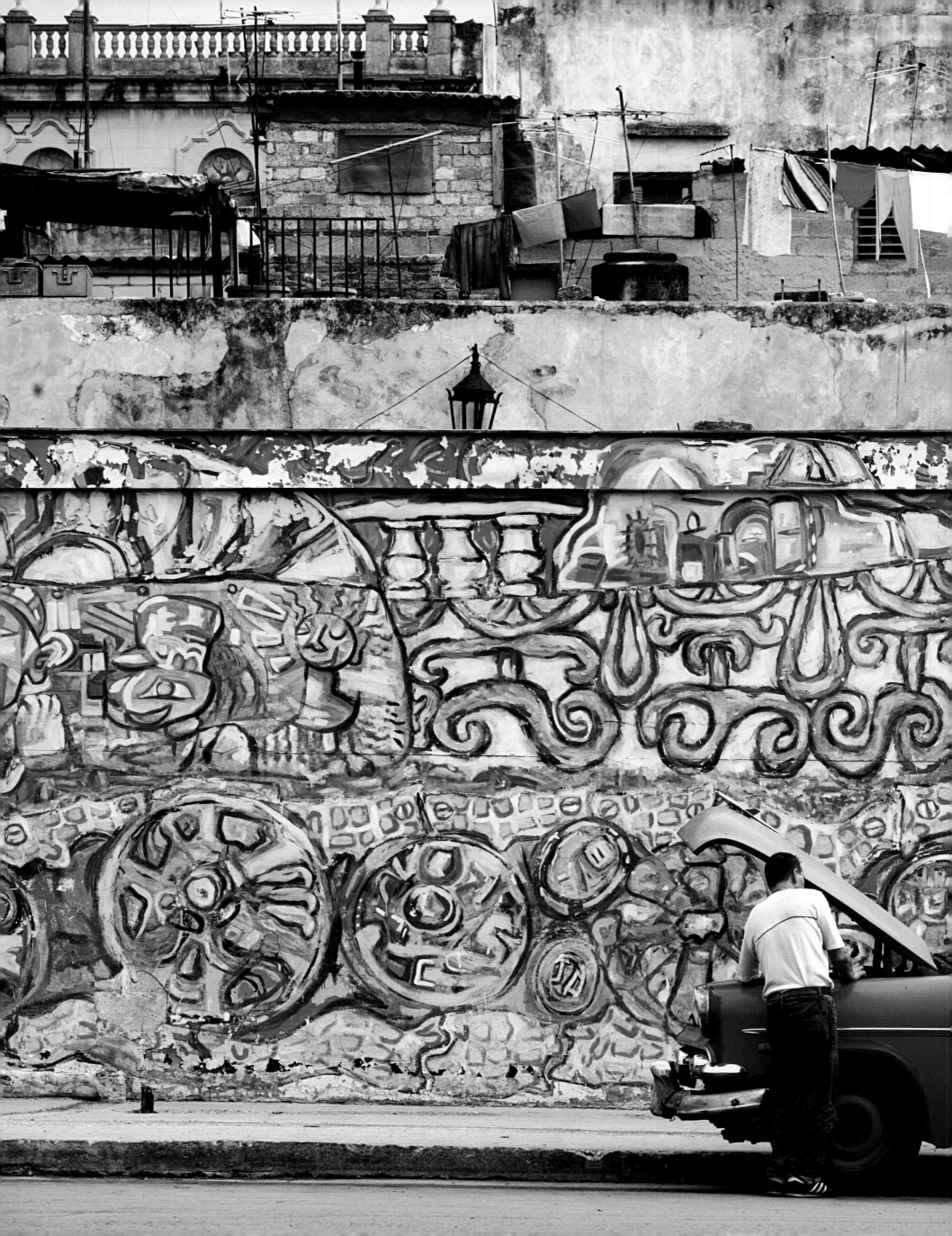

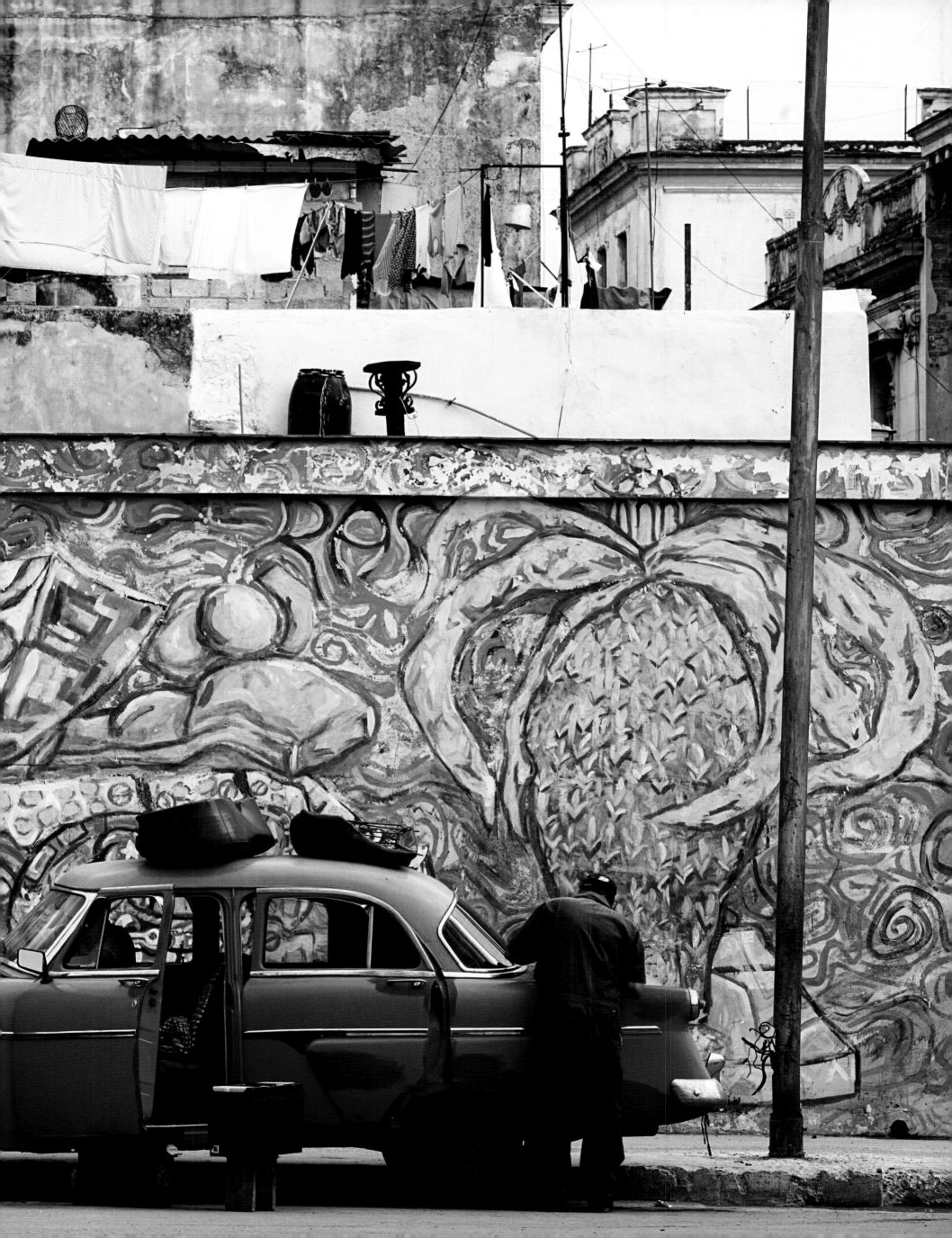

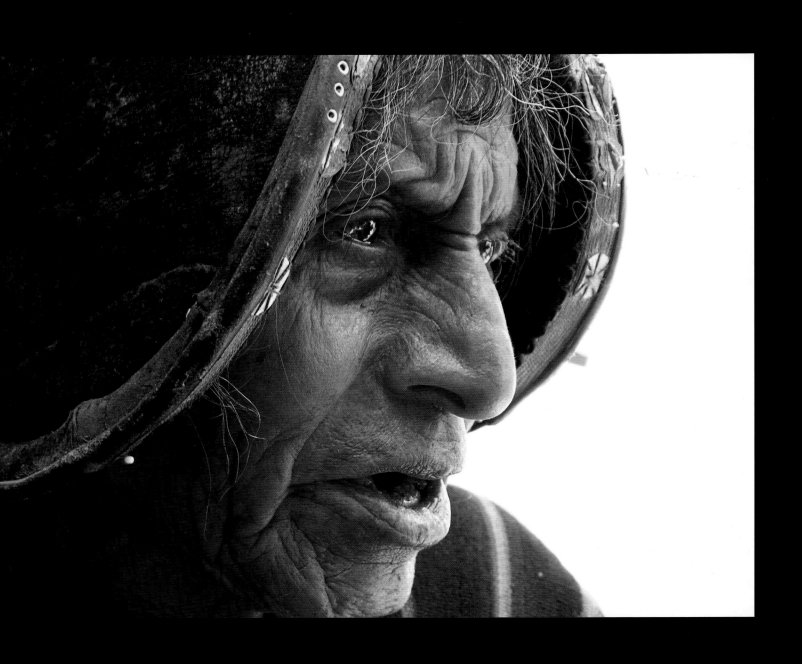

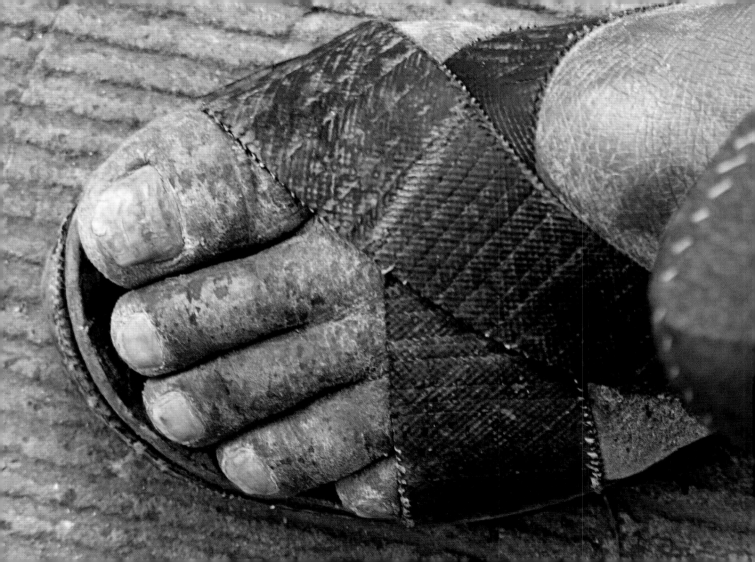

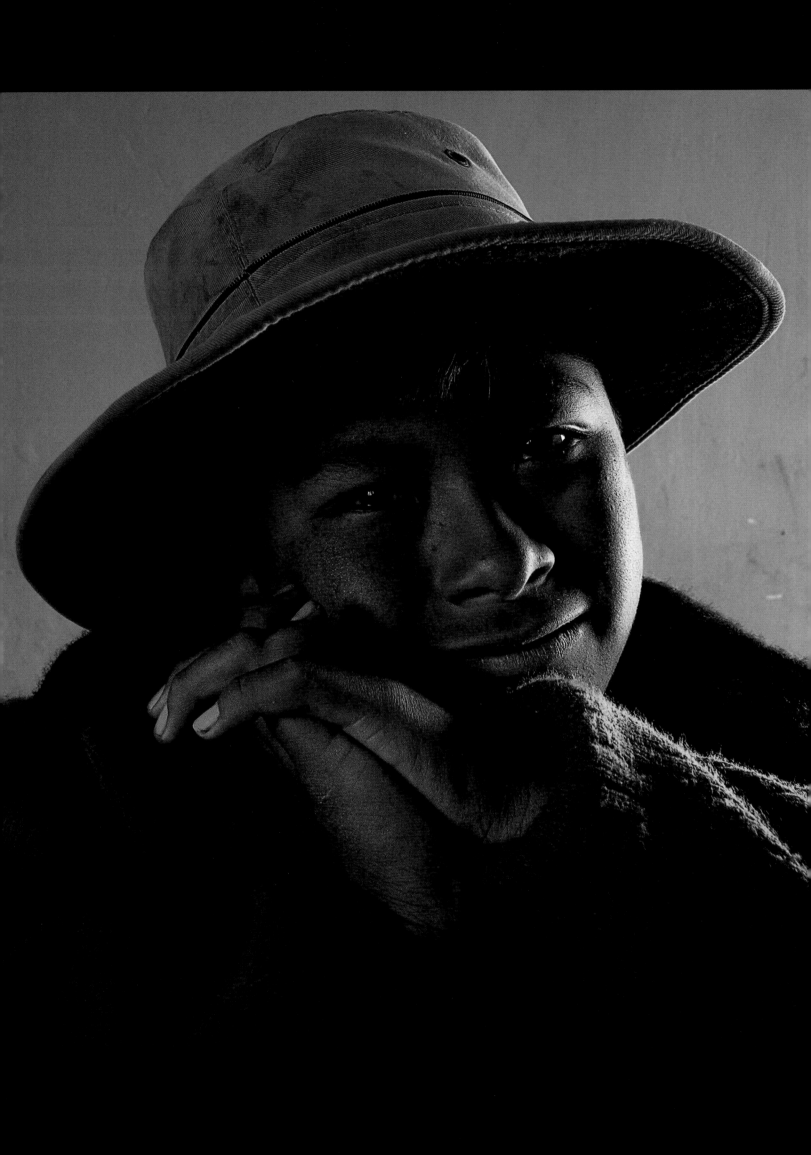

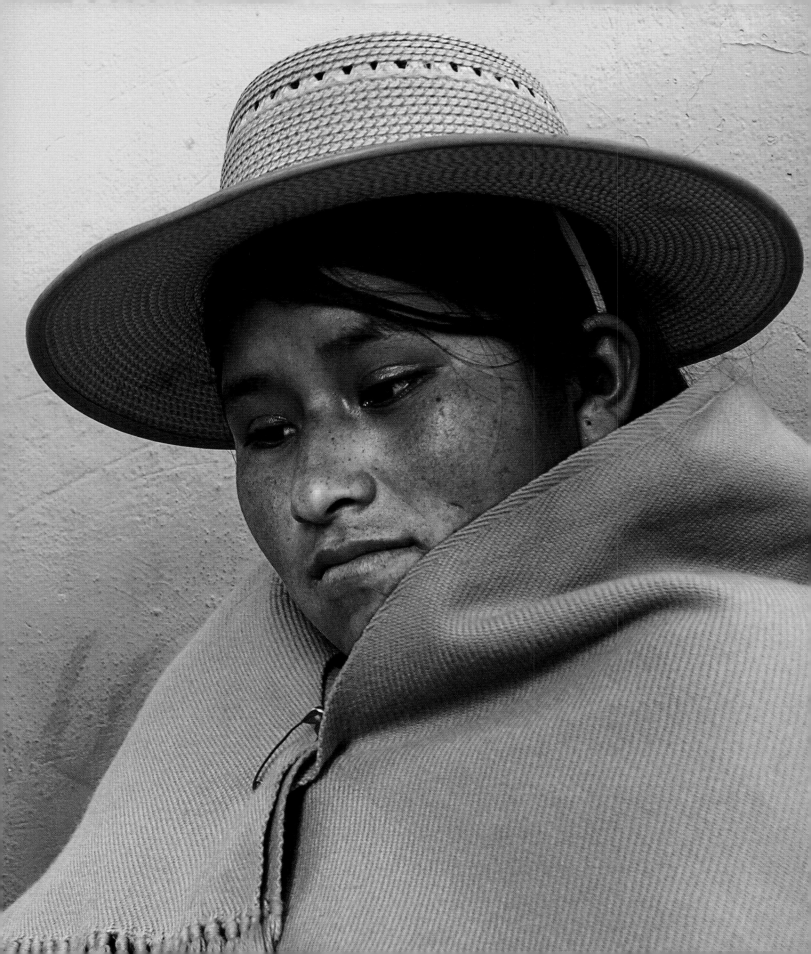

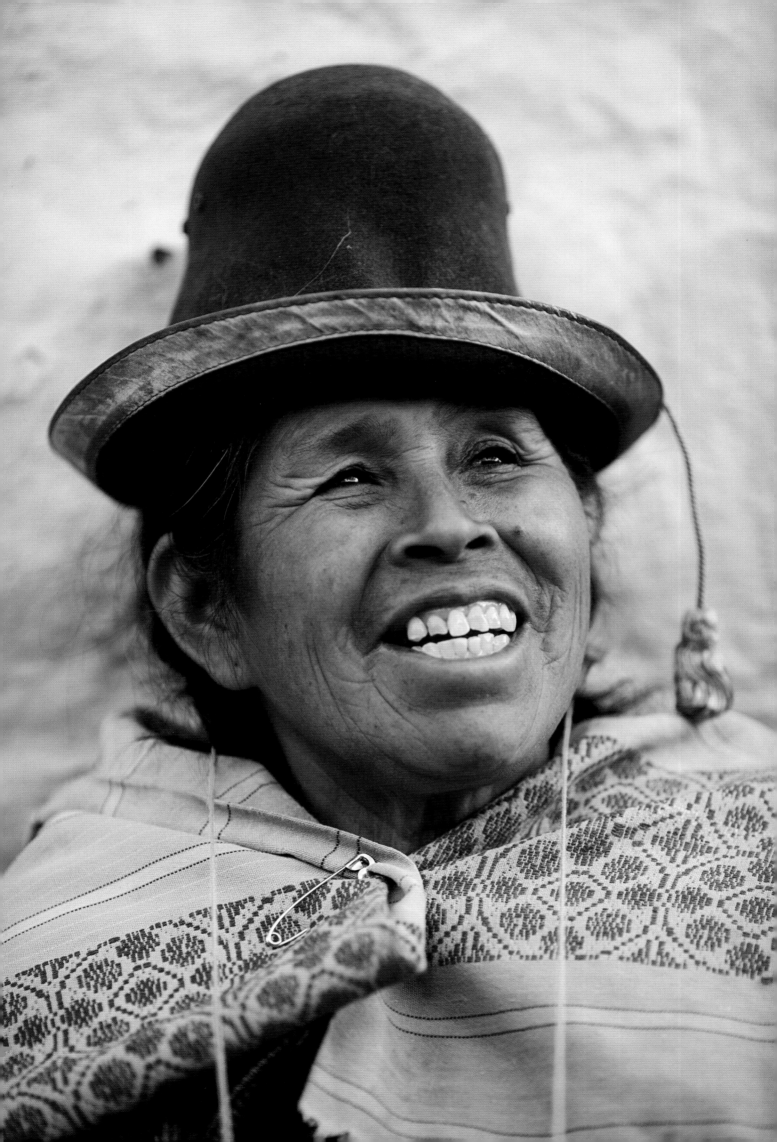

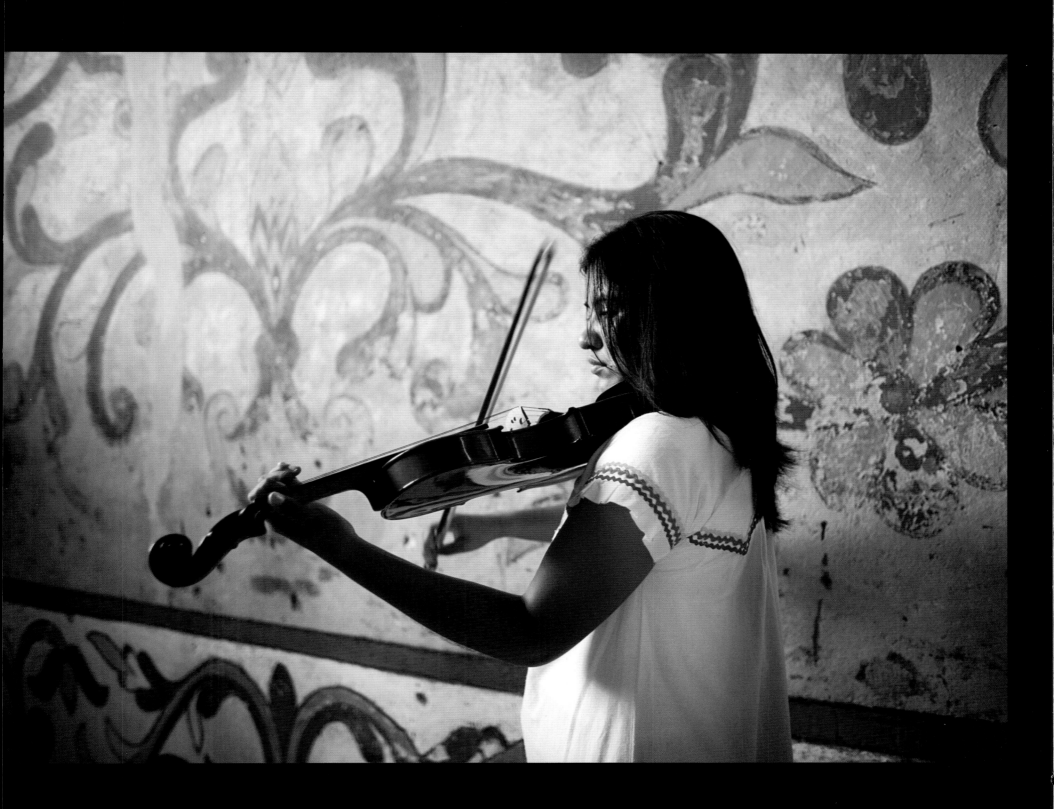

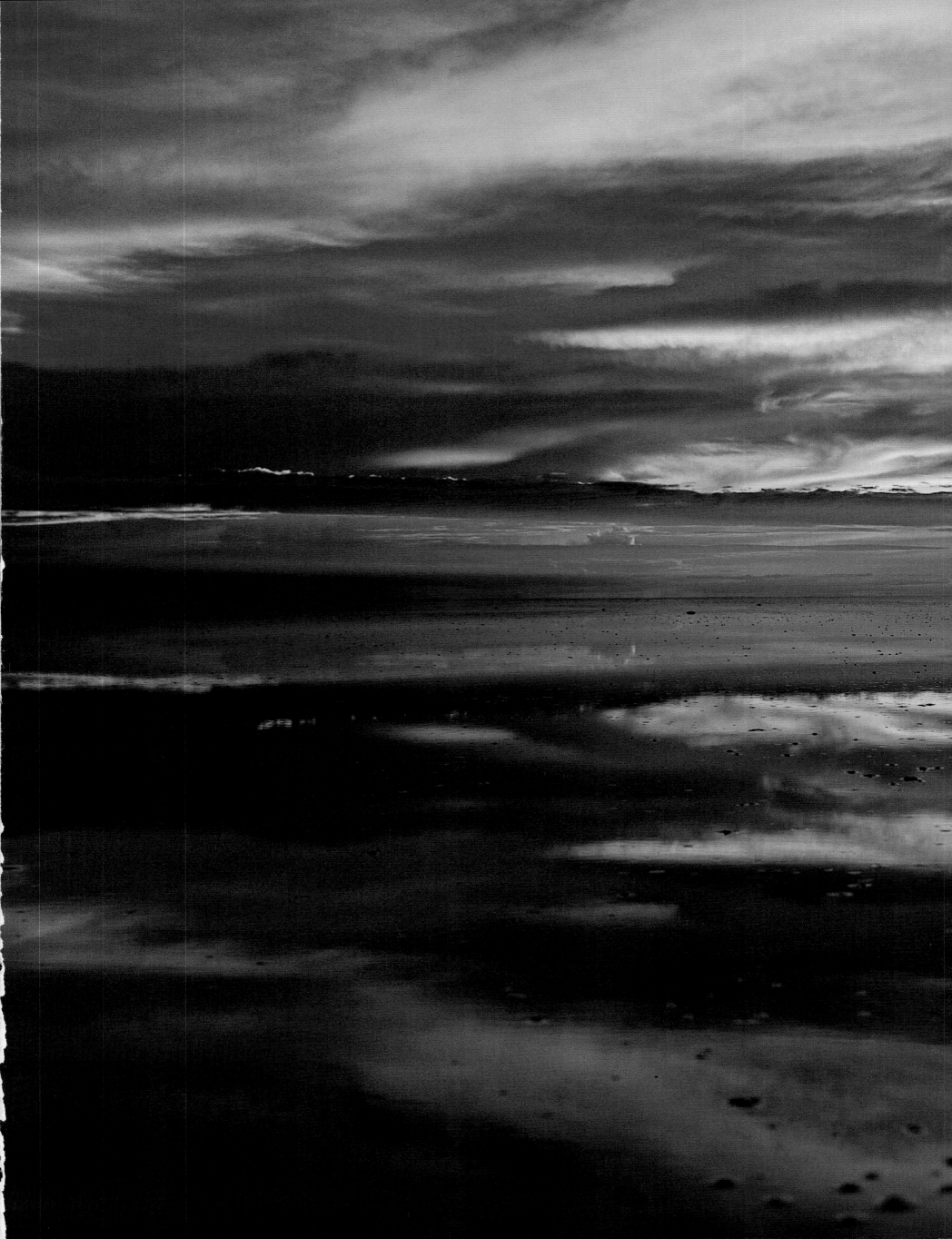

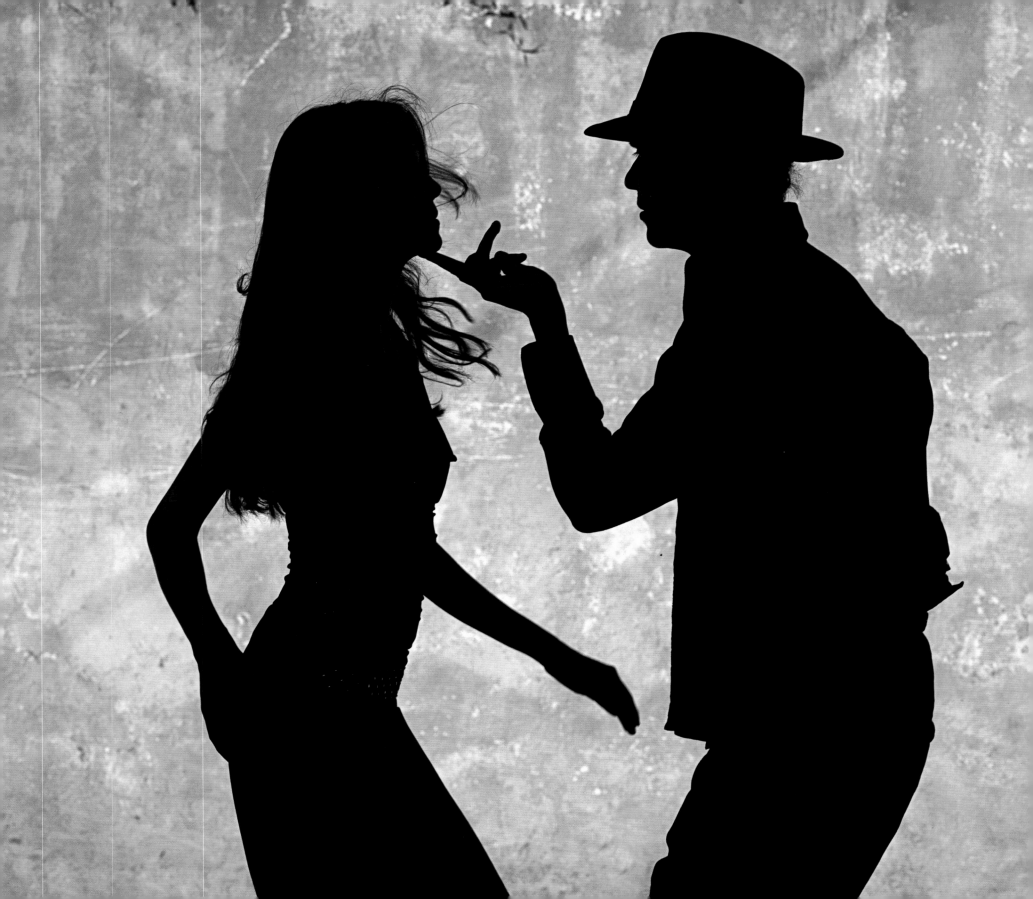

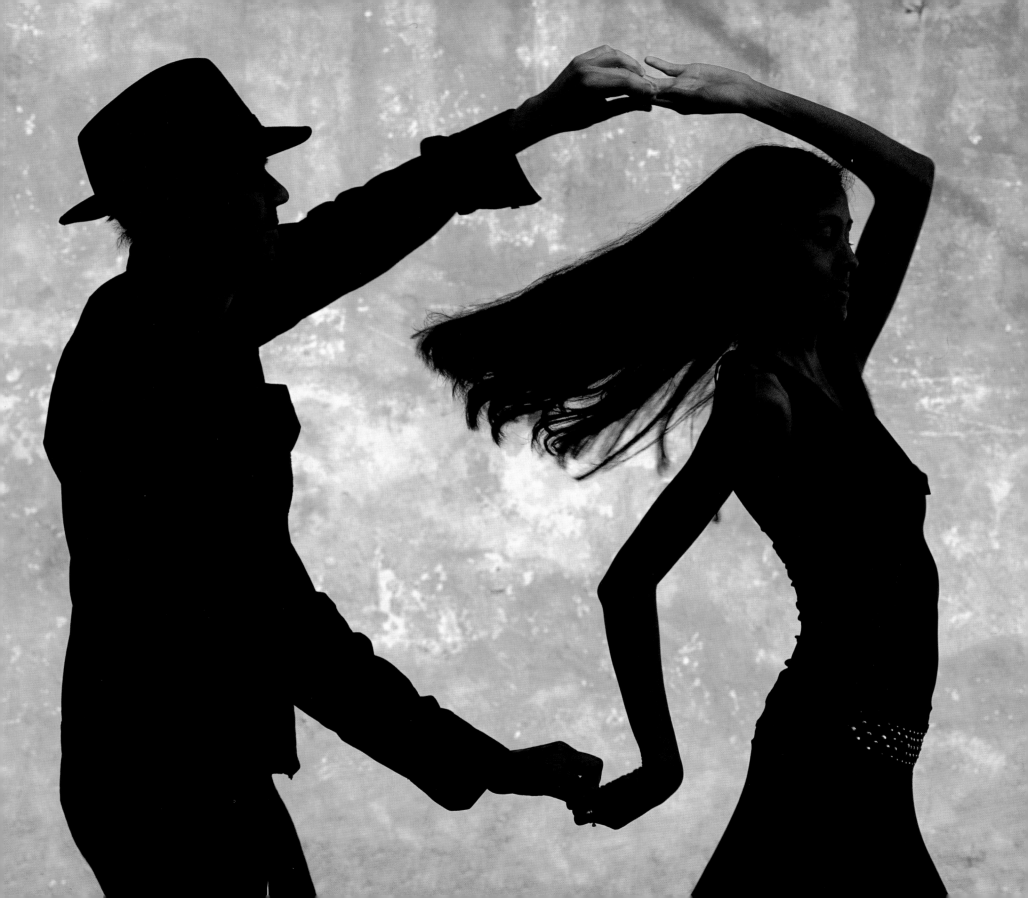

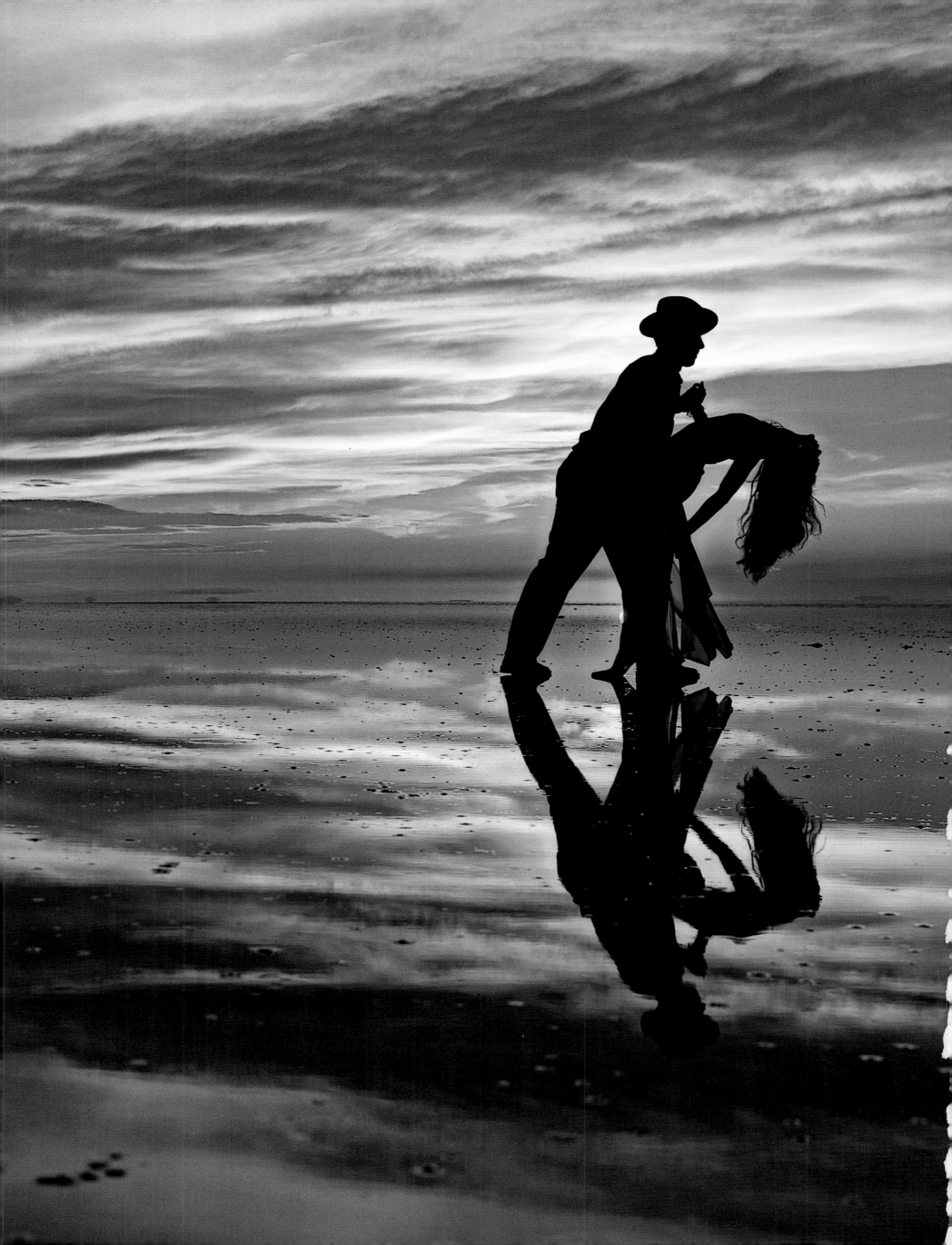

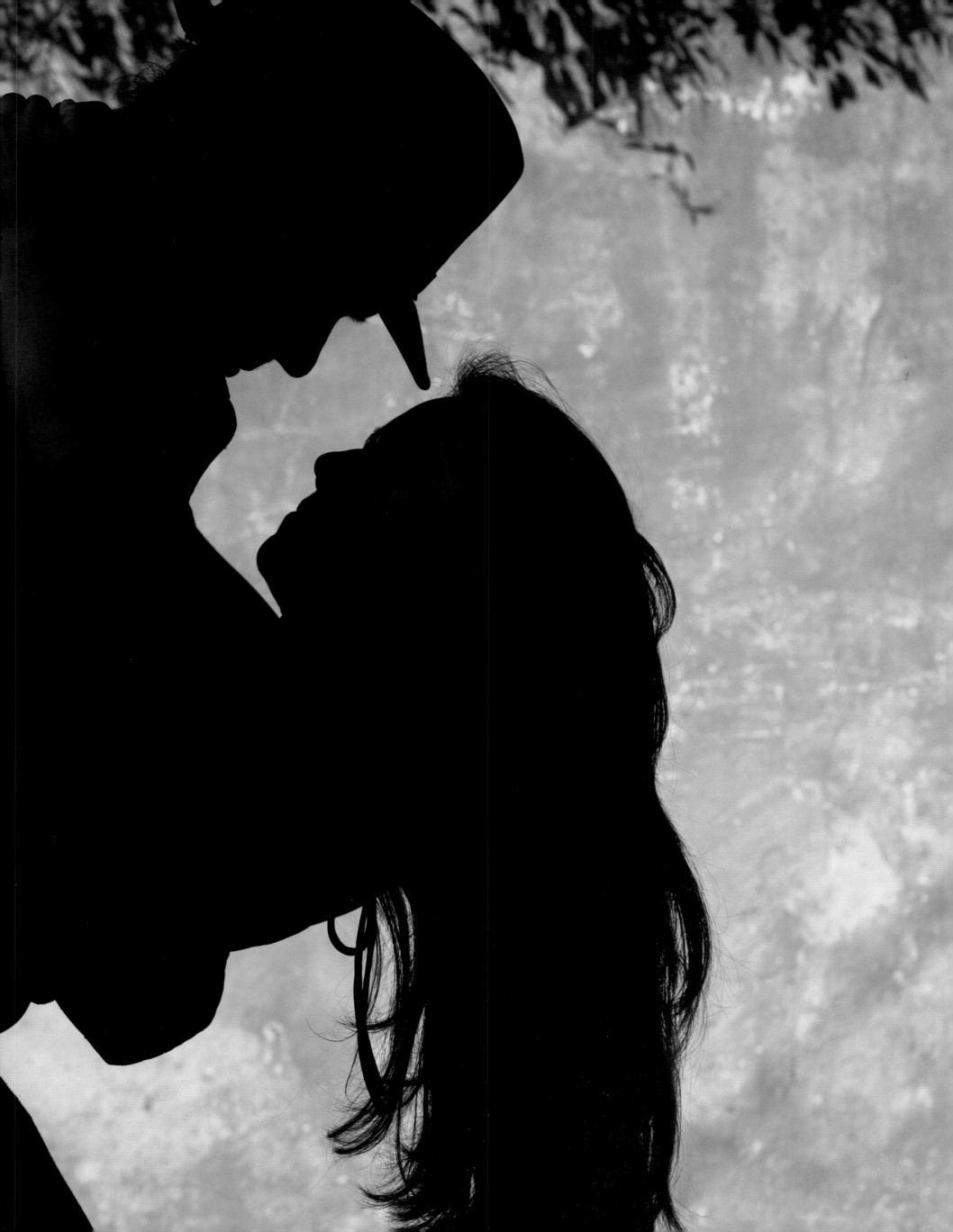

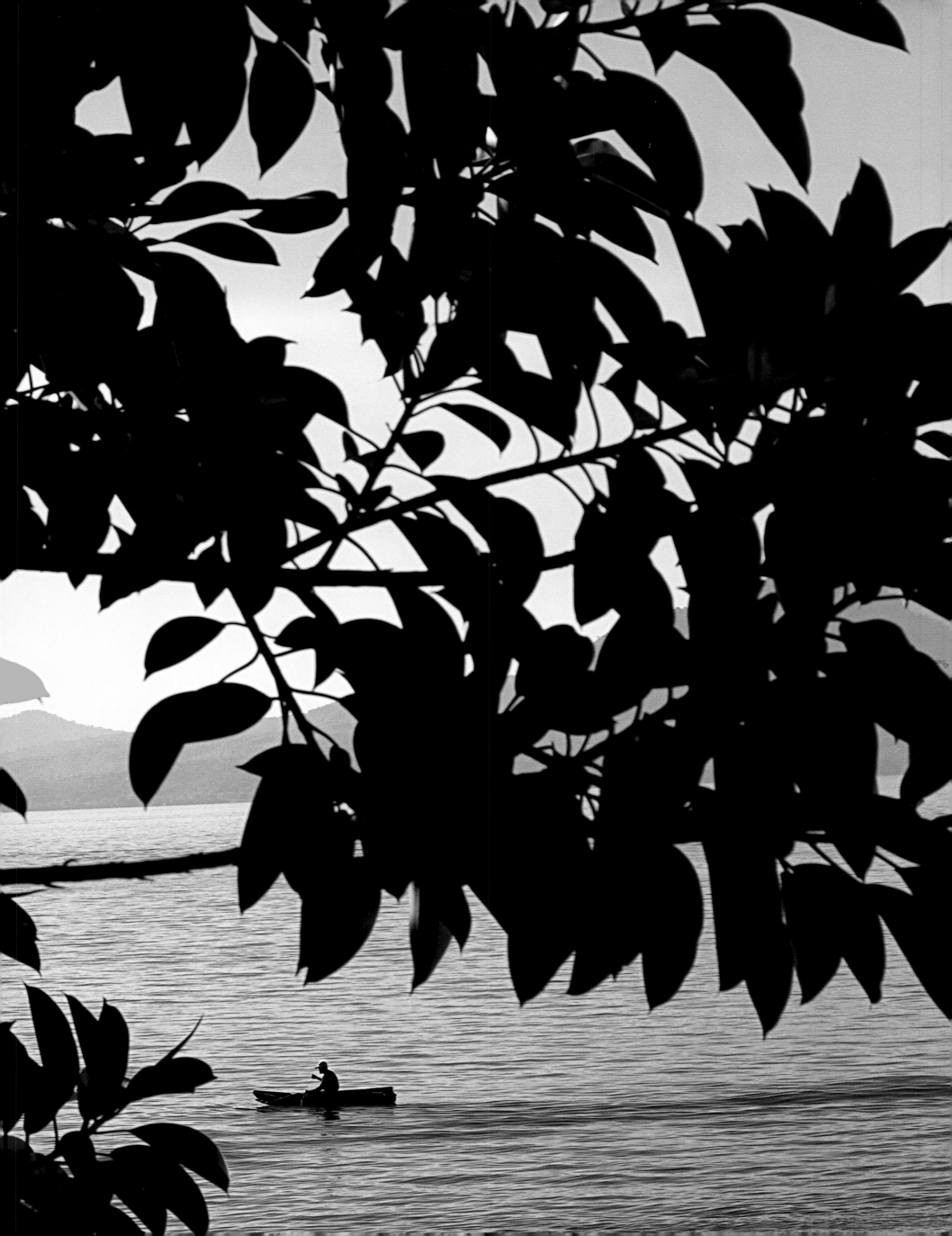

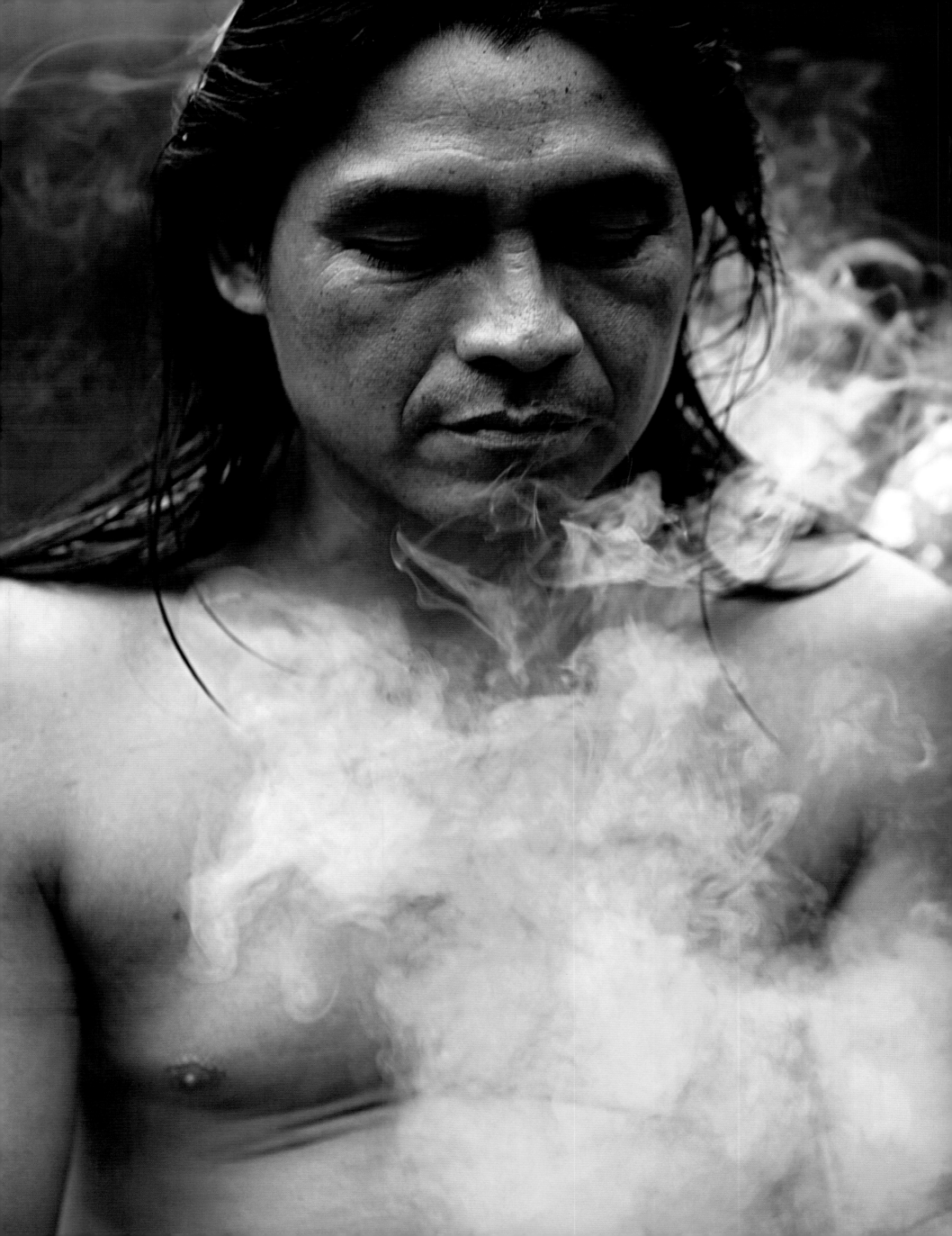

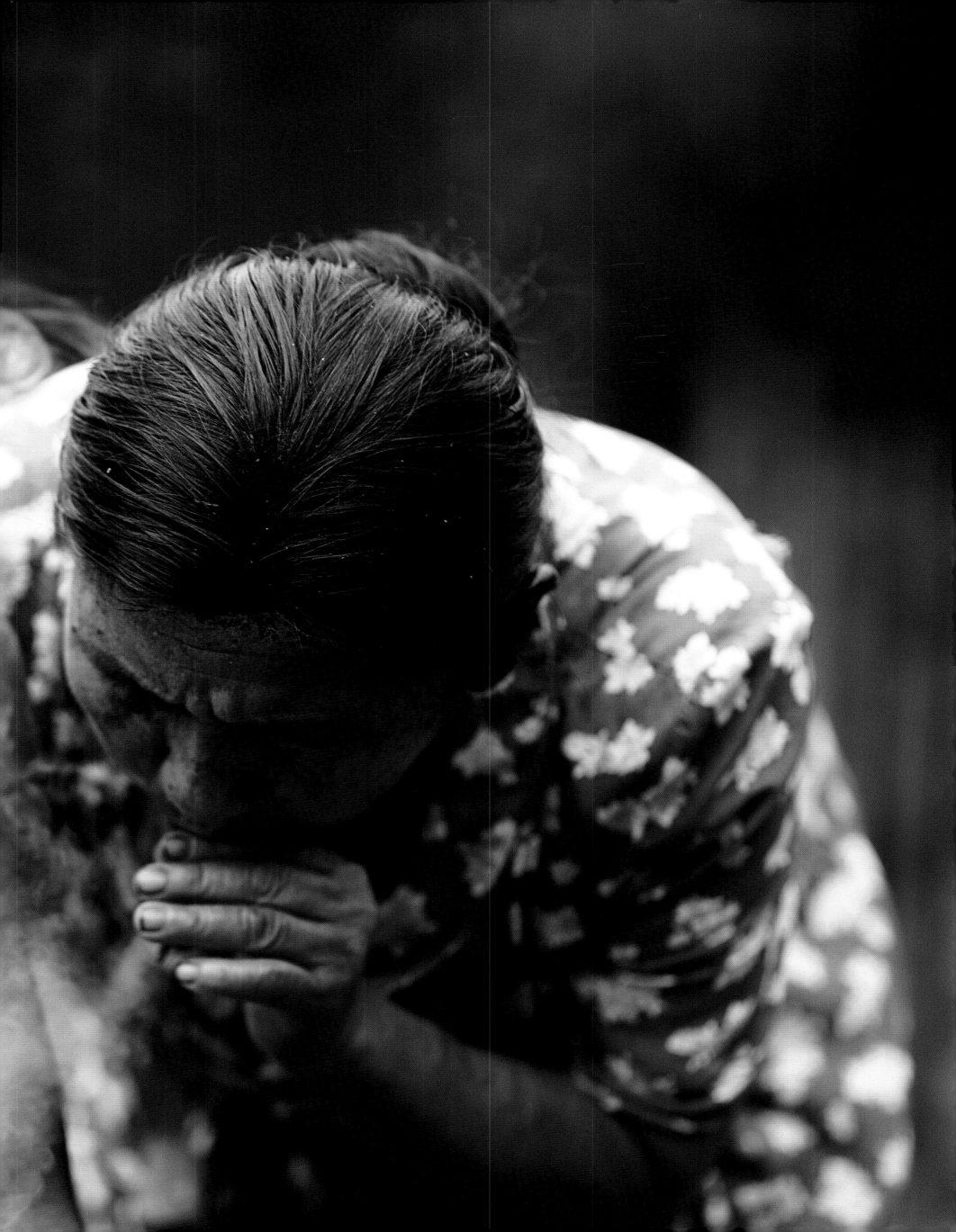

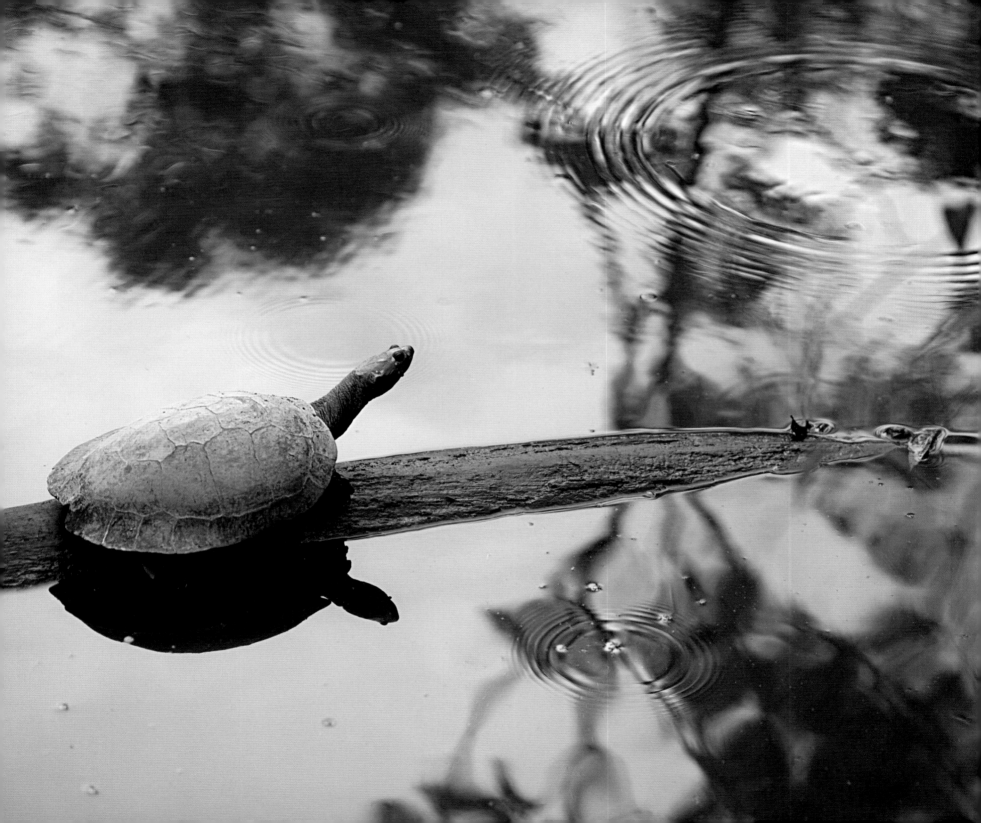

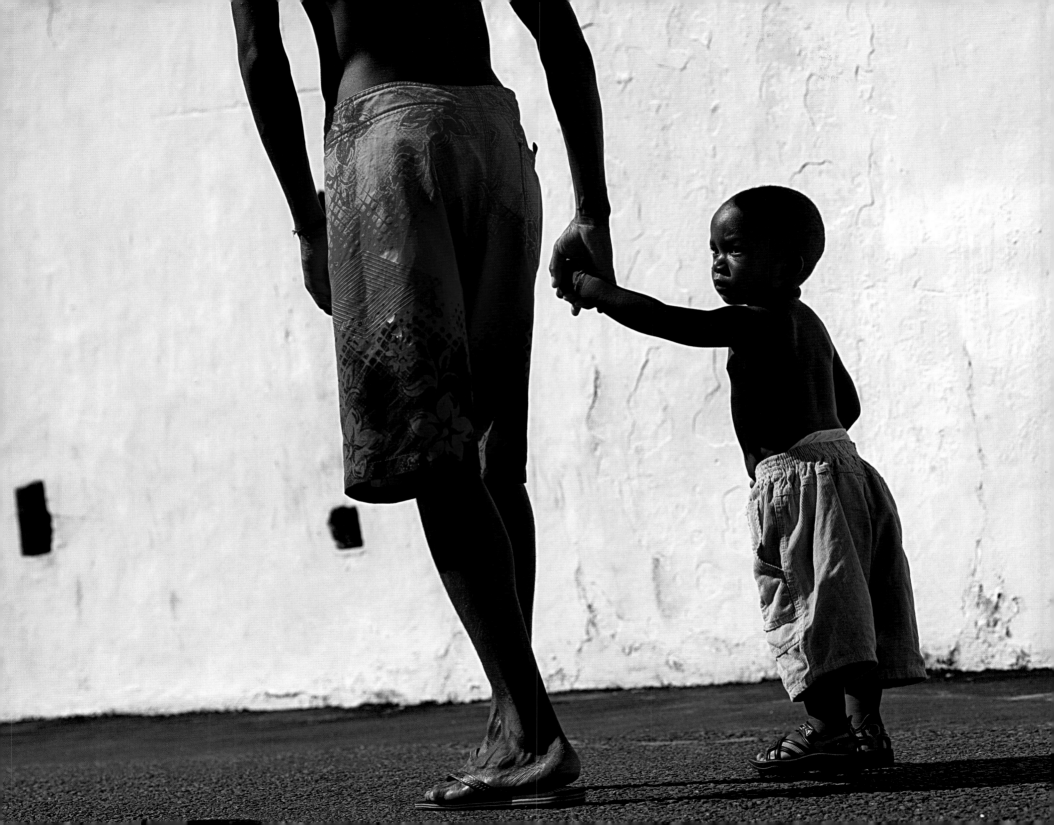

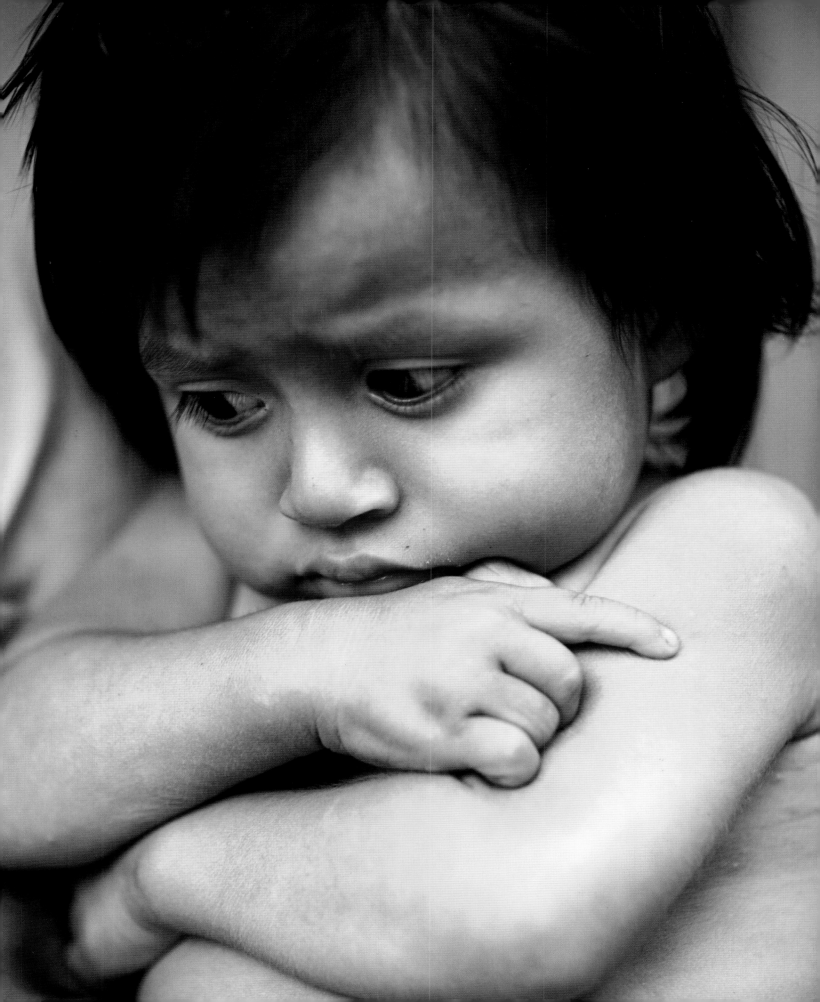

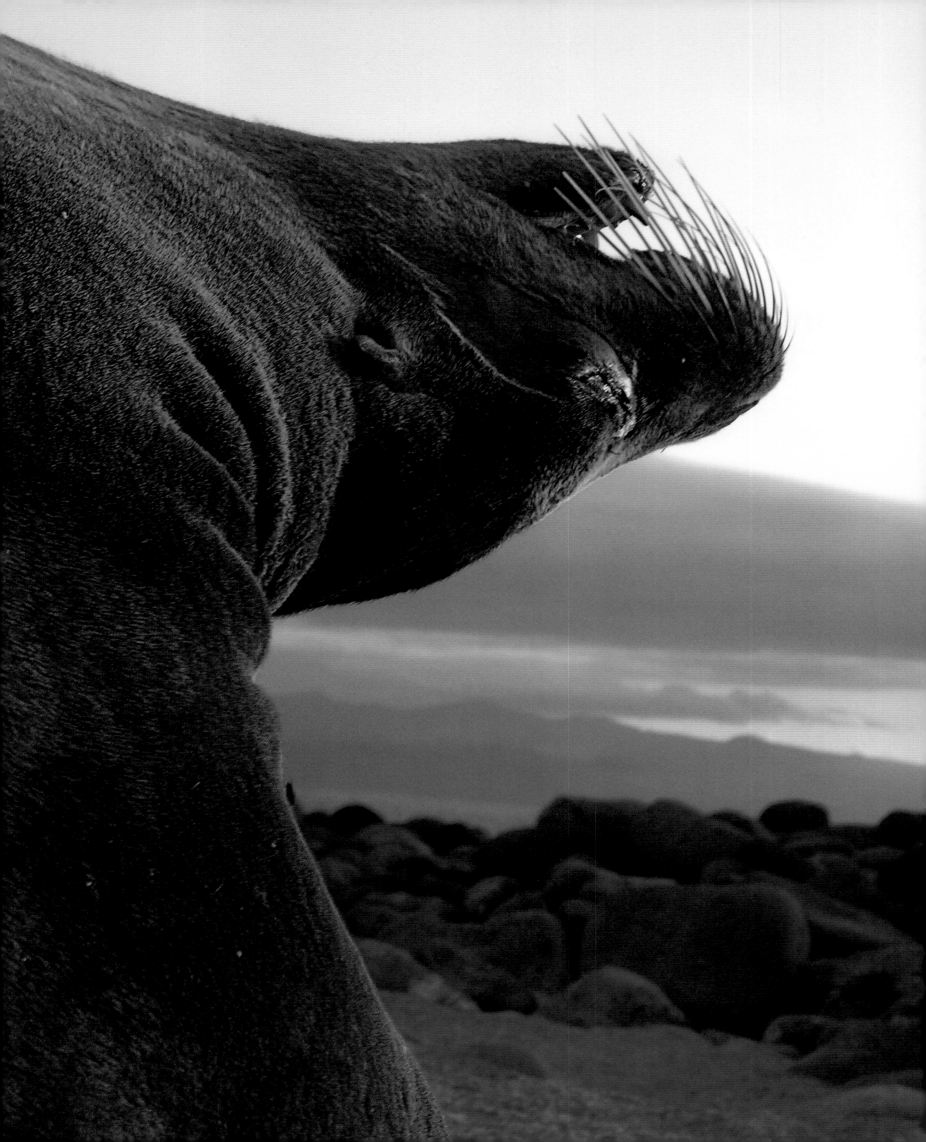

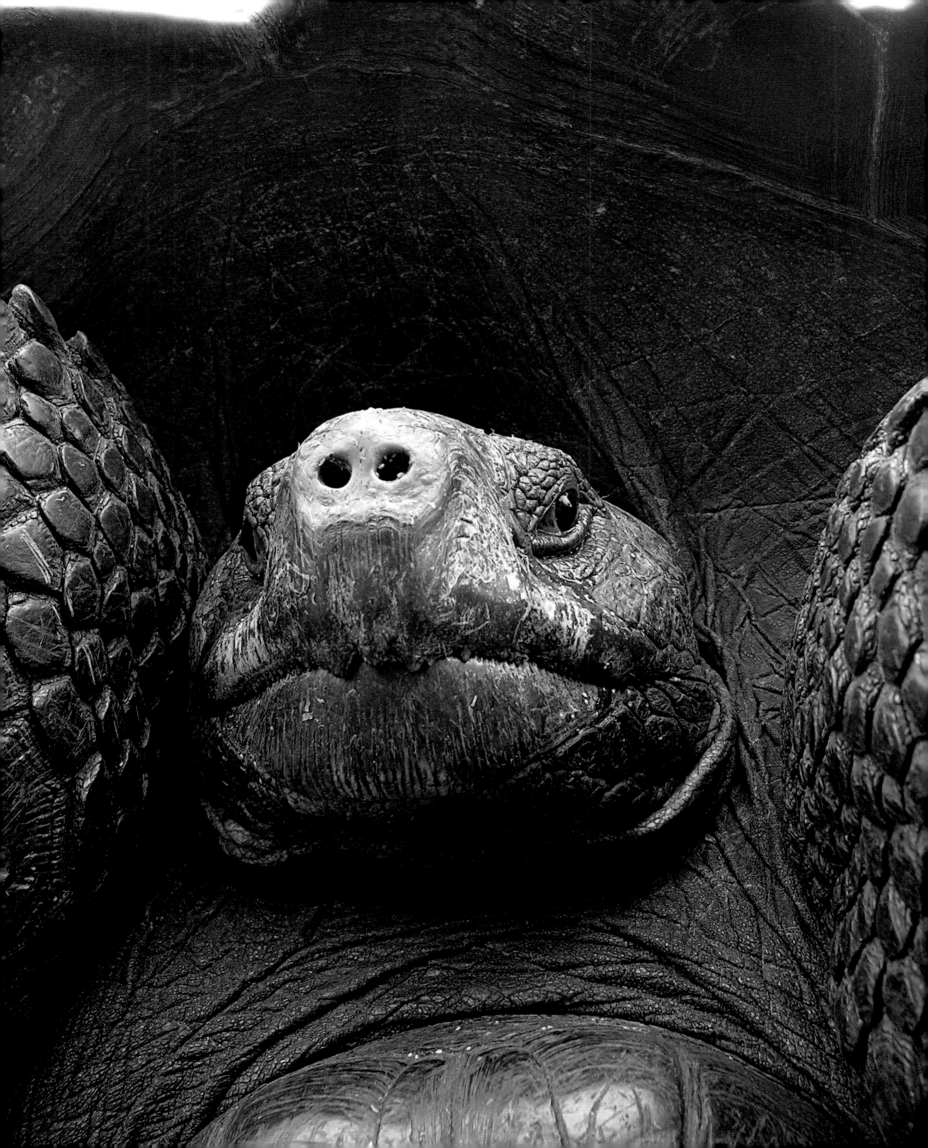

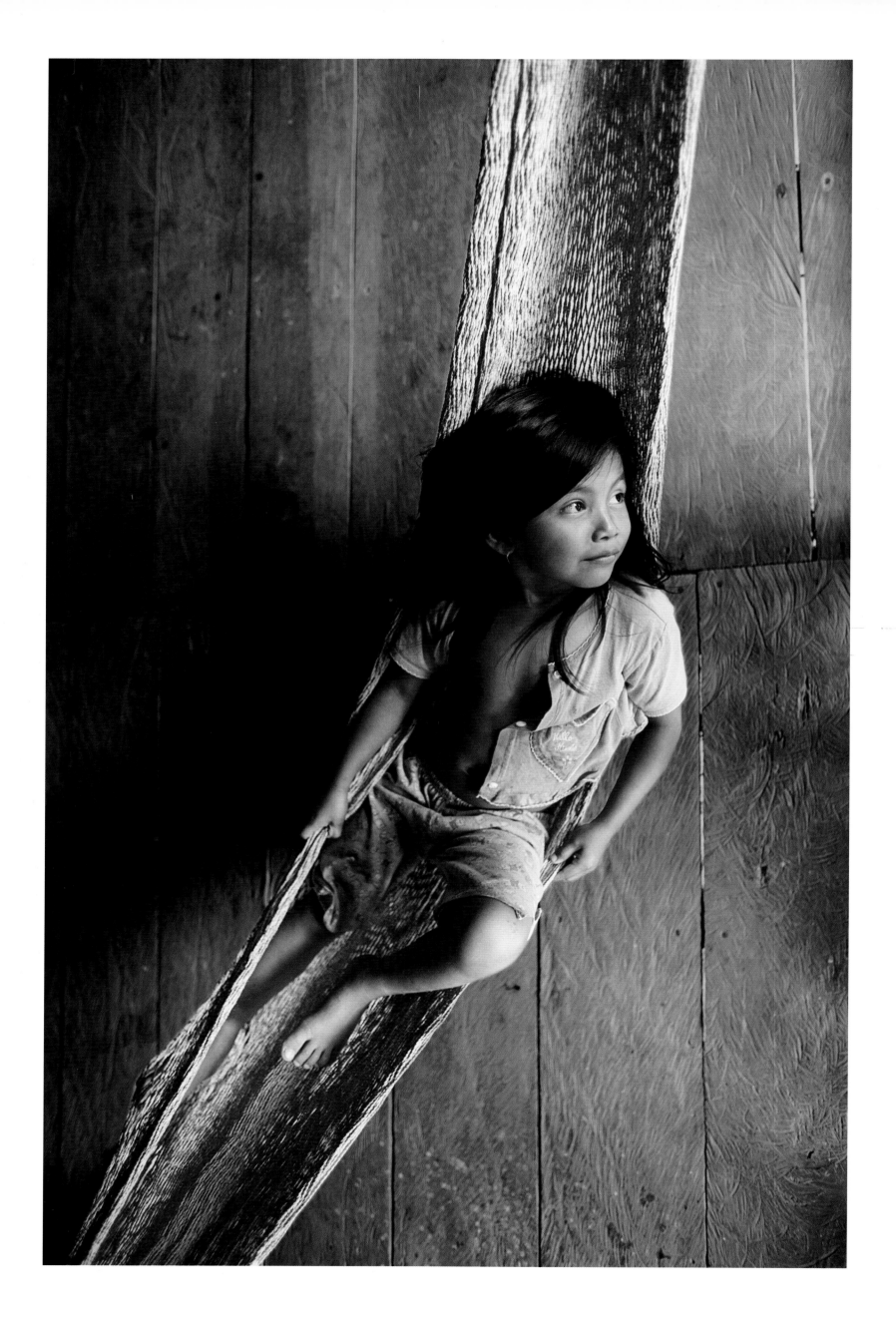

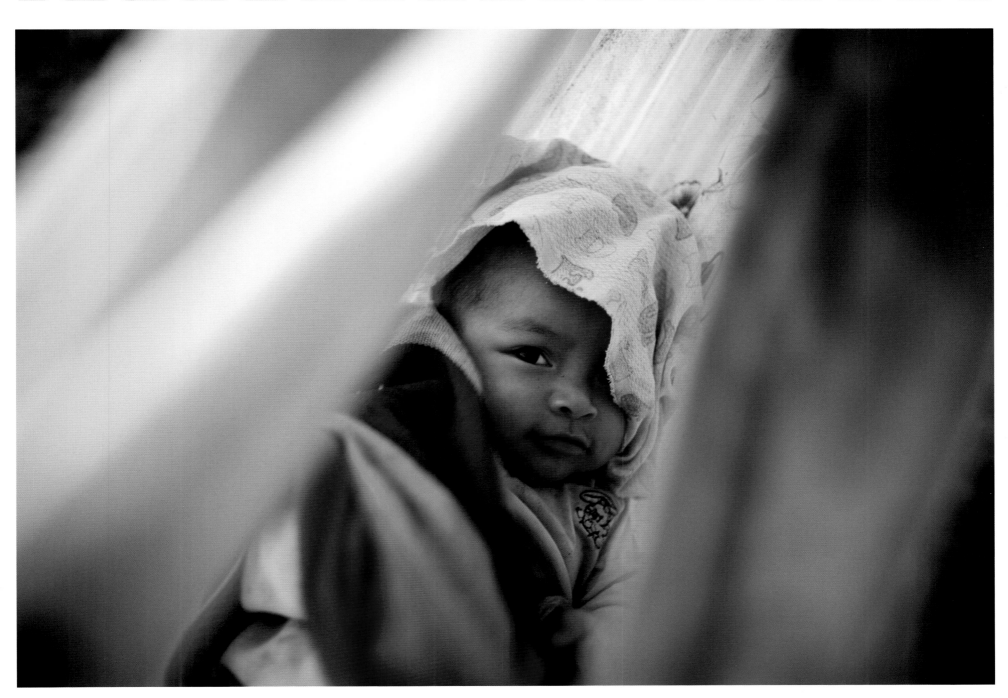

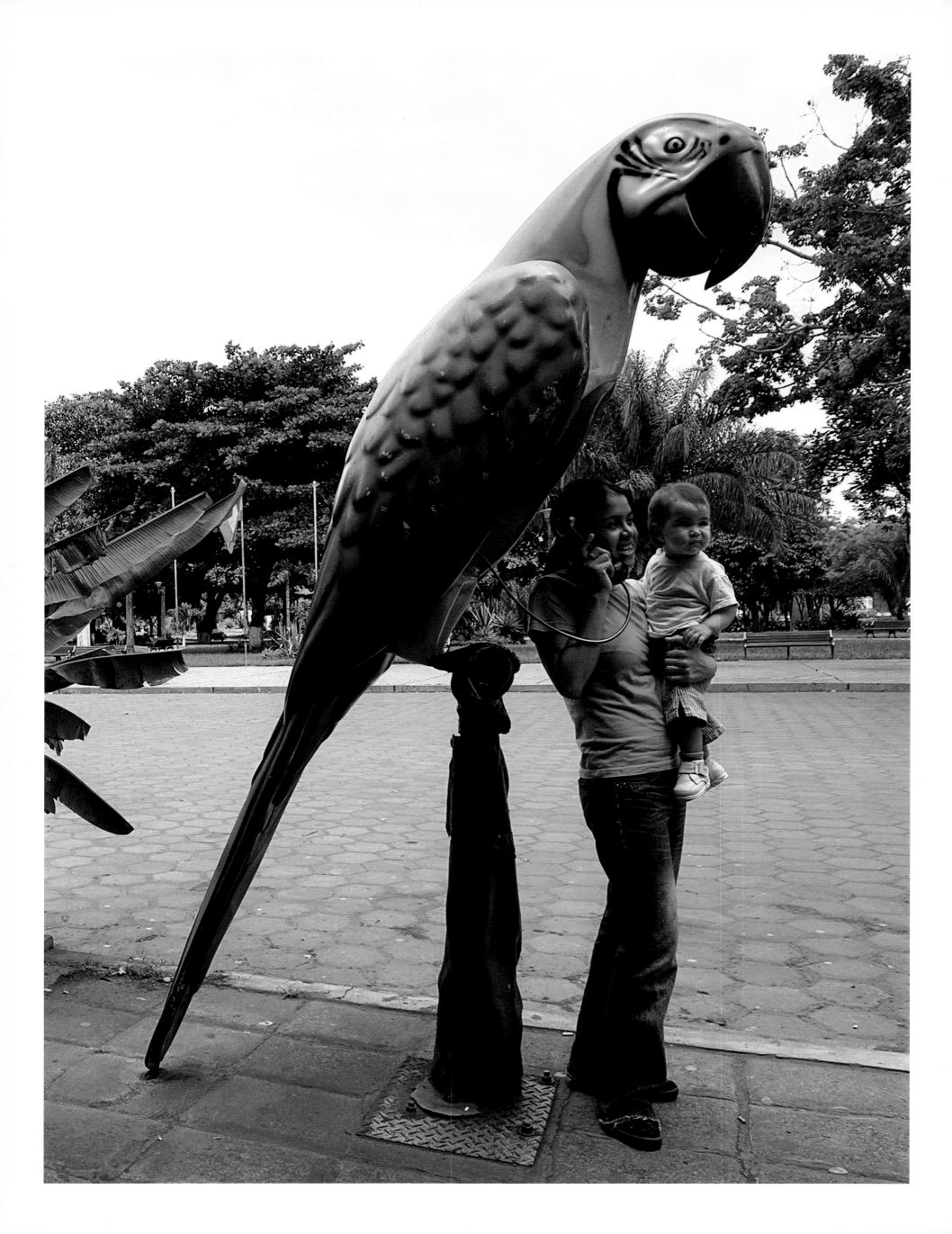

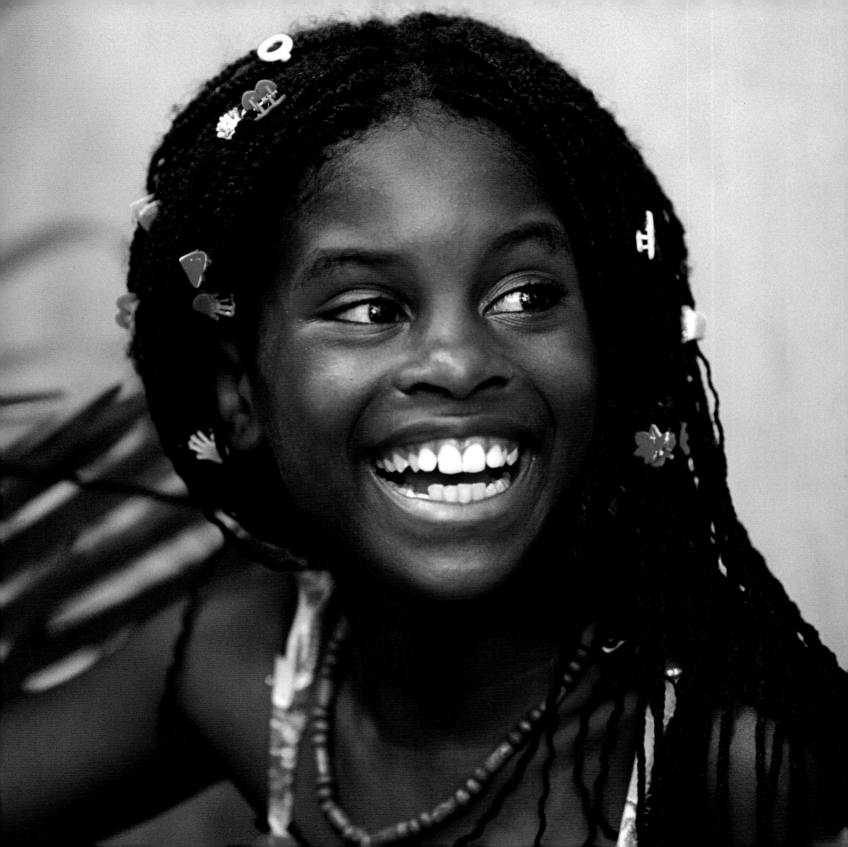

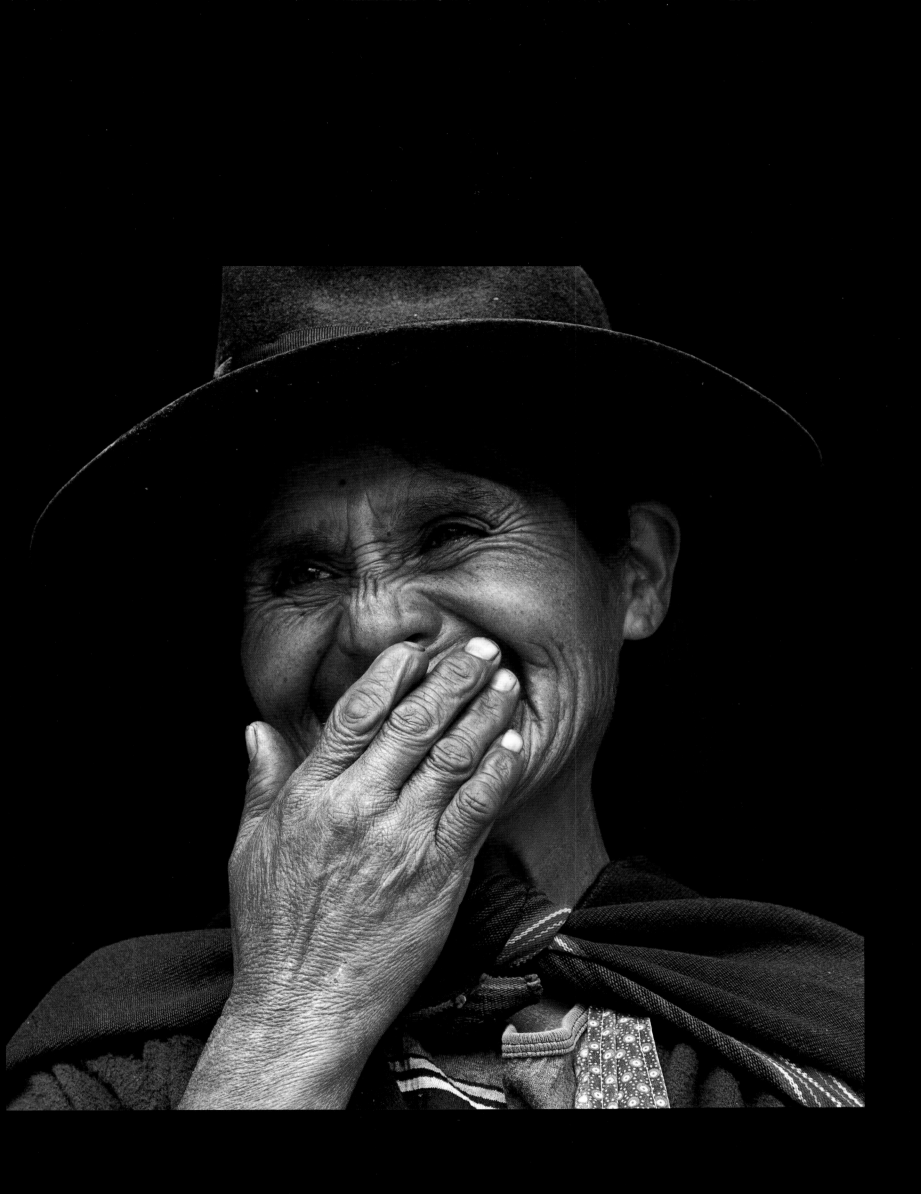

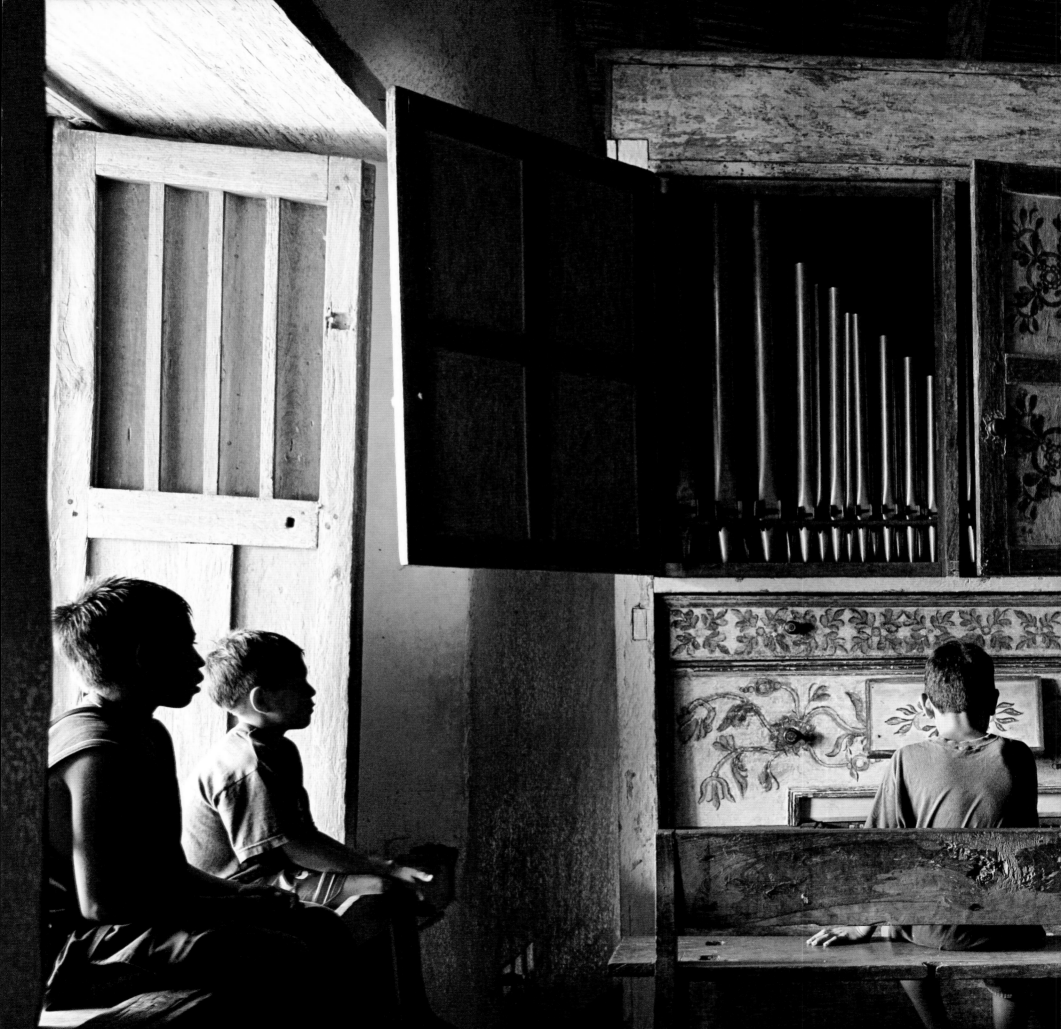

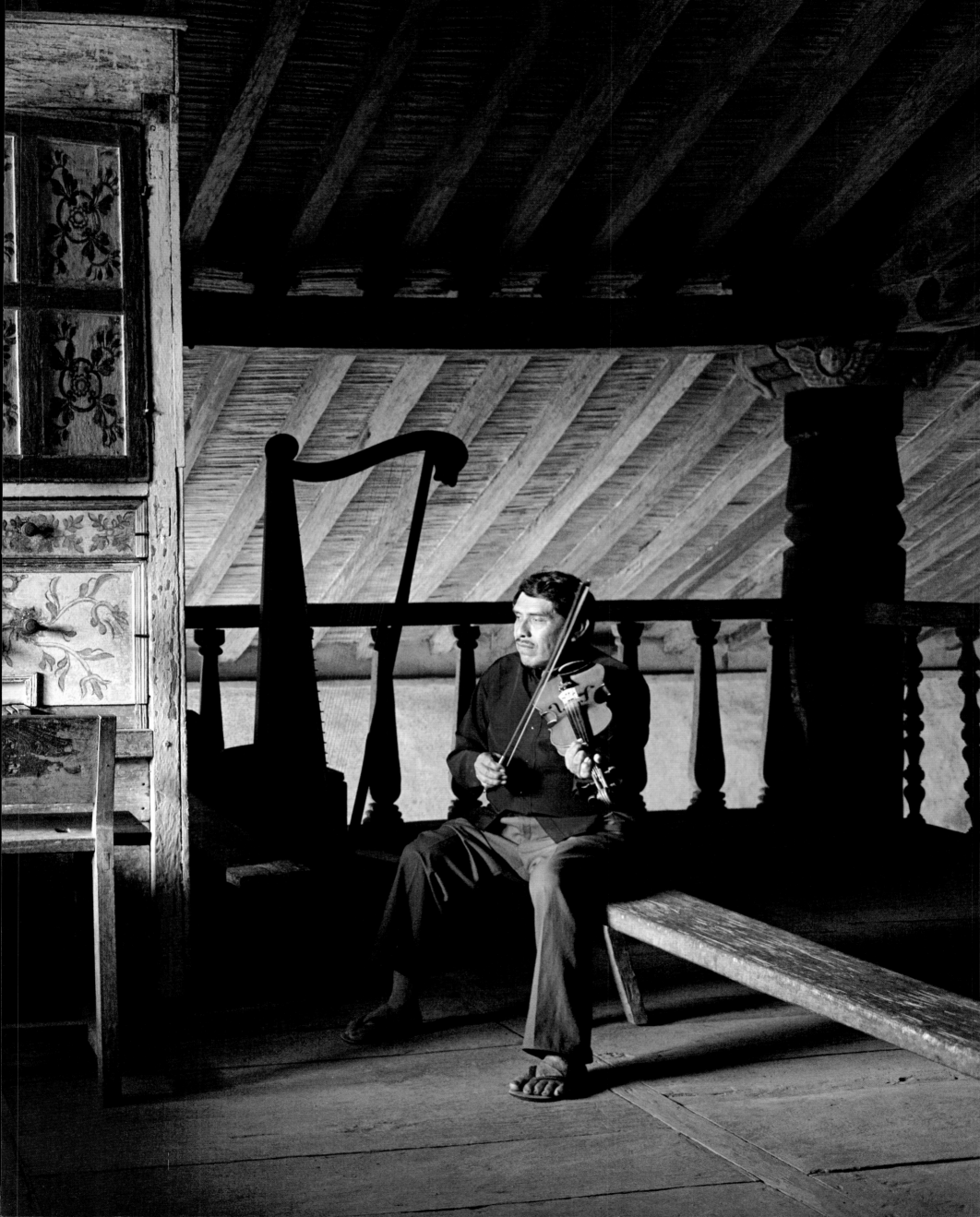

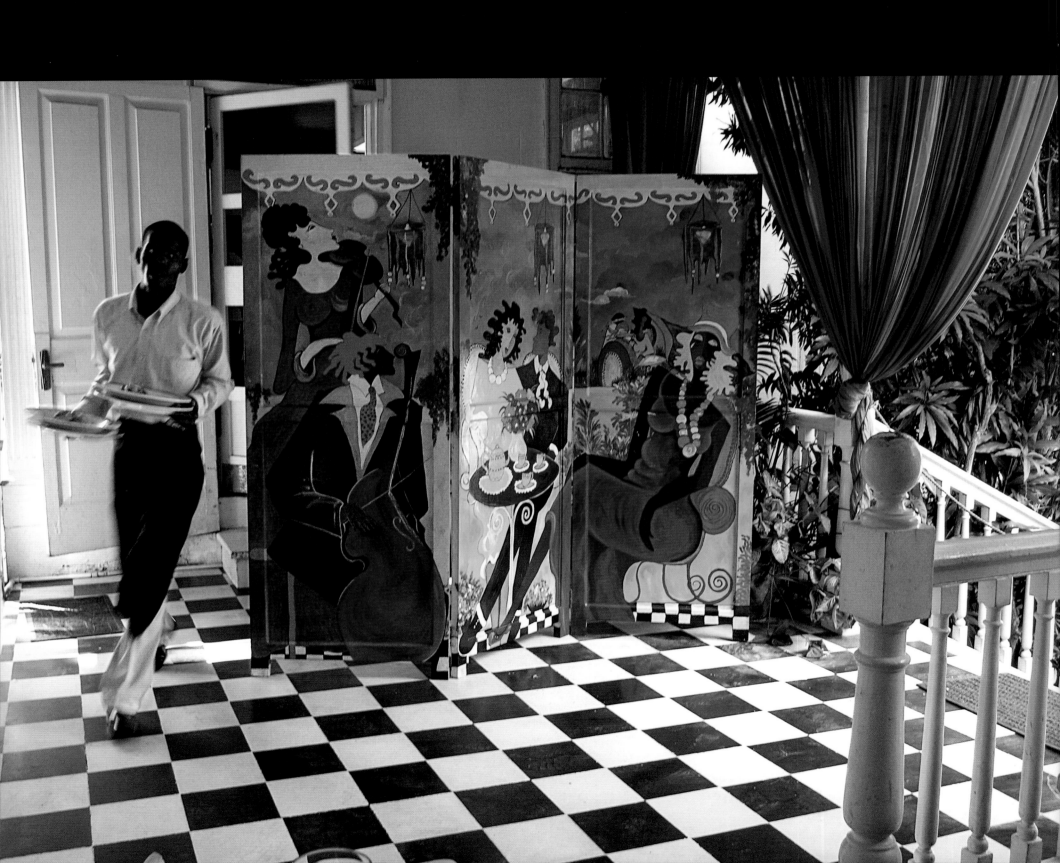

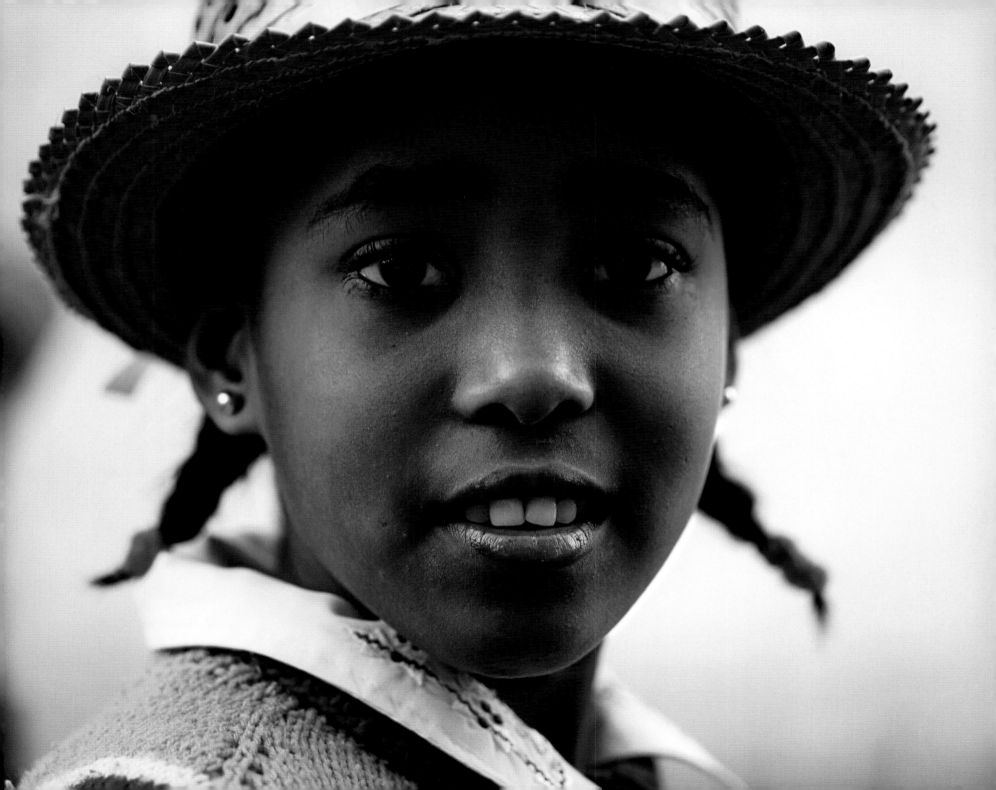

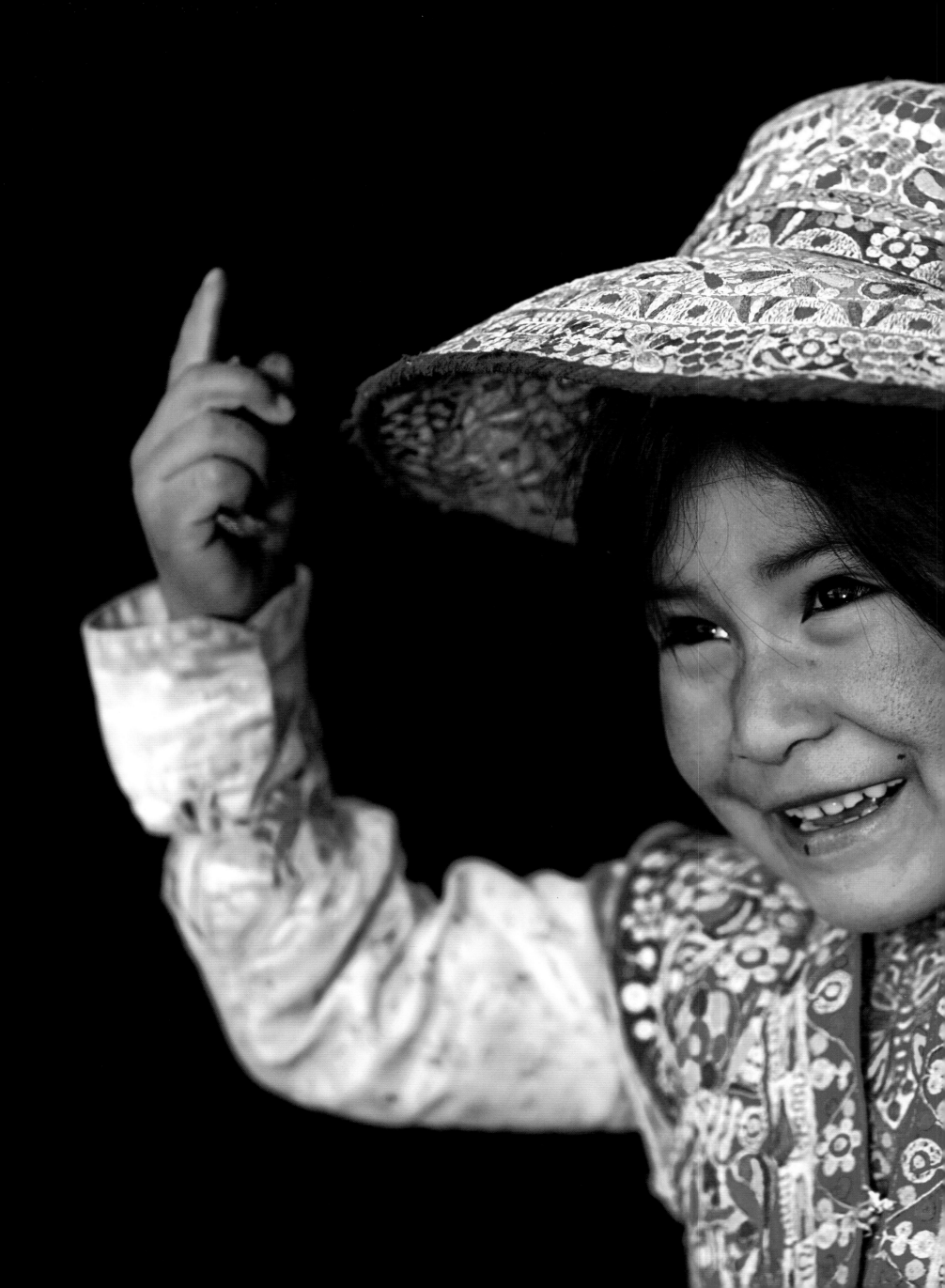

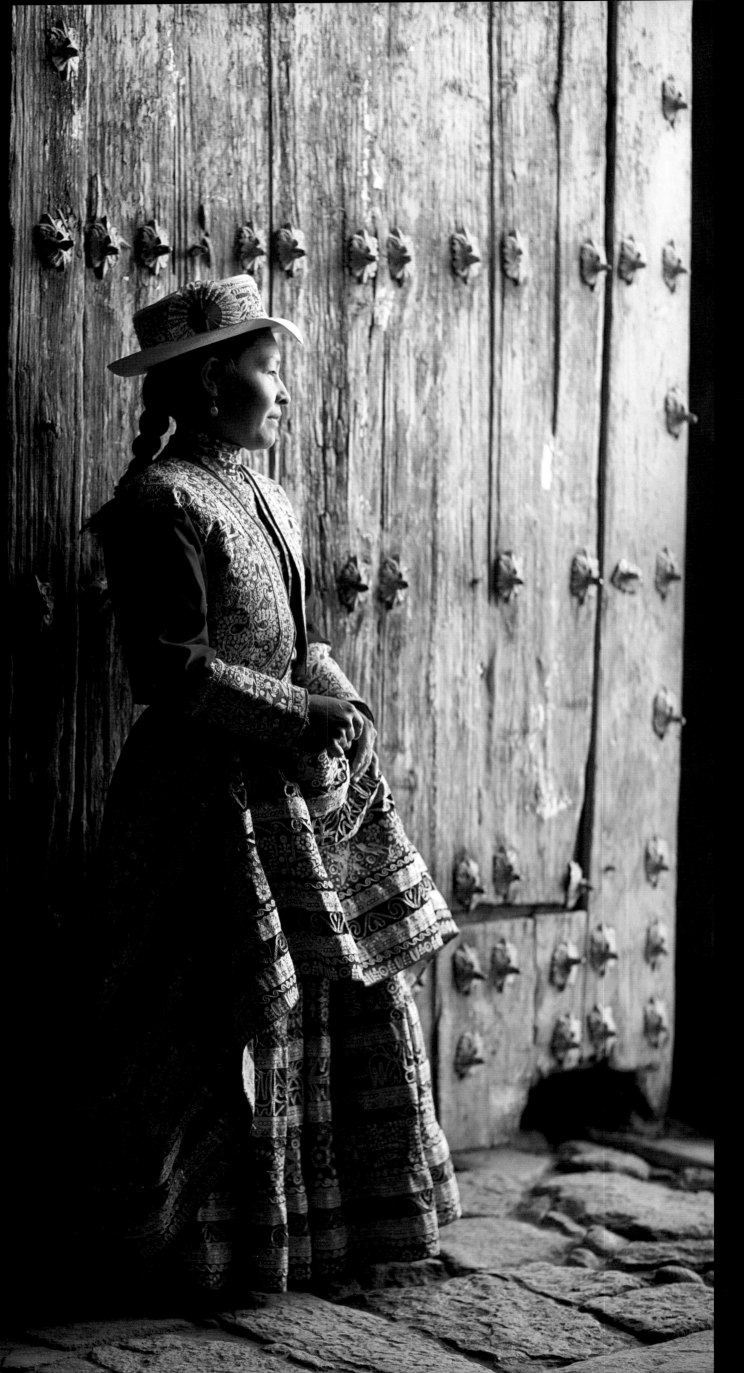

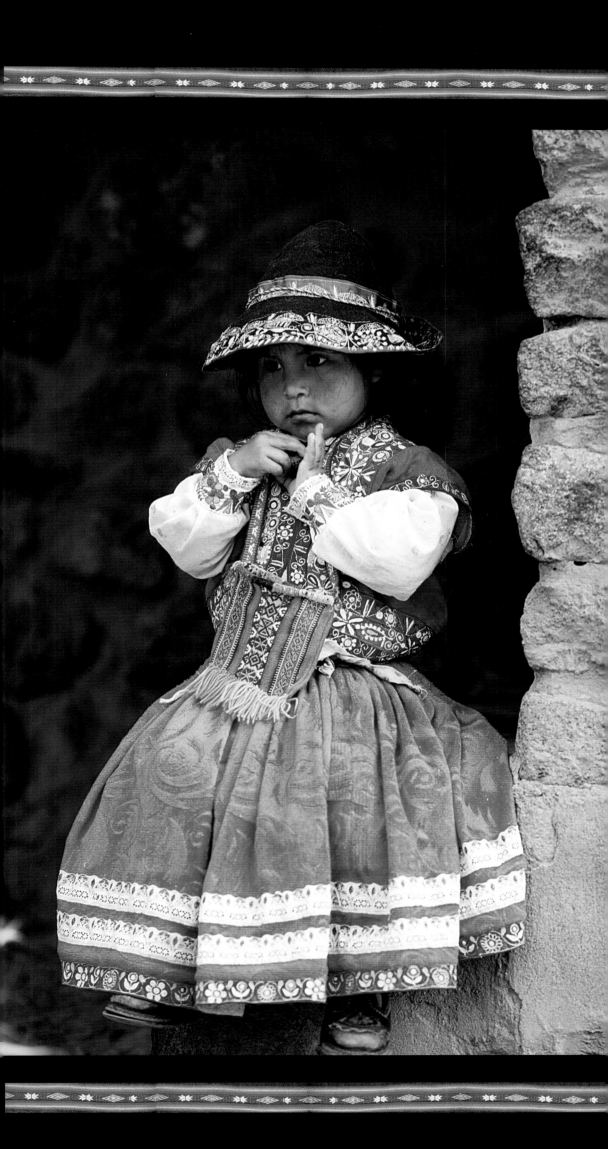

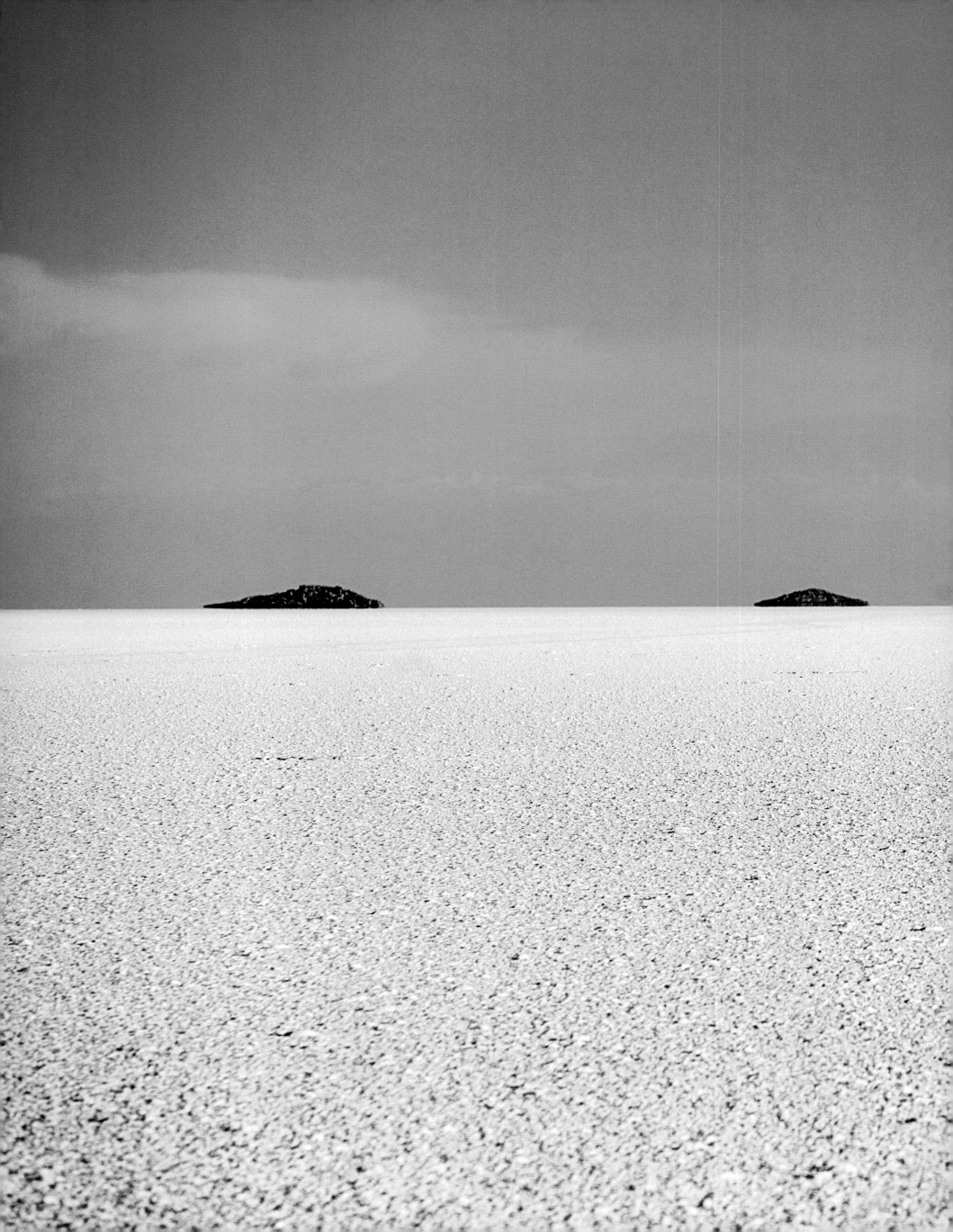

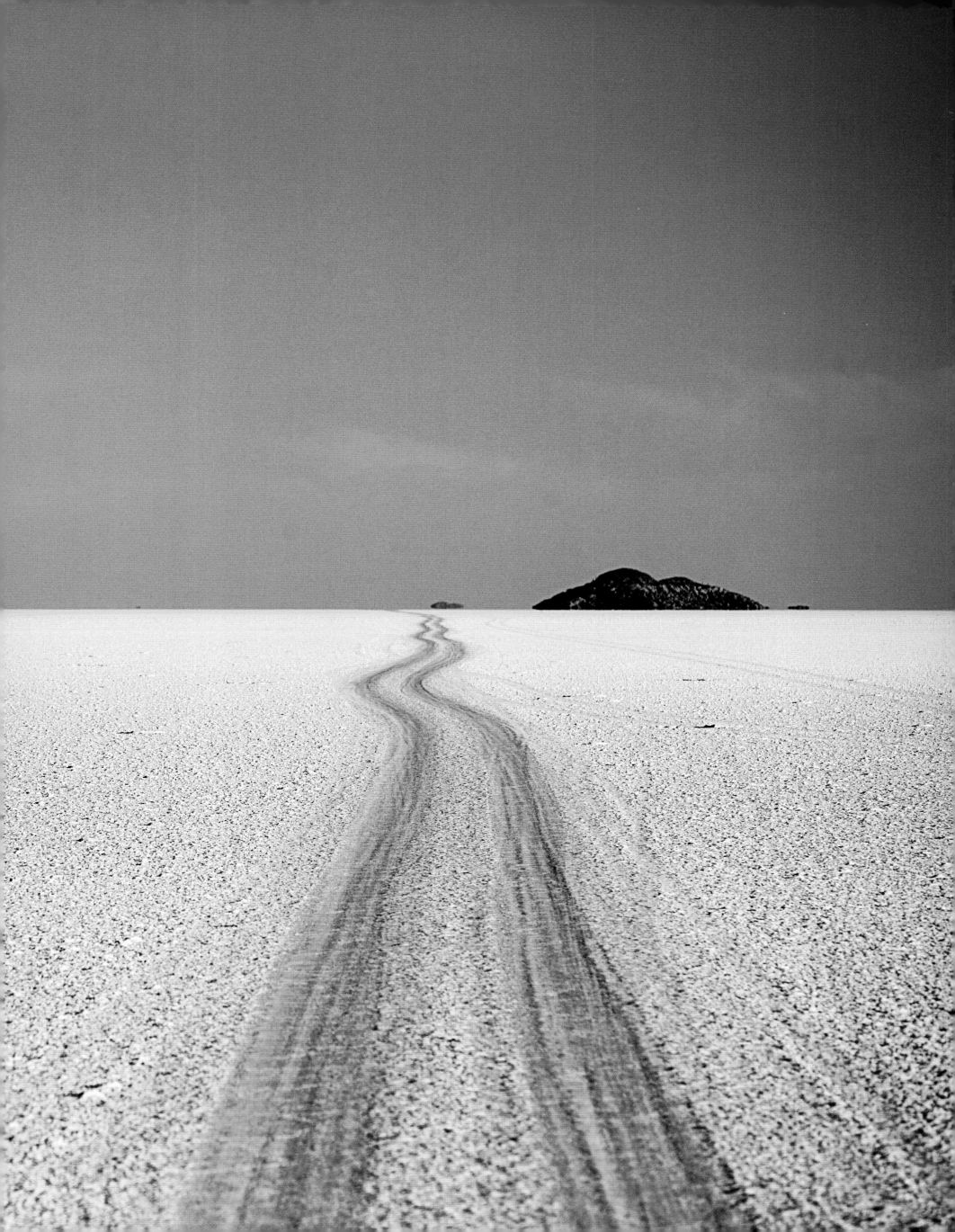

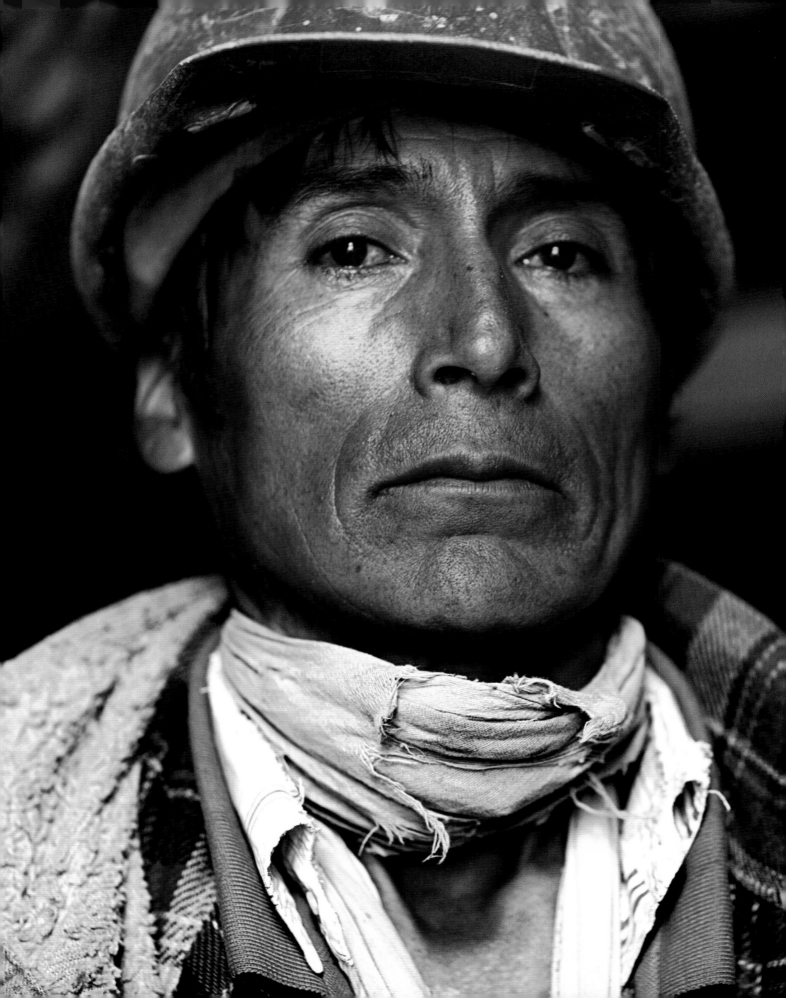

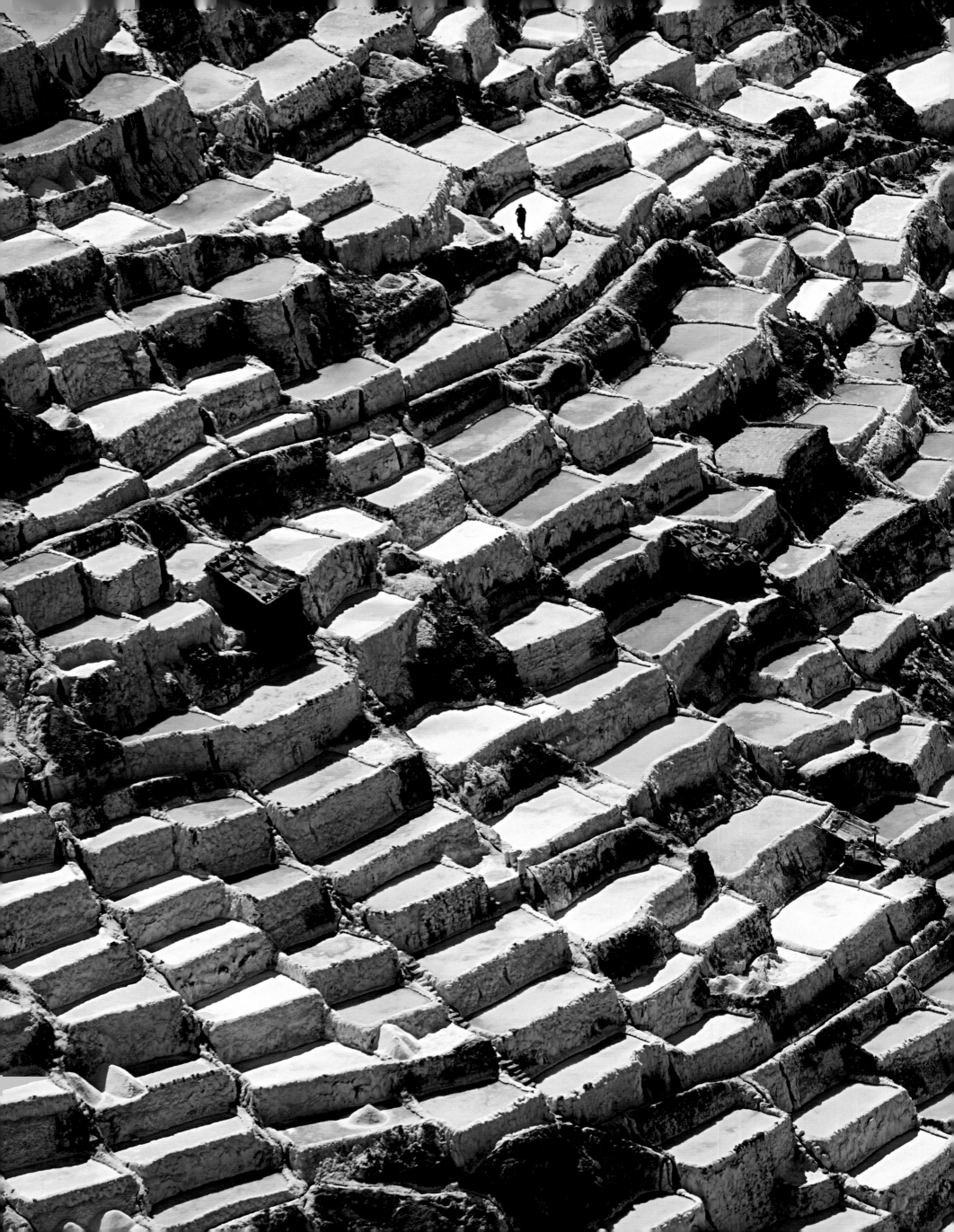

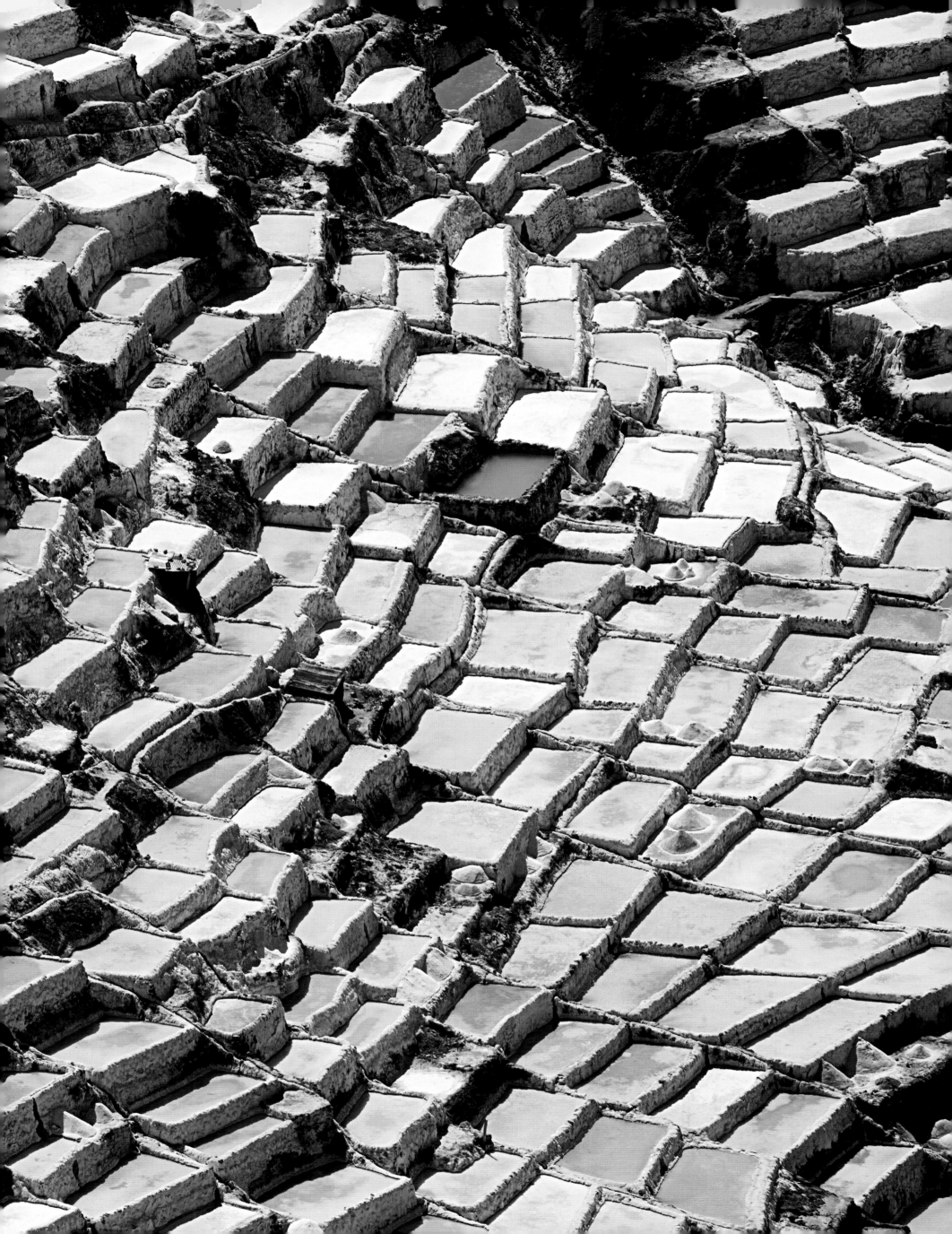

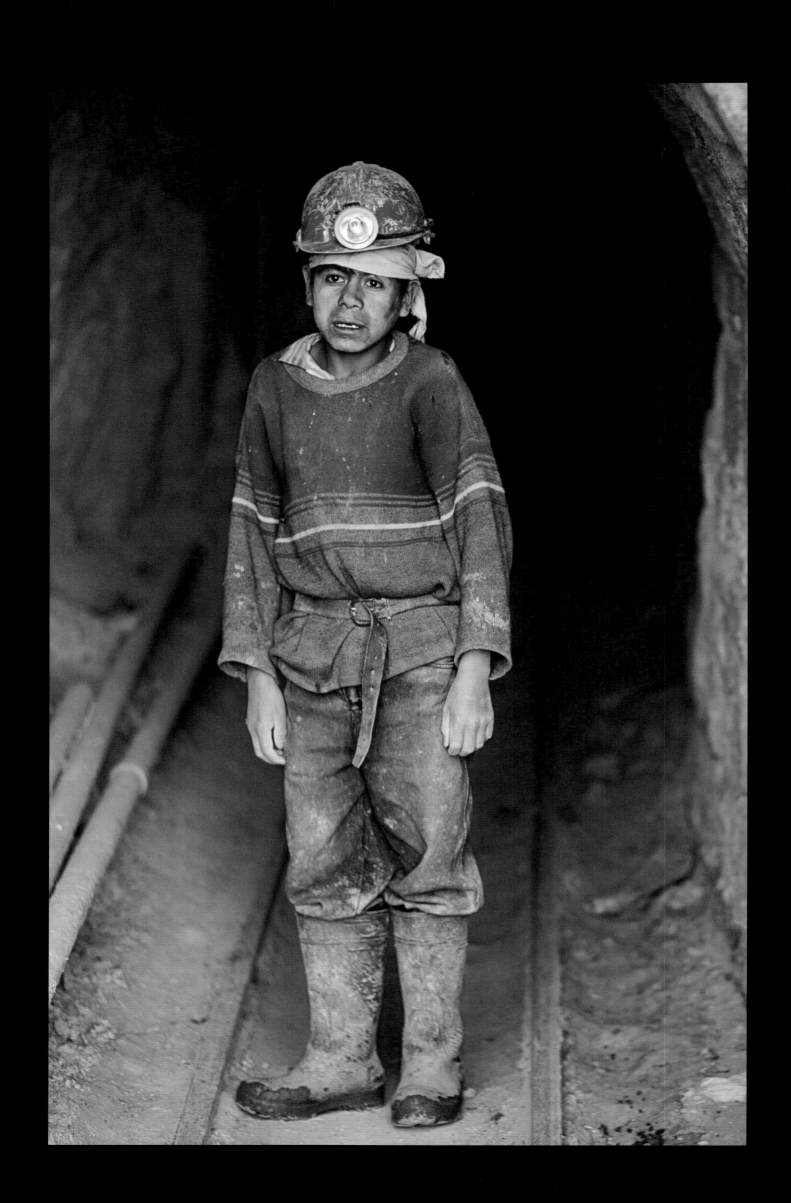

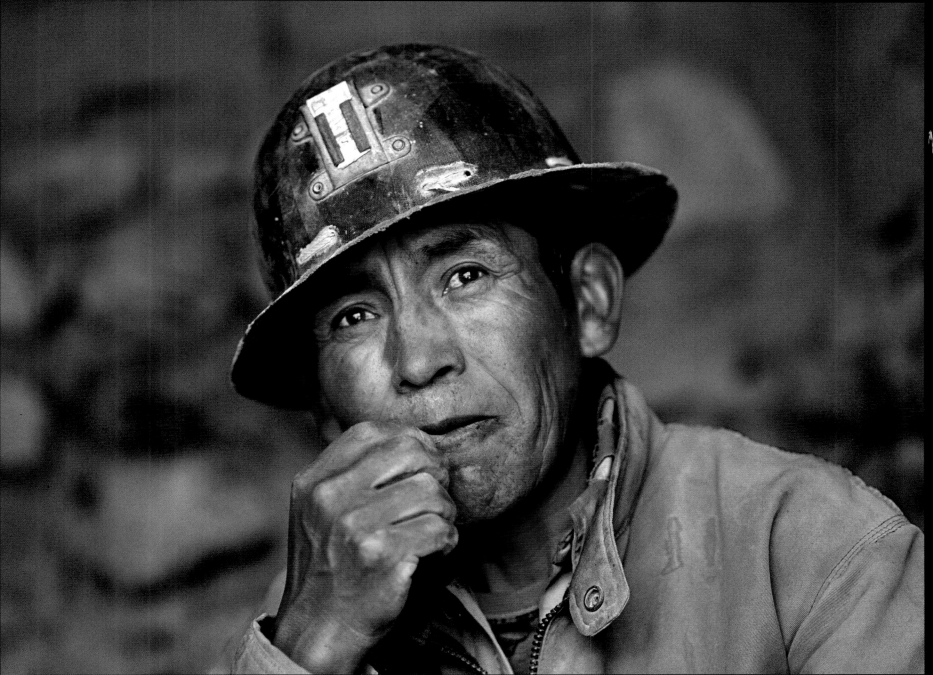

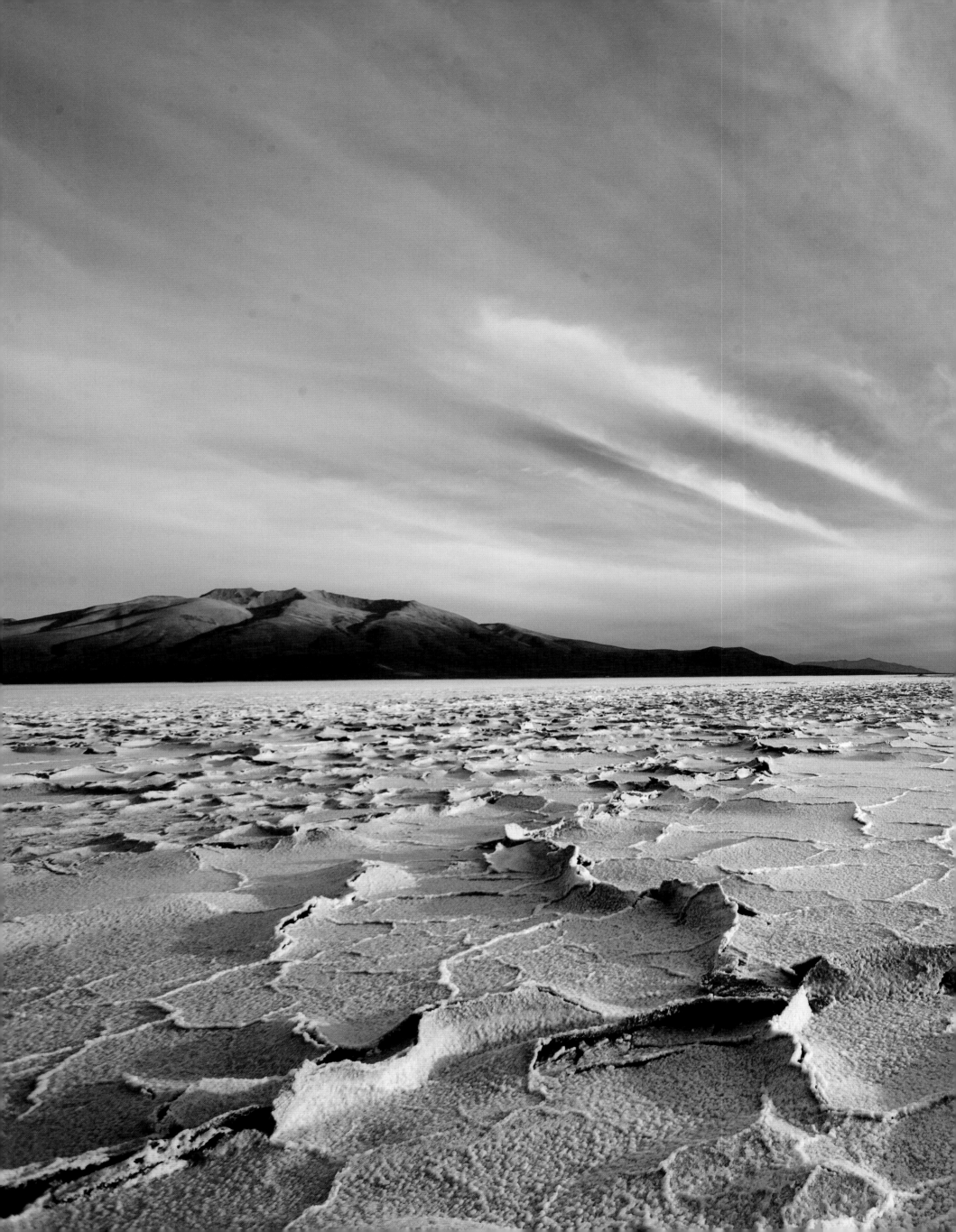

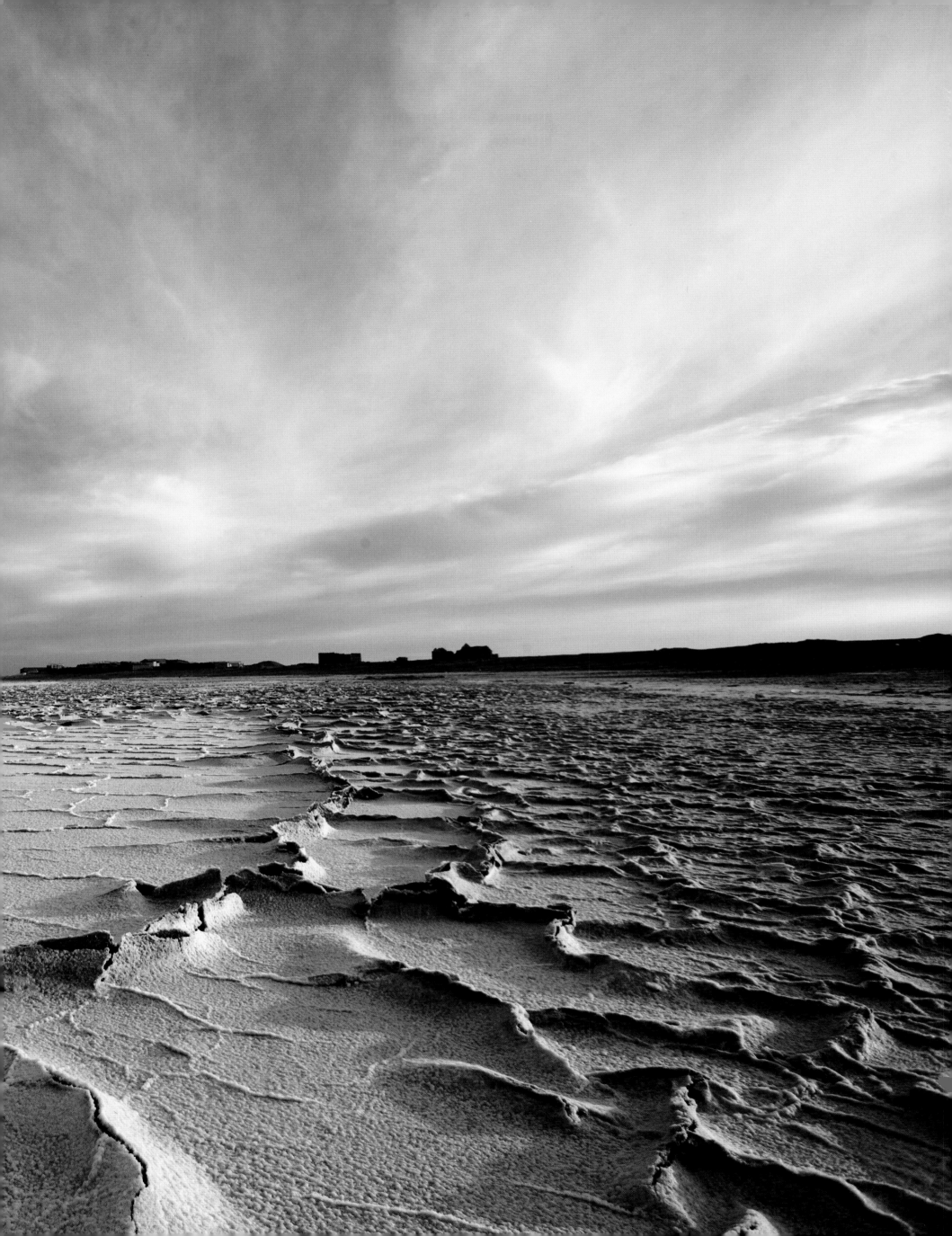

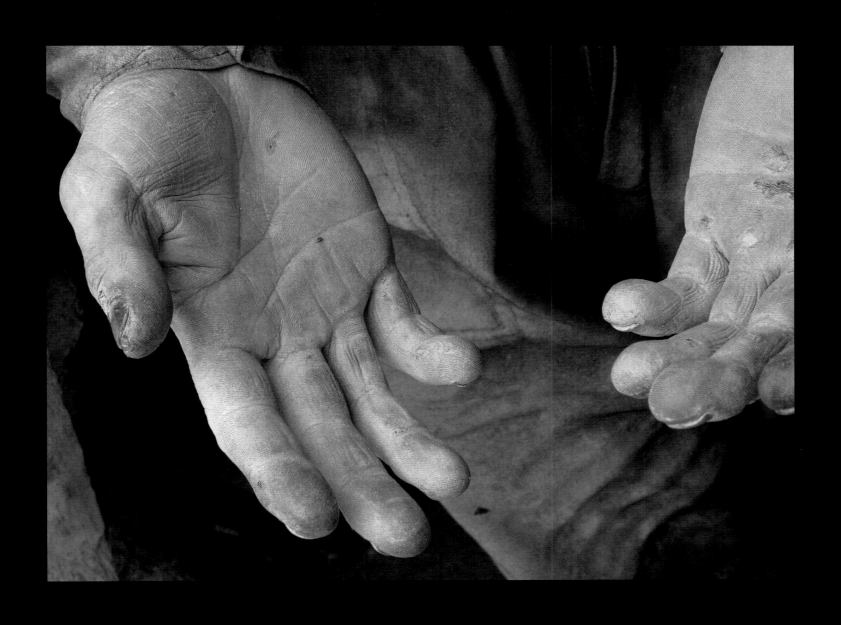

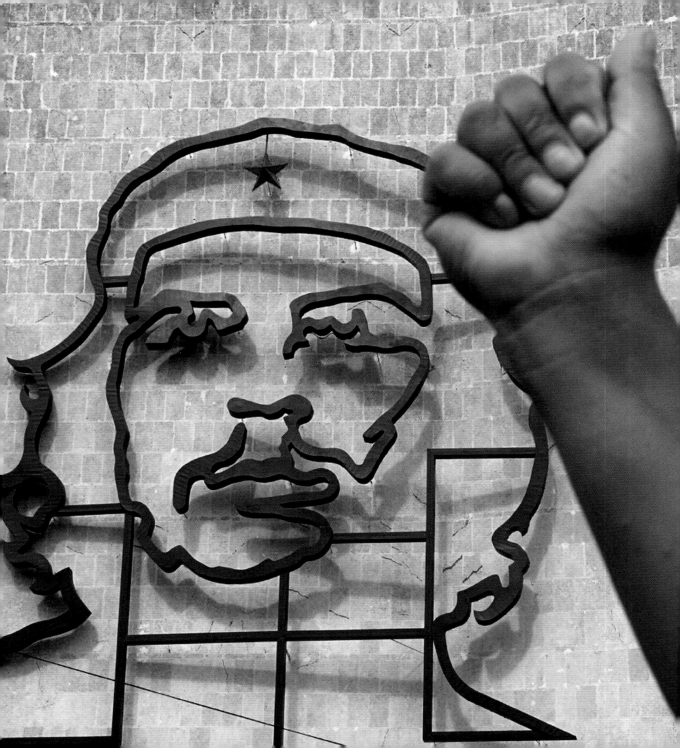

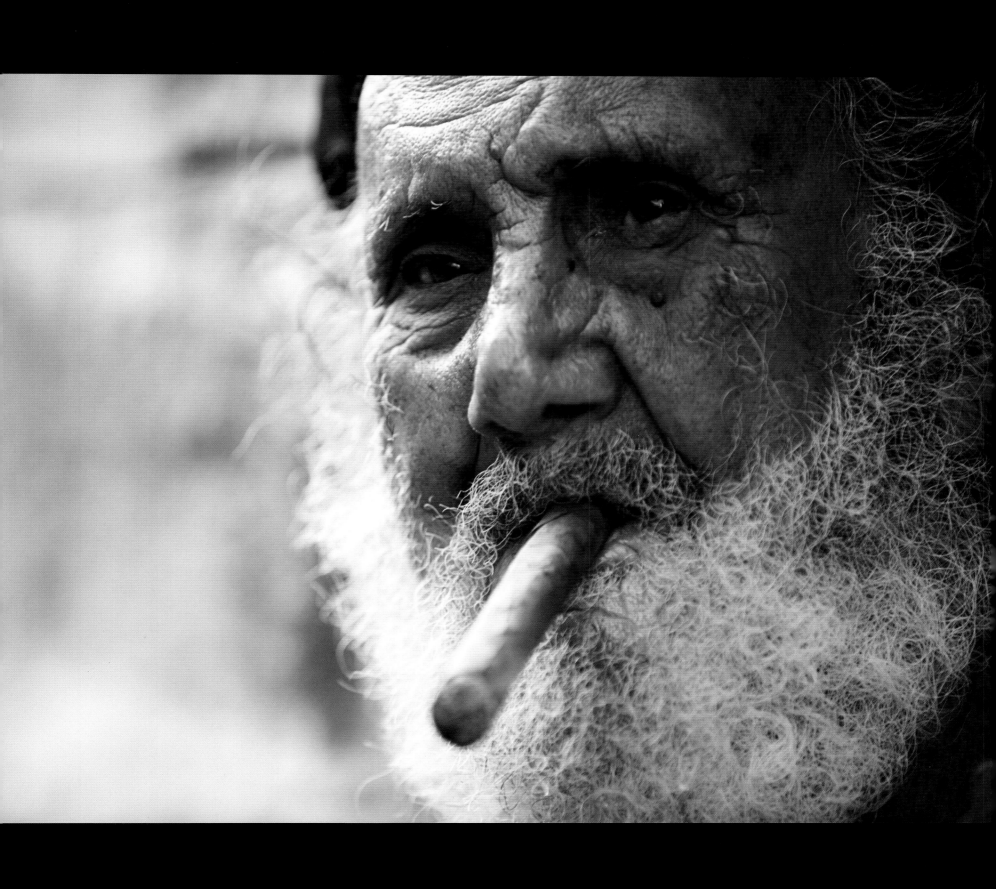

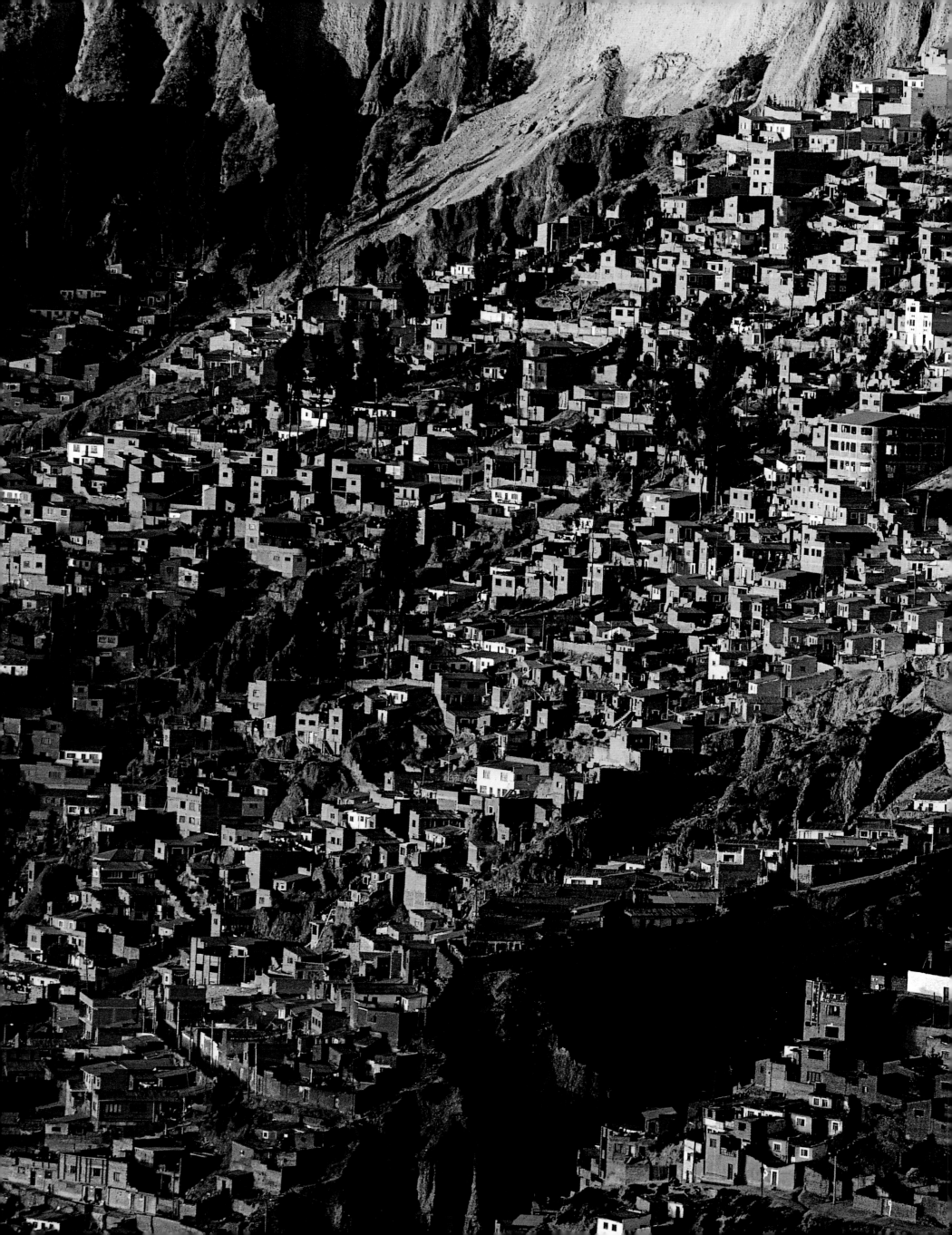

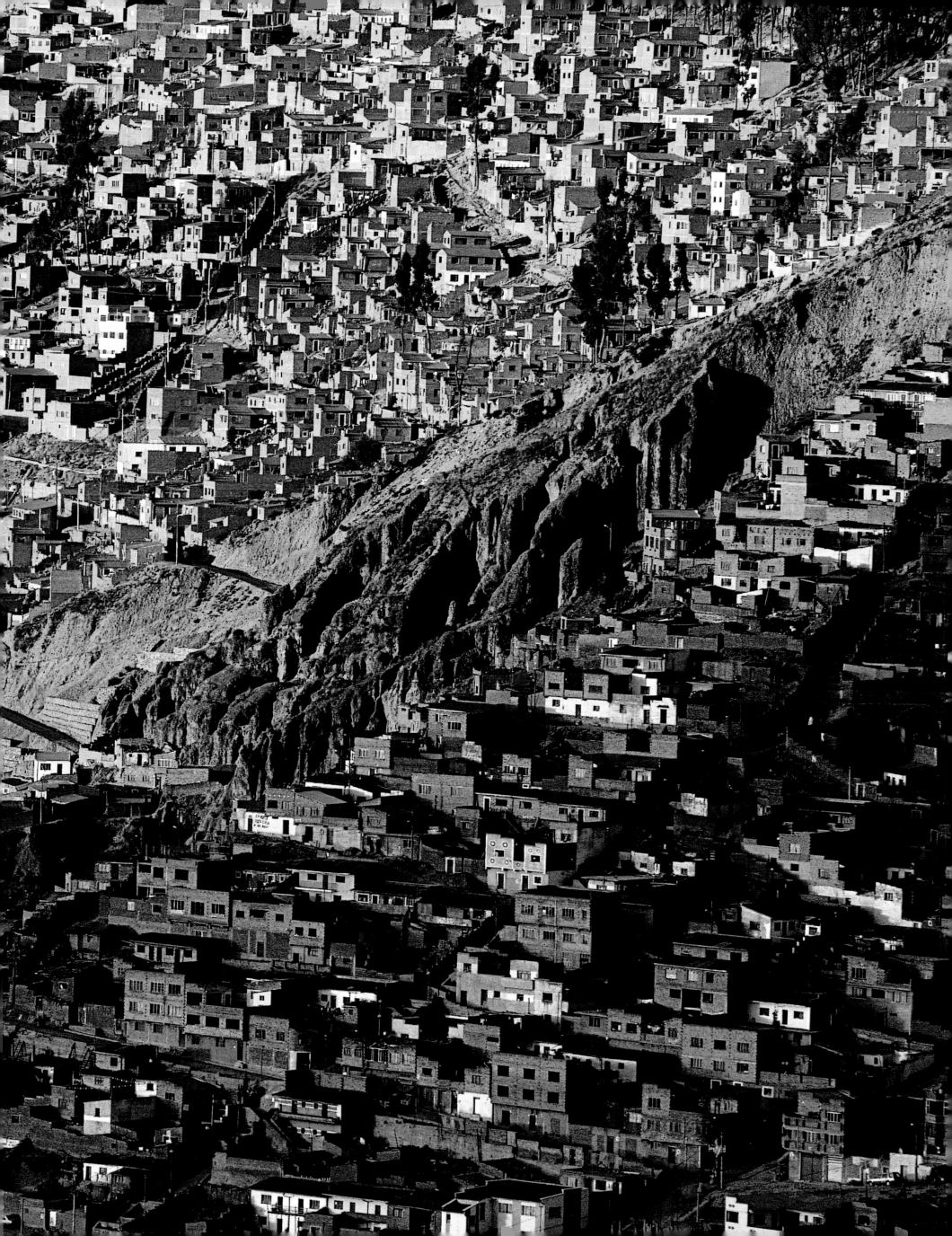

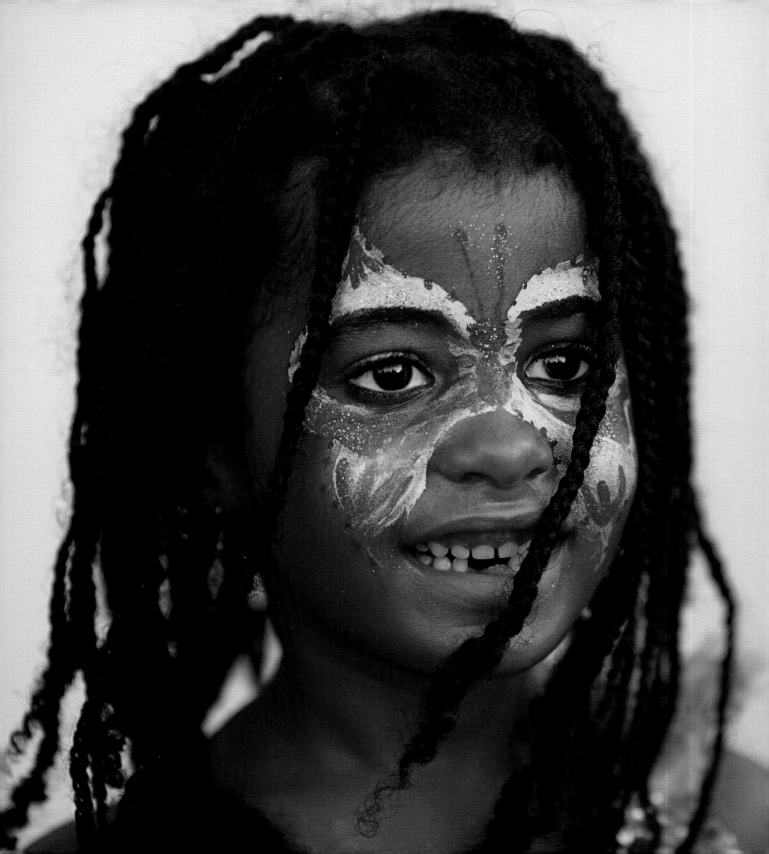

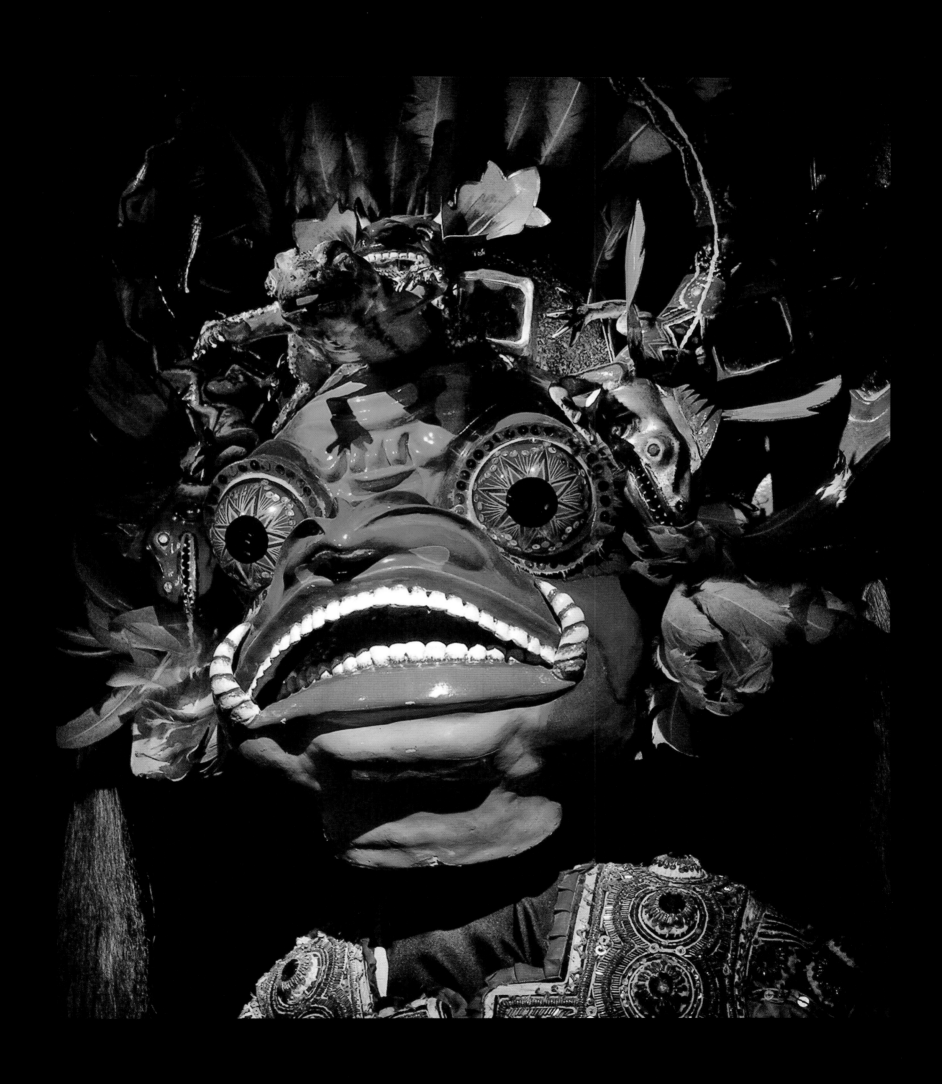

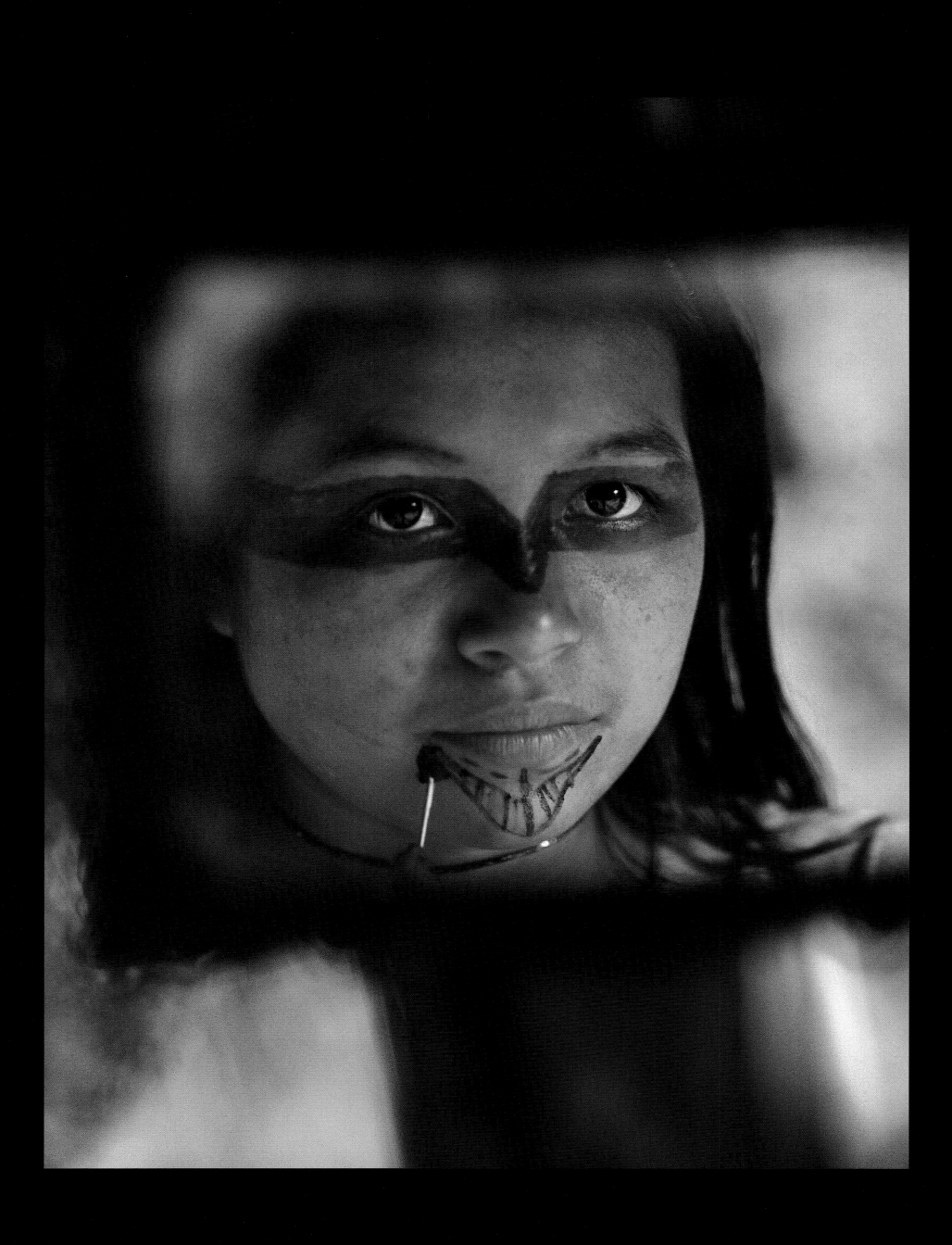

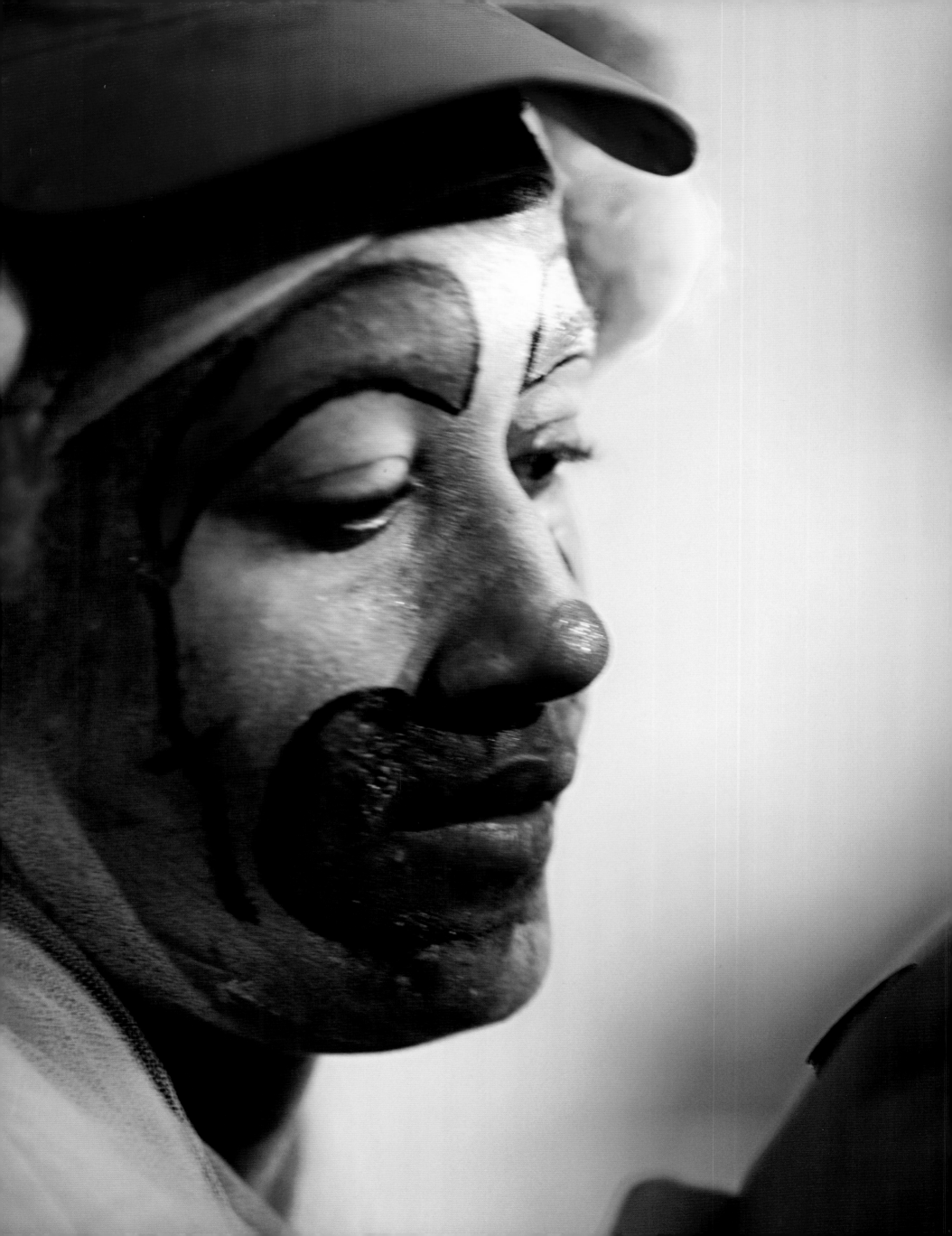

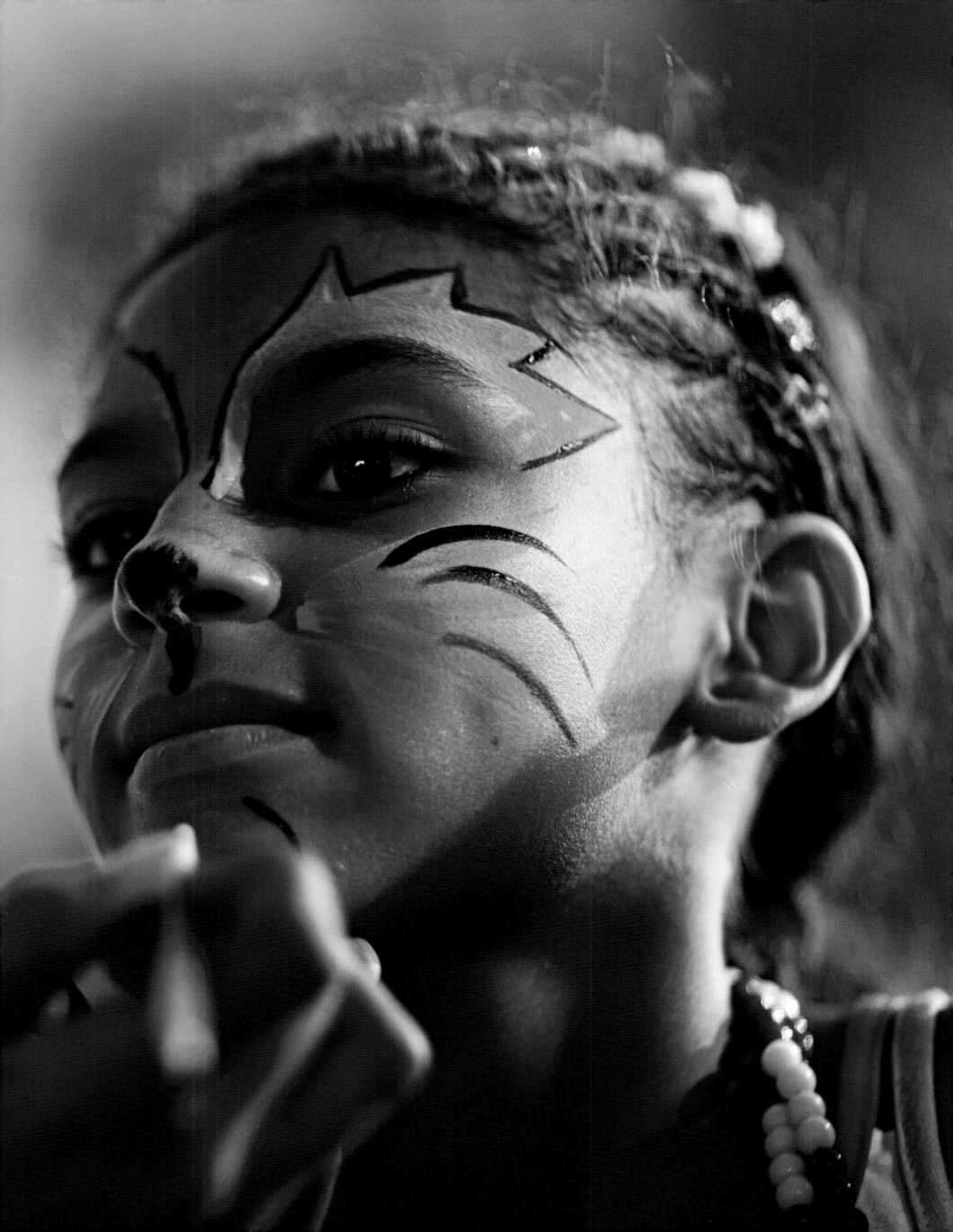

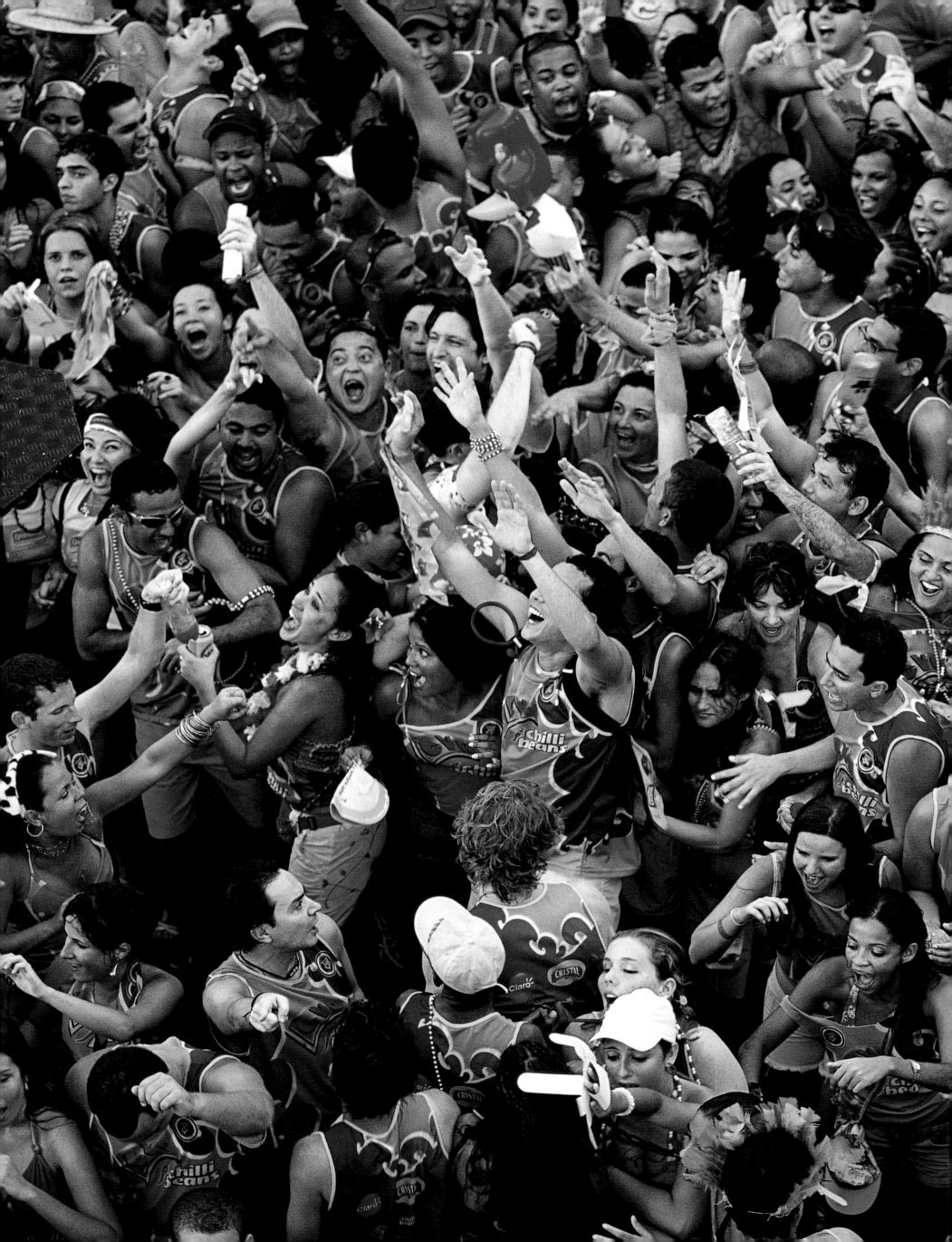

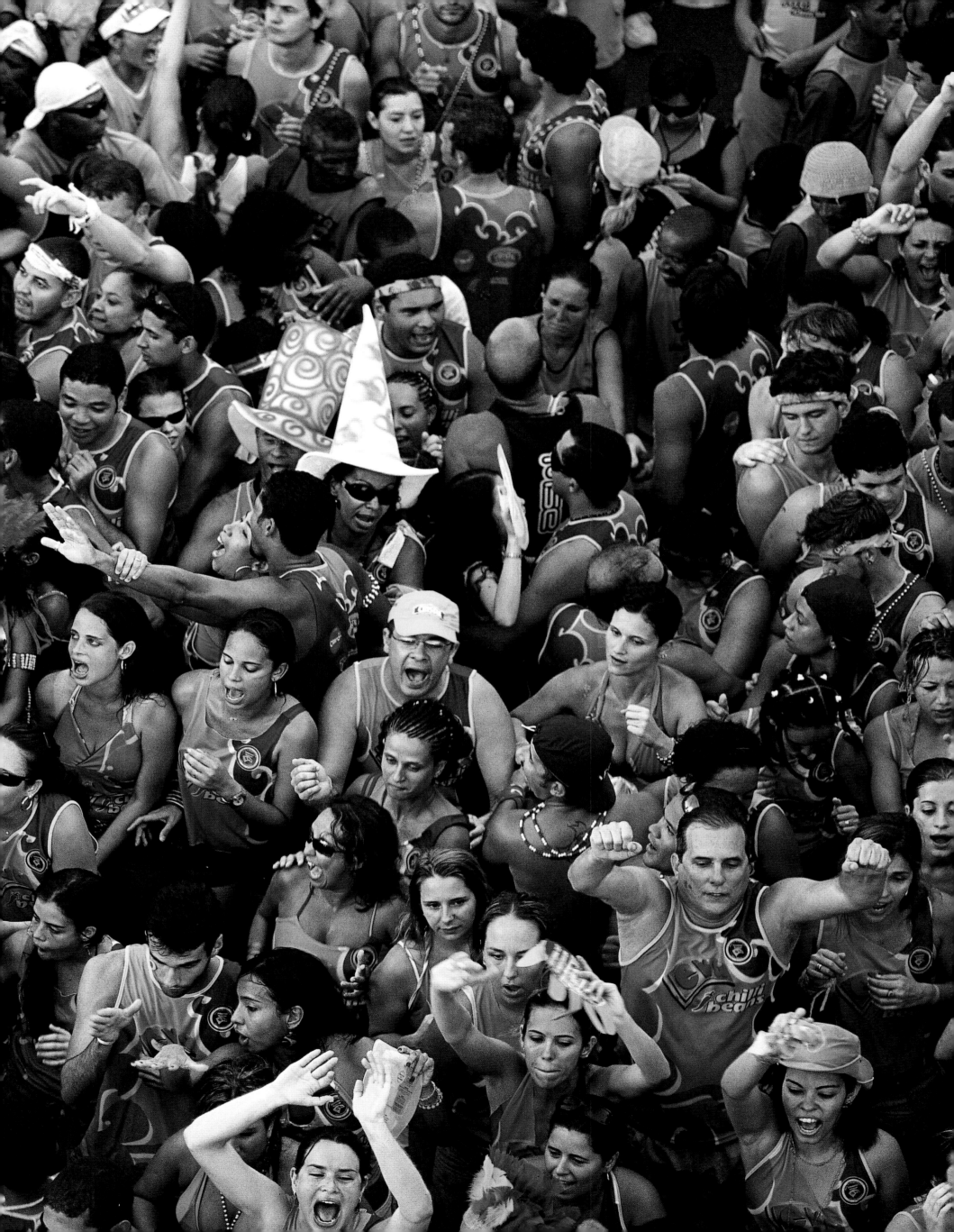

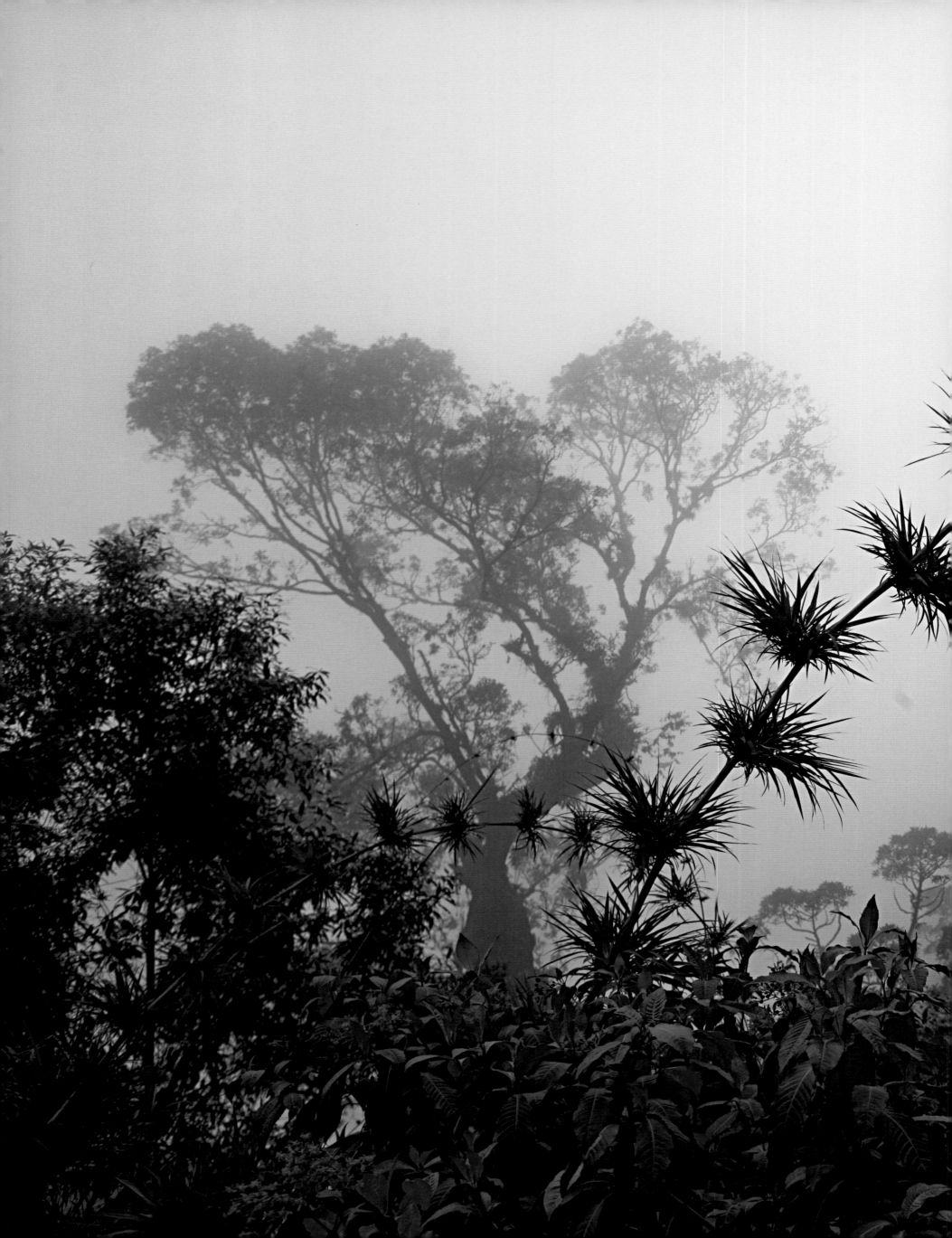

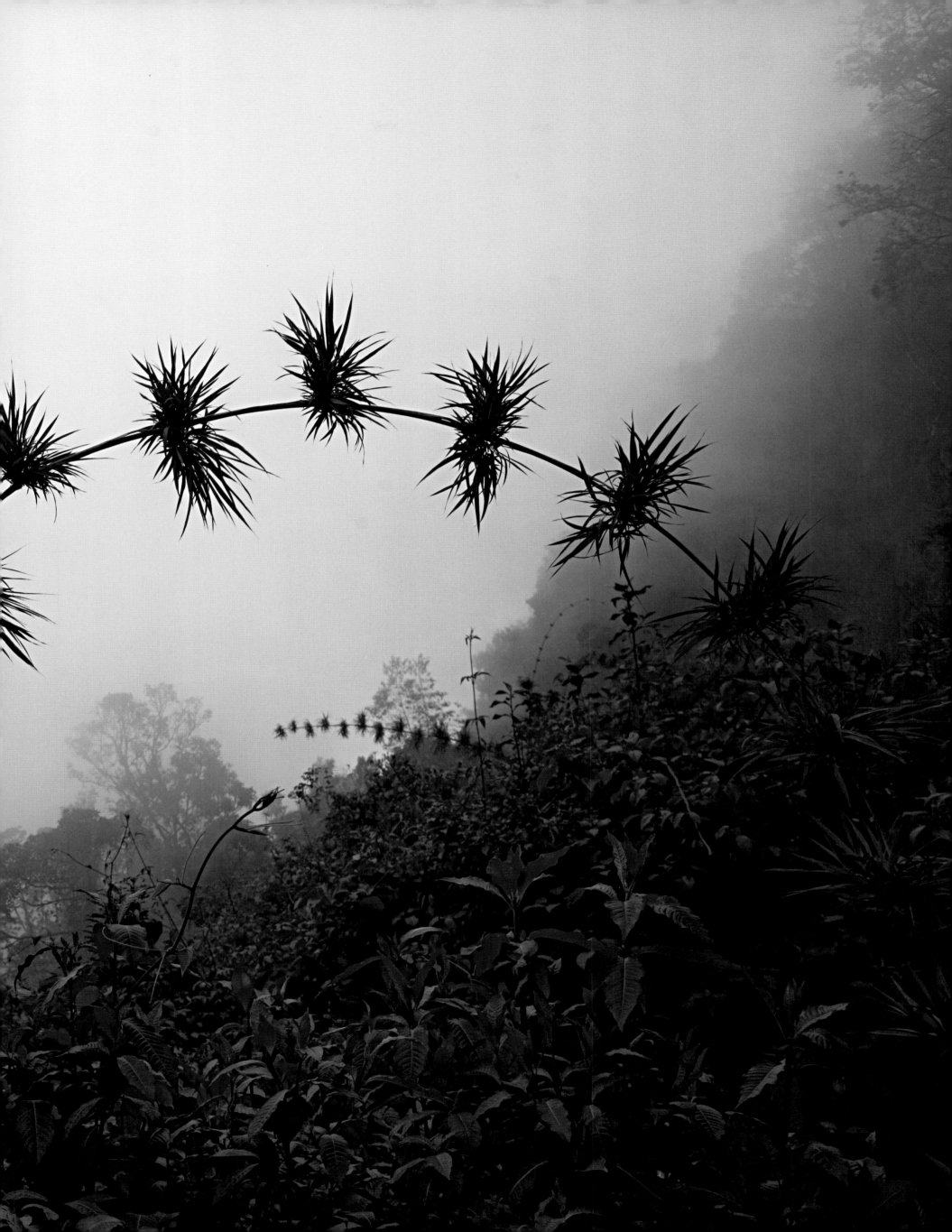

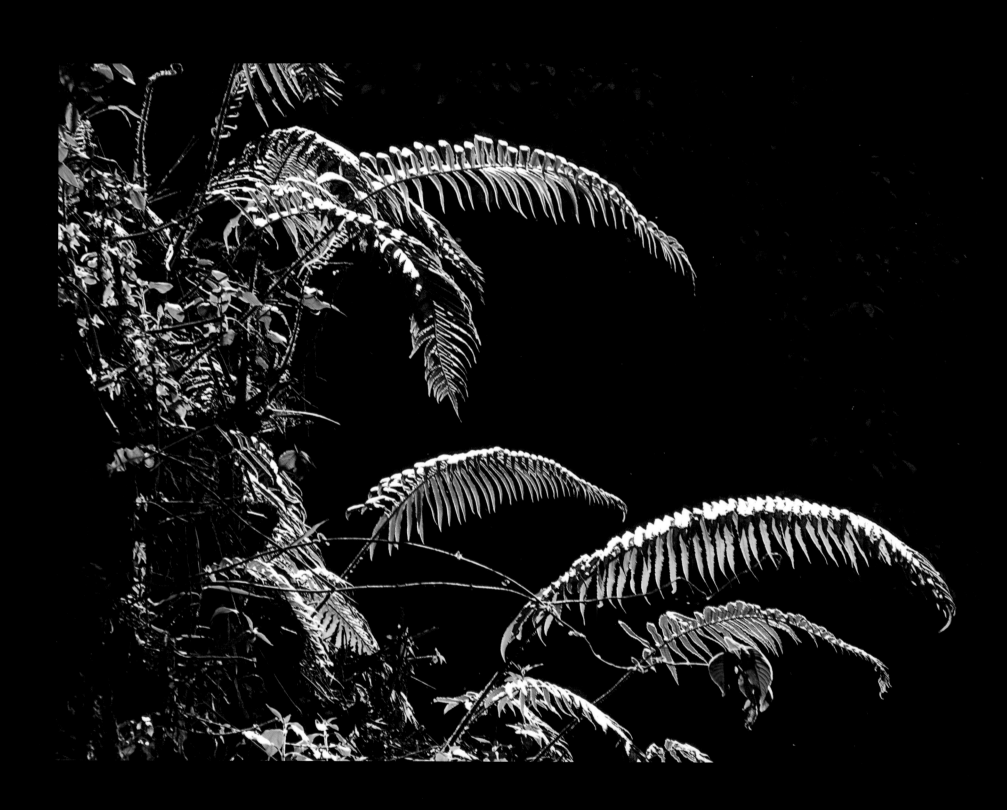

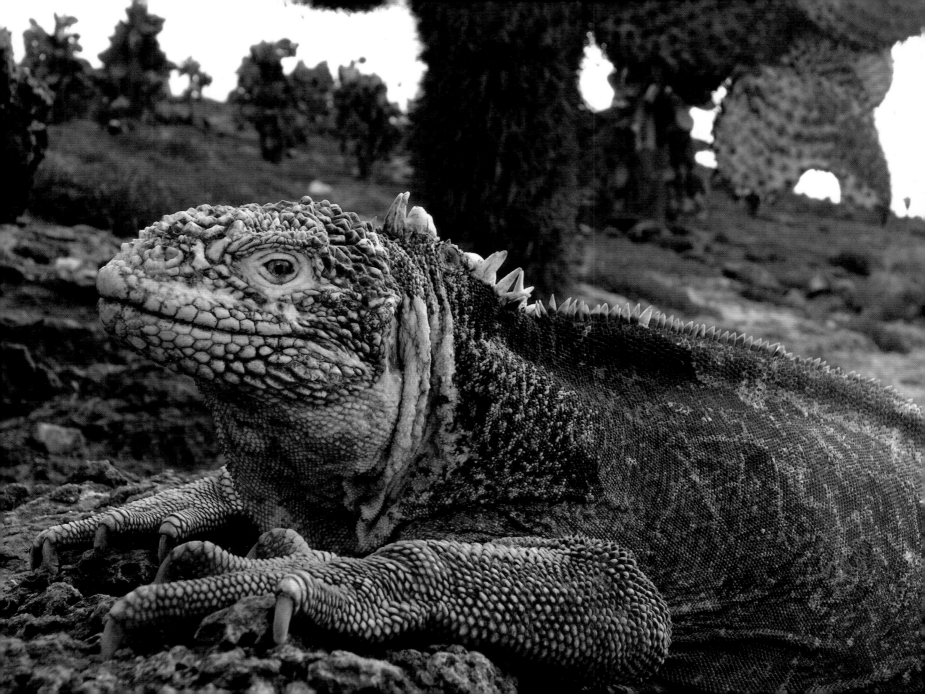

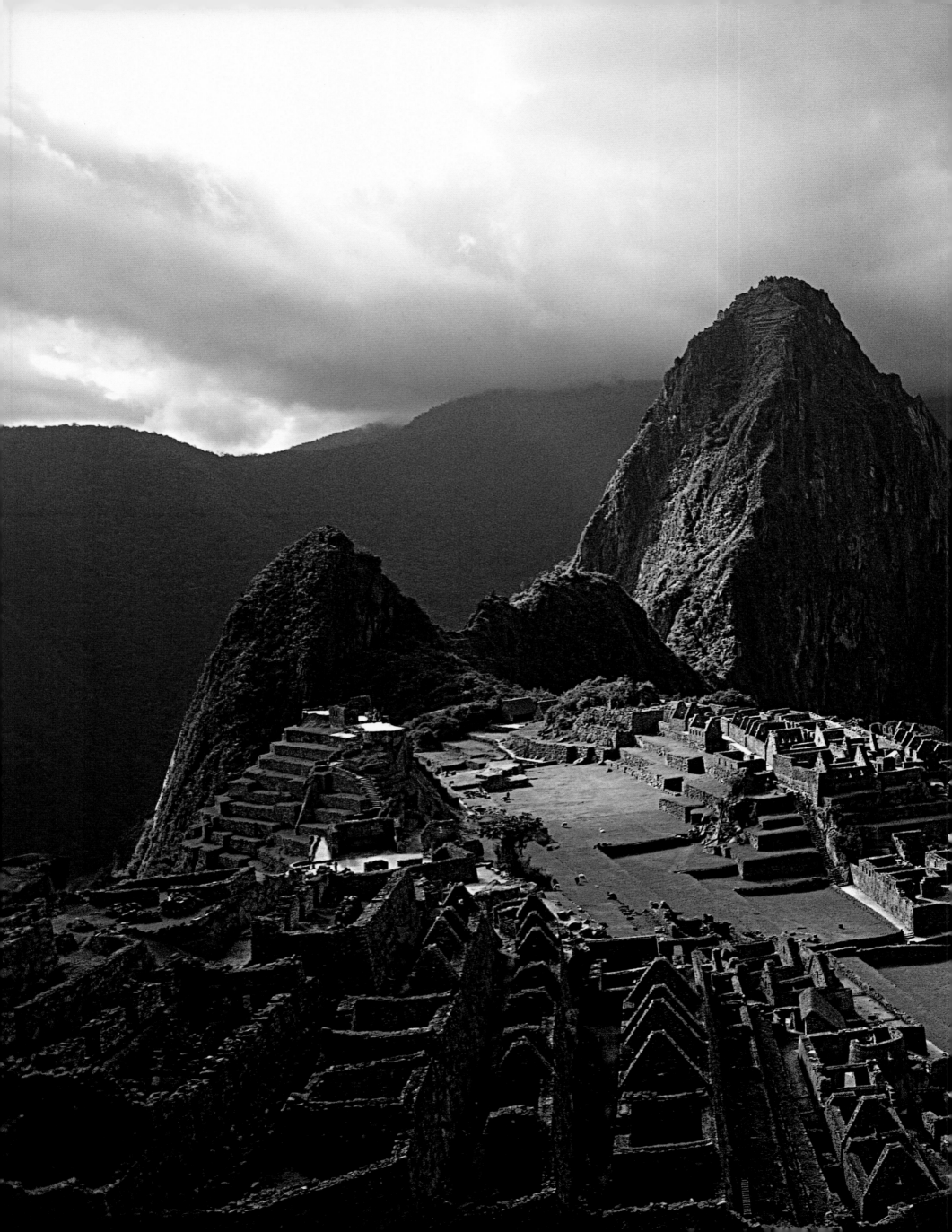

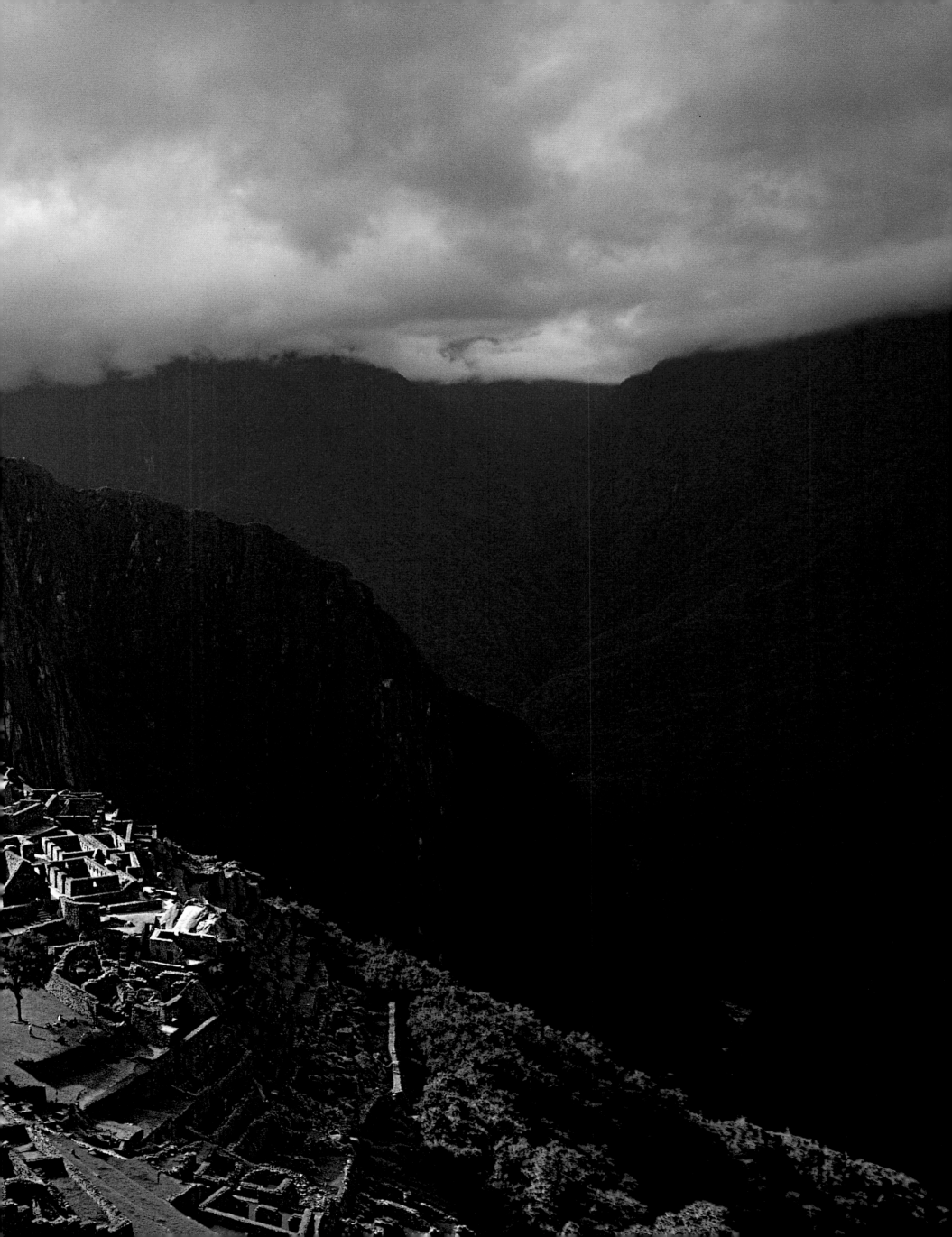

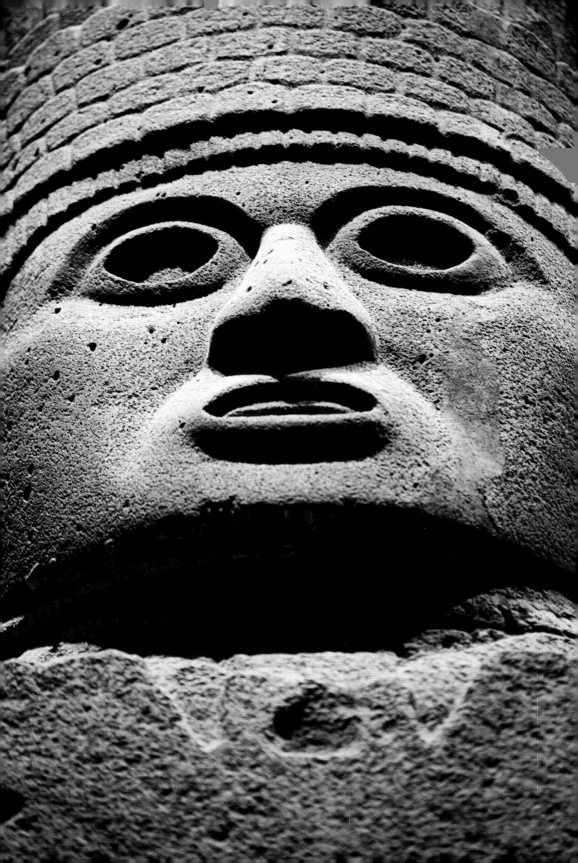

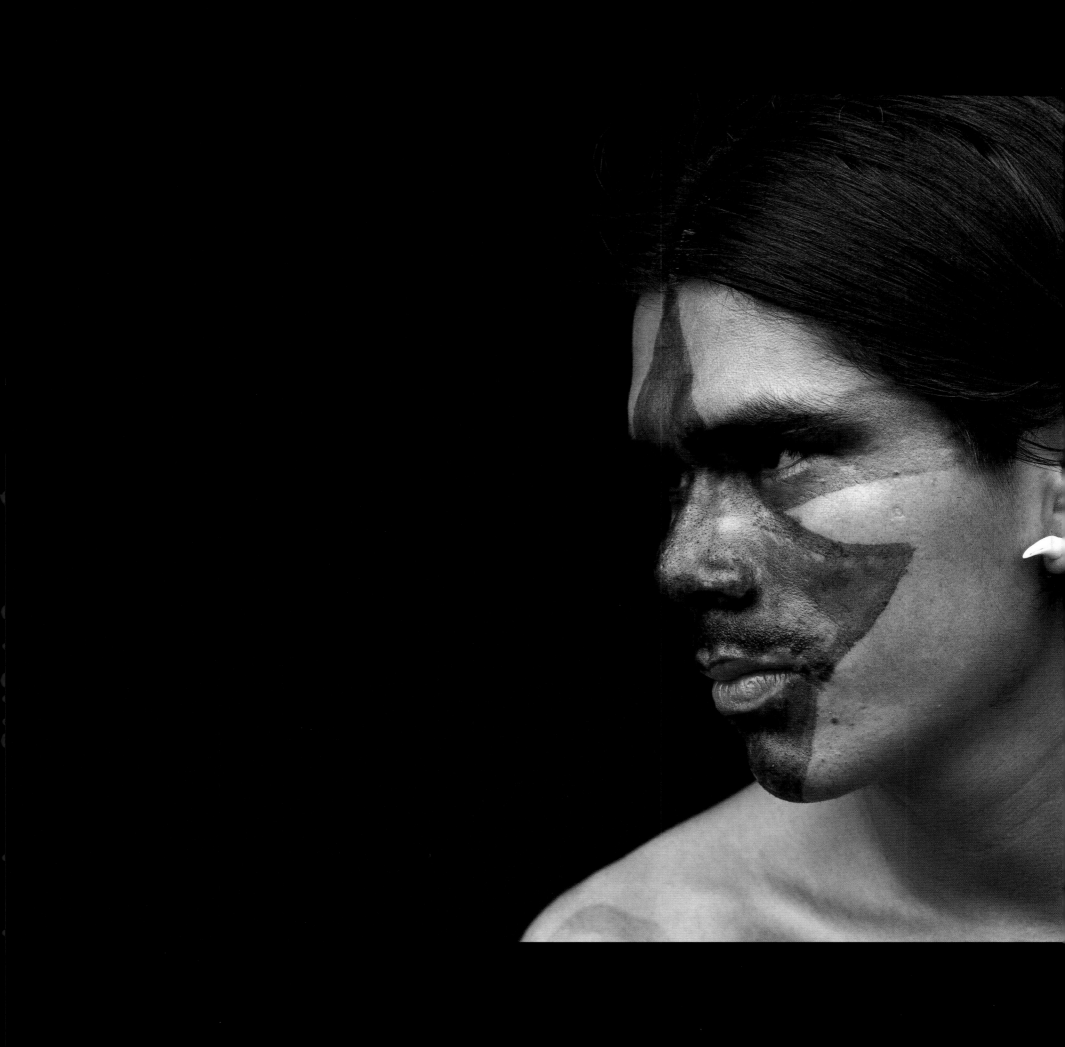

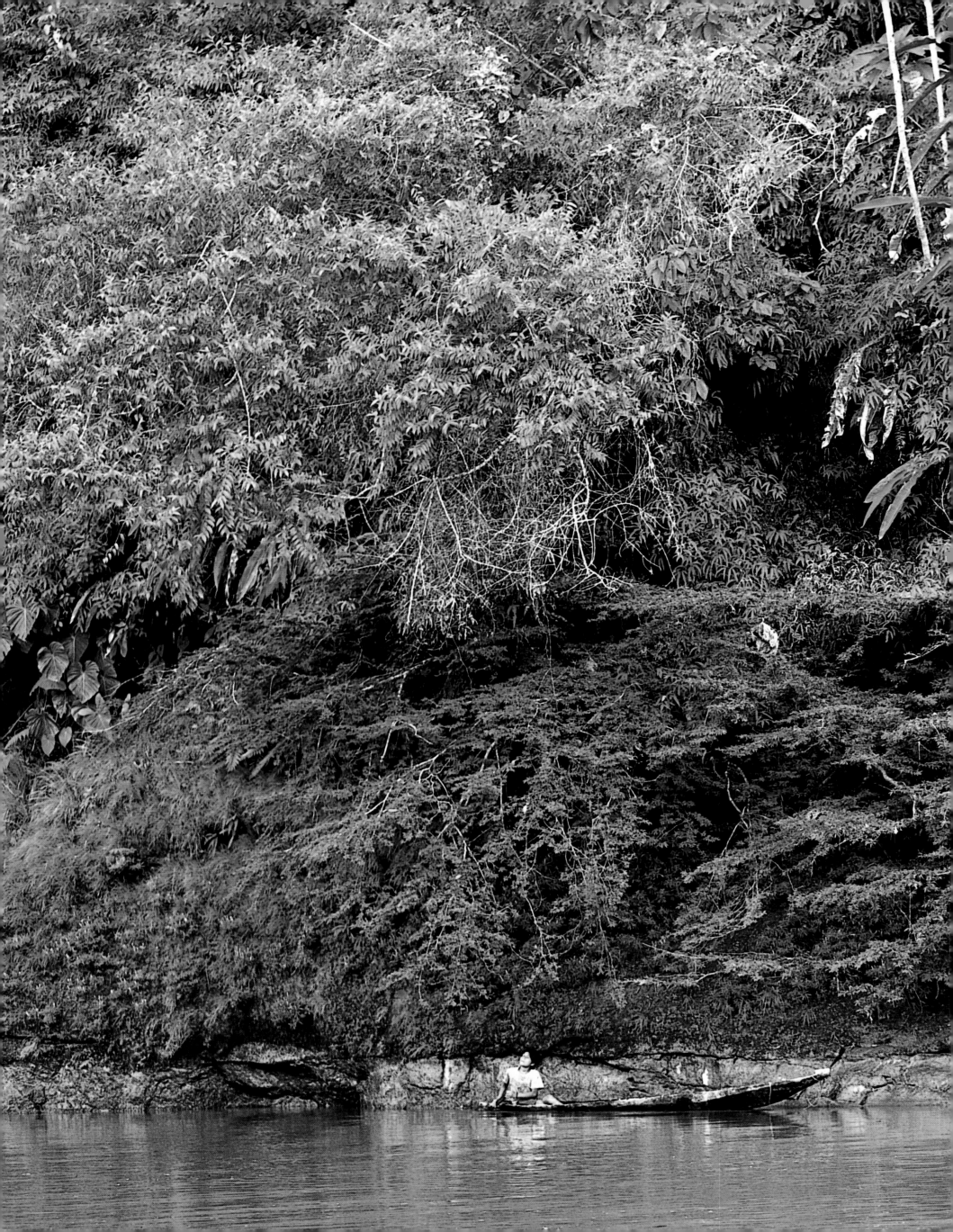

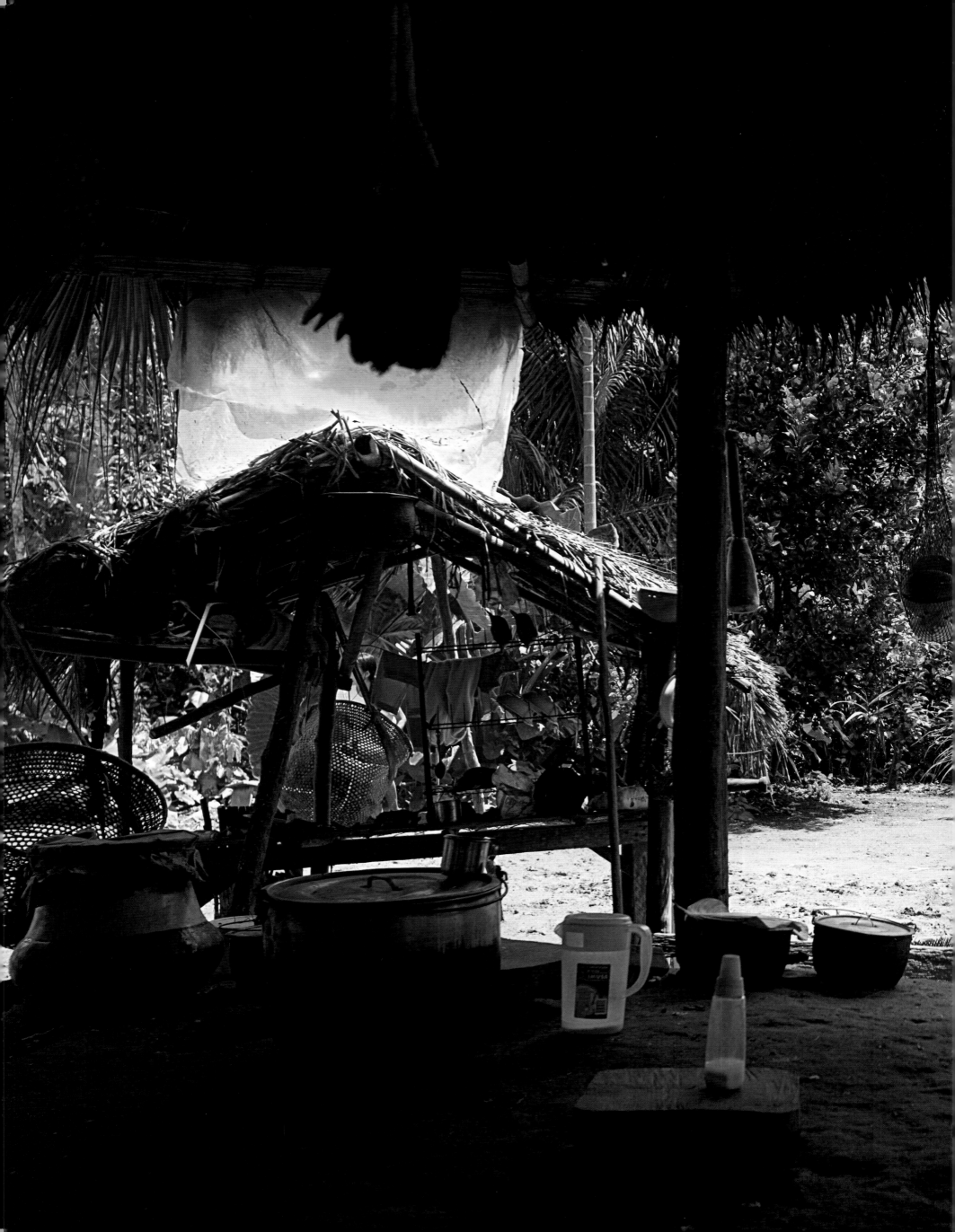

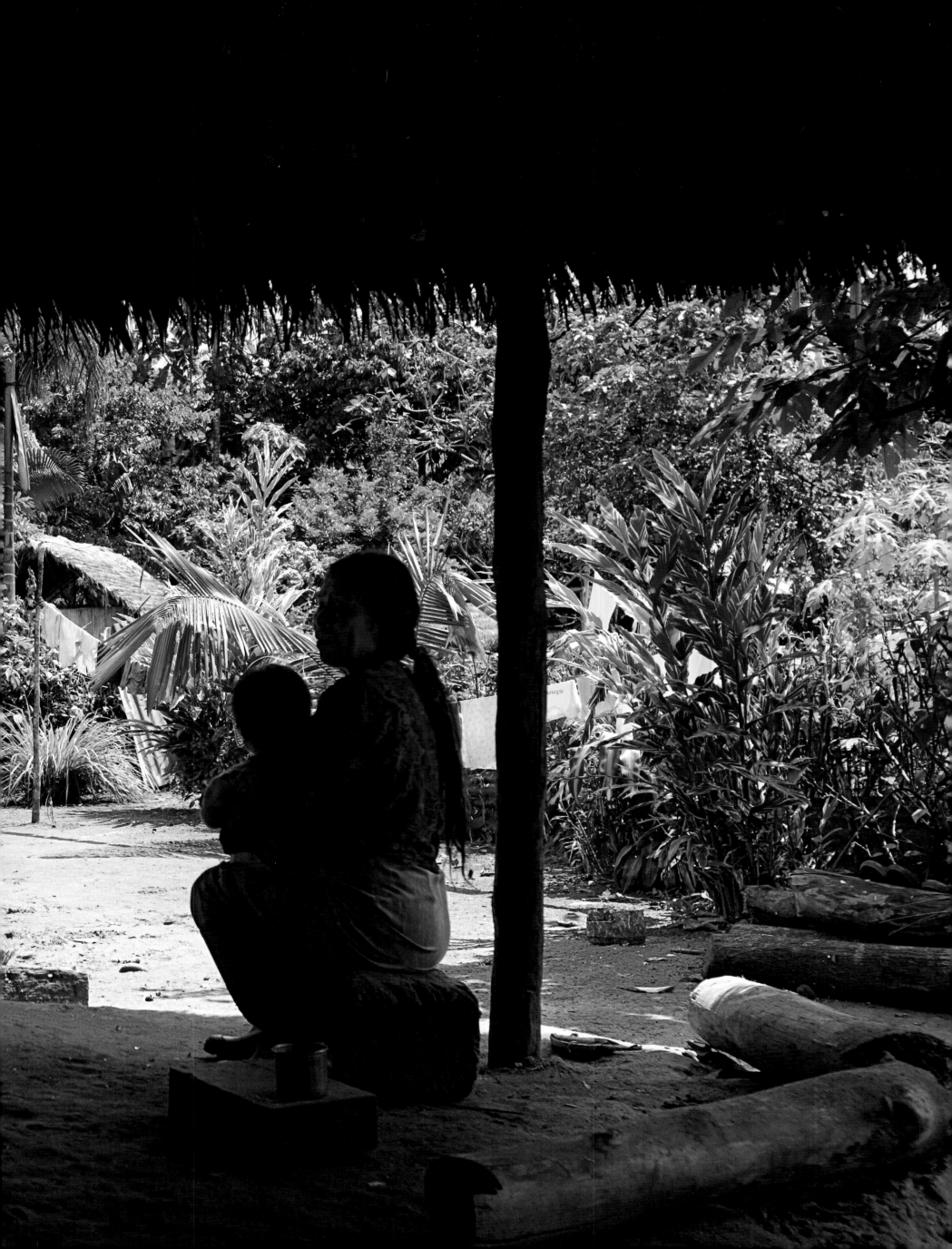

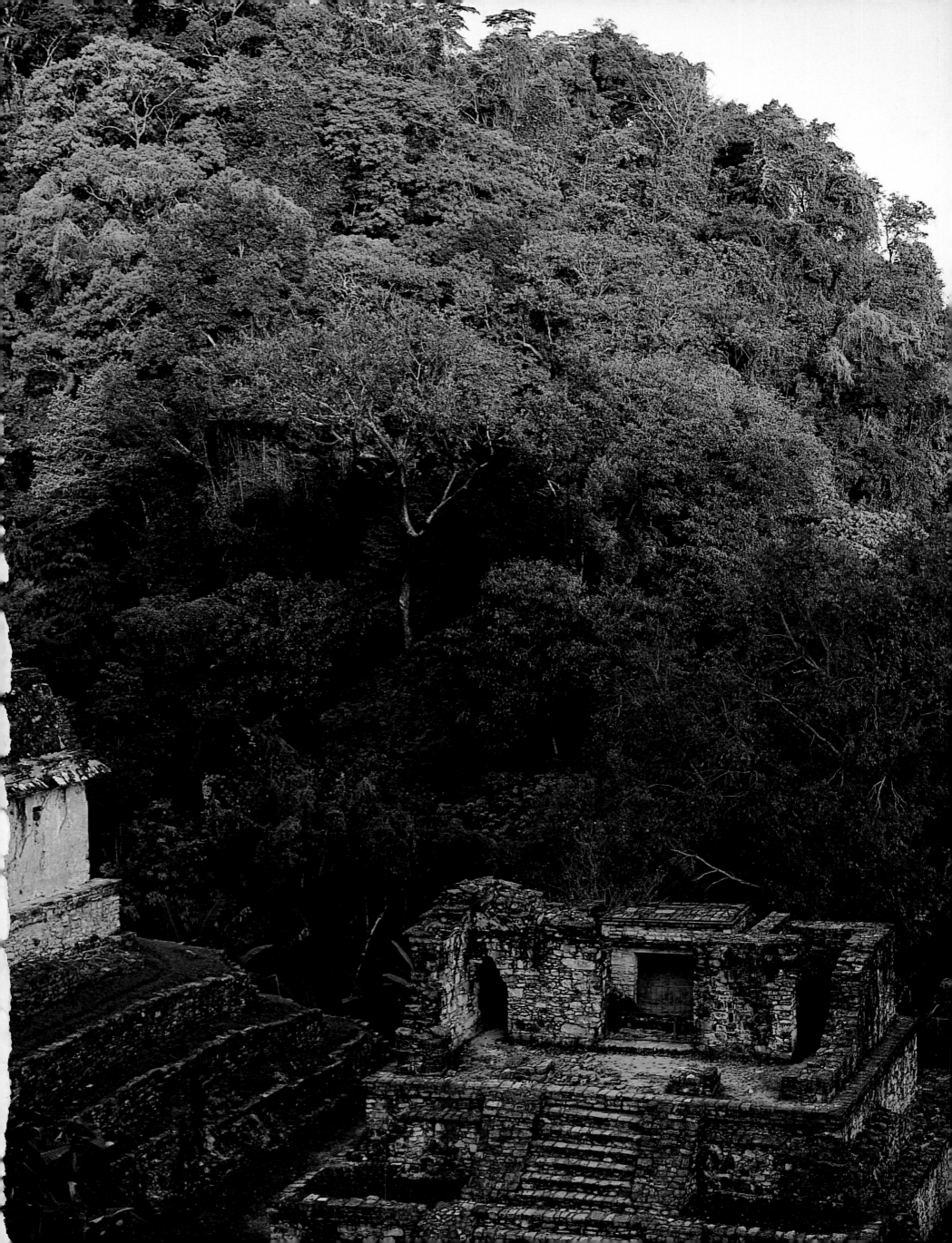

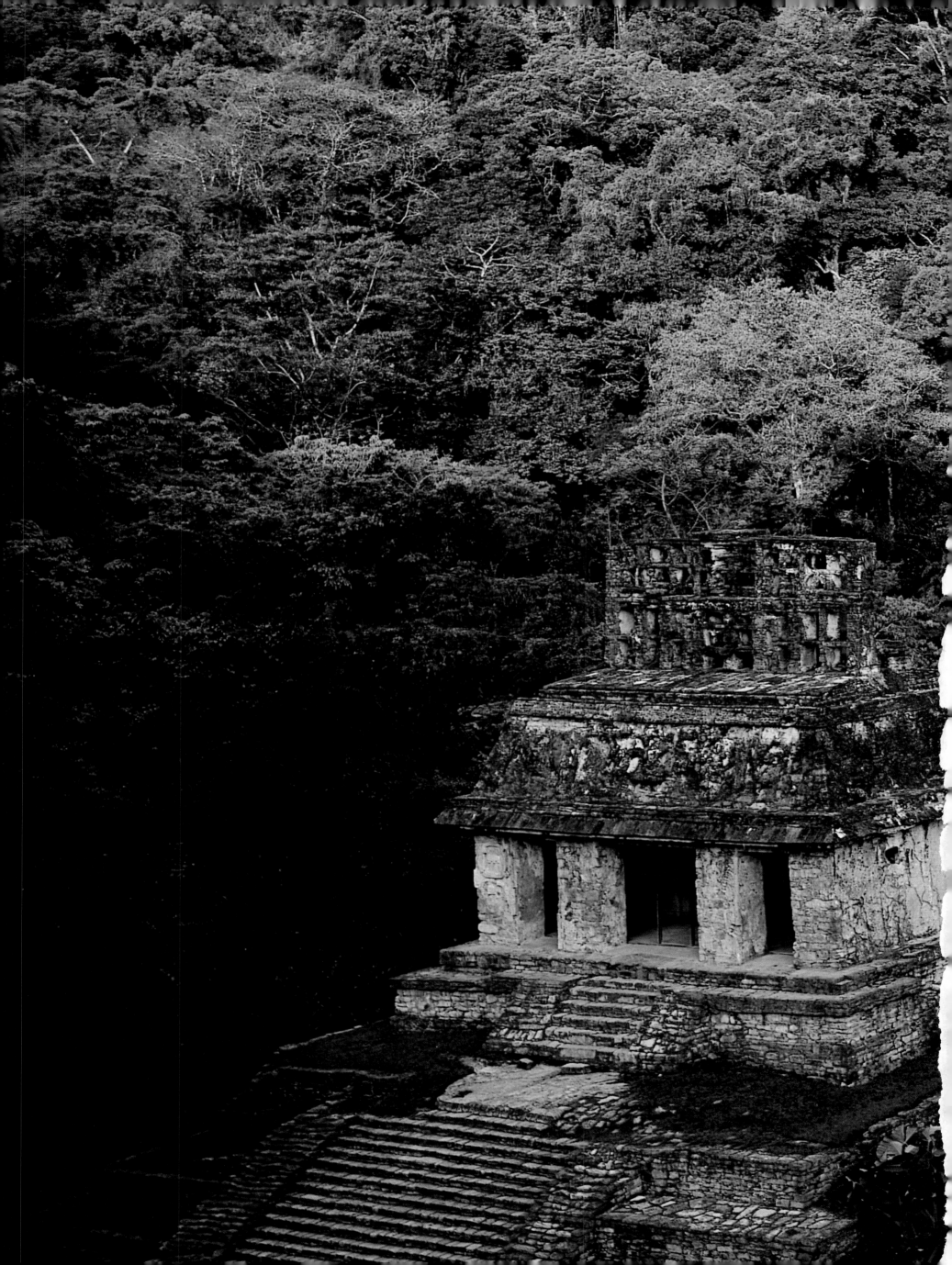

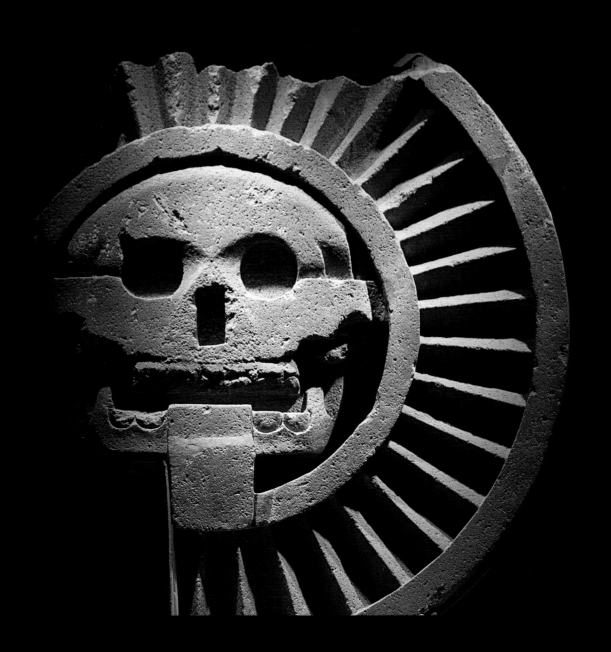

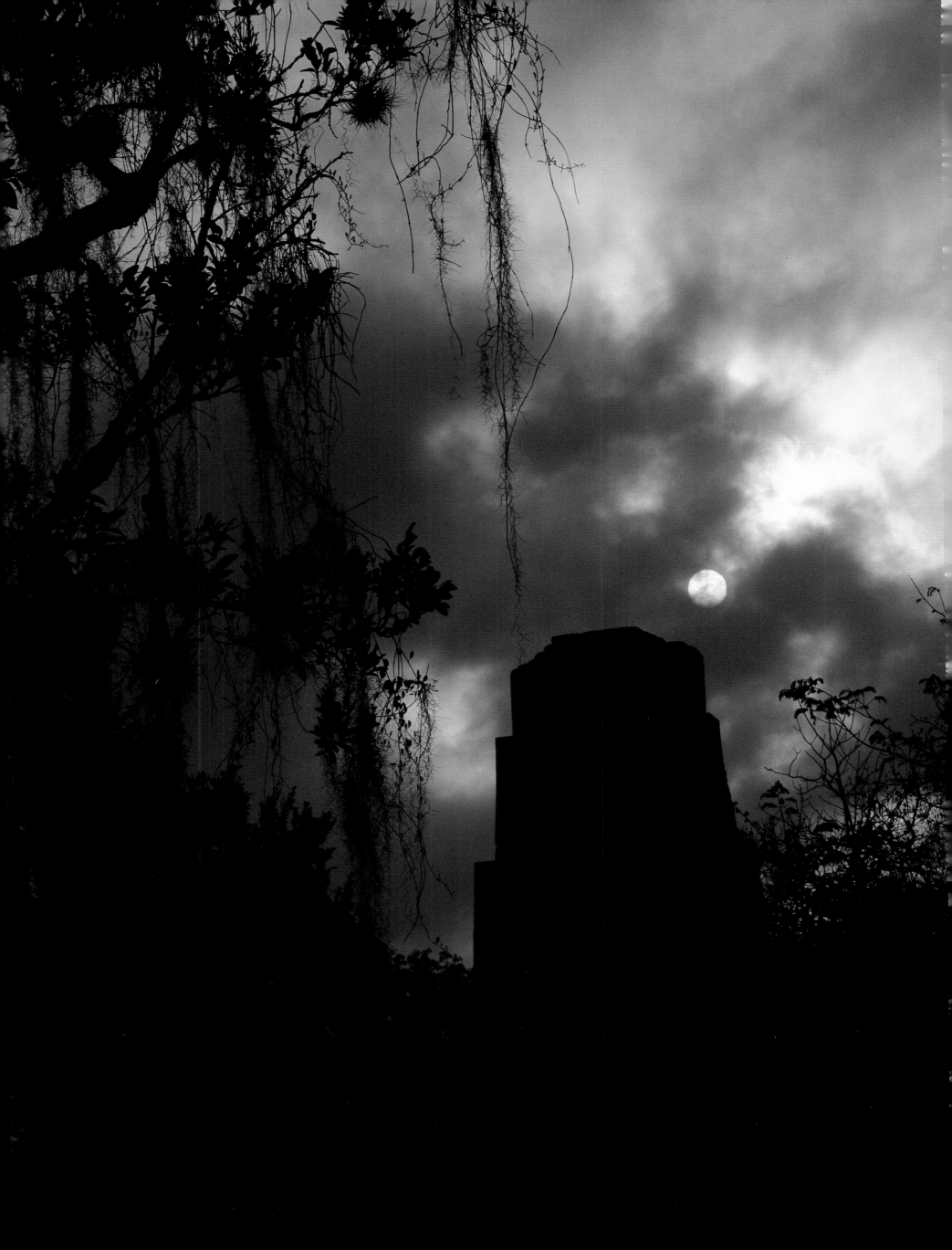

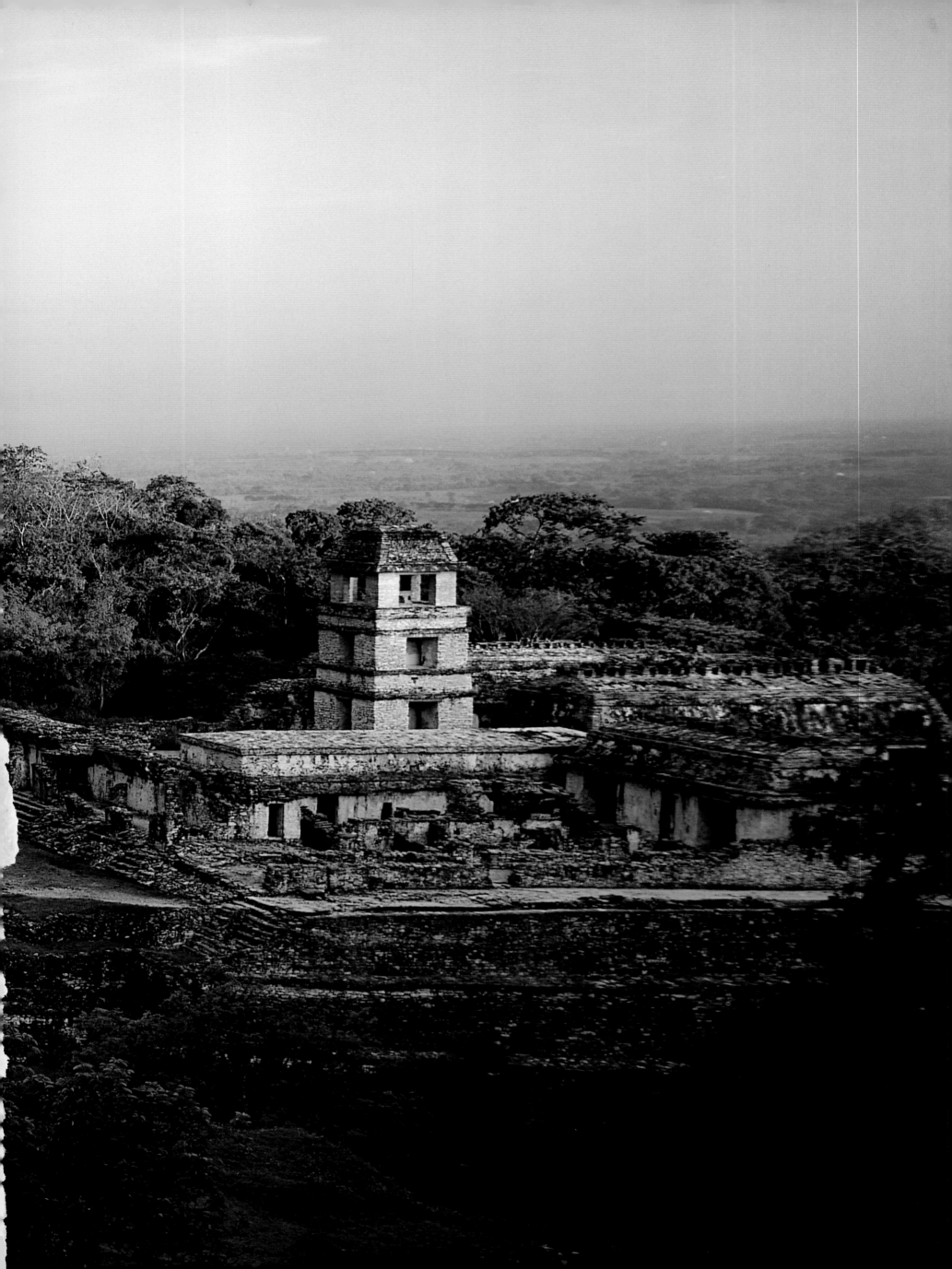

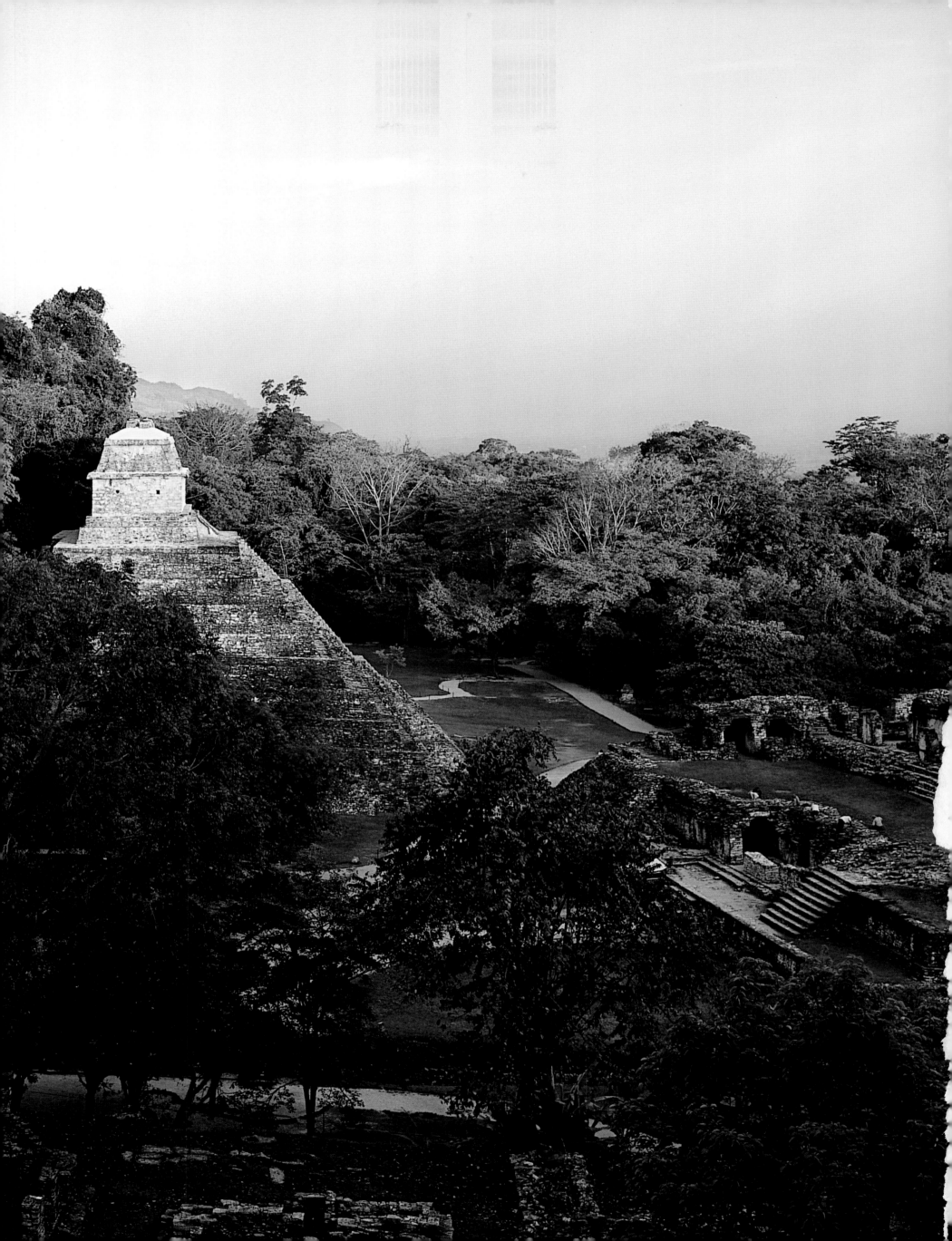

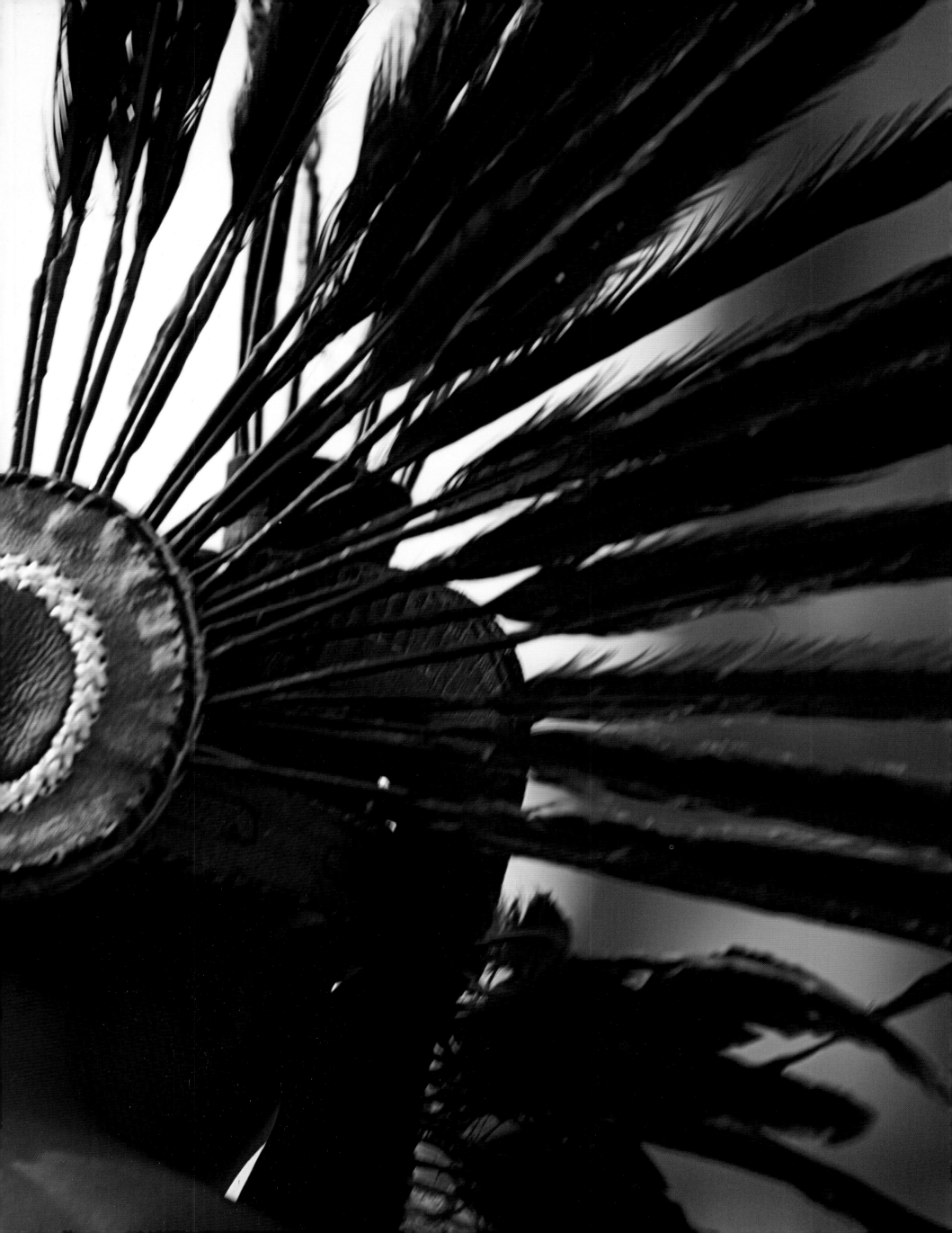

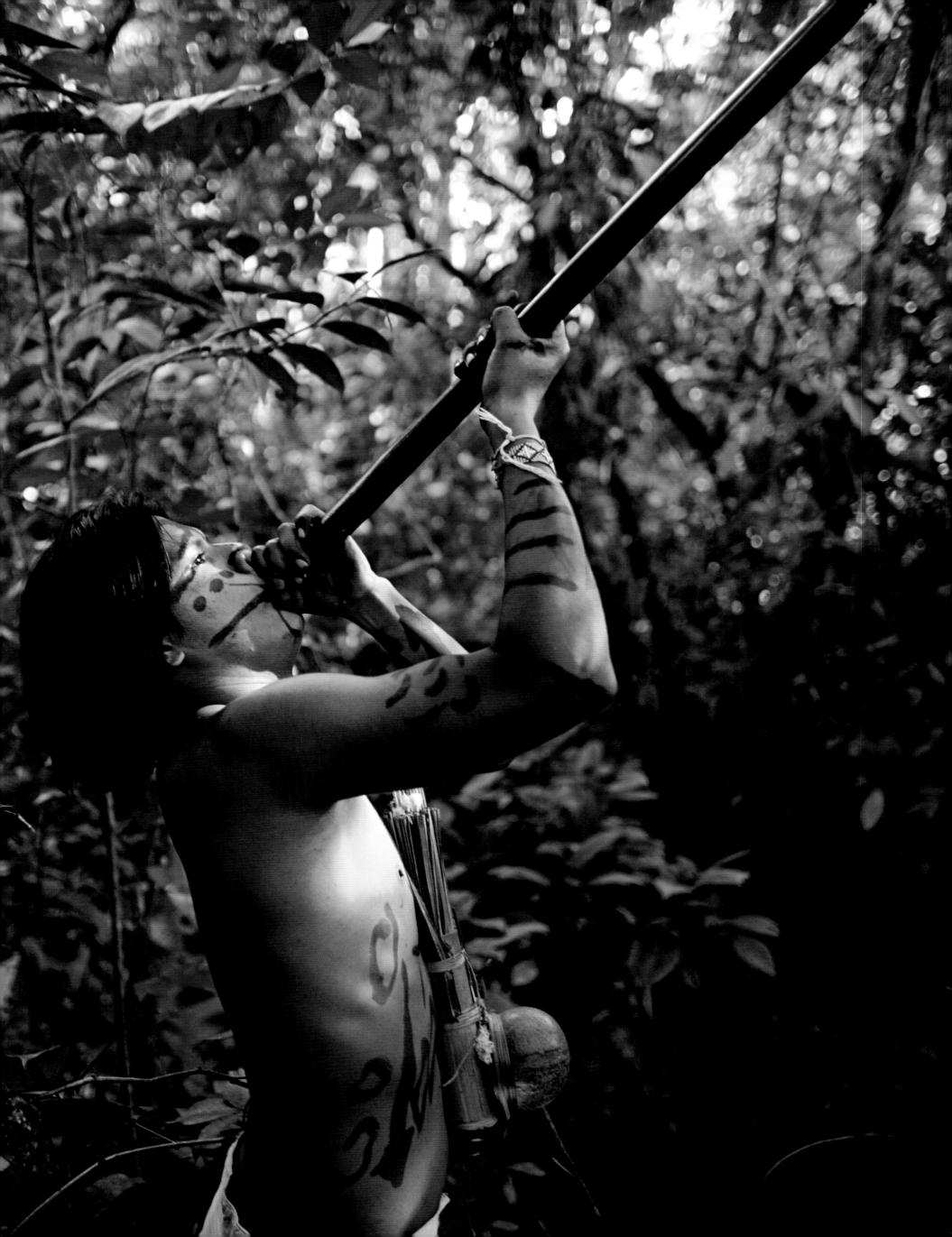

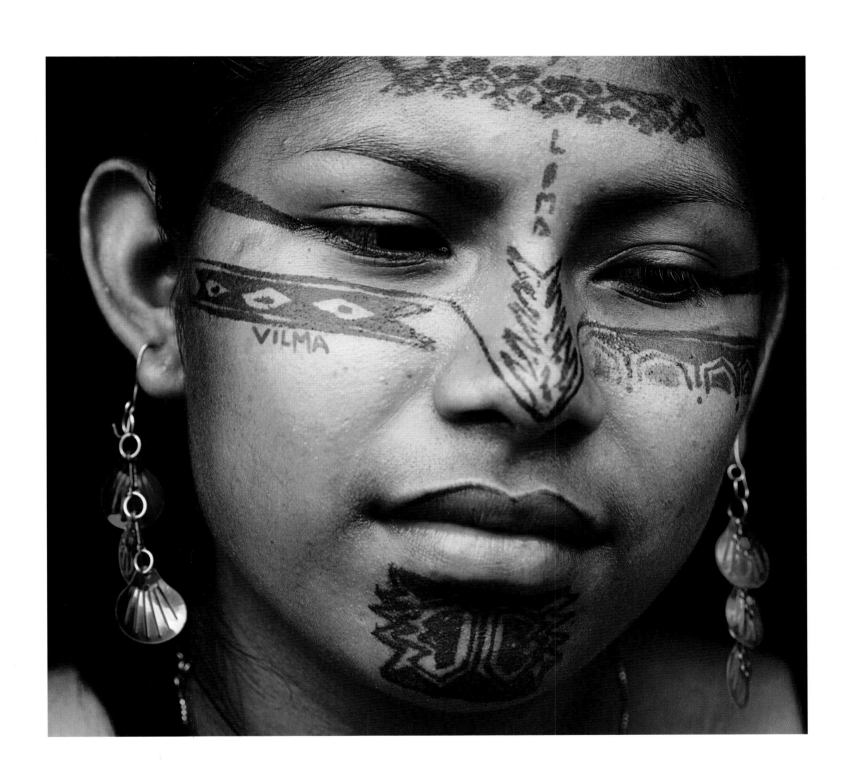

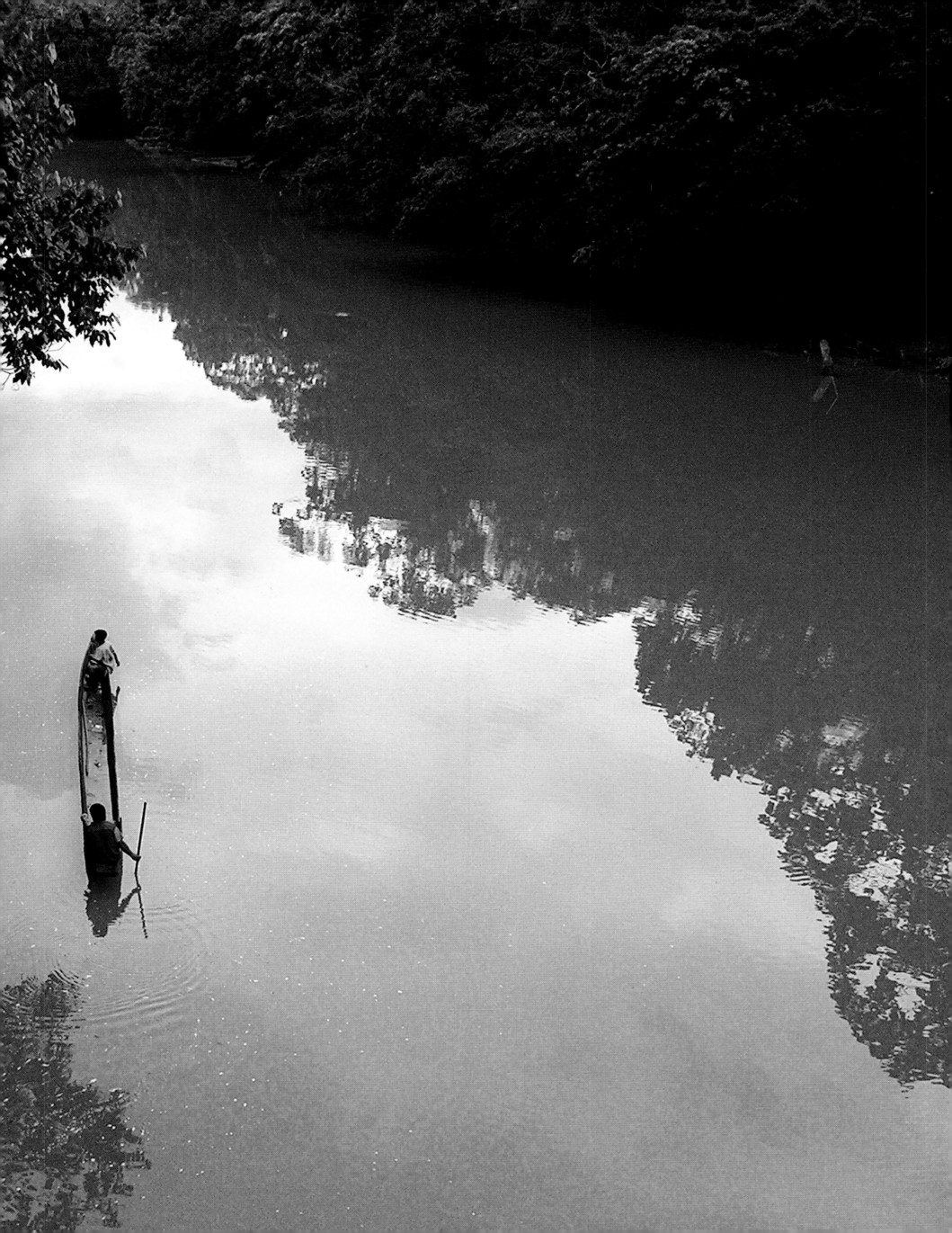

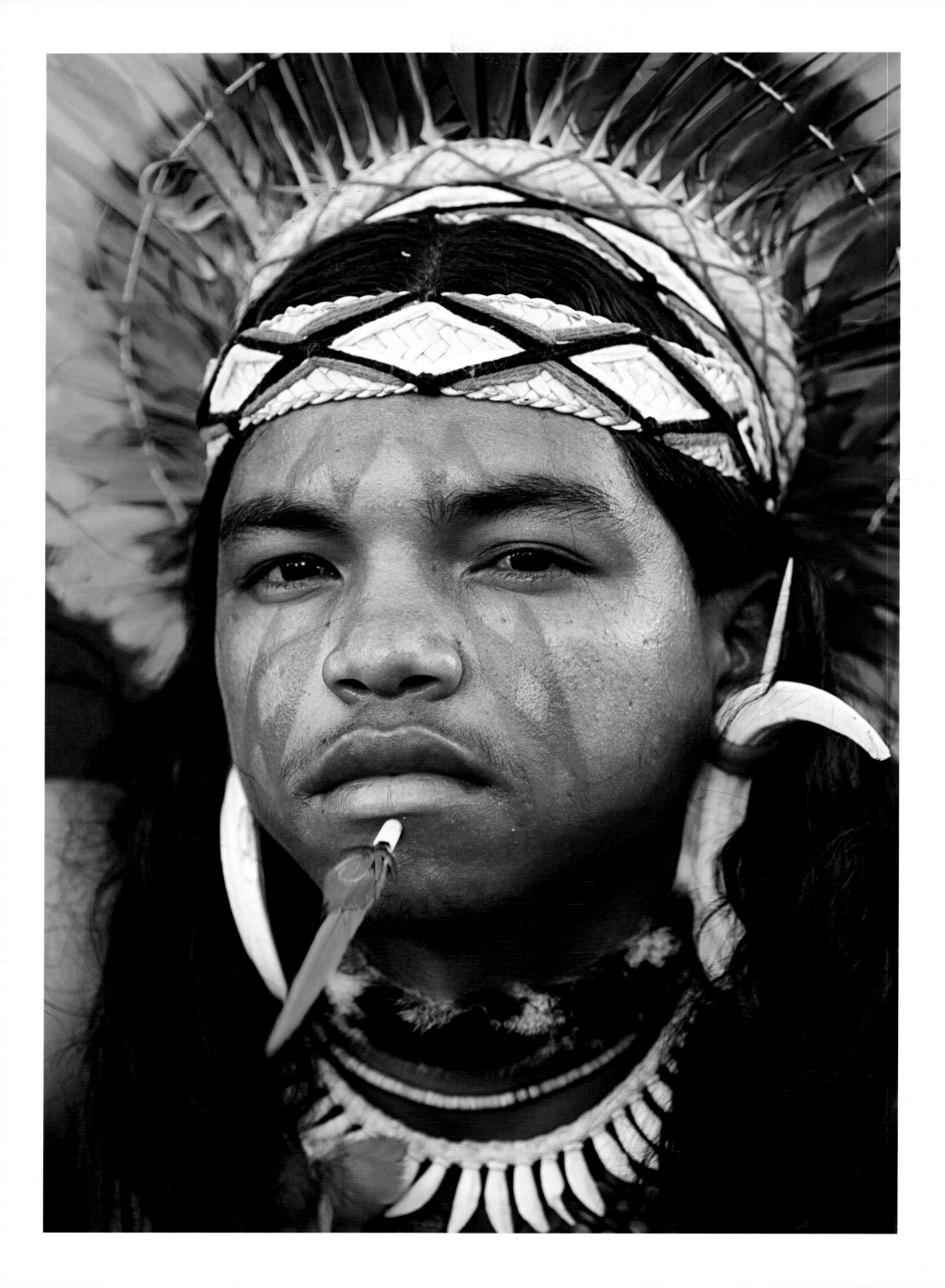

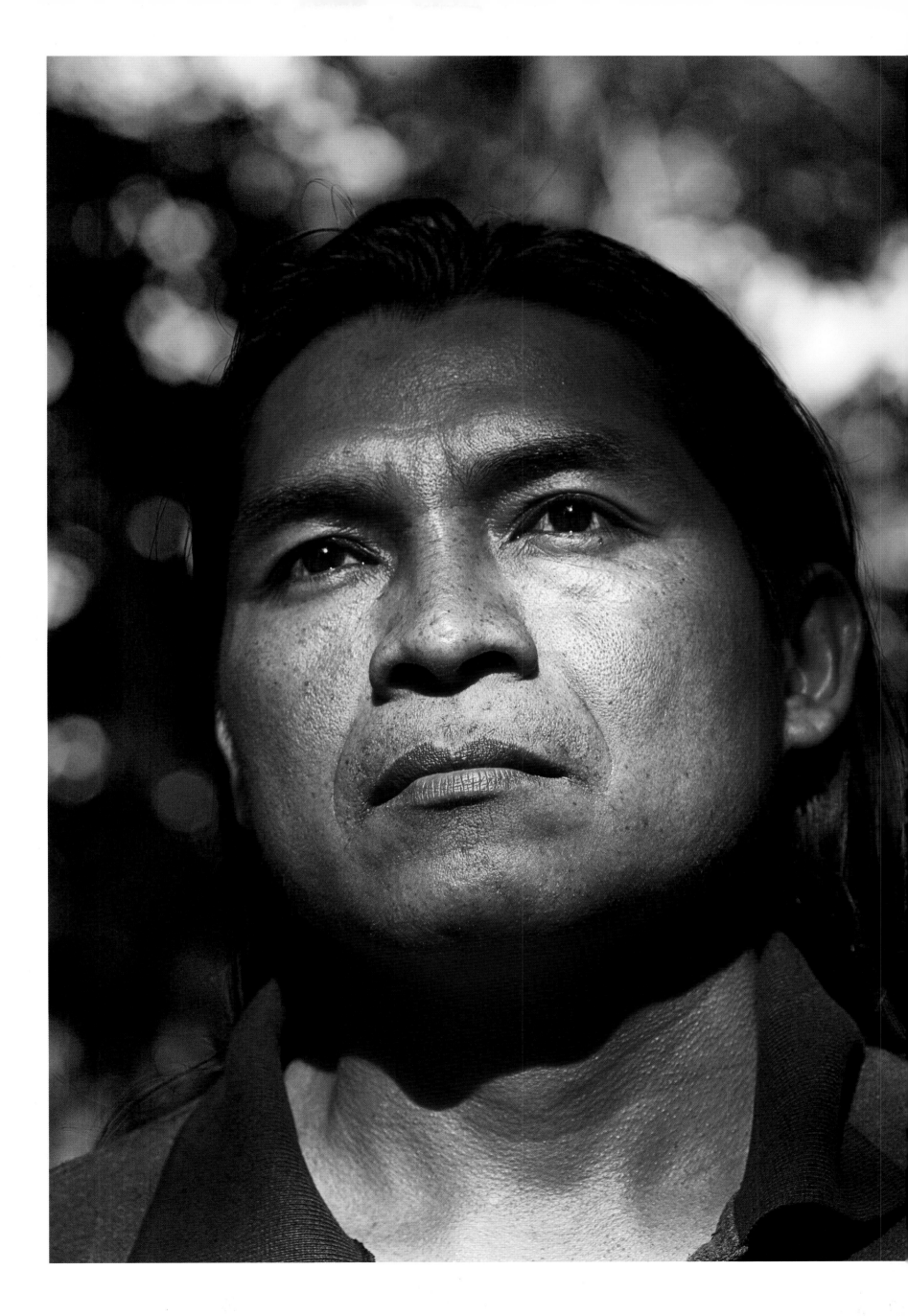

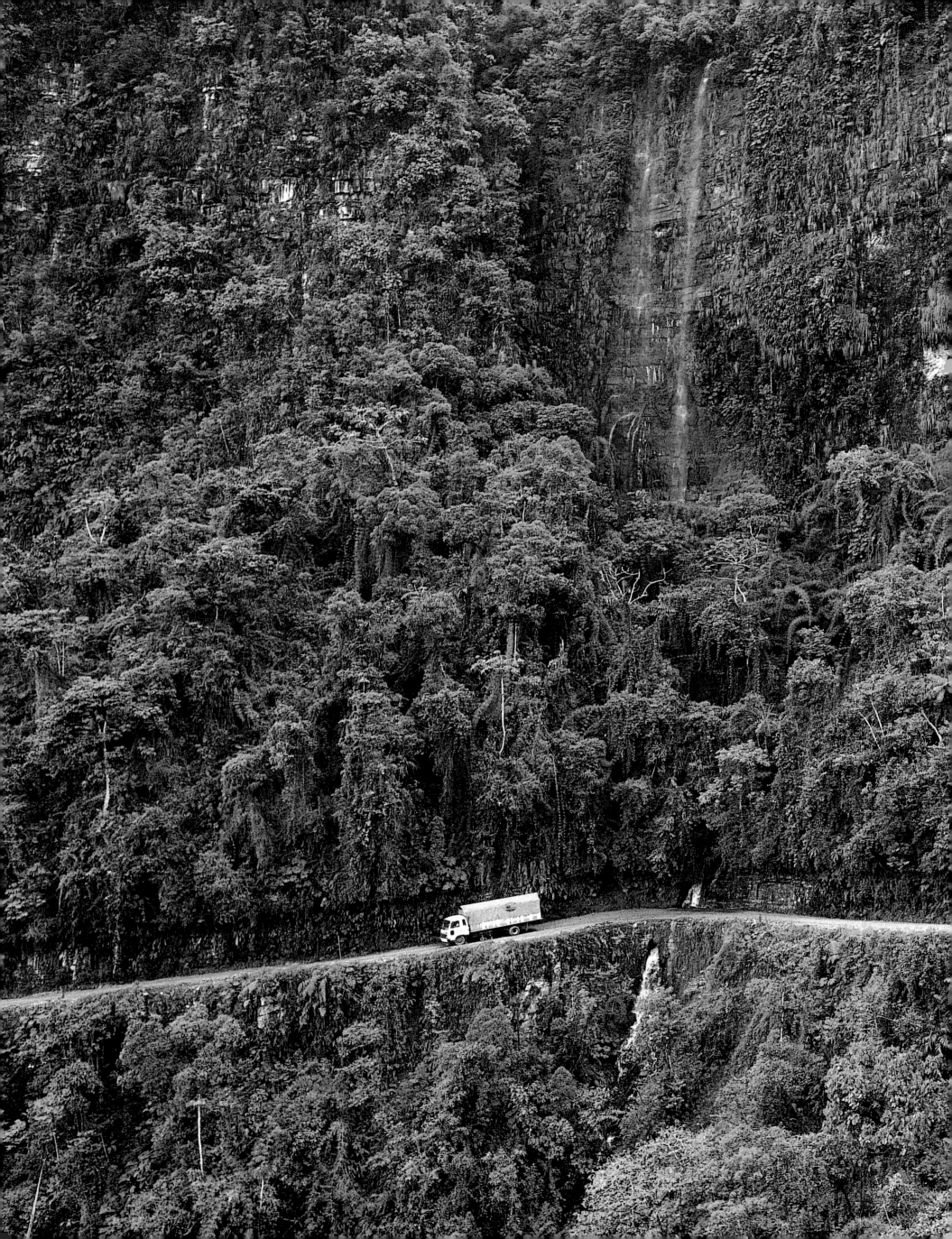

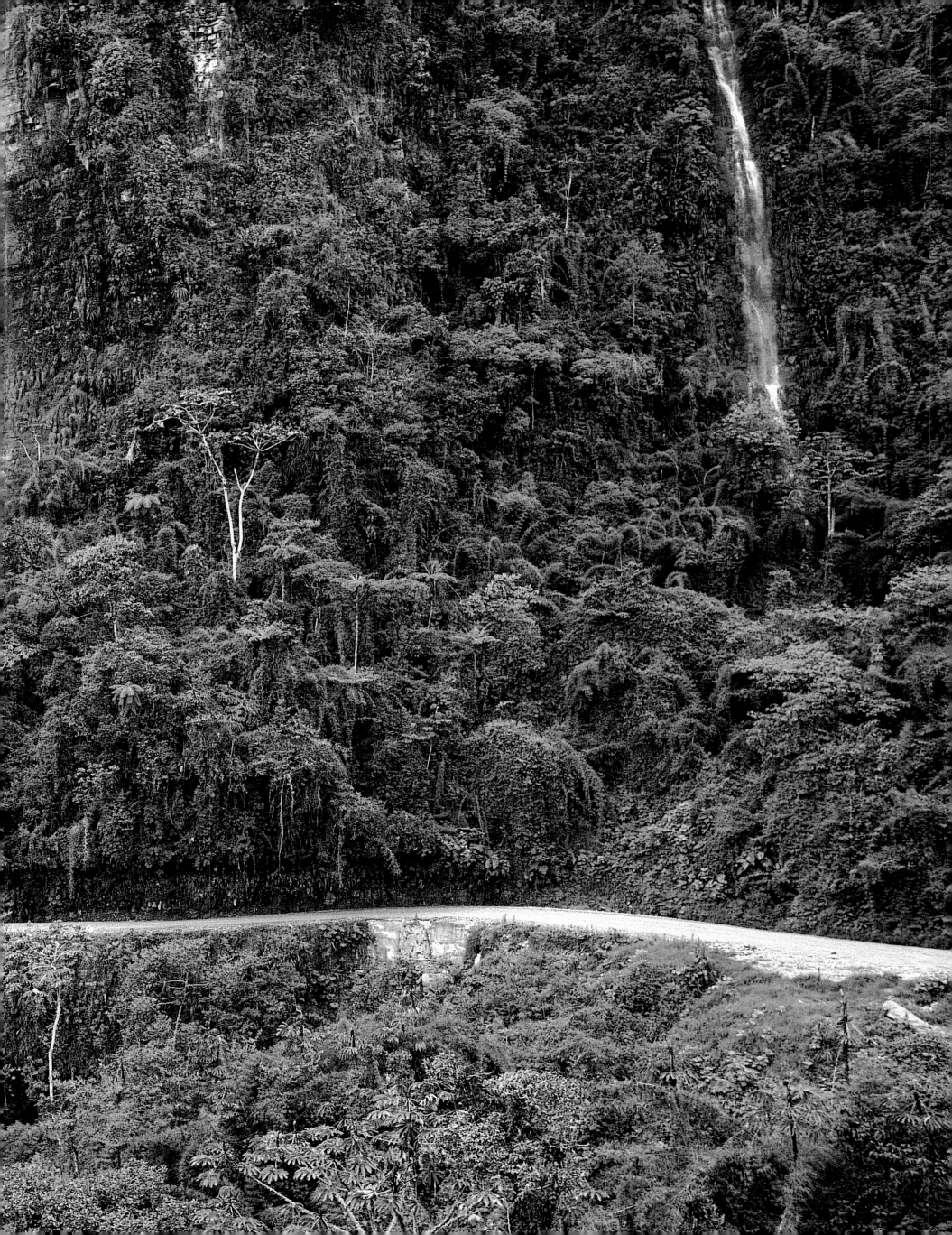

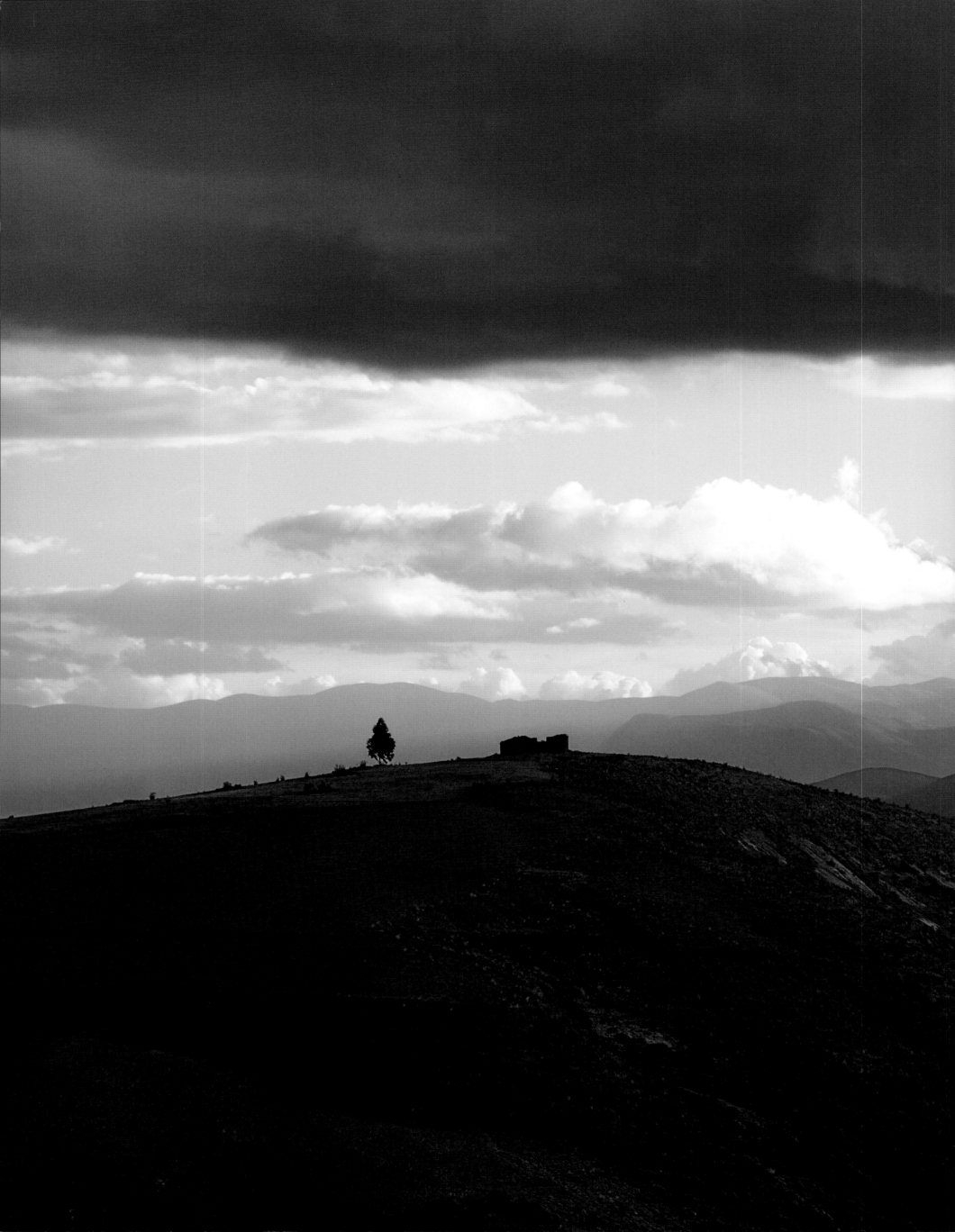

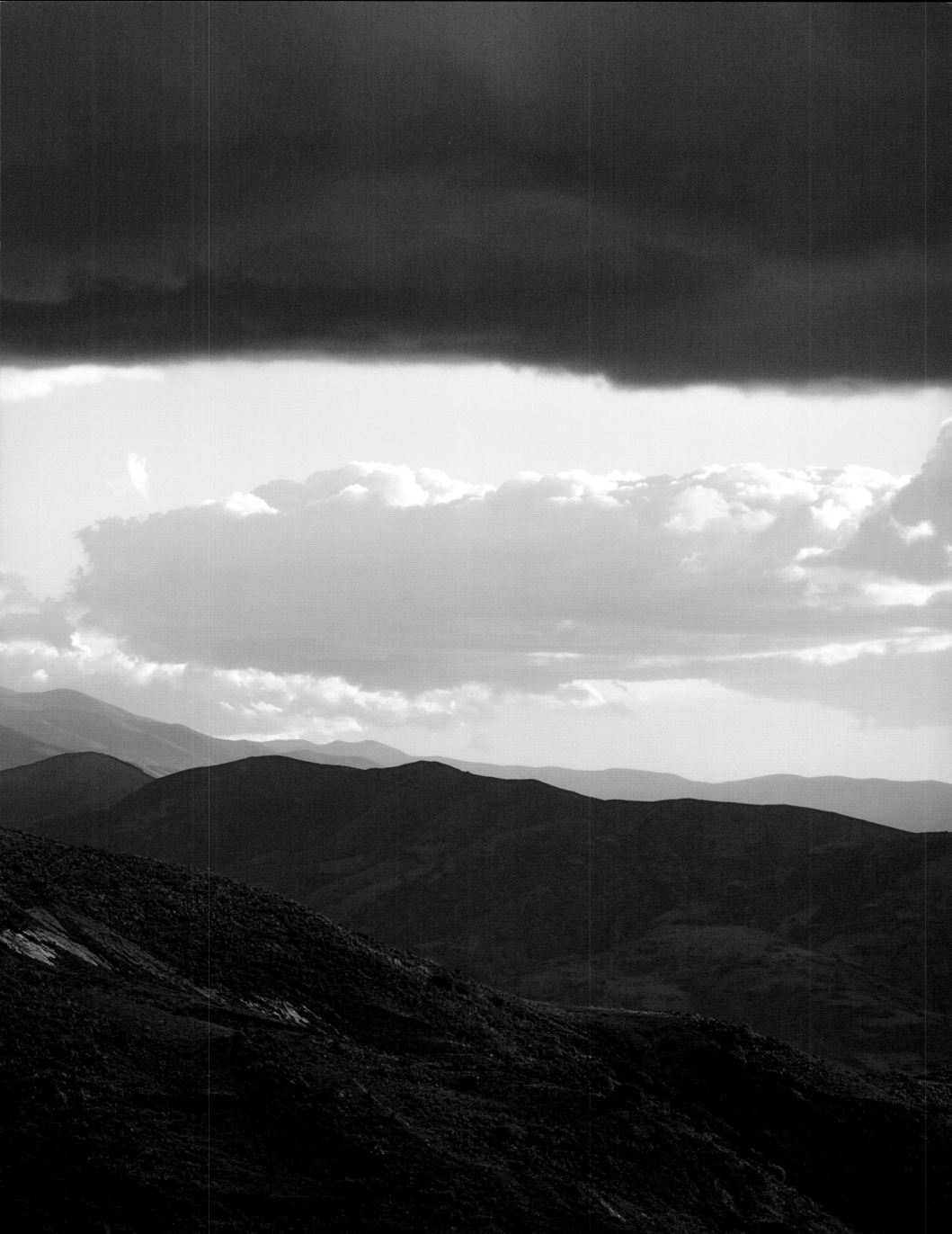

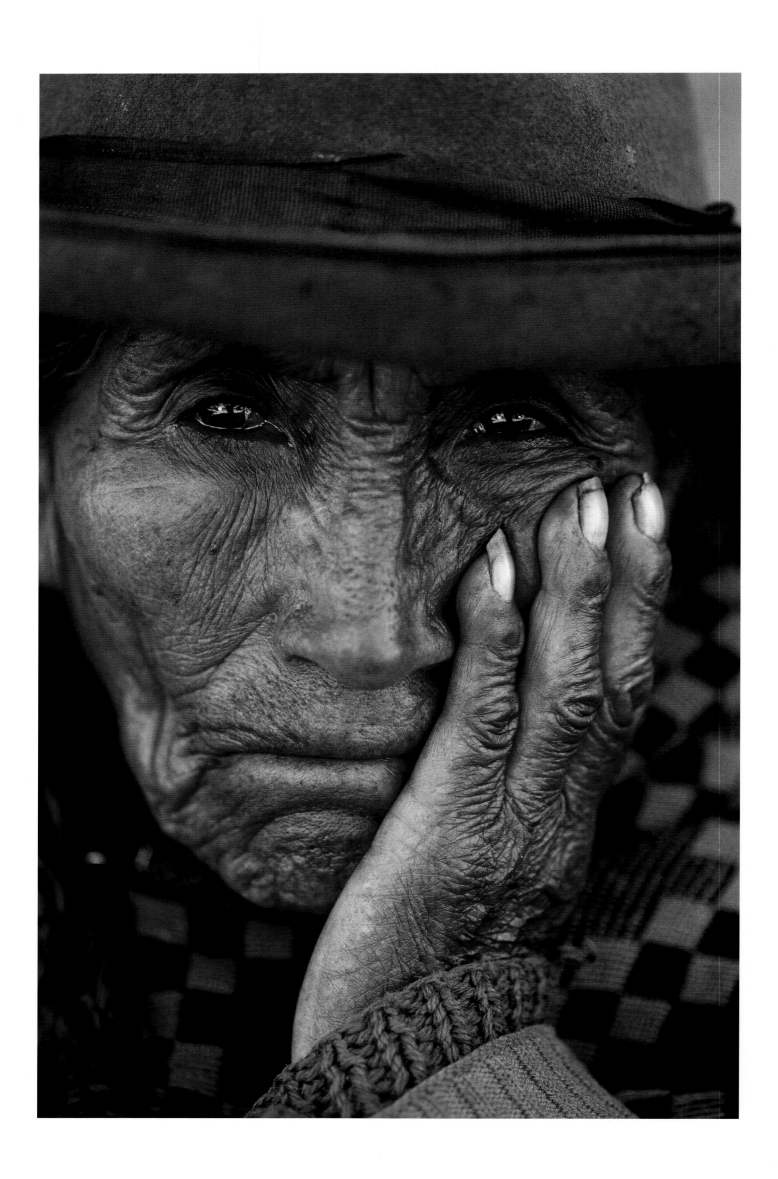

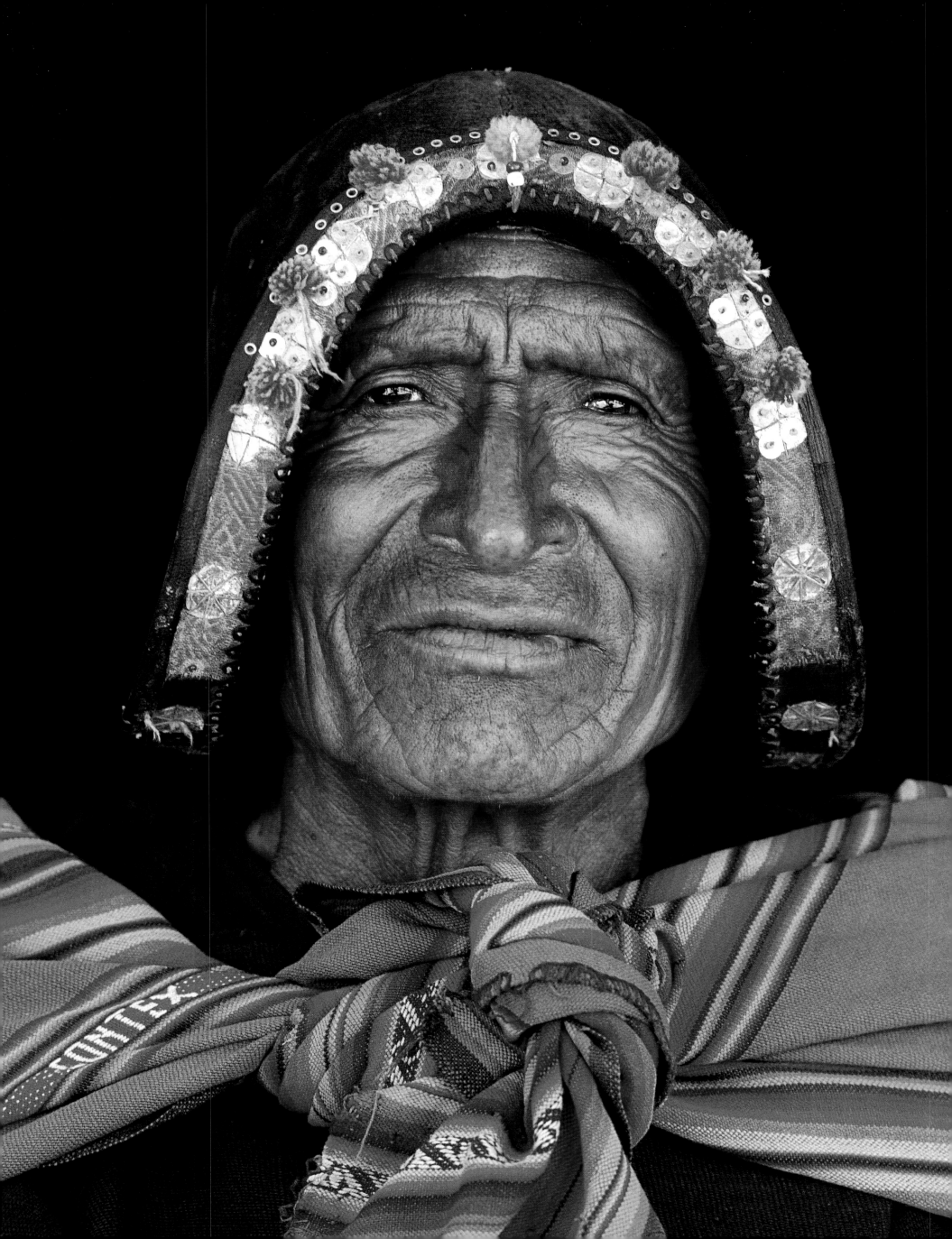

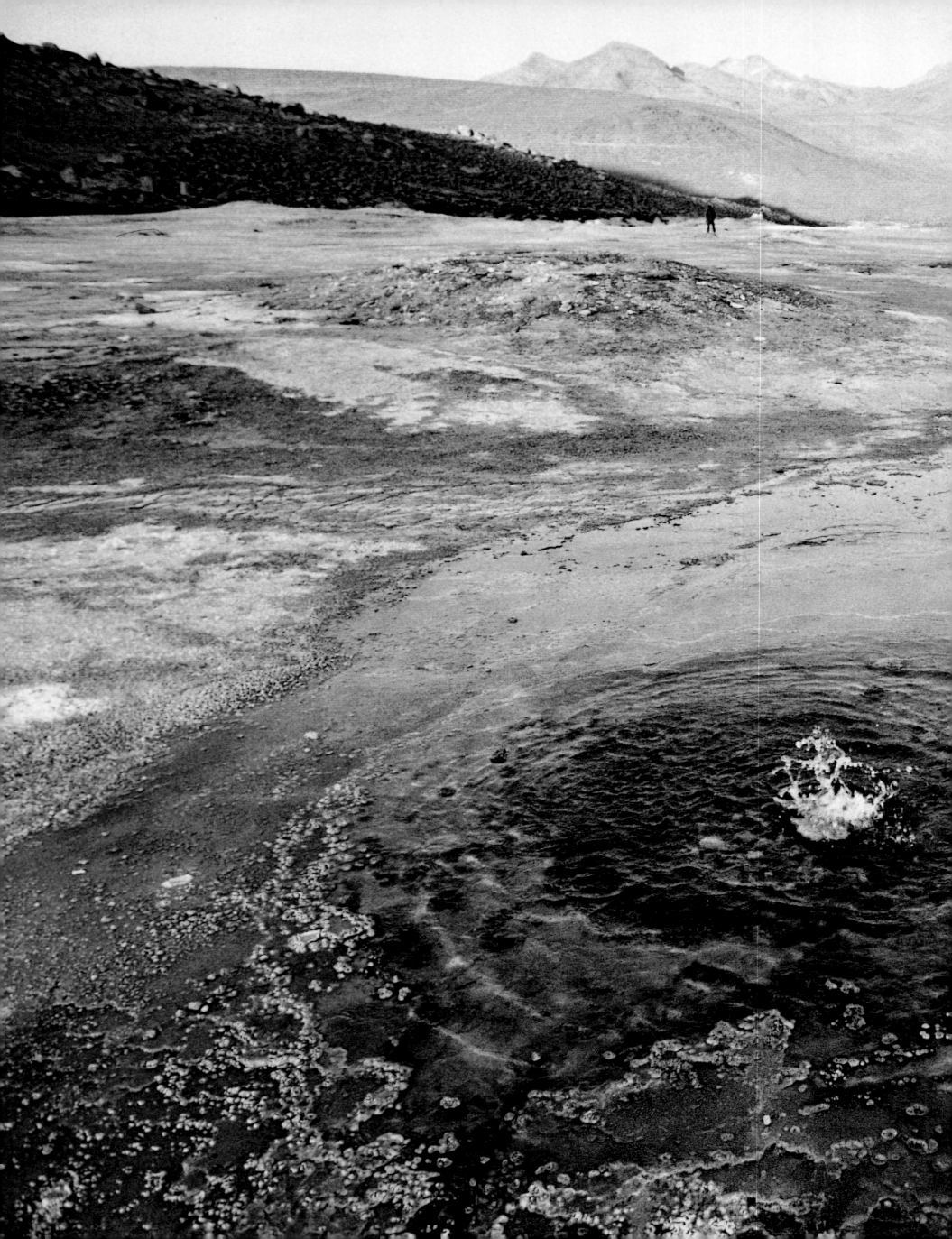

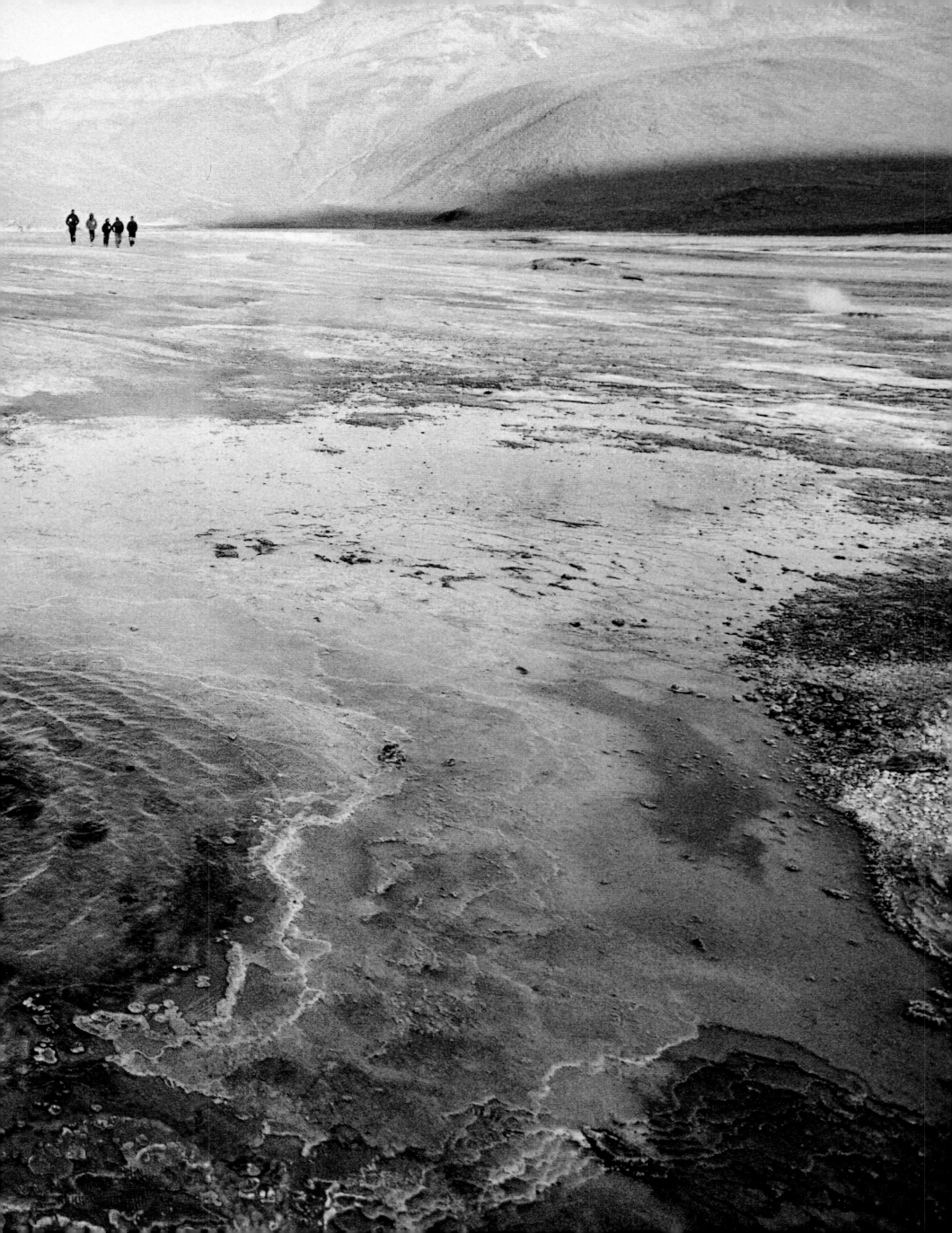

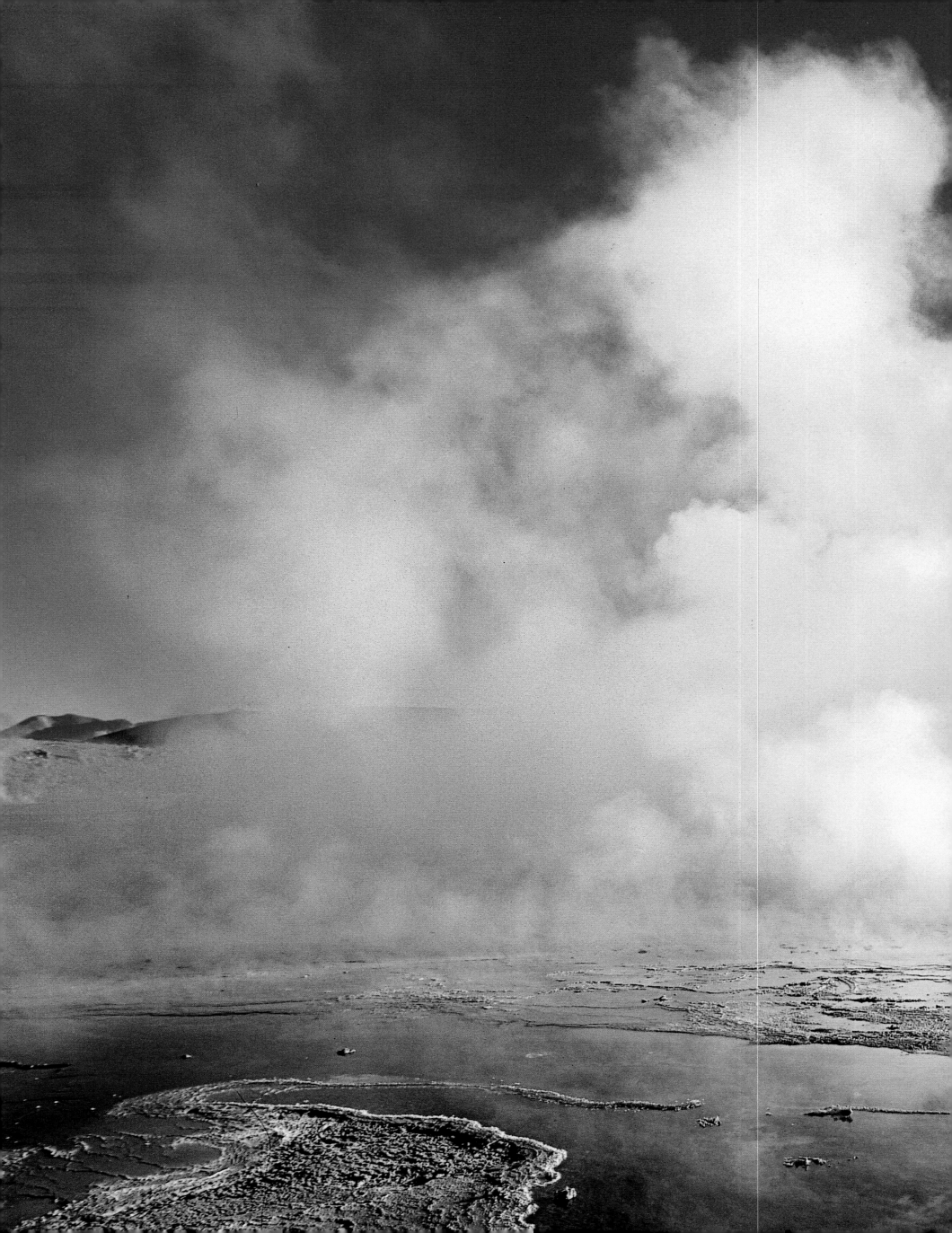

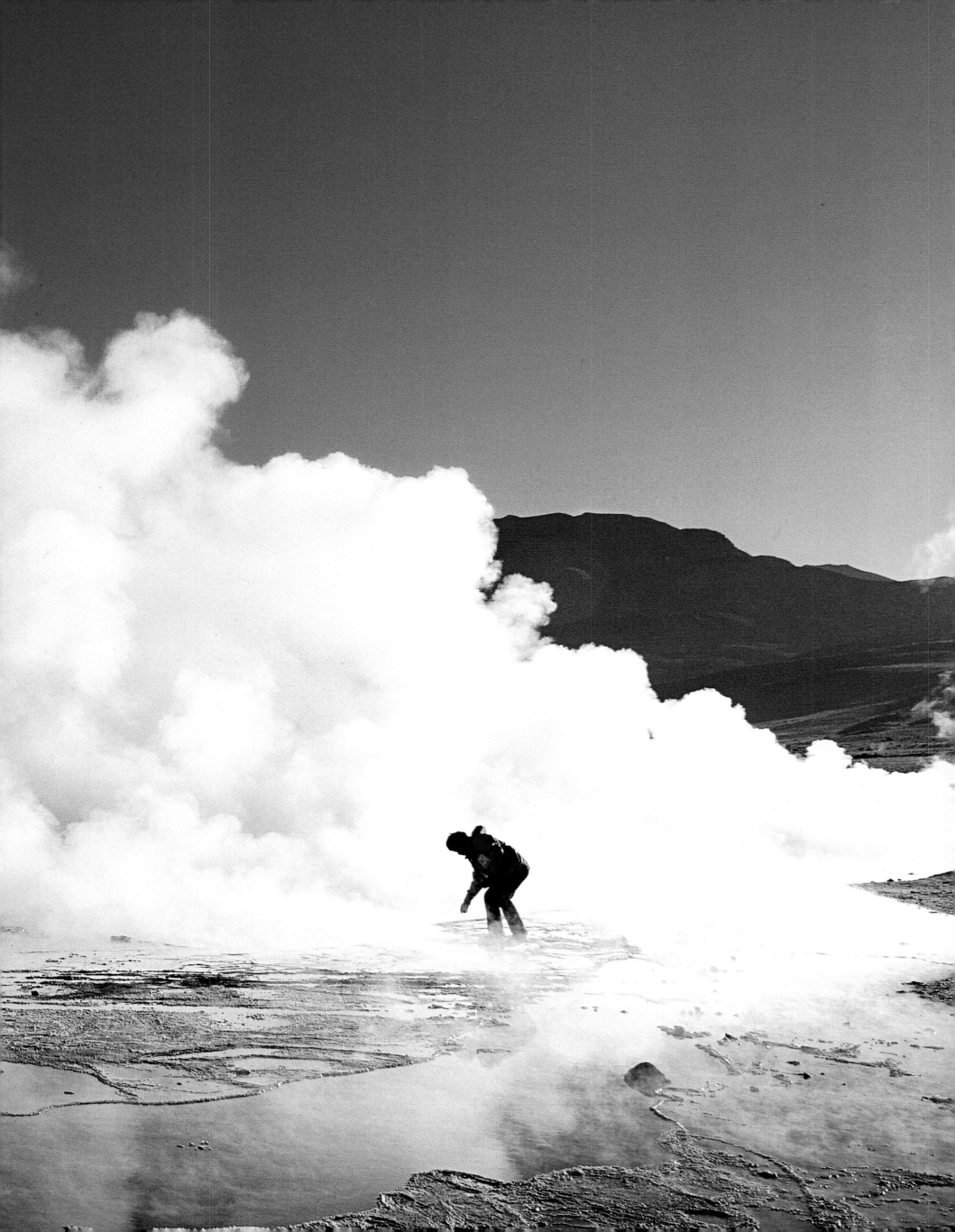

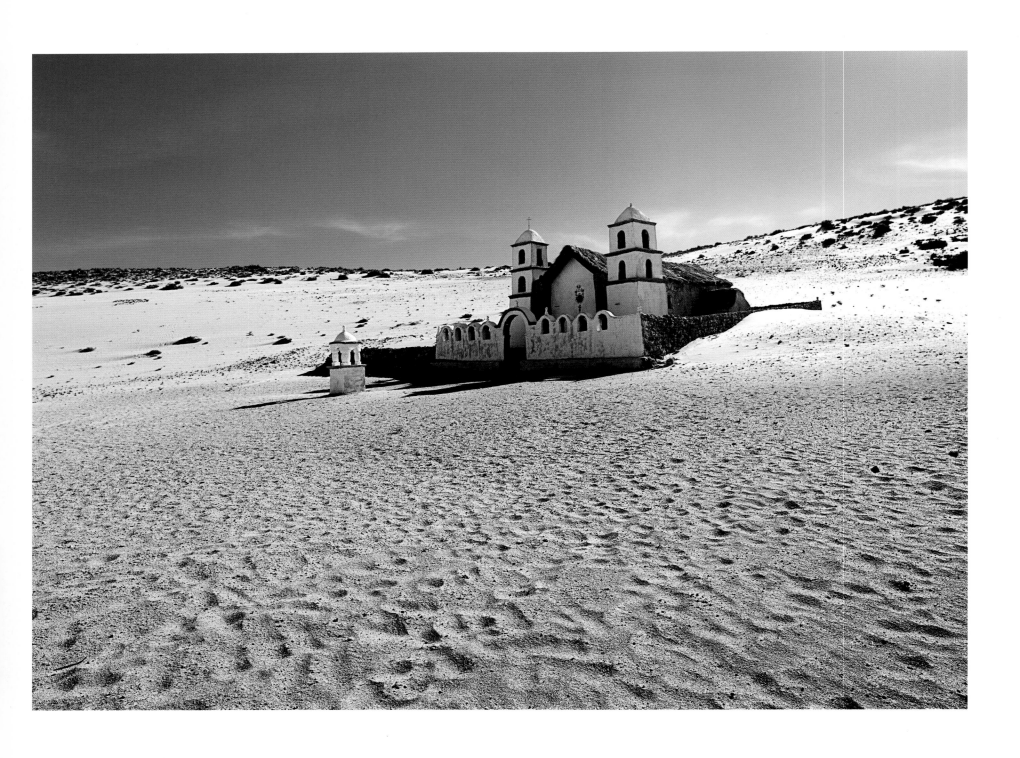

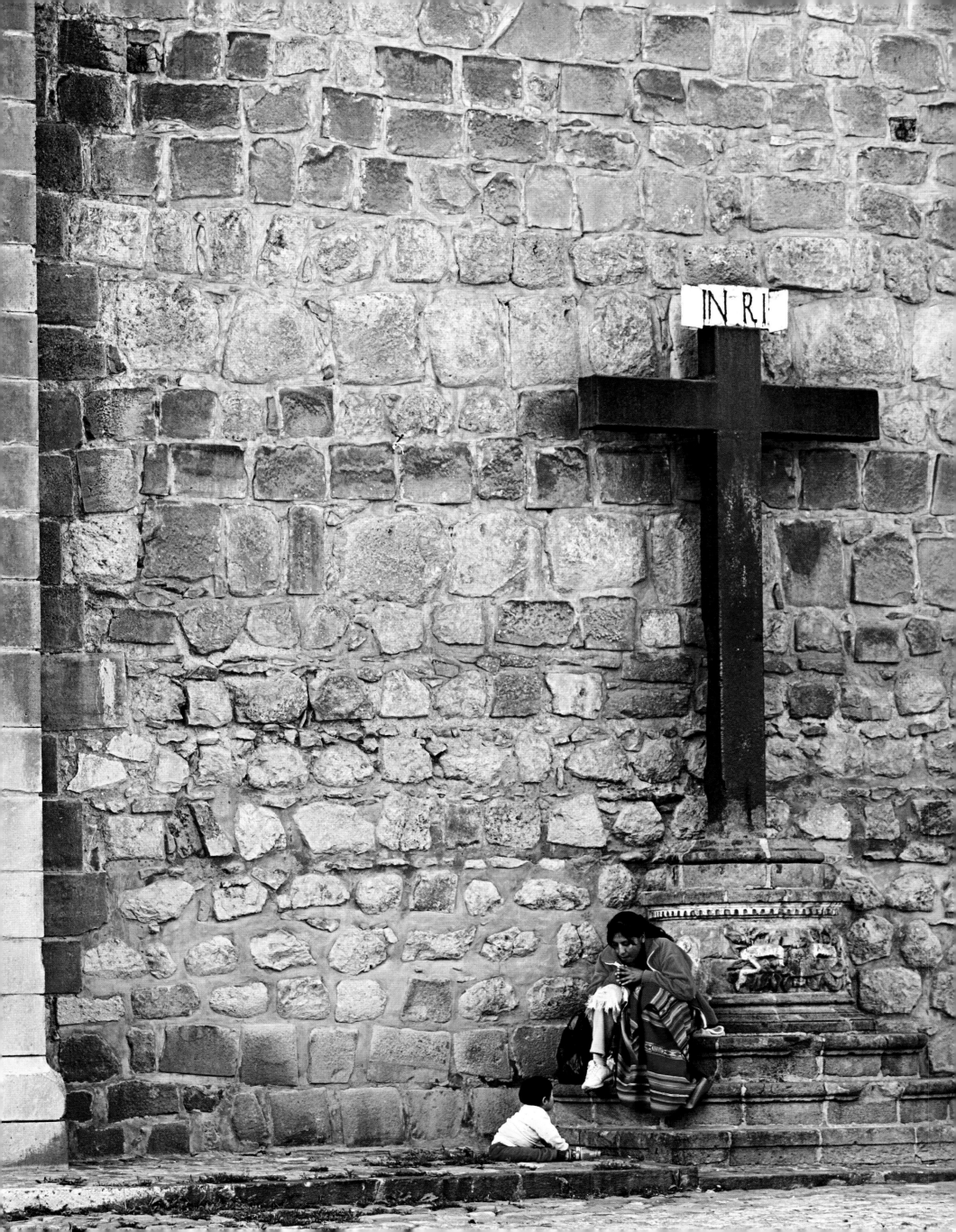

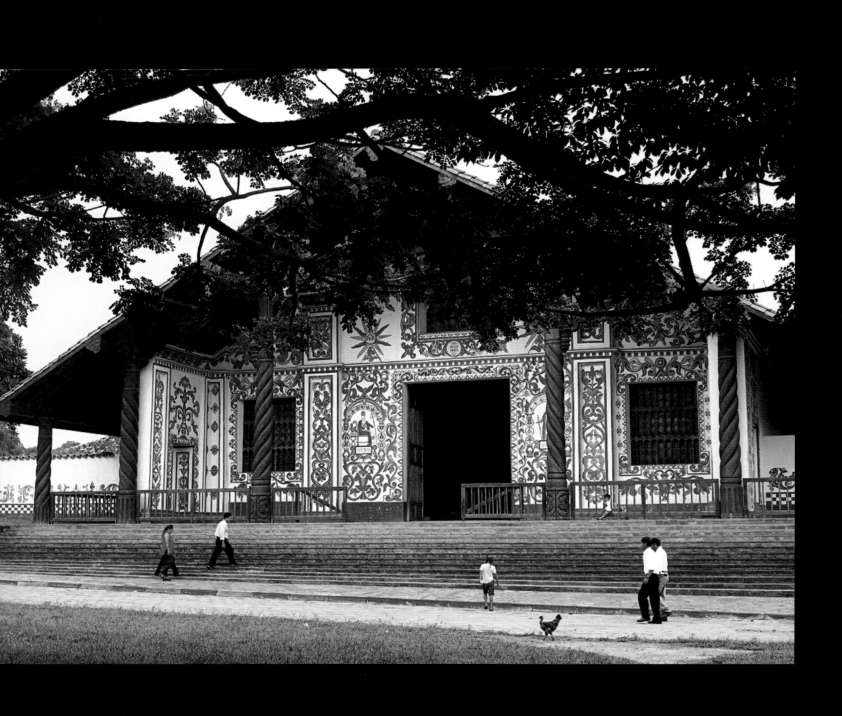

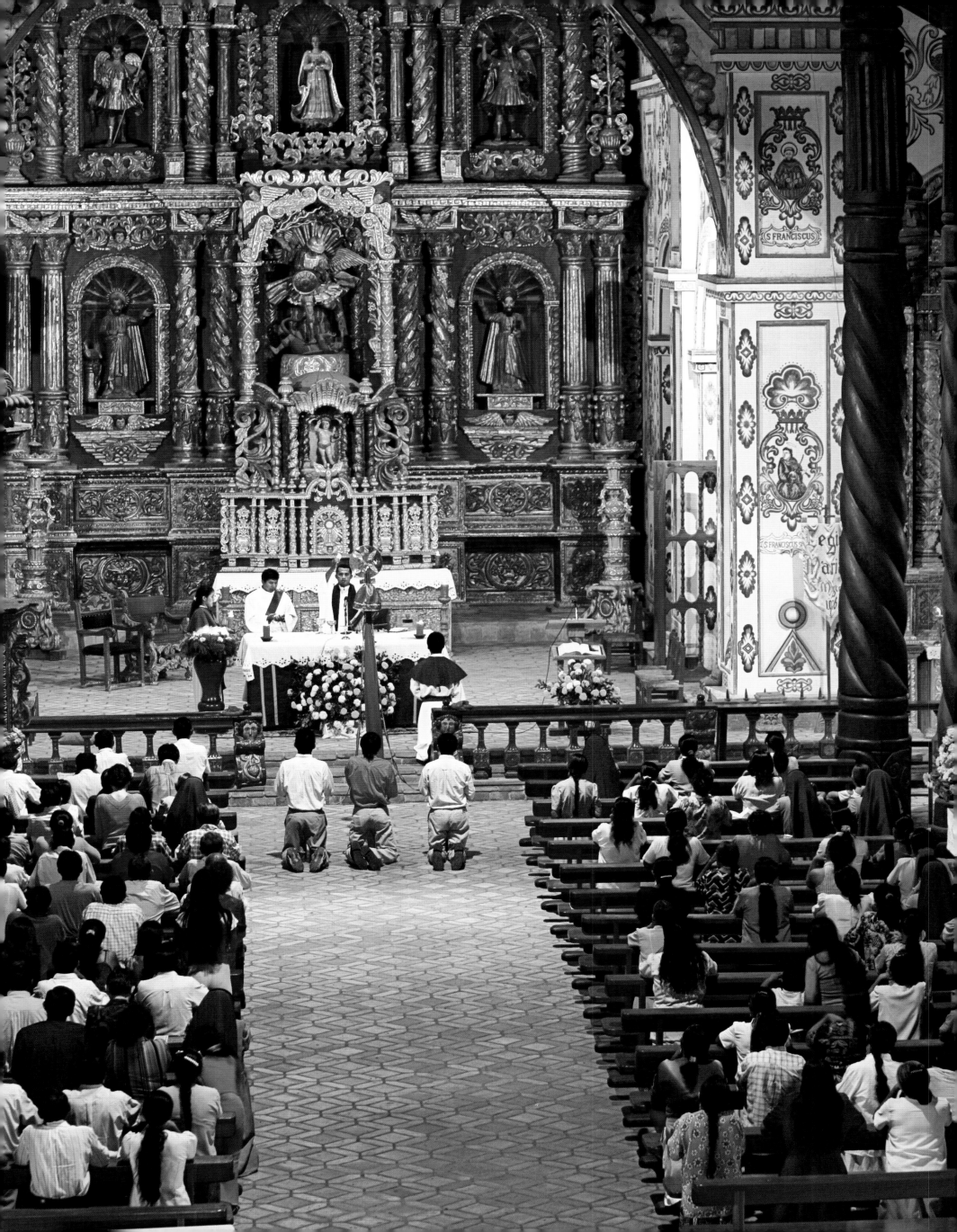

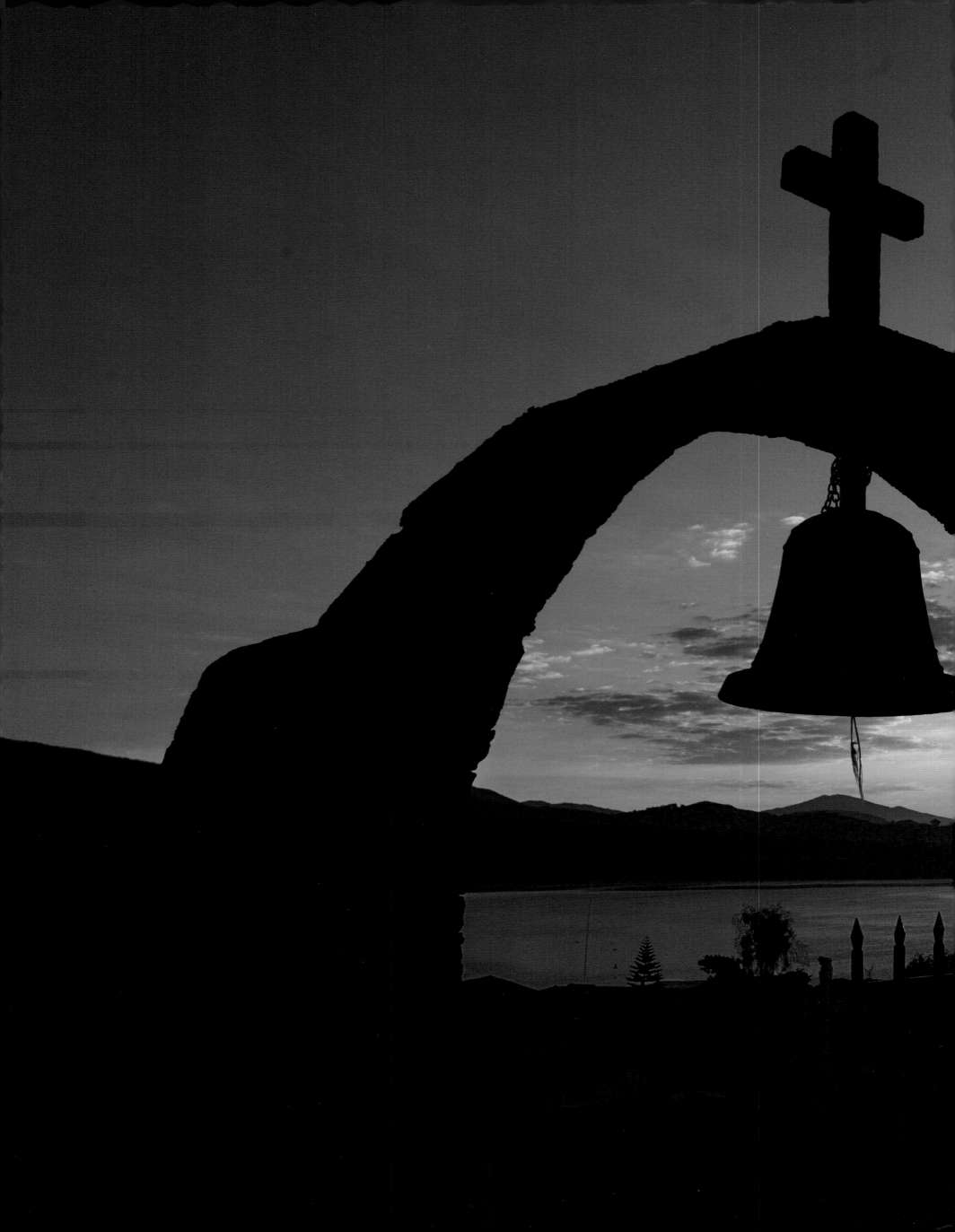

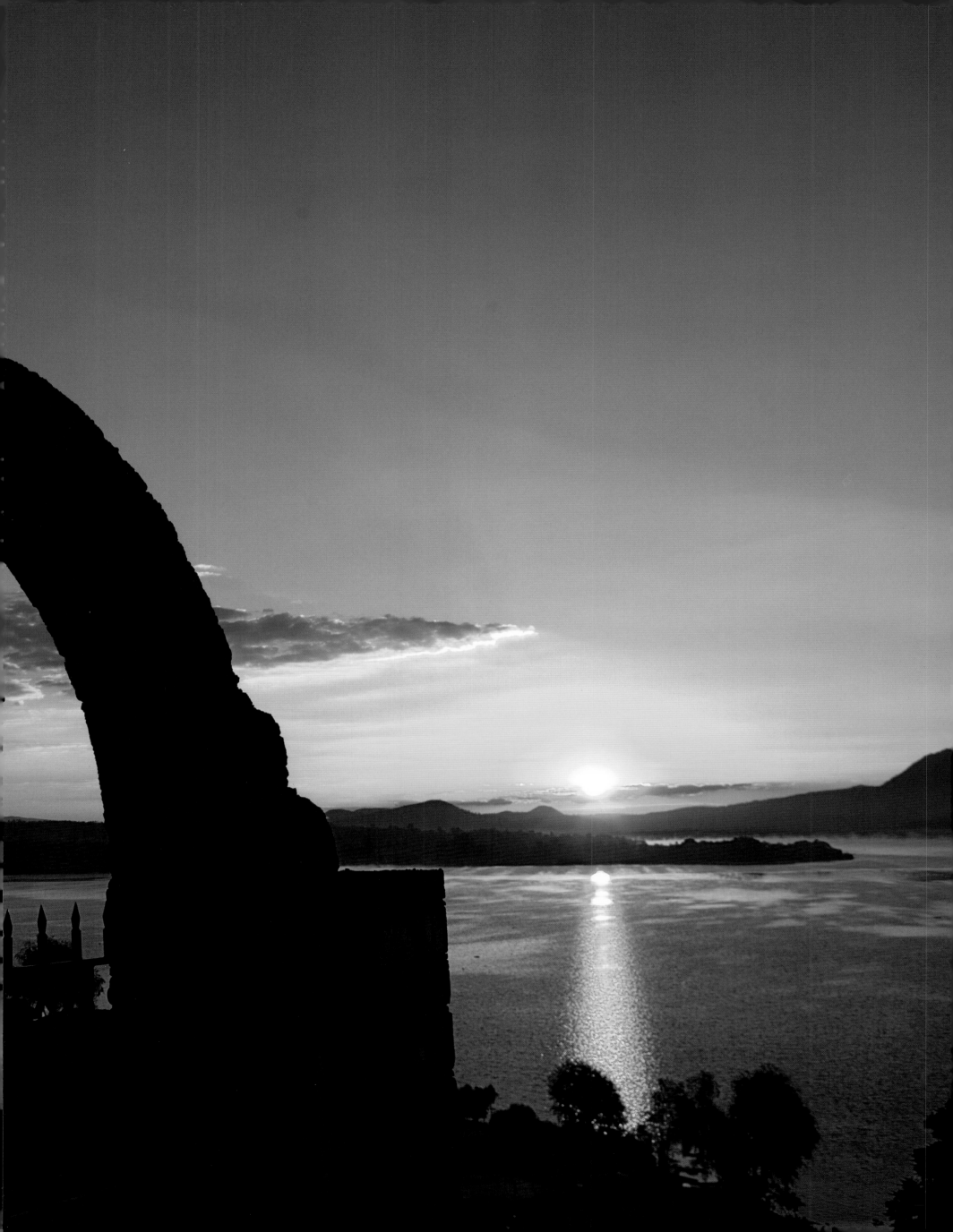

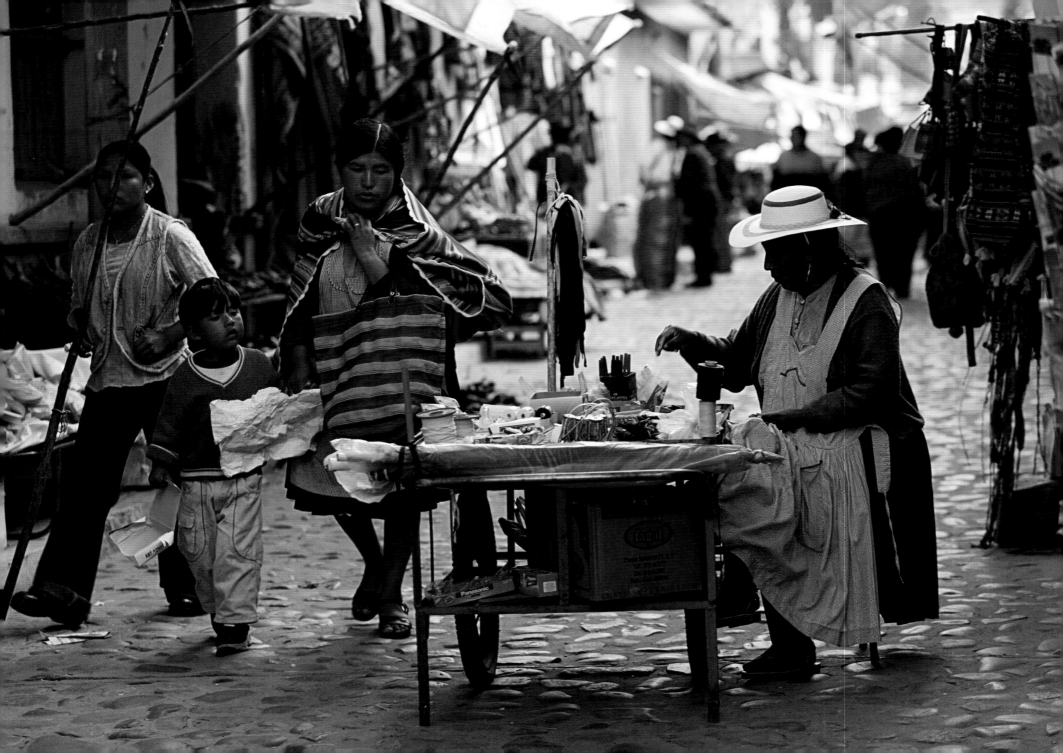

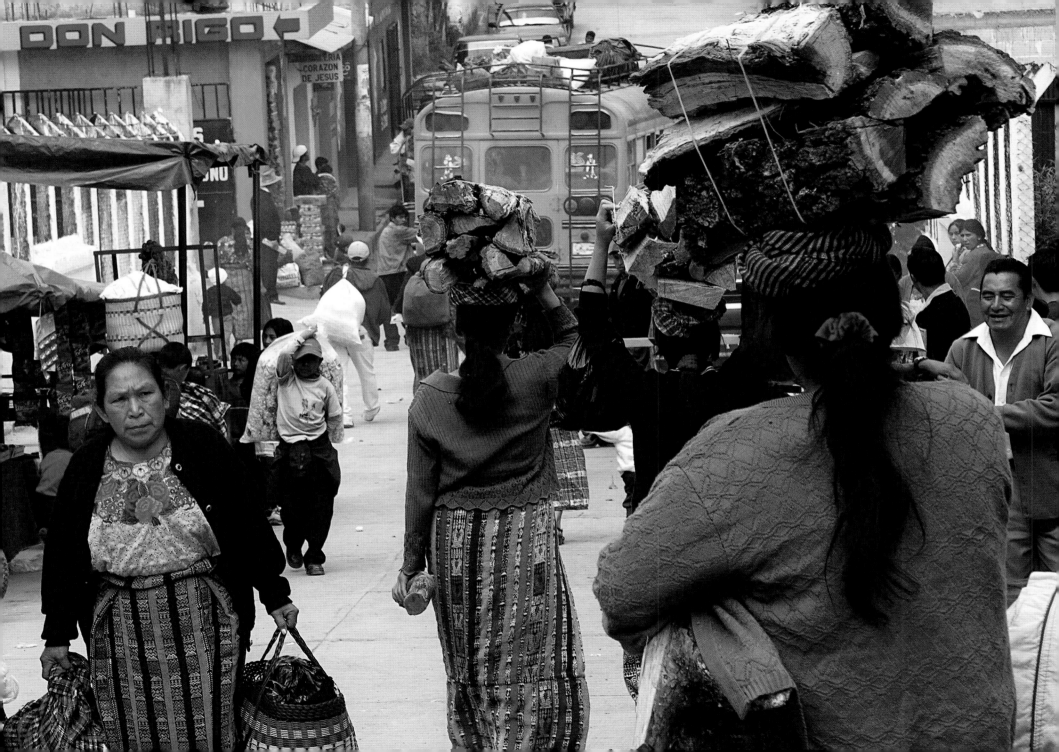

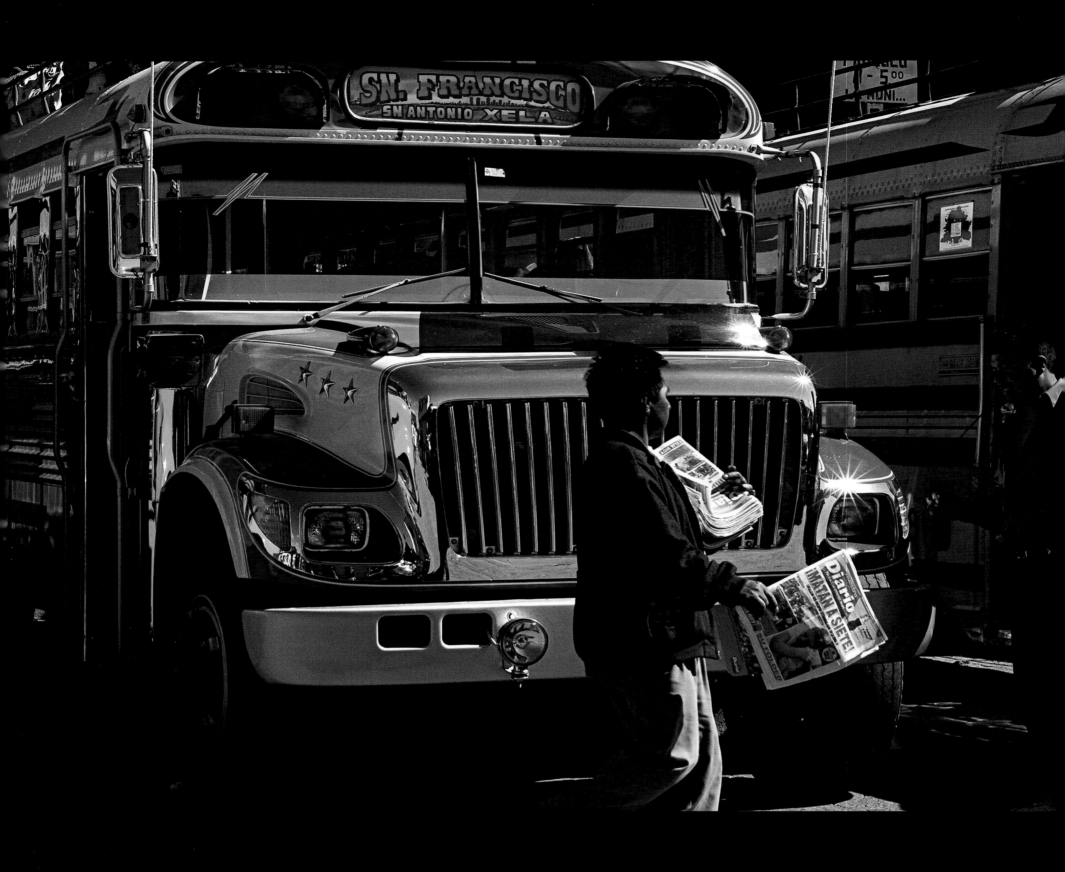

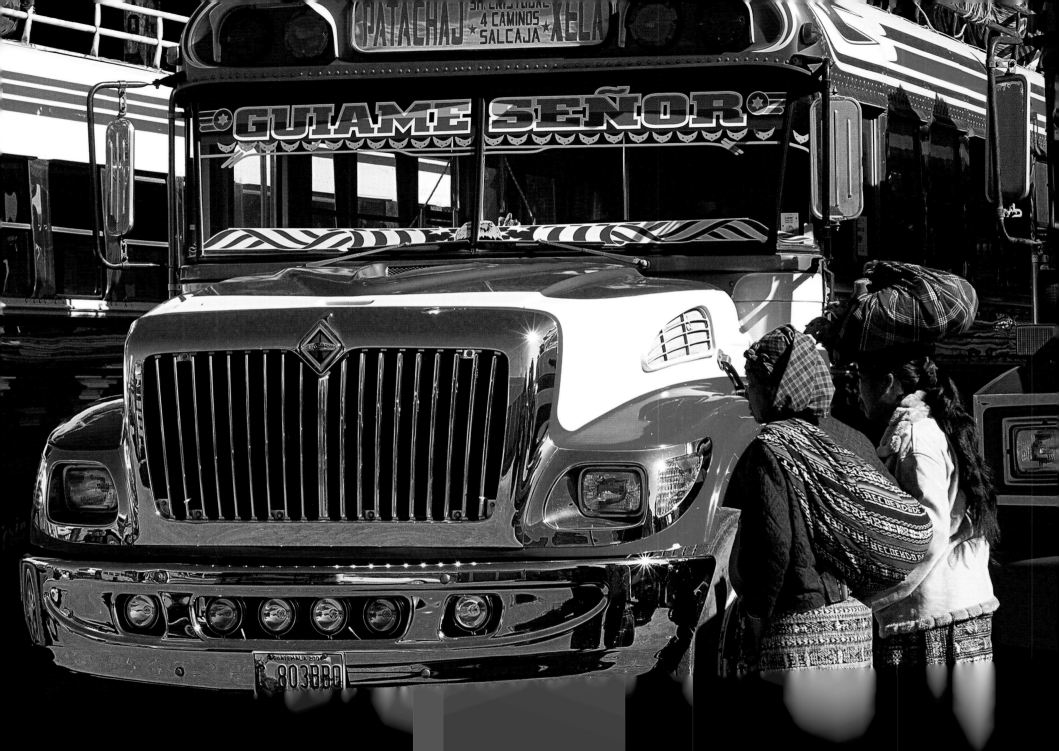

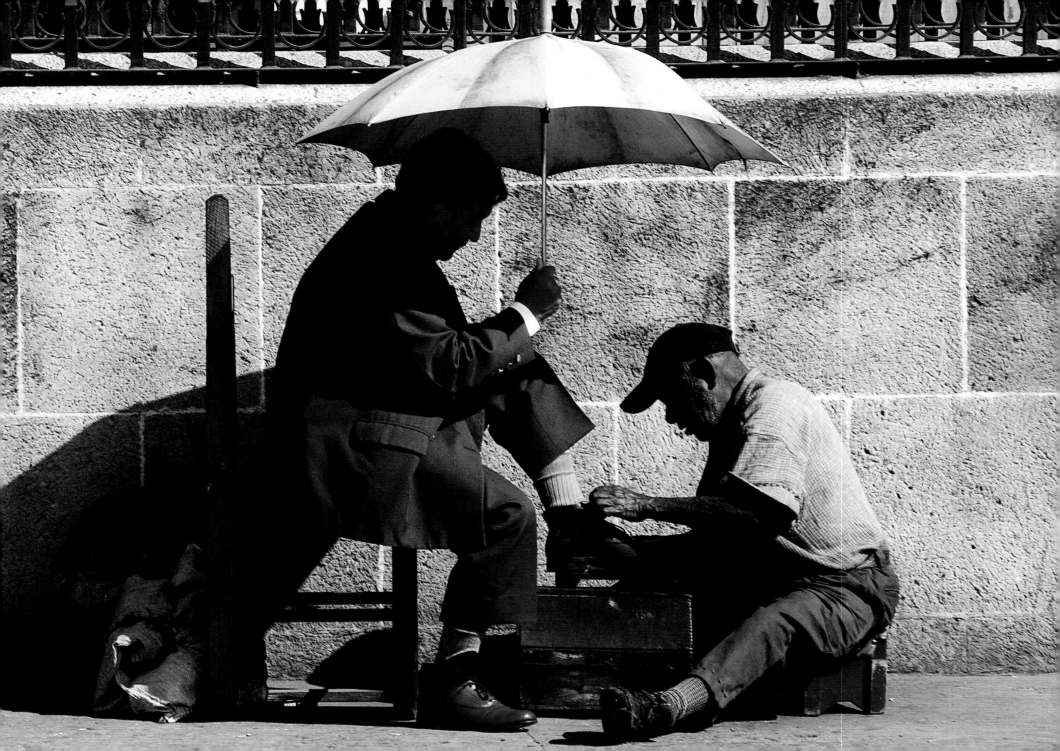

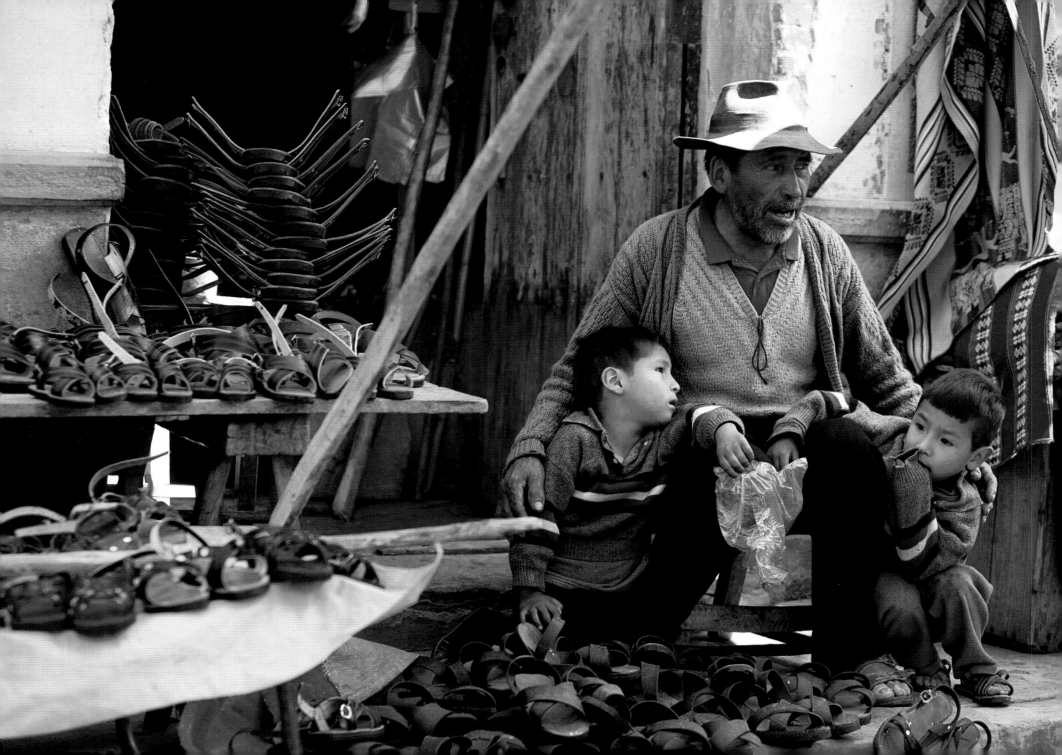

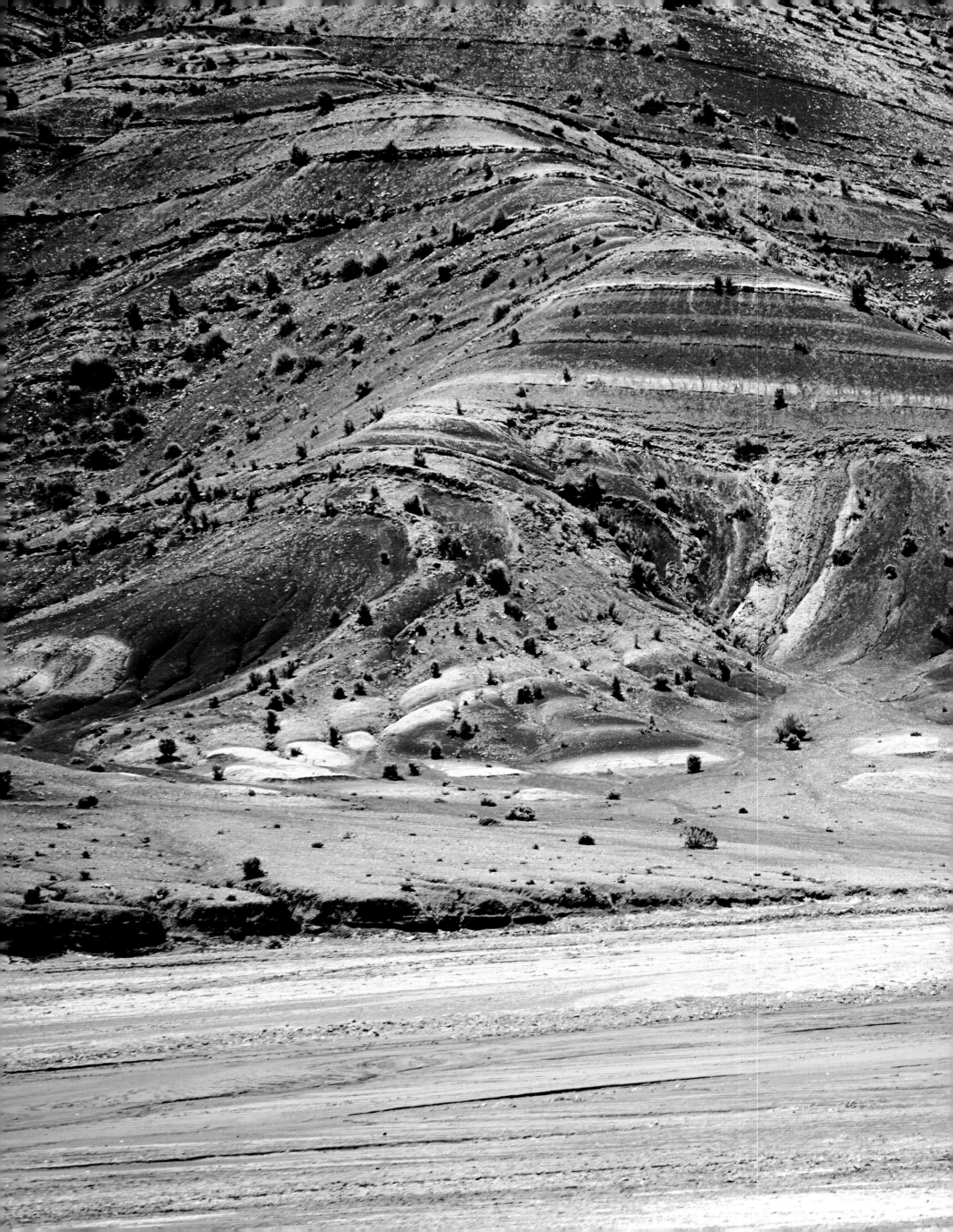

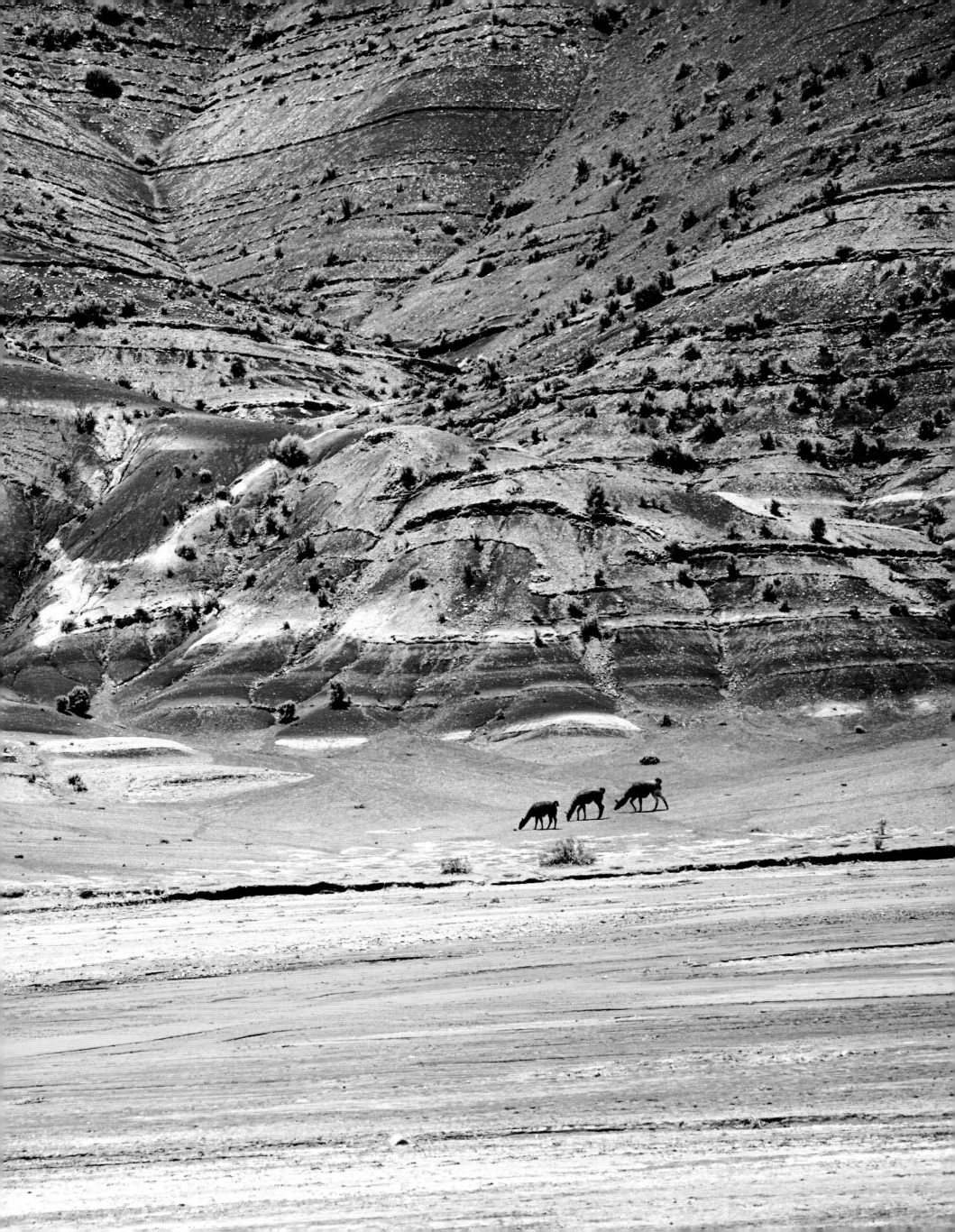

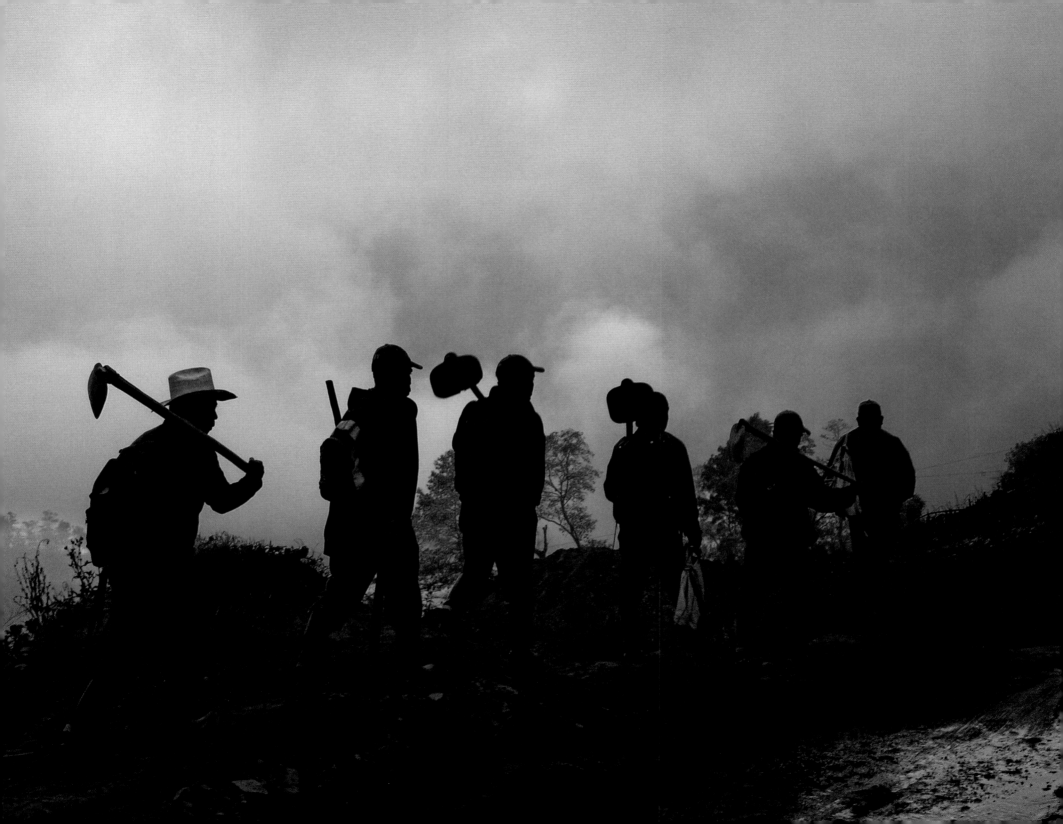

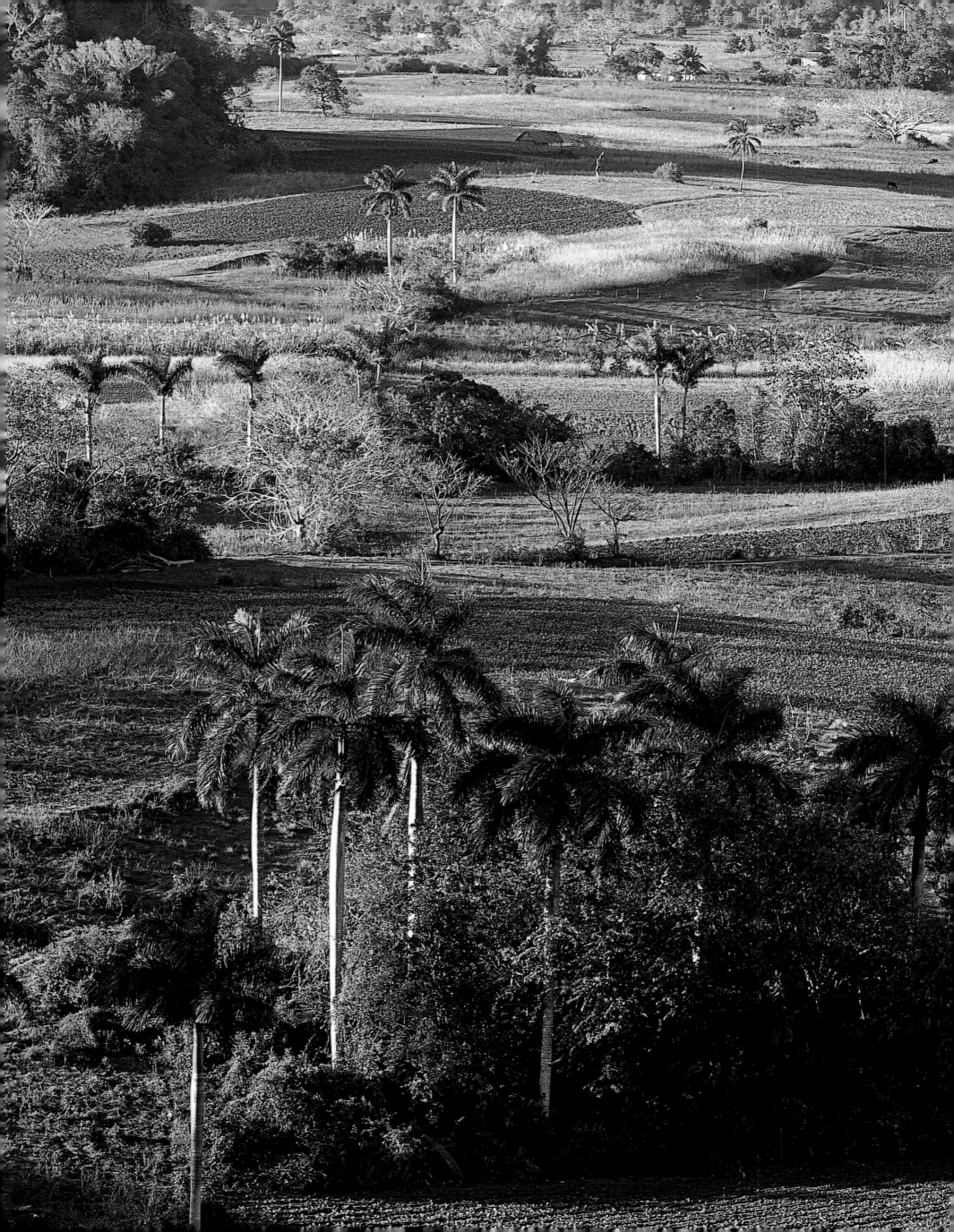

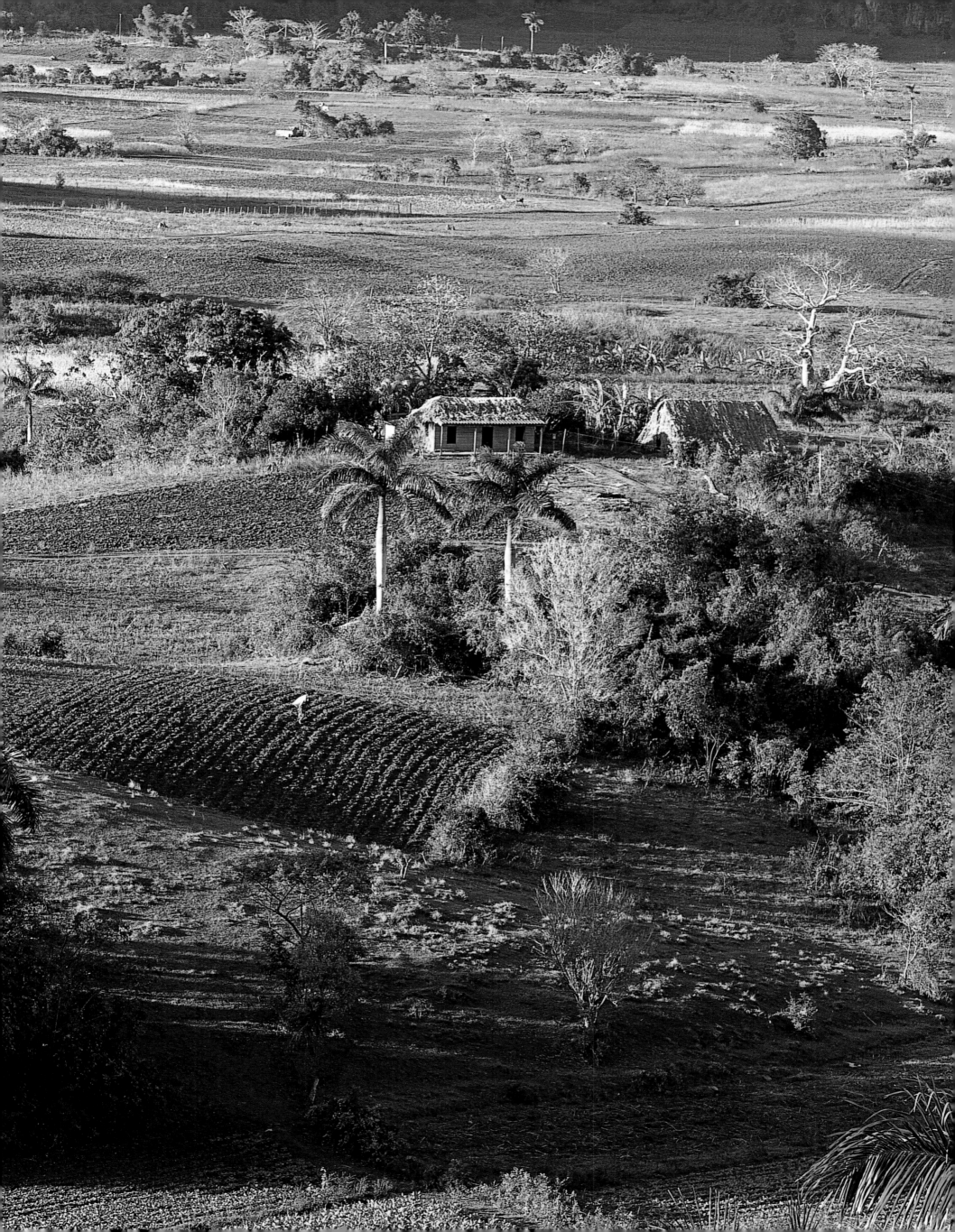

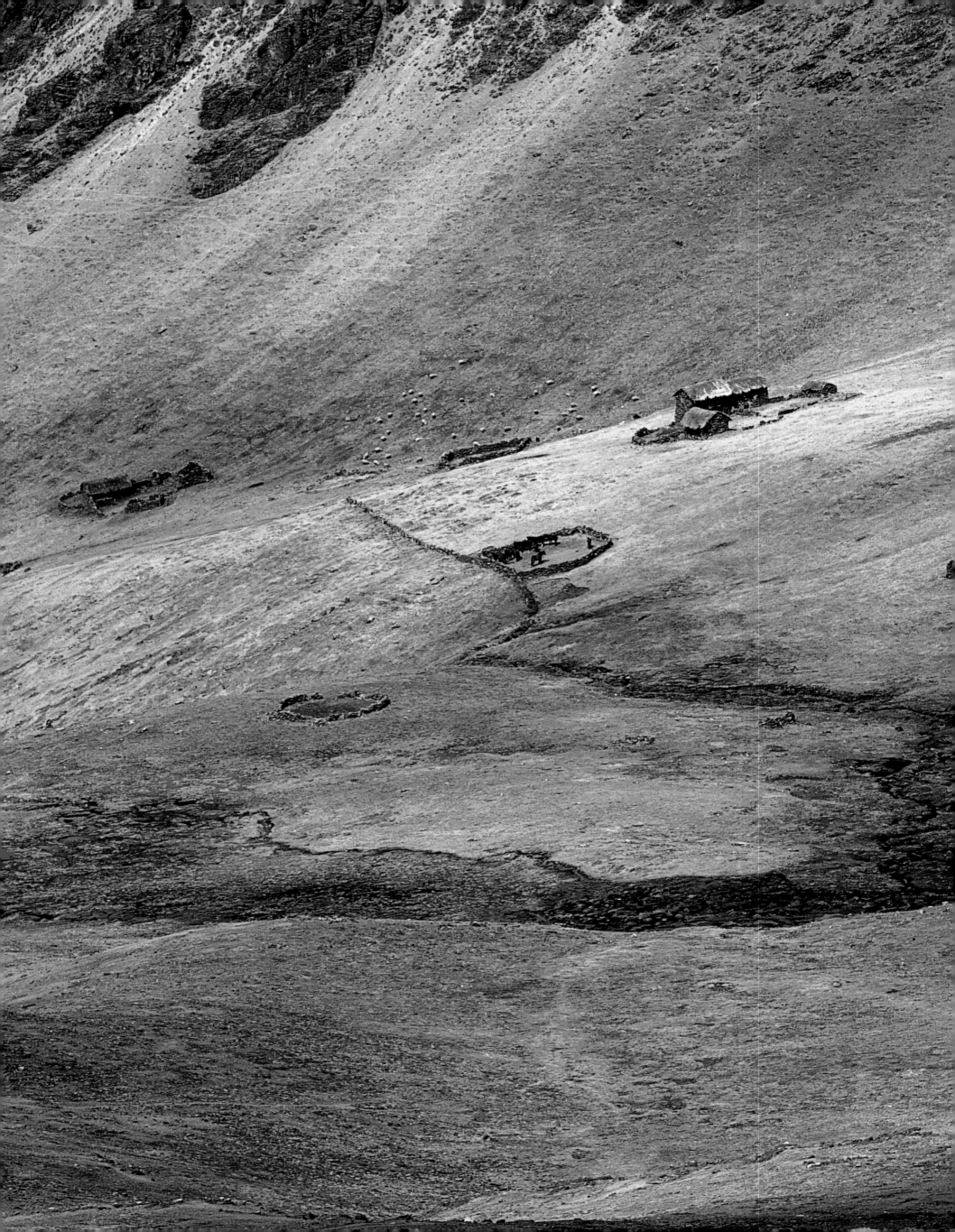

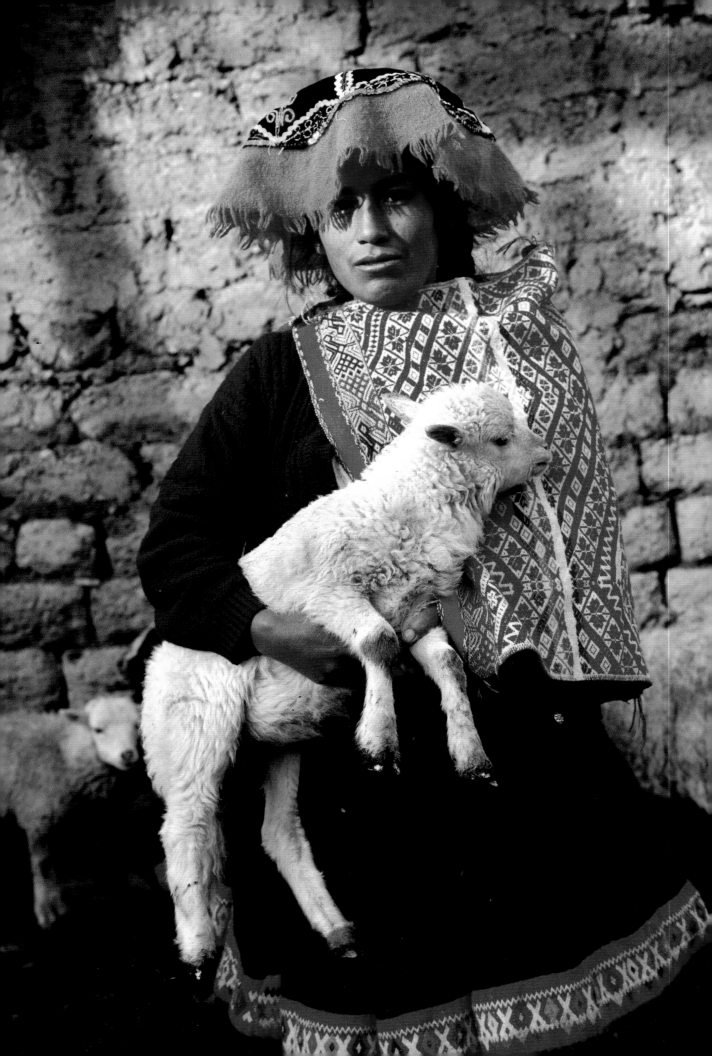

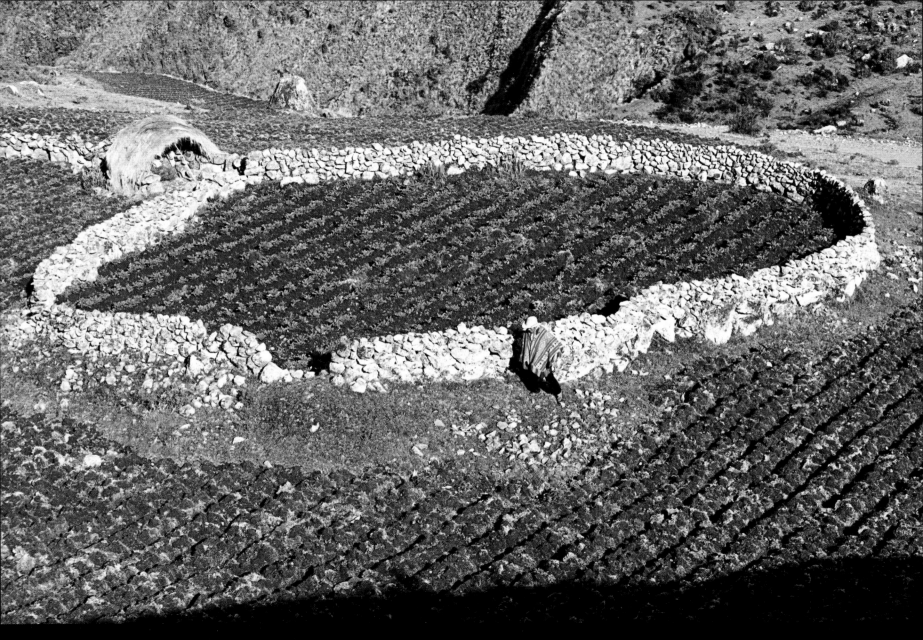

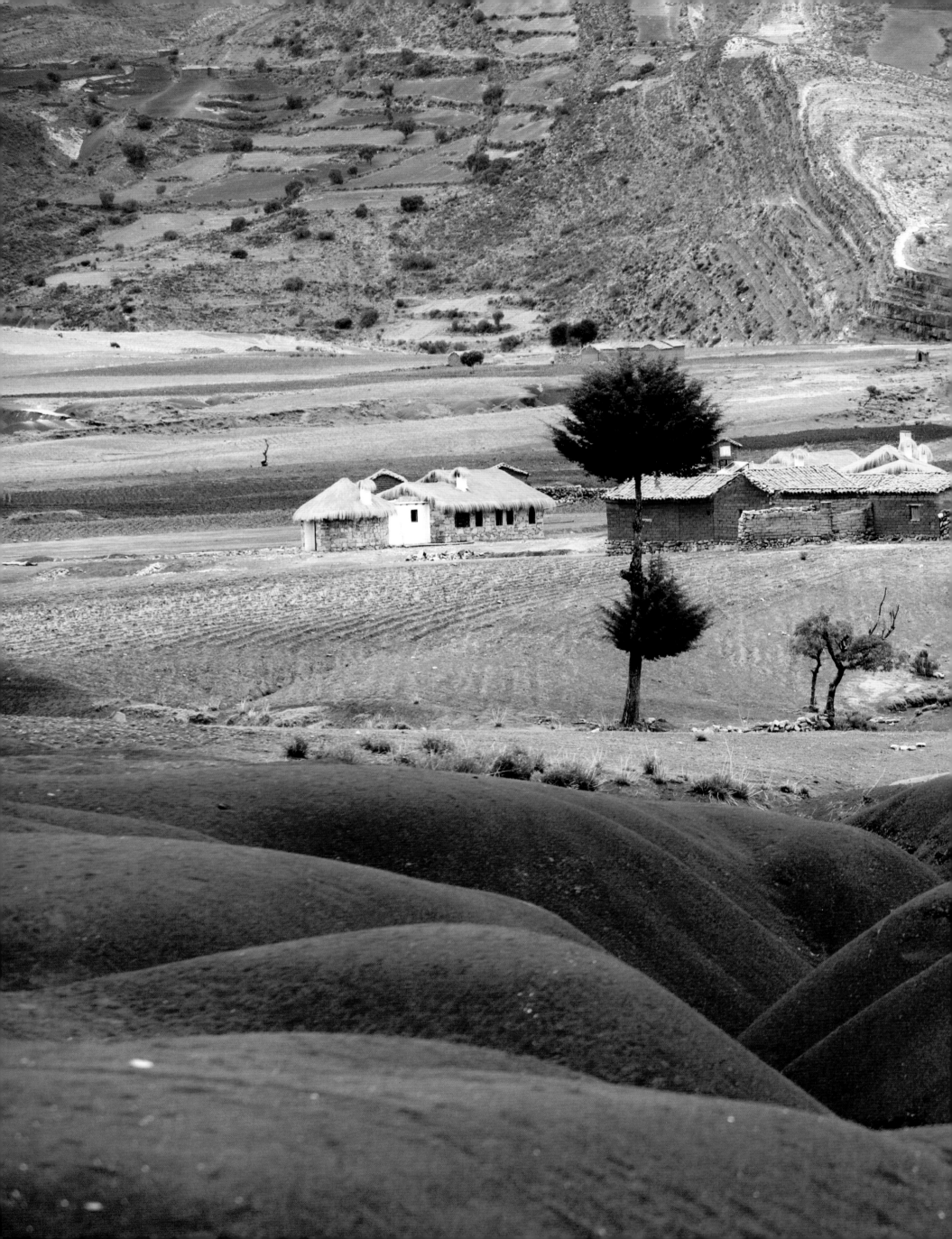

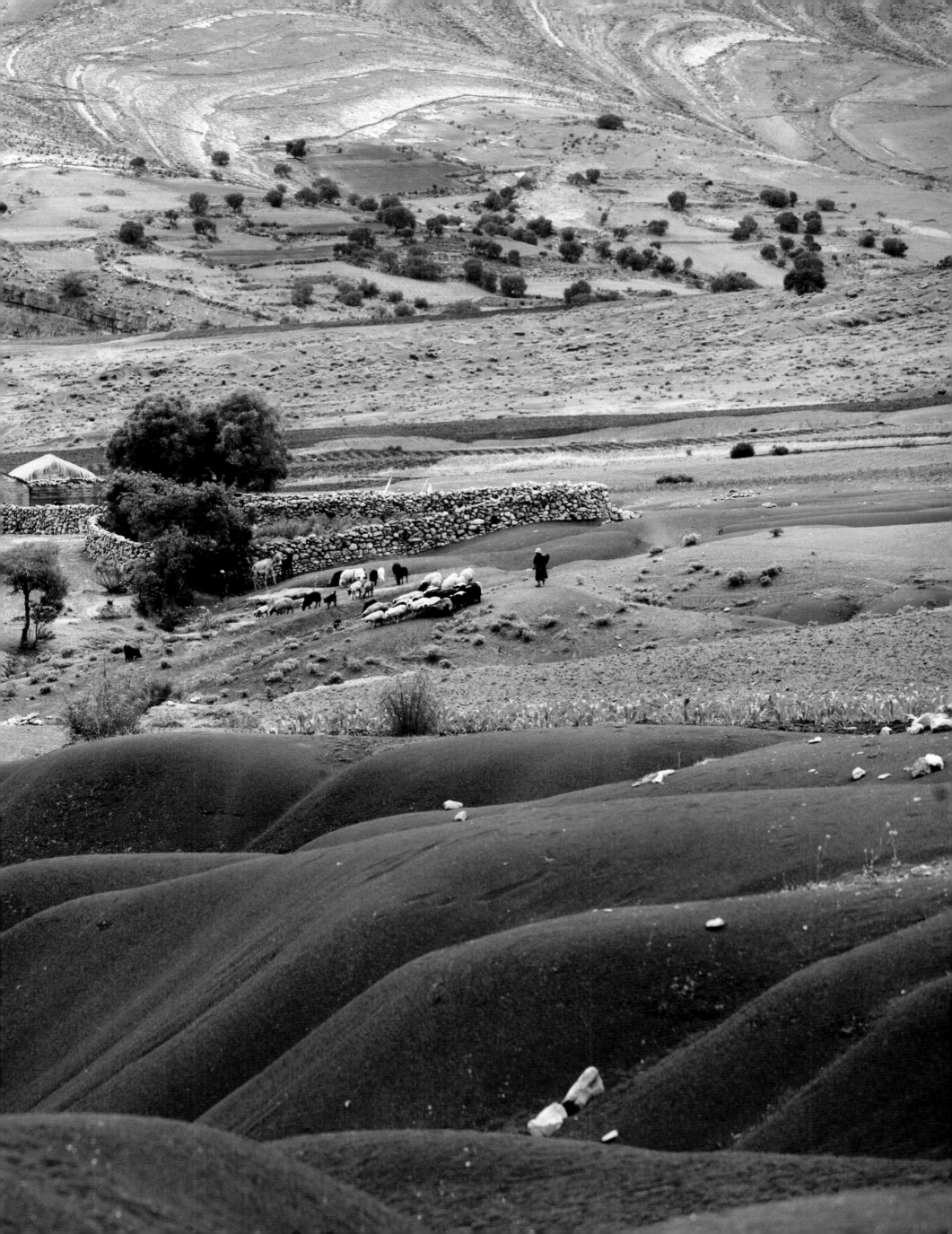

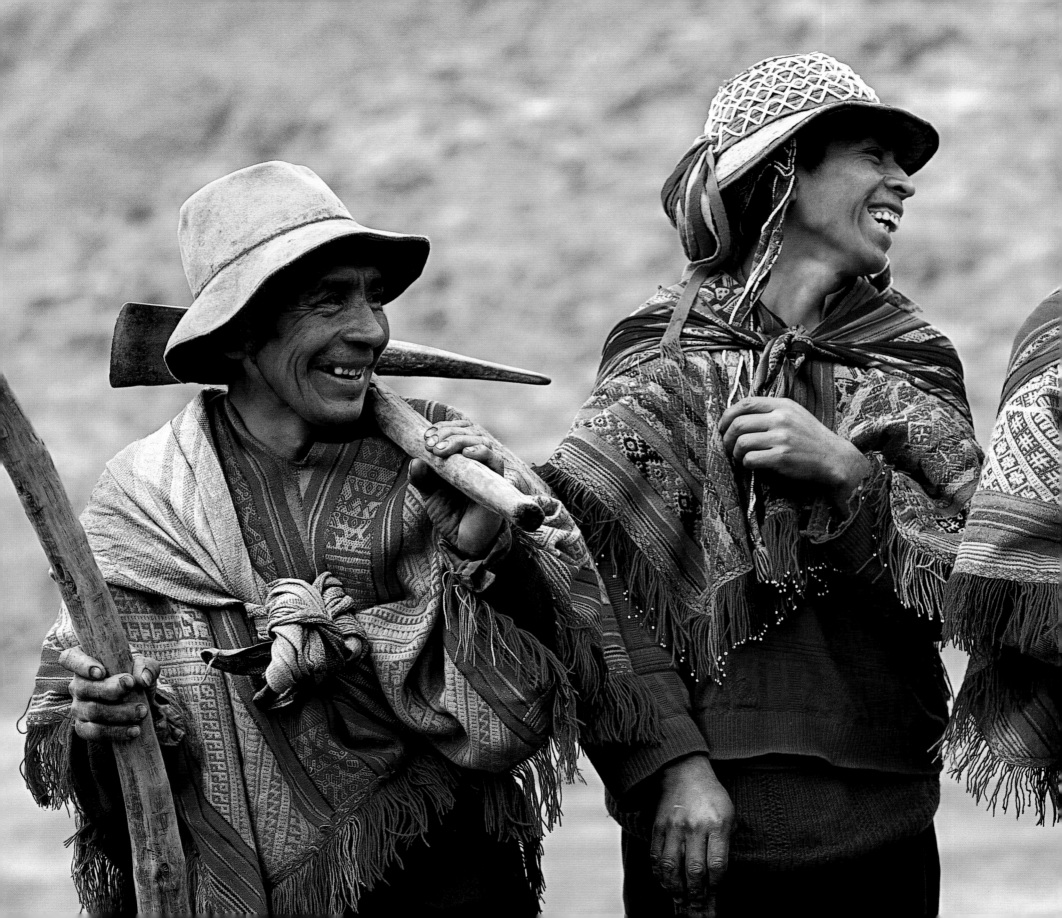

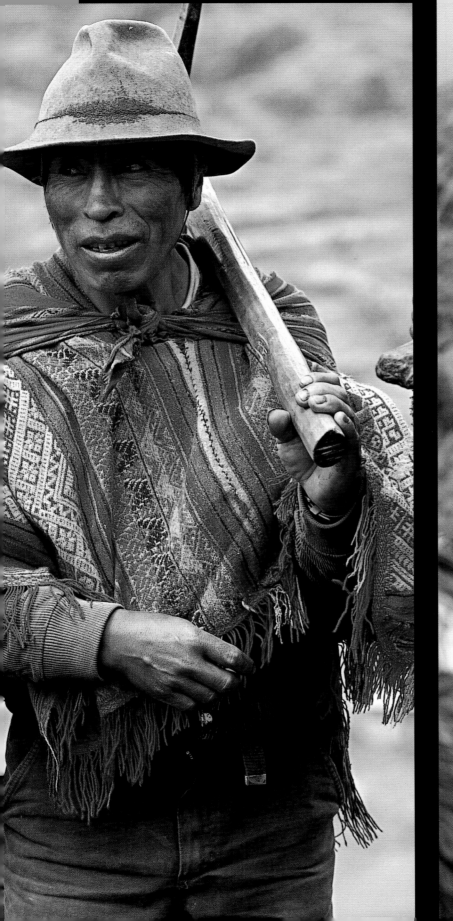
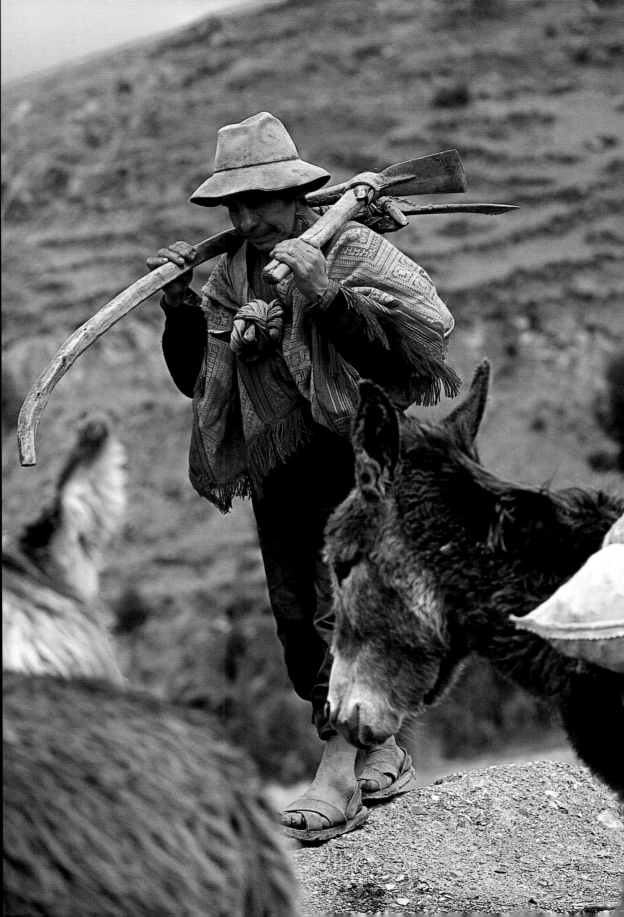

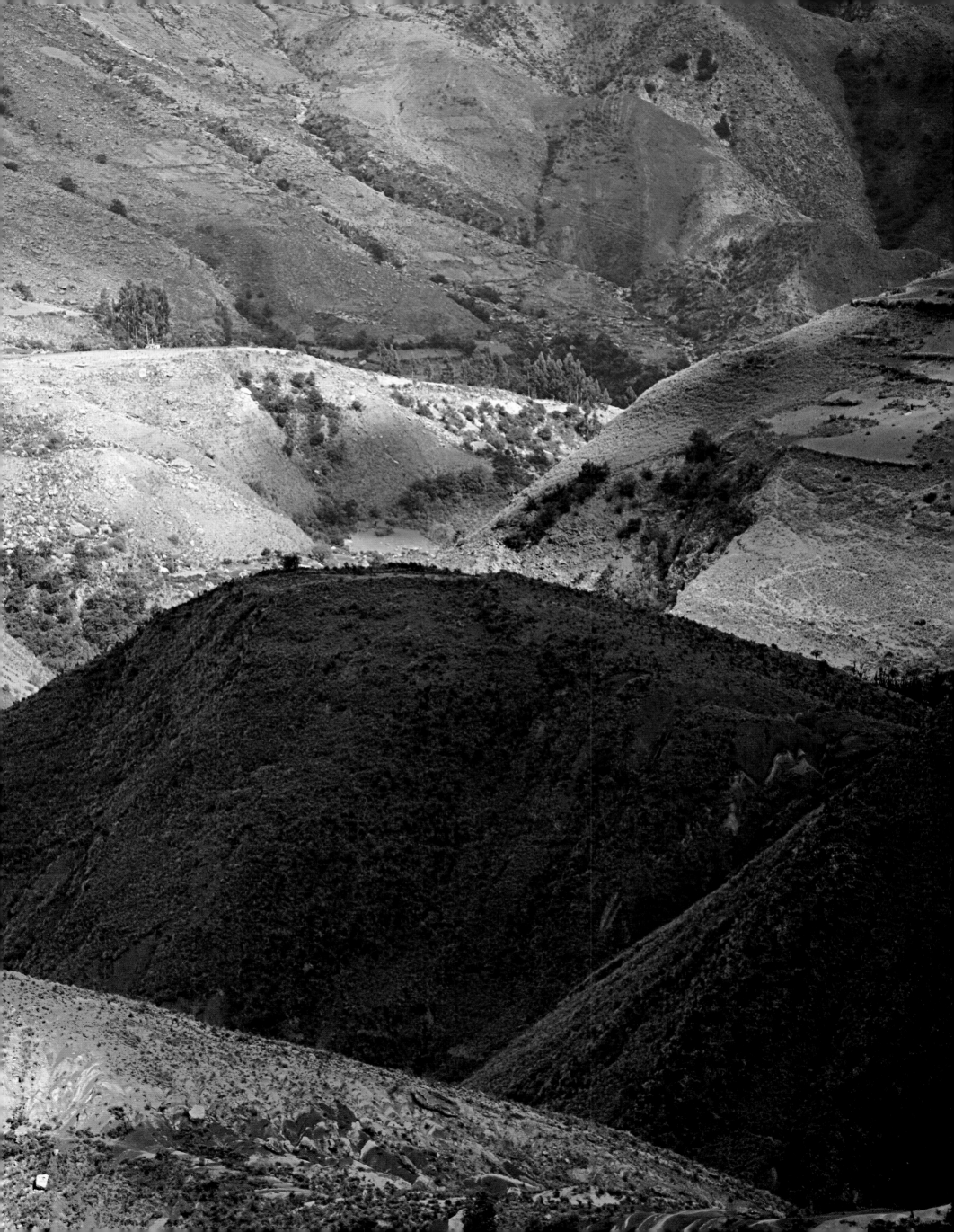

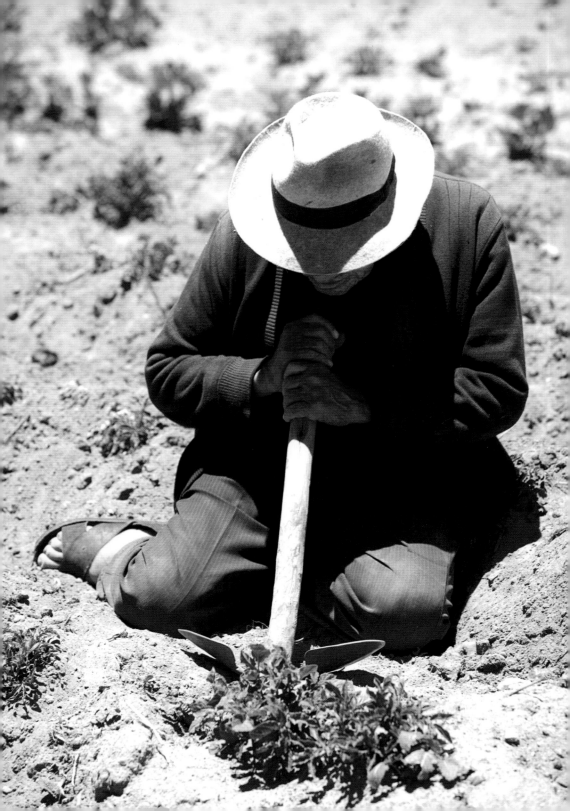

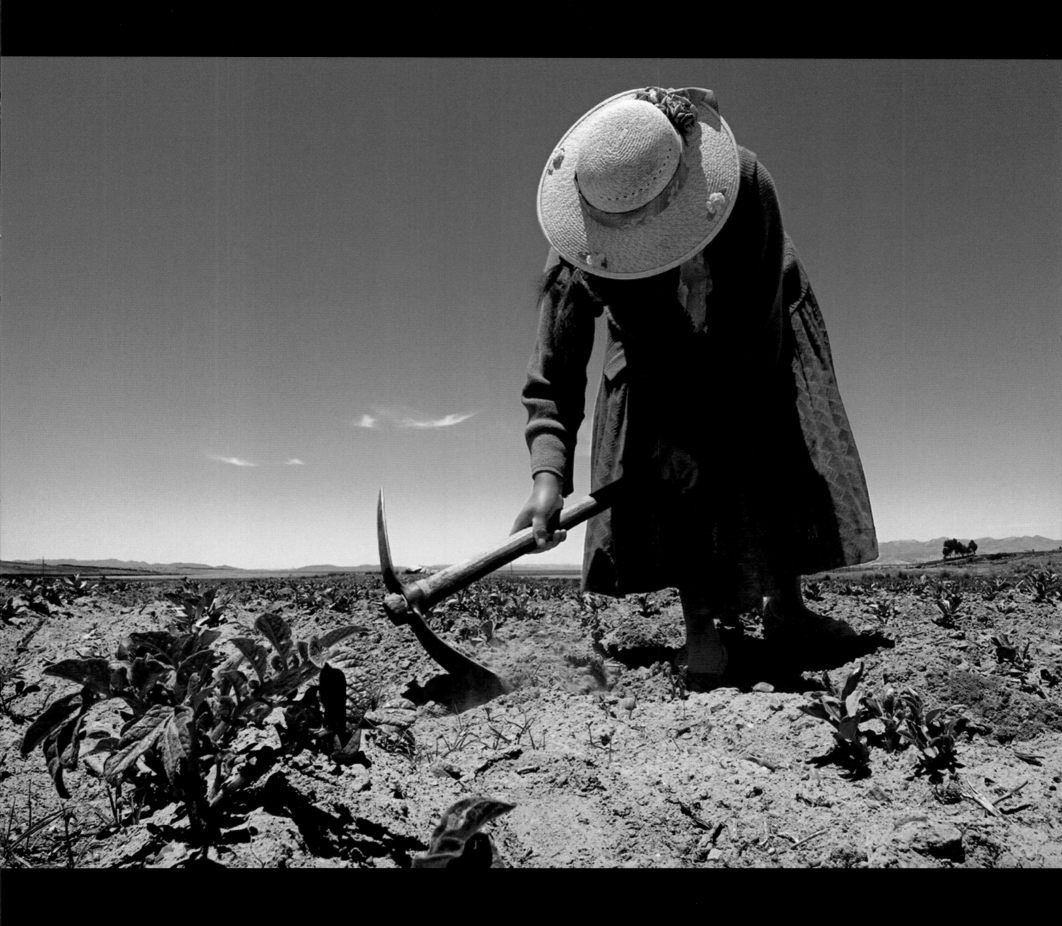

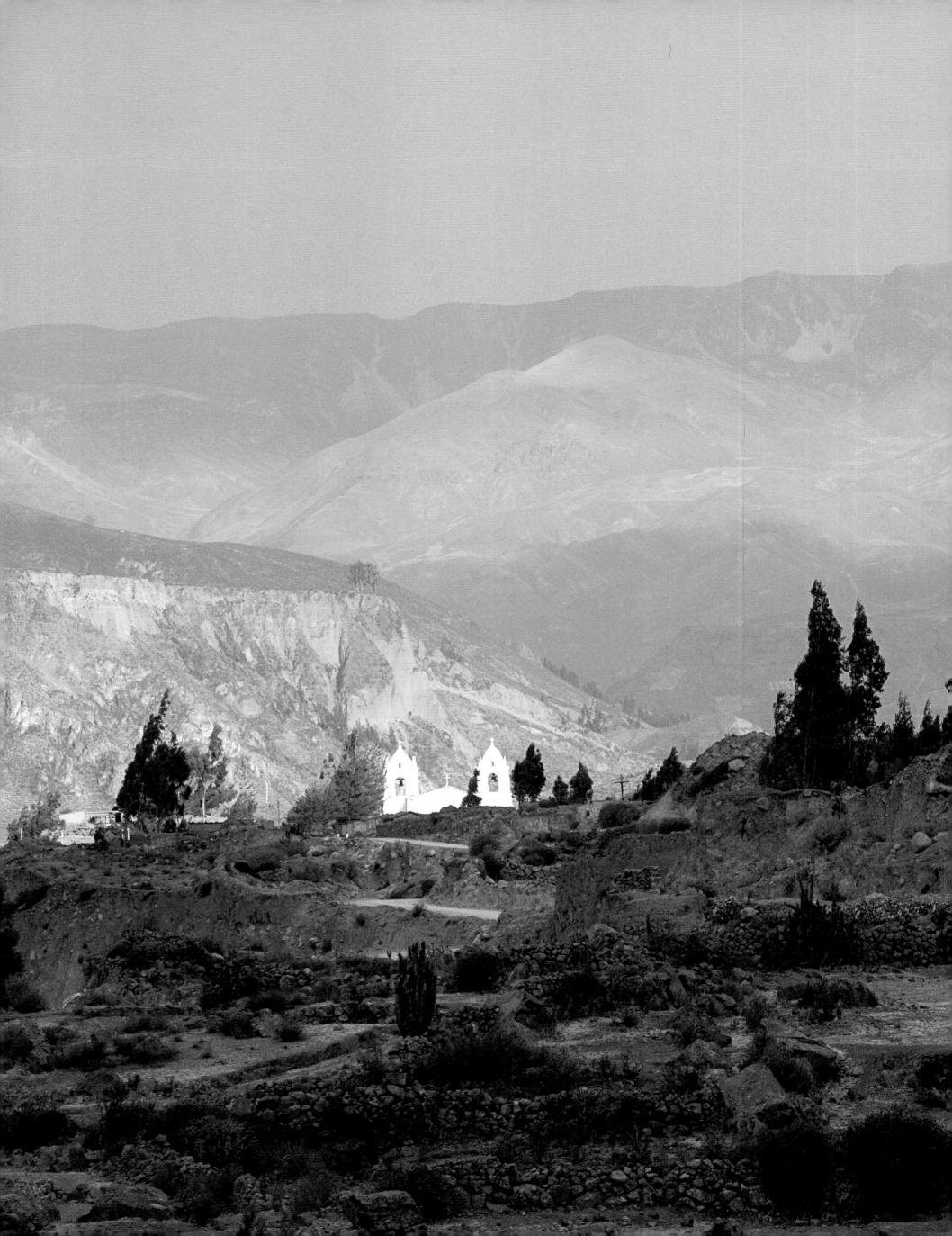

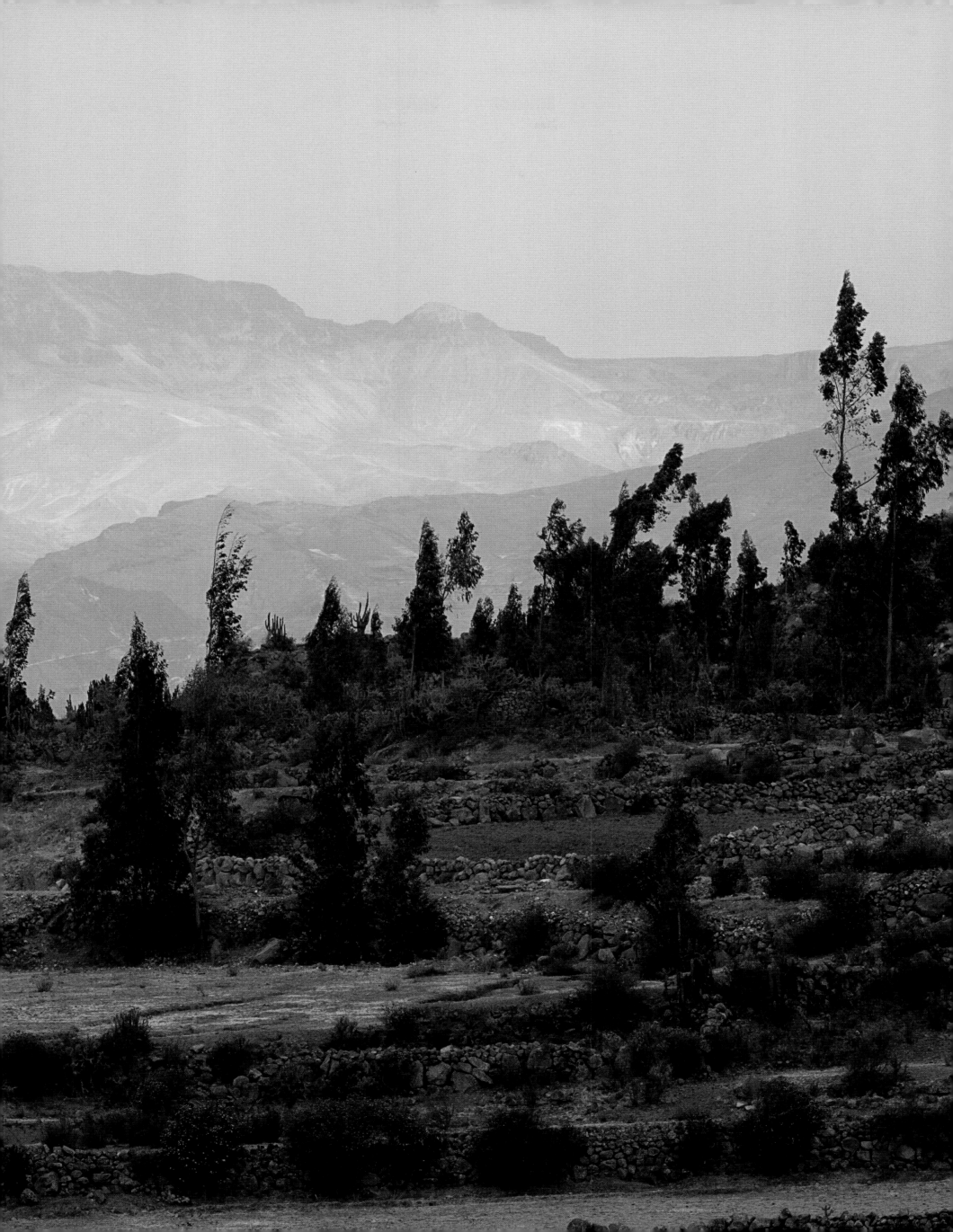

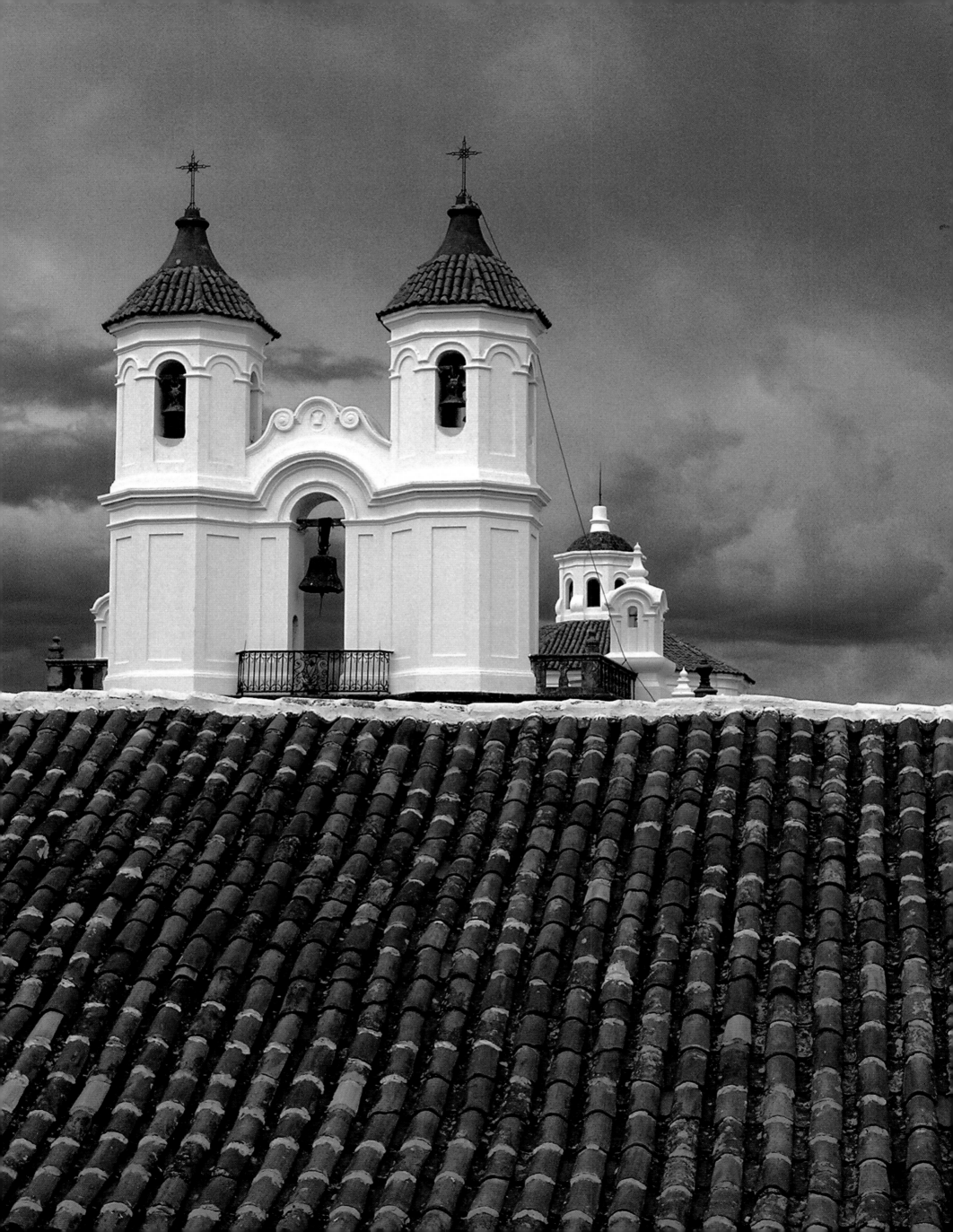

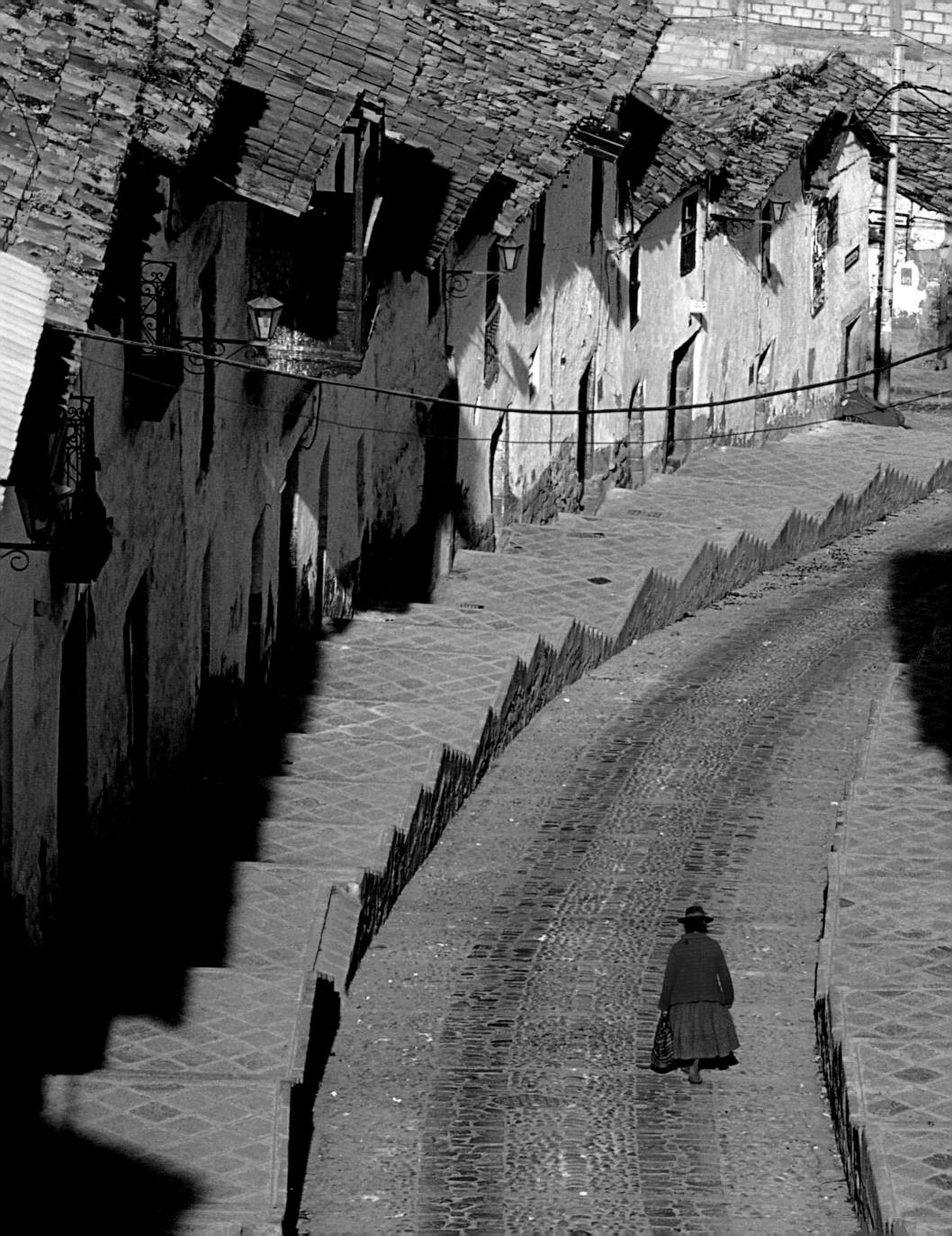

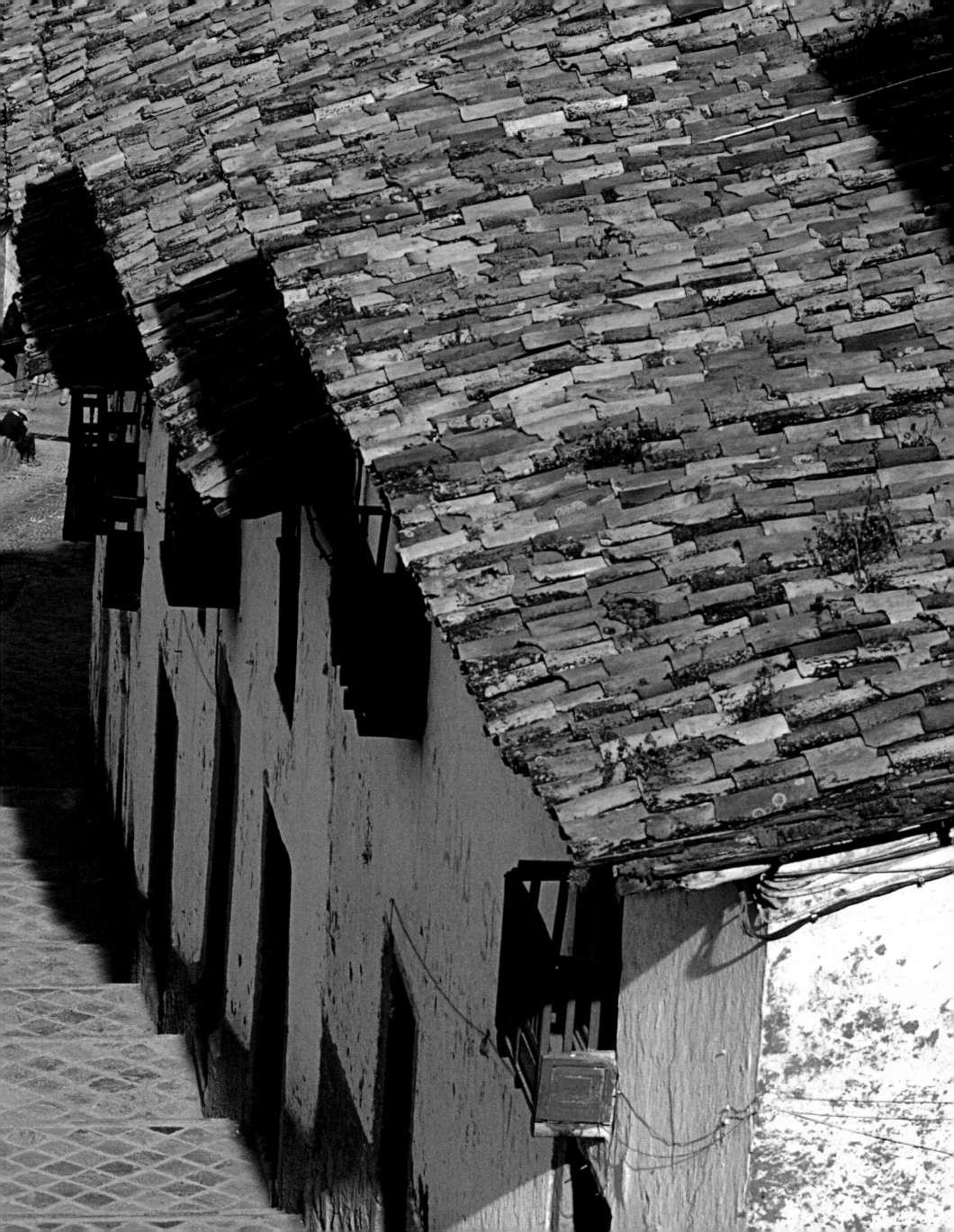

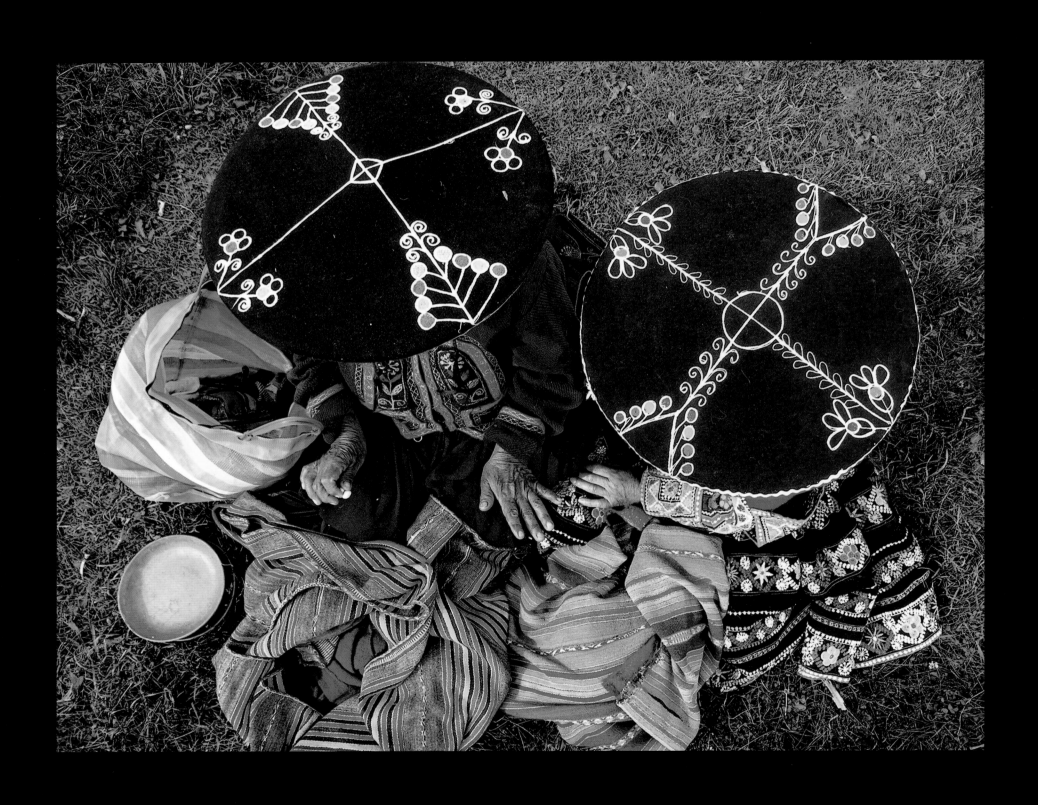

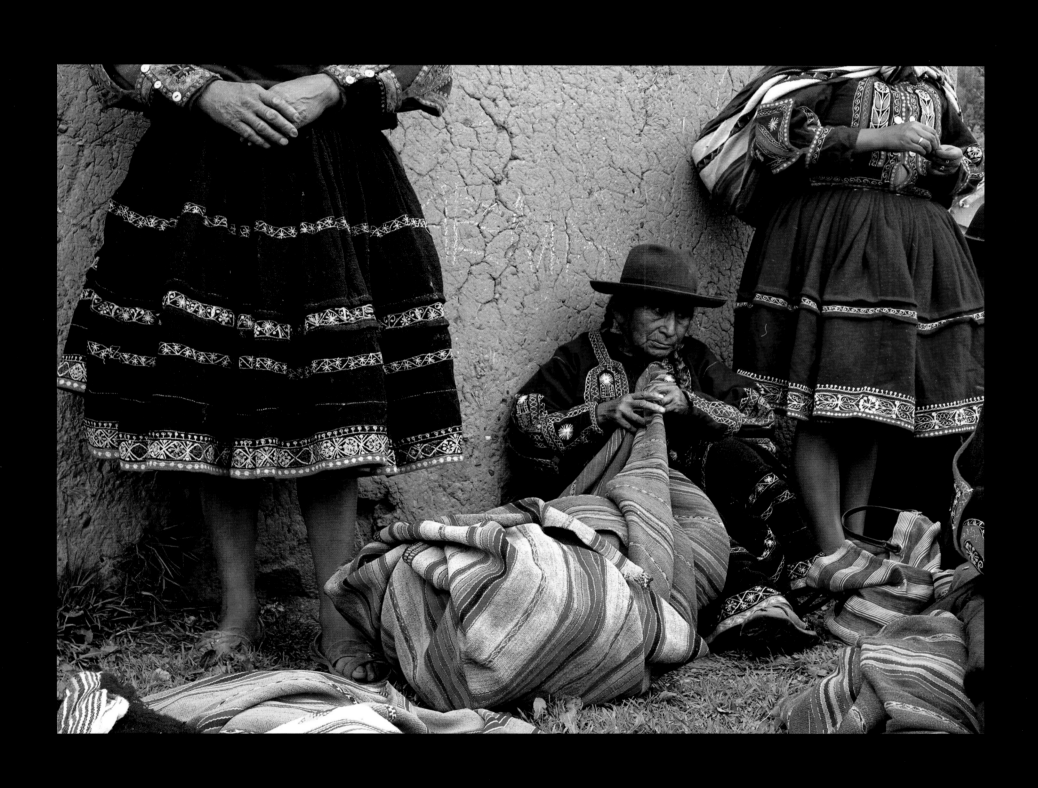

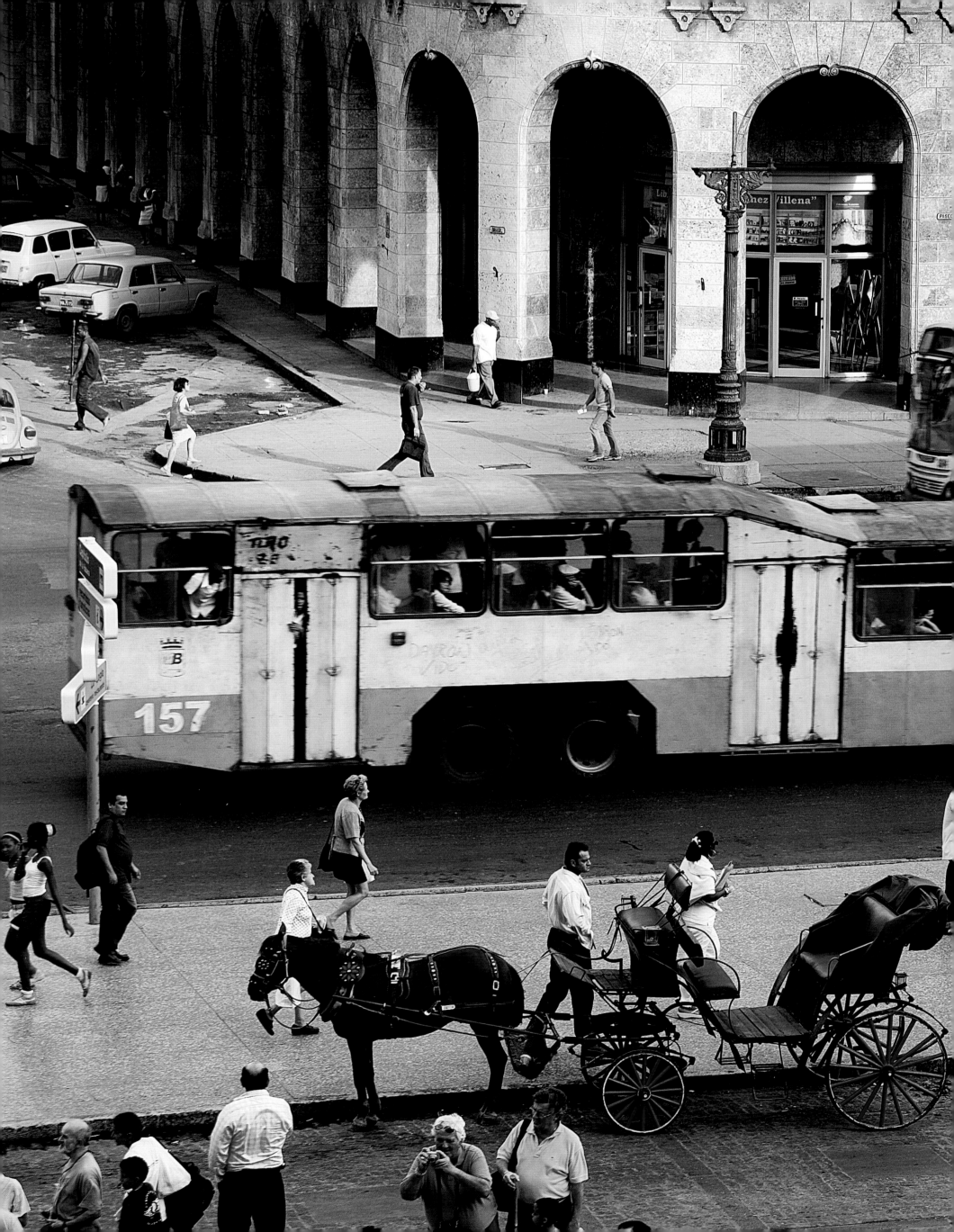

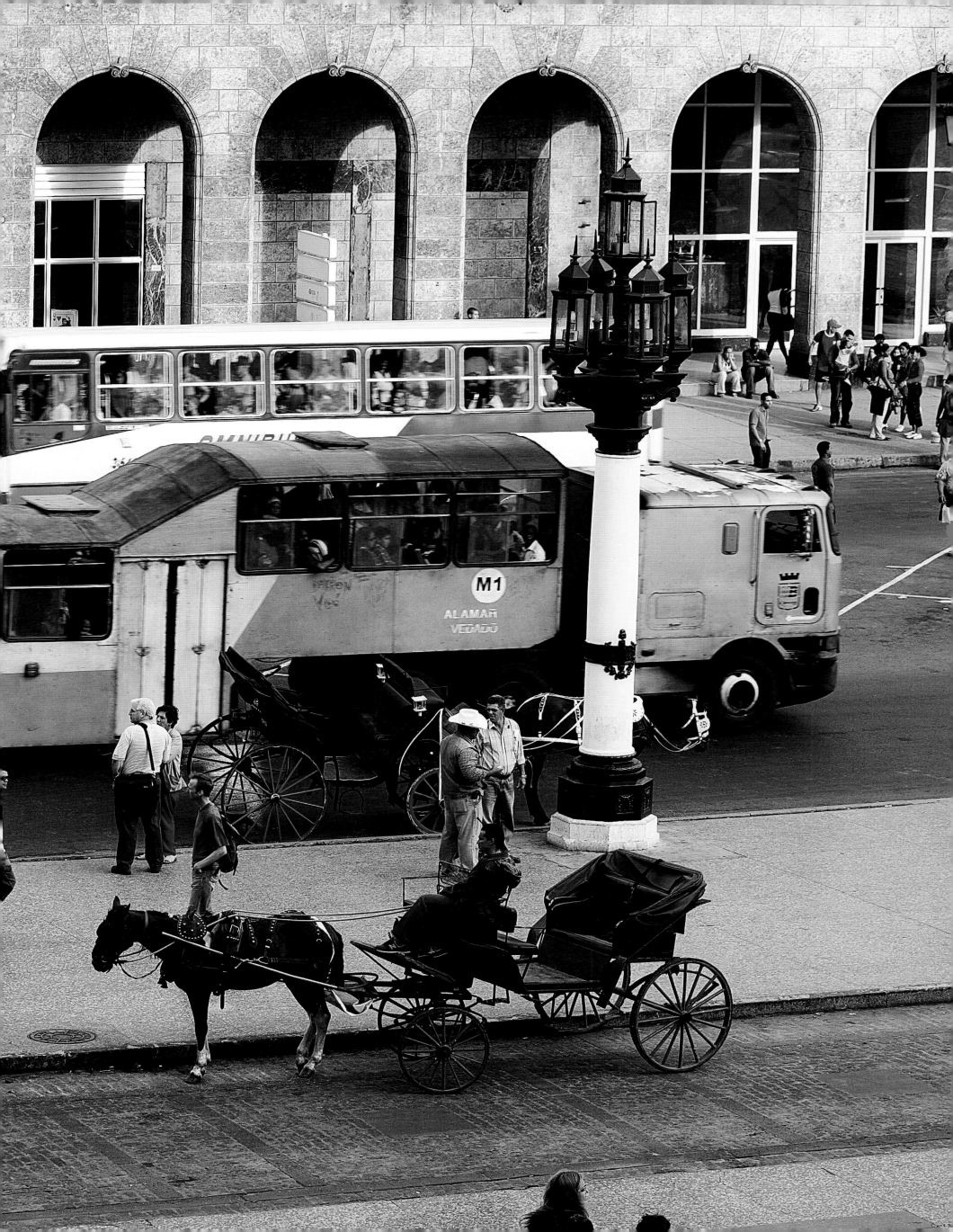

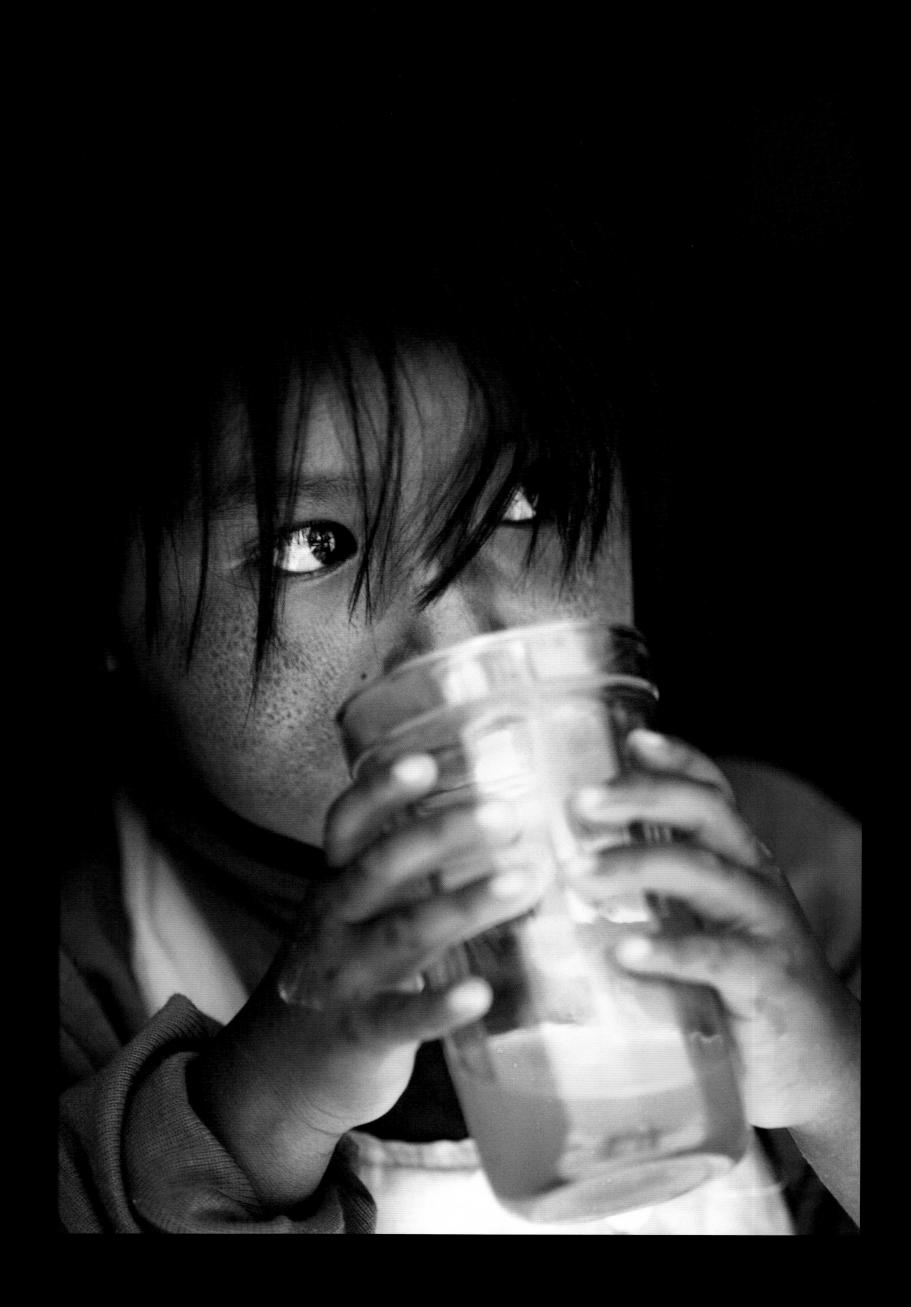

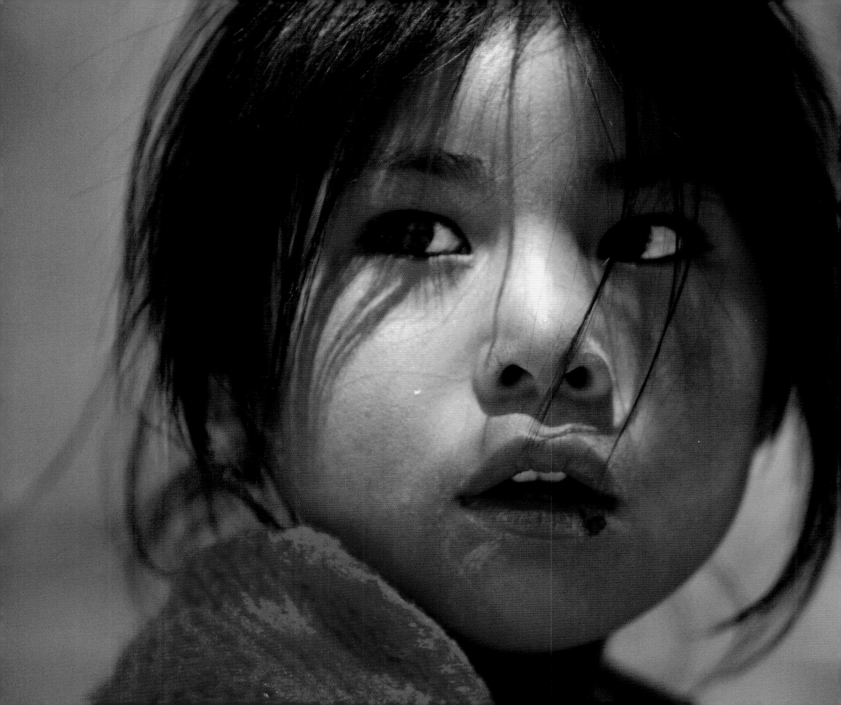

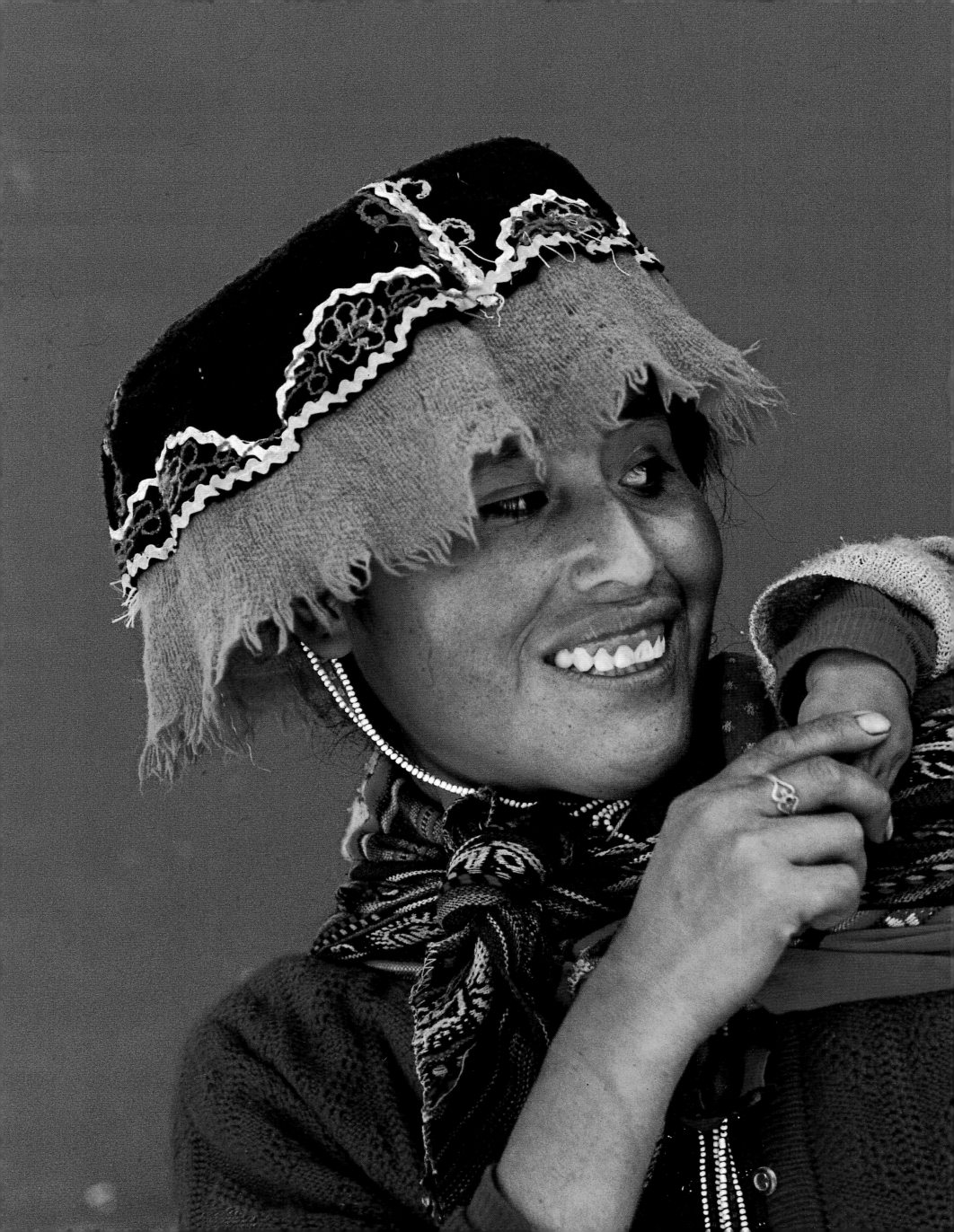

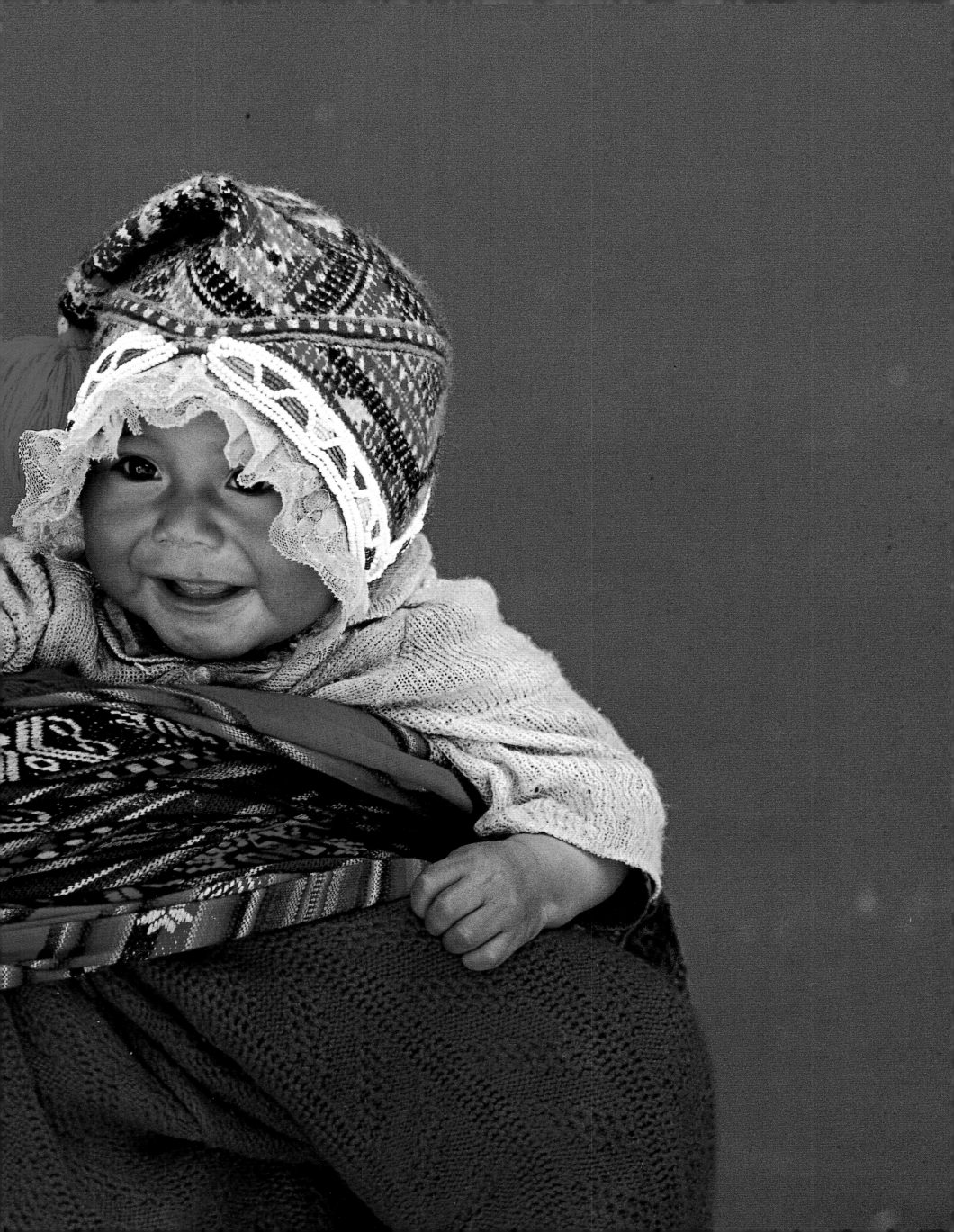

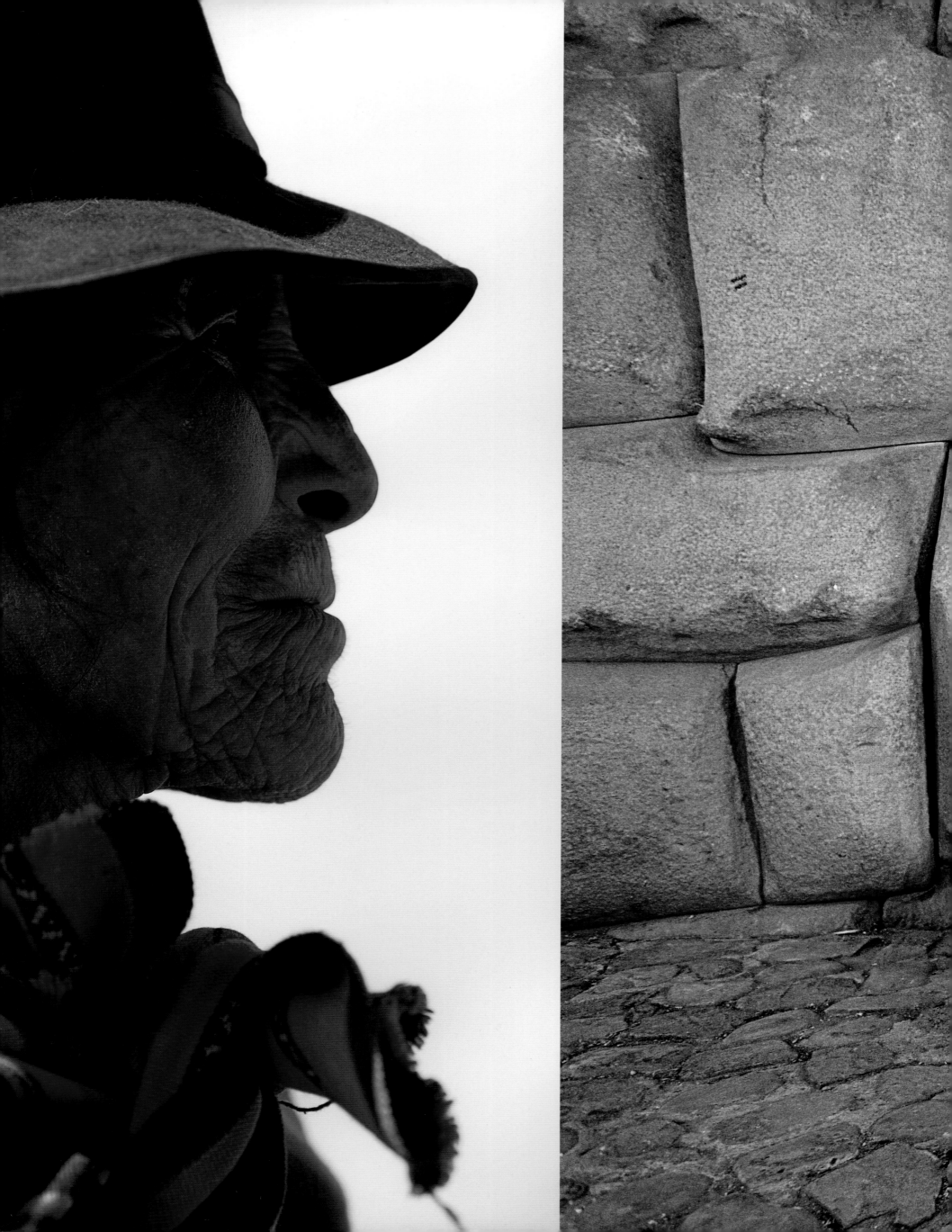

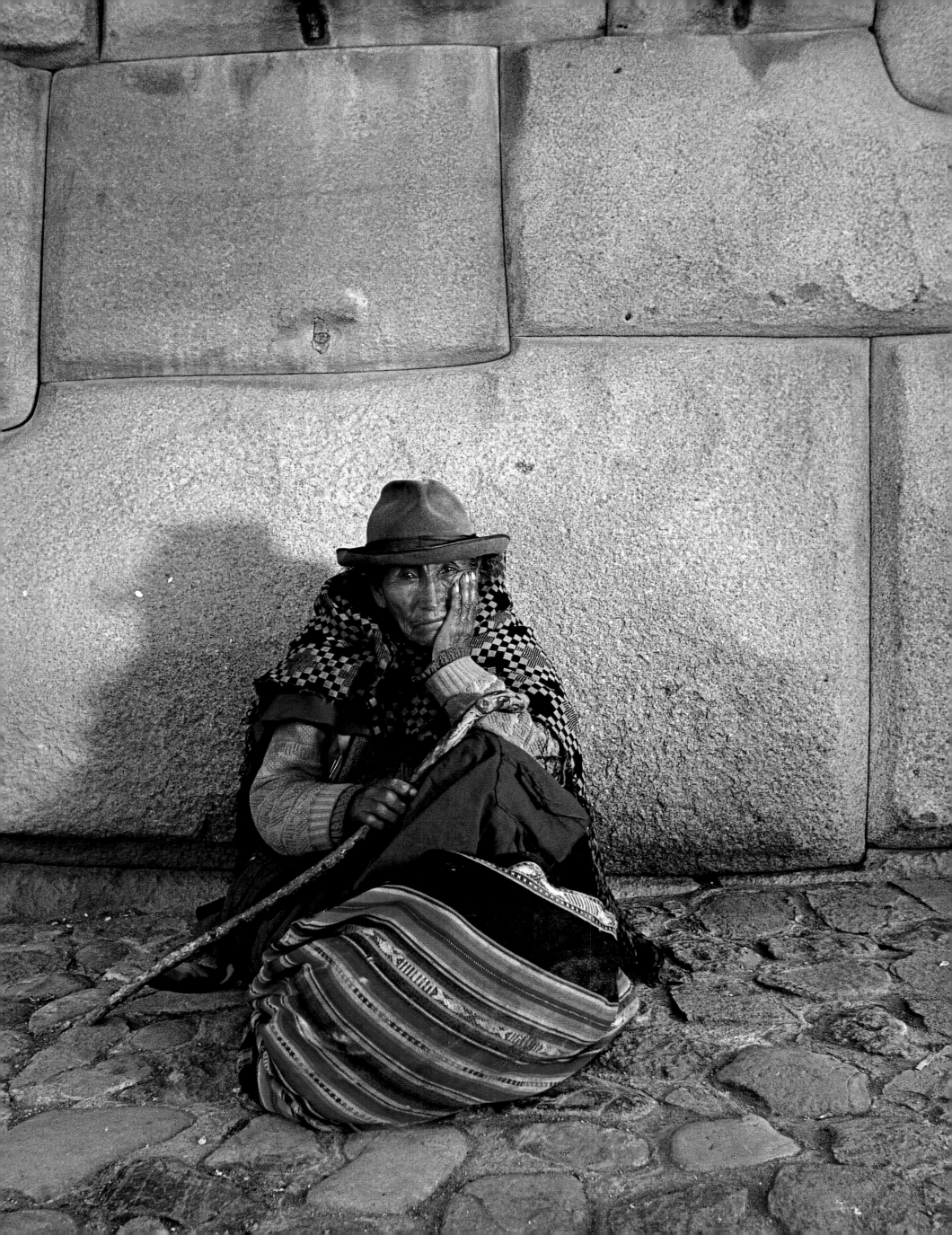

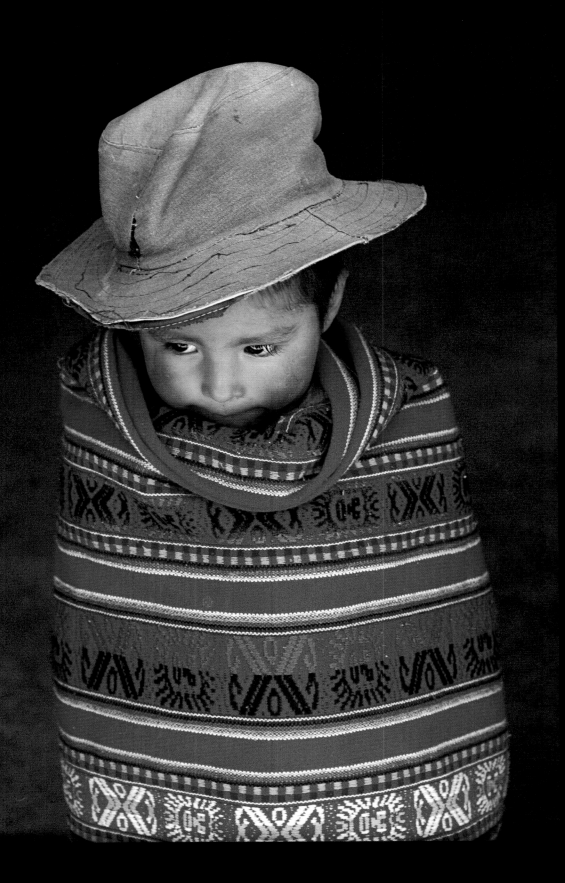

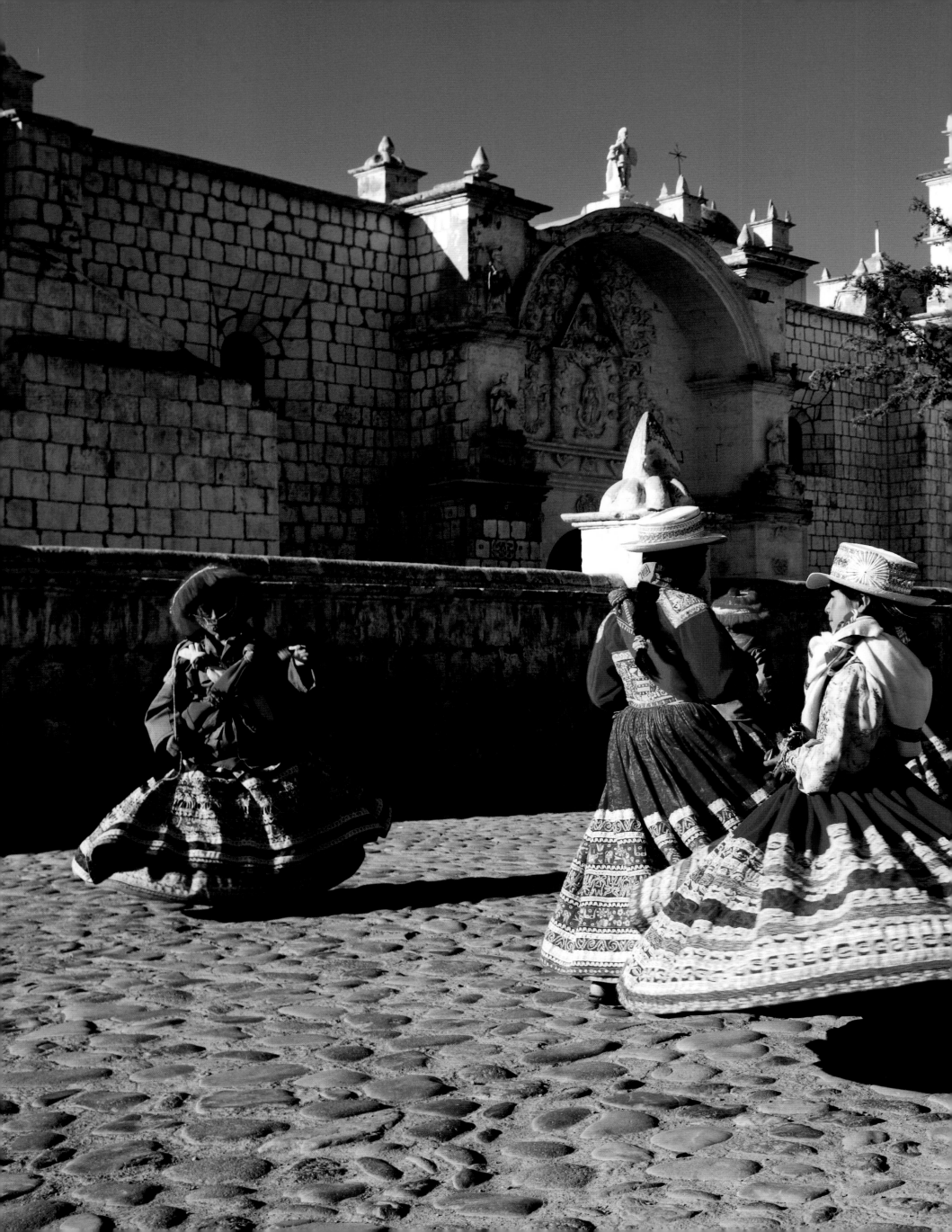

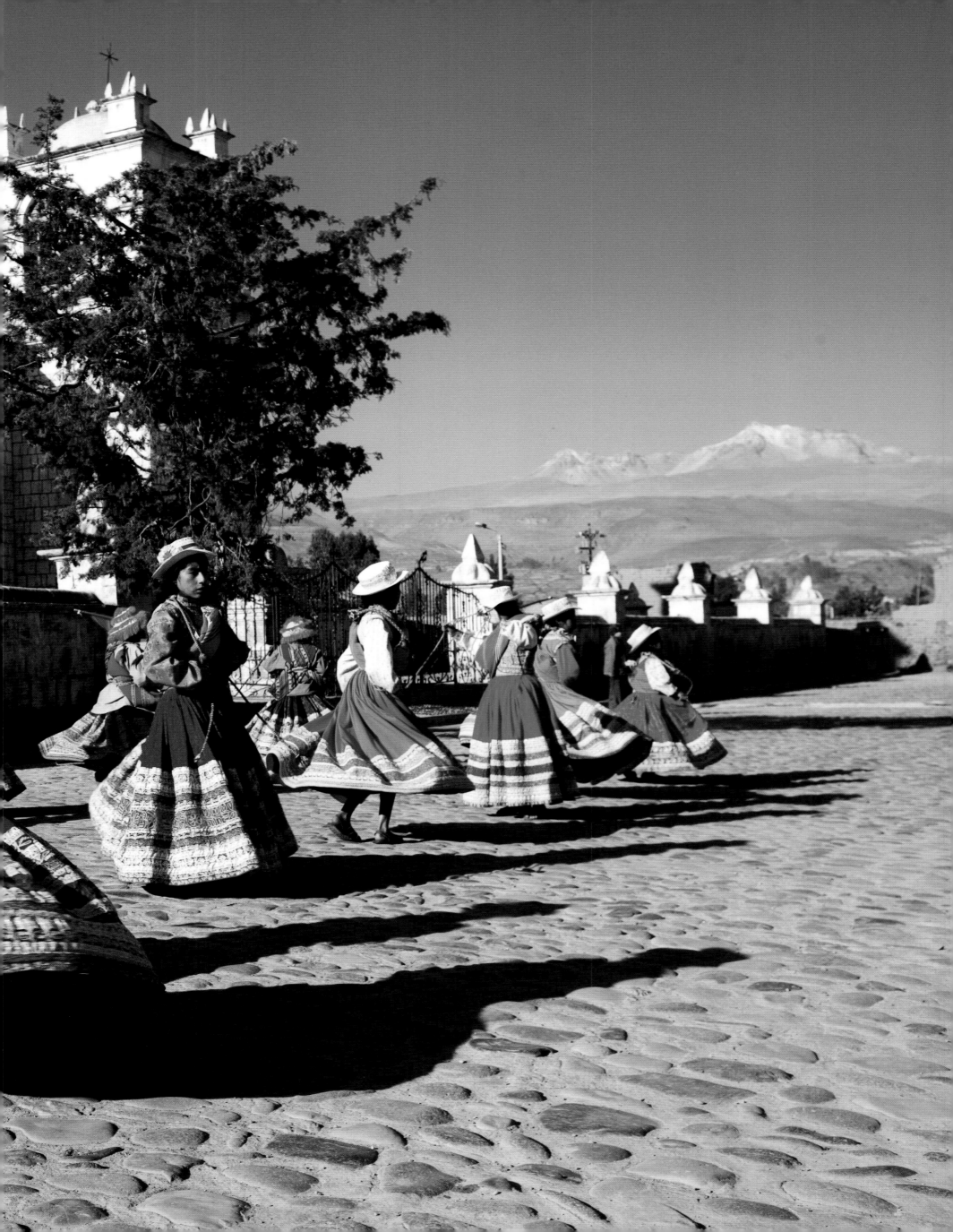

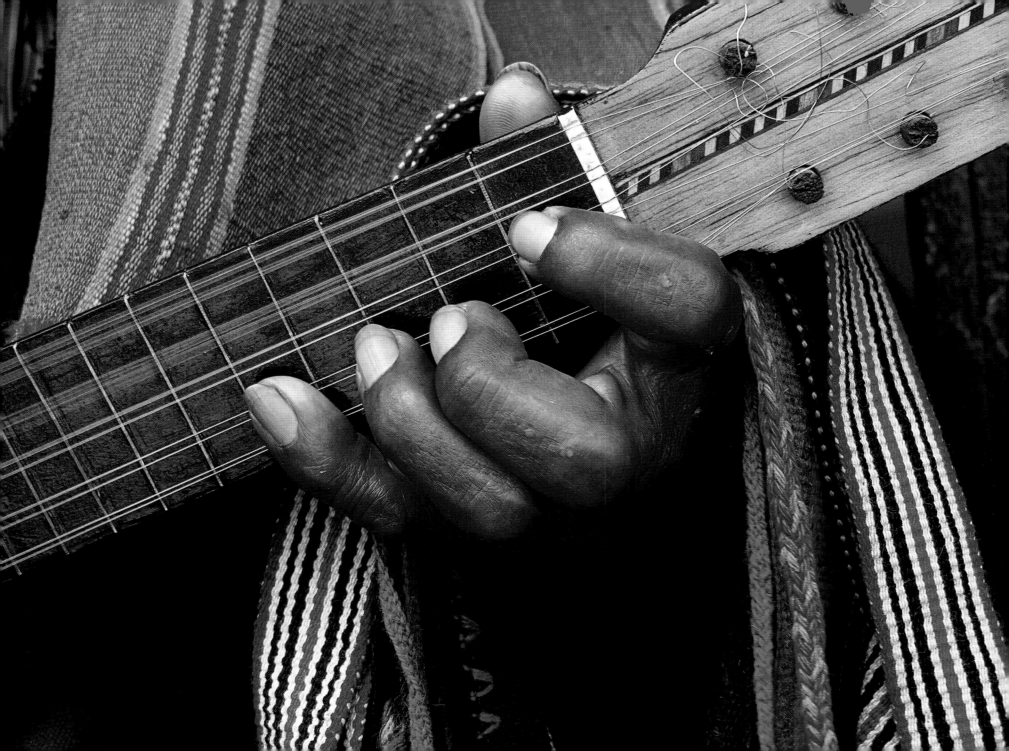

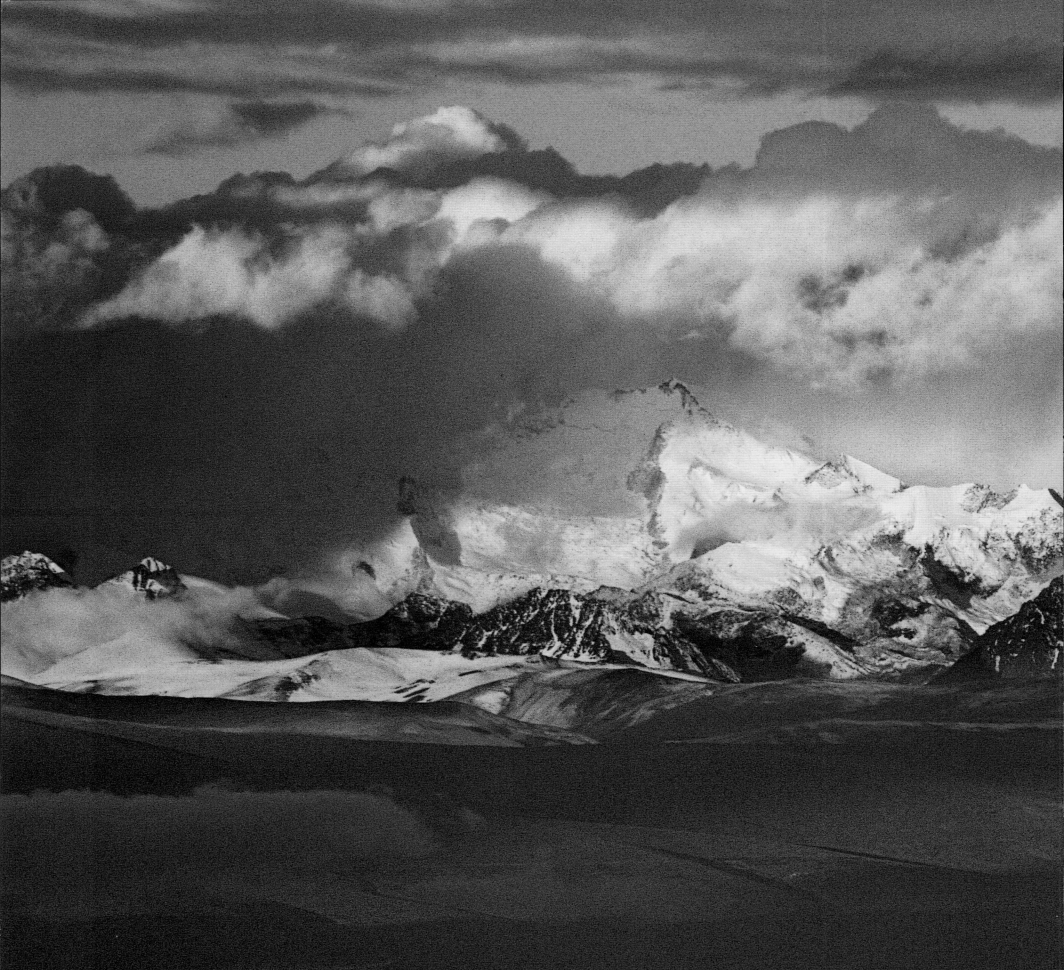

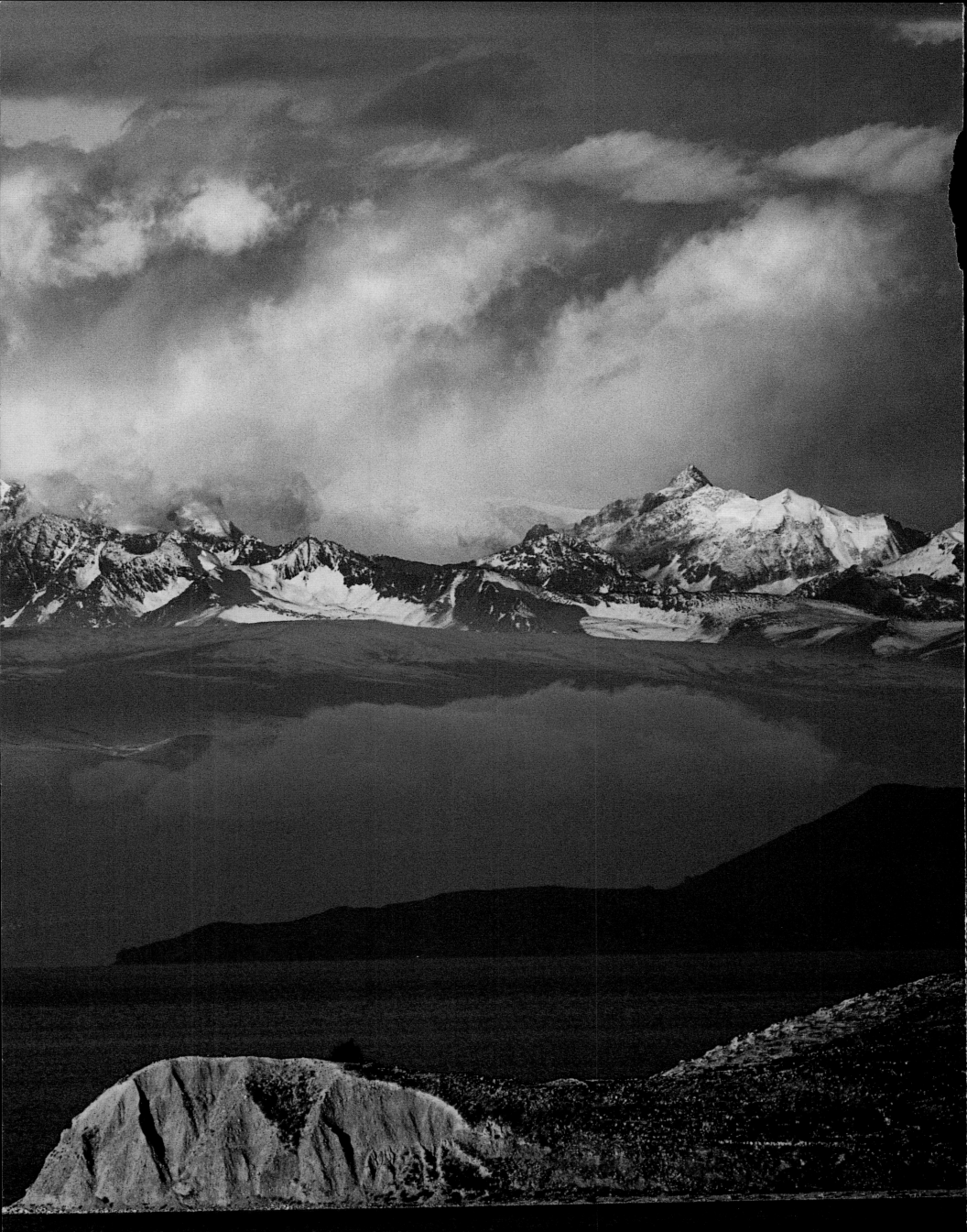

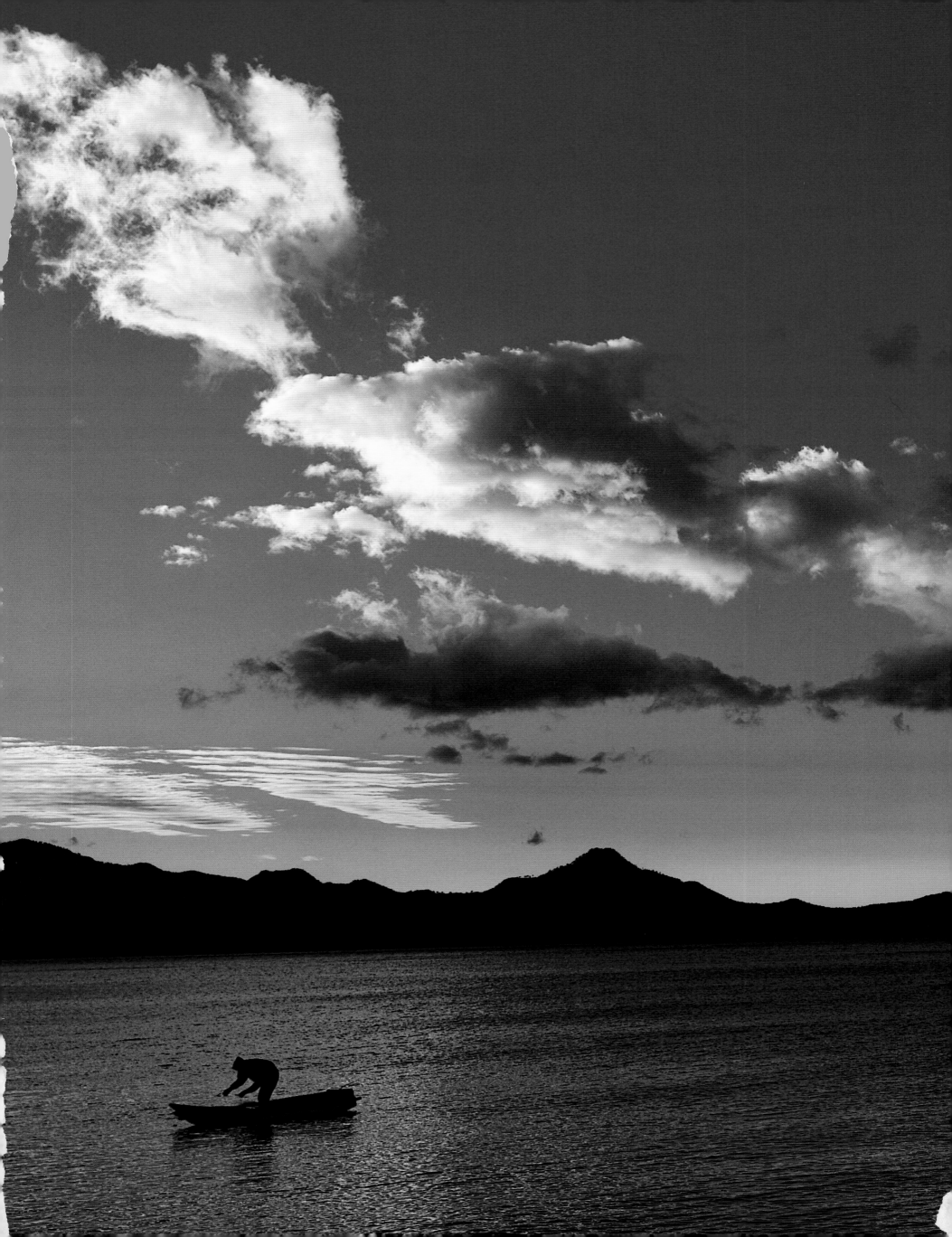

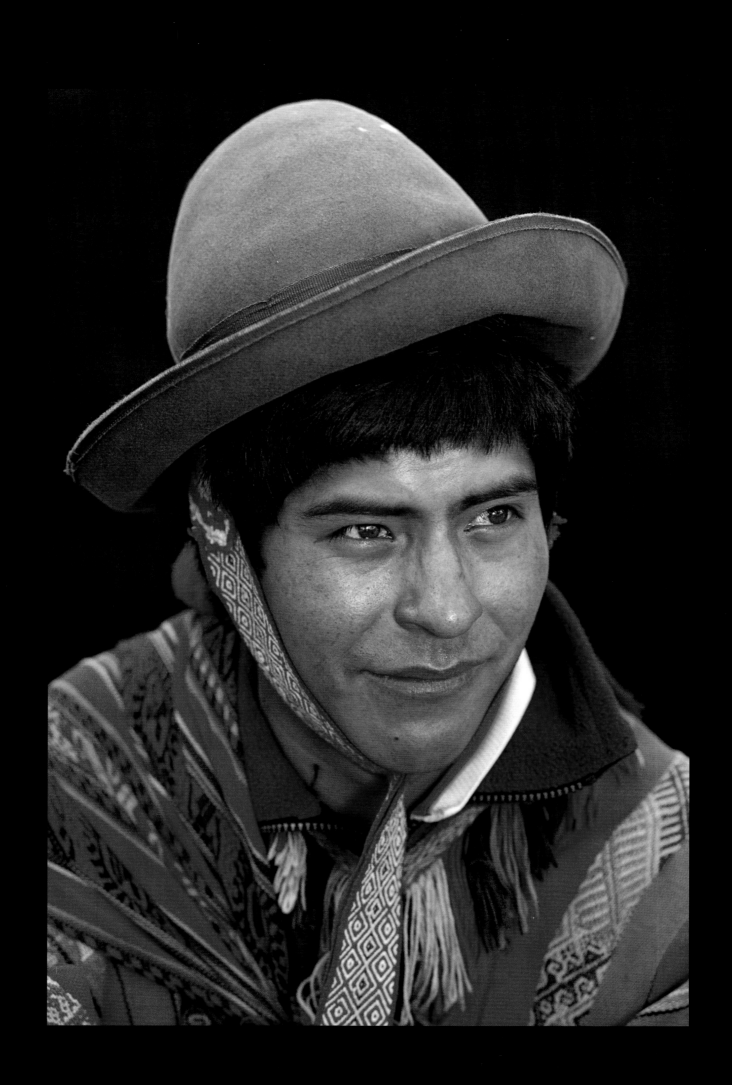

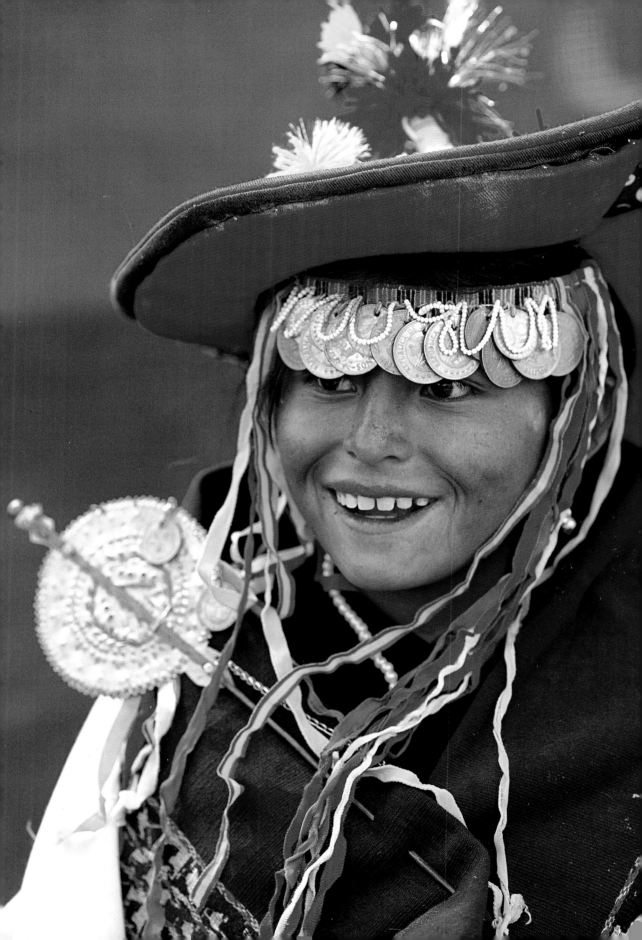

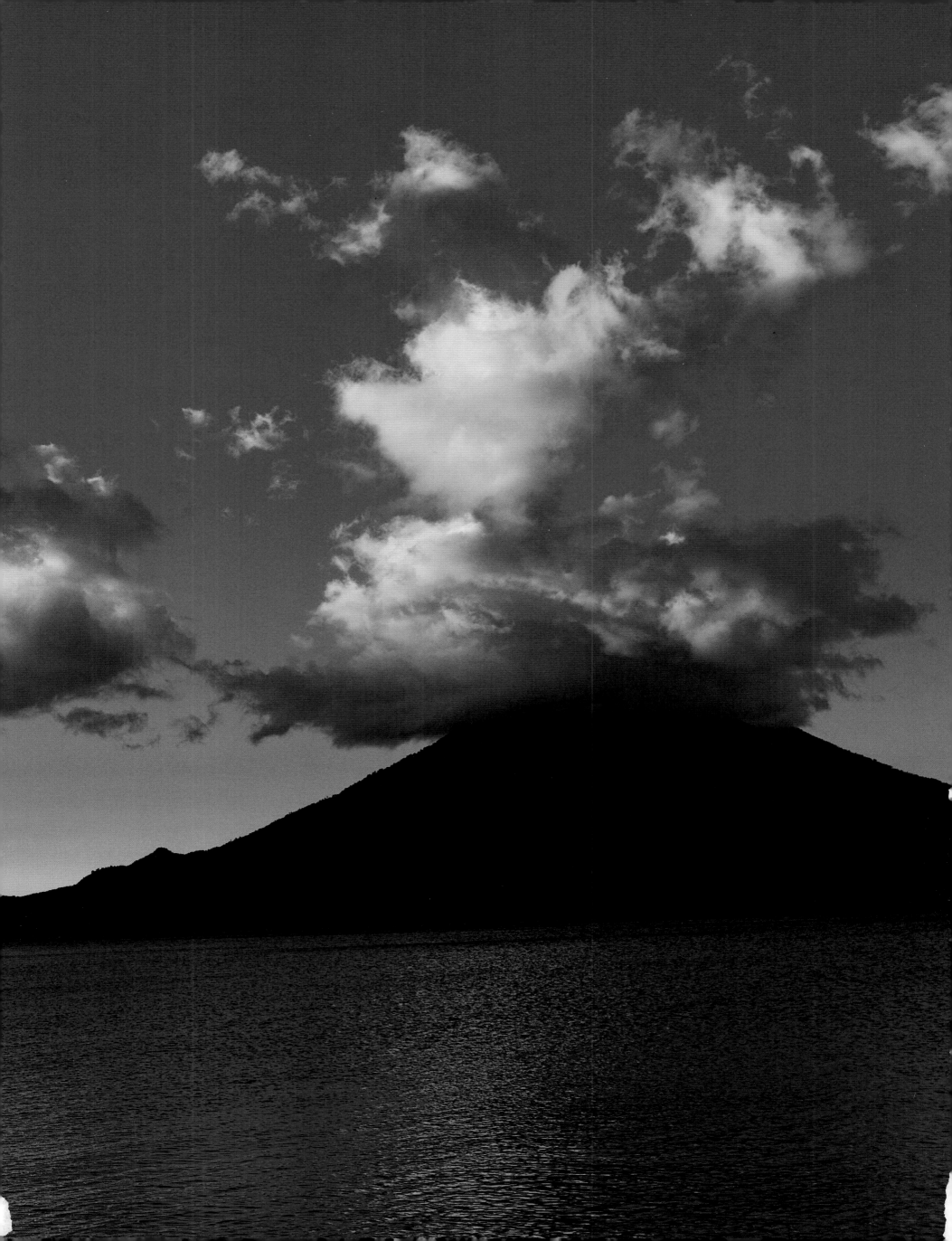

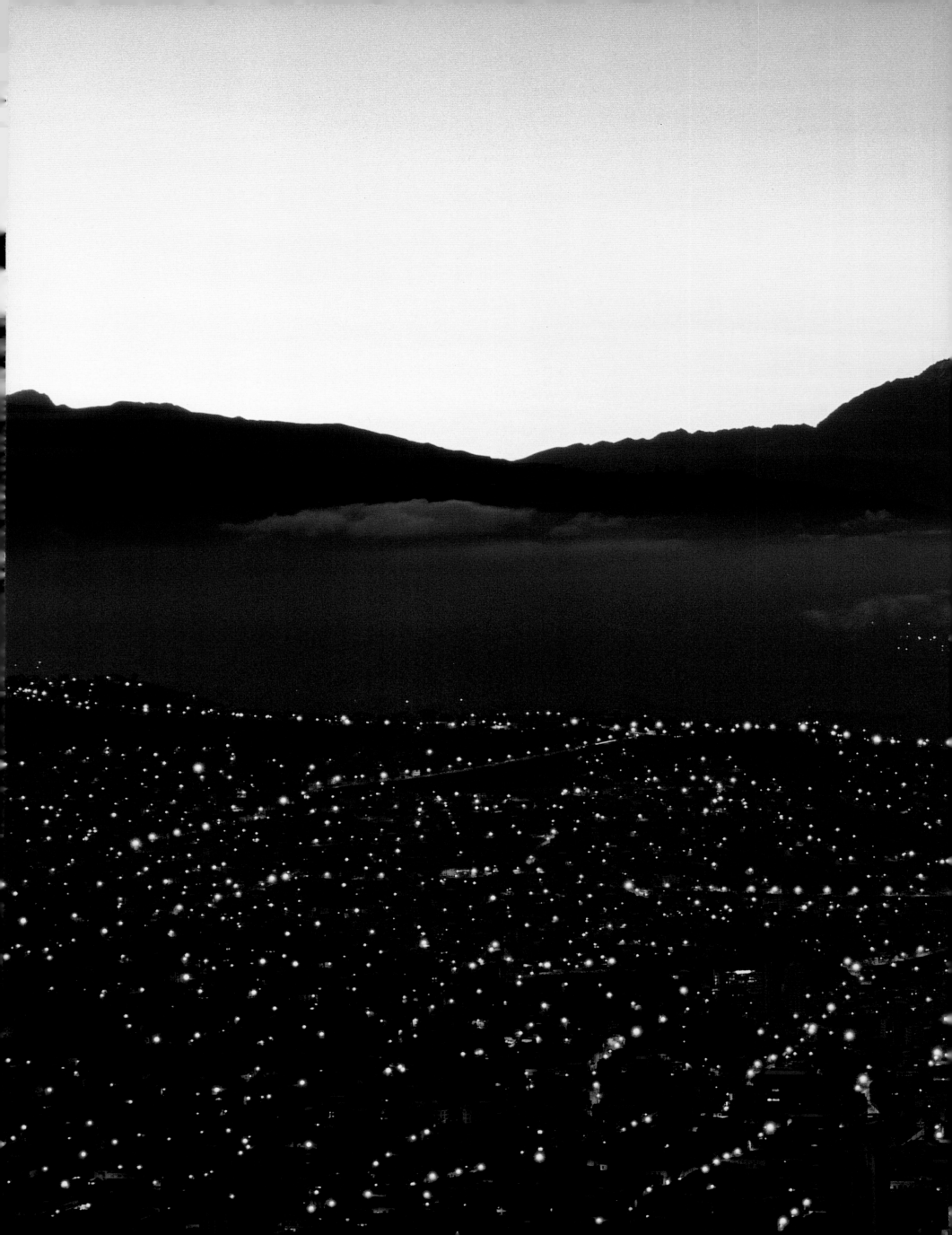

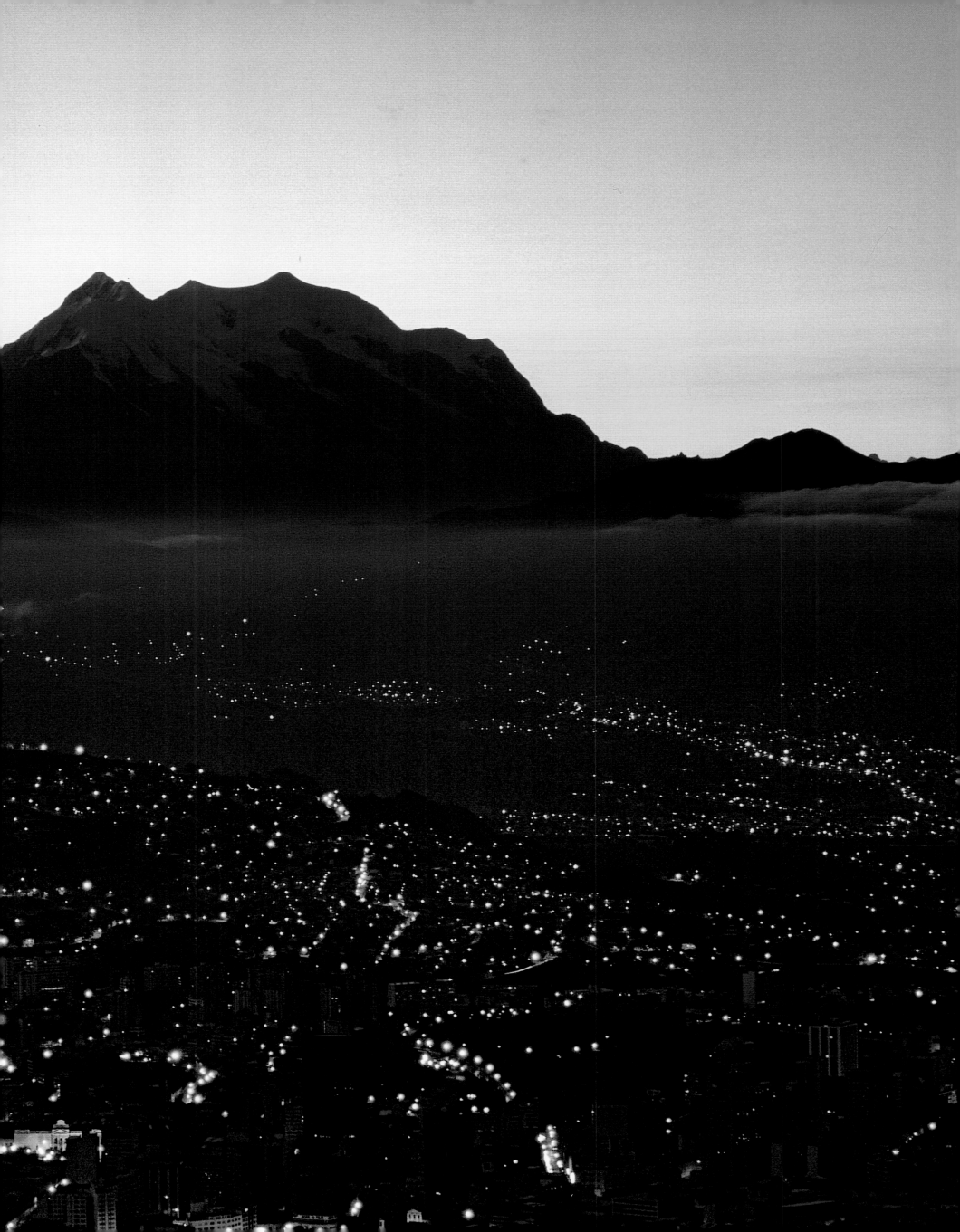

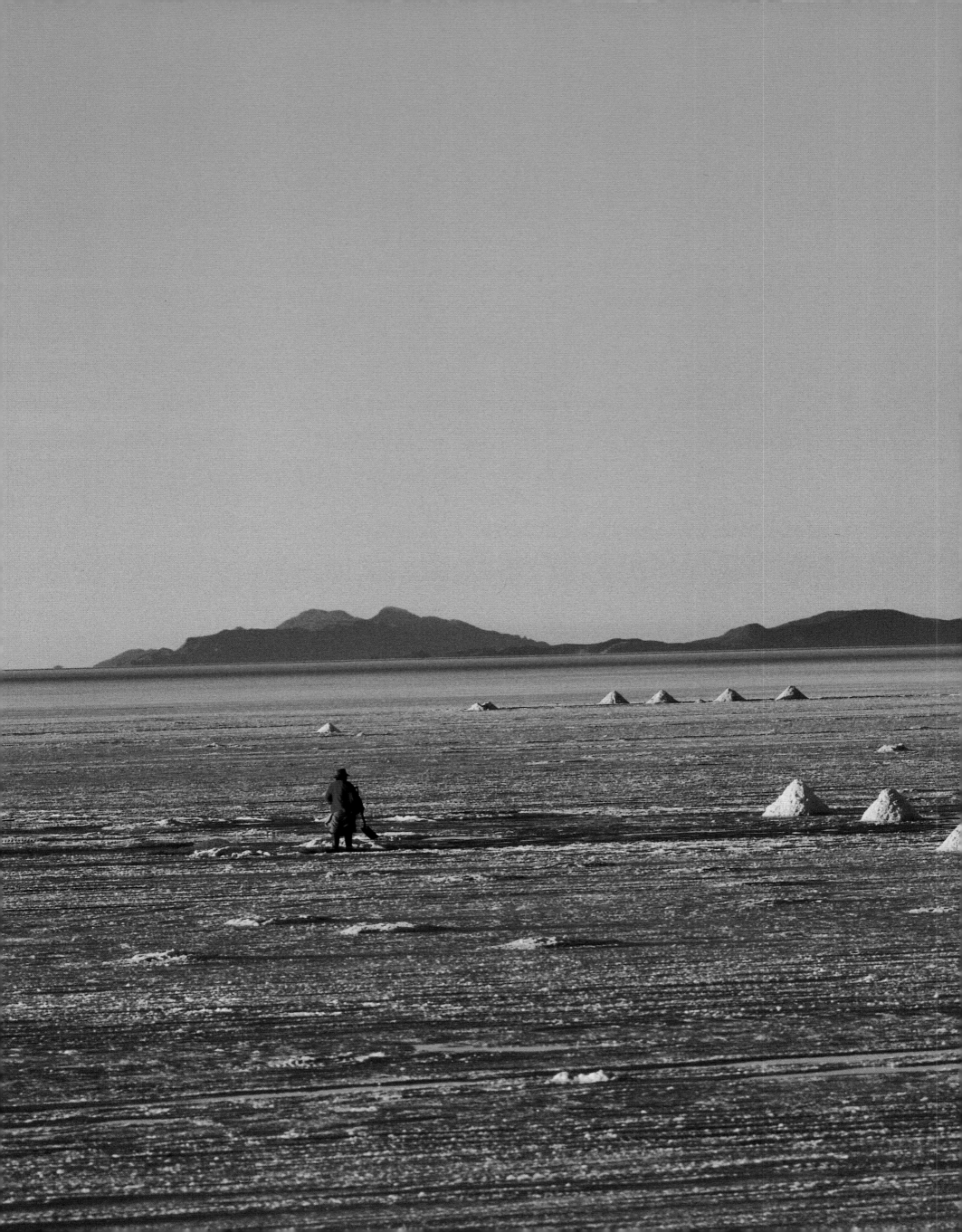

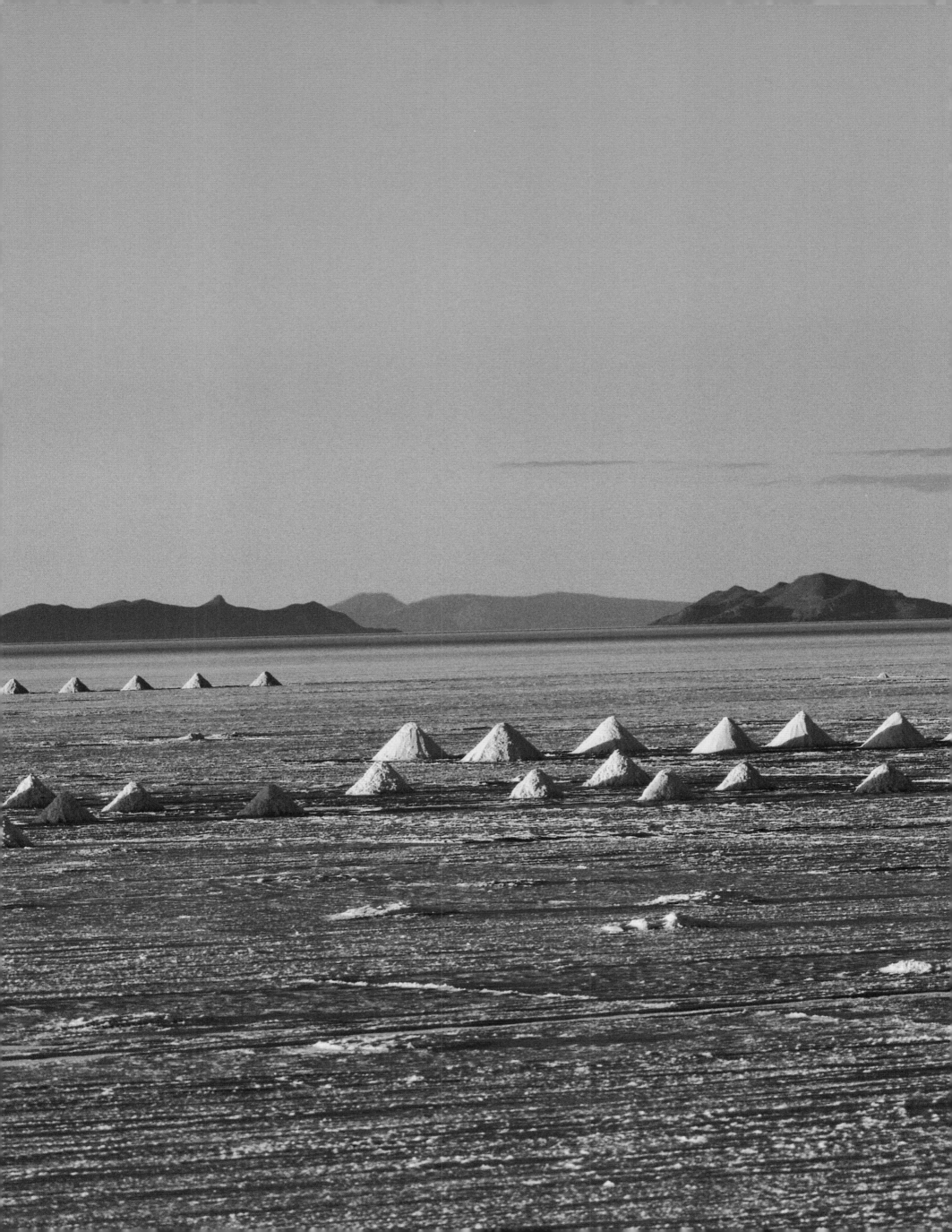

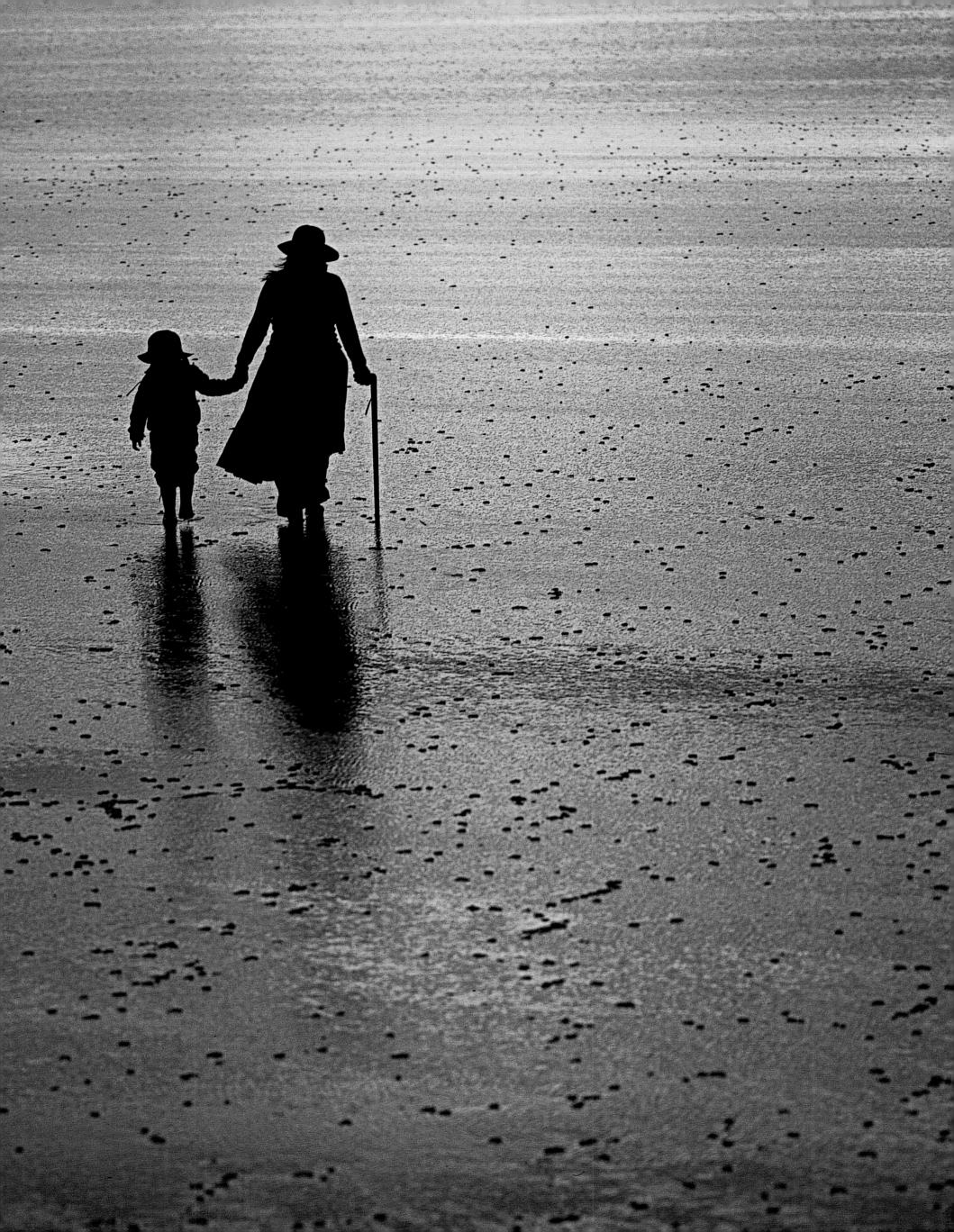

CROSSING THE OCEAN TO LATIN AMERICA

To get to Latin America coming from France, I wanted to cross the Atlantic by boat, in the wake of the slaves and conquistadors. This way, I would better understand the Africa I had left four months before and better discover America. Fourteen days crossing with my wife Danielle would make us more receptive to that new world, over there, hidden behind the ocean's horizon. We therefore got on the freighter *Capo Blanco* in Belgium, where it was docked in Antwerp, embarking at night amid giant cranes heaving enormous and threatening containers up into the air. To get us on board, an unstable bridge was diagonally attached to the ship's orange hull, but gripping onto the rail, we could locate the bow and stern of this metallic monster. Lighted by searchlights, our ship seemed too big to be able to set sail.

A strike on the pilot-boats stalled us for two days in the port's gloomy fog. Those two days' delay doing nothing but waiting did us a lot of good. They helped us leave our baggage of certitude at the dock and turn toward the treasures in the unknown. New thoughts germinated in this quiet waiting.

Our journey had begun.

At the tail end of the storm

On the seventh day, a weather bulletin sent out a warning: In two days, we would cross Hurricane Wilma. Mircza, the captain, changed course to skirt the worst, but was unable to avoid the tail end. In two days of growing turbulence, we prepared to meet the sky's fury vented on the sea. On the ninth day, at the top of the ship, beneath the radar tower, we experienced the full force and rage of the ocean at the ship's headquarters, bunkered behind the panoramic windows and their frenetic wipers. Relentless, the dark horizon filled with mountains of water rising from the depths of hell and unfurling at us one after the other. With each attack, we were certain we would die. Tossed well above the horizon and then dropping down into what seemed to be great abysses, *Capo Blanco* did seem to be an uncertain refuge. The bow of the ship sank over and over again beneath explosions of foam. No one said a word for over an hour. Alexandru, the first mate, turned off the little radio that crackled cheerful Caribbean music. Silence made its presence known as it does in all serious situations. I liked being with these sailors living their lonely lives, toughing it out, their worries betrayed only by slight eye movements and a somewhat stiffer stare. When battling the impossible, they insist on respect. Man becomes the rightful mediator between sea and ship. Without man's decision, there would be nothing but wrecks.

The salsa of colors

Every morning we would advance our watches one hour to be in phase with the other side of the ocean. Every day, the sky changed with the hours. The fires of dusk began to take on the fragrances of tropical America. The warm air became moist.

One morning, the island of Haiti appeared in the distance, like both a promised land and a scary destination, veiled in hazy heat. We sailed alongside its faraway coast, flat and mysterious. I was amazed to see this land with the eyes of a slave who had also crossed the ocean. I was seized by the emotion of the trip. Tears filled my eyes.

That night, we approached Jamaica, the homeland of Bob Marley. In the morning, we set foot on land to better feel our first step in America. The city was a grid; dusty avenues were lined by cement cubes and fast food chains. Livingstone seemed to me to be like a sorry return to an Africa stripped of its soul. But this first stop in America taught me to expand my beliefs, to understand that through the centuries, styles had mixed.

Latin America greeted us for real in Colombia, with a celebration filled with color and music. The restored old city of Cartagena is painted with the hues of a happy life. In the cobblestone streets, colonial-style houses with their arabesque metalwork look like parakeets. Each window sings a song, filling you with a desire to dance through the streets. People on holiday in Bogotá stroll in couples, hand in hand; peddlers offer shoe shines, their rickety wooden boxes wedged under their arms. Wearing a full dress, walking as gracefully as a famous actress, a woman from the country sells colorful tropical fruit artfully arranged in a wicker basket balanced on her head. Her luminous smile outlines the laughing cheekbones of her dark face. And yet, you see her difficult life in her mended dress and bare feet. But a joyful spirit needs no resources when it can connect to others. The residents of the old city are nourished by her cheer, and Angelina is nourished by selling fruit. We buy mangoes from her to look into her large, sparkling eyes. With her, Latin America springs into my life like a passionate salsa dance.

First revelation

Mexico City, a capital confident about itself and history, reunites all the continents. Its American style is scented with every Latin ingredient through its diversity and heritage. To fully take it in, visit the National Museum of Anthropology, where you can walk through history with solemnity and respect. Each gallery is endowed with a sanctified treasure. The exhibition continues when you walk through the city. In the streets, you'll see every kind of person, from every background. People with white skin, black skin, florid skin, with slanting eyes, frizzy hair, long braids, people wearing ties, others, worn-out shoes. In the earthenware tunnels of the ultramodern subway system, two Indian children with long black hair hang on to the full and embroidered skirt their barefoot mother wears. Their father, his face weathered by the sun, finds his way using the symbols provided for illiterate passengers beneath each destination. The family does not seem disoriented in the least. From where do they come? What are they doing here? Oddly, Mexico City seems made for them as well.

Mexico City has the sad reputation of being the most polluted megacity in the world, but it is nevertheless one of the most wonderful cites there is. In the streets, never-ending love songs seep from taverns, from windows and carriage entrances, making you want to embrace the world from the moment you wake. On a village square, in the heart of the city, mariachis with large black sombreros wait to find young couples to sing to them about romance to the sound of their guitars. On a lively café terrace, a fancy waiter scurries to serve tequilas, offering such kind words to everyone that the glasses he elegantly places on the emerald tablecloths turn into bouquets of flowers.

Each neighborhood feels like a village. Everyone knows each other and exchanges courteous greetings nuanced with grace, respect, and consideration. There is perfect civility here. Not one sentence ends without a respectful word, without care, a tender word. My first revelation in Latin American is this care for others in daily life. Whether superficial or not, it takes nothing away from the value of the gesture: You feel you exist.

The country to die in

Throughout Latin America, life is celebrated with splendor and elegance until death. On All Saint's Day, families gather in cemeteries to honor their dead with a big celebration. On that day, the gulf between the dead and the living is crossed. Graves spill over with bouquets of flowers and serene care. The favorite songs of those who have passed are played and their favorite drinks are sipped. Families cheerfully spend the whole night with their dead, talking to them, bringing them back to life. In Patzcuaro, in a corner of the cemetery, an old widower sits by his wife's lovingly decorated grave, whispering sweet words to her. Perhaps he's telling her to wait for him. Not far away, a large family has gathered to merrily dine around the family tomb. The men are somewhat drunk, and the children play around the women, who are huddled together. In the middle of the cemetery, sitting on a grave skimpily honored with three damaged flowers probably taken from another bouquet, a teenager sadly waits for the end of the day. I stayed a long time watching this boy, his eyes lowered. I'm certain his two parents had died and that he is left alone to fend for himself. I didn't dare bother him in his sorrow. I still regret it. I should have gone to him and offered him something to eat and drink. I should have offered him a celebration. I didn't know what to say to him. But did he need words? A friend, even a silent one, would have sufficed.

A band parades across the cemetery in front of a family, their arms filled with the bright bouquets they use to decorate the tomb of their daughter, who died last year at eighteen in a car accident. Nostalgic violins play the girl's favorite tunes, and the father offers us rum. I thank him with sad sympathy. He offers me a simple smile, cheerful and generous. Today, he is with his daughter. Here, I have to relearn everything. Mexico is a country where you want to stop and live. It is also a good place to die.

Landscapes and never-ending kisses

We fly to Clara in Peru to beat the rainy season. At the foot of the Andes, Arequipa is an enchanting city that has both the excitement of the busy plains and the tranquility of the white-capped mountains.

In the shade of a public park, an orchestra of nostalgic violins makes love hopeful. On benches, young couples kiss, united by an unspoken dream.

This romantic atmosphere inspires me to illustrate a wonderful love poem by Pablo Neruda and seek out lovers to photograph. In a store, I find Jennifer, a young sensual woman with long frizzy jet-black hair and large black eyes filled with life. Would she be willing to pose for me? Two hours later, Jennifer meets me in the Monasterio, one of the most beautiful colonial cloisters in Latin America, with small intertwining alleys. Its walls are amazing backdrops. Jennifer arrives dressed stylishly with Luis, her partner, a handsome slim man with a sharp face and frank eyes. We choose a beautiful clay wall painted an intense blue for a backlit picture. In the time it takes to set up my tripod, the couple begins a never-ending kiss. Never has a shot embarrassed me so. With her fiery eyes, Jennifer devours her boyfriend, his eyes folding expectantly. My session drags on, but it doesn't matter: they have completely forgotten about me.

For ten days, we cross Peru's Colca Valley, where condors soar through the deep shadow of the deepest canyon in the world. We regularly visit the ruins of the lost city of Machu Picchu and travel along the shores of Lake Titicaca amidst vast landscapes, with snow-capped mountains chiseling emerald waves. Then we head down to southern Bolivia, toward the Salar de Uyuni.

At thirteen thousand feet and surrounded by arid mountains dotted with llamas grazing peacefully, the Salar de Uyuni salt flat is a very old dried lake on which you can drive for hours without reaching its end. We set out at dawn, traveling along the crust of immaculate salt without coming across another living soul. Our battle against the sun, our eyes squinting, is lost. A few bare islands rise above the white desert like shipwrecked peaks. Cacti wave their short spiny arms like survivors amid the

vastness. We camp on the shores of one of them, before a dead sea, with neither wave nor bird. The burning sun sprinkles crimson into a sky filled with clouds that look like comet trails. The salar stretches before us like a large white tablecloth. We're delighted to be guests in this sumptuous celestial reception hall. But in the last ray of sunlight, once the last cactus candelabra has dimmed, our reception hall grows dark and the door to infinity opens, releasing the sound of a howling wind. The stars join a huge nightly celebration that is far too far away for us. We are too insignificant for the night ballet; the stars have already reserved their places. We find refuge near our tents uprooted by the wind, crouching like pariahs around a few rocks, protecting our little fire spitting its yellow flames beneath our pan. The stars are neither hungry nor thirsty, and hurry by the millions dressed to the nines to their huge gala around the salar. Beneath the stage of their celebration, we make do with our warm soup, guarded by cacti standing at attention.

Little Tomas

At more than thirteen thousand feet, Potosi is the highest city in the world. For a while, it was also the largest, at a time when gold from the Potosi mines provided the splendor of the Spanish kingdom between the fifteenth and seventeenth century. This gold was extracted by African slaves who survived the ocean journey in ship holds, and by Indian slaves. Seven million people died working at the mountain over three centuries. Potosi is therefore charged with a terrible past. The mountain is now hollowed out with tunnels and its gold is exhausted, but Indian miners still attempt to extract its last tin seams, working in dangerous tunnels, some only big enough to crawl through, as in slave times. I am, overwhelmed before even arriving.

We spend three days under the mountain with Gaëlle, photographing men who make a living but dwindle their life expectancy. At night, as they leave the mines, their faces are weary, their wrinkles accentuated by the dust, a betrayal of their difficult labor. But their eyes are proud: From the bowels of the earth, they have made enough to feed their families one more night.

On the third day, in the depths of a narrow tunnel, in the dim light of our headlamps and surrounded by dynamite dust, we meet Tomas, a twelve-year-old child with a face too serious for his years. He carries ore on his back to a large, wobbly wheelbarrow that is way too big for him. In a quiet voice, he tells us that his father died in the mine. When his mother also died, last year, he left school to work in the dark tunnels. It is very humid, and the child is trembling in the icy draft, sockless in the huge boots he wears to wade through the mud. We take him by the hand and leave together.

With Elena, a young Indian fighting for child miners, we go to meet Tomas's older brother, who also works in the mine. He feeds and houses the boy with his wife and their newborn in a meager room. Tomas has to work to help pay for food and contribute to the family's expenses. We tell the brother we want to enroll Tomas in school and finance his contribution to the family. He accepts, with neither joy nor regret, as if it were fate. We enroll Tomas in a good boarding school, two hours from Potosi, so that he's far from his heavy past, from the mine that prevents him from imagining a future. Within two months, Tomas has adapted well to his new life. He is the best student in his math class. Two months later, returning to Bolivia, I go to find him in Potosi with

Nora to encourage him. We learn that Tomas has just run away from school but find him by chance wandering through Potosi. Was he too lonely? Had he been treated wrongly? We take him with us for four days to understand and give him some confidence again. We try to find solutions to best help him. Nora suggests she take him to Peru in two months, at the end of our trip, to help him on a daily basis and be a loving presence. Tomas is happy. I make him promise to stick to his studies until he meets up with Nora. He hugs me, cries in my arms, and swears he will seize the opportunity. But a month later, Tomas runs away again from the boarding school. Too hard, too lonely, too much an orphan to take on life… I'm not sure. When we hear the news, we're already in North America. My little Tomas, how we wanted to help you escape the dark future the mine offered you and guide you to new horizons. But you embody the hardships of your Indian people, of the generations of overlooked men resigned to their exploitation, condemned, with no hope for the future.

Potosi continues to weigh on me like the chains of a slave.

An invitation to the beginning of the world

The Galapagos Islands are abandoned in the Pacific Ocean at some six hundred miles from the coast of Ecuador. The plane we take becomes a time travel machine. Taking a boat to the bare Semonote island, we arrive at the beginning of the world in a few paddle strokes. On the black island there stand dusty cacti from another time. In the shade of a rock submerged by waves, an iguana, hideous with age, absorbs the heat on the burned soil, as if weary of waiting since prehistory. His scaly skin, his steady eye hidden sometimes by a heavy and nonchalant eyelid, and his snarling mouth lend him the blasé attitude people who have lived too much often have. Not one predator has ever traumatized him. He takes in the times like an old retired man. Long-beaked gulls nest in the bushes and watch us with a curious eye but without worry. No one bothers them, ever. They are not afraid of anything, especially not the men who come to observe them. In the western part of the island, the foam rolls against the gray, rocky shore. The waters go from turquoise to emerald depending on whether clouds hide or reveal the setting sun. Awkward sea lions bask on the shore in couples or families, raising their mustaches as we pass as if to question our presence. None of the animals are afraid. We seem to be invited. The sun once again blinds the water and then disappears behind threatening heavy clouds in the distance. An albatross skims above the waves like a guard making his rounds. A streak of bright light continues to hover above the horizon. Then night takes hold of the island without bothering its inhabitants, accustomed to so many peaceful dawns and dusks, rhythmed like an ancient metronome. We return to the boat to the sounds of the lapping oars, stunned by this visit into eternity.

In the Amazon

The Amazon fascinates and disheartens me. I am thrilled to discover it, with Nora, but am apprehensive about its humid heat, its bright light, its dense shadows, difficult to photograph.

Ninety-three hundred feet from Quito, we descend rocky plateaus eroded by the wind to the Amazon forest, which is almost at sea level. Each turn on our toboggan trail takes us farther away from the sun and wraps us further in fog. Eccentric vegetation drips heavy sheets of water. Waterfalls vanish into precipices covered with moss. Every turn throws us into a world on the brink of the abyss. We finally escape the fog beneath heavy large clouds that hang over the forest and fill the earth and horizon. Finally, slowly, the road straightens and the descent turns into a long lazy slope that leads to the first marshes.

Puyo is the last town before the trees. We are meeting three members of the Sarayaku Indian community there who want to know our intentions before letting us go to their village in the heart of the forest. Fighting off aggressive mosquitoes next to a fan blowing moist air, we explain our reasons for wanting to go to Sarayaku to Patricia, a splendid young Indian woman with piercing eyes and very long black slick hair.

Patricia and Fernando have pursued higher education in Quito. Their principal concern is having their territory recognized as a World Heritage Site by UNESCO so that they can protect their community and preserve their forest against oil investors who want to dig wells in Sarayaku. Patricia has therefore become an expert in public advocacy, Fernando an international jurist.

At dawn the following day, we charter a small single-engine plane and set out with Gerardo, our interpreter from the community, and the bare minimum of things. Under the cockpit canopy with the sun beating down, the humid heat makes us sweat profusely. The forest is so dense, we can only see a huge carpet of leaves in every tone of green. Under it, branches, trunks, creepers, thousands of plants, animals, and insects hide. Sometimes, like a large brown vein in the serration of leaves, a lazy river travels through the forest, meandering. Then the leaves regain possession of their opaque mystery. With its gnat wings, the plane flies straight ahead like an insect guided by its instinct above the awning that seems to cover the entire earth. Silent and dumbfounded, we watch this prison of green pass beneath us, cutting us off entirely from the world.

Seen from the sky, the landing strip clearing seems to me to be ridiculously insufficient for our plane, but I have forgotten how small it is. Up there, I lose my sense of proportion. The plane lands thrashing about as if trying to shake off its wings. Along the long landing strip, children with copper skin and round faces with black markings hurry toward the plane, half-afraid, half-fascinated. A machine that moves and makes noise is an impressive thing when you live in the forest where there's no traveling. . . . And who are these strange people with no markings? We come out shyly, furtively. We do not yet understand who we are. Later, we'll smile about it.

We climb up to the village, twenty minutes by foot under the leaves on a mud path. Like a warning, lightning tears across the dark sky. A deluge hammers down on the forest, drowning our boots. Then the sun blinds the top of the trees and pierces the foliage like lasers of light. Insects begin their cacophony once again. In the clearing of the village with a few huts, five barefoot adults and a dozen children with markings watch us in silence from the swampy open area. A new deluge pours down on the forest. Roofs of woven creepers are streaming with water, the open area is flooded, and the air sweats with humidity. Dripping, we visit the community chief, David. Without with reservation, he welcomes us into a bamboo hut, holding the ritual stake that designates his title. Respectfully, Gerardo carefully explains our intentions and the chief nods occasionally, sometimes looking at us with a kind eye. Then he skims over the letter of introduction that Patricia has given us. David is young, perhaps twenty-five years old, but he seems very mature. His long hair falls over his large bare shoulders, accenting the strength that emanates from his face and his piercing eyes. I like this peaceful and confident man, his serious demeanor sometimes lighting up with a broad smile like the sun suddenly coming through the clouds and flooding the forest.

Will we one day be able to thank them?

We stay one week in Sarayaku without noticing the time pass and are sorry to leave. Yet, the week was a peculiar combination of intense days and hellish nights. Nora and I stay with a family in a large wood hut and sleep in two scrawny hammocks on a raised little wooden porch with a branch border. We ooze with sweat during the day, but also spend our nights wiping off our brows. The darkness makes the insects frenetic. We're attacked from every angle; it's an all-out war. Our sweet skin is a dessert. The plethora of incessant buzzing electrifies me. Curled up on my hammock, I try every fetal position and then stretch out, defeated, on the humid floor, my back broken. I listen to the forest palpitating with the groan of sounds that are both disparate and miscellaneous: the humming of wings around us, the gossip of birds, a strange and sometimes frightening cawing, branches cracking beneath animals, muffled sounds of waterlogged foam falling from trunks, very close sounds that I ignore. Then comes the sound of the rain, a few large and heavy drops crashing against large leaves. The storm approaches muttering, explodes, and disappears. The usual sounds of the forest return after the deafening deluge. There are also the sounds you don't hear but that you nevertheless perceive. This is the soul of the forest, charged with energy, emanating from everything that is living, that grows, that matures, or that rots to feed other plants. This is perhaps the most impressive sound because you don't hear it and yet it fills your ears. Omnipresent, it is either oppressive or exalting, depending on whether you feel at one with the pulse of the forest. Thus, during my long nights of no sleep, spent listening and perceiving, I face doubts I have not known before and I feel exalted in ways I have never imagined.

In the morning and at night, we eat with the family. They cook over a wood fire on the ground. In the morning, we have warm cereal that fills our plate, but at night, in the flickering light of an oil lamp, we cannot tell what it was we are eating. Certainly a snake or large worm carefully rolled into our plates. But where is the head or tail? Tough to cut, not pleasant to chew, impossible to swallow whole. We try to guess what it is by looking at how our hosts are eating. Finally, I take advantage of the darkness and throw the rest of my plate into the jungle outside the hut door.

Every day with David, the chief, we set out by foot or canoe to visit families throughout the forest. Shortly before arriving at a hut, David pulls ahead to see if the family will welcome us. We wait in the humid heat or in the rain. After the necessary introductions, we sit on the sofa, an old trunk eroded through generations. Without fail, at every visit, we are ceremoniously passed a plate of chicha, an unpleasant liquid that we have to consume to honor the hospitality. Chicha consists of a paste chewed by the mother of the household so that it ferments. She then spits it into a bowl before mixing it with river water. Containing a small amount of alcohol, chicha has almost no taste, but it is thirst quenching. Once the chicha ceremony is complete, the timid but friendly families quickly disappear into the forest to clear the land, cultivate, harvest plants, and hunt. The forest is generous but demanding because you have to penetrate it in order to gather its fruits. All around the small clearings where the huts stand, the stranglehold of green is impenetrable unless you work through it with a machete.

By the yellow light of the oil lamp, we spend our nights talking with David, the community chief, and with young people, their faces marked with black paint, which emphasizes the depths of their shiny eyes. The world is not unknown to them here in the heart of the forest. Being a forest sage, Gerardo's father was invited to a spiritual summit with the Dalai Lama and shamans from Africa. Asked to attend a forum on defending minority races, Patricia traveled to Paris, Fernando to New York. But all these young people chose to return to the forest, to their roots, which they fervently defend. They reconcile the modern world with tradition, organize seminars with their elders in the shade of the huts, so that their heritage is passed down to the new generations of their community. There is no electricity here, no telephone, no television sets. Aware and respectful of its riches, they all cultivate knowledge about the forest.

We organize a party for the villagers the night before our departure to thank them for their hospitality. Chicha is passed around between glasses of strong alcohol extracted from a forest plant. It quickly takes its effect on me. Because of the heat, the day's fatigue, and sleepless nights, I'm completely drunk. I'm asked to say something but I can't talk. Nora lets me know I have to try. I get up, hanging on to the trunk holding up the hut. My speech, delivered in a broken Spanish mixed with a bit of French and stutters of English, is entirely incomprehensible. But, stoic, Nora reinvents my speech as I go and everyone applauds me. To congratulate me for these brilliant words, I'm handed more chicha and more alcohol. Then I remember the moon shining between the dark leaves. Then nothing. Not heading back, held up by Nora and David, not the night mosquitoes. For once, I sleep until dawn.

The little plane comes to get us and spins around in the sky to find the way back through the trees and take us back to the city. I don't want to go back to the brutish world that knows nothing about trees and the spirits of the forest. I take in one last look and say my good-byes to these men so determined to protect their Amazon, the lungs of our earth. Will we one day be able to thank them?

So many differences

In Cuba, strolling through Havana is a delight. The old colonial buildings eroded by the humidity lend it a charm from another era. The city is filled with nonchalant large cars with rounded fenders and large, myopic headlights that make up for a deficient bus system. Cuba is a country where you make do and help out. At every corner, a man in an undershirt is dipping under his car hood, lying under a truck, fixing it with a friend or neighbor. The Cubans exude kindness and consideration. Leaning from their cast-iron balconies and talking from their windows, they take in the atmosphere. Here, your social standing does not determine the quality of your life. Cubans have little access to the modern world, but music sings in buildings, to the sound of bass and trumpet. In the tobacco fields of Viñales, shirtless peasants work peacefully, using basic horse-drawn plows. Nora finds advantages in Cuban life she never would have imagined: free medical care, free education at every level. The instruction level of every citizen is one of the highest in Latin America. We appreciate these aspects when landing in Brazil, a key country in the continent, which has as many riches as it does miseries. Here, inequality is rampant. But Brazil quickly enchants us in its daily celebration. In Rio de Janeiro, the city lives on its jam-packed beaches. The beach is where you meet, even for business, before going home in a bathing suit or tie. Going shirtless and wearing shorts to buy groceries or walk your dog in the city won't bother anyone. Brazil is a country where you feel very free. But it's especially a country that bursts with an incredible energy for life.

Drugged on the joy of life

In Salvador de Bahia the community is preparing a jubilee: Young people across the country come for a weeklong carnival that never sleeps, filling the streets with music and dancing crowds and saturating the city's main roads.

We meet Carlos, a beautiful black man with frizzy hair, solidly built. Carlos lives on odd jobs, day in and day out. When we see him, in his huge pants and his tiny T-shirt, he is guarding the door to a cheap restaurant on the beach. Yesterday, he was helping park cars. Tomorrow, who knows. Carlos is twenty-four years old. He lives in a favela in Bahia and knows all the gangs. But he doesn't belong to their world. He invests the little money he earns into establishing a capoeira school for the Brazilian martial art that came out of an African slave tradition. His steadfast goal is to turn young people in the favelas away from drugs and delinquency. We clearly run a great risk of getting robbed during the carnival: Going with photography equipment is like waving dollars above the crowd. . . . We really trust Carlos. He therefore becomes my bodyguard for the week.

At sunset, the Bahia bay, the avenue that runs alongside the beach, is impenetrable. A solid crowd waits for the floats to leave. These are enormous trucks with speakers carrying the country's biggest music stars. Trucks set out at twenty-minute intervals, moving ahead at the dance pace of fanatic groupies following their idols perched a few feet above them. From the time the first electric guitar note is played to signal departure, the crowd is hysterical. The rhythms cry out from the speakers, a forest of arms shoots up, fans shout with joy. For one week without interruption, people are crazed with dancing and music. I've never been one to participate in such jubilation. Carlos fends off the crowds in front of me, protects me with his big arms, holds me up on his shoulders to take pictures of young people high on dance and joy. It's impossible to talk and hear each other. We learn to communicate through signs. We're dripping with sweat. The crowds call out to be hosed down by water as the procession goes by, which replenishes its energy. Exhausted at night when we return to our room, we reel from the frenzy and music. The sound of the bass drowns our contorted and dancing dreams. We're also possessed, rising from our morning torpor like a jack-in-the-box to join the ever-dancing crowd again. We're drugged. On the pure joy of life. No additives. Drugged on the crowd, the jubilation, on musical communion. Drugged on the beauty of our travels too. We're drugged on Latin America.

The vast beauty of Latin America

In Guatemala, we return to peaceful squares and fountains on the other side of this America. With its cobblestone streets, its colorful houses, Antigua astounds me. From dawn to dusk, its walls burst with lively color and dark shadows. Backlit peasant women, wearing bright and full dresses, baskets on their heads, amble past me in this surrealist painting.

During Holy Week in Antigua, a long procession of pious people, dressed in purple tunics, crosses the cobblestone streets of the city, followed by an orchestra of large drums, trombones, and trumpets, weeping moving music. Immersed in a cloud of incense, a group of some thirty young women wearing mantillas shoulders a heavy statue of Jesus bearing his cross and covered in flowers. Seriously, their eyes staring to the ground, they walk at a steady and very slow pace, gently undulating, rendering Jesus' suffering on the way to crucifixion all the more real. The cross swings against the sky and the cloud of smoke from the Volcán de Agua rises over the city. The statue of Jesus seems to be bleeding. You expect to see him fall to the ground, crushed by the cross, to see women in tears trying to raise him back up. It hurts. A religious silence fills the crowd watching the procession. No one can contain their emotion, their faces are serious, pronounced.

The great beauty of Latin America lies in this ability to dive into fiction to the point of making it real, of experiencing it with its entire heart. It is this ability to make it through life, to express both joy and suffering, to live through the soul, deeply reconciling secular and religious life. Latin America is a homage to man, to his divine nature, his bonds to the cosmic, to creation and destruction, which we all harbor.

Cosmic connections

Within Guatemala, in the jungle of primary forests along the Caribbean Sea, there stands Tikal, one of the great Mayan cities that existed between the first and ninth centuries. It is one of the most impressive cities in Latin America. In order to reach its distant ruins at dawn, we set out the night before. The forest surrounds us and we walk in silence along a dark path, between impenetrable groves, beneath a cover of trees and giant creepers, amid the cries of howler monkeys. Little by little, a growing cacophony of bird cries allows us to believe that above our green cage, it is daybreak. Here, the sun cannot reach the ground. In Tikal, we understand better why the Maya worshiped the day star, the Sun, invisible from the ground. . . .

We reach the ruins at the hour when the parakeets are setting out. Followed by their long tails, monkeys swing from branch to branch. Some of the ruins are buried under hills of vegetation, as if time were buried there. Over the course of a few centuries, the forest has taken back the area. I'm overwhelmed and fascinated by nature's power. It cries out its cosmic force, the timelessness of the universe. The leaves that cover the ground are those that hang from large stems, their roots feeding off the rot, taking in new life. All plant life exclaims its interdependence, how it is linked to the earth, water, light, how it contributes to life. I think again about the Sarayaku Indians and their bond to their forest, their struggle against oil companies. With his lust, man is nothing but a butterfly blinded by ignorance, burning his wings. The more man strays from his relationship to nature, the more his actions become destructive. In the urgency of his ephemeral life, he panics, wastes. He loses sense of the profound meaning of his life, a sense of generations, of space, of Pachamama, Mother Earth, of the cosmic ballet. He becomes a lonely and destructive rodent. He measures time because for him it is limited. And he dies poorly because he is unaware of the vein that he is in the great forest of life. If man were more aware of his cosmic connection, he would not need to fight to prove his point of view. His life would be as serene as his death, as simple as a leaf that falls and grows again.

Latin America, gracias!

Present-day Latin America springs from a past stripped of humanity. Millions of men and women have died on the continent, over centuries of battles to build kingdoms that only fall with the arrival of more mighty ones. From the Incas to the conquistadors, to modern dictators, this continent has aroused every desire, was the playground of every power. Its riches were a disservice. Nevertheless, the continent continues to produce gold through its plurality, its joy, its culture, its diversity. Latin America is a fabulous mine, which, far from being exhausted, is being revived with help from all the men and women that live and unite there. This old continent is still young. For Latin America is a continent that has learned to regenerate, like the forest. Therefore, it can teach the world a new set of values.

OLIVIER FÖLLMI

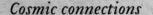

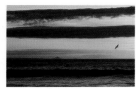

GALAPAGOS, ECUADOR. The Galapagos archipelago, situated in the Pacific Ocean about 600 miles (1,000 kilometers) from the Ecuadorian coast, consists of thirteen islands and some forty smaller islands and islets. All are submerged volcano peaks. Seismic activity and active volcanism illustrate the process that formed them. Designated a World Heritage Site, the archipelago is a protected zone, a national park, with strict rules on tourism. At the confluence of three ocean currents, the Galapagos are a marine life haven.

SALAR DE UYUNI, BOLIVIA. What do we know about Bolivia? A few clichés, a few record figures: La Paz, the highest capital in the world; Titicaca, the highest navigable lake in the world; and maybe, Salar de Uyuni, the world's largest salt flat. Bolivia seems to be the heart of South America, and its surface area has only shrunk, like shagreen leather, ever since its independence in 1821. With each war with its neighbors, the country has lost a part of its territory. At the end of the twentieth century, in a war with Chile, it lost access to the sea, opening a gaping wound that continues to ache to this day.

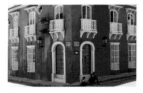

CARTAGENA OF THE INDIES, COLOMBIA. Christopher Columbus never set foot on this territory in present-day Colombia, but it is named after him! It was Alonso de Ojeda, a fellow explorer who, in 1499, disembarked in Cabo de la Vela in the Guarija Peninsula in the south and first trod on Colombian soil. He was accompanied by an explorer from Florence, Amerigo Vespucci, and a cartographer from Spain, Juan de la Cosa. In 1533, another conquistador, Pedro de Heredia, founded Cartagena—naming it Cartagena of the Indies, so as not to be confused with the port of Cartagena in Spain. The city would quickly become the hub of gold and emerald trading of the American continent, and the most extraordinary fortified city of the Spanish Empire.

Left: SALVADOR DE BAHIA, NORDESTE, BRAZIL. In the most African city of Brazil, an encounter with a young boy dressed for carnival. He stands in a street in the historic quarter of Pelourinho, a wonderful example of colonial Brazil, named a World Heritage Site by UNESCO in 1985 and since, entirely restored.

Right: CARTAGENA OF THE INDIES, COLOMBIA. Its history is that of the Spanish conquistadors in search of gold; its military architecture is the most impressive in the New World; and its colonial homes, which make it one of the most interesting Hispanic urban centers in the Caribbean, along with Santiago in Cuba and San Juan in Puerto Rico, render Cartagena a magnificent city. Its location, its lights, its colors, the role it played in the country's independence movement also contribute to the glory. Within its ramparts, Simón Bolívar pronounced words that have become a part of the continent. They are engraved on the equestrian statue built in his honor in Plaza de Bolívar, the city's central square: "If Caracas gave me life, Cartagena gave me glory."

HAVANA, CUBA. Cuba's music is mixed, as are its people. It combines genres as different as French quadrille and African bongo, which at the dawn of the nineteenth century gave birth to the famed *son.* With the development of tourism, orchestras began filling the streets and playing nightly in the *Casas de la Trova,* or music clubs found in every city of the country.

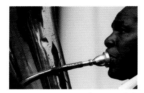

Left: CARTAGENA OF THE INDIES, COLOMBIA. Cartagena has a rhythm: that of salsa, cumbia, and other music. It has a sensuality: that of its residents. It is the key to Colombia and its history, but also its haven of peace. It is a city where you can take a deep breath, away from the violence and the country's tumult. Cartagena was founded in the fifteenth century, growing out of the conquistados' craving for gold and precious stones. Penetrating deeper and deeper into the heart of the country, it took them months to reach the port of Cartagena. But it was here that, twice a year, galleon convoys returned to Spain, stopping first in Havana and San Juan in Puerto Rico. Cartagena, the hub of the Iberian Empire, was edified with impressive fortresses, ramparts, barriers, and fortified castles, all of which can still be admired today.

Right: LAKE TITICACA, PERU. Tradition and folklore are very rich in this country of twenty-three million. Sixty percent of Peruvians live on the coast, thirty percent in the valleys of the Andes and the Altiplano, and finally, ten percent in the Amazon forest. Here, on Anapia Island, in the middle of Lake Titicaca, the Aymara communities find their music, for which the pan flute is an essential instrument. The neighboring city of Puno on the lake is one of the cradles of Incan civilization and is considered to be the folkloric capital of Peru. There are religious, popular, mythical, and historic celebrations year round.

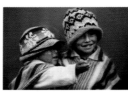

OTAVALO, ECUADOR. Nacer, age three, and his little brother were born in this city of 22,000 residents, located to the north of Quito in the Andes cordillera. Known throughout the country for its weekly Saturday market, Otavalo brings together every kind of agricultural and craft product from the communities of the region. The most visited city in Ecuador has always been known for its indigenous men with long braids. The *Otavaleños* are traders at heart and have a reputation of being the toughest merchants among the country's various Indian communities.

Left: MEXICO CITY, MEXICO. The Folkloric Ballet of Mexico at the Palacio de Bellas Artes. The Mexican national folkloric symbol is the mariachi, the musician wearing an enormous sombrero. In certain parts of the country, a celebration without mariachis is inconceivable. In this sumptuous show at the Palacio de Bellas Artes, they accompany *charros,* cowboys in colorful costumes who perform Mexican rodeos.

Right: MORELIA, MICHOACÁN, MEXICO. A group of schoolchildren plays in the courtyard of the Michoacán Regional Museum, one of the oldest in the country. The capital of the State of Michoacán, this ancient colonial city was founded in the mid-sixteenth century on the fertile lands belonging to the Tarascan kings. Entirely built from pink freestone, *la cantera,* it has been designated a World Heritage Site. Named Valladolid by the Spaniards, the city changed its name in the nineteenth century in honor of José Maria Morelos, one of the heroes of the independence movement who witnessed its fruition.

SALVADOR DE BAHIA, NORDESTE, BRAZIL. This mural fresco is a reminder that the majority of the city's population has African roots, giving it its nickname "Black Rome." In Salvador, African culture is omnipresent. It can be felt in the spicy food, in the voodoo rituals, dances like the axé and samba, and especially in the vibrant and colorful carnival. *Afoxés* and *Blocos Afros,* not as popular as the *trios eléctricos,* but equally as famous, fill the streets.

Left: JANITZIO ISLAND, PÁTZCUARO, MEXICO. This musician is waiting for the boat to Janitzio Island, where he hopes to earn a day's pay playing violin. Music is everywhere in Mexico. Pre-Hispanic musicians played with wind instruments and percussions; it was the Spanish who introduced string instruments. This predominant role played by music dates back to the Zapotec, Toltec, Aztec and Mayan civilizations, which held it in high esteem and accorded great social prestige to players. To quote Carlos Chavez, the great Mexican composer, "Music is the most profound expression of the Mexican soul."

Right: ANTIGUA, GUATEMALA. Ana Lucia Mendez Diaz is seven years old, the oldest of three children. Olivier Föllmi was introduced to her after meeting her mother, who was taking

dance classes at a school in Antigua and was a model for some of his photographs.

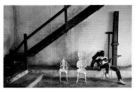 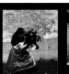

HAVANA, CUBA. "Havana, the first colonial foundation of the Americas . . . is clearly a woman. She is almost fifty years old in the revolutionary era, but under the tatters of her evening dress, she still has the powerful seduction of a flamboyant beauty," in *Cuba en attendant l'année prochaine,* by Marc Trillard (Éditions Vilo, Paris, 1999).

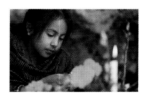

Left: JANITZIO ISLAND, PÁTZCUARO, MEXICO. On November 1, day of the *angelitos* (little angels), a Purépecha village woman takes offerings to the cemetery to honor her deceased son. At night, all Mexicans will commemorate their dead. But on Janitzio Island—the largest island on Lake Pátzcuaro—and in the neighboring villages, ceremonies are spectacular, because Indian roots are so deep in the mentality of the region's residents. Although traditions vary from one region to the next, it is believed everywhere that the souls of children return on October 31, and the souls of adults, on November 1. On November 2, the dead, sated and happy, set out for another year of traveling.

Right: PÁTZCUARO, MICHOACÁN, MEXICO. In the center and south of the country, it is traditional to place red and orange flowers on graves on November 2. In homes, altars to the deceased are decorated with photographs, flowers, candles, alcohol, water, and the favorite foods of those honored. This event, which has roots in old indigenous traditions, is a way of poking fun at death. People draw sniggering skeletons to scoff at this final stage of life.

JANITZIO ISLAND, PÁTZCUARO, MEXICO. For All Souls Day, Naney set up a small street altar to honor those in her family. Between traditional flowers and candles, she places offerings, prays, and communes, respecting the traditions of her ancestors. It is popularly believed that God authorizes the dead to return to earth once a year to visit family and friends.

Left: POTOSI, BOLIVIA. Jimena, age two, is the daughter of a miner of Cerro Rico, the notorious mountain of silver ore, which is one of the richest in the world. It is estimated that sixteen thousand tons of pure silver were exported to Spain in the first two centuries after the discovery. The city's opulence was unrivaled and had the entire world dreaming. With 160,000 residents, it became the second largest city in the world, after Naples, and before Paris and London.

Right: TZINTZUNTZAN, PÁTZCUARO, MEXICO. The ancient capital of the Tarascan people, who had a kingdom comparable to that of the Aztecs, their enemies. Tzintzuntzan—meaning "place of the hummingbirds"—is now only a quiet village near Lake Pátzcuaro. It also celebrates the moving reunion of the dead and living. Here, the Christ is wonderfully

decorated with *cempasúchil* or African marigolds, also called "the flower of the dead."

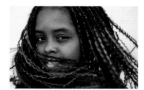

SALVADOR DE BAHIA, NORDESTE, BRAZIL. The wild beauty of a young Brazilian woman, a reflection of the city she lives in, in front of the Bahia de Todos os Santos, the huge and majestic bay, discovered on November 1, 1501 by the explorer Amerigo Vespucci. Colonized more than fifty years later by the Portuguese, Salvador de Bahia de Todos os Santos was one of the African slave centers during this period of history. Surpassing suffering and sacrifice, Salvador is proud of its black roots and traditions, and is today the cradle of Afro-Brazilian culture in the country.

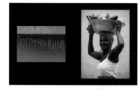

Left: SAN ANDRÉS XECUL, TOTONICAPÁN, GUATEMALA. Ears of corn dry under the canopy. Corn is essential in Mayan civilization and one of the three key ingredients of its cuisine. The "three sisters" are corn, beans, and squash. A family sits cross-legged under the canopy. It will gather around the hearth—a central element of their thatched *ranchitos*—before the men leave to work in the fields.
Right: CARTAGENA OF THE INDIES, COLOMBIA. Doña Angelica sells fruit in the street to feed her seven children whom she raises on her own. Colombia is a nation of many races, and therefore fundamentally Latin American. Descendants from African slaves, imported by the millions to the American continent starting in the sixteenth century, blacks represent a minor percentage of the population. They live predominantly on the coast of the Caribbean, between Cartagena, once the hub of the Colombian slave trade, and the port of Barranquilla. They also live around Buenaventura, on the Pacific Ocean coast, and in the region of Cali. They were forced to settle here to work in the sugar cane plantations and mines.

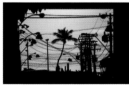

SALVADOR DE BAHIA, NORDESTE, BRAZIL. Twilight crossed with electrical wires. A healthy palm tree emerges. A typical view in large and chaotic tropical cities. Electrical outages are common.

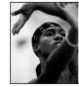

Left: HAVANA, CUBA. What would have happened to the Cubans if they didn't have music and dance? These fantastic outlets have certainly kept "the green crocodile" going. Here, a Barrara dance troupe rehearses in the courtyard of a handsome abandoned building in the city.
Right: HAVANA, CUBA. With its rhythm and sensuality, dance is a part of everyday life in Cuba. Dictators have never stopped Cubans from dancing. On every street corner, in every apartment, on every balcony, at all hours of the day and night, a few quick steps are made to the sound of warm, entrancing, and nostalgic music. In Cuba, dancing expresses a fierce pride.

Left: HAVANA, CUBA. A show at the Tropicana, the Cuban club that is to Havana what the Moulin-Rouge is to Paris. Fantastic bodies swing to the rhythms of the rumba, *danzón,* and cha-cha-cha. The shining Tropicana dancers in feathers perform in the open air nightly. Their show is stunning, magical and also kitsch.
Right: MEXICO CITY, MEXICO. The Folkloric Ballet of Mexico at the Palacio de Bellas Artes. Every trip to Mexico should start with Amalia Hernandez's national ballet. It is stunning and reveals how Mexico has in its own way integrated the traditions of its motherland. It is hard to ignore Spain's influence when seeing these dancers. It should be noted that murals by great Mexican artists, like Rufino Tamayo, Alfaro Siqueiros, José Clemente Orozco, and Diego Rivera decorate the walls of this handsome early twentieth-century building.

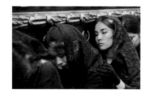

COLCA CANYON, PERU. The Colca Valley is accessed from Arequipa. One crosses the vast desert plains of the pampa of Aguada Blanca, a national reserve covered in *ichu* grass where vicuña live. In this cradle of Peruvian prehistory, there are cave paintings that are more than five centuries old. A landscape of majestic mountains leads to the foot of the canon, which is almost two miles (three kilometers) deep and almost four miles (six kilometers) wide.

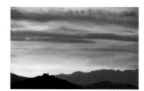

ANTIGUA, GUATEMALA. Procession during Holy Week. A young woman parading down the streets of the city holding up one of the many floats that travel about day and night during Holy Week. The expression on her face and the fervor that can be seen in her features strikingly resembles the grief of the Blessed Virgin, with whom she unconsciously identifies.

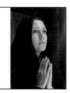

Left: ANTIGUA, GUATEMALA. Holy Week. In this central American country, religion is everywhere. It is intense—here, this young woman prays fervently during Holy Week—but also varied! For a country of this size, the diversity of religions is remarkable. After the Spanish missionaries, Protestants and North American evangelicals invaded Guatemala at the end of the nineteenth century, waging a relentless war against the Catholic church to convert indigenous populations.
Right: ANTIGUA, GUATEMALA. Holy Week. Although the vast majority of residents are direct descendents of the Maya, in large cities there is a Ladino population, which is multiracial and entirely Spanish in beauty.

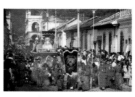

ANTIGUA, GUATEMALA. Procession during Holy Week. If there is one place in which to truly celebrate Holy Week, it is in the heart of the colonial old city of Antigua. Participants wear colorful tunics and austere pointed hats and walk for hours at a time through the city. They tread on fresh flowers that line the streets and are placed by the families of penitents sometimes just right before.

Left: SALVADOR DE BAHIA, NORDESTE, BRAZIL. Brazil's population is young, which makes it unbelievably powerful and dynamic. Here, two young people enjoy perfecting their diving from the small port.
Right: MEXICO CITY, MEXICO. *Voladores* perform the *palo volador,* a flying dance in the tradition of an ancient Nahua and Totonac ritual, which still exists in certain Guatemalan villages. Although at first it took place during the Corpus Christi celebrations, it has now become a simple tourist attraction. Five Indians go atop a pole. Four of them descend by hanging from a rope attached to their foot. It's like an air ballet to the sound of flute and drum played by the fifth person, standing on the small platform above. Turning thirteen times each, they fulfill the sacred fifty-two year cycle. Wearing pointed hats decorated with mirrors, symbolizing the sun, and multicolored ribbons, reminiscent of firebird feathers, the *voladores* represent the four elements and the four cardinal points.

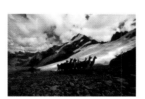

CORDILLERA DE APOLOBAMBA, BOLIVIA. The Andes are a young mountain range, dating approximately to the birth of man some four or five million years ago. They are the result of the subduction of the Nazca plate beneath the South American plate, a movement that is still active today, known as the Pacific Ring of Fire. The cordillera, which is divided into two parts—the Cordillera Oriental and the Cordillera Occidental—at La Raya Pass in Peru, is called the Royal Cordillera to the east. It is itself divided into several mountain systems, including the Cordillera Apolobamba, between Peru and Bolivia. Here, at 6,000 feet (4,900 meters) at the Lusini Pass, the only life form you'll find are llamas and alpacas. Their wool is adapted to the extreme conditions.

LA ARAUCANIA, VILLARRICA, CHILE. The Villarrica volcano looks over the small city of Pucon, in the Araucania region, south of Santiago and north of Patagonia. This superb volcano, with its perfect peak, almost 9,500 feet (2,847 meters) high, has been fully active since at least 1810 B.C., when there was a major eruption.

LAGUNA SAN RAFAEL NATIONAL PARK, PATAGONIA, CHILE. If this giant park, some 7,000 square miles (2,000,000 hectares) large, is one of the most famous tourist destinations in the region, it is because it is one of the most spectacular. On this lake float the detached icebergs from the ice fields of Monte San Valentin, which, at 13,000 feet (4,058 meters), dominates the southern Andes.

QUINTANA ROO, YUCATÁN, MEXICO. The most famous sites of the Latin American continent are found on Yucatán peninsula, including the magnificent cities of Chichén Itza, Uxmal, and Tulum, and other less known ones, like Coba, Edzna, and Ekbalam. On the coast of the Caribbean Sea, one will also find the most beautiful beaches of Mexico and the Cozumel Islands and the Isla Mujeres, with its clear turquoise water.

SALAR DE UYUNI, BOLIVIA. During the rainy season (between December and March), everything at the world's largest salt flat, at almost 12,000 feet (3,563 meters), is covered in a thin layer of water. Nora Delgado Vega is one with the sky and earth, uniting them through the mirror effect caused by the sunlight. The lake is not uniform throughout. A large part of its surface consists of polyhedrons formed by the wind when the water evaporates after the rainy season. They take on remarkable colors at sunset, when low-angle rays tinge them with orange that then turns to pink.

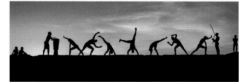

SALVADOR DE BAHIA, NORDESTE, BRAZIL. Capoeira, the Afro-Brazilian martial art that combines dance and fighting, involves trying to make your opponent lose his balance and fall. The name comes from Guarani and means "area of thin vegetation," a reference to the cleared forest areas left for slaves, who practiced this form of fighting, which was at once real, played, and danced. It is believed that music was introduced to camouflage the combative nature of the game. The movements are performed to the rhythm and cadence offered by the sound of the *berimbaus.* Later used by criminals (*os capoeristas pretos*) against the police, it became a powerful system of attack and defense, until it was banned. It was only in the 1960s that it became legal and popular again.

LAKE ATITLÁN, GUATEMALA. Nestled at 5,100 feet (1,562 meters) in the southwest highlands and surrounded by a chain of volcanoes, Lake Atitlán stretches out over more than 50 square miles (130 square kilometers). Considered to be one of the most beautiful lakes in the world, it emits a majestic serenity. In the morning, when the air is clear, the

water mirrors the three principal volcanoes. In the afternoon, clouds appear and gather around the peaks, forming a hat over the lake's surface.

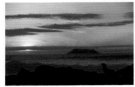

GALAPAGOS, ECUADOR. Five islands cover an area of roughly 190 square miles (500 square kilometers): Isabela, Santa Cruz, Ferdinandina, San Salvador, and San Cristobal, which is home to its capital, Puerto Baquerizo. The others, much smaller islands, include Santa Maria, Marchena, Espanola, Pinta, and Seymour, among others. Sheltered from continental life, the archipelago is a unique part of the world, where nature's treasures are preserved. The climate is tempered by the cold Humboldt current, which explains why warm-climate animals like turtles, iguanas and birds commingle with cold-climate animals, such as penguins and sea lions, like those seen here on Seymour Island.

LAKE TITICACA, PERU. On the floating islands of Puno Bay, there once lived the Uru people, an Indian population originally from the Urubamba Valley, from where it has totally disappeared. Forced by the Incas to settle on terra firma and work in the Potosi mines, the last Uru descendants were deported to Rio Desaguadero, where the race died out. The Aymaras who now live on these islands have taken up their traditions and lifestyles. In fields of reeds, they harvest *llachu,* a plant used for cow feed.

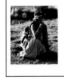 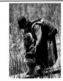

Left: LAKE TITICACA, PERU. A rare moment of rest for an Aymara woman. These Indians live as a community on one of the many lake islands. The Aymaras represent one of the main Indian ethnic groups in Latin America, along with the Incas, Maya, and Aztecs. The Aymaras, who founded Tiwanaku to the south of the lake, were conquered by the Quechuas (the name means "people of the warm valley"). The Incas were the main Quechua people. Under their rule and despite the fact that Quechua was the official language of the empire, they were able to preserve their language and customs.
Right: LAKE TITICACA, PERU. Lidia walks with her seventh child on Anapia Island, where she lives with her family. In the foreground, you can see the reeds used to feed the cattle of the Altiplano. They are also used to make the *totoras* or local boats. Once the reeds are cut, the Indians tie them into bundles. These long bunches are attached together one by one using ties. The rafts have a limited lifespan—six months to a year—since the reeds rot as time goes on. On the floating islands, the same phenomenon can be observed. One regularly sees Indians replacing rotted reeds and heading out onto the lake.

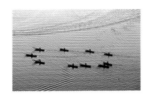

LAKE PÁTZCUARO, MICHOACÁN, MEXICO. Considered to be one of the jewels of the Michoacán, Lake Pátzcuaro is situated in a beautiful mountainous and wooded region inhabited by the Tarascan and Purépechan Indians. They have no ties to other indigenous populations in this part of Latin America, although their language bears some relation to Peruvian Quechua! Their livelihood is fishing. They set out at dawn on their canoes to catch a white fish that is treasured in the region.

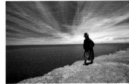

LAKE TITICACA, PERU. Agripina, an Aymara Indian in her forties, is setting out to herd her sheep, which graze all day along the lake shore. The Aymaras founded Tiwanaku, one of the largest Pre-Columbian sites in Latin America, situated to the south of Lake Titicaca in Bolivia. It has been designated a World Heritage Site.

CUZCO, PERU. Standing at 11,500 feet (3,600 meters) above sea level, Cuzco is a remarkable and entrancing city, nestled in the heart of the South Andes and the Indian world. The capital of the Incan Empire until the conquest, its monuments are remarkably well preserved and continue to illustrate the history of the Andean and Spanish civilizations in the twenty-first century. The Incas, who worshiped their Sun god, took little interest in feat of arms. Instead, they aimed to achieve prodigious architectural, hydraulic, and horticultural projects, as well as develop metal, weaving, and pottery work. The central square, or Plaza de Armas, depicted here, was the center of the empire. The name in Quechua means "navel of the world."

Left: TODOS SANTOS, ALTIPLANO, GUATEMALA. Ubiquitous throughout Latin America, this iconic emblem has huge cultural power, to the point that its advertising message is secondary. Coca-Cola remains the symbol par excellence of the consumer society.
Right: HAVANA, CUBA. On this island that lives in another time, motorized vehicles, aside from the dying breed of beautiful American ones, are rare. Since the city is flat, there are many bicycles and taxi-bikes.

Left: TODOS SANTOS, ALTIPLANO, GUATEMALA. Dressed in traditional costume, a man strolls down the little streets of the small village of Todos Santos, isolated at 8,000 feet (2,500 meters) in the middle of the Sierra de los Cuchumatanes. A narrow mountain road that leaves from Huehuetenango and crosses magnificent landscapes leads there.
Right: ANTIGUA, GUATEMALA. In the morning, a father brings his son to school in this charming city perched at

5,000 feet (1,500 meters) above sea level. Approximately 30 miles (50 kilometers) to the west is Guatemala City, the "new capital" built after the 1773 earthquake. Originally named Santiago de Los Caballeros, it is known for being the most beautiful city not only in the country but in all of Central America. Today it is simply called "La Antigua," meaning the old capital.

ANTIGUA, GUATEMALA. In its time of glory, the city of Antigua was one of the largest cities in the Spanish colonial empire, rivaling Lima and Mexico City in size. It was home to the "General master's office of Coathemala," which included all of Central America and Chiapas.

Left: TARABUCO, SUCRE, BOLIVIA. At 40 miles (65 kilometers) from Sucre and at more than 10,000 feet (3,230 meters) above sea level, the city of Tarabuco is today known around the country for its Sunday market. It was also famous in the past when, on March 12, 1816, during the battle of Jumbate, troops of campesinos from the region, led by a Calisaya Indian chief, stormed Spanish invaders under the command of Captain Herrera. In the central square, a statue of the Indian chief commemorates this unforgettable victory over the occupying forces.
Right: ANTIGUA, GUATEMALA. A fruit merchant on one of the perfect streets built by the Spanish around the central park, typical of Spanish colonial cities. After the devastating earthquake of 1976, which left it on its knees, it was designated as a World Heritage Site in 1979. Antigua still nobly shows signs of its glorious past.

Left: SOLOLA, ATITLÁN, GUATEMALA. A few miles from Panajachel, the village of Solola at 6,700 feet (2,060 meters) above sea level is a crucial stop on the way down to Lake Atitlán. Neglected by tourists who prefer its neighbor, Solola has remained amazingly authentic. Its daily market is colorful, with Indians coming from all the lake villages to purchase everything from staples to bright fabric.
Left: ZUNIL, ALTIPLANO, GUATEMALA. This Quiche village a few miles from Quetzaltenango—the locals know it as Xela—is in the heart of the Altiplano. The Almolonga and Zunil market display fruits and vegetables that are traded and transported by women of unmatched elegance.

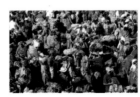

ALMOLONGA, ALTIPLANO, GUATEMALA. A typical Altiplano market scene, a few miles from Quetzaltenango. What is remarkable here is the size of the vegetables, and the symphony of scents and colors.

Left: SAN FRANCISCO EL ALTO, ALTIPLANO, GUATEMALA. An hour away from Xela, the village of San Francisco el Alto is known throughout the region for its market. The small city literally comes to life every Friday, attracting indigenous peoples to the colonial church on the main square. It is their sole source of income and an important pastime, an occasion to talk, trade, eat, and drink, amid animals, for the market is also a cattle fair.
Right: SAN FRANCISCO EL ALTO, ALTIPLANO, GUATEMALA. The region of Quetzaltenango is filled with villages rich in local tradition. You can stroll their markets, admire their churches, or participate in one of their many celebrations, combinations of Christian and indigenous traditions, throughout the year.

Left: SARAYAKU, PASTAZA PROVINCE, AMAZONIA, ECUADOR. Raul Santi Aranda, age five, with his father from the Sarayaquillo community. They are fighting from inside the Ecuadorian forest to defend ancestral land from hungry oil companies.
Right: SAN FRANCISCO EL ALTO, ALTIPLANO, GUATEMALA. This is the epitome of a hardware store where every implement, device, and product of every kind, in copper, zinc, iron, tin, and more can be found. This store, discovered on a detour around an Altiplano market, is everything it claims to be.

Left: SALVADOR DE BAHIA, NORDESTE, BRAZIL. This young Brazilian woman is beaming with joy. She has been waiting for "her" carnival all year. Although it only lasts a few days, residents get ready for it months in advance. Starting at Christmas, one will see small pick-up bands playing and dancing in the street. It is here, in Bahia, that the country's largest display of popular culture is at its most democratic. Everyone enjoys the "street carnival." In other cities, the event takes place in designated areas and there's an admission fee.
Right: SALVADOR DE BAHIA, NORDESTE, BRAZIL. This young Brazilian man, met on the beach, embodies the pride, strength, and vitality of this young and dynamic nation. The country will surely be joining the big kids in the twenty-first century.

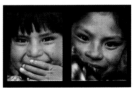

Left: ATACAMA DESERT, NORTE GRANDE, CHILE. This small child lives in one of the Atacama Desert villages in the north of the narrow strip of land that is Chile, on the border of Argentina and Bolivia. Although considered to be one of the most perfect deserts in the world, Atacama is also one the most arid and inhospitable ones. But there are advantages. It has rich deposits of nitrate and minerals, both of which are mined, and the sky is so clear that two of the world's most powerful telescopes were installed there to study the universe.
Right: ATACAMA DESERT, NORTE GRANDE, CHILE. A young girl confidently plays in her grandfather's store in an Atacama Desert village. The region is the driest in Chile, situated in the central depression, where salt flats or salars are located, between the Coastal Cordillera and the Andes.

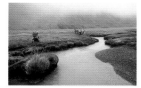

CORDILLERA DE APOLOBAMBA, BOLIVIA. Under a dark sky and low clouds, and in temperatures that hover around 30°, typical of the Altiplano rain season, a shepherd leads his llamas and alpacas to graze. Camelids are everywhere in the Andes cordillera, feeding on the grasses (*pajonales* and *ichu*) that grow in the harsh climate.

Left: ANGAHUAN, MICHOACÁN, MEXICO. Situated on the outskirts of Uruapán, the village of Angahuan has a beautiful sixteenth-century church, built in a Mudéjar and Purépecha style. Here, residents still speak the Tarascan language and women continue to wear the colorful traditional costume.
Right: ANTIGUA, GUATEMALA. Designated a World Heritage Site, this colonial city has retained its unique charm and beauty. Neither war nor nature's ravages has conquered it. Churches, one more beautiful than the next, fill the city, as do colonial homes with shaded interior patios, hidden behind heavy wooden doors.

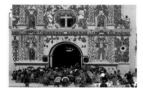

SAN ANDRÉS XECUL, TOTONICAPAN, GUATEMALA. The Mayan esthetic and symbolic sense is delightfully combined here with Catholic traditions. The Church of San Andrés Xecul's ocher facade is the most famous in the country. With its multicolored angels, its twisted columns with plant motifs, and its bright colors, it resembles the embroidered *huipils* worn by the Guatamaltec Indians.

Left: ACTOPAN, HIDALGO, MEXICO. A large steeple, a Mudéjar style square tower reminiscent of the Almohad minarets in Andalusia, vaults with exposed ribs at the entrance and the choir, a remarkable fresco in the back of a room in the monastery, a cloister, a large refectory with a barrel vault ceiling and octagonal coffering, an open chapel (the largest in Mexico) with mural paintings illustrating the Old Testament, a beautiful Plateresque facade: All make the monastery San Nicolas Tolentino, founded by the Augustinians in 1548, a haven of peace amid the large city of Actopan, where the traditions of the Otomis Indians are still very much alive.
Right: MEXICO CITY, MEXICO. Interior of the Cathedral on the Zocalo. Hernán Cortés built Mexico City on the ruins of Tenochtitlan, the Aztec city. And the cathedral of the new city was constructed on the foundation of the great pyramid where the sacrificial blood once dripped. It took 389 years, from 1524 to 1813, to complete. During these three centuries, each viceroy attempted to outdo his predecessors in advancing the project and adding to its splendor. With its five main altars and its sixteen side chapels, decorated with paintings and sculptures, the Mexico City cathedral represents the largest Catholic diocese in the world and the almighty power of the Church during colonization.

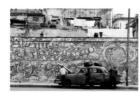

HAVANA, CUBA. Cuban reality reflects its beautiful and worn cars, magnificent American vehicles patched up from end to end. Cuba has had to endure the longest economic blockade in history.

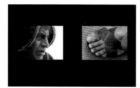

Left: TARABUCO, SUCRE, BOLIVIA. The hats the men wear at the Sunday market, crowded with visitors from the entire region, point to different ethnic origins within Bolivia. This man is wearing the most famous kind, a *montenera* made from boiled leather, based on the helmet models worn by the Spanish conquistadors. He is a Yamparaes Indian, also identifiable by his colorful poncho, his purse made from coca leaves, and his musical instruments, which include the well-known *charango*.
Right: TARABUCO, SUCRE, BOLIVIA. No waste here, no useless expenses. This is what they need for clothing, no more, no less. There are only a few campesinos who wear shoes, despite the cold!

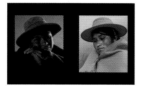

Left: LAKE TITICACA, PERU. Jesus Omar, age twelve, is an Aymara Indian from Anapia Island, where he lives with his family. Life on these islands is not easy. Even the climate is a challenge, with temperatures changing considerably within a single day. On Lake Titicaca, there can be an over 60°F (35°C) range. During the day, the thermometer can read 77°F (25°C) and at night drop to 14°F (-10°C).
Right: POTOSI, BOLIVIA. A young popcorn merchant in the streets of the highest mining town in the world, standing at over 13,000 feet (4,070 meters). Warmly dressed, he has to bear a harsh climate. In the summer, with the rains, temperatures never go above 50°F (10°C). In the icy winter, hoarfrost, hail, snow, and frigid winds from the Altiplano are common. This is a stony world on the edge of life, where hardships reign, and the landscape is infinitely stark.

Left: CHIVAY, COLCA VALLEY, PERU. Fortunata Chuqui Mamani lives in Chivay, one of the peaceful villages in this magnificent valley in the south of the country. Her bowler hat, worn at the top of her head, indicates that she is an Aymara, for in Peru, the headgear people wear indicates their origins. She leads a life that is more isolated than in other villages visited up until now. After Chivay no more bridges straddle the canyon, which is growing deeper and deeper. On the road leading there, there are stone piles or *apachetas* placed by passersby as an offering to the *huamanis,* mountain guardian spirits.
Right: SAN MIGUEL DE VELASCO, CHIQUITOS, BOLIVIA. A young violinist plays in one of the Jesuit missions in the Llanos de Chiquitos, a subtropical area along the border of Brazil and Paraguay. Mission history in South America begins in 1569, when the first Jesuits landed in Lima. Father Martin Schmid worked in Bolivia for thirty-seven years, until the fateful year of 1767 when the Jesuits were expelled from the continent.

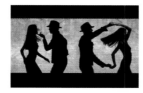

ANTIGUA, GUATEMALA. Student and teacher, Claudia Mendez Diaz and Alberto Rafael Gonzalez, perform an outdoor dance to the rather slow rhythm of the tango.

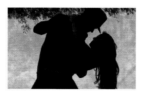

SALAR DE UYUNI, BOLIVIA. Cecilia Antequera Camacho and Julio Santander practice a few dance steps on the largest salt flat of the world. Its area (almost 5,000 square miles [12,545 square kilometers]) is double the size of the largest salt flat in the United States! The *Gran Salar* is what remains of the large Lake Ballivian that once occupied the entire Altiplano. All that is left are Lake Titicaca, the small Lake Uru Uru, the Lake Poopo, and a few salars like Coipasa and Uyuni.

ANTIGUA, GUATEMALA. The sensuality of Latin American dance is expressed in South America's extensive repertoire, from salsa to bossa-nova, to the rumba, the samba, the *marinera,* and the tango, perhaps the most famous of all. Here, a tango is danced by Claudia Diaz Lopez and her dance teacher, Alberto Rafael Gonzalez Figueroa.

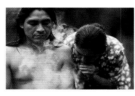

LAKE ATITLÁN, GUATEMALA. On this clear and silent early morning, a fisherman sails on Lake Atitlán, a gem of the Guatemalan highlands surrounded by three huge volcanoes.

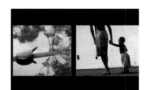

SARAYAKU, PASTAZA PROVINCE, AMAZONIA, ECUADOR. Rebeca Gualinga, age seventy-three, is here performing a purification ritual on one of the men of the community who is about to leave his territory.

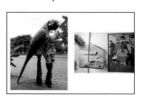

Left: PUYO, AMAZONIA, ECUADOR. This *charapa* turtle lives in Fatima, a wildlife center for endangered species.
Right: SALVADOR de BAHIA, NORDESTE, BRAZIL. A father leads his little boy by the hand through the children's carnival. His dark skin is a reminder that Brazil is the country with the largest population of African descendants outside the continent of Africa.

Left: GALAPAGOS, ECUADOR. The climate on the islands is surprising. Situated below the equator, temperatures are not very high and rain is rare. The Galapagos Islands have a uniquely diverse fauna. You'll find multicolored *Grapsus grapsus* crabs with their impressive eyes, as seen here. But there are also seals, white sharks, and sea urchins and almost three hundred varieties of fish of every color and size.
Right: SARAYAKU, PASTAZA PROVINCE, AMAZONIA, ECUADOR. This small child does not want to visit with the Sarayaquillo healer. *Yachaks* (shamans) live in Sarayaku and bear ancestral knowledge. They act as healers, spiritual guides, and protectors of their environment.

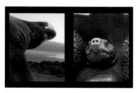

Left: GALAPAGOS, ECUADOR. When Charles Darwin set foot on San Cristobal Island in 1835, he was enthralled. The land iguanas, the giant turtles, and the many species of chaffinches inspired his theory of evolution. Because of their extremely fragile ecosystem, some of the islands cannot be visited.
Right: GALAPAGOS, ECUADOR. Unique in the world, the land turtles on the Galapagos Islands are the largest of their species. Some have massive, scaly feet and can weigh up to 550 pounds (250 kilograms)! Known as *galápagos,* they inspired the archipelago's name.

Left: SARAYAKU, PASTAZA PROVINCE, AMAZONIA, ECUADOR. A young Sarayaquillo woman waits in her hammock for the torrential rain to end, protected by the canopy. Rainfall is heavy throughout Amazonia.
Right: PUYO, PASTAZA PROVINCE, AMAZONIA, ECUADOR. Shana Gualinga Santi, four months old, is the most recent addition to the Sarayaquillo community.

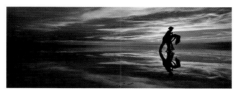

Left: SAN MIGUEL DE VELASCO, CHIQUITOS, BOLIVIA. Eccentric public telephone on the central square of San Miguel Velasco, one of the seven Bolivian Jesuit missions, founded in 1721 in this isolated region of Amazonia by the disciples of Father Martin Schmid. It is appropriately considered to be the gem of the Chiquitos missions.
Right: CARTAGENA OF THE INDIES, COLOMBIA. Behind its ramparts, the old city retains the splendor of its past: churches, palaces, houses, gardens, and small streets with poetic names. In the center of Cartagena, a treasure trove of colonial art, there are superb colonial homes that are unique in Latin America. In this one, for example, a birdcage is next to a work by the Colombian painter and sculptor, Fernando Botero, born in Medellin in 1932.

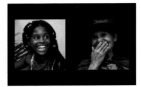

Left: SALVADOR DE BAHIA, NORDESTE, BRAZIL. This beaming teenager embodies the ethnicity of this city, which was the first capital of Brazil, from 1549 to 1763. It stood at the crossroads of the European, African and Amerindian cultures.
Right: TARABUCO, SUCRE, BOLIVIA. When a family goes to the Sunday market, they are elegantly dressed. While men wear colorful clothes, women are generally dressed in black and sport typical hats inspired by those worn by colonial ladies.

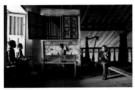

SANTA ANA DE VELASCO, CHIQUITOS, BOLIVIA. Luis Rocha and his grandson, Luis, age ten, who is learning the organ, play in the Santa Ana church. Built in 1755 by the Indians themselves, guided by Jesuit fathers, this is the only Jesuit church that has survived intact and where one can still admire the original paintings and sculptures. The Jesuit fathers not only offered Indians a religious education, but also a cultural one, teaching them woodwork and silver work. Some Indians from the missions became artists in their own right. Their instrument-making skills (violins and harps) were exceptional.

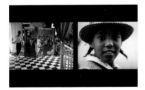

Left: KINGSTON, JAMAICA. Coming from Europe and stopping here with his cargo, Olivier Föllmi could not resist taking this picture to immortalize the attentive service at this restaurant in the capital! The island of Jamaica, situated some 70 miles (150 kilometers) to the south of Cuba and some 100 miles (200 kilometers) to the west of Haiti, takes its name from the Arawak word *Xamaica,* which means "land of springs."
Right: HAVANA, CUBA. This schoolgirl in uniform—they're called *pineiros*—is getting ready to celebrate the birthday of José Marti, a national hero and Cuban writer. The son of Spanish immigrants, he founded the Cuban Revolutionary Party in 1892. Expressing nationalist ideas at a young age, Marti spent his life in exile and devoted himself to Cuban liberation and freedom from Spanish rule.

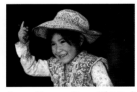

COLCA VALLEY, PERU. This Indian girl in traditional dress is Collagua, an ethnic group living in the valley. Wearing typical colorful costumes in bright colors and with fine embroidery, these Indians are the heirs of a civilization. The Collaguas speak Quechua, although they more directly descend from the Aymaras.

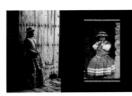

Left: YANQUE, COLCA VALLEY, PERU. This young Indian woman stands before the superb church door in Yanque in the center of the Colca Valley.
Right: CHIVAY, COLCA VALLEY, PERU. Ruth Cahuchia is two years old. She is dressed in red traditional garb from Cabanaconde. The bright color of her skirt is a reminder that one of the main activities of the Collagua Indians in the valley is collecting cochineals. This small insect grows on nopal leaves, cacti, and the large flat leaves known as *tuna,* and produces this beautiful natural red.

SOLOLA, ATITLÁN, GUATEMALA. Josefina is at the market on her mother's back. Like most women in her situation in the Altiplano, Josefina's mother takes care of the family home, raises children, prepares meals, and knits. The whole family will usually go to the market as it is the nexus of social life for Guatemalan peasants. It's an occasion to get dressed up, buy, and sell, and especially to see friends from neighboring villages, sometimes hours away by foot. It's a time to exchange ideas, seek advice, and for young people, possibly meet a soulmate.

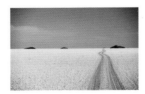

SALAR DE UYUNI, BOLIVIA. A path suitable for vehicles crosses the flat at almost 13,000 feet (4,000 meters). Consisting of eleven layers, each varying in width from six to sixty-five feet (two to twenty meters), the top layer of non-iodized salt is thirty feet (ten meters) thick and contains the largest concentration of salt in the world. Furthermore, the quantity of lithium (five to nine million tons according to some estimates) represents the largest reserve in the world. It could change the entire economy of the region as well as the life of its residents.

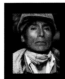

Left: POTOSI, BOLIVIA. The eyes of Julian Astoraique, photographed in the Cerro Rico mine, reflect the martyrdom of the Indian people in this region. In Potosi, eight million Indians were sacrificed in the mine at the alarming rate of fifty thousand deaths per year! The Spanish regime had imposed the terrible *mita* (a variation on an Incan way of organizing labor) that forced work in the mines. Indians from the entire vice-royalty of Peru were sent to work. A miner's life expectancy in the mine at the time was no more than a few weeks on average, a few months at best. The only alternative to the suffering, cold, fatigue, and hunger was the right to consume coca leaves, which until then was a privilege reserved for Incan chiefs.
Right: TARABUCO, SUCRE, BOLIVIA. In the indigenous world from Guatemala to Bolivia, including Mexico and Peru, textiles, like hats, indicate ethnic background. In Bolivia, the *jalq'a* is a beautiful fabric. There are no geometric prints or symmetry, which is common in Andean cultures. There is even a fabric named after the city, *tarabuco.*

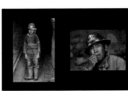

URUBAMBA VALLEY. PERU. In the heart of the valley created by the Rio Vilcanota, a beloved Incan area, there are still salt marshes from Incan times against the side of the mountain. They are mined in the traditional fashion since the land is not suited for mechanization. A handful of men supervise the process by running swiftly along the fragile edges of the basins.

POTOSI, BOLIVIA. Meeting Tomas Mayo Vargas, age twelve and an orphan, and Andre Valle, at the Cerro Rico mine was one of the most powerful and painful moments of Föllmi's travels throughout Latin America. Tomas embodies the entire situation of the Potosi Indians in the twenty-first century. There is no more money in Potosi. The mountain yielded eight hundred million tons of ore. The seam is now exhausted. But tin was found, and therefore people are still dying for Cerro Rico. Instead of going to school, young children go down into the mine, as does Tomas. It's hard to imagine how unsafe conditions are. In Potosi today, a miner's life expectancy is no more than forty-five years.

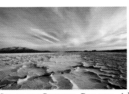

SALAR DE COIPASA, BOLIVIA. A lake at the end of the world at the Chilean border. A vast white expanse from which emerges an island that is as deserted and isolated as everything around it. It is a landscape worth seeing, as beautiful as the long and difficult road that leads there. The rough terrain floods in the summer once the large clouds have dumped their torrents of rain on the Altiplano. A hostile and rocky world in which only cacti and the Chipayas, the sole survivors of a dying ethnic group, have found refuge.

Left: ANTIGUA, GUATEMALA. In this city that lives to the rhythm of its colonial past, there are elegant and remarkable statues, like the one seen here, which are surprisingly well preserved, despite the many earthquakes that have ravaged the city. They fill the churches and are perhaps the best indicators of religious, economic, and political life in the seventeenth and eighteenth century.
Right: POTOSI, BOLIVIA. After the price of tin fell in 1986 and after the closing that followed (eighteen thousand people found themselves unemployed overnight), the Indians decided to take their destiny into their own hands. Grouping themselves into small cooperatives, they returned to the mine. Each worker was responsible for his equipment (helmet, dynamite, candles, etc.) and worked in groups of three or four, for ten to twelve hours or more a day, in temperatures reaching 110°F (45°C). Outside it was freezing. The day is spent in the dark and is long. Workers are trucked to the mine before dawn, and only emerge from the bowels of Cerro at sunset. In 1987, UNESCO declared Potosi a World Heritage Site.

Left: HAVANA, CUBA. Ernesto Rafael Guevara de la Serna, known as "Che," is a true Cuban legend. Because he had the typically Argentinean habit (he was from Argentina) of starting or ending his sentences with the expression "che" (hey), he was called "El Che." Raised in a middle class milieu, this young doctor abandoned his profession to join Fidel Castro, with whom he waged the Cuban Revolution from 1956 to 1959. He later resigned as Minister of Industry to help organize liberation movements in the Congo and in Bolivia. It was there that he died at age thirty-nine, fighting with the guerillas. Fidel Castro, Che Guevara, and Camilio Cienfuegos, the three major figures of the revolution, are depicted throughout the island, on public buildings, schools, and factories, and in streets.
Right: HAVANA, CUBA. Sugar cane is not originally from Cuba. But tobacco was known and smoked by residents before the Europeans arrived. When the conquistadors landed in Cuba, they remarked that the Indians inhaled leaves they called *tabaco.* It was said to calm the body and relax the mind. Once they tried this strange plant, they were eager to grow it. A century later, Spain had a monopoly, making Seville the cigar capital of the world.

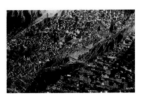

LA PAZ, BOLIVIA. Nuestra Señora de la Paz—its full name when it was founded in 1548 by Alonso de Mendoza—is today the administrative capital of Bolivia and home to its government. But this was not always the case. The Spanish could not tolerate the Altiplano climate and therefore preferred this center to Sucre. The remarkable international airport is the highest in the world at almost 14,000 feet (4,200 meters). From there, there is a magnificent view of the city, built around the deep basin of the Choqueyapu River.

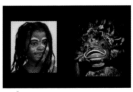

Left: SALVADOR DE BAHIA, NORDESTE, BRAZIL. During the children's carnival, smiling and happy young faces are painted with colorful makeup.
Right: SUCRE, BOLIVIA. Danzanti Mask from the region of La Paz, exhibited at the National Museum of Ethnography and Folklore in the city of Sucre. In Bolivia, folklore continues to be exceptionally rich in the twenty-first century. Each region has retained its celebrations, traditions, and costume. As perfect pastimes, festivities are often prepared months in advance and have a huge impact on this hardworking population. Everything is pretext for celebration, from major religious holidays to local events, and the themes attest to the survival of ancient Pre-Colombian customs. The founding cult in the Andes was to Pachamama, mother earth.

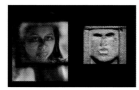

Left: SARAYAKU, PASTAZA PROVINCE, AMAZONIA, ECUADOR. A young girl from Sarayaquillo draws the traditional markings of her community on her face. She is proud to display them and will teach them to her children so as to perpetuate the ancestral tradition of Amazonian Indians.
Right: MEXICO CITY, MEXICO. Detail of an anthropomorphic sculpture. Chicomecoatl, goddess of fertility. Castillo de Teayo, Veracruz, Huaxtec post-classic culture (900–1521 A.D.). Sometimes also identified as the goddess of corn or food, this sculpture is part of the extraordinary Pre-Colombian Mexican collection at the National Museum of Anthropology, built in the 1960s by Pedro Ramirez Vasquez.

SALVADOR DE BAHIA, NORDESTE, BRAZIL. Children have their own carnival, for which adults enjoy making them up. It takes patience and skill to turn a child into a butterfly, a ladybug, or a princess-cat, as is cleverly demonstrated here by a white clown.

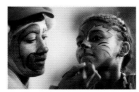

SALVADOR DE BAHIA, NORDESTE, BRAZIL. More than two million people dance day and night either behind *trios elétricos* (large motorized floats that drive through the streets with huge stereos, local musicians and their most famous stars on board), with *afoxés* (groups that draw on African culture, playing the atabaque, a kind of drum), or within *blocos* (groups of people wearing an *abada* or costume within a roped area). Furthermore, impressive crowds known as *pipocas* (popcorn) fill the streets, dancing and jumping!

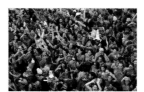

SALVADOR DE BAHIA, NORDESTE, BRAZIL. Jubilant crowds, a flood of color, movement, and music during carnival. You go to dance, drink, and have fun. Here, the celebration is at its peak. Unlike most other carnivals in the country, the Bahia one doesn't end on Ash Wednesday at noon, but continues until the following Sunday. During the weeklong festivities, *Bahianos,* under the spell of music, let lose behind the *trios elétricos.*

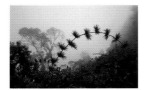

GUATEMALA. In the tropical forest between the Pacific and the high plateaus, in the heart of this wild and authentic country, it is interesting to remember that Guatemala gets its name from the Maya word *Cuauhtemallan,* which means "place of many trees."

Left: GUATEMALA. Covered by a dense tropical forest, the warm region of Petén, in the north of the country, is barely populated. Bordering Belize, which the Guatemaltecs have been disputing over for years, the region has become a strategic area ever since oil fields were discovered in the 1960s.
Right: GALAPAGOS, ECUADOR. Of all the animals in the Galapagos, iguanas are by far the ones that most attract curious visitors. There are two kinds, those that live in the water and those that live on land. This marine iguana from Espanola Island, with its jagged dorsal crest and powerful claws, resembles a prehistoric monster. Its land counterpart is yellowish in color, mostly vegetarian, and even more massive.

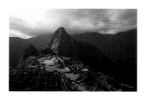

MACHU PICCHU, PERU. Not much is known about this exceptional site, not even its real name. For Machu Picchu is the name of the mountain on which it stands and means "old peak" in Quechua. Discovered by chance in 1911 by the American Hiram Bingham, who was studying Vilcabamba la Vieja. This was the lost Incan city from where anti-Spanish forces continued to fight the Spanish forty years after the conquest, until Tupac Amaru, the last indigenous leader, was executed. Is Machu Picchu therefore a religious center, a city protected by the Virgins of the Sun, a military fortress, an area that had experimental agricultural practices? Perhaps. For we do know that the Incas were masters of hybridization and grew hundreds of different kinds of potatoes and several varieties of corn, ranging from white to purple, as well as yellow and orange. The majesty of the site, the beauty of the mountains and surrounding landscape, and the mystery that fills it, make this one of the most extraordinary places in the world.

Left: MEXICO CITY, MEXICO. Detail of an anthropomorphic atlante. Tula. Toltec Culture. Early Post-Classic period (850–1250 A.D.). At thirty miles (sixty-five kilometers) north of Mexico City, Tula was one of the most dynamic city-states of the period, ruling over important territories for more than two centuries. In the tenth century, its power was strengthened by the arrival of the Toltecs, descendants from the North, who introduced original and sturdy architecture with atlantes pillars or warrior statues, snake columns with quetzal feathers, etc. The most famous example of atlantes are those that stand atop the pyramid at Tula.
Right: SARAYAKU, PASTAZA PROVINCE, AMAZONIA, ECUADOR. This young man from Sarayaku is defending his Amazonian forest against the onslaught of large international oil companies. In 2004, he decided with his family to make an official declaration in order to bring the world's attention to the conditions of their community.

SARAYAKU, PASTAZA PROVINCE, AMAZONIA, ECUADOR. Occupying almost three million square miles (seven million square kilometers) in the heart of South America, Amazonia is a vast basin sustained by the Amazon and its tributaries. It is divided into eight countries, Bolivia, Brazil, Colombia, Ecuador, Guyana, Peru, Surinam, and Venezuela, all allied for almost thirty years now by a cooperation treaty. Endowed with a warm and humid climate, Amazonia represents a third of the word's tropical forests and is home to countless animal and plant species.

SARAYAKU. PASTAZA PROVINCE, AMAZONIA, ECUADOR. Family life is peacefully spent in the Sarayaquillo community hut, where knowledge is passed down from generation to generation. Older members teach younger ones not only about plants and their medicinal, ornamental, ritual, and poisonous properties, but also about how to find wood to build homes, canoes, useful objects, and other necessary tools.

Left: MEXICO CITY, MEXICO. The National Museum of Anthropology is a crucial stop for learning about civilizations that lived in Mexico, from the Olmecs to the Aztec, Mayas, Toltecs, Zapotecs, and others. The architect who designed the museum wanted to create a space that would forge historical consciousness, as was the wish of the president at the time, Lopez Mateos. On the day it was inaugurated, he declared: "I want Mexicans to be proud when they leave here." More than forty years later, and despite the incredible architectural revival in the museum world over these past years, this institution is still among the most remarkable feats in contemporary architecture.
Right: TIKAL, PETÉN, GUATEMALA. Listed as a World Heritage Site in 1979, Tikal, which means "place of echoes" in Quiche Maya, is still a mystery today. Why did the Mayas, as early as the seventh century BC, choose this inhospitable site, located right in the middle of the jungle, with all its mosquitoes, snakes, jaguars, pumas, and howler monkeys, for this incredible city, both a religious center and a dynamic town? During its first days of glory, the city was allied with Teotihuacán in Mexico. It was one of the most powerful Mayan cities, extending over 60 square miles (160 square kilometers) and home to over fifty thousand residents. Why it fell in 900 A.D. is still unknown.

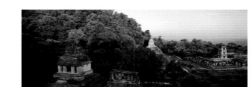

PALENQUE, CHIAPAS, MEXICO. On the first foothills of the Altiplano in the state of Chiapas, in the heart of the jungle, stand the impressive ruins of Palenque. A true jewel of Mayan architecture, nestled in the tropical forest, the city ruled over the entire region between 600 and 800 A.D. It was abandoned at the beginning of the twentieth century. As is the case with Tikal, archaeologists around the world are still searching for the real

reasons for this brutal fall. The various pyramids, the central palace, the latest frescoes to be uncovered, all communicate sophistication. Astounding bas-reliefs offer an idea of the lifestyle and costume, customs, and war strategies of its inhabitants.

MEXICO CITY, MEXICO. Wearing his feather headgear, an Indian performs the Quetzales dance on the zocalo. For pre-Hispanic peoples, dance is a natural form of expression used to worship the gods or to celebrate magical rituals. During major religious festivals, the *Concheros* don both feather costumes and the skirts worn by their Aztec ancestors to dance to the sound of drums on city squares in Mexico City. This is a way of promoting and maintaining their traditions.

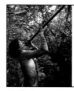

Left: SARAYAKU, PASTAZA PROVINCE, AMAZONIA, ECUADOR. A young hunter practices using the blowgun, for he knows that the community's resources depend on contributions made by every member. He has to know how to hunt, fish, farm, raise animals, and participate in community projects.
Right: SARAYAKU, PASTAZA PROVINCE, AMAZONIA, ECUADOR. Luisana, age sixteen, lives in the Sarayaquillo community in the heart of Amazonia and loves the primary forest in which she was born. She hopes to pass down all her knowledge about the forest's treasures, despite the threat large oil companies pose to the land and its resources, not to mention its sacred sites.

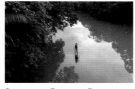

SARAYAKU, PASTAZA PROVINCE, AMAZONIA, ECUADOR. The Kichwas Canelo Indians, related to the Zapara and the Mainas in the Amazon, were subjugated by the conquistadors and evangelized by the Jesuits. They live on the banks of the Bobonaza River in the Ecuadorian part of Amazonia. They make use of its resources, like fish.

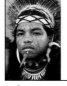

Left: SALVADOR DE BAHIA, NORDESTE, BRAZIL. A young *Salvadoreño,* with his makeup and hairdress, is ready for carnival. He embodies the diversity of Brazilian culture, which is expressed during celebrations.
Right: SARAYAKU, PASTAZA PROVINCE, AMAZONIA, ECUADOR. Silvio David Malaver Santi, head of the Sarayaquillo community in Sarayaku, defends the Amazon against oil wells in this part of Amazonia. He wants to prevent his ancestral land from being transformed into a large oil field, which would mean death, destruction, and pollution. His aim is to preserve the biodiversity of the area, his history, and heritage.

THE ROAD FROM LA PAZ TOWARD THE YUNGAS AND AMAZONIA, BOLIVIA. Considered to be one of the most dangerous in the world, the road between La Paz and Amazonia passes through the deep valleys of the Yungas with its tropical vegetation. From La Paz, a wonderful road climbs the cordillera right to La Cumbre pass at 15,000 feet (4,658 meters). From there, you head down almost 10,000 feet (3,000 meters) at thirty-five miles (seventy kilometers) an hour, on a narrow road that runs alongside drastic drops. Passing another car is a feat. Truckers travel this hellish road day and night throughout the year, but decorate their vehicles with pious images for protection.

VILLAHERMOSA, YUCATÁN, MEXICO. Relics from the Olmec civilization in the Parque-Museo de la Venta. Taking its name from the largest Olmec site, situated about 60 miles (100 kilometers) from Villahermosa, this open-air museum is located on the shores of the Laguna de las Illusiones. Considered to be the *cultura madre* (mother culture) of Mexico, the Olmecs, about whom little is known, settled on the warm and humid coast of the Gulf of Mexico around 1200 A.D. Establishing political, economic, and religious power over a large part of the region and its inhabitants, they built a large road network, leaving enormous stone head sculptures as ruins. They were created in basalt stone that can weigh up to twenty tons, and were most likely transported on rafts.

BETWEEN SUCRE AND TARABUCO, BOLIVIA. Traveling at altitudes between 9,000 (2,700) and almost 11,000 feet (3,200 meters), cacti and adobe houses are the only elements punctuating the scenery. Bolivia is snow-capped but mostly tropical. There is a large range of landscapes and climates here, divided into three main regions: the Cordillera and Altiplano, the Yungas and Valles, and finally the Llanos or tropical plains.

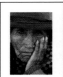 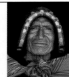

Left: CUZCO, PERU. The pensive face of an old Indian woman on the streets of Cuzco. For better or worse, the indigenous world in South America was able to withstand the ravages of the conquest and five centuries of Hispanicization. But can it survive growing globalization?
Right: TARABUCO, SUCRE, BOLIVIA. This resident from a village in the region of Tarabuco is going to the *Pujillay,* the large annual fair in the area, which every year during carnival commemorates the Calisaya Indian chief's victory over Spanish invaders. This is the largest indigenous event in the country. Beginning with a Mass sung in Quechua that draws on local folkloric melodies, it is a colorful and authentic occasion.

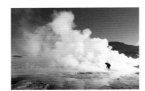

NORTE GRANDE, TATIO, CHILE. Chileans say that after creating almost all of South America, God looked at what was left—some desert, mountains, valleys, glaciers, forest, and coast—and decided to make one last country: Chile! Situated some 60 miles (100 kilometers) to the north of San Pedro de Atacama, the El Tatio volcano is the highest geyser field in the world. It's like crossing a huge steam room with sixty-four springs of boiling water. An unusual and disorientating landscape at 14,000 feet (4,300 meters).

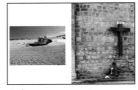

NORTE GRANDE, CHILE. With the smoke, steam, and noise—as if thousands of kettles were all going at once—and with the rays of the rising sun illuminating this Dante-like scene, the geysers of Tatio, known throughout the world, are an amazing sight. What's more, strange sculptures, resulting from water evaporation, punctuate the landscape.

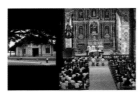

Left: PONTAREMA, ALTIPLANO, BOLIVIA. At more than 12,000 feet (3,800 meters), lost between the Salar de Coipasa and the Salar de Uyuni, the Pontarema church stands as a unique witness to Spanish civilization in this deserted landscape. Man has been living in the Andean highlands, with its harsh conditions, since the most distant times (between 4000 and 3000 B.C.).
Right: CUZCO, PERU. You have to take time to stroll through the streets of the old city, where you'll see that the walls of Incan palaces served as the foundation for colonial homes and as entrances to amazing churches like San Blas or La Merced, which has one of the most dazzling cloisters in the country.

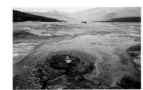

Left: SAN MIGUEL DE VELASCO, CHIQUITOS, BOLIVIA. A huge roof upheld by graceful twisted wood pillars, a facade decorated with stylized motifs, an original campanile, a sculpted and gilded wooden altar, and delicate religious figures: all make San Miguel the gem of the Chiquitos missions. It is amusing to see how the founding priests from Bavaria, Austria, and Switzerland influenced the architecture. The two-sided roof is inspired by alpine chalets!
Right: SAN MIGUEL DE VELASCO, CHIQUITOS, BOLIVIA. Sunday mass in the Church of San Miguel, founded in 1721 by the Jesuit father Martin Schmid, originally from a small village in the heart of Switzerland. In 1992, the splendor of the Chiquitos missions was restored by Swiss architect Hans Roth, with more than a hundred local artisans. Their work was fruitful. The missions are now included on the prestigious list of World Heritage Sites.

JANITZIO ISLAND, PÁTZCUARO, MEXICO. Sunrise. When Charles Quint asked Cortés to define the geography of New Spain, the latter crumpled a piece of paper and threw it on the table. He judged it impossible to outline this huge country, where in a few hours one goes from cold mountains to tropical jungles. In this continent, lakes outnumber rivers and each has its own legend.

Left: TARABUCO, SUCRE, BOLIVIA. The Sunday market takes over the square and spills into the neighboring streets. The range of goods is difficult to fathom: from coca leaves to the colorful fabric for which the village is known; every kind of object to please the gods, from amulets to llama fetuses; blocks of salt from the flats in the south of the country, balls of llama fat, kitchen batteries, shampoo, and soap.
Right: QUETZALTENANGO, ALTIPLANO, GUATEMALA. Market day. An opportunity to bathe in the Mayan culture strongly rooted in the Guatemaltec cordillera, markets are an important part of indigenous life. Here, in Xela, located at about 8,000 feet (2,500 meters) between the volcanoes of Santa Maria and Santiaguito, we are at the site of the former capital of the Quiche kingdom.

Left: SAN FRANCISCO EL ALTO, QUETZALTENANGO, GUATEMALA. Bus Terminal. You can cross the country in these richly colored buses that brighten roads throughout Central America.
Right: SAN FRANCISCO EL ALTO, QUETZALTENANGO, GUATEMALA. Bus Terminal. With little regard for safety, buses allow too many passengers on board. A trip can turn into a real obstacle course. Some riders have to transfer three and four times depending on their destination, which adds quite a bit to travel time.

Left: QUETZALTENANGO, ALTIPLANO, GUATEMALA. Shoe shiner. Traveling merchants, trying to make ends meet to support their families, are everywhere in this country, one of the poorest in the continent. Illiteracy is very high as well. The society is divided in two: the mixed population, known in Guatemala as Ladinos, and the other indigenous communities, lower on the social ladder, known as *Naturales.* This latter category, which is larger, represents 60 percent of the population (95 percent in the Altiplano). It is divided into twenty-three distinct communities, each of which has its own language. The population has neither economic nor political power.
Right: TARABUCO, SUCRE, BOLIVIA. Family scene with a grandfather and his two grandsons at the Sunday market in Tarabuco, some thirty miles (sixty kilometers) from Sucre.

ALTIPLANO, BOLIVIA. Members of the camelid family, like alpacas, guanacos, and vicuñas, llamas live at high altitudes in the high plateaus of Bolivia, for example here around the Salar de Uyuni. They also live in southern Peru, northeast Chile, and northwest Argentina. Their hair makes a thick and coarse wool, unlike that produced by its alpaca relatives, which is sought after for its softness and delicacy. Vicuna wool, considered to be the finest in the world, can be astronomically expensive.

FUENTES GEORGINAS, QUETZALTENANGO, GUATEMALA. Mayan descendants continue to live by their ancestral beliefs and still identify with the "corn man" today, in communion with the earth and natural forces. *Milpa* or corn, a few basic foodstuffs, the market, and religious rituals are the essential elements of their life. On his way out of Zunil, on a picturesque road that winds through the mountain, valleys, and fields, Olivier Föllmi met Pablo. He was standing amid exuberant vegetation, at 7,800 feet (2,400 meters), in a magnificent landscape where hot springs abound.

VIÑALES, CUBA. For cigars and wine, soil quality is a top concern. The tobacco fields of the Viñales region in the province of Pinar del Rio are known for yielding the most prestigious fine crops: In an area totaling almost a hundred thousand acres there grows the best tobacco in the world. Situated at the western tip of the island, the province was called "New Philippines" at the start of the Conquest because its landscape was thought to resemble Southeast Asia more than the Caribbean, with its fertile green plains, its narrow valleys dotted with palm trees, its *magotes* (magnificent karstic mountains), and *bohios* (small peasant thatched huts with thin plank walls). Filled with silence and serenity, the Viñales valley is enchanting.

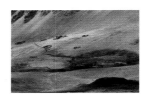

CORDILLERA DE APOLOBAMBA, BOLIVIA. This isolated village in the middle of a hostile landscape makes you wonder how man arrived in these kinds of regions. We tend to think that primitive man left a changed coast for the cordillera by traveling along rivers. Being nomad hunters, they migrated with the fauna, their staple diet, into the land. There are many traces of this existence, including hunting scenes painted on cave walls. The climate of the Altiplano was certainly even harsher than today and agricultural areas were probably much larger.

Left: ALTIPLANO, PERU. This young shepherd from the village of Pampacorral, wearing her community's skirt, poncho, and hat, is responsible for the sheep, a duty that in the Andes is often delegated to girls.

Right: URUBAMBA VALLEY, PERU. In his The Royal Commentaries of Peru, Garcilaso de la Vega explains that the Urubamba Valley was the most fertile and pleasant valley in the country. All the Incan kings made it their garden, a place to rest and spend leisure time. With its temperate climate, women continue to grow potatoes, and spin and weave wool, while preserving Quechua, the Indian common language, forced on conquered peoples by the Incas. Nothing seems to have changed here for two thousand years.

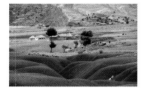

MARAGUA, BOLIVIA. In the mountainous region of Sucre near Tarabuco, the landscape becomes austere again: arid land and bare hills with a few scattered trees contrast with the fertile valleys surrounding the city. Occasionally, one sees small village homes that hint at the colonial style with their curved tile roofs.

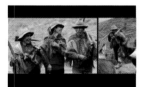

Left: URUBAMBA VALLEY, PERU. Peasants come home from working in the fields of the Sacred Valley, as it is called today. From the village of Urubamba on, the Rio Vilcanota is called Urubamba throughout the valley. Under the Incas, the Urubamba was named the Huilka Mayo, which in Quechua means the sacred river (hence the recent name Sacred Valley).

Right: URUBAMBA VALLEY, PERU. Anzelmo Landa, a peasant from the valley, returns home after a day of work. Fated to be a laborer, he knows that the guardian spirits of the *cerros* (mountains) watch over him and that it is best not to contradict them.

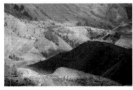

SUCRE, BOLIVIA. Founded on seven poetically named hills—wind, reeds, loves, etc.—and nicknamed the city of four names (each after a period in its history), Sucre was designated a World Heritage Site. It is also the constitutional capital of Bolivia and home to its Supreme Court. Located in the heart of the magnificent valley at 9,000 feet (2,750 meters), it enjoys a tropical climate that is ideal for this altitude and that already appealed to the Spanish in 1538. It would become the first major city of Alto Peru, the name given to Bolivia by the conquistadors.

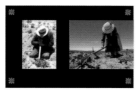

Left: LAKE TITICACA, PERU. Victor Chalco, an Aymara Indian, lives on Anapia Island. At age ninety, he is still strong and spirited enough to work the land. Before turning to the soil that sustains him, he tells us one of many legends (the shortest and most cruel) describing the origins of the lake. As the story goes, it was formed by the tears spilled by the Sun god when a puma had devoured his children.

Right: LAKE TITICACA, PERU. In addition to the floating islands, there are more than sixty terra firma islands on Lake Titicaca. Communities of Indians live there, just as they did during the Incan period, electing their local representatives during island-wide assemblies. An island is divided into *suyos,* or areas cultivated in alternating periods so that land can lay fallow. Here, an Indian woman works the potato field her community has given her.

COLCA VALLEY, PERU. In southern Peru, Arequipa, called the White City, is surrounded by a chain of volcanoes and *cañones* like the Colca and the Cotahuasi, one of the deepest depressions in the world, twice the size of the Grand Canon! To reach it, one crosses the villages of Pulpera, Callali, Tuti, Chivay, Yanque and Coporaque as well as vast valleys, over which giant condors fly. The wingspan of these raptors can reach nine feet (three meters).

Left: MORELIA, MICHOACÁN, MEXICO. In the courtyard of the cathedral of the Transfiguration of Christ, built in the sixteenth century and presenting a combination of styles, neoclassical, Herreresque, and Baroque, there reigns a century-old bougainvillea that is in full bloom in November. Noblemen and religious orders developed the city, building palaces, churches, and monasteries along its handsome paved avenues and around its magnificent squares. Its charm remains intact today.

Right: SUCRE, BOLIVIA. An amazingly charming city, where one strolls up and down small paved streets lined with white facades and Andalusian roofs. In colonial times, religious orders were ubiquitous here, leaving many traces of their presence. In addition to the cathedral, there are countless churches that fill the city, for example the chapel of Nuestra Señora de Guadalupe, the Church of San Miguel with its high bell, the Church of Santa Monica, San Francisco, Santo Domingo, the monastery of Santa Clara, La Merced, and the church of San Felipe Neri, with its beautiful rooftop view of the historical center.

CUZCO, PERU. The heart of the city and its road system have not changed since the Incans. When the Spanish discovered Cuzco in the sixteenth century, they were amazed to see all the temples covered in gold and silver. Even the garden next to the Sun temple was called "garden of gold." Since 1990, massive renovations have been undertaken to scrupulously restore the city. In the narrow paved streets of the San Angel neighborhood, life goes on, as if indifferent to the frenzy of the world around it.

Left: VILCANOTA VALLEY, PERU. Community gathering at Raqchi (11,000 feet [3,486 meters]). In the Andean valleys and high plateaus, a vast stretch of land 1,200 miles (2,000 kilometers) long but only 200 miles (350 meters) wide at most, extends from Abra La Raya in the Vilcanota Valley to Lake Titicaca in Bolivia. The average altitude is about 13,000 feet (4,000 meters). Communities here have gradually adapted to the extreme climatic conditions, which include powerful icy winds, a burning sun, thin air and enormous temperature fluctuations between day and night.

Right: VILCANOTA VALLEY, PERU. Community gathering of Indians near the ancient pre-Incan city of Raqchi standing at 11,000 feet (3,486 meters), part of the district of San Pedro de Cacha. Women sit against the wall of adobe homes, waiting to leave for the big Sunday market in the neighboring town. Women wear layers of wool skirts, embroidered blouses and felt hats. They collect their goods—crafts and foodstuffs—in large wool patterned blankets, which they carry on their backs as large bundles.

HAVANA, CUBA. At once young and old, wrinkled and made up, weathered by salt and rejuvenated, old-fashioned and bewitching, but above all, shunted by history, Havana is a mythical city. It takes many visits to take it all in, and especially to try to understand it. Old American cars, Chinese bicycles, horse-drawn carriages, pink and white public buses, all are means to conquer a place that has been fighting proudly against the onslaught of the Caribbean Sea ever since it was founded in 1519, by Panfilo de Narvaez, the forgotten conquistador, commanded by Diego Velázquez, the island's first governor.

Left: ATACAMA DESERT, NORTE GRANDE, CHILE. A young boy from Toconao village. In Chile, the Indians represent about 10 percent of the population. But, in this region bordering Bolivia, there is a very large population of Aymara Indians.

Right: ATACAMA DESERT, NORTE GRANDE, CHILE. This little girl from the northern Andes is an Atacameña Indian. Among the Indian ethnic groups in southern Latin America in Araucania, there are the invincible *Mapuches* (*mapu* meaning "land" and *che,* "people"), the only Indians indigenous to Chile and the only ones to resist attack! The Mapuche nation was sadly destroyed and occupied by the Chilean army in the middle of the nineteenth century. Later, a tribal reservation system was established, modeled after North American examples.

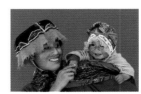

PISAC, URUBAMBA VALLEY, PERU. Urubamba, which means "the plain of Urus" in Quechua after the ethnic group that lived in the region and that totally disappeared at the beginning of the twentieth century, is a valley also known for its markets. The one in Pisac has become a tourist attraction. Away from the center of activity, in a corner of the main square where this photograph was taken, there are still a few peasants.

Left: ON THE ROAD TO SALAR DE COIPASA, BOLIVIA. Might this shepherd be a Chipaya, the endangered ethnic group that found a home at the mouth of the Rio Laucas? Some ethnologists believe the Chipayas are the direct descendants of the first peoples to live on the Latin American continent. Their roots date back to 2500 B.C. and their language is particular. In addition to Aymara, a guttural language with sharp sounds, they speak Puquina, which has a soft and melodious rhythm.

Right: CUZCO, PERU. An old woman patiently waits for anyone who might want to take her picture at the foot of the famous Inca Wall, one of the highlights in the old city. She is from one of the surrounding Indian communities, coming down a few times a week from the arid highlands or tropical valleys that surround Cuzco. She sits at a strategic spot best for *propinas* (tips).

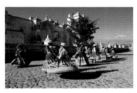

Left: SOLOLA, ATITLÁN, GUATEMALA. At the market, picturesque scenes abound and will fascinate any curious budding ethnologist. This is the perfect place to observe the mores and customs of the *Naturales.* It's best to remain in one spot as discreetly as possible, to observe the activity and listen to conversations in one of the twenty-three languages spoken in the country. Wrapped in colorful fabrics, women carry their newborns and their personal items, the products they have to sell and those they have just bought. And often, even their chickens!

Right: CHIVAY, COLCA VALLEY, PERU. Pablito, age three, is crying because he has just been scolded by his mother for getting into mischief. Responsible and hardworking Indian women from the Altiplano often have a swarm of children behind them.

YANQUE, COLCA VALLEY, PERU. A folkloric troupe appears in the harsh morning light in front of this monumental village church in the province of Caylloma. The dancers draw on their long *polleras* or skirts, and spin elegantly, performing a typical dance from the Colca Valley known as *El Witite.*

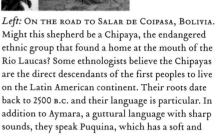

Left: GUATEMALA. Fabric and textile production has been an integral part of Mayan culture for centuries. The colors and motifs used today are, however, very different from when the conquistadors arrived on the continent. The Spanish introduced wool and new weaving techniques that continue to be used in the twenty-first century. Mayan women have recently developed a taste for fluorescent colors, like the pink and pale green seen on this piece of fabric.

Right: TARABUCO, SUCRE, BOLIVIA. This street musician is a reminder that music is ever present in

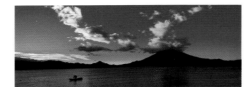

Latin American daily life. Among the many musical instruments used, the most popular are the *caja,* a small drum, the *caña,* a long bamboo shoot with leather strips that offers a doleful and monotone sound, the *charango,* a tiny guitar developed for Indians during the conquest with a resonance chamber made from an armadillo shell, the *erke* or *phututo,* a bull horn attached to a tube of reeds, producing a deep sound, the Indian harp, the *huancara,* a large drum, the *mukululo,* a curved wooden flute that produces a deep sound, the *pincuy,* a bone flute, bells, and bracelets made from llama or goat nails worn around the wrist or ankle. Some instruments were introduced by the Spanish, but others are indigenous to different regions of the country. There is even a representation of an instrument on the *Puerta del Sol* frieze in Tiahuanaco.

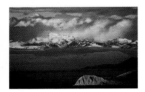

LAKE TITICACA, PERU. This huge navigable lake is the highest in the world, at more than 12,000 feet (3,800 meters), and is deep blue. It is historically considered to be the cradle of Incan civilization. Legend has it that Manco Capac, the first Inca, along with his wife Mama Oqllo and her three brothers and respective wives, left its waters to found Cuzco. Fifteen times bigger than Lake Geneva, it is sustained by dozens of rivers and streams coming off of the Andes cordillera. It only has one outlet—the Rio Desaguadero—which itself feeds into Lake Poopo in Bolivia. These waters, which will never reach the ocean, are reduced through evaporation, a process accentuated by thin air and the intensity of the sun at this altitude. Although it is known to be the remnant of a vast inland sea that covered the entire Altiplano along with Lake Poopo, the Salar de Uyuni and the Salar de Coipasa in Bolivia, there is concern today because some of the floating islands do not anymore! The most famous lake in the world has not been spared from the effects of climate changes. It has already begun to dry up.

Left: URUBAMBA VALLEY, PERU. This young peasant from the Sacred Valley, wearing a hat and poncho woven locally by the women of her community, does not speak Spanish, only Quechua, the standard Indian language in this region and Peru's second language. It is spoken throughout the country except for around Lake Titicaca, where Aymara is spoken. It is also the Indian language of northwestern Argentina, northern Chile, Bolivia, Ecuador, and southern Colombia. Quechua is not only the tongue the Incas imposed on all the conquered peoples, but also the one missionaries used to preach the Gospel. *Right:* TARABUCO, SUCRE, BOLIVIA. In the valley near Tarabuco, a young village resident has put on her best clothes for the annual *Pujillay* celebration. On the occasion of this large fair, which takes place the second Sunday in March, ten thousand peasants indigenous to eighteen communities and dressed in the traditional costumes from their regions, pay homage to their ancestors who defeated the Spanish in 1816 in the battle of *Jumbate.* Some women wear brightly colored clothes with remarkable abstract motifs and patterns.

LAKE ATITLÁN, GUATEMALA. Guatemala is home to three permanently erupting volcanoes in rather close proximity of each other: the Pacaya near Guatemala City with its constant lava flow, the Fuego seen here over Lake Atitlán, and the dynamic Santiaguito, which releases large bursts of volcanic ash several times a day.

LA PAZ, BOLIVIA. The highest capital in the world is built around what is like a huge crater, five miles (ten kilometers) wide, fifteen miles (thirty kilometers) long and 4,000 feet (1,200 meters) deep. During the day the view from El Alto is impressive, but the view at night is perhaps even more spectacular, offering the fairy-like twinkling of thousands of electric lights amid the snow-capped mountains of the Cordillera Real. From here, one begins a long descent toward posh neighborhoods where there still exist a few homes with terraces, the last survivors of a bygone era.

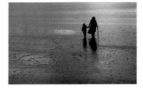

SALAR DE UYUNI, BOLIVIA. At 12,000 feet (3,653 meters), the sun burns skin, salt eats away at everything, and the wind is biting. This is a harsh world of amazing beauty. Conditions are hostile and not meant for man. It is nevertheless here that the *salineros,* residents who exploit the land, spend their days. Warmly dressed, their faces covered by masks, and wearing dark glasses to protect them from intense ultraviolet rays, they move about by bicycle. The salt is transported by truck or sometimes still by caravans of llamas, who wear leather covers to protect their feet from corrosion. There are two ways of harvesting salt: in grains, by raking the ground, or in lumps, as seen here, by cutting into the surface with an ax.

ALTIPLANO, BOLIVIA. In the western part of the country, in the heart of this forgotten world, a grandmother and her granddaughter walk at dusk to their village. An image full of hope for a new world beyond the hardships, sacrifices, and injustices that have filled Latin American history since time immemorial.

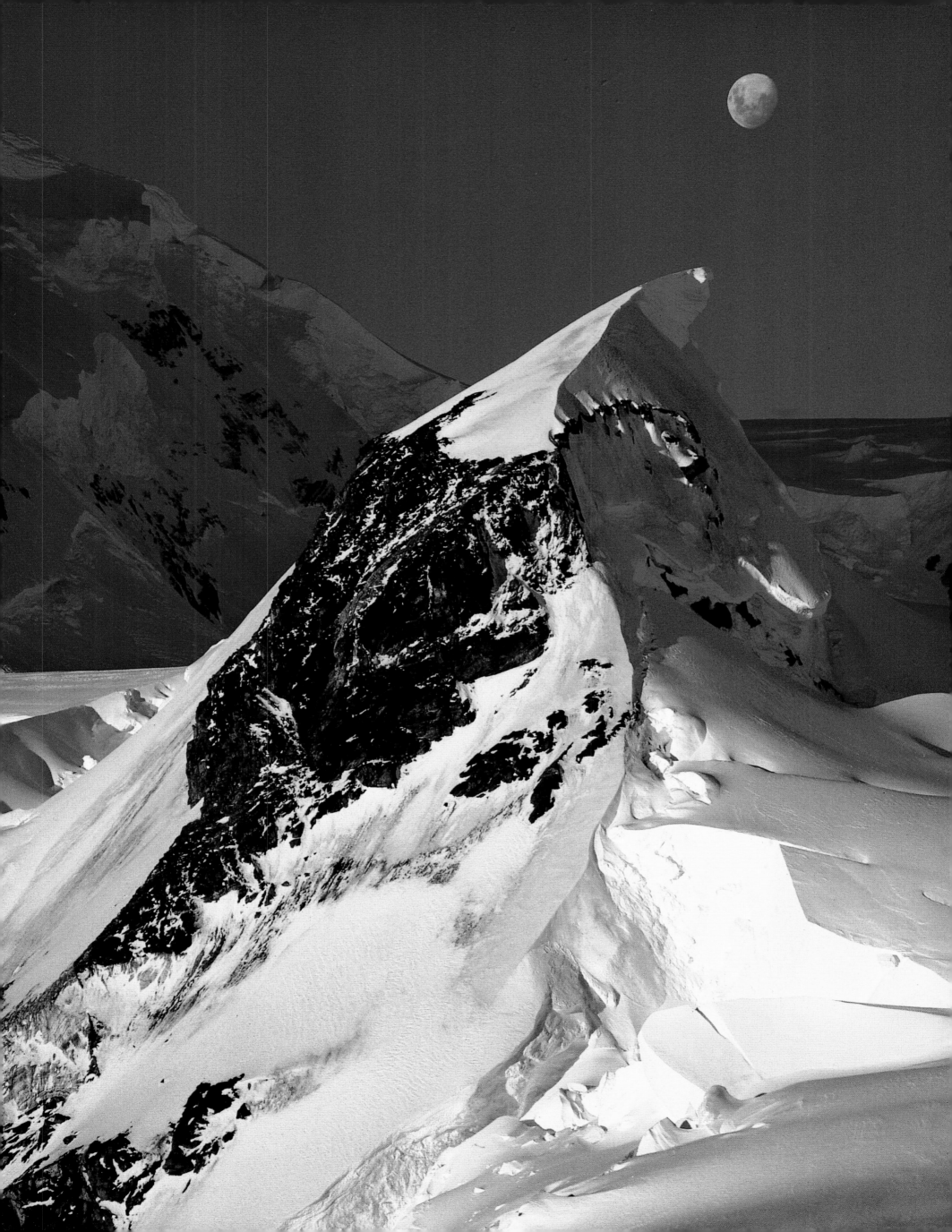

A Note from the Photographer

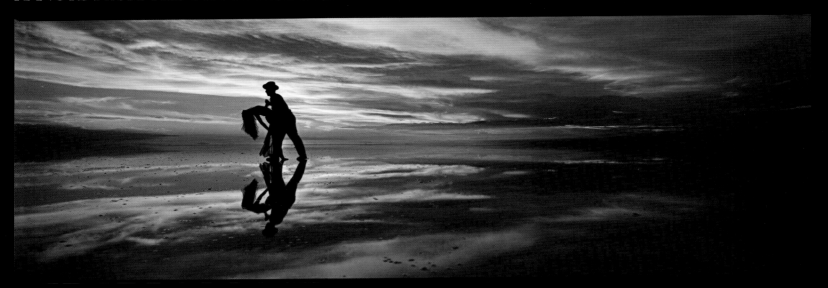

Dancers on the Salar. Cécilia Antequera Camacho and Ulio Santander dance on the Salar de Uyuni, Bolivia, during the rainy season. The Salar is the largest salt flat in the world, measuring almost 12,000 feet (3,653 meters).

Obtaining the photos for this book and for the book *Revelations: Latin American Wisdom for Every Day,* required (in seven months of travel between 2005 and 2006 and in three subsequent voyages of one month in Argentina, Chile, and Bolivia):

travel through 11 countries, taking planes 56 times, spending 14 days on a ocean freighter, navigating for 3 days in a pirogue, 9 days on a fishing boat, changing hotel rooms 154 times, pitching a tent 61 times, sleeping under the stars 10 times, walking for 56 days, driving for 89 days, finding 14 chauffeurs, 12 local guides, 1 bodyguard, communicating 1,221 times by e-mail and 33 times by telephone, and pressing the shutter release nearly 12,000 times. I never counted the miles traveled, but on the other hand, I remember each person whom I met and who, the majority of the time, justified all of these efforts.

The photography is for me a pretext for interacting with others. On arriving in a village, I never have a camera on me, but a bag of magic tricks in order to establish a connection. I love magic, because it is a universal language and causes laughter even in the most remote of villages. If I become close to people, I will not photograph them except with their consent and agreement. Before taking a photo, it is important to me that I give something back: sometimes a smile, a few words, some money, a souvenir, a meal, a present, a snapshot. It all depends on the relationship, the need, or the expectation of the other person. Most of the time, in isolated villages where people never own photos of themselves, I will take an instant photo with the pose chosen by each person, often full length and surrounded by family. I like to take my time with the people whom I photograph. I never invent an attitude or a scene, but I re-create it. I am usually inspired by an ambiance or emotion, seen or shared with someone, and try to photograph it as it happened. I like to share these special moments because it honors the person I photographed. For the photo shoot, I often work with a tripod using light reflectors. Sometimes this is unnecessary, but the mise-en-scène lends a feeling of importance to the situation and to the group. To put the people on stage is to emphasize their value, like putting them up on a pedestal.

For the sake of creativeness, I have also done some completely staged work. When a photo appears in one of my dreams, I put it down on paper the next day and then search for the ideal place and people to bring it to fruition. This method requires true teamwork and the photos are magical to create. However, I never rework a photograph, digital or film. If it includes retouching, I would make mention of it in order to distinguish between the photograph and the photomontage, because they are two entirely different processes.

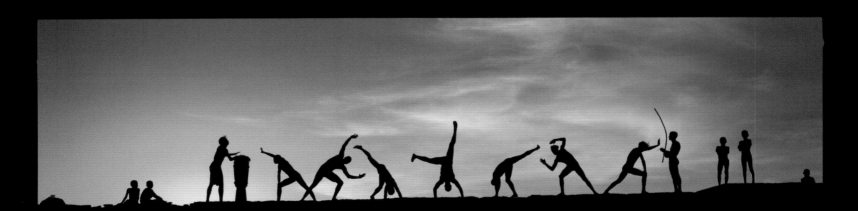

Capoeira. Capoeira is an Afro-Brazilian martial art that combines dance and fighting.

Biographies

Photographer OLIVIER FÖLLMI was born in the Alps in 1958. At the age of eighteen, his passion for mountains led to his discovery of the Himalayas, which he photographed for twenty years. He and his Latin American wife, Danielle, established HOPE (Himalayan Organization for People and Education), an association dedicated to education and mutual assistance among rural communities (www.hope-organisation.com). Since 2003, Olivier Föllmi and his wife have traveled the world to work on the Offerings for Humanity and Wisdom of Humanity projects. He publishes here his twenty-third book. His works and projects can be found on the website www.follmi.com.

A speaker of Spanish and Quechua languages and a worker for the association Traditions for Tomorrow, CLARA GUIOMAR, from Quebec, assisted Olivier Föllmi in Peru and then went on to work in isolated villages in the Andes to collect popular wisdom for the Offerings for Humanity project.

After having finished a degree program in Communications in Brussels, his hometown, GAËLLE JACQUES worked for one year with street children in Mexico before joining Olivier Föllmi's project in Peru, Bolivia, and Ecuador.

Creator of beautiful books at Éditions de La Martinière, BENOÎT NACCI applies his considerable talents to the world of photography as he assembles the work on his screens and light tables. He gives value to each one of the images through a juxtaposition that favors emotion. His work has influenced an entire generation of French photographers.

NORA DELGADO VEGA was born in the Valley of Colca, Peru. Her education, which combined tradition with modernity, her expertise in tourism, and her knowledge of the Quechua, Spanish, and English languages allowed her to help Olivier Föllmi in the Ecuadorian Amazon, Cuba, Guatemala, Brazil, Bolivia, and Mexico. She lives in Arequipa, Peru, where she organizes specialized trips in all of Latin America with Turismo Noal (turismonoalperu@gmail.com).

French calligrapher JIGMÉ DOUCHE draws out the soul of cultures through script and stroke. Having left the Western world for the Himalayas, he continues along the Silk Road to transcribe every example of calligraphy. He wanted to offer in this book one of the greatest calligraphy in humanity: the Maya glyphs.

VIRGINIE DE BORCHGRAVE D'ALTENA became a journalist after graduating in Roman philology at the Catholic University of Louvain in Belgium. More than bilingual, she is bicultural—she has traveled in Latin America for the past twenty years, and published her travel writings in diverse magazines (in her native Belgium and abroad), trying to establish a bridge between the two continents.

Latin America is the fourth volume in the art photography series Wisdom of Humanity. The series presents different cultures through photographs and thoughts that reveal dignity, courage, and altruism as a homage to humanity.

This project started in 2003 and will last seven years. It was made possible by the generous support of:

an anonymous donor

Lotus & Yves Mahé

and the involvement of

 FUJIFILM

And the photography laboratories:

DUPON

Canon

which join their effort to promote humanity in the world.

In Latin America, the project Wisdom of Humanity enjoyed a close collaboration with Traditions pour Demain:

1986-2006

an organization that supports Amerindian cultural initiatives in order to promote dignity and self-confidence, necessary tools to allow the people to take their future back into their hands.

Wisdom of Humanity is realized with active sponsorship from

UNESCO

under the patronage of the UNESCO's Swiss Commission

Acknowledgments

A diverse network of people and friends—holders of Wisdom—helped, supported, advised, and guided us and made our project Wisdom of Humanity possible in Latin America. I deeply thank each and every one.

IN EUROPE:

Aziza Aarab, Paris

Fernando de Almeida (scholar on Latin America), Paris

Teodolinda Banegas de Makris (former Honduras Ambassador), Paris

Bruno Baudry and Fujifilm France

Pierre Bigorgne, Grenoble, France

Alain and Virginie de Borchgrave, Brussels

Guy Bourreau (marketing director at Canon France)

Jean-François Camp (director of the laboratory DUPON), Paris

Luis Chuquihuara (Peruvian Ambassador to Belgium and Luxembourg)

Maria de Lourdes Dieck Assad (Mexican Ambassador to Belgium and Luxembourg) and her spouse, Pedro Quintanilla Gomez-Noriega, as well as Abel Escartin Molina (second secretary for Financial Affairs at the Mexican embassy), Brussels

Cyril Drouet, Paris

Gil Dumas, Neuchâtel, Switzerland

Nicolas Echavarria Mesa (former Colombian ambassador) Brussels

Guy Frangeul and Jean Michel Krief (manager at Photo d'Objectif Bastille), Paris

Martha Garcia, Nice, France

Pablo Garrido Arauz (Panama Ambassador to Belgium and Luxembourg)

Pierre and Josée Godé, Paris

Diego and Christiane Gradis, Rolle, Switzerland

Gilberto Guevara (second secretary for Cultural Affairs at the Peruvian embassy), Brussels

Mircea Hainaru, Constanta, Romania

Sébastien Jacques, Brussels

Corneille Jest (researcher at Centre national de la recherche scientifique), Paris

Maria Cecilia Laverde Montoya (Colombian psychotherapist), Grenoble, France

Thierry Legros, Nice, France

Hervé de La Martinière, Paris

Margarita Miguelanez Compuzano, Madrid

Gitte Elisabeth Moeller, Copenhagen

Jorge Molina Santizo (Guatemalan Consul), Paris

Edmond Mulet-Lesieur, (former Guatemalan Ambassador in Brussels, Special Representative for the Secretary General and United Nations Mission for Stabilization in Haïti [Minustah]), and his spouse, Karen Lind Sverdrup de Mulet, Brussels

Armando Ortuño Yañez (Bolivian Ambassador to Belgium and Luxembourg) as well as Ana Isabel de La Goublaye (second secretary for Cultural Affairs), Brussels

Gabriela Perez Palma y Elorduy, Brussels

Blanca Polio (psychotherapist and psychoanalyst at University of Barcelona) and Eduardo Polio, Spain

Michel Pons, Paris

Laura Pujols (second secretary for Consular Affairs at the Cuban embassy), Brussels

Guy de Régibus (at the laboratory DUPON), Paris

Helen Rios Filipps

Chantal Soler, Paris

Philippe and Dominique Ullens, Brussels

Alexandru Ureche, Constanta, Romania

Guillermo Uribe (director of Groupe de recherche en sciences sociales sur l'Amérique latine, sociology conferences professor), Grenoble, France

Méntor Villagomez-Merino (Ecuadorian Ambassador to Belgium and Luxembourg)

Madeleine Viviani (UNESCO's Swiss Commission), Bern, Switzerland

AT ATELIER FÖLLMI IN ANNECY, FRANCE:

Viviane Bizien, Emmanuelle Courson, Corinne Morvan-Sedik, Stéphanie Ly, and Nicolas Pasquier

AT ÉDITIONS DE LA MARTINIÈRE, PARIS:

Emmanuelle Halkin, Dominique Escartin, Marianne Lassandro, Agnès Poirson, and Cécile Vandenbroucque

IN AMERICA:

Gustavo Aguilar Salvador (Regional Coordinator for MUSEF), Sucre, Bolivia

José Ramón López de León (Mexican Consul), Lima

Juan Angola Maconde (representative of the Yungas people), Bolivia

Cecilia Antequera Camacho and Andrés Chacon, Sucre, Bolivia

Carmiña Cabrera Essanguino and her cousin Walter Kuljis Fishner, Santa Cruz, Bolivia

Jennifer Centy Paco and Luis Juares Pinto, Arequipa, Peru

Association for the Prevention of Delinquency (Aprede), Antigua, Guatemala

Patricio Atkinson (founder of the God's Child project), Antigua, Guatemala

Cristina Bubba (ethnologist), La Paz

Pedro Camaja (director of the Fundebase Association), Antigua, Guatemala

Benigno Ramos Challco, Arequipa, Peru

Claudia Lucia Diaz Lopez and her family, Antigua, Guatemala

Julieta Gil Elorduy (ethnologist) and the staff at the National Museum of Anthropology library), Mexico City

Dario Espinosa (Quechua language specialist), La Paz

Dario Espinoza (historian and founder of the language center SAMI), Cuzco, Peru

Suzanne Pons Fernandez, Cayenne, French Guiana

Hugo Fernandez, Felipe Santos Quispe, and Rodolfo Quisbert Peña (Association of Aymaras and Andean Oral History [THOA]), La Paz

Hector Flores (Nasa Andean cultural assertion team), Puno, Peru

Alain Fouquet (French Ambassador), La Paz

Alberto Rafael Gonzales Figueroa (salsa teacher), Antigua, Guatemala

Geovany Ranjel Grijalva, Panajachel, Guatemala

Melva Patricia Gualinga Montalvo (Regional Council's Legal Land Associated Department), Ecuador

Éric Van Hecke, Rio de Janeiro

Gloria de la Luz (International Press Center), Havana

Silvio David Malaver Santi (a member of Atayak [a group of wise men charged with perpetuating the tradition] and of the Sarayaku community), Ecuador

Guia and Tomas Mayo Vargas, Potosi, Bolivia

Veronica Milchorena (director of the Short Film Festival), Miami, Florida

Renaud and Claudia Neunbauer, Quito

Ricardo Olmedo, Julia Pons, and Rita Pons (connoisseurs of Salvadoran popular tradition), San Salvador

Ana Maria Pedroni (literature professor), Antigua, Guatemala

Maria del Perpetuo Socorro Villareal Escarrega (national coordinator for the National Institute of Anthropology and History), Mexico City

Gloria Perpetuo Varga (Quechua language teacher), Ayacucho, Peru

David Pinto Reyfeo (university of San Carlos), Guatemala City

Evelyn Pons (oral tradition researcher), El Salvador

Grimaldo Rengifo and Jorge Ishizawa (founder of Proyecto Andino de Tecnologias Campesinas), Lima

Silvia Rojo Lugo and Gloria Amtmann Aguilar (specialists in Mexican popular singers), Mexico City

Marco Antonio Sagastume Gemmelle (manager at the university of San Carlos, coordinator of the Gran Confederación de Aj'quijab Principales), Guatemala City

Ulio Santander, La Paz

Gustavo Adolfo Terceros, Uyuni, Bolivia

Juan Carlos Schulze (director of the Programa Regional de Apoyo a los Pueblos Indígenas Amazónicos), La Paz

Helène Toury, La Paz

Carlos Vasquez Corrales (director of international cooperation), Lima

Juan de Dios Yapita (teacher at the Aymara Language and Literature Institute), Lima

Jose Carlos Da Conceicao Ferreira, Salvador do Bahia, Brazil

Dante Valdes (engineer), Guatemala City